Art of the Twentieth Century
A Reader

Art of the Twentieth Century

A Reader

Edited by Jason Gaiger and Paul Wood

Yale University Press, New Haven and London
in association with The Open University

This volume accompanies the Open University course Art of the Twentieth Century, which examines the fundamental changes that took place in the concepts and practices of art during the last century. There are four other books in the series, all published by Yale University Press in association with the Open University:

Frameworks for Modern Art, edited by Jason Gaiger
The Art of the Avant-Gardes, edited by Steve Edwards and Paul Wood
Varieties of Modernism, edited by Paul Wood
Themes in Contemporary Art, edited by Gill Perry and Paul Wood

Jason Gaiger is a Lecturer in the History of Art at the Open University.
Paul Wood is a Senior Lecturer in the History of Art at the Open University.

First published 2003

For information about this and other Yale University Press publications, please contact:
U.S. Office: sales@press@yale.edu yalebooks.com
Europe Office : sales@yaleup.co.uk www.yalebooks.co.uk

Printed in Great Britain by Biddles Ltd.
Library of Congress Catalog Card Number 2003114629
ISBN 0-300-10144-9

A catalogue record for this book is available from the British Library

CONTENTS

Acknowledgements IX
A Note on the Presentation and Editing of Texts X
List of Illustrations XI

Introduction XIX

I Modernism and the Crisis of Modernism

Introduction 3

1 Selection of statements on early modernism 4

 (i) Clive Bell 4
 'Simplification and Design', 1913

 (ii) Roger Fry 7
 'Negro Sculpture', 1920

 (iii) Carola Giedion-Welcker 10
 from *Modern Plastic Art*, 1937

 (iv) Robert Goldwater 16
 'A Definition of Primitivism', 1938

 (v) Sheldon Cheney 18
 from *The Story of Modern Art*, 1941

 (vi) Elaine de Kooning 20
 'Statement', 1959

2 Meyer Schapiro 22
 'The Nature of Abstract Art', 1937

3 Eugene Lunn 31
 'Modernism in Comparative Perspective', 1982

4 T.J. Clark 38
 from *Farewell to an Idea*, 1999

II Avant-Garde and Neo-Avant-Garde

Introduction 55

1 Peter Bürger 56
 from *Theory of the Avant-Garde*, 1974

2 Paul Smith 62
 'How a Cubist Painting Holds Together', 2002

3 Clement Greenberg 89
 'The Pasted-Paper Revolution', 1958

4 Henri Lefebvre 94
 from *The Critique of Everyday Life*, 1947

5 Benjamin Buchloh 98
 'The Primary Colours for the Second Time:
 A Paradigm Repetition of the Neo-Avant-Garde', 1986

III Modernity and Photography

Introduction 109

1 Walter Benjamin 110
 'News about Flowers', 1928

2 Hannah Höch 112
 'A Few Words on Photomontage', 1934

3 Rosalind Krauss 114
 'Photography in the Service of Surrealism', 1986

4 John Szarkowski 132
 from *The Photographer's Eye*, 1969

5 Allan Sekula 139
 'Dismantling Modernism, Reinventing
 Documentary (Notes on the Politics of Representation)',
 1976–8

6 Jeff Wall 145
 ' "Marks of Indifference": Aspects of
 Photography in, or as, Conceptual Art', 1995

IV Subjects and Objects

Introduction 167

1 Philip Leider 168
 'Literalism and Abstraction', 1970

2 Alex Potts 174
 'Space, Time and Situation', 2000

3 Lucy Lippard 189
 'Escape Attempts', 1995

4 Clement Greenberg 198
 'Convention and Innovation', 1976

5 Charles Harrison 205
 'Art Object and Art Work', 1989

6 Miwon Kwon 213
 'One Place After Another: Notes on Site Specificity', 1997

V The Performance of Identity

Introduction 225

1 Frank O'Hara 225
 'Personism: A Manifesto', 1960

2 Griselda Pollock 227
 'Painting, Feminism, History', 2001

3 Craig Owens 249
 'The Discourse of Others: Feminists and
 Postmodernism', 1985

4 Amelia Jones 261
 from *Body Art: Performing the Subject*, 1998

5 Briony Fer 274
 'Objects Beyond Objecthood', 1999

VI Globalisation

Introduction 289

1 Stuart Hall 290
 'What is this "black" in black popular culture?', 1992

2 Sarat Maharaj 297
 'Perfidious Fidelity: the Untranslatability of the Other',
 1994

3 Rex Butler 304
 'Emily Kame Kngwarreye and the
 Undeconstructible Space of Justice', 1998

4 Okwui Enwezor 319
 'The Black Box', 2002

Index 327
Text Acknowledgements 345

ACKNOWLEDGEMENTS

Our first and most important acknowledgement is to the authors who have allowed their material to be reprinted in the present book, often in edited form. We are grateful for their co-operation, without which the collection could not have been compiled. The book stands as an independent anthology of art-historical texts on the art of the twentieth century. Its primary purpose, however, is to serve as a Reader for an Open University art history course (AA318), also titled *Art of the Twentieth Century*. Open University courses are by their nature collaborative affairs, and both the format of this Reader and its particular contents have been collectively approved by the course team. The full-time academic members of the course team were, in addition to ourselves, Steve Edwards, Charles Harrison, Gill Perry and Niru Ratnam. We would also like to thank our course manager, Heather Kelly, and Julie Bennet and Denise Hall who worked on the preparation of the typescript. Without their efforts, the project would not have been possible.

Jason Gaiger
Paul Wood

A NOTE ON THE PRESENTATION AND EDITING OF TEXTS

Where a published document was originally given a title, we have retained that title, given in single quotation marks. Titles of books are given in italics. The date of original publication is given after each title on the contents pages. The details of original publication are provided in full at the end of each text introduction, with page references for the extracts we have taken.

Where texts have been edited, the following conventions have been used throughout. Ellipses '. . .' are used to denote the omission of words or phrases within a sentence. Ellipses within square brackets [. . .] are used to denote omissions extending from a complete sentence to a paragraph. More substantial omissions are indicated by * * *.

Notes and references have been included only when necessary to the extracts as we have printed them. Footnotes have been renumbered as required. We have avoided the insertion of editorial footnotes, but have attempted to provide relevant information in the various Part and text introductions. Some of the texts included here were edited and introduced by Steve Edwards and Gill Perry. Their contribution is acknowledged by their initials in square brackets at the end of the relevant introductions.

J.G.
P.W.

LIST OF ILLUSTRATIONS

Colour plate Pablo Picasso, *Houses on the Hill, Horta d'Ebro*, summer 1909,
oil on canvas, 65 x 81 cm. The Museum of Modern Art,
New York. Nelson A. Rockefeller Bequest. Digital image
© 2002 The Museum of Modern Art, New York. Scala 0122028
© Succession Picasso/DACS, London 2003.

PART I

Plate 1 Paul Cézanne, *Three Bathers*, 1879–82, oil on canvas,
52 x 55 cm. Copyright Photothèque des Musées de la Ville
de Paris/Cliché. 5

Plate 2 Constantin Brancusi, *Fish*, 1926, bronze, metal and wood,
93 x 50 x 50 cm. © Tate, London, 2003. © ADAGP, Paris and
DACS, London 2003. 12

Plate 3 Elaine de Kooning, *Untitled*, c. 1948, enamel on cardboard,
8 x 9⅞ inches. Photo: Arkansas Arts Centre. Foundation Purchase,
1999.99.8. Courtesy of the Estate of Elaine de Kooning. 21

Plate 4 Adolph Menzel, *Moltke's Binoculars*, 1871, pencil and
gouache on paper, 26 x 40 cm. Kupferstichkabinett, Staatliche
Museen, Berlin. Courtesy of BPK, Germany. Photo: Joerg
P. Anders. 38

Plate 5 John Heartfield, '*A New Man – Master of a New World*', 1934,
photomontage, 38 x 27 cm. Stiftung Archive der Akademie
der Künste. Copyright © DACS, London, 2003. 40

Plate 6 Pablo Picasso, *Italian Woman*, oil on linen, 98.5 x 70.5 cm, 1919.
Private Collection. 41

Plate 7 Kasimir Malevich, *Complex Presentiment (Half-Figure in a
Yellow Shirt)*, 1928–32, oil on canvas, 98.5 x 78.5 cm. State Russian
Museum, St Petersburg. Photo: Bridgeman Art Library, London. 42

Plate 8 Tina Modotti, *Men Reading 'El Machete'*, 1924, photograph,
17.1 x 23.5 cm. Courtesy of Throckmorton Fine Art, New York. 44

PART II

Plate 9 Paul Cézanne, *Still Life with Plaster Cupid*, c.1894, oil
 on paper laid on board, 70.6 x 57.3 cm. Courtauld Institute
 Gallery, Somerset House, London. 64

Plate 10 Pablo Picasso, *Figure*, 1907, traces of oil and gesso, brass pins, wood,
 23.5 x 5.5 x 5.5 cm, Art Gallery of Ontario, Toronto. Purchase 1980.
 Photo: AGO/Carlo Catenazzi. © Succession Picasso/
 DACS, London 2003. 65

Plate 11 Georges Braque, *Mandora*, 1910, oil on canvas, 73 x 60 cm.
 © Tate, London 2003. © ADAGP, Paris and DACS,
 London 2003. 67

Plate 12 Georges Braque, *The Castle at la Roche-Guyon*, 1909,
 oil on canvas, 92 x 73 cm. Van AbbeMuseum, Eindhoven, The
 Netherlands. © ADAGP, Paris and DACS, London 2003. 68

Plate 13 Kurt Schwitters, *Aphorism*, 1923, collage on card, support
 8.9 x 7.3 cm. © Tate, London 2003. © DACS, London 2003. 92

PART III

Plate 14 Man Ray, *Monument to D.A.F de Sade*, 1933, gelatin silver
 print and ink, 20 x 16 cm. Israel Museum, Jerusalem, courtesy of
 The Vera, Silvia and Arturo Schwarz Collection of Dada and
 Surrealist Art. Photo: Avshalom Avital. © Man Ray Trust/
 ADAGP, Paris and DACS, London 2003. 117

Plate 15 Jacques-André Boiffard, *The Big Toe*, 1929, photograph
 from Georges Bataille 'Le gros orteil' in *Documents, No 6*, 1929.
 Centre Pompidou-MNAM-CCI, Paris. Photo: © CNAC/MNAM
 Dist. RMN. 121

Plate 16 Raoul Ubac, *Women/Cloud (La Nébuleuse)*, 1939, Centre Pompidou-
 MNAM-CCI, Paris. CNAC/MNAM Dist. RMN © ADAGP Paris and
 DACS, London 2003. 121

Plate 17 André Breton, *L'Ecriture Automatique*, 1938, photomontage,
 14.2 x 19 cm. The Vera, Silvia and Arturo Schwarz Collection of Dada
 and Surrealist Art at the Israel Museum, Jerusalem. Photo: Avshalom
 Avital © ADAGP, Paris and DACS, London 2003. 122

Plate 18 Salvador Dali, *The Phenomenon of Ecstasy*, photomontage
 from *Minotaure*, Nos. 3–4, 14 December 1933. Courtesy of The
 British Library, London. BL c.180.d.1. © Salvador Dali, Gala -
 Salvador Dali Foundations/DACS, London 2003. 125

Plate 19 Hans Bellmer, *Doll*, 1936/49, silverprint coloured with aniline,

	41 x 32.9 cm. Centre Pompidou-MNAM-CCI, Paris. © Photo: CNAC/MNAM Dist. RMN. © ADAGP, Paris and DACS, London 2003.	127
Plate 20	Man Ray, *Slipper-spoon*, 1934, photograph. Courtesy of Telimage – 2003. © Man Ray Trust, ADAGP, Paris and DACS, London 2003.	128
Plate 21	Martha Rosler, *The Bowery in Two Inadequate Descriptive Systems*, 1974–5, detail. Photo: Courtesy Gorney Bravin and Lee, New York. © Martha Rosler.	144
Plate 22	Alfred Steiglitz, *Flatiron Building*, c.1902–3, photograph, 17 x 8 cm. Museum of Fine Arts, Boston, Gift of Miss Georgia O'Keefe. 50.833. Photo: © 2003 Museum of Fine Arts, Boston. © The Georgia O'Keefe Foundation.	146
Plate 23	André Kertész, *Meudon*, 1928, photograph, 42 x 32 cm. Courtesy of The Metropolitan Museum of Art, New York. © Estate of André Kertész.	147
Plate 24	Richard Long, *A Line Made by Walking*, 1967, photograph and pencil on board, 37 x 32 cm. © Tate, London 2003. © Richard Long.	151
Plate 25	Bruce Nauman, *Dance or Exercise on the Perimeter of a Square (Square Dance)*, 1967–68, Courtesy of Electronic Arts Intermix (EAI), New York. © ARS, NY and DACS, London 2003.	154
Plate 26	Edward Ruscha, *Some Los Angeles Apartments*, 1965, Courtesy of Gagosian Gallery, New York.	162

PART IV

Plate 27	Frank Stella, *Six Mile Bottom*, 1960, metallic paint on canvas, 300 x 182 cm. Courtesy of © Tate, London 2003 © ARS, NY and DACS London 2003.	171
Plate 28	Barnett Newman, *Vir Heroicus Sublimis,*, 1950–1, oil on canvas, 243 x 542 cm. The Museum of Modern Art, New York. Gift of Mr and Mrs Ben Heller. DIGITAL IMAGE © 2002 The Museum of Modern Art, New York/Scala, Florence. © ARS, NY and DACS, London 2003.	177
Plate 29	Donald Judd, *Untitled*, 1972, copper, enamel and aluminium, 91.6 x 155 x 178 cm. © Tate, London 2003. Art © Donald Judd Foundation/VAGA,New York/DACS, London 2003.	182
Plate 30	Donald Judd, *Untitled*, 1970, brass and red fluorescent Plexiglas, 15.2 x 68.6 x 61 cm (ten units each), 305 x 68.6 x 61 cm overall.	

Courtesy of Pace Wildenstein, New York. Photo: Ellen Page
Wilson. Art © Donald Judd Foundation/VAGA, New York/DACS,
London 2003. 183

Plate 31 Anthony Caro, *Early One Morning*, 1962, painted steel and
aluminium, 290 x 620 x 335 cm. © Tate, London 2003.
© Anthony Caro. 184

Plate 32 Carl Andre, *144 Magnesium Square*, 1969, magnesium, 144
units each 30.5 x 30.5 cm. Overall 1 x 365.5 x 365.5 cm. © Tate,
London 2003. © Carl Andre/VAGA, New York/ DACS,
London 2003. 186

Plate 33 Mierle Laderman Ukeles, *Washing Tracks/Maintenance:
Inside*, 1973, black and white photograph of performance at
Wadsworth Atheneum, Hartford, Connecticut. Courtesy of
Ronald Feldman Fine Arts, New York. 195

Plate 34 Art & Language, *Index 01*, ('*Documenta Index*'), 1972,
Installation at 'l'art conceptuel, une perspective', Musée d'Art
Moderne de la Ville de Paris, 1989. Eight file cabinets, text
and photostats, dimensions variable. Collection Daros, Zurich.
Photo: Charles Harrison. 210

PART V

Plate 35 Henri Matisse, *The Painter and his Model*, 1917, oil on canvas, 146.5
x 97 CM. Centre Pompidou-MNAM-CCI, Paris. Photo: ©
CNAC/MNAM Dist. RMN. © Succession H. Matisse/DACS,
London 2003. 228

Plate 36 Martha Rosler, *The Bowery in Two Inadequate Descriptive
Systems*, 1974–5, detail. Courtesy Gorney Bravin and Lee,
New York. © Martha Rosler. 253

Plate 37 Cindy Sherman, *Untitled Film Still, # 21*, 1978, photograph,
76.2 x 101.6 cm. Courtesy Cindy Sherman and Metro
Pictures, New York. 256

Plate 38 Barbara Kruger, *Untitled, (Your Body is a Battle Ground)*,
1989, photographic silkscreen on vinyl, 92¾ x 126 inches.
Courtesy of The Broad Art Foundation, California. © Mary
Boone Gallery, New York. 257

Plate 39 Ana Mendieta, *Untitled* from Silueta Series, 1978, earth work
with gunpowder, executed in Iowa. Courtesy of the Estate of
Ana Mendieta and Galerie Lelong, New York. 265

Plate 40 Eva Hesse, *Several*, 1965, acrylic paint and papier-mâché over
seven balloons with rubber cord, 84 x 117 inches. © The Estate
of Eva Hesse, Galerie Hauser and Wirth, Zurich. 276

Plate 41 Eva Hesse, *Metronomic Irregularity II*, 1966, painted wood,
 sculpmetal and covered wire, 48 x 240 inches. © The Estate of
 Eva Hesse, Galerie Hauser and Wirth, Zurich. 276
Plate 42 Louise Bourgeois, *Double Negative*, 1963, latex over plaster,
 49.2 x 92.2 x 79.6 cm. Kröller-Müller Museum, Otterlo, The
 Netherlands. © Louise Bourgeois/VAGA, New York/DACS,
 London 2003. 277
Plate 43 Louise Bourgeois, *Le Regard*, 1966, latex and cloth, 12.7 x 39.4 x
 36.8 cm. Courtesy of Cheim and Reed, New York. Photo:
 Christopher Burke. © Louise Bourgeois/VAGA, New York/DACS,
 London 2003. 278

PART VI

Plate 44 Chohreh Feyzdjou, *Sans Titre* [*Boutique Product of Chohreh
 Feyzdjou*], 1975–89, Courtesy of Documenta Archiv, Kassel,
 Germany. © Fonds national d'art contemporain, Ministère de
 la culture, Paris. 301
Plate 45 Emily Kam Kngwarrey, Eastern Anmatyerre, *c.* 1910–1996,
 Anker Mern-Intekw, 1990, synthetic polymer paint on canvas,
 199.4 x 128.3 cm, Purchase from Admission Funds 1990,
 National Gallery of Victoria, Melbourne. Australia.
 © DACS, London 2003. 308
Plate 46 Emily Kam Kngwarrey, *Anooralya II*, 1995, Purchase from
 Admission Funds 1990, National Gallery of Victoria, Melbourne.
 Australia. © DACS, London 2003. 309
Plate 47 Installation view of Queensland Art Gallery exhibition
 Emily Kam Kngwarrey, 1996, showing installation of
 Utopia Panels, synthetic polymer paint on canvas, 18 panels
 each 280 x 100 cm (approx). Commissioned 1996 by the
 Queensland Art Gallery with Funds from the Andrew Thyne
 Reid Charitable Trust through and with assistance of the
 Queensland Art Gallery Foundation. Queensland Art Gallery,
 Brisbane. © DACS, London 2003. 310
Plate 48 Emily Kam Kngwarrey, Eastern Anmatyerre, *c.* 1910–1996,
 Utopia Panel, 1996, synthetic polymer paint on canvas,
 262.8 x 85.6 cm. Commissioned 1996 by the Queensland
 Art Gallery with Funds from the Andrew Thyne Reid
 Charitable Trust through and with assistance of the
 Queensland Art Gallery Foundation. Queensland Art Gallery,
 Brisbane. © DACS, London 2003. 314
Plate 49 Emily Kam Kngwarrey, Eastern Anmatyerre, *c.* 1910–1996,

Body Paint: Awelye I-VI, 1994, synthetic polymer paint on paper, 6 works each 77 x 56.3 cm. Purchased through The Art Foundation of Victoria with assistance of Alcoa of Australia Ltd, Governor, 1194. National Gallery of Victoria, Melbourne, Australia. © DACS, London 2003. 315

Plate 50 Emily Kam Kngwarrey, Eastern Anmatyerre, *c.* 1910–1996, *Untitled (Awelye)*, 1989, synthetic polymer paint on linen, 90.5 x 60.5 cm. Purchased 1999. Queensland Art Gallery Foundation Grant and Queensland Art Gallery Functions Reserve Fund. Collection: Queensland Art Gallery, Brisbane. © DACS, London 2003. 317

Fig. 1 The significance of the direction of tonal contrast in photographs and line drawings. A photograph of a face, and the same photograph passed through a 'cartoon operator' geared to extracting sharp falls in the image's luminosity. From J. Willats, *Art and Representation: New Principles in the Analysis of Pictures*, 1997, Princeton University Press, New Jersey. Copyright © PUP. Reprinted by permission of Princeton University Press, fig. 14.6. 72

Fig. 2 Illustration of all the corners possible in drawings of rectangular objects. Arrows denote occluding edges, plus signs denote a convex edge, and minus signs denote a concave edge. From Willats, *Art and Representation*, Princeton University Press, 1997, fig. 5.3. 74

Fig. 3 *The Penrose Triangle*. Originally published in: R. Penrose, 'Impossible Objects: A Special Type of Visual Illusion', *British Journal of Psychology*, 49, pp. 31-3, 1958. 74

Fig. 4 Vector Primitives in a $2\frac{1}{2}$D sketch of a cube. The slant of the arrows indicates surface orientation with respect to the viewer; and their length indicates their distance from the viewer. The dotted lines indicate occluding contours. From D. Marr, *Vision: a computational investigation into human representation and processing of visual information*, New York, Freeman, 1982, figure 4.2. 74

Fig. 5 Features exhibited by a cube allowing an object-centred description to be derived from them. From V. Bruce, P. Green, and M.A. Georgeson, *Visual Perception: physiology, psychology and ecology*, 3rd edition, Hove, Psychology Press, 1996/7, fig. 9.19. 75

Fig. 6 Drawings of shapes which can be mentally rotated for comparison. Only the pairs (a) and (b) are indentical. From Marr, *Vision*, fig. 1.2. 76

Fig. 7 Drawing indicating how a human can be recognised in relation to a series of progressively more finely articulated object-centred descriptions of cylinders (although these are shown lying along

viewer-centred axes). From Marr, *Vision*, figure 5.3. 77

Fig. 8 'Geons' and their combinations in objects. From Bruce, Green
 and Georgeson, *Visual Perception*, fig. 9.22. 77

Fig. 9 Illustration from J.P.Thénot, *Traité pratique pour dessiner d'après
 nature mis à la portée de toutes les intelligences*, Paris, Carilian-
 Goeury et Dalmont, 1845. 78

Fig. 10 Drawing and denotation systems used in children's drawings of
 cubes. Object-centred descriptions are indicated by (o-c); and
 viewer-centred descriptions are indicated by (v-c). The asterisk
 indicates distortion in the drawing of regions. From Willats, *Art
 and Representation*, fig. 8.4. Based on drawings of cubes originally
 published in: A.L. Nicholls and J.M. Kennedy, 'Drawing
 Development: from similarity of features to direction', *Child
 Development*, 63, pp. 227–41, 1992. 79

Fig. 11 Drawing indicating the role played by shadows in the perception
 of objects' relationships to one another. In (a) the absence of
 shadows means there is no evidence with which to judge whether
 they touch one another or the ground; in (b) shadows make it
 possible to judge that the shapes touch one another or the ground
 in those places marked by asterisks; (c) shadows provide evidence
 that the objects neither touch one another nor the ground in those
 places marked by asterisks. From Willats, *Art and Representation*,
 fig. 6.6 (p. 138). 82

Fig. 12 The Necker illusion. The drawing (a) is ambiguous, since it
 contains too many depth clues, which allow it to be seen as
 either of the two cubes represented in (b) and (c). From Marr,
 Vision, fig. 1.5, p. 26. 85

Fig. 13 Plan of a Winnebago village according to informants of the
 lower phratry. 305

Fig. 14 Plan of a Winnebago village according to informants of the
 upper phratry. 305
 Both taken from *Structural Anthropology*.
 Claude Lévi-Strauss, Allen Lane, The Penguin Press, 1963
 reprint 1969.

INTRODUCTION

This book collects together a variety of critical and art-historical reflections on the art of the twentieth century. Clearly, this is an enormous field, and our selection is just that: a selection. The texts we have brought together are primarily intended to serve as a dedicated Reader for the Open University art history course *Art of the Twentieth Century*. As such they relate in the first instance to the four books that make up that course. But beyond that, the present book stands independently as a selective survey of an evolving field of debate. The essays we have collected are not of one single type. For example, we reprint a number of historical documents, including two texts by the Bloomsbury critics Clive Bell and Roger Fry, an essay on photomontage by the German artist Hannah Höch, dating from the 1930s, and a 'manifesto' from the 1950s by the American poet Frank O'Hara. More usually, however, we have sought to present texts that discuss and debate historical developments in modern art. Not exclusively, but principally, this is a collection of writings by art historians, or other interested commentators, *about* art.

Art history, and in particular the art history of the modern period, is a relatively young discipline. Attempts were made to plot the already varied development of modern art during the 1920s and 1930s. These ranged from treatments such as *The ISMs of Art*, compiled by the artists El Lissitsky and Lázló Moholy-Nagy in 1924, which is basically an illustrated list of recent avant-garde movements, through to considered attempts to map the field: such as Herbert Read's *Art Now* of 1933 or Alfred H. Barr's *Cubism and Abstract Art* of 1936. But modern art history as an academic discipline is fundamentally of the second half of the twentieth century. Indeed, it expanded enormously in the period of postmodernism, since the 1970s. During this time, the range of approaches has also multiplied dramatically. With this in mind, therefore, this collection is intended to provide not just a reasonably comprehensive set of discussions of key themes and issues in modern art, but different ways of conducting those discussions. We offer, that is to say, not just treatments of important subjects, but examples of different art-historical methods. These include variant approaches to the formal analysis of artworks; attention to the social context of the production of art; phenomenological analysis; and approaches that variously draw on semiotics, on structuralism and on psychoanalysis.

We have provided short introductions to each of the texts, as well as introductions to each of the book's six Parts. The purpose of this Introduction is to say a few words about the structure of the book as a whole. The first Part is devoted to modernism. No discussion of art in the twentieth century

could afford to ignore the concept of modernism, yet what constitutes modernism, as well as what is good and bad in it, remains a matter of considerable debate. The term is employed in two different ways: one relatively inclusive, the other relatively exclusive. In the former, the term is interchangeable with what used to be called the 'modern movement' as a whole, running from Impressionism in the late nineteenth century, through the 'isms' of the earlier twentieth century (including such diverse movements as Expressionism, Cubism, Futurism, Constructivism, Dadaism and Surrealism), to mid-twentieth-century practices such as Abstract Expressionism, Pop Art and Minimal Art. At the risk of over-simplification, it is probably true to say that this inclusive sense of modernism tends to stress the response of artists to the world beyond art, that is, to the condition of modernity. Thus, the specific forms of modern art, such as vivid colours, distortions of various kinds or three-dimensional constructions are related to social alienation, say, or technological advance.

The other, more exclusive sense of modernism does precisely the opposite: it stresses the increasing autonomy of modern art. In this view, modernist art centres on the production of aesthetic effects for its viewers, rather than on communicating information about the world, or offering political and ethical exhortations to action of various kinds. This sense of modernism, sometimes capitalised as 'Modernism', was given its most articulate formulation by postwar American critics. Most notable among these was Clement Greenberg (with whom the term 'modernism' itself is closely identified). This conception of modernism was animated by a closely interlinked pairing: the 'form' of the work of art, dubbed 'significant form' by Clive Bell, and the resulting aesthetic response, the 'aesthetic emotion', which the resolved formal configuration should cause in the adequately attuned spectator. This is the conceptual heart of modernism. Form predominates over subject-matter and content, and what art is for is to make the spectator *feel* something, not *know* something. The paradigmatic type of art that answered to these requirements was abstract. This view, according to which an autonomous art was seen to have evolved over a century-long process of jettisoning superfluous conventions, issued in an idea of the evolution of a 'modernist mainstream'. Again at the risk of oversimplification, one could say that whereas the inclusive sense of modernist art tends to be characterised by additive strategies, for example collage, or montage, construction and hybrid performances or installations, the exclusive sense is characterised by a progressive logic of purification, whereby artworks are purged of apparently extraneous elements in the pursuit of a unitary aesthetic effect.

It was the second sense of modernism that had become hegemonic by the 1960s. Indeed, it was the entry of that modernism into a crisis from which it failed to recover that prompted various re-readings of the art of the twentieth century, in particular the broaching of the idea that from the 1960s

onwards art has been produced out of a distinct 'postmodernist' situation. The art that was excluded from the modernist mainstream, because of factors such as its evident political allegiance, its continuing involvement with 'literary' narrative, or its implication in popular culture or in adjacent fields such as design or architecture, has come to be regarded as part of an oppositional 'avant-garde'. This too is a term that is open to interpretation in different ways. In Greenberg's usage, the notion of the avant-garde was identified with the development of a purified abstract art, culminating in the work of the post-war Abstract Expressionists and their immediate successors. However, since the 1960s, it has become more usual to reserve the notion of 'avant-garde' for those movements that sought to overcome the gap between autonomous modernist art and the wider modern condition, rather than art that emphasised that distance. Here the term is used to refer to Futurism, Dada, Constructivism and Surrealism, with Cubism and Expressionism occupying more ambiguous positions. The category is then often extended from these 'classic' avant-gardes of the early twentieth century to cover the so-called 'neo-avant-garde' of the 1950s and 1960s, when certain artists continued to resist the exclusive focus on the purified aesthetic characteristic of the by-then dominant theory and practice of modernism. Such categorisations, it goes almost without saying, are open to challenge. The boundaries are distinctly porous, and there are exceptions to every rule.

Our first two Parts, then, are devoted to modernism on the one hand, and the avant-garde on the other. The first includes a cluster of pioneering texts that bring out various important aspects of early modernism, ranging from the premium placed on form, to the thorny question of the 'primitive'. This Part also includes three essays that variously seek to criticise, contextualise and broaden this view of modernism. The second Part contains different treatments of the avant-garde, ranging from Bürger's now classic distinction of avant-gardism from modernism, to Greenberg's resolutely modernist reading of Cubist collage. These interests then carry over into our third Part, which we have separated out because the issue of photography seems to merit distinct attention. Photography has played a key role in the avant-garde tradition in inverse proportion to its exclusion from the abstract art of the modernist mainstream. However, at the height of modernism's hegemony in the 1960s, a powerful attempt was made to offer a modernist reading of photography itself. We have included Szarkowski's text in Part III as a kind of counterpoint to the other pieces there.

The crisis of modernism in the late 1960s prompted various 'revisionist' approaches: these extended from the practice of art itself to new aspects of the writing of art history. 'Postmodernism' appeared in the literature as yet another contested term, which, if it did nothing else, served to indicate that some order of important change was taking place, even if few could agree on what characterised it. Part IV includes a variety of texts that discuss this turning point from several different points of view. Its main subjects are the late mod-

ernism, Minimalism and Conceptual Art of the 1960s, as well as the 'expanded field' of subsequent postmodernist installation. Once again, however, the different methods employed by art historians are perhaps as significant as the subjects they address, and the treatments here range from formal analysis, to institutional and feminist histories.

If modernism can be said to have centred on the aesthetic, and eventually to have become something of an official art for the highly differentiated liberal-capitalist societies of the West, its historical opposition in the shape of the politicised avant-gardes of the early twentieth century tended to draw upon left-wing class analysis for critical support. The concept of the avant-garde was itself rooted in the nineteenth-century utopian socialist tradition. Surrealism and Constructivism in particular represent the high water mark of this counter to the social and cultural norms of 'bourgeois society'. The period of the late 1960s and early 1970s witnessed the beginning of an ongoing crisis of the traditional Left that was no less severe than the crisis of modernism in art. With gathering force through the 1980s, social class became decentred in art-critical debate, balanced now by a plurality of oppositional languages focused on questions of gender, sexuality and ethnicity. Indeed, identity politics, if it did not entirely eclipse class politics, certainly led to a thoroughgoing revision during the later twentieth century in the sense both of what cultural radicalism might consist in and what it was for. The goal of a revolutionary overthrow of capitalism, which had been as prevalent in the language of critical art practice around 1970 as it was half a century earlier, tended to moderate into a less chiliastic sense of 'resistance': resistance, that is, to the incursions of an increasingly totalising system apparently bent on the regulation and commodification of everything from daily life to individual subjectivity. After the end of the Cold War, critically minded artists found themselves addressing the closures of a global system, closures that seemed to operate simultaneously on microscopic and macroscopic levels. The final two Parts of the book are thus devoted to, on the one hand, a selection of texts discussing questions of subjectivity and gendered identity, and on the other, the consequences of the increasing globalisation of culture that took place towards the end of the twentieth century.

We thus find ourselves a long way from modernism, at least from modernism in its canonical sense: the modernism that, in Greenberg's phrase 'avoided subject matter like the plague'. At the end of the twentieth century, modernity in its myriad forms returned explicitly to the centre of the agenda for advanced art. Arguably, however, the modern condition has never been far from modern art, even at its most resolutely abstract. As our retrospect lengthens, and we are enabled to move beyond interim distinctions and periodisations, a more comprehensive picture will eventually emerge of modern art's relation to its time. For the present, this Reader, and the art history course it serves, offer a provisional account of the art of the twentieth century before the dust has settled.

PART I

MODERNISM AND THE CRISIS

OF MODERNISM

Introduction

Many of the central theoretical statements of artistic modernism have been frequently reprinted. These include Roger Fry's 'Essay in Aesthetics' (1909), Clive Bell's 'The Aesthetic Hypothesis' (1914), Alfred H. Barr's *Cubism and Abstract Art* (1936), Harold Rosenberg's 'American Action Painters' (1952), and above all Clement Greenberg's 'Avant-Garde and Kitsch' (1939) and 'Modernist Painting' (1960/65). Accordingly we offer a selection of short statements, often from less well-known texts, that provide a cross-section of key modernist themes. In this way we hope to refresh what has become a stale understanding of classic 'formalist' modernism. Clive Bell seeks to establish the priority of judgements of value ('In art the only important distinction is the distinction between good art and bad'), the status of Cézanne as the great progenitor, and the freeing of art from 'literary and scientific irrelevancies'. Sheldon Cheney condenses modernism into a set of basic precepts concerning progressive development, consciousness of form, and the dominance of sensibility and intuition over reason and intellect. Modernist theory tended to privilege painting at the expense of sculpture. An exception is Carola Giedion-Welcker's *Modern Plastic Art*, which is as interesting for its attempt to relate modernist sculpture to wider contemporary intellectual currents, as for its formal analysis of sculpture itself. Roger Fry and Robert Goldwater both address the paradox of modernism's dependence on an ideology of the primitive and the authentic: in Goldwater's words, the belief that 'the further one goes back ... the simpler things become', and that 'because they are simpler they are more profound'. This cross-section of modernist thinking is rounded off by Elaine de Kooning's emphatic Rosenberg-influenced assertion of painting as an intense, passionate *activity*, 'abstract action, action for its own sake'.

These statements of canonical modernism are followed by three critical reflections upon modernism. Meyer Schapiro underlines the importance of attending to social context in any attempt to understand the meaning of putatively autonomous art. Eugene Lunn offers a comparative assessment of some central traits of modernism. T.J. Clark, writing at the very close of the twentieth century, offers a complex set of reflections upon the relationship of artistic modernism to the wider modern condition, and perhaps the beginnings of a more nuanced understanding of what modernism in its fullest sense might have been: the simultaneous registration and transfiguration of a disenchanted world, an attempt to acknowledge the contingency of everything, and yet, in Clark's words to 'find a way back to totality'.

1. Selection of statements on early modernism

We offer here a collage of six texts illuminating different aspects of modernist theory.

1(i). Clive Bell, 'Simplification and Design'

The critic Clive Bell had gained first-hand experience of modern French art during a stay in Paris in 1904. Later, in 1910, at the age of twenty-nine, he met the older critic Roger Fry and helped in organising the seminal 'Post-Impressionist' exhibitions in 1910 and 1912. Bell's book *Art* was published in 1914. It offers a resolutely formalist and essentialist account of art. In his opening chapter, 'The Aesthetic Hypothesis', Bell asked, 'What quality is shared by all objects that provoke our aesthetic emotions?' The answer he gave was 'significant form'. 'Simplification and Design' appears in the final part of the book, titled 'The Movement', which traces the debt of modern art to Cézanne, and rehearses some of modernism's main features. The following extracts are taken from Clive Bell, *Art*, ed. J.B. Bullen, Oxford University Press, Oxford, 1987, pp. 215–17, 219–20, 223–5 and 228–9.

AT the risk of becoming a bore I repeat that there is something ludicrous about hunting for characteristics in the art of to-day or of yesterday, or of any particular period. In art the only important distinction is the distinction between good art and bad. That this pot was made in Mesopotamia about 4,000 B.C., and that picture in Paris about 1913 A.D., is of very little consequence. Nevertheless, it is possible, though not very profitable, to distinguish between equally good works made at different times in different places; and although the practice of associating art with the age in which it was produced can be of no service to art or artists, I am not sure that it can be of no service whatever. For if it be true that art is an index to the spiritual condition of an age, the historical consideration of art cannot fail to throw some light on the history of civilisation. It is conceivable therefore that a comparative study of artistic periods might lead us to modify our conception of human development, and to revise a few of our social and political theories. Be that as it may, this much is sure: should anyone wish to infer from the art it produced the civility of an age, he must be capable of distinguishing the work of that age from the work of all other ages. He must be familiar with the characteristics of the movement. It is my intention to indicate a few of the more obvious characteristics of the contemporary movement. [...]

The period in which we find ourselves in the year 1913 begins with the maturity of Cézanne (about 1885). [Plate 1] It therefore overlaps the

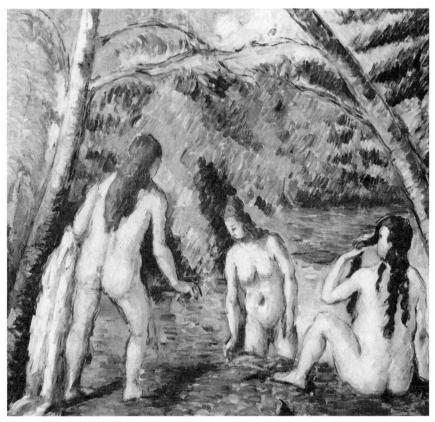

Plate 1 Paul Cézanne, *Three Bathers*, 1879–82, oil on canvas, 52 x 55 cm. Copyright
Photothèque des Musées de la Ville de Paris/ Cliché.

Impressionist movement, which certainly had life in it till the end of the
nineteenth century. Whether Post-Impressionism will peter out as
Impressionism has done, or whether it is the first flowering of a new artistic
vitality with centuries of development before it, is, I have admitted, a matter
of conjecture. What seems to me certain is that those who shall be able to con-
template our age as something complete, as a period in the history of art, will
not so much as know of the existence of the artisans still amongst us who cre-
ate illusions and chaffer and quarrel in the tradition of the Victorians. When
they think of the early twentieth-century painters they will think only of the
artists who tried to create form – the artisans who tried to create illusions will
be forgotten. They will think of the men who looked to the present, not of
those who looked to the past; and, therefore, it is of them alone that I shall
think when I attempt to describe the contemporary movement.

Already I have suggested two characteristics of the movement; I have said
that in their choice of forms and colours most vital contemporary artists are,
more or less, influenced by Cézanne, and that Cézanne has inspired them with

the resolution to free their art from literary and scientific irrelevancies. Most people, asked to mention a third, would promptly answer, I suspect — Simplification. To instance simplification as a peculiarity of the art of any particular age seems queer, since simplification is essential to all art. Without it art cannot exist; for art is the creation of significant form, and simplification is the liberating of what is significant from what is not. [...]

In a work of art nothing is relevant but what contributes to formal significance. Therefore all informatory matter is irrelevant and should be eliminated. But what most painters have to express can only be expressed in designs so complex and subtle that without some clue they would be almost unintelligible. For instance, there are many designs that can only be grasped by a spectator who looks at them from a particular point of view. Not every picture is as good seen upside down as upside up. To be sure, very sensitive people can always discover from the design itself how it should be viewed, and, without much difficulty, will place correctly a piece of lace or embroidery in which there is no informatory clue to guide them. Nevertheless, when an artist makes an intricate design it is tempting and, indeed, reasonable, for him to wish to provide a clue; and to do so he has only to work into his design some familiar object, a tree or a figure, and the business is done. Having established a number of extremely subtle relations between highly complex forms, he may ask himself whether anyone else will be able to appreciate them. Shall he not give a hint as to the nature of his organisation, and ease the way for our aesthetic emotions? If he give to his forms so much of the appearance of the forms of ordinary life that we shall at once refer them back to something we have already seen, shall we not grasp more easily their aesthetic relations in his design? Enter by the backdoor representation in the quality of a clue to the nature of design. I have no objection to its presence. Only, if the representative element is not to ruin the picture as a work of art, it must be fused into the design. It must do double duty; as well as giving information, it must create aesthetic emotion. It must be simplified into significant form.

Let us make no mistake about this. To help the spectator to appreciate our design we have introduced into our picture a representative or cognitive element. This element has nothing whatever to do with art. The recognition of a correspondence between the forms of a work of art and the familiar forms of life cannot possibly provoke aesthetic emotion. Only significant form can do that. Of course realistic forms may be aesthetically significant, and out of them an artist may create a superb work of art, but it is with their aesthetic and not with their cognitive value that we shall then be concerned. We shall treat them as though they were not representative of anything. The cognitive or representative element in a work of art can be useful as a means to the perception of formal relations and in no other way. It is valuable to the spectator, but it is of no value to the work of art; [...]

Every form in a work of art has, then, to be made aesthetically significant;

also every form has to be made a part of a significant whole. For, as generally happens, the value of the parts combined into a whole is far greater than the value of the sum of the parts. This organisation of forms into a significant whole is called Design; and an insistence – an exaggerated insistence some will say – on design is the fourth characteristic of the Contemporary Movement. This insistence, this conviction that a work should not be good on the whole, but as a whole, is, no doubt, in part a reaction from the rather too easy virtue of some of the Impressionists, who were content to cover their canvases with charming forms and colours, not caring overmuch whether or how they were co-ordinated. Certainly this was a weakness in Impressionism – though by no means in all the Impressionist masters – for it is certain that the profoundest emotions are provoked by significant combinations of significant forms.

1(ii). Roger Fry, 'Negro Sculpture'

Roger Fry was the leading modernist critic of the visual arts in England from the beginning of the twentieth century to his death in 1934. His 'Essay in Aesthetics' of 1909 was the most articulate early statement of the formalist viewpoint in the English language at that time. Fry had wide interests extending beyond the modern movement to include the Old Masters and wider questions such as the role of art in society. Among the most significant of these was his fascination with what was then known as 'primitive art'. Many postmodernist writers regard 'primitivism' as an implicitly racist ideology, whose centrality to modernism further serves to undermine modernism itself. But the situation is complex. Although Fry's writing is marked by sentiments that few would countenance today, it should be clear that his embrace of negro sculpture was made in the cause of liberation from the constraints of the classical-academic tradition. More dubious, however, is the distinction Fry draws between what he calls the 'creative aesthetic impulse' and the preconditions of *culture* in conscious intellectual judgement. If there is an implicit racism in Fry's writings, then it is here rather than in the overt terminology of 'ignorance and savagery'. Fry's exhibition review, which is reprinted in full, was first published in *The Athenaeum* in April 1920. It is taken from Roger Fry, *Vision and Design* (1920), Oxford University Press, Oxford, 1981, pp. 70–3.

WHAT a comfortable mental furniture the generalisations of a century ago must have afforded! What a right little, tight little, round little world it was when Greece was the only source of culture, when Greek art, even in Roman copies, was the only indisputable art, except for some Renaissance repetitions! Philosophy, the love of truth, liberty, architecture, poetry, drama, and for all

we know music – all these were the fruits of a special kind of life, each assist-
ed the development of the other, each was really dependent on all the rest.
Consequently if we could only learn the Greek lessons of political freedom
and intellectual self-consciousness all the rest would be added unto us.

And now, in the last sixty years, knowledge and perception have poured
upon us so fast that the whole well-ordered system has been blown away, and
we stand bare to the blast, scarcely able to snatch a hasty generalisaton or two
to cover our nakedness for a moment.

Our desperate plight comes home to one at the Chelsea Book Club, where
are some thirty chosen specimens of negro sculpture. If to our ancestors the
poor Indian had 'an untutored mind', the Congolese's ignorance and savagery
must have seemed too abject for discussion. One would like to know what Dr
Johnson would have said to any one who had offered him a negro idol for sev-
eral hundred pounds. It would have seemed then sheer lunacy to listen to
what a negro savage had to tell us of his emotions about the human form. And
now one has to go all the way to Chelsea in a chastened spirit and prostrate
oneself before his 'stocks and stones'.

We have the habit of thinking that the power to create expressive plastic
form is one of the greatest of human achievements, and the names of great
sculptors are handed down from generation to generation, so that it seems
unfair to be forced to admit that certain nameless savages have possessed
this power not only in a higher degree than we at this moment, but than we
as a nation have ever possessed it. And yet that is where I find myself. I have
to admit that some of these things are great sculpture – greater, I think,
than anything we produced even in the Middle Ages. Certainly they have
the special qualities of sculpture in a higher degree. They have indeed com-
plete plastic freedom; that is to say, these African artists really conceive form
in three dimensions. Now this is rare in sculpture. All archaic European
sculpture – Greek and Romanesque, for instance – approaches plasticity
from the point of view of bas-relief. The statue bears traces of having been
conceived as the combination of front, back, and side bas-reliefs. And this
continues to make itself felt almost until the final development of the tra-
dition. Complete plastic freedom with us seems only to come at the end of
a long period, when the art has attained a high degree of representational
skill and when it is generally already decadent from the point of view of
imaginative significance.

Now, the strange thing about these African sculptures is that they bear, as
far as I can see, no trace of this process. Without ever attaining anything like
representational accuracy they have complete freedom. The sculptors seem to
have no difficulty in getting away from the two-dimensional plane. The neck
and the torso are conceived as cylinders, not as masses with a square section.
The head is conceived as a pear-shaped mass. It is conceived as a single whole,
not arrived at by approach from the mask, as with almost all primitive

European art. The mask itself is conceived as a concave plane cut out of this otherwise perfectly unified mass.

And here we come upon another curious difference between negro sculpture and our own, namely, that the emphasis is utterly different. Our emphasis has always been affected by our preferences for certain forms which appeared to us to mark the nobility of man. Thus we shrink from giving the head its full development; we like to lengthen the legs and generally to force the form into a particular type. These preferences seem to be dictated not by a plastic bias, but by our reading of the physical symbols of certain inner qualities which we admire in our kind, such, for instance, as agility, a commanding presence, or a pensive brow. The negro, it seems, either has no such preferences, or his preferences happen to coincide more nearly with what his feeling for pure plastic design would dictate. For instance, the length, thinness, and isolation of our limbs render them extremely refractory to fine plastic treatment, and the negro scores heavily by his willingness to reduce the limbs to a succession of ovoid masses sometimes scarcely longer than they are broad. Generally speaking, one may say that his plastic sense leads him to give its utmost amplitude and relief to all the protuberant parts of the body, and to get thereby an extraordinarily emphatic and impressive sequence of planes. So far from clinging to two dimensions, as we tend to do, he actually underlines, as it were, the three-dimensionalness of his forms. It is in some such way, I suspect, that he manages to give to his forms their disconcerting vitality, the suggestion that they make of being not mere echoes of actual figures, but of possessing an inner life of their own. If the negro artist wanted to make people believe in the potency of his idols he certainly set about it in the right way.

Besides the logical comprehension of plastic form which the negro shows, he has also an exquisite taste in his handling of material. No doubt in this matter his endless leisure has something to do with the marvellous finish of these works. An instance of this is seen in the treatment of the tattoo cicatrices. These are always rendered in relief, which means that the artist has cut away the whole surface around them. I fancy most sculptors would have found some less laborious method of interpreting these markings. But this patient elaboration of the surface is characteristic of most of these works. It is seen to perfection in a wooden cup covered all over with a design of faces and objects that look like clubs in very low relief. The *galbe*[1] of this cup shows a subtlety and refinement of taste comparable to that of the finest Oriental craftsmen.

It is curious that a people who produced such great artists did not produce also a culture in our sense of the word. This shows that two factors are necessary to produce the cultures which distinguish civilised peoples. There must be, of course, the creative artist, but there must also be the power of conscious critical appreciation and comparison. If we imagined such an apparatus of critical appreciation as the Chinese have possessed from the earliest times

applied to this negro art, we should have no difficulty in recognising its sin-
gular beauty. We should never have been tempted to regard it as savage or
unrefined. It is for want of a conscious critical sense and the intellectual pow-
ers of comparison and classification that the negro has failed to create one of
the great cultures of the world, and not from any lack of the creative aesthetic
impulse, nor from lack of the most exquisite sensibility and the finest taste.
No doubt, also, the lack of such a critical standard to support him leaves the
artist much more at the mercy of any outside influence. It is likely enough
that the negro artist, although capable of such profound imaginative under-
standing of form, would accept our cheapest illusionist art with humble
enthusiasm.

 1 Galbe: the contour or outline.

1(iii). Carola Giedion-Welcker, from *Modern Plastic Art*

While early modernist theory tended to address a variety of different artis-
tic media, its later development privileged painting, leaving sculpture as
something of a poor relation. The postmodernist critic Rosalind Krauss has
described Carola Giedion-Welcker's *Modern Plastic Art* of 1937 as 'the first
book to deal seriously with twentieth-century sculpture'. The book largely
consists of full-page black and white photographs of sculpture, ranging from
Stone Age megaliths to the work of Brancusi and Picasso, among others. The
facing pages often feature a quotation from the artist or a brief, resolutely
formalist analysis by the author. The book opens with a short essay in which
Giedion-Welcker provides an account of the key formal innovations of the
various modern movements: Cubism, for example, offers an analysis of 'the
object' in terms of 'weight, density and volume'. But she then goes on to
draw connections between the analytical cast that she discerns in modern
art and the wider intellectual temper of the time, as manifest in architec-
ture, music, philosophy and science. The following extracts are taken from
Carola Giedion-Welcker, *Modern Plastic Art. Elements of Reality, Volume and
Disintegration*, English translation by P. Morton Shand, H. Girsberger, Zurich,
1937, pp. 7–8 and 15–18.

Plastic art is visible and tangible. It is derived from the formation of actual
bodies.
 In periods of great religious activity this art was the vehicle of various cults
that enshrined the memory of the departed or symbolized the conception of
immortality. Plastic art, therefore, became an essential part of human culture
almost from the outset. From the remotest times symbols, which were in no

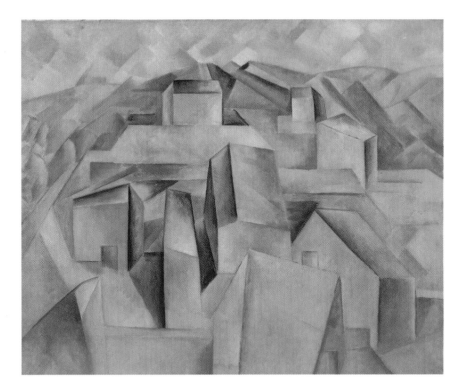

Pablo Picasso, *Houses on the Hill, Horta d'Ebro*, summer 1909, oil on canvas, 65 x 81 cm. The Museum of Modern Art, New York. Nelson A. Rockefeller Bequest. Digital image © 2002 The Museum of Modern Art, New York. Scala 0122028 © Succession Picasso/DACS, London 2003.

sense attempts at direct portrayal, were employed as intermediaries for man's relations with the gods, the stars, the seasons, life and death. Their impersonal and spiritual function was part and parcel of a far wider complex of nature, religion and cult, the tribe, or state, and its monuments.

The emergence of individual at the expense of communal achievement, which began with the Renaissance, developed towards the end of the Nineteenth Century into a complete estrangement between art and life; for once the former was debarred from its objective function an artificial barrier was interposed. Simultaneously with this intellectual isolation art became increasingly adulterated with elements that were alien to it, such as literature and psychology. The result of that infiltration is clearly evinced in late Nineteenth-Century memorials. These not only reflect lack of contact with nature, religion and contemporary society, but actually embody historic reminiscences, literary associations, etc., which denote a fundamental negation of the basic principles of plastic art.

In order to understand the aesthetic goal of the Twentieth Century we must examine not only the reactions of our own age to these aberrations, but also its attempts to recreate a new plastic world for itself.

Since the man of to-day has no longer any vital link with his religious observances we cannot hope to revitalize religious plastic art. On the other hand a secular plastic art based on the reality of modern life, and embodying a direct and honest approach to contemporary culture, seems perfectly feasible. If 'subject' tends to disappear, content does not. Modern plastic art provides the cultural transmutations that our new way of living instinctively demands.

Concentration on legitimate means of plastic expression will not lead to an 'art for art's sake' introversion so long as plastic art remains an intrinsic part of a much wider cosmic unity. In point of fact the very reverse of what happened at the end of the previous century is now taking place: there is a rearticulation into the comprehensiveness of daily life, accompanied by the awakening of a new sincerity in means of expression which ruthlessly eliminates all that is extraneous or incidental. [Plate 2]

Our life is divided between town and country, the technical and the natural worlds, and it is from our transitions between them that variety ensues. What is physical in us inevitably lives in a world of physical forms. From our impact with the reality of a tree growing in a wood, or the equal reality of a traffic-signal in the street, down to our daily associations with cups and saucers, apples and eggs, a continuous chain of impressions results which is obviously capable of influencing plastic design.

The problems of statics and dynamics, as of the disintegration of mass and the space-time interrelation of volumes, are bound to become a new plastic medium once their divorce from literary and psychological suggestion allows a return to first principles. What the artists who are preoccupied with these

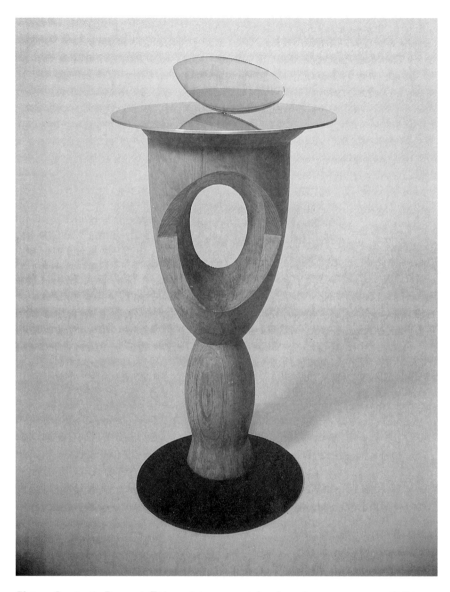

Plate 2 Constantin Brancusi, *Fish*, 1926, bronze, metal and wood, 93 x 50 x 50 cm. © Tate, London, 2003. © ADAGP, Paris and DACS, London 2003.

problems have to say can no longer be embodied in interesting or heroic motifs, but must rely exclusively on force of expression or the kind of symbols they choose. That these images are so simple is a direct reflection of our new attitude to life. In contrast to that of the preceding age our own signifies the subordination of the individual, and his reacclimatisation to nature and experience. This change is simply part of the psychological and social evolu-

tion of our age, and is in no sense due to esoteric little artistic *coteries*.

The examination of various recent movements in art which follows has been undertaken, not as an attempt to establish some sort of definitive classification, but solely in order to prove that in spite of wide divergencies of idiom they have a common aim and a common basic language.

* * *

If we probe deeper into the many different tendencies during the last thirty years, every one of them reveals the same constantly recurring phenomenon: a pronounced reaction from the sensual-sentimental individualist angle towards a wider and more objective human outlook, combined with a vigorous revolt against the anthromorphicization of art or its use as an overflow reservoir for our private emotions.

In direct contradiction to the pathos, heroics, or 'inspiration of genius' of Art with a capital A, the first prerequisite for this kind of plastic exteriorisation is an unbiassed concentration on the most elementary demands of expression. By deliberately sacrificing what in the last analysis is only incidental, it becomes possible for the artist to confine himself to a very few, but all the more direct, means of expression which may be defined as the shaping of volumes perceived in terms of space.

The close accord between these deliberate abnegations and those of the New Architecture should bring about a final liberation from the specious ornamentalism or theatricality which has hitherto atrophied the vitality of plastic art. Once we discard imitation and illusion, and with them all literary top-hamper, a self-sufficient plastic reality is free to emerge, which is just as real as the reality of nature and human life, if necessarily different to both.

The new freedom and independence of conception which results from this transmutation of static into dynamic values through the sort of formal shorthand that has surplanted wealth of description goes hand in hand with complete subordination to the specific nature and utilisation of the medium chosen. The human scale, the human angle, has ceased to be the universal norm. Hence there is no longer any finite or 'consecrated' ideal of beauty; no emphasis on detail, no senseless flamboyance or waste of good material.

This universal adoption of an elementary formal idiom and commonplace motifs seems to be in conformity with a far-reaching intellectual process that has been closely identified with the general cultural revolution of our age.

The underlying solidarity among the various aspects of plastic art that have already been referred to clearly points to a consensus of convictions held by all of them. This prompts a leading question: Is there a direct analogy between what is happening in modern sculpture and recent developments in other spheres of culture? To ask it is forthwith to envisage the evolution of plastic art from a much wider angle than the purely aesthetic. The really important con-

sideration here is that these other spheres have already effected an equally drastic purge of alien influences. The rehabilitation of everyday themes and their reassimilation to the broad stream of life, which spells the progressive eclipse of the overweening pretensions of individual inspiration, has permeated not only the arts, but philosophy and science as well.

In much the same way the practical organisation of the interior in terms of spatial design is the dominant note of the *New Architecture*.[1] The comprehensive planning of a city supersedes representational pomp and chaotic juxtaposition; and its master-plan is the carefully calculated result of a detailed technical study of all the relevant biological, sociological and climatic conditions.

With *Modern Poetry*[2] the immediate stimulus to the creation of new forms has been a rediscovery, a reanimation of the primal visual images and oral values latent in simple words. Slang has been laid under contribution for the excellent reason that it provides the most direct and vivid form of verbal impact on the reader. Psychological reflections, anecdotage, and the personal point of view, are studiously avoided. The rule is stressed, the exception ignored. There is a renunciation of the old structural development sentence by sentence in favour of a dynamic association of ideas, accomplished by a successively penetrative effect rather than a consecutive use of words; while the stylistic balance between the latter echoes emotion rather than logic.

The equivalent process in *Painting* is the abandonment of illusory perspective and the recognition of surface, colour and light as the true components of a picture.

In *Music*[3] it is the direct, primal relation of tone picture to tone picture without intermediate psychological elaboration. Igor Stravinsky has said that his composition is architectonic, not reminiscent, 'an objective, not a subjectively descriptive, structure'. Here the deliberate introduction of modern dance music, extraneous noises, etc., once more implies a return to the soundtrack of daily life.

In certain branches of *Philosophy*, too, there has been a return to those essentials which Rudolph Carnap deals with in his '*Scheinprobleme in der Philosophie*'.[4] A notable instance of the similarity between the revolutions in artistic and scientific methods at the beginning of the present century can be found in the work of the English philosopher Bertrand Russell. Some thirty years ago Russell succeeded in formulating a series of basic axioms, uncoloured by metaphysical speculation, that are common to logic and certain branches of mathematics. A group of Viennese philosophers known as *der Wiener Kreis* has developed this side of Russell's philosophy into a 'system of axioms', for which, in part anyhow, mathematical formulæ were adopted — yet another example of symbolical expression! The standpoint of the modern philosopher is no longer that of the poet, for he has to keep a near eye on mathematics and physics. His work must be severely to the point, severely scientific.

There is an even closer affinity between contemporary *Physics* and modern

plastic art. The fundamental transformation undergone by the former has rad-
ically modified our conceptions of space, time and motion; and has likewise
superseded the old ideal of mass, since the ponderosity of mass is now consid-
ered as a factor conditioned by speed.

This necessarily rather sketchy outline of the parallelism between the
methods now being adopted in the various fields of cultural activity at least
provides sufficient evidence of the vitality of each. The community of spirit
between science and art, which even to-day is often considered a far-fetched
notion, was regarded as a self-evident platitude right up to the age of baroque.

The evolution of modern art is not yet complete. But this much can already
be discerned with some confidence: it is not a form of aesthetic self-indul-
gence, disdainfully remote from daily life, but a vital creative force intimate-
ly associated with the general cultural development of our age. [. . .] It is no
longer possible to remain blind to the direct formal affinity between the pure-
ly utilitarian mechanism of modern industry, transport and publicity,5 and
those so-called utopian experiments in art which, in part at least, had antici-
pated them. The priority of one or the other in point of date is far less impor-
tant than their reciprocal stimulus.

Finally, yet another remarkable similarity remains to be considered: that
between modern and primitive art, whether savage, archaic or prehistoric.
This is not inspired by any romantic or modish hankering after the barbaric,
or a nostalgia for what is strange and distant. There is an absence of literary
influences in both, and a common predilection for a clear structural forma-
tion and simple plastic transmutations. It is perhaps not without significance
that a century as conscious of the highly-developed and complex civilization
it has evolved as our own should manifest such a warm sympathy for the
unsophisticated emotions and forthright plastic creations of mythical times.6
The morphological synthesis of these chronologically and culturally opposite
poles has resulted in the perfection of sculptural forms (that highly special-
ized modern tools have revealed to us) which in the simplicity of their line
recall the first dawn of plastic art.7

1 The open planning of the New Architecture, the lightening of its volumes, and its emphasis on transpar-
 ent, almost imponderable, surfaces finds an echo in certain prominent tendencies in modern plastic art.
2 To say that Rimbaud's *'poésie pure . . . verbe accessible à tous les sens'* has begotten a decadent verbal
 mannerism is an unjustified assumption. To use language primarily as a sensitive tonal medium does
 not mean playing with words for the mere fun of the thing, any more than an absence of plot means
 an absence of content. The pioneers of the modern literary movement, Baudelaire, Rimbaud and
 Mallarmé, continually reaffirmed the spiritual purpose of poetry; whereas the next generation revert-
 ed to a severely formalized euphony. The explosive, yet associative dynamicism of Arp, Ball, Schwitters,
 Eluard, and Tzara's writing evokes a continuous sequence of mental vistas. In James Joyce's latest pub-
 lication, 'Work in Progress' [i.e. *Finnegan's Wake*], the logical time sequence of characters and events,
 human and natural history, is deliberately discarded. Instead we are given a vivid reconstruction of his
 subject-matter into something that is at once wholly new, yet by force of association virtually familiar.
 His projection of images on to a universal plane of time-space presents a close parallel to the empha-
 sis on 'simultaneity' in the plastic arts.

3 Thus the basis of Hindemith's musical idiom is 'anti-individualistic counterpoint'. Vide H. Curjel's
 '*Triumph der Alltäglichkeit*' (Hesse-Verlag, Berlin, 1929), and C.F. Ramuz's '*Souvenir sur Igor
 Stravinsky*' (1932), as also Igor Stravinsky's '*Chroniques de ma Vie*' (Denoel et Steele, Paris, 1935.)

4 Vide Carnap's '*Der Logische Aufbau der Welt*' (Weltkreis-Verlag, Berlin 1928), Schlick's '*Raum und Zeit
 in der gegenwärtigen Physik*' (Berlin, 1918), and Hans Reichenbrach's '*Wahrscheinlichkeitslehre*' (A.
 Sijthoff, Leiden, 1935).

5 E. g. Traffic-signals, various types of modern transport, shop-window-dressing, advertisement lay-outs,
 etc.

6 As long ago as 1910 Umberto Boccioni wrote '*Siamo i primitivi di una nova sensibilità*'.

7 A peep into Brancusi's studio, with its extraordinary collection of tools and instruments, reveals certain
 points of contact between even work of so timeless a quality as his and the field of modern inventions.
 Brancusi's preference for showing his sculpture on revolving turn-tables, and his claim that films are
 the only adequate means of illustrating it, provide pertinent cases in point.

1(iv). Robert Goldwater, 'A Definition of Primitivism'

Early modern art was Janus-faced. In one direction, its gaze was fixed on contemporary modernity: the city, technology, cars, speed – the future, even. Yet in the other, modernists sought to anchor their resistance to the negative aspects of modernity – to the alienation and inauthenticity of bourgeois society – by recourse to the ancient, the unsophisticated, in a word to the 'primitive'. Artefacts from the colonies had been appearing in western museums since the mid-nineteenth century. Initially they were perceived as curios, or symptoms of arrested cultural development, until in an extraordinary reversal of values the artists of the avant-garde began to accord them the aesthetic power they denied to the western academic canon. This complex identification with the victims of the very culture that simultaneously sustained and marginalised them is one of the most contested legacies of modernism. Robert Goldwater's groundbreaking attempt to catalogue the varieties of 'primitivism' in the modern movement, *Primitivism in Modern Art*, first appeared in 1938. Its final chapter sought to offer a definition of the phenomenon as a whole. Much contested by postmodernist historians, the essay remains the best source for an understanding of the modernist construct of 'the primitive'. The following extract is taken from Robert Goldwater, *Primitivism in Modern Art* (1938), The Belknap Press of Harvard University Press, Cambridge, Mass., and London, 1986, pp. 250–3.

In attempting a definition of the artistic attitude whose course we have been following, we do not mean to set down an exclusive description. It would be possible to collect the final residue after filtering out all those manifestations which are not common or typical, or which may be found accompanying other attitudes in art besides the primitivist, no matter how important or characteristic they may be for certain phases of primitivism, and this meager

residue could then be reduced to an epigram. Such an attempt, though it might arrive at a paradigm which would serve as a base in the search for exceptions, would hardly find any other useful purpose. It will have been obvious throughout that the unity of this study lay more in the various attitudes and intentions which were being described than in the formal, or even the psychological similarity of the works of art created in accordance with these attitudes. And it will have become clear that, in detail at least, the attitudes and intentions also – conditioned by their immediate cultural and artistic situation as well as by the larger factors common to them all – varied among themselves. The purpose of this final chapter is therefore to summarize the different phenomena while preserving their individuality; to rewind in comparative haste the connecting thread we have been unraveling so slowly.

But if this thread is not in the art nor in its theoretical program, where can it be? We think it is possible to say (without being guilty of any more primitivism of analysis than comes from an adaptation to our subject), that is lies in a *common assumption* that pervades the works and their apologetics. This is the assumption that externals, whether those of a social or cultural group, of individual psychology, or of the physical world, are intricate and complicated and *as such not desirable*. It is the assumption that any reaching under the surface, if only it is carried far enough and proceeds according to the proper method, will reveal something 'simple' and basic which, because of its very fundamentality and simplicity, will be more emotionally compelling than the superficial variations of the surface; and finally that the qualities of simplicity and basicness are things to be valued in and for themselves: In other words, it is the assumption that the further one goes back – historically, psychologically, or aesthetically – the simpler things become; and that because they are simpler they are more profound, more important, and more valuable. Certainly we have seen that the nature of this 'simplicity' – even in the rare cases in which it is found – varies with the nature of the seekers. But (since it is primitivism and not the primitive we have been studying), its axiomatic existence and desirability remain.

Primitivism presupposes the primitive, and at the core of an artistic primitivism we may expect to find a nucleus of 'primitive' works of art. In the case of each of the divisions we have made – the romantic, the emotional, and the intellectual or formal, there were works of art considered primitive by the modern artists, and appreciated and influential because of that. Without going into the question of what the *really primitive* is, the paleolithic or the neolithic, the African or the Eskimo, we may note that in accordance with the primitivist assumption just described, these supposedly primitive arts are not united by any common qualities of form and composition. This is evident from their variety: for Gauguin they were the Egyptian, the Indian, and the Polynesian alike; for the *fauves* the 'curious' phases of African sculpture and the *images d'Epinal*; for the *Brücke* and the *Blaue Reiter* the sculpture of the

exotic peoples generally, the drawings of children, and their own provincial folk art; while for Picasso primitive meant Ivory Coast sculpture and the painting of Henri Rousseau. This is to say that for the modern artist the primitiveness of these different arts lay in the common quality of simplicity attributed to them. More psychological than formal, it was a quality read into the objects rather than objectively observed and so it was bound to vary with the orientation of each group. The possibility of finding such simplicity in any form of aboriginal art, no matter how formally complicated it might be, was of course facilitated by an assumption inherited from the nineteenth century, still continuing though often avowedly rejected. This was the correlation automatically made between the assumed simplicity of the physical and social organization of a people and the simplicity (in both the senses of unvariegated and whole-hearted) of the import of their works of art. In the case of child and folk art it was based upon an appreciation of psychological beginnings. Far from being the cause of any 'primitive' qualities that may be found in modern art, primitive art only served as a kind of stimulating focus, a catalytic which, though not itself used or borrowed from, still helped the artists to formulate their own aims because they could attribute to it the qualities they themselves sought to attain. For these reasons the very limited direct formal influence of primitive art is not to be wondered at; the causal action is indeed rather the reverse. Even the use of aboriginal art as an example to be quoted against the necessity of copying from nature and of following academic rules could easily have been dispensed with, since this process and protest in its modern form had begun before the discovery of primitive art in 1904. Consequently its continued reiteration as an example in favor of a return to 'fundamentals' is only evidence of a more widespread primitivist drive.

1(v). Sheldon Cheney, from *The Story of Modern Art*

Sheldon Cheney was an American historian who did much to popularise modern art in the face of widespread hostility to its unfamiliar appearance. Indeed, in a Foreword to his book *The Story of Modern Art*, first published in 1941, he anecdotally recounts its origin in the antagonism towards the modern movement that he had encountered among American patrons and museum directors. Cheney had published *A Primer of Modern Art* as early as 1924, and *Expressionism in Art* a decade later. The latter book's underlying tone was the kind of mystical philosophical idealism that influenced so many early supporters of modern art. Cheney saw modern art as a 'plastic synthesis', a manifestation of 'cosmic unity', and the modern artist's creation as an echo of divine Creation. He was not an original thinker, but it is sometimes very useful to have typical statements of an ethos to counterbalance more daring or

innovative claims. *The Story of Modern Art* provides a survey extending from
the French Revolution to the development of abstract art. Cheney offers a con-
cise and basic statement of then orthodox thinking about modern art, empha-
sising progress, form and intuition. The following extract is taken from the
Foreword to Sheldon Cheney, *The Story of Modern Art*, revised and enlarged
edition, Methuen, London, 1958, pp. vi–viii.

My generalizations about modern art may be summarized in a very few precepts:

1. *In the succession of 'isms that comprise the story of modern art there is
traceable a unity of progress.* From about 1860 (Manet's time) to the late 1950s
the progression is evident as a retreat from 'serious' subject matter, as a with-
drawal from preoccupation with objective nature; and positively as a likeness of
aim on the part of the artists, expressed in an ever more rigorous purification of
the means of their art, and in a grasp toward expression of inner feeling and
formal beauty. If the reader will leaf through this book with attention to the
illustrations only, ignoring text and captions, he will have graphic proof of the
validity of this thesis. Once the painstaking naturalness and tightness of
David's picturing are left behind there is a unity of progression, expressed first
in a loosening-up of the picture; then in a grasping at certain means character-
istic of impressionism and post-impressionism, in the works especially of Goya,
Turner, Whistler, and Monet; and finally in the full denial of subject interest,
from Cézanne to the mid-twentieth-century abstractionists.

2. *Form-consciousness is the typical attribute in the succession from Cézanne
to the latest abstractionists.* The form-seeking schools were the most important
ones through a hundred years. What Whistler was concerned with as 'arrange-
ment,' what Cézanne agonized over as 'realization,' what the cubists sought to
fix in paint after discarding all but a very few of nature's objects, what
Kandinsky visioned when he initiated free composition in painting as an ana-
logue of music: all this was summed up by would-be explainers as *form*. This
indefinable element in art, intangible and mysterious, hidden to the unedu-
cated eye but open to the æsthetic sense of the modern appreciator, has gone
by many names. The recent historian Wilenski marked it as the architectural
or architectonic element that separated creative art from the merely illustra-
tional sort; Clive Bell gave weight to the word by speaking always of *signifi-
cant* form. Certainly today the quality (or magic) that is characteristically put
into the picture by the modern artist is known to most people as form.

3. *In the approach to art it is the intuitive faculties that should be kept alive.*
Reason and the intellect – so very important in science, very necessary for sur-
vival – help little in this connection. If you rush at a work of art with your
intellect, you spoil all; cultivate a serene approach and a technique of *contem-
plative* seeing. At last the Occident joins the Orient in understanding that art
is a product of the inner life. The essence of it, the formal life revealed, is a

reward for intuitive sensibility, serenity of being, and contemplative regard.

4. *Art works are themselves the best teachers.* The life in a painting is a cre-
ated thing put in by the artist, and it can be justified only by the response of
the beholder. In the modern view its special form of livingness is constituted
in movement; wherefore it is often said that the formally rich picture presents
(or conceals) a path for the eye. It is technically the corporeal eye that sees,
and we may say that it is pleasured by the painting; but the eye is only an
instrument – it is the mind within that sees, that delights in the picture, and
often in memory retains delight long after the picture is lost to sight. Each
painting is an entity in itself, and its aim is to evoke this unique pleasure, an
æsthetic experience.

To you it is not art if your faculties do not respond to it. The fine thing about
modern art is that if you live with it open-mindedly it will itself call forth a
response, and you will have made it your own in an intimate and joyful way.
There is not one of the types of modern art described in this book which did
not at first puzzle and baffle great numbers of gallery-goers; not one – except
such aberrant sorts as dadaism and surrealism – that did not later find under-
standing and grateful audiences. Above all, live with modern works of art, rec-
ognize their livingness, as of this age; and distrust critics, teachers, writers.

1(vi). Elaine de Kooning, 'Statement'

The mainstream of modernist theory, from Maurice Denis, through Roger
Fry, Clive Bell and Alfred H. Barr, to Clement Greenberg and Michael Fried,
emphasised pictorial (or sculptural) form over all else, and the aesthetic
emotion it caused in the disinterested, sufficiently attuned spectator. A vari-
ant tradition emphasised self-expression and the activity of art-making over
the production of self-contained objects for contemplation. The classic state-
ment of this position is articulated in Harold Rosenberg's 'The American
Action Painters' of 1952. Rosenberg offers an existentialist-influenced
account of Abstract Expressionist painting, which he characterises as 'not a
picture but an event'. Elaine de Kooning was an abstract painter who assim-
ilated this way of thinking. Her 'Statement' of 1959 emphasises both an
activist understanding of painting as centred upon gesture and the primary
importance of colour as a vehicle for the expression of feeling. The statement
is reprinted in full from Elaine de Kooning, *The Spirit of Abstract Expressionism:
Selected Writings*, George Braziller, New York, 1994, pp. 175–6.

For me the most important thing about the words 'painting' and 'drawing' is
that they end in ing. A painting to me is primarily a verb, not a noun – an
event first and only secondarily an image. For years these events occurred for

Plate 3 Elaine de Kooning, *Untitled*, c. 1948, enamel on cardboard, 8 x 9⁷⁄₈ inches.
Photo: Arkansas Arts Centre. Foundation Purchase, 1999.99.8. Courtesy of the Estate of
Elaine de Kooning.

me in vertical space. Now they interact in horizontal areas.

The interaction of color in these events is one kind of drawing. Drawing of
any kind has always been my passion, drawing can be swift or slow. Through
the years, I seem to have increasing desire for an increasing tempo. In the
past, I wanted compressed Gothic space squeezed upward, dense hidden col-
ors, forms cornered and crammed into the surface, airlessness – a sense of suf-
focation. At that time, the main thing about a painting for me was that it was
against the wall.

Now my colors have become claustrophobic; they want to burst the bound-
aries, to expand, radiate, explode – anything can happen just as long as it's
outward. [Plate 3]

If a man wants to come and sit down in my painting, he's welcome, and he
can leave when he pleases. If a bull finds himself charging through, if bull-
fighters wave their capes, if ballplayers want to play in my colors, it's O.K.
with me. Or if El Greco or Tiepolo wants to throw in a pile of old magenta
robes, I can always use them. I don't choose my subjects or my style or my col-
ors, they choose me and I'm grateful to them. Nor do I ever decide to aban-
don them; I'm torn away from them.

There are conflicts. The excessive liberality of idea struggles with the illiberality of desire, and desires contradict each other, but the strongest desire always wins. I inform the painting of my ideas; the painting informs me of my desires. Right now, I gather, I want pageantry, splendor, panoramas, clamorous color – trumpeting reds and shrieking yellows – the phony glitter of tough bordertown façades, the heraldic colors of the corrida.

If I fall in love with a tree, as I did with the yellow-leaved cottonwood in Albuquerque, or with a New Mexican twilight that scoops up the ground under my feet and turns it purple, these experiences yearn to get into my painting. So do my feelings for the go-for-broke champ: for Joe Louis and Sugar Ray, for Herzog and Johnny Acropolis and Caryl Chessman. I do not 'recollect' these feelings – I just have them – and there is no way to 'represent' them, nor am I interested in doing so. I want more than composition in painting.

For one thing, I want gesture – any kind of gesture, all kinds of gesture – gentle or brutal, joyous or tragic; the gestures of space soaring, sinking, streaming, whirling; the gestures of light flowing or spurting through color. I see everything as possessing or possessed by gesture. I've often thought of my paintings as having an axis around which everything revolves.... When I painted my seated men, I saw them as gyroscopes. Portraiture has always fascinated me because I love the particular gesture of a particular expression of stance. I'm enthralled by the gesture of the silhouette (for portraits or anything else), the instantaneous illumination that enables you to recognize your father or a friend three blocks away or, sitting in the bleachers, to recognize the man at bat. Working on the figure, I wanted paint to sweep through as feelings sweep through. Then I wanted the paint to sweep the figure along with it – and got involved with men in action – abstract action, action for its own sake – the game. And finally, I wanted the paint to sweep through, around, over and past, to hack away at contours and engulf silhouettes.

If the gestures are inhabited by landscapes, arenas, bodies, faces or just by colors, it makes no difference to me. However, if red is blood or wine or a rose or a box of matches or a muleta or earth, if red is smeared or dripped or dragged or glazed or spattered or trowelled on, it makes all the difference in the world to red. Red can be tormented or serene or ecclesiastical. Red can be anything it wants. Likewise yellow, blue, green, black, etc. Every color has a million ideas about itself – but fortunately desire has veto power, otherwise nothing would ever get painted.

2. Meyer Schapiro, 'The Nature of Abstract Art'

Alfred H. Barr's exhibition *Cubism and Abstract Art* at the Museum of Modern Art in New York in 1936 was a key intervention that did much to establish the view of the modern movement as an evolving lineage. Barr

accompanied the exhibition with a catalogue containing a scholarly essay and a diagram plotting the development of abstract art from Post-Impressionism to two different kinds of then contemporary abstract art: Geometrical and Non-Geometrical Abstraction. In line with his formalist analysis, Barr told a story of internal action and reaction, in which art was purged of inessential literary or political accretions and culminated in the 'purified' forms of abstraction. The Marxist historian and critic Meyer Schapiro was quick to take issue with Barr's separation of art from its social context. In an extensive treatment ranging from early Impressionism to the art of the 1930s, Schapiro demonstrated time and again that the meaning of art was inseparable from the social circumstances of its production. The following extracts from 'The Nature of Abstract Art', first published in the *Marxist Quarterly* in 1937, are taken from Meyer Schapiro, *Modern Art. 19th and 20th Centuries. Selected Papers*, George Braziller, New York, 1978, pp. 185–90, 195–202.

Before there was an art of abstract painting, it was already widely believed that the value of a picture was a matter of colors and shapes alone. Music and architecture were constantly held up to painters as examples of a pure art which did not have to imitate objects but derived its effects from elements peculiar to itself. But such ideas could not be readily accepted, since no one had yet seen a painting made up of colors and shapes, representing nothing. If pictures of the objects around us were often judged according to qualities of form alone, it was obvious that in doing so one was distorting or reducing the pictures; you could not arrive at these paintings simply by manipulating forms. And in so far as the objects to which these forms belonged were often particular individuals and places, real or mythical figures, bearing the evident marks of a time, the pretension that art was above history through the creative energy or personality of the artist was not entirely clear. In abstract art, however, the pretended autonomy and absoluteness of the aesthetic emerged in a concrete form. Here, finally, was an art of painting in which only aesthetic elements seem to be present.

Abstract art had therefore the value of a practical demonstration. In these new paintings the very processes of designing and inventing seemed to have been brought on to the canvas; the pure form once masked by an extraneous content was liberated and could now be directly perceived. Painters who do not practice this art have welcomed it on just this ground, that it strengthened their conviction of the absoluteness of the aesthetic and provided them a discipline in pure design. Their attitude toward past art was also completely changed. The new styles accustomed painters to the vision of colors and shapes as disengaged from objects and created an immense confraternity of works of art, cutting across the barriers of time and place. They made it pos-

sible to enjoy the remotest arts, those in which the represented objects were no longer intelligible, even the drawings of children and madmen, and especially primitive arts with drastically distorted figures, which had been regarded as artless curios even by insistently aesthetic critics. Before this time Ruskin could say in his *Political Economy of Art*, in calling for the preservation of medieval and Renaissance works that 'in Europe alone, pure and precious ancient art exists, for there is none in America, none in Asia, none in Africa.' What was once considered monstrous, now became pure form and pure expression, the aesthetic evidence that in art feeling and thought are prior to the represented world. The art of the whole world was now available on a single unhistorical and universal plane as a panorama of the formalizing energies of man.

These two aspects of abstract painting, the exclusion of natural forms and the unhistorical universalizing of the qualities of art, have a crucial importance for the general theory of art. Just as the discovery of non-Euclidian geometry gave a powerful impetus to the view that mathematics was independent of experience, so abstract painting cut at the roots of the classic ideas of artistic imitation. The analogy of mathematics was in fact present to the minds of the apologists of abstract art; they have often referred to non-Euclidian geometry in defense of their own position, and have even suggested an historical connection between them.

Today the abstractionists and their Surrealist offspring are more and more concerned with objects and the older claims of abstract art have lost the original force of insurgent convictions. Painters who had once upheld this art as the logical goal of the entire history of forms have refuted themselves in returning to the impure natural forms. The demands for liberty in art are no longer directed against a fettering tradition of nature; the aesthetic of abstraction has itself become a brake on new movements. Not that abstract art is dead, as its philistine enemies have been announcing for over twenty years; it is still practiced by some of the finest painters and sculptors in Europe, whose work shows a freshness and assurance that are lacking in the newest realistic art. The conception of a possible field of 'pure art' – whatever its value – will not die so soon, though it may take on forms different from those of the last thirty years; and very likely the art that follows in the countries which have known abstraction will be affected by it. The ideas underlying abstract art have penetrated deeply into all artistic theory, even of their original opponents; the language of absolutes and pure sources of art, whether of feeling, reason, intuition or the subconscious mind, appears in the very schools which renounce abstraction. 'Objective' painters strive for 'pure objectivity,' for the object given in its 'essence' and completeness, without respect to a viewpoint, and the Surrealists derive their images from pure thought, freed from the perversions of reason and everyday experience. Very little is written today – sympathetic to modern art – which does not employ this language of absolutes.

In this article I shall take as my point of departure Barr's recent book, the best, I think, that we have in English on the movements now grouped as abstract art. It has the special interest of combining a discussion of general questions about the nature of this art, its aesthetic theories, its causes, and even the relation to political movements, with a detailed, matter-of-fact account of the different styles. But although Barr sets out to describe rather than to defend or to criticize abstract art, he seems to accept its theories on their face value in his historical exposition and in certain random judgments. In places he speaks of this art as independent of historical conditions, as realizing the underlying order of nature and as an art of pure form without content.

Hence if the book is largely an account of historical movements, Barr's conception of abstract art remains essentially unhistorical. He gives us, it is true, the dates of every stage in the various movements, as if to enable us to plot a curve, or to follow the emergence of the art year by year, but no connection is drawn between the art and the conditions of the moment. He excludes as irrelevant to its history the nature of the society in which it arose, except as an incidental obstructing or accelerating atmospheric factor. The history of modern art is presented as an internal, immanent process among the artists; abstract art arises because, as the author says, representational art had been exhausted. Out of boredom with 'painting facts,' the artists turned to abstract art as a pure aesthetic activity. 'By a common and powerful impulse they were driven to abandon the imitation of natural appearance' just as the artists of the fifteenth century 'were moved by a passion for imitating nature.' The modern change, however, was 'the logical and inevitable conclusion toward which art was moving.'

This explanation, which is common in the studios and is defended by some writers in the name of the autonomy of art, is only one instance of a wider view that embraces every field of culture and even economy and politics. At its ordinary level the theory of exhaustion and reaction reduces history to the pattern of popular ideas on changes in fashion. People grow tired of one color and choose an opposite; one season the skirts are long, and then by reaction they are short. In the same way the present return to objects in painting is explained as the result of the exhaustion of abstract art. All the possibilities of the latter having been explored by Picasso and Mondrian, there is little left for the younger artists but to take up the painting of objects.

The notion that each new style is due to a reaction against a preceding is especially plausible to modern artists, whose work is so often a response to another work, who consider their art a free projection of an irreducible personal feeling, but must form their style in competition against others, with the obsessing sense of the originality of their work as a mark of its sincerity. Besides, the creators of new forms in the last century had almost always to fight against those who practiced the old; and several of the historical styles were formed in conscious opposition to another manner – Renaissance against

Gothic, Baroque against Mannerism, Neo-classic against Rococo, etc.

The antithetic form of a change does not permit us, however, to judge a new art as a sheer reaction or as the inevitable response to the spending of all the resources of the old. No more than the succession of war and peace implies that war is due to an inherent reaction against peace and peace to a reaction against war. The energies required for the reaction, which sometimes has a drastic and invigorating effect on art, are lost sight of in such an account; it is impossible to explain by it the particular direction and force of the new movement, its specific moment, region and goals. The theory of immanent exhaustion and reaction is inadequate not only because it reduces human activity to a simple mechanical movement, like a bouncing ball, but because in neglecting the sources of energy and the condition of the field, it does not even do justice to its own limited mechanical conception. The oppo-siteness of a reaction is often an artificial matter, more evident in the polemics between schools or in the schemas of formalistic historians than in the actual historical change. To supply a motor force to this physical history of styles (which pretends to be antimechanical), they are reduced to a myth of the per-petual alternating motion of generations, each reacting against its parents and therefore repeating the motions of its grandparents, according to the 'grand-father principle' of certain German historians of art. And a final goal, an unex-plained but inevitable trend, a destiny rooted in the race or the spirit of the culture or the inherent nature of the art, has to be smuggled in to explain the large unity of a development that embraces so many reacting generations. The immanent purpose steers the reaction when an art seems to veer off the main path because of an overweighted or foreign element. Yet how many arts we know in which the extreme of some quality persists for centuries without pro-voking the corrective reaction. The 'decay' of classical art has been attributed by the English critic, Fry, to its excessive cult of the human body, but this 'decay' evidently lasted for hundreds of years until the moment was ripe for the Christian reaction. But even this Christian art, according to the same writer, was for two centuries indistinguishable from the pagan.

The broad reaction against an existing art is possible only on the ground of its inadequacy to artists with new values and new ways of seeing. But reac-tion in this internal, antithetic sense, far from being an inherent and univer-sal property of culture, occurs only under impelling historical conditions.

* * *

The logical opposition of realistic and abstract art by which Barr explains the more recent change rests on two assumptions about the nature of painting, common in writing on abstract art: that representation is a passive mirroring of things and therefore essentially non-artistic, and that abstract art, on the other hand, is a purely aesthetic activity, unconditioned by objects and based

on its own eternal laws. The abstract painter denounces representation of the outer world as a mechanical process of the eye and the hand in which the artist's feelings and imagination have little part. Or in a Platonic manner he opposes to the representation of objects, as a rendering of the surface aspect of nature, the practice of abstract design as a discovery of the 'essence' or underlying mathematical order of things. He assumes further that the mind is most completely itself when it is independent of external objects. If he, nevertheless, values certain works of older naturalistic art, he sees in them only independent formal constructions; he overlooks the imaginative aspect of the devices for transposing the space of experience on to the space of the canvas, and the immense, historically developed, capacity to hold the world in mind. He abstracts the artistic qualities from the represented objects and their meanings, and looks on these as unavoidable impurities, imposed historical elements with which the artist was burdened and in spite of which he finally achieved his underlying, personal abstract expression.

These views are thoroughly one-sided and rest on a mistaken idea of what a representation is. There is no passive, 'photographic' representation in the sense described; the scientific elements of representation in older art — perspective, anatomy, light-and-shade — are ordering principles and expressive means as well as devices of rendering. All renderings of objects, no matter how exact they seem, even photographs, proceed from values, methods and viewpoints which somehow shape the image and often determine its contents. On the other hand, there is no 'pure art,' unconditioned by experience; all fantasy and formal construction, even the random scribbling of the hand, are shaped by experience and by nonaesthetic concerns. [. . .]

In regarding representation as a facsimile of nature, the abstract artist has taken over the error of vulgar nineteenth century criticism, which judged painting by an extremely narrow criterion of reality, inapplicable even to the realistic painting which it accepted. If an older taste said, how exactly like the object, how beautiful! — the modern abstractionist says, how exactly like the object, how ugly! The two are not completely opposed, however, in their premises, and will appear to be related if compared with the taste of religious arts with a supernatural content. Both realism and abstraction affirm the sovereignty of the artist's mind, the first, in the capacity to recreate the world minutely in a narrow, intimate field by series of abstract calculations of perspective and gradation of color, the other in the capacity to impose new forms on nature, to manipulate the abstracted elements of line and color freely, or to create shapes corresponding to subtle states of mind. But as little as a work is guaranteed aesthetically by its resemblance to nature, so little is it guaranteed by its abstractness or 'purity.' Nature and abstract forms are both materials for art, and the choice of one or the other flows from historically changing interests.

Barr believes that painting is impoverished by the exclusion of the outer

world from pictures, losing a whole range of sentimental, sexual, religious and social values. But he supposes in turn that the aesthetic values are then available in a pure form. He does not see, however, that the latter are changed rather than purified by this exclusion, just as the kind of verbal pattern in writing designed mainly for verbal pattern differs from the verbal pattern in more meaningful prose. Various forms, qualities of space, color, light, scale, modelling and movement, which depend on the appreciation of aspects of nature and human life, disappear from painting; and similarly the aesthetic of abstract art discovers new qualities and relationships which are congenial to the minds that practice such an exclusion. Far from creating an absolute form, each type of abstract art, as of naturalistic art, gives a special but temporary importance to some element, whether color, surface, outline or arabesque, or to some formal method. The converse of Barr's argument, that by clothing a pure form with a meaningful dress this form becomes more accessible or palatable, like logic or mathematics presented through concrete examples, rests on the same misconception. Just as narrative prose is not simply a story added to a pre-existing, pure prose form that can be disengaged from the sense of the words, so a representation is not a natural form added to an abstract design. Even the schematic aspects of the form in such a work already possess qualities conditioned by the modes of seeing objects and designing representations, not to mention the content and the emotional attitudes of the painter.

When the abstractionist Kandinsky was trying to create an art expressing mood, a great deal of conservative, academic painting was essentially just that. But the academic painter, following older traditions of romantic art, preserved the objects which provoked the mood; if he wished to express a mood inspired by a landscape, he painted the landscape itself. Kandinsky, on the other hand, wished to find an entirely imaginative equivalent of the mood; he would not go beyond the state of mind and a series of expressive colors and shapes, independent of things. The mood in the second case is very different from the first mood. A mood which is partly identified with the conditioning object, a mood dominated by clear images of detailed objects and situations, and capable of being revived and communicated to others through these images, is different in feeling tone, in relation to self-consciousness, attentiveness and potential activity, from a mood that is independent of an awareness of fixed, external objects, but sustained by a random flow of private and incommunicable associations. Kandinsky looks upon the mood as wholly a function of his personality or a special faculty of his spirit; and he selects colors and patterns which have for him the strongest correspondence to his state of mind, precisely because they are not tied sensibly to objects but emerge freely from his excited fantasy. They are the concrete evidences, projected from within, of the internality of his mood, its independence of the outer world. Yet the external objects that underlie the mood may re-emerge in the abstraction in a masked or distort-

ed form. The most responsive spectator is then the individual who is similarly concerned with himself and who finds in such pictures not only the counterpart of his own tension, but a final discharge of obsessing feelings.

In renouncing or drastically distorting natural shapes the abstract painter makes a judgment of the external world. He says that such and such aspects of experience are alien to art and to the higher realities of form; he disqualifies them from art. But by this very act the mind's view of itself and of its art, the intimate contexts of this repudiation of objects, become directing factors in art. When personality, feeling and formal sensibility are absolutized, the values that underlie or that follow today from such attitudes suggest new formal problems, just as the secular interests of the later middle ages made possible a whole series of new formal types of space and the human figure. The qualities of cryptic improvisation, the microscopic intimacy of textures, points and lines, the impulsively scribbled forms, the mechanical precision in constructing irreducible, incommensurable fields, the thousand and one ingenious formal devices of dissolution, penetration, immateriality and incompleteness, which affirm the abstract artist's active sovereignty over objects, these and many other sides of modern art are discovered experimentally by painters who seek freedom outside of nature and society and consciously negate the formal aspects of perception – like the connectedness of shape and color or the discontinuity of object and surroundings – that enter into the practical relations of man in nature.

We can judge more readily the burden of contemporary experience that imposes such forms by comparing them with the abstract devices in Renaissance art, especially the systems of perspective and the canons of proportion, which are today misunderstood as merely imitative means. In the Renaissance the development of linear perspective was intimately tied to the exploration of the world and the renewal of physical and geographical science. Just as for the aggressive members of the burgher class a realistic knowledge of the geographical world and communications entailed the ordering of spatial connections in a reliable system, so the artists strove to realize in their own imaginative field, even within the limits of a traditional religious content, the most appropriate and stimulating forms of spatial order, with the extensiveness, traversability and regulation valued by their class. And similarly, as this same burgher class, emerging from a Christian feudal society, began to assert the priority of sensual and natural to ascetic and supernatural goods, and idealized the human body as the real locus of values – enjoying images of the powerful or beautiful nude human being as the real man or woman, without sign of rank or submission to authority – so the artists derived from this valuation of the human being artistic ideals of energy and massiveness of form which they embodied in robust, active or potentially active, human figures. And even the canons of proportion, which seem to submit the human form to a mysticism of number, create purely secular stan-

dards of perfection; for through these canons the norms of humanity become physical and measurable, therefore at the same time sensual and intellectual, in contrast to the older medieval disjunction of body and mind.

If today an abstract painter seems to draw like a child or a madman, it is not because he is childish or mad. He has come to value as qualities related to his own goals of imaginative freedom the passionless spontaneity and technical insouciance of the child, who creates for himself alone, without the pressure of adult responsibility and practical adjustments. And similarly, the resemblance to psychopathic art, which is only approximate and usually independent of a conscious imitation, rests on their common freedom of fantasy, uncontrolled by reference to an external physical and social world. By his very practice of abstract art, in which forms are improvised and deliberately distorted or obscured, the painter opens the field to the suggestions of his repressed interior life. But the painter's manipulation of his fantasy must differ from the child's or psychopath's in so far as the act of designing is his chief occupation and the conscious source of his human worth; it acquires a burden of energy, a sustained pathos and firmness of execution foreign to the others.

The attitude to primitive art is in this respect very significant. The nineteenth century, with its realistic art, its rationalism and curiosity about production, materials and techniques often appreciated primitive ornament, but considered primitive representation monstrous. It was as little acceptable to an enlightened mind as the fetishism or magic which these images sometimes served. Abstract painters, on the other hand, have been relatively indifferent to the primitive geometrical styles of ornament. The distinctness of motifs, the emblematic schemes, the clear order of patterns, the direct submission to handicraft and utility, are foreign to modern art. But in the distorted, fantastic figures some groups of modern artists found an intimate kinship with their own work; unlike the ordering devices of ornament which were tied to the practical making of things, the forms of these figures seemed to have been shaped by a ruling fantasy, independent of nature and utility, and directed by obsessive feelings. The highest praise of their own work is to describe it in the language of magic and fetishism.

This new responsiveness to primitive art was evidently more than aesthetic; a whole complex of longings, moral values and broad conceptions of life were fulfilled in it. If colonial imperialism made these primitive objects physically accessible, they could have little aesthetic interest until the new formal conceptions arose. But these formal conceptions could be relevant to primitive art only when charged with the new valuations of the instinctive, the natural, the mythical as the essentially human, which affected even the description of primitive art. The older ethnologists, who had investigated the materials and tribal contexts of primitive imagery, usually ignored the subjective and aesthetic side in its creation; in discovering the latter the modern critics with an equal one-sidedness relied on feeling to penetrate these arts. The very fact

that they were the arts of primitive peoples without a recorded history now made them all the more attractive. They acquired the special prestige of the timeless and instinctive, on the level of spontaneous animal activity, self-contained, unreflective, private, without dates and signatures, without origins or consequences except in the emotions. A devaluation of history, civilized society and external nature lay behind the new passion for primitive art. Time ceased to be an historical dimension; it became an internal psychological moment, and the whole mess of material ties, the nightmare of a determining world, the disquieting sense of the present as a dense historical point to which the individual was fatefully bound – these were automatically transcended in thought by the conception of an instinctive, elemental art above time. By a remarkable process the arts of subjugated backward peoples, discovered by Europeans in conquering the world, became aesthetic norms to those who renounced it. The imperialist expansion was accompanied at home by a profound cultural pessimism in which the arts of the savage victims were elevated above the traditions of Europe. The colonies became places to flee to as well as to exploit.

The new respect for primitive art was progressive, however, in that the cultures of savages and other backward peoples were now regarded as human cultures, and a high creativeness, far from being a prerogative of the advanced societies of the West, was attributed to all human groups. But this insight was accompanied not only by a flight from the advanced society, but also by an indifference to just those material conditions which were brutally destroying the primitive peoples or converting them into submissive, cultureless slaves. Further, the preservation of certain forms of native culture in the interest of imperialist power could be supported in the name of the new artistic attitudes by those who thought themselves entirely free from political interest.

To say then that abstract painting is simply a reaction against the exhausted imitation of nature, or that it is the discovery of an absolute or pure field of form is to overlook the positive character of the art, its underlying energies and sources of movement. Besides, the movement of abstract art is too comprehensive and long-prepared, too closely related to similar movements in literature and philosophy, which have quite other technical conditions, and finally, too varied according to time and place, to be considered a self-contained development issuing by a kind of internal logic directly from aesthetic problems. It bears within itself at almost every point the mark of the changing material and psychological conditions surrounding modern culture. [. . .]

3. Eugene Lunn, 'Modernism in Comparative Perspective'

The artistic avant-garde and the political Left have a long and complex history of interrelationship, sometimes mutually reinforcing, sometimes mutu-

ally contradictory. Debates within the Left focused with particular intensity on the question of realism in art, since realism was both the favoured artistic approach and, in one of its forms at least, that approach with which the modern movement had decisively broken. In his book *Marxism and Modernism*, published in 1982, Eugene Lunn discusses the work of four representatives of the western Marxist tradition in terms of their variously positive and negative relationships to artistic modernism. These four are Georg Lukács, Bertolt Brecht, Walter Benjamin and Theodor Adorno. He prefaces his analysis with a rehearsal of the main outlines of Marx's thought on the relation of art to society, and a schematic overview of four exemplary traits of modernism in both literature and the visual arts. Lunn then goes on to examine in more historical detail the development of the avant-garde from *c.*1880 to *c.*1930 in relation to these four recurrent motifs. The extract reprinted here is taken from the opening pages of Chapter Two of Eugene Lunn, *Marxism and Modernism*, University of California Press, Berkeley, Los Angeles, London, 1982, pp. 34–42.

At the risk of being too schematic about such a complex and broad phenomenon, the following may be seen as major directions of aesthetic form and social perspective in modernism as a whole.

1. *Aesthetic Self-Consciousness or Self-Reflexiveness.* Modern artists, writers, and composers often draw attention to the media or materials with which they are working, the very processes of creation in their own craft. Novelists, for example, explore the problems of novel writing within their works (e.g., Joyce's *Ulysses* or Gide's *The Counterfeiters*); visual artists make the evocative or constructive function of colors a recurrent 'subject matter' (e.g., Matisse, Nolde, or Kandinsky) or try to exploit the possibilities of a now acknowledged two-dimensional surface (e.g., Braque or Picasso). Symbolists and later poets demonstrate a heightened self-consciousness about the nature of poetic language and view words as objects in their own right (e.g., Mallarmé); playwrights intentionally reveal the theatrical constructions of their dramas (e.g., Meyerhold, Pirandello, Brecht). In doing so, modernists escape from the time-worn attempt, given new scientific pretensions in naturalist aesthetics, to make of art a transparent mere 'reflection' or 'representation' of what is alleged to be 'outer' reality. They also depart from the more direct expression of feeling favored by the romantics. The modernist work often willfully reveals its own reality as a construction or artifice, which may take the form of an hermetic and aristocratic mystique of creativity (as in much early symbolism); visual or linguistic distortion to convey intense subjective states of mind (strongest in expressionism); or suggestions that the wider social world is built and rebuilt by human beings and not 'given' and unalterable (as in Bauhaus architecture or constructivist theatre).

2. *Simultaneity, Juxtaposition, or 'Montage.'* In much modernist art, narra-

tive or temporal structure is weakened, or even disappears, in favor of an aesthetic ordering based on synchronicity, the logic of metaphor, or what is sometimes referred to as 'spatial form.' Instead of narrating outer sequential or additive time, modern novelists explore the simultaneity of experience in a moment of psychological time, in which are concentrated past, present, and future (e.g., Joyce, Woolf, and especially Proust). Things do not so much fall apart as fall together, reminding us of the derivation of the ubiquitous 'symbol' from the Greek *symballein*, 'to throw together.'[1] Unity is often created from juxtaposing variant perspectives − of the eye, the feelings, the social class or culture, etc. − as in modern visual montage (e.g., Eisenstein, Grosz); metaphorical relationships suggested in modern poetry (e.g., Baudelaire); rhythmic and tonal simultaneity in music (e.g., Bartok or Stravinsky);[2] or the multiple consciousnesses which intersect in a modern novel (e.g., Woolf's *To the Lighthouse*). Cyclical or mythical recurrence is frequently viewed as a deeper reality than the surfaces disclosed in temporally unfolding historical events, the frame of reference which is so prominent in the literature of nineteenth-century realism. Instead of a traditional art of transitions from one event, one sensation, one thing at a time, presented sequentially, modern art is often without apparent causal progression and completion. It is intended to exist within an open-ended and 'continuous present' in which various experiences, past and present, inner and outer, of different persons are juxtaposed, their distances eclipsed as though on a flat surface.[3]

Whether or not such a procedure shows an escape from historical thinking, or merely its purely linear evolutionary or additive forms, is a question that shall concern us later. For now it is enough to point out that in exploring simultaneity modernists were accepting the ephemeral and transitory present as the locus of art, the moment which is seen, in Ezra Pound's phrase, as a 'brief gasp between one cliché and another.'[4] At best, such an 'aesthetic of the new' could freshen perceptions and cleanse the senses and language of routine, habitual, and automatic responses to the world, to 'defamiliarize' the expected and ordinary connections between things in favor of new, and deeper, ones. Montage need not have such liberating functions, however, and could be readily applied in manipulative advertising and political propaganda, while the cult of novelty might easily degenerate into a worship of changing fashions.[5]

3. *Paradox, Ambiguity, and Uncertainty.* To confront the decline, by the late nineteenth century, of religious, philosophical, and scientific certainties (of God, objective truth, historical progress, etc.), as well as the very notion of a fixed viewpoint, modernists explore the paradoxical many-sidedness of the world. Alarmed at the spectre of nihilism, the loss of meaning in transcendent imperatives and firm secular values,[6] modernists view reality as necessarily constructed from relative perspectives, while they seek to exploit the aesthetic and ethical richness of ambiguous images, sounds, and authorial points of view. Many modernist works turn on ambiguous treatments of the

contemporary city, the machine, or the 'masses.'[7] Modernists find aesthetic value in confronting urban experience, for example, from a variety of seemingly contradictory angles (the city as liberation from tradition and routine, but also as the locus of interpersonal estrangement and fragmented experience, as in the pioneering urban poems of Baudelaire).

Instead of an omniscient and reliable narrator, modern writers develop either single or multiple, but all limited and fallible, vantages from which to view events. Open-ended paradoxes may be structured in such a manner as to suggest to the reader or audience how they may resolve the contradictions outside the intentionally unfinished work (as Brecht attempted to do), or provisionally synthesize the multiple perspectives (as cubist painters encourage their viewers). More radically, however, the paradoxes may be heightened to the point of apparent irresolution, confronting the reader or audience with a 'Janus-faced' reality, impenetrable in its enigmas (e.g., Kafka or Beckett).

4. *'Dehumanization' and the Demise of the Integrated Individual Subject or Personality.* In both romantic and realist literature of the nineteenth century, individual characters are presented with highly structured personality features and develop their individuality through a life of social interaction. (We have seen the importance that Marx and Engels attached to this in their view of realism.) The narrator or playwright, through descriptions of conduct or psychic states, or through dramatic dialogue, endeavors to reveal integrated human characters in their process of more or less orderly formation and transformation. 'Character, for modernists like Joyce, Woolf, Faulkner, however,' Irving Howe has written, 'is regarded not as a coherent, definable and well-structured entity, but as a psychic battlefield, or an insoluble puzzle, or the occasion for a flow of perceptions and sensations. This tendency to dissolve character into a stream of atomized experiences . . . gives way . . . to an opposite tendency . . . in which character is severed from psychology and confined to a sequence of severely objective events.'[8] In modern painting, the human form is violently distorted by expressionists, decomposed and geometrically resynthesized by cubists, and disappears entirely, of course, in nonfigurative abstract art. We shall see repeatedly in this chapter and the ones that follow how impersonal poetics, dehumanization in the visual arts, collective or mass characters in theatre, and the fragmentation of personality in the novel are important features of the modern cultural landscape.[9] Yet, it will be necessary to show the widely contrasting manner in which this 'crisis of individuality,' so to speak, was handled within the variety of modernist currents.

In the sections which follow, an attempt will be made to historically situate the various seminal currents of modernism. For the moment, a few comments are in order concerning the general cultural and social environment in which the overall 'movement' developed. First, it is worth considering aspects of the broad sweep of European cultural and political life in the period. Aesthetic

modernism developed in its initial stages within a wider context of declining religious faith among the educated population in the late nineteenth century, encouraging among artists, writers, and musicians an attitude toward art and its craft as, in a certain sense, a surrogate for religious certainties. The 'revolt against positivism' in natural science and social thought, in addition, antici-pated by Baudelaire and Nietzsche in the 1860s and 1870s, gained momentum by the 1890s and helped the spread of the pioneering symbolist revolt against mimetic aesthetics, while preparing some of the groundwork for later depar-tures from nineteenth-century realism.[10] In a more specialized way, the very desire to simply reproduce or represent the natural or social world, as such, was undercut for many painters and novelists by the increasing importance of photography, on the one hand, and fact-finding social research, on the other, leaving them free to develop imaginative constructions or explore the peculi-arities of their own aesthetic medium. (This was far from a universal conclu-sion; naturalism and symbolism coincided in time, after all, in their late nine-teenth-century heyday.)

The threats to positivist science and secular optimism at the end of the nineteenth century were brought on, in part, by a political and intellectual crisis of liberalism, one from which the socialists of the Second International felt themselves immune. Middle-class radicalism of the 1789–1870 era had waned or become absorbed by the 1880s. [. . .]

All of the major criteria of modernism that we have discussed – formal pre-occupations, spatial montage, the cultivation of paradox, the demise of the individual subject – were influenced, in their origins, by this broad crisis of eighteenth- and nineteenth-century liberal thought. Stress upon simultaneity and a heightened 'present consciousness,' as opposed to temporal unfolding, resulted, in part, from a loss of belief in the beneficent course of linear his-torical development (although, as we shall see, the era 1905–25 saw a resur-gence of historical hope now mixed also with dread, which was fueled by an opposition to notions of *automatic* progress). The 'crisis of individuality' in modern art reflected the fears (or, in some cases, the hopes) of many intellec-tuals and artists concerning the coming of an age of 'masses' and unprece-dented technological power. Finally, paradoxical formulations and ambiguous images, as well as a concentration upon the formal craft of one's art, were all encouraged by the general loss of religious and secular certainties.[11] [. . .]

Still another body of inherited belief that could no longer sustain the modernists was the conception of nature (developed by some of the roman-tics) as an effective counterfoil to modern urban and industrial society.[12] By the end of the nineteenth century, the increasingly visible extension of the constructed, urban, industrial, and scientific world had begun to remove the countryside as an available refuge and emotional inspiration for most of the literary and artistic avant-garde. This did not merely mean that nature diminished in importance as a subject of art and literature. The technical abil-

ity to master and control the given environment, the 'humanization' of nature through the modern city and its various technological extensions, was also a source of the tendency since Baudelaire to view art and science as objects in their own right – as self-reflexive constructions, instead of as more or less direct expressions of feeling or as representations of outer or inner reality (as they had largely been seen in romantic aesthetics).[13] In modernist experience, 'decadent' weariness with a 'finished' or 'completed' world (and its routine practices) alternates with hopes for a radical remaking of what has been humanly constructed (which can take right-wing or left-wing forms, e.g., D'Annunzio or Meyerhold). In this way, languid melancholia and revolutionary enthusiasm (the latter of which grew after 1905) may each be seen as a different response, in part, to the pervasive spread of a technological society.[14]

The influence of such broad cultural and political changes upon the modernists was mediated by their own particular social and economic position, their new professional role as artists in an increasingly commercial society. Modernists were often members of defensive and belligerent coteries, circles, or self-proclaimed 'avant-gardes.' For such groups, the tyrannies of commercialization, conventional public opinion, and an innocuous and clichéd classical or romantic culture acted as an irritant and a provocation for revolt, but were exercised within limits that allowed the free play of scandal and experimentation (which themselves eventually could be absorbed and become a new cliché).[15] The military connotations of the phrase 'avant-garde' suggest an embattled small community, desperately needing mutual support among themselves – encouraging an art for one's aesthetic peers, concerned with questions of craft and form[16] – so as to be able to launch 'guerrilla raids' on the various cultural establishments.

By the last third of the nineteenth century, the professional position of the artist, writer, or musician (as a purveyor of cultural commodities on the market) also played a role in the growth of a modernist aesthetic and social outlook. The shift from patronage to market systems in the arts had begun in eighteenth-century England, and had antedated the modernists, on a wider scale, by at least a couple of generations, as César Graña has shown in his study of Parisian literati of 1830–60. By the mid-nineteenth century, the decline of the patronage system and the conditions of salability in a crowded, competitive market had placed a new emphasis upon originality and innovation and promised rapid fortune and fame as the reward for 'creative' work; on the other hand, however, the uncertain response of a new, distant, mass middle-class public, and sheer dependence on impersonal business considerations, encouraged feelings of martyrdom among artists, writers, and musicians and rendered them impotent in a crass and hostile world.[17]

It was not, however, until the late nineteenth century that the full implications of the new market situation, taken together with the cultural changes discussed above, were to be felt in a radically altered aesthetic form

and perspective: the modernist stress upon art as a self-referential construct instead of as a mirror of nature or society. Whereas earlier, among romantics and realists, feelings of isolation and the gulf between artist and public had not loomed quite so large – mitigated by the prevalence of integrative concepts such as those of a wider natural environment or an encompassing social process – such sustaining beliefs were by now in decline. By the 1880s or 1890s, many writers and artists, breaking fully from mimetic aesthetics, were more than ever thrown back upon their own selves or their own craft as a central object of their work, with only an 'avant-garde' circle of initiates to share it with. As with other groups of intellectuals by the last third of the century, they too were becoming 'experts' within a delimited field. Championing their own special rights (e.g., 'art for art's sake') as another isolated 'interest group,' they were in this respect much like lawyers, journalists, or professors, except that artists, writers, and musicians were less comfortably self-employed, generally lacking a regular clientele.[18] It is easier to condemn this seemingly self-absorbed posture, as many Marxists have done, and the often contemptuous and disdainful aristocratic attitudes it undoubtedly spawned, than to recognize the equally significant, but more promising, other result: a heightened attention to the ways in which all reality allegedly 'pictured' in art is, in fact, constructed by aesthetic activity, form, and materials.

1 James McFarlane, 'The Mind of Modernism,' in *Modernism: 1890–1930*, ed. Malcolm Bradbury and James McFarlane (New York, 1976), p. 92. McFarlane writes: 'The very vocabulary of chaos – disintegration, fragmentation, dislocation – implies a breaking away or a breaking apart. But the defining thing of the Modernist mode is not so much that things fall *apart* but that they fall *together*.'

2 H.H. Stuckenschmidt, *Twentieth-Century Music* (New York, 1969), pp. 71–90.

3 See Roger Shattuck, *The Banquet Years: The Arts in France, 1885–1918* (New York, 1958), pp. 331–360; and the pioneering study by Joseph Frank, first published in 1945, 'Spatial Form in Modern Literature,' in *The Widening Gyre* (New Brunswick, N.J., 1963), pp. 3–62.

4 Quoted in Renato Poggioli, *Theory of the Avant-Garde* (Cambridge, Mass., 1968), p. 82.

5 Ibid., pp. 79–84.

6 Irving Howe, 'The Idea of the Modern,' in *Literary Modernism*, ed. Irving Howe (New York, 1967), pp. 36–40.

7 See Peter Gay, *Art and Act: On Causes in History – Manet, Gropius, Mondrian* (New York, 1976), pp. 108–110.

8 Howe, 'Idea of the Modern,' p. 34.

9 See, particularly, José Ortega y Gasset, *The Dehumanization of Art; and Other Essays on Art, Culture and Literature* (Princeton, N.J., 1968).

10 For a general discussion of the 'revolt against positivism,' see H. Stuart Hughes, *Consciousness and Society: The Reconstruction of European Social Thought, 1890–1930* (New York, 1961), chap. 2. For its impact on aesthetic modernism, see McFarlane, 'The Mind of Modernism,' pp. 71–94.

11 The most meticulous and sustained study of the relation between the crisis of liberalism and one case of the rise of aesthetic modernism is in Carl E. Schorske, *Fin de Siècle Vienna: Politics and Culture* (New York, 1980).

12 On this aspect of romanticism, see M.H. Abrams, *Natural Supernaturalism: Tradition and Revolution in Romantic Literature* (New York, 1973), especially pp. 88–116. Abrams warns against viewing the romantics as desiring a simple return to an easeful and undifferentiated nature; all the major writers, and especially Blake, he argues, 'set as the goal of mankind the reachievement of a unity which has been earned by unceasing effort and which is . . . an equilibrium of opponent forces which preserves all the products and powers of intellection and culture' (p. 260).

13 See M.H. Abrams, *The Mirror and the Lamp: Romantic Theory and the Critical Tradition* (Oxford, England, 1953). For further contrasts between symbolism and romanticism, see Anna Balakian, *The Symbolist Movement: A Critical Appraisal* (New York, 1967), pp. 34–38.

14 On the influence of the technical 'humanization of nature' upon modern writers and artists, I have found useful: Stephen Spender, *The Struggle of the Modern* (Berkeley, Calif., 1963), pp. 143–155; Fredric Jameson, 'The Vanishing Mediator: Narrative Structure in Max Weber,' *New German Critique*, 1 (Winter 1974); and Wylie Sypher, *Literature and Technology: The Alien Vision* (New York, 1968).

15 Poggioli, *Theory of the Avant-Garde*, pp. 95–100 and 106–108.

16 Malcolm Bradbury, 'The Cities of Modernism,' in *Modernism*, p. 100.

17 César Graña, *Modernity and Its Discontents: French Society and the French Man of Letters in the Nineteenth Century* (New York, 1967), especially chap. 5.

18 Poggioli, *Theory of the Avant-Garde*, pp. 112–114, where he writes that the artist is led 'to assume the fiction of being a self-employed professional, but in most cases he lacks the doctor's, lawyer's and engineer's regular clientele.' On the professionalization process among intellectuals and artists, I have also drawn upon John R. Gillis, *The Development of European Society, 1770–1870* (Boston, 1977), pp. 271–274; and Wolfgang Sauer, 'Weimar Culture: Experiments in Modernism,' *Social Research*, 39:2 (Summer 1972).

4. T.J. Clark, from *Farewell to an Idea*

T.J. Clark's book *Farewell to an Idea*, published in 1999, is a complex and ambitious attempt to re-read key episodes from an extended history of modernism in terms of their relation to the embracing condition of modernity. The book opens with a discussion of Jacques-Louis David's *Marat* of 1793, and, via encounters with

Plate 4 Adolph Menzel, *Moltke's Binoculars*, 1871, pencil and gouache on paper, 26 x 40 cm. Kupferstichkabinett, Staatliche Museen, Berlin. Courtesy of BPK, Germany. Photo: Joerg P. Anders.

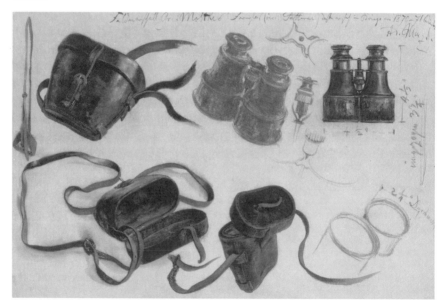

Pissarro, Cézanne, Cubism and Suprematism, closes with an examination of Abstract Expressionism, c.1950. The book is renowned for the melancholic character of its retrospect, occasioned by Clark's sense that modernism is over, but that its being over signals not some transcendence of modernity (into a more egalitarian social formation), but the Pyrrhic victory of capitalism. Modernity is everywhere now, and that means that the 'idea' of transforming it into something else is effectively lost. For Clark, this gives modernism the character of a ruin, one whose fragments the historian-as-archaeologist must excavate. This clearly involves a more extended sense of modernism than that to which we have become used, something beyond its conventional assessments, positive (free, independent, purified, etc.), and negative (incomprehensible, idle, elitist, etc.), alike. At bottom, Clark's modernism seems to be characterised by a sense of the contingency of everything in history, which nonetheless strives to impose some kind of totality on the fragments of modernity at the level of the imagination, if not in lived history itself. We reprint in full the Introduction to T.J. Clark, *Farewell to an Idea. Episodes from a History of Modernism*, Yale University Press, New Haven and London, 1999, pp. 1–13.

> Gebrochen auf dem Boden liegen rings
> Portale, Giebeldächer mit Skulpturen,
> Wo Mensch und Tier vermischt, Centaur und Sphinx,
> Satyr, Chimäre – Fabelzeitfiguren.
>
> (Broken on the ground lie round about/Portals, gable-roofs with sculptures,/Where men and animals are mixed, centaur and sphinx,/Satyr, chimera – figures from a legendary past.)
>
> Heine, 'Für die Mouche'

For a long time, writing this book, I had a way of beginning it in mind. I wanted to imagine modernism unearthed by some future archaeologist, in the form of a handful of disconnected pieces left over from a holocaust that had utterly wiped out the pieces' context – their history, the family of languages they belonged to, all traces of a built environment. I wanted Adolph Menzel's *Moltke's Binoculars* [Plate 4] to have survived; and John Heartfield's *A New Man – Master of a New World* [Plate 5]; and Picasso's *Italian Woman* [Plate 6]; and Kasimir Malevich's *Complex Presentiment (Half-Figure in Yellow Shirt)* [Plate 7]. The questions that followed from the thought-experiment were these. What forms of life would future viewers reconstruct from this material? What idea of the world's availability to knowledge would they reckon the vanished image-makers had operated with? What imaginings of past and future? Or of part and whole? Would it be just the archaeologists' fancy that the surviving images had ruin, void, and fragmentariness already written into them, as counterpoint to their hardness and brightness? The rep-

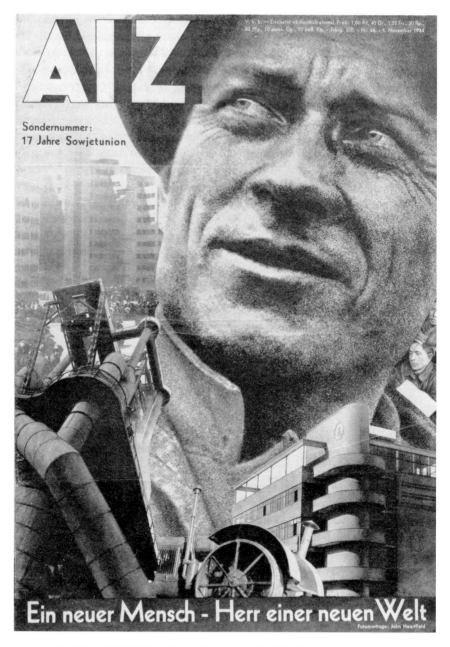

Plate 5 John Heartfield, '*A New Man – Master of a New World*,' 1934, photomontage, 38 x 27 cm. Stiftung Archive der Akademie der Künste. Copyright © DACS, London, 2003.

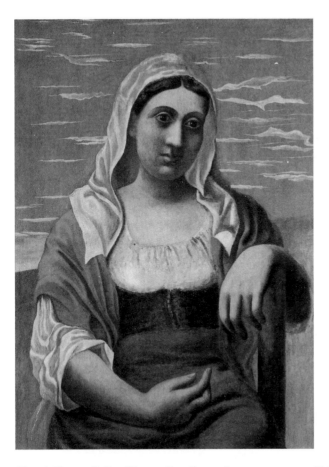

Plate 6 Picasso, *Italian Woman*, oil on linen, 98.5 x 70.5 cm. 1919, Private collection.

etition of *neuer* and *neuen* in the Heartfield might strike the interpreters as keys to all this, but the words themselves would mean nothing. Likewise the writing on the back of the Malevich, elaborate and careful, presumably in the painter's hand. Our archaeologists would not know it read: 'The composition coalesced out of elements of the sensation of emptiness, of loneliness, of the exitlessness [*besvykhodnosti*] of life.'[1] And even if by some fluke they deciphered it, how far would that get them in making sense of Malevich's (modernism's) tone? The painting is ostensibly jaunty, almost flippant. Its man, house, and landscape have the look of toys. But in what sort of game? Played by which wanton children? Was it the same game as Heartfield's (or even Moltke's)?

I find it hard to imagine any human viewer, even on the other side of Armageddon, not responding to the tenderness and punctiliousness of Picasso's modeling in *Italian Woman* – the shading of eyes and mouth, the

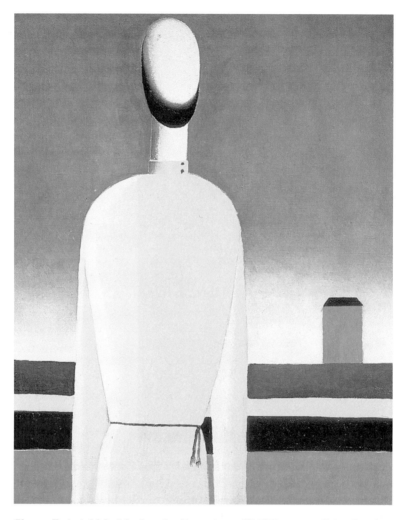

Plate 7 Kasimir Malevich, *Complex Presentiment (Half-Figure in a Yellow Shirt)*,
1928–32, oil on canvas, 98.5 x 78.5 cm. State Russian Museum, St Petersburg.
Photo: Bridgman Art Library, London.

different sheens and textures of what the woman is wearing, the pressure of
hand on lap – and understanding they were offerings of love. But beyond
that, this world of persons and sexualities would be opaque. (Would future
viewers sense that Picasso's woman is wearing fancy dress? Would they take
their cue from the clouds in the sky?) Is the male in *Complex Presentiment*
being teased for his phallic dutifulness – those two little buttons! that draw-
string at the waist! – or are these his last shreds of humanity? I have no more
idea than the archaeologists. Are Field Marshal Moltke's binoculars wonder-
ful or silly? Here they are, snug in their carrying case! And here is the case

empty, with magenta lining visible. And here it is shut tight and buckled. And this is how the focus screw works. 'Is there an object for which the nineteenth century did not invent a case or a holder? It had them for watches, slippers, egg-cups, thermometers, playing cards. And if not cases and holders, it invented envelopes, housings, loose covers, dust sheets.'[2] It is as if an object did not properly exist for this culture until it sat tight in its own interior; and one is hard put to say – certainly on the evidence of Menzel's gouache – whether this was because the object was felt to need protection from the general whirl of exchange (or bullets), or whether it was thought to be so wonderful in its own right that a separate small world should be provided for it, like a shell or calyx. Heartfield's new man, photographically grimy, is similarly encased – touched on two sides by blast furnaces, cooperative apartment blocks, tractors, trucks full of soldiers, the new Baku Palace of the Press. He looks to the future, eyes airbrushed full of tears.

Now that I sit down to write my introduction, I realize that what I had taken for a convenient opening ploy – the fragments, the puzzling scholars, the intervening holocaust – speaks to the book's deepest conviction, that already the modernist past is a ruin, the logic of whose architecture we do not remotely grasp. This has not happened, in my view, because we have entered a new age. That is not what my book title means. On the contrary, it is just because the 'modernity' which modernism prophesied has finally arrived that the forms of representation it originally gave rise to are now unreadable. (Or readable only under some dismissive fantasy rubric – of 'purism,' 'opticality,' 'formalism,' 'elitism,' etc.) The intervening (and interminable) holocaust was modernization. Modernism is unintelligible now because it had truck with a modernity not yet fully in place. Post-modernism mistakes the ruins of those previous representations, or the fact that from where we stand they seem ruinous, for the ruin of modernity itself – not seeing that what we are living through is modernity's triumph.

Modernism is our antiquity, in other words; the only one we have; and no doubt the Baku Palace of the Press, if it survives, or the Moltke Museum, if it has not been scrubbed and tweaked into post-modern receptivity (coffee and biscotti and interactive video), is as overgrown and labyrinthine as Shelley's dream of Rome.

This Poem was chiefly written upon the mountainous ruins of the Baths of Caracalla, among the flowery glades, and thickets of odoriferous blossoming trees, which are extended in ever winding labyrinths upon its immense platforms and dizzy arches suspended in the air. The bright blue sky of Rome, and the effect of the vigorous awakening spring in that divinest climate, and the new life with which it drenches the spirits even to intoxication, were the inspiration of this drama.[3]

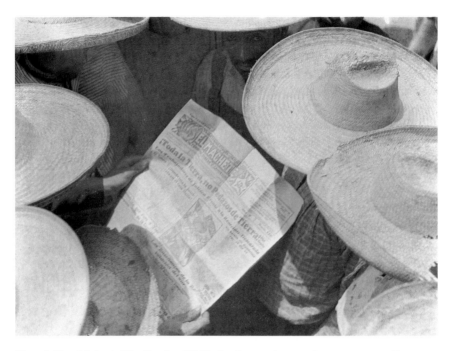

Plate 8 Tina Modotti, *Men Reading 'El Machete'*, 1924, photograph, 17.1 x 23.5 cm. Courtesy of Throckmorton Fine Art, New York.

The tears in the eyes of Heartfield's new man will soon be as incomprehensible as scratches on Mousterian bone. And as for Menzel's passion for binoculars! His careful measurements in inches, his depthless swivelling of things to reveal their visual truth, his dreaming of state-formation in terms of a gadget in a battle-worn case . . . This is a world, and a vision of history, more lost to us than Uxmal or Annaradapurah or Neuilly-en-Donjon. We warm more readily to the Romanesque puppets on God's string, or the kings ripping blood-sacrifice from their tongues, than to workers being read to from *Izvestia* or *El Machete* (Plate 8).

These are the reasons I could not escape in writing this book from the dangerous (and no doubt absurd) idea that it was addressed to posterity. Of course this was fantasy, not prediction: it was a way of writing, or dreaming of writing; and from it derives much of the book's basic form – its brokenness and arbitrariness, and the accompanying effort at completeness of knowledge, at least in the few test cases I do present. I think of them as core samples, or preliminary totalizations. The modernist arrogance of that ambition is precisely why I could not let it go. (Not that I am claiming that this is how the book proceeds all through. Chapters vary in length and tactics. 'Completeness' is not the same as comprehensiveness. But the chapters and moments the book hinges on – Pissarro in 1891, UNOVIS in 1920, David in Year 2, Picasso in the

first flush of Cubism – are turned in the hand, I hope, as fiercely as Moltke's binoculars. They are items from a modernist dig.)

Addressed to posterity, then – but posterity meaning us.

No one expects books on Romanticism, Dada, or the Scientific Revolution to come up with capsule definitions of their subjects. Why modernism has been the exception here is a story in its own right. I shall operate with a loose and capacious notion of modern art, and spend a lot of my time (not all) on limit cases; the assumption being that in these the pressures and capacities of a particular mode of representation (maybe we should call it a family of modes) will tend to be clearest, just because the capacities are pressed to breaking point. 'Limits' in this case does not mean edges. I want to avoid thinking of modernism in spatial terms, even in terms of conceptual space. I want modernism to emerge as a distinctive patterning of mental and techni-cal possibilities. Limit cases, like Pissarro in 1891 or Malevich in 1920 or Pollock from 1947 to 1950, seem to me characterized by a thickening or thin-ning of those patterns – by kinds of simplification or overload, stabs at false immediacy or absolute muteness, ideas of beginning again or putting an end to representation, maybe moving finally from representation to agency (from art to politics, or from sign to trace, or to signs whose meanings only the future will grasp).

As for the word 'modernity,' it too will be used in a free and easy way, in hopes that most readers know it when they see it. 'Modernity' means contingency. It points to a social order which has turned from the worship of ancestors and past authorities to the pursuit of a projected future – of goods, pleasures, freedoms, forms of control over nature, or infinities of information. This process goes along with a great emptying and sanitizing of the imagination. Without ancestor-wor-ship, meaning is in short supply – 'meaning' here meaning agreed-on and insti-tuted forms of value and understanding, implicit orders, stories and images in which a culture crystallizes its sense of the struggle with the realm of necessity and the reality of pain and death. The phrase Max Weber borrowed from Schiller, 'the disenchantment of the world,' still seems to me to sum up this side of modernity best. Or the throwaway aphorism of Paul Valéry: 'The modern contents itself with little [*Le moderne se contente de peu*].' (And of course it is no argument against Weber's thesis to say that 'we live in the middle of a religious revival,' that Marxism became a grisly secular messianism in the twentieth cen-tury, that everyday life is still permeated by the leftovers of magic, and so on. The disenchantment of the world is horrible, intolerable. Any mass movement or cult figure that promises a way out of it will be clung to like grim death. Better even fascism than technocracy: there is a social id in most of us that goes on being tempted by that proposition.)

'Secularization' is a nice technical word for this blankness. It means spe-cialization and abstraction; social life driven by a calculus of large-scale sta-

tistical chances, with everyone accepting (or resenting) a high level of risk; time and space turned into variables in that same calculus, both of them saturated by 'information' and played with endlessly, monotonously, on nets and screens; the de-skilling of everyday life (deference to experts and technicians in more and more of the microstructure of the self); available, invasive, haunting expertise; the chronic revision of everything in the light of 'studies.' I should say straightaway that this cluster of features seems to me tied to, and propelled by, one central process: the accumulation of capital, and the spread of capitalist markets into more and more of the world and the texture of human dealings. I realize this is now a minority view, and will be seen by many readers as a vestige of the early twentieth-century messianism I just tried to put at a distance. If I cannot have the proletariat as my chosen people any longer, at least capitalism remains my Satan.

Let me try to strike a bargain with the reader over this. Could we agree on the following, which I think may be a necessary, or at least helpful, hypothesis if what we are trying to do is understand why modernity and modernism go together? Leaving the word 'capitalism' aside, is it not the case that the truly new, and disorienting, character of modernity is its seemingly being driven by merely material, statistical, tendential, 'economic' considerations? We know we are living a new form of life, in which all previous notions of belief and sociability have been scrambled. And the true terror of this new order has to do with its being ruled – and obscurely felt to be ruled – by sheer concatenation of profit and loss, bids and bargains: that is, by a system without any focusing purpose to it, or any compelling image or ritualization of that purpose. It is the blindness of modernity that seems to me fundamental, and to which modernism is a response: the great act, to go back to Adam Smith's insight, is the hiddenness of the 'hidden hand'; or rather, the visibility of that hiddenness – the availability to individual consciousness of more and more 'information' (a ludicrous, lobotomizing barrage of same) pointing to the purposelessness of social action.

Blindness, purposelessness, randomness, blankness; pictures built out of statistical accumulations of thrown marks, or touch after touch of pure surfaceness, pure sensation; but equally, pictures clinging to a dream of martyrdom, or peasant leisure, or naked intensity in the woods; and pictures fantasizing themselves the voice – the image, the plan – of a post-human calculus in the making. 'I declare Economy to be the new fifth dimension, the test and measure of all creative and artistic work.' 'THE FACTORY BENCHES ARE WAITING FOR YOU. LET US MOVE PRODUCTION FORWARD.'[4] Modernism is caught interminably between horror and elation at the forces driving it – between 'Less Is More' and 'NO CHAOS DAMN IT.' It takes its own technicality and specialization as guarantees of truth. But at the same time it knows these qualities are potentially smug and philistine, always threatening to turn into a Bauhaus- or École de Paris-orthodoxy. Modernism's disdain for the world and wish for a truly

gratuitous gesture in the face of it are more than just attitudes: they are the true (that is, agonized) form of its so-called purism. Wilde and Nietzsche are this agony's spokesmen, Rimbaud's its exemplary life. And yet the thought of belonging and serviceability (of Economy as an ideal) haunts modernism, all the more so because belonging and serviceability are sensed to be modernity's true opposites – the dimensions to experience it most ruthlessly outlaws or travesties. These antinomies of modern art, and their relation to a history it invents and resists and misrecognizes, are what this book is mainly about.

The book was written after the Fall of the Wall. That is, at a moment when there was general agreement, on the part of masses and elites in most of the world, that the project called socialism had come to an end – at roughly the same time, it seems, as the project called modernism. Whether those predictions turn out to be true, only time will tell. But clearly something of socialism and modernism has died, in both cases deservedly; and my book is partly written to answer the question: If they died together, does that mean that in some sense they lived together, in century-long co-dependency?

Socialism, to remind you, was the idea of 'the political, economic and social emancipation of the whole people, men and women, by the establishment of a democratic commonwealth in which the community shall own the land and capital collectively and use them for the good of all.'5 Co-dependency, we know to our cost, does not necessarily mean mutual aid or agreement on much. Modernism was regularly outspoken about the barrenness of the working-class movement – its politics of pity, its dreary materialism, the taste of the masses, the Idea of Progress, etc. But this may have been because it sensed socialism was its shadow – that it too was engaged in a desperate, and probably futile, struggle to imagine modernity otherwise. And maybe it is true that there could and can be no modernism without the practical possibility of an end to capitalism existing, in whatever monstrous or pitiful form.

Monstrous or pitiful. We are back in Heartfield territory. You will see in what follows that I interpret the terms 'socialism' and 'working-class movement' broadly. Two of my main cases are Jacobinism and the sans-culottes in 1793, and anarchism in the early 1890s. Even my third test case, War Communism in Russia in 1919 and 1920, is deliberately extreme: it is maybe as close as any modern society has come to a wholesale dismantling of the money economy, but of course the dismantling was largely involuntary – and where deliberate, doctrinaire and foolhardy – with results that were truly horrible. I make no apology for my strange trio. The Jacobin moment is foundational (sadly) for the imaginings of mass politics that followed. Anarchism is an aspect of socialism (among many others) that those of us wishing socialism, or some comparable form of resistance, to survive will have to think about again, this time without a prearranged sneer. War Communism was utopia as well as horror and abyss, and it leaves us with the question, which we should not allow

the enemies of anti-capitalism to monopolize, whether a utopian form of opposition to the present is always in practice infernal. 'Modernity, the time of hell,' reads one of Walter Benjamin's jottings.[6] There was a kind of socialism that toyed with, and in the end realized, the possibility of making that hell actual. In hopes of the fire being purgative. This has a ghastly attractiveness for modernists, we shall see. UNOVIS tried to get on the bandwagon/tumbril. Modernism regularly joins hands with socialism when socialism is in extremis. That is another reason for my choice of examples.

Socialism was one of the forces, maybe *the* force, that made for the falsely polarized choice which modernism believed it had before it – between idealism and materialism, or *Übermensch* and lumpen, or esoteric and popular. Between the cultic and the utterly disenchanted. Between the last exacerbation of individuality and its magical disappearance into pure practice or avant-garde collectivity. I sense that what lay between those mad alternatives was above all socialism – again, broadly construed. (Revolution, or the cult of class consciousness, would be other words for much the same cluster of images and actions.) Socialism occupied the real ground on which modernity could be described and opposed; but its occupation was already seen at the time (on the whole, rightly) to be compromised – complicit with what it claimed to hate. This is not meant as excuse for the thinness and shrillness of most of modernism's occupation of the *un*real ground. There could have been (there ought to have been) an imagining otherwise which had more of the stuff of the world to it. But I am saying that modernism's weightlessness and extremism had causes, and that among the main ones was revulsion from the working-class movement's moderacy, from the way it perfected a rhetoric of extremism that grew the more fire-breathing and standardized the deeper the movement bogged down on the parliamentary road.

Modernism had two great wishes. It wanted its audience to be led toward a recognition of the social reality of the sign (away from the comforts of narrative and illusionism, was the claim); but equally it dreamed of turning the sign back to a bedrock of World/Nature/Sensation/Subjectivity which the to and fro of capitalism had all but destroyed. I would be the last to deny that modernism is ultimately to be judged by the passion with which, at certain moments, it imagined what this new signing would be like. Cézanne and Cubism are my touchstones, and Pollock in the world of his drip paintings. But at the same time I want to say that what they do *is* only imagining, and fitful imagining at that – a desperate, marvellous shuttling between a fantasy of cold artifice and an answering one of immediacy and being-in-the-world. Modernism lacked the basis, social and epistemological, on which its two wishes might be reconciled. The counterfeit nature of its dream of freedom is written into the dream's realization: this is an argument that crops up several times in the book. The chapter on UNOVIS may show the link between counterfeit and the modern artist's social isolation more specifically than the

chapter on Cubism can. But the link is essentially the same. Some avant gardes believe they can forge a place for themselves in revolution, and have real truck with languages in the making; others believe that artists can be scientists, and new descriptions of the world be forged under laboratory conditions, putting aside the question of wider intelligibility for the time being. I do not see that either belief is necessarily (logically) misguided. It is just that in the actual circumstances of modernism – in modernity, that is – they have so far proved to be.

A book about nineteenth- and twentieth-century culture will inevitably turn on the question of money and the market, and their effect on artmaking. This book does so three times: in its dealings with the Terror and War Communism, and with Pissarro in 1891. Again, two of the three cases are extreme. In 1793 in France and 1920 in Russia the very relation between markets and money seemed, for a while, to be coming to an end. We shall see that certain Bolsheviks looked back to Year 2 explicitly, and exulted in the notion of the socialist state's being able now to drown its enemies in a flood of paper. It was a fantasy, but not an entirely empty one. Money is the root form of representation in bourgeois society. Threats to monetary value are threats to signification in general. 'Confidence in the sign' was at stake, to quote one historian of Jacobinism, talking of inflation in 1793 and the role of new banknotes.[7] In their different ways David and Malevich confronted that crisis of confidence, I think, and tried to give form to its enormity. In coming to terms with money, or with money seemingly about to evaporate as a (central) form of life, modernism at moments attained to true lucidity about the sign in general.

I did say 'at moments.' I am not forgetting the a priori emptiness of most of modernism's pronouncements on matter and the production of meaning. Of course modernism usually vacillated between a crude voluntarism and an equally crude positivity ('in the nature of materials' and so on). But again, limit cases reflect back on normal ones. What modernism thought was possible when the whole signifying basis of capitalism went into free flow – what it thought it might do with the opportunity – may tell us something about where the crude voluntarism and positivism were always meant to be going, even when modernity was as solid as a rock.

A word that has come up already, and will do so again, is 'contingency.' It points to the features of modernity I began with: the turning from past to future, the acceptance of risk, the omnipresence of change, the malleability of time and space. What it does not mean, I should stress, is that modern life is characterized by an absolute, quantitative increase in uncontrolled and unpredictable events. Tell that to societies still in the thrall of Nature, meaning floods, famine and pestilence. Tell it to parents coping with pre-modern levels of infantile mortality. Obviously modern society offers the majority of

its citizens – we could argue about the precise size of that majority – safer and more humdrum lives. But it is this very fact, and the stress put on the achievement in modern society's endless self-apology, that makes the remaining and expanding areas of uncertainty the harder to bear. Again, the capitalist market is key. Markets offer hugely increased opportunities for informed calculation and speculation on futures. That is why they rule the world. But they do so only if players are willing to accept that conduct *is* calculus and speculation, and therefore in some fundamental sense hit or miss. Markets are predictable and risky. Human beings are not used to living their lives under the sign of both. (Or of either, in a sense. Pre-modern social orderings were not 'predictable.' They were the very ground of experience as such – of having and understanding a world – confirmed and reconfirmed in the rituals of everyday life. Pre-modern natural disasters were not experienced as risk. They were fury or fate. The very idea of natural disaster is a modern one, an invention of actuaries, aiming to objectify a previous congeries of terrors.)

This is what 'contingency' means. It is an issue of representation, not empirical life-chances. And using the word is not meant to imply that modern societies lack plausible (captivating) orders of representation, or myths of themselves – how could anyone living the triumph of late-twentieth-century consumerism, or watching ten-year-olds play computer games, have any illusions on that score? Contingency is good business. It may even turn out to be good religion. (It remains to be seen if the ten-year-olds grow up and get born again. When I said a few pages ago that modern societies were ruled 'by a system without any focusing purpose to it, or any compelling image or ritualization of that purpose,' I knew my vocabulary would seem old-fashioned, at least to some. Maybe focus and purpose are things human beings can do without. Maybe not.) All I want to insist on is the novelty of our current ways of understanding self and others, and the fact that for modernism, risk and predictability were felt to be endlessly irresolvable aspects of experience (and of artmaking), endlessly at war. Modernism could not put contingency down. But the forms it gave it – think of Seurat's identical, mechanical, all-devouring paint atoms, or Pollock's great walls of accident and necessity – were meant to be ominous as well as spellbinding, and even after a century or half-century still register as such. Sit in the room full of Pollock's pictures at MoMA, and listen to visitors protest against both sides of the equation. 'Risk' here, in their view, is randomness and incompetence, and 'predictability' lack of incident, lack of individuating structure. A child of five could do it. Or a painting machine.

Seurat and Pollock are unfair examples, of course. They are as close as modernism comes to embracing contingency and making it painting's structural principle. By and large modernism's relation to the forces that determined it were more uneasy, as I said before, more antagonistic. Contingency was a fate to be suffered, and partly to be taken advantage of, but only in order to conjure back out of it – out of the false regularities and the indiscriminate free flow –

a new pictorial unity. Out of the flux of visual particles would come the body again (says Cézanne) – naked, in Nature, carrying the fixed weaponry of sex. Out of the shifts and transparencies of virtual space (says Picasso) would come the violin and the mandolin player. Tokens of art and life. Modernist painters knew the market was their element – we shall see Pissarro in 1891 half-railing, half-revelling in its twists and turns – but by and large they could never escape the notion that art would absolve or transfigure its circumstances, and find a way back to totality. Call it the Body, the Peasant, the People, the Economy, the Unconscious, the Party, the Plan. Call it Art itself. Even those moments of modernism that seem to me to have understood the implications of the new symbolic order (or lack of it) most unblinkingly – Malevich and Pollock are my chief examples – are torn between exhilaration and despair at the prospect. I call the exhilaration nihilism, and the despair unhappy consciousness. But I do not pretend they are easy to tell apart.

One further concession. I realize that my view of modernism as best understood from its limits makes for some notable silences in the book, or for hints at a treatment I do not provide. Matisse is a flagrant example. Above all there is an ominous leap in what follows from 1793 to 1891. Partly this is accident: I have had my say in previous writings on aspects of nineteenth-century art that would connect most vividly to the story I am telling (Courbet's attempt to seize the opportunity of politics in 1850, for example, or the pattern of risk and predictability occurring in paintings of Haussmann's new Paris), and I saw no way to return to them properly here. In any case, I want Pissarro and anarchism to stand for the nineteenth century's best thoughts on such topics. I believe they do stand for them. The true representativeness of 1891 and Pissarro is one of my book's main claims. But I know full well the claim is disputable, and that some readers will see my leap over the nineteenth century as the clue to what my argument as a whole has left out. I cannot bear to face, they will say, the true quiet – the true orderliness and confidence – of bourgeois society in its heyday, and the easy nesting of the avant garde in that positivity. I will not look again at Manet because I do not want to recognize in him the enormous distance of modern art from its circumstances, and the avant garde's willingness to seize on the side of secularization – the cult of expertise and technicality – that seemed to offer it a consoling myth of its own self-absorption.

Of course I bring on this sceptical voice because one side of me recognizes that it points to something real – how could anyone looking at Manet fail to? But equally, I am sure this view of Manet and the nineteenth century is wrong. I have no quarrel with the words 'enormous distance' and 'self-absorption' with reference to Manet's achievement. What I should want to insist on, though, is the terrible, inconsolable affect which goes with the look from afar. In general I think we have barely begun to discover the true strangeness and tension of nineteenth-century art, lurking behind its extroversion. Michael

Fried's books have opened the way. And do not make the mistake of believing that extremism is Manet's and Courbet's property exclusively, with maybe Seurat and van Gogh as co-owners. Ingres is more ruthless and preposterous than any of them. Cézanne around 1870 exists at, and epitomizes, the century's mad heart. Even Corot is a monster of intensity, pushing innocence and straight-forwardness to the point where they declare themselves as strategies, or magic against modernity in general. His gray pastorals grapple head on (not even defiantly) with the disenchantment of the world. They aim to include the disenchantment in themselves, and thus make it bearable. Sometimes they succeed. (Pissarro in 1891 is still trying out variants on his master Corot's tactic.) Even Monet's art is driven not so much by a version of positivism as by a cult of art as immolation, with more of the flavor of Nerval and Géricault to it than of Zola and Claude Bernard. 'I plunge back into the examination of my canvases, which is to say the continuation of my tortures. Oh, if Flaubert had been a painter, what would he ever have written, for God's sake!'[8] All of the nineteenth century is here.

Friends reading parts of this book in advance said they found it melancholic. I have tried to correct that as far as possible, which in the circumstances may not be very far. Melancholy is anyway an effect of writing; which is to say, this particular practice of writing – green-black words tapped nearly soundlessly into screen space at fin de siècle. The reason I write history is that I am interested in other practices, less cut off and abstract, which once existed and might still be learned from. I hope this proves true of Pissarro and El Lissitzky. Modernism may often have been negative; it was rarely morose. It is the case that many, maybe most, of my chapters come to a bad end. Trust the beginnings, then; trust the epigraphs. Trust Freud, and Stevens, and Frank O'Hara. So cold and optimistic, modernism. So sure it will get there eventually.

1 See Armand Hammer Museum catalogue, *Kasimir Malevich 1878–1935* (Los Angeles, 1990), p. 213.
2 Walter Benjamin, *Gesammelte Schriften*, vol. 5, *Das Passagen-Werk*, ed., Rolf Tiedemann (Frankfurt, 1982), I, p. 292.
3 Percy Bysshe Shelley, 'Preface to Prometheus Unbound', in Thomas Hutchinson, ed., *Shelley, Poetical Works* (Oxford, 1970), p. 205.
4 UNOVIS slogans, discussed and translated by Clark, pp. 226–9.
5 'Platform of the Church Socialist League', 1906, quoted in Peter d'A. Jones, *The Christian Socialist Revival 1877–1914* (Princeton N.J., 1968), p. 241.
6 Benjamin, *Das Passagen-Werk* II, p. 1010.
7 Marc Bouloiseau, *La République jacobine* (Prais, 1972), p. 123.
8 Claude Monet to Alice Hoschéde, 30 April 1889, in Daniel Wildenstein, *Claude Monet, Biographie et catalogue raisonné*, 5 vols., (Lausanne and Paris, 1874–91), 3: p. 247.

PART II
AVANT-GARDE AND NEO-AVANT-GARDE

Introduction

The selection of texts in this Part is framed by two contrasting evaluations of the legacy of the historical avant-garde, the first by Peter Bürger and the second by Benjamin Buchloh. Both authors consider its achievements in light of the subsequent emergence of a so-called 'neo-avant-garde'. The first term is characteristically employed to describe a range of art movements from the early years of the twentieth century, including Constructivism, Dada, Surrealism and, somewhat more problematically, Cubism, Futurism and Expressionism. The term 'neo-avant-garde', on the other hand, is employed to describe the radical art movements of the 1950s and 1960s, including Fluxus, Happenings, and later Conceptual Art, Installation and Performance Art. The contemporary theorist or historian of art is confronted by the dilemma that the avant-garde's assault on the institution of art has not only been comfortably withstood, but has been fully assimilated into the mainstream of twentieth-century art practice. The question that both authors address is whether and how art can sustain some form of critical or oppositional challenge to the status quo.

One principal impetus behind the historical avant-garde was the call to break down the barriers between art and everyday life. In part, this was a conscious strategy of resistance against the isolation of art as a discrete domain of aesthetic pleasure and its treatment as a commodity that could be bought and sold like any other. However, it was also intended to allow art to have a more direct impact on the forms and experiences of modern life. Here we include two essays on Cubism. The first, by Paul Smith, offers a detailed analysis of the way in which early Cubist paintings incorporate a range of sensory experiences in the representation of objects, including touch. The second, by Clement Greenberg, considers the introduction of collage. The development of this medium by Braque and Picasso represents a key moment in the history of modern art insofar as fragments of the real, including newspaper clippings, handbills, mass-produced papers and commercial cards, were incorporated into the artwork. For Greenberg, however, the achievement of collage lay chiefly in the way it drew the viewer's attention to the distinction between the picture plane and the fictive or illusionistic space behind it. Finally, we include a short extract from Henri Lefebvre's pioneering study, *The Critique of Everyday Life*, in which he explores the possiblity of a reconfigured relation between art and life.

1. Peter Bürger, from *Theory of the Avant-Garde*

Peter Bürger's short but highly influential book, *Theory of the Avant-Garde*, published in 1984, 'reflects a historical constellation of problems that emerged after the events of May 1968' (as Bürger himself noted in a post-script added to the second German edition). While broadly Marxist in its orientation, it forms part of a vigorous questioning of the categories and assumptions of Marx's analysis of society and culture. In the extract reprinted here, Bürger addresses the attempt by the 'historical avant-garde' to break free of the aestheticisation of art in bourgeois society by bringing about a reintegration of art and life. The extract includes the important footnote in which, as well as listing the constituents of the historical avant-garde, Bürger contrasts those movements of the early twentieth century with the 'neo-avant-garde movements' of the 1950s and 1960s. Bürger maintains that the latter are condemned to 'inauthenticity' and argues that under changed historical circumstances it is perhaps necessary to hold open rather than to close the distance between art and life. The book was originally published in German in 1974 as *Theorie der Avantgarde*. The following extracts are taken from the translation by Michael Shaw, *Theory of the Avant-Garde*, University of Minnesota Press, Minneapolis, 1984, pp.14, 17, 22–6, 49–54, 109.

History is inherent in esthetic theory. Its categories are radically historical (Adorno).[1]

1. The Historicity of Aesthetic Categories

Aesthetic theories may strenuously strive for metahistorical knowledge, but that they bear the clear stamp of the period of their origin can usually be seen afterward, and with relative ease. But if aesthetic theories are historical, a critical theory of art that attempts to elucidate what it does must grasp that it is itself historical. Differently expressed, it must historicize aesthetic theory. [...]

It is my thesis that the connection between the insight into the general validity of a category and the actual historical development of the field to which this category pertains ... also applies to objectifications in the arts. Here also, the full unfolding of the constituent elements of a field is the condition for the possibility of an adequate cognition of that field. In bourgeois society, it is only with aestheticism that the full unfolding of the phenomenon of art became a fact, and it is to aestheticism that the historical avant-garde movements respond.[2]

* * *

My second thesis is this: with the historical avant-garde movements, the social subsystem that is art enters the stage of self-criticism. Dadaism, the most radical movement within the European avant-garde, no longer criticizes schools that preceded it, but criticizes art as an institution, and the course its development took in bourgeois society. The concept 'art as an institution' as used here refers to the productive and distributive apparatus and also to the ideas about art that prevail at a given time and that determine the reception of works. The avant-garde turns against both – the distribution apparatus on which the work of art depends, and the status of art in bourgeois society as defined by the concept of autonomy. Only after art, in nineteenth-century Aestheticism, has altogether detached itself from the praxis of life can the aesthetic develop 'purely.' But the other side of autonomy, art's lack of social impact, also becomes recognizable. The avant-gardiste protest, whose aim it is to reintegrate art into the praxis of life, reveals the nexus between autonomy and the absence of any consequences. The self-criticism of the social subsystem, art, which now sets in, makes possible the 'objective understanding' of past phases of development. Whereas during the period of realism, for example, the development of art was felt to lie in a growing closeness of representation to reality, the one-sidedness of this construction could now be recognized. Realism no longer appears as *the* principle of artistic creation but becomes understandable as the sum of certain period procedures. The totality of the developmental process of art becomes clear only in the stage of self-criticism. Only after art has in fact wholly detached itself from everything that is the praxis of life can two things be seen to make up the principle of development of art in bourgeois society: the progressive detachment of art from real life contexts, and the correlative crystallization of a distinctive sphere of experience, i.e., the aesthetic.

* * *

The European avant-garde movements can be defined as an attack on the status of art in bourgeois society. What is negated is not an earlier form of art (a style) but art as an institution that is unassociated with the life praxis of men. When the avant-gardistes demand that art become practical once again, they do not mean that the contents of works of art should be socially significant. The demand is not raised at the level of the contents of individual works. Rather, it directs itself to the way art functions in society, a process that does as much to determine the effect that works have as does the particular content.

The avant-gardistes view its dissociation from the praxis of life as the dominant characteristic of art in bourgeois society. One of the reasons this dissociation was possible is that Aestheticism had made the element that defines art as an institution the essential content of works. Institution and work con-

tents had to coincide to make it logically possible for the avant-garde to call art into question. The avant-gardistes proposed the sublation of art — sublation in the Hegelian sense of the term: art was not to be simply destroyed, but transferred to the praxis of life where it would be preserved, albeit in a changed form. The avant-gardistes thus adopted an essential element of Aestheticism. Aestheticism had made the distance from the praxis of life the content of works. The praxis of life to which Aestheticism refers and which it negates is the means-ends rationality of the bourgeois everyday. Now, it is not the aim of the avant-gardistes to integrate art into *this* praxis. On the contrary, they assent to the aestheticists' rejection of the world and its means-ends rationality. What distinguishes them from the latter is the attempt to organize a new life praxis from a basis in art. In this respect also, Aestheticism turns out to have been the necessary precondition of the avant-gardiste intent. Only an art the contents of whose individual works is wholly distinct from the (bad) praxis of the existing society can be the center that can be the starting point for the organization of a new life praxis.

With the help of Herbert Marcuse's theoretical formulation concerning the twofold character of art in bourgeois society, the avant-gardiste intent can be understood with particular clarity. All those needs that cannot be satisfied in everyday life, because the principle of competition pervades all spheres, can find a home in art, because art is removed from the praxis of life. Values such as humanity, joy, truth, solidarity are extruded from life as it were, and preserved in art. In bourgeois society, art has a contradictory role: it projects the image of a better order and to that extent protests against the bad order that prevails. But by realizing the image of a better order in fiction, which is semblance (*Schein*) only, it relieves the existing society of the pressure of those forces that make for change. They are assigned to confinement in an ideal sphere. Where art accomplishes this, it is 'affirmative' in Marcuse's sense of the term. If the twofold character of art in bourgeois society consists in the fact that the distance from the social production and reproduction process contains an element of freedom and an element of the noncommittal and an absence of any consequences, it can be seen that the avant-gardistes' attempt to reintegrate art into the life process is itself a profoundly contradictory endeavor. For the (relative) freedom of art vis-à-vis the praxis of life is at the same time the condition that must be fulfilled if there is to be a critical cognition of reality. An art no longer distinct from the praxis of life but wholly absorbed in it will lose the capacity to criticize it, along with its distance. During the time of the historical avant-garde movements, the attempt to do away with the distance between art and life still had all the pathos of historical progressiveness on its side. But in the meantime, the culture industry has brought about the false elimination of the distance between art and life, and this also allows one to recognize the contradictoriness of the avant-gardiste undertaking.

In what follows, we will outline how the intent to eliminate art as an institution found expression in the three areas that we used above to characterize autonomous art: purpose or function, production, reception. Instead of speaking of the avant-gardiste work, we will speak of avant-gardiste manifestation. A dadaist manifestation does not have work character but is nonetheless an authentic manifestation of the artistic avant-garde. This is not to imply that the avant-gardistes produced no works whatever and replaced them by ephemeral events. We will see that whereas they did not destroy it, the avant-gardistes profoundly modified the category of the work of art.

Of the three areas, the *intended purpose or function* of the avant-gardiste manifestation is most difficult to define. In the aestheticist work of art, the disjointure of the work and the praxis of life characteristic of the status of art is bourgeois society has become the work's essential content. It is only as a consequence of this fact that the work of art becomes its own end in the full meaning of the term. In Aestheticism, the social functionlessness of art becomes manifest. The avant-gardiste artists counter such functionlessness not by an art that would have consequences within the existing society, but rather by the principle of the sublation of art in the praxis of life. But such a conception makes it impossible to define the intended purpose of art. For an art that has been reintegrated into the praxis of life, not even the absence of a social purpose can be indicated, as was still possible in Aestheticism. When art and the praxis of life are one, when the praxis is aesthetic and art is practical, art's purpose can no longer be discovered, because the existence of two distinct spheres (art and the praxis of life) that is constitutive of the concept of purpose or intended use has come to an end.

We have seen that the *production* of the autonomous work of art is the act of an individual. The artist produces as individual, individuality not being understood as the expression of something but as radically different. The concept of genius testifies to this. The quasitechnical consciousness of the makeability of works of art that Aestheticism attains seems only to contradict this. Valéry, for example, demystifies artistic genius by reducing it to psychological motivations on the one hand, and the availability to it of artistic means on the other. While pseudo-romantic doctrines of inspiration thus come to be seen as the self-deception of producers, the view of art for which the individual is the creative subject is let stand. Indeed, Valéry's theorem concerning the force of pride (*orgueil*) that sets off and propels the creative process renews once again the notion of the individual character of artistic production central to art in bourgeois society. In its most extreme manifestations, the avant-garde's reply to this is not the collective as the subject of production but the radical negation of the category of individual creation. When Duchamp signs mass-produced objects (a urinal, a bottle drier) and sends them to art exhibits, he negates the category of individual production. The signature, whose very purpose it is to mark what is individual in the work, that it owes its existence to

this particular artist, is inscribed on an arbitrarily chosen mass product, because all claims to individual creativity are to be mocked. Duchamp's provocation not only unmasks the art market where the signature means more than the quality of the work; it radically questions the very principle of art in bourgeois society according to which the individual is considered the creator of the work of art. Duchamp's Ready-Mades are not works of art but manifestations. Not from the form-content totality of the individual object Duchamp signs can one infer the meaning, but only from the contrast between mass-produced object on the one hand, and signature and art exhib-it on the other. It is obvious that this kind of provocation cannot be repeated indefinitely. The provocation depends on what it turns against: here, it is the idea that the individual is the subject of artistic creation. Once the signed bottle drier has been accepted as an object that deserves a place in a muse-um, the provocation no longer provokes; it turns into its opposite. If an artist today signs a stove pipe and exhibits it, that artist certainly does not denounce the art market but adapts to it. Such adaptation does not eradicate the idea of individual creativity, it affirms it, and the reason is the failure of the avant-gardiste intent to sublate art. Since now the protest of the histori-cal avant-garde against art as institution is accepted as *art*, the gesture of protest of the neo-avant-garde becomes inauthentic. Having been shown to be irredeem-able, the claim to be protest can no longer be maintained. This fact accounts for the arts-and-crafts impression that works of the avant-garde not infrequently convey.

The avant-garde not only negates the category of individual production but also that of individual *reception*. The reactions of the public during a dada manifestation where it has been mobilized by provocation, and which can range from shouting to fisticuffs, are certainly collective in nature. True, these remain reactions, responses to a preceding provocation. Producer and recipi-ent remain clearly distinct, however active the public may become. Given the avant-gardiste intention to do away with art as a sphere that is separate from the praxis of life, it is logical to eliminate the antithesis between producer and recipient. It is no accident that both Tzara's instructions for the making of a Dadaist poem and Breton's for the writing of automatic texts have the char-acter of recipes. This represents not only a polemical attack on the individual creativity of the artist; the recipe is to be taken quite literally as suggesting a possible activity on the part of the recipient. The automatic texts also should be read as guides to individual production. But such production is not to be understood as artistic production, but as part of a liberating life praxis. This is what is meant by Breton's demand that poetry be practiced (*pratiquer la poesie*). Beyond the coincidence of producer and recipient that this demand implies, there is the fact that these concepts lose their meaning: producers and recipients no longer exist. All that remains is the individual who uses poetry as an instrument for living one's life as best one can. There is also a danger

here to which Surrealism at least partly succumbed, and that is solipsism, the retreat to the problems of the isolated subject. Breton himself saw this danger and envisaged different ways of dealing with it. One of them was the glorification of the spontaneity of the erotic relationship. Perhaps the strict group discipline was also an attempt to exorcise the danger of solipsism that surrealism harbors.

In summary, we note that the historical avant-garde movements negate those determinations that are essential in autonomous art: the disjunction of art and the praxis of life, individual production, and individual reception as distinct from the former. The avant-garde intends the abolition of autonomous art by which it means that art is to be integrated into the praxis of life. This has not occurred, and presumably cannot occur, in bourgeois society unless it be as a false sublation of autonomous art. Pulp fiction and commodity aesthetics prove that such a false sublation exists. A literature whose primary aim it is to impose a particular kind of consumer behavior on the reader is in fact practical, though not in the sense the avant-gardistes intended. Here, literature ceases to be an instrument of emancipation and becomes one of subjection. Similar comments could be made about commodity aesthetics that treat form as mere enticement, designed to prompt purchasers to buy what they do not need. Here also, art becomes practical but it is an art that enthralls. This brief allusion will show that the theory of the avant-garde can also serve to make us understand popular literature and commodity aesthetics as forms of a false sublation of art as institution. In late capitalist society, intentions of the historical avant-garde are being realized but the result has been a disvalue. Given the experience of the false sublation of autonomy, one will need to ask whether a sublation of the autonomy status can be desirable at all, whether the distance between art and the praxis of life is not requisite for that free space within which alternatives to what exists become conceivable.

1 Th. W. Adorno, *Ästhetische Theorie*, ed. Gretel Adorno and R. Tiedemann (Frankfurt: Suhrkamp, 1970), p. 532.

2 The concept of the historical avant-garde movements used here applies primarily to Dadaism and early Surrealism but also and equally to the Russian avant-garde after the October revolution. Partly significant differences between them notwithstanding, a common feature of all these movements is that they do not reject individual artistic techniques and procedures of earlier art but reject that art in its entirety, thus bringing about a radical break with tradition. In their most extreme manifestations, their primary target is art as an institution such as it has developed in bourgeois society. With certain limitations that would have to be determined through concrete analyses, this is also true of Italian Futurism and German Expressionism. Although cubism does not pursue the same intent, it calls into question the system of representation with its linear perspective that had prevailed since the Renaissance. For this reason, it is part of the historic avant-garde movements, although it does not share their basic tendency (sublation of art in the praxis of life). The concept 'historic avant-garde movements' distinguishes these from all those neo-avant-gardiste attempts that are characteristic for Western Europe and the United States during the fifties and sixties. Although the neo-avant-gardes proclaim the same goals as the representatives of the historic avant-garde movements to some extent, the demand that art be reintegrated in the praxis of life within the existing society can no longer be seriously made after the failure of avant-gardiste intentions. If an artist sends a stove pipe to an

exhibit today, he will never attain the intensity of protest of Duchamp's Ready-Mades. On the con-
trary, whereas Duchamp's *Urinoir* is meant to destroy art as an *institution* (including its specific orga-
nizational forms such as museums and exhibits), the finder of the stove pipe asks that his 'work' be
accepted by the museum. But this means that the avant-gardiste protest has turned into its opposite.

2. Paul Smith, 'How a Cubist Painting Holds Together'

In this essay, which was specially written for this volume, Paul Smith draws on
recent discoveries in the psychology of perception to provide a detailed analy-
sis of Picasso's *Houses on the Hill, Horta d'Ebro* of 1909. This painting belongs
to the first, 'analytic' stage of the development of Cubism. Close attention to
the particular visual experience that the painting offers provides a valuable
means of distinguishing analytic Cubism from other forms of representation.
Smith also considers the few first-person statements by Braque and Picasso of
which we have reliable report and seeks to reconstruct the artists' intentions
at this stage in their development. He is particularly concerned with their
attempt to incorporate the dimension of 'touch' into their work and opens up
his analysis to include an expanded phenomenology of human experience.

Because it is not exactly easy to make sense of most Cubist paintings, this
essay will offer a way into a few, hopefully representative, works. It will con-
centrate first of all on Picasso's *Houses on the Hill, Horta d'Ebro* of 1909
[Frontispiece] because this picture is *relatively* straightforward. It nonetheless
exhibits – at least in embryo – many of the complexities typical of many later
Cubist paintings.[1] Like these, for instance – but unlike more traditional paint-
ings – *House on the Hill, Horta d'Ebro* does not give transparently onto a
world like our own. Nor is it 'flat' in the sense that it has no visual interest
aside from that of 'pigment' laid on a two-dimensional 'surface',[2] even though
it does exhibit many marks, such as lines and areas of tone, that seem to lie
on or near the picture plane – at least on first acquaintance. With a Cubist
painting, in other words – even a 'simple' one – it is far from immediately
apparent how it holds together, or how its component parts make sense visu-
ally. Its marks neither decipher readily into static images, nor do they fall into
any clear pattern. Moreover, the relationship between the three- and two-
dimensional aspects of the painting can be especially perplexing.

 In offering a detailed analysis of how Cubism looks, this essay assigns
importance by default to a particular view of what a painting is, but it also
does so deliberately. The view in question is that a painting is an *intentional*
object. Taking the term in its strict (philosophical) sense, this means, first of
all, that a specific painting corresponds to a particular visual experience of, or
about, the world. It follows that the painting is also intended (or 'intentional'
in a looser sense) in that it is made the way it is *so that* it can give rise to that

experience: for the artist; and for other spectators too. Of course, the artist can only know her or his intention once the painting is made, especially if she or he is responsive to the possibilities it throws up as it comes along.3 But an intentional painting is not pure serendipity, since artists learn to build on previous experience to ensure that, as often as not, their paintings turn out to be satisfying. (Braque later described how he and Picasso were like two 'mountaineers roped together',4 implying they routinely encountered unforeseen possibilities in the course of 'inventing' Cubism, but also that they marshalled the experience they had gained along the way to ensure that they could proceed reliably when this happened.)

What sort of visual experience, then, does a Cubist painting offer? One argument is that, like many other kinds of picture, the Cubist picture shapes and brings to light the artist's visual experience of the world during the activity of painting.5 It can therefore endow our routine visual experience with a depth we do not normally notice, by using marks which bring out some aspects of what we see with particular salience. Even as it does this, however, a Cubist painting comes close to recasting our world in the terms of its pictorial world. In many ways, these two aspects of any painting – its similarity to and difference from perceptual reality – are closely intertwined within the experience of looking at it.

Whatever a Cubist painting achieves, it does its work through the coherence that its many, seemingly disparate, parts accomplish *in concert*. Notwithstanding, to understand the work as the sum of multifarious visual interactions it is necessary first of all to analyse its component elements.

The Building-blocks of Early Cubism[6]

One evidently fundamental feature of the Cubist style in *Houses on the Hill, Horta d'Ebro* [Frontispiece] is 'faceting': the way it breaks down every visible surface (and even some empty spaces) into relatively discrete, relatively flat planes. These generically resemble the planes in some of Cézanne's paintings [Plate 9], and those exhibited by rough-hewn wooden sculptures of the sort Picasso made around the time in imitation of Teke (Congo) or similar statues [Plate 10]. In Picasso's paintings, each plane is separated from its neighbour by a relatively defined *arras*, or sharp dividing line. And almost everything – including the sky – is resolved into separate, but abutting, facets. As a consequence, it depicts a variety of quasi-geometric shapes: cubes, but other, more complex shapes as well.

Faceting is closely related to another significant feature of Cubism: so-called 'multiple viewpoint'. This term refers to the way that objects in the painting appear as if seen from several positions simultaneously, as though the picture were compounding the changing views seen by a spectator mov-

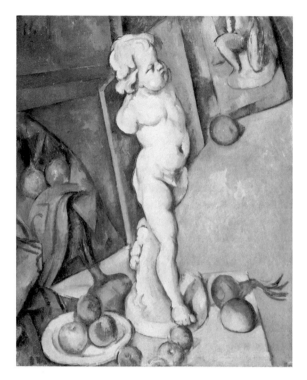

Plate 9 Paul Cézanne,
*Still Life with Plaster
Cupid, c.* 1894, oil on
paper laid on board, 70.6
x 57.3 cm. Courtauld
Institute Gallery,
Somerset House, London.

ing around the scene depicted. In *Houses on the Hill, Horta d'Ebro,* 'multiple
viewpoint' is very fully developed through the disposition of facets, so that
objects composed of planes appear splayed out, as they might if seen simulta-
neously (somehow) from a variety of standpoints. Many roofs, for example,
are 'seen' from above (and are therefore tilted up towards the picture plane),
while the walls on which they rest are seen face on. The walls and roofs of
some houses – particularly the two in the centre foreground – appear as they
might to a spectator approaching them from high above and behind them.

Houses on the Hill, Horta d'Ebro also employs 'floating' contour lines. The
most obvious example occurs in the left edge of the wall of the smallest house
in the right background. Here, as elsewhere, such contours refuse to 'disap-
pear' or resolve into the edge of a shape. Instead, they affirm their presence
as marks, as indeed do many other lines in the painting.

Another signature characteristic of early Cubism adapted from Cézanne that
is deployed wholesale in *Houses on the Hill, Horta d'Ebro* is so-called *passage.*
Strictly speaking, this term describes how two planes situated at different dis-
tances in the picture space from the spectator are linked together by another,
small, bridging plane. More loosely, it can refer to the way that a background
plane rides over, or merges with, one in the foreground. Or it can refer to the
interpenetration of less spatially determinate, semi-transparent planes. In the
area below and to the left of the house at the left, for example, there are several

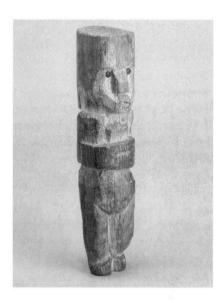

Plate 10 Pablo Picasso, *Figure*, 1907, traces
of oil and gesso, brass pins, wood, 23.5 x
5.5 x 5.5 cm. Art Gallery of Ontario,
Toronto. Purchase 1980.Photo: AGO/Carlo
Catenazzi. © Succession Picasso/DACS,
London 2003.

places where planes are elided. A more subtle instance of *passage* occurs in the
area of the lower right side of the roof of the central house: here tonal changes
suggest that the darker background plane (representing a shadow?) is infiltrat-
ing the foreground. (The light source here, as elsewhere in the painting, is gross-
ly inconsistent, which adds to the confusion engendered by its partner device.)

Other features of the early Cubist style in *Houses on the Hill, Horta d'Ebro*
are the painting's solid background and its shallow depth. The mountains and
sky, for instance, assume much of the solidity, and proximity, of the foreground
houses. To the left of centre there is even considerable ambiguity as to whether
this area represents mountain or sky.

Lastly, it should be noted that colour (as hue) is banished from early
Cubism. This absence nonetheless makes a positive contribution to the paint-
ing. The point is that, although colour is less effective than line and tone in
indicating space and shape (except in exceptional paintings like Cézanne's), it
can still affect a painting's spatial effects, and even disrupt them. (This
explains why Braque spoke of how: 'colour could give rise to sensations which
would interfere with our conception of space'.[7]) Comparing *Houses on the
Hill, Horta d'Ebro* with the marginally earlier *Brick Factory in Tortosa*, it is
plain that colour can indeed make the business of painting shape too compli-
cated to manage. It is excluded from early Cubism, then, to allow line and
tone to do their job without hindrance.

Touch in Early Cubism

Listing such features is only a preliminary step; it does not describe what *work* they do — on their own, or together. One argument is that the cumulative effect of an early Cubist painting is to make the spectator's *movement* around the depicted scene explicit. Since movement entails the dimensions of space *and* time, Cubism must therefore make time, or the duration of perception, part of its content. This may be an appropriate conclusion, but it is not obviously consistent with the argument — based on many statements by Picasso and Braque, and advanced by recent commentators also — that Cubism was meant to make the pictorial world look tactile. Of course, artists' intentional statements do not necessarily indicate even an intentionally correct way of looking at a picture, since they may not succeed in verbalising what the picture actually does, for a variety of reasons.[8] But Picasso's and Braque's statements are unusually cogent and lucid, and deserve serious attention.

Cubism Against Perspective

Some idea of what the artists meant is indicated by the contrast both drew between 'their' picture-space and the space of conventional pictures based on perspective. This, they argued, impoverished the tactile quality that objects actually possessed in perception. For example, Braque stated: 'Scientific perspective . . . forces the objects in a picture to disappear away from the beholder instead of bringing them within his reach as painting should.[9]

A further indication of the 'tactile' quality Braque — and Picasso too — aimed for is that *both* turned, at an early stage of Cubism, to painting objects that lay within their reach. Braque later explained:

> What particularly attracted me [to Cubism] was the materialisation of this new space that I felt to be in the offing. So I began to concentrate on still lifes, because in the still life you have a tactile, I might almost say a manual space. . . . This answered to the hankering I have always had to touch things and not merely see them.[10]

Elsewhere he described how: 'In still life, space is tactile, even manual, while the space of landscape is a visual space.'[11] What Braque meant by 'tactile' and 'visual' space can perhaps be shown by a comparison of his *Mandora* of 1910 [Plate 11] with the slightly earlier *Castle at la Roche-Guyon* [Plate 12]. Clearly enough, the treatment of the central 'block' of houses in the landscape — as a hovering, spilling, mass of interpenetrating planes — makes the motif appear close to the spectator, and tactile. This landscape, then, exhibits a kind of 'tactile space'. But this 'tactile space' looks incongruous in a landscape painting because the motif is normally seen across an empty space which can only be traversed by the eye, and

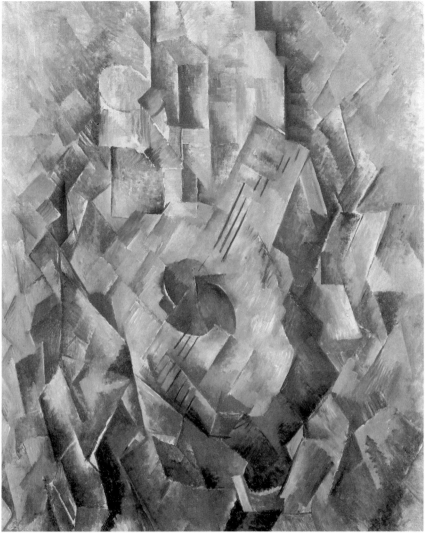

Plate 11 Georges Braque, *Mandora*, 1910, oil on canvas, 73 x 60 cm. © Tate, London 2003. © ADAGP, Paris and DACS, London 2003.

not by the hand. A landscape normally appears, in other words, in a purely 'visual space'. Probably as a consequence of this incongruity, Braque turned away from landscape painting to painting still lifes, where the objects lie 'within reach of the hand', that is, in a 'tactile space' whose definition is that it can be traversed by the hand *at the same time as* the eye.[12] (Braque thus transposed the spatial effects he had developed in *Castle at la Roche-Guyon* more or less wholesale into *Mandora*, where they work perfectly.)

Picasso said something very similar to Braque's remark on measuring 'dis-

Plate 12 George Braque, *The Castle at la Roche-Guyon*, 1909, oil on canvas, 92 x 73 cm. Van AbbeMuseum, Eindhoven, The Netherlands. © ADAGP, Paris and DACS, London 2003.

tance' when (according to his dealer, Kahnweiler) he stated: 'In a painting by Raphael it is not possible to ascertain the distance between the tip of the nose and the mouth. I would like to paint pictures in which that would be possible.'[13] Of course, a great deal hangs on what both artists meant by 'measure', but it makes most sense to think it refers to an attempt on their part to represent an

awareness of depth that was more intuitive and bodily than rational and intel-
lectual. One way of taking their statements, therefore, is that both artists aimed
to evoke the tactility of nearby objects by marking out the positive volume and
shape that these possess for the viewer of a scene, and by making the space they
inhabit explicit too, and even 'positive'. Cubist picture space is, in other words,
the opposite of perspectival space, in which solid objects only ever recede from
the spectator, and where space itself is always empty, or hollow.

Cubism and Touch

Perspective as a system enshrines some deep-seated western prejudices about
perception, and part of the 'difficulty' of Cubism is that it goes against the
grain of these. In effect, Picasso and Braque repudiate the tradition dating
back at least to the fourteenth century, in which a good picture is equated with
a copy of the pattern of light on the back of the eye. Along with this theory,
they reject the conception of vision on which it is predicated: that seeing con-
sists in 'having' a (virtual) *mental* image that copies the (real) physical image
on the retina. Nowadays both notions are widely regarded as incoherent;[14] they
also lead to an impoverished description of what it is like to see. By contrast,
Picasso's and Braque's attempt to put the 'poetry' – including tactility – back
into seeing has found articulate and sympathetic expression of late.[15]

 One successful explanation of the Cubist project has involved assimilating
its concern with tactility to a phenomenological account of seeing. For phe-
nomenologists, seeing is first and foremost an activity *performed* by embod-
ied creatures inhabiting a meaningful world of objects and spaces. In the the-
ory of perception developed by Maurice Merleau-Ponty, for instance, seeing
is a kind of embodied 'probing', or grasping, with the eye. We relate to objects
through an unconscious bodily background supplying an 'intentional arc' that
makes them 'fleshy' for us. In mundane perception, however, the meaningful-
ness of objects – including their tactility – can often become submerged
through sheer familiarity with them (among other things). But when painting,
the artist's engagement with the medium as something 'living' and responsive
(i.e. as more than a set of inert materials) enables a 'primary perception' that
transcends the habitual 'carnal formulae' of our perceived world. Hence all-
too-familiar and thus unconscious features of it assume a novel freshness and
clarity.[16] Phenomenology thus goes some way towards mapping out the kind of
enrichment, or revitalisation, of everyday seeing that early Cubism achieved
by bringing out the tactility of objects – and perhaps also the ebb and flow of
this tactility through space and time during the act of seeing.

 In much the same vein, the phenomenology of Edmund Husserl argues
that an object seen in the world, far from being a flat pattern of light on the
retina, is possessed of (sensuous) 'sense' (or meaning) because we know

through bodily experience what the world is like. One view of an object is therefore indicative of other views; one perceived property is also redolent of the different qualities possessed by its other aspects. We see any object, in other words, against the 'horizon' of the spatial and sensuous possibilities its sight implies. This way, an object can readily suggest solidity and tactility, and a painting can bring this out. But a work of art is an object too, of its own special sort. So while it may resemble the objects it depicts, it never simply duplicates their 'sense' because it has its own specific qualities. The peculiar marks that make up a Cubist painting, for example, contribute their own unique sense to the objects they depict, one which transforms the sense they have even in acts of seeing where their tactile sense is relatively developed. A Cubist picture thus give its own *unique* kind of tactility to things.[17]

While phenomenology is strong on the significance of the tactility a Cubist painting can achieve, other theories go into greater detail about just *how* it does its work. One such is J.J. Gibson's theory of 'direct perception'. The basis of this is that we have evolved to see our environment in a way which is useful to us as the embodied creatures we are. Hence we see the world as composed of solid, stable objects in space, which move in relation to ourselves (when we do), and to one another (when they do), in predictable ways. We are able to do this because we extract a set of 'invariants' about the shape, texture and spatial location of objects which allows us to make an even 'flow' out of the shifting flux of visual data reaching the moving eye. These invariants yield 'affordances', or ecologically meaningful contents: a cube, for instance, affords 'solidity' or 'graspability'. In a painting, such a property can assume an especial significance if the artist uses the medium to extract it at the expense of others.[18] *Houses on the Hill, Horta d'Ebro* plainly concentrates on using marks that convey information about invariants of shape, at the expense of invariants carrying information about, say, atmosphere or texture. It thereby affords tactility above all else.

A similar general view of perception as an environmentally adapted (or evolved) activity occurs in the theory developed by David Marr. This also models the human perceptual system in terms of a series of computational processes performed upon retinal events by neurons and larger structures in the brain. Marr's theory can therefore track (or at least hypothesise) the nitty-gritty of the processes whereby the visual system extracts stable structures from the light striking the eye. Central to this enterprise is the idea that we synthesise internal 'representations' (or visual models) of solid objects from these various acts of computational processing. Marr says little about pictures, but recently John Willats has developed his ideas to argue that there is a broadly systematic relationship between the structures exhibited by drawings and the structures of the internal representations Marr posits. Willats's work thus makes it possible to connect a detailed description of the marks in a Cubist picture directly to the spatial and volumetric effects they produce. In

essence, Willats suggests that since it is possible to specify precisely how pic-
tures project or transform internal visual representations of shape and space,
it must be possible to say how pictures – including early Cubist pictures – pro-
duce their spatial, and tactile, effects.[19] His work thereby makes it possible to
offer a reasonably precise analysis – and justification – of what Picasso and
Braque achieved intuitively, at the same time recuperating at least some of
the insights of phenomenology within a more empirical system of descrip-
tion. Of course, Cubism is not so neat and tidy as any such theory, however
complex and flexible, might suggest. Indeed, its very irreducibility to system,
and to closure, remains an important part of its meaning. Nevertheless, the
best way towards this sophisticated position is the kind of step-by-step expla-
nation of how Cubism works that Marr and Willats have made possible.

How We See Shape

How then do the pictorial features described thus far actually *work* according
to computational models of perception and representation? Very crudely, the
answer is that pictorial representations 'map' into two-dimensional symbols
several different kinds of internal visual representations of the world, which
are constructed at three stages, or levels, of perceptual processing. To explain
this in detail, a digression into the processes involved in seeing and repre-
senting is needed.[20]

Viewer-centred Internal Representations of Shape

A preliminary point that needs making in this context is that internal repre-
sentations are not what seeing (as conscious experience) consists of, but they
are the material out of which seeing is 'made'. Nor should internal represen-
tations be confused with reality itself. They are not copies of the visible world,
but are assembled from output that represents an enormous number of com-
plex (serial and parallel, analytic and synthetic) processing operations per-
formed upon the luminous input that is initially registered in the chemical
and electrical responses of the rods and cones in the retina. Notwithstanding,
because the brain is adapted to produce representations of the world (i.e. of
its shapes, surfaces, and spaces) that *work*,[21] our internal visual representations
are unlikely to be purely arbitrary, or completely unlike what they represent.
Instead, it would seem that they possess internal structures of a sort that
sometimes do correspond in some respects to the kinds of structure possessed
by objects (and hence spaces) in the world.

 According to Marr, the primary job of the visual system is to construct an
internal representation of the *shape* of objects in the world. But this task is

Fig. 1 The significance
of the direction of tonal
contrast in photographs
and line drawings. A pho-
tograph of a face, and the
same photograph passed
through a 'cartoon opera-
tor' geared to extracting
sharp falls in the image's
luminosity. From J. Willats,
*Art and Representation:
New Principles in the
Analysis of Pictures*, 1997,
Princeton University Press,
New Jersey. Copyright © PUP. Reprinted by permission of Princeton University Press.
Fig. 14.6.

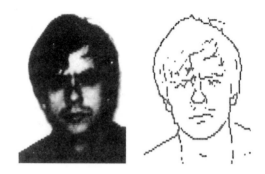

more difficult than it sounds because there is no simple correlation between
the light and dark intensities registered by the retina and the edges of
objects, which provide the main clues about their shape. Instead, each point
of the visual array is a light/dark value that could indicate any combination of
three variables in luminosity at the corresponding point in the world, since it is
determined by (1) the intensity of the light source, (2) the quality of the reflec-
tive surface and (3) the orientation of that surface to the light. To isolate shape,
the eye must determine which intensity values actually relate to shape alone,
and extract them (which also entails filtering out meaningless accidental vari-
ations in light intensity.) To do this, it concentrates on analysing *sharp* rises and
falls in illumination, since these correspond to edges in the world. This infor-
mation is then processed into the brain's first-level representation: the 'raw pri-
mal sketch'. This isolates segments of 'edges', 'bars' (in the areas between
edges), 'terminations' (where edges and bars end), and 'blobs' (where edges
form a closed contour indicating an area).

Marr argues that we are never subjectively aware of the raw primal sketch.
We are aware, though, of the 'full primal sketch', which the brain constructs by
grouping the elements of the raw primal sketch according to their orientation
into larger structures like contours and regions. These represent edges, and sur-
face markings and textures as well. Recent research shows that even at this
stage the visual system is especially geared towards detecting and representing
'luminescence valleys', or sharp *drops* in surface reflectance, rather than being
equally sensitive to decreases *and* increases in reflectance alike. The primal
sketch may therefore represent the same sort of structures as those to be found
in a 'cartoon' composed of lines marking reflectance 'valleys' (Figure 1).[22]

The second stage of visual processing is the formation of the '2½D sketch',
an internal representation which is neither flat, not yet fully three dimen-
sional. In this, the data of the primal sketch is combined with other, sepa-
rately processed material, including information about stereo disparity (how

a shape presents itself differently to the two eyes), motion parallax (how the front of the shape moves in relation to what is behind this), texture gradients (how texture patterns change), occlusion (how edges hide edges, and therefore surfaces, behind them), perspective (how objects diminish in size as they recede), and surface shading. All these variables behave in law-like ways, hence their variations contain mathematically rigid regularities which can be used to compute the shape and position of objects relative to the viewer.

The $2\frac{1}{2}$D sketch may have structural components like those of a carefully articulated line drawing, in which all the lines begin and end in the 'right' place relative to one another, that is, where they must if they are to map a particular view of an object. The 'lines' of the $2\frac{1}{2}$D sketch effectively correspond therefore to the edges of visible surfaces, and so can play a decisive role in articulating surfaces and shapes. That is: we can infer virtually three-dimensional surfaces from the virtually two-dimensional patterns of 'lines' in the $2\frac{1}{2}$D sketch *within* unconscious perceptual processing, simply by analyzing how these 'lines' relate to one another. Indeed, work on computer programmes designed to analyse shape in line drawings suggests that the method whereby we infer shape from the $2\frac{1}{2}$D sketch is generically the same.[23]

Such inferences can only work, however, if the properties of lines in representations can be taken as reliable indicators of the properties of edges in the world. In other words, it is only *because* we make internal representations in which straight lines generally stand for straight edges, and parallel lines for parallel edges, that we can see shape in the $2\frac{1}{2}$D sketch, or a drawing, *at all*. There are also other conditions to the analysis of the $2\frac{1}{2}$D sketch, or a drawing. It only works if the representation is of the object as it appears from a 'general position': that is, if the representation does not contain too many 'accidental alignments' between lines that represent edges actually located at different distances from the viewer.[24] Furthermore, it only works if lines do not change their 'meaning' as edges – that is, from convex to concave – as they run their course.[25] But because the world is such that false attachments and changes in convexity and concavity along an edge do not happen in *it*, the $2\frac{1}{2}$D sketch and line drawings are generally unambiguous and usable. It should be noted, however, that Cubism exploits the plausibility that these very ambiguities can sometimes assume. With $2\frac{1}{2}$D representations of objects consisting of interlocking angular surfaces – of the sort depicted in *Houses on the Hill, Horta d'Ebro* – we only need a few 'lines' in order to extract and represent shape. This is because plane surfaces can only coincide to form edges and corners in a small number of ways. For rectangular shapes, there are in fact only four variations (Figure 2). Hence a line in any such representation can only have one of four basic meanings: it can represent a convex edge with receding planes on either side, or a concave edge with protruding planes on either side, or an occluding edge, i.e. one that hides parts of the scene that lie behind it relative to the viewer. There is then a kind of

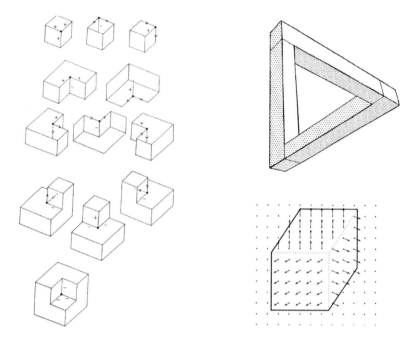

Fig. 2 Above left. Illustration of all the corners possible in drawings of rectangular objects. Arrows denote occluding edges, plus signs denote a concave edge, and minus signs denote a convex edge. From Willats, *Art and Representation*, Princeton University Press, 1997. Fig. 5.3.

Fig. 3 Top right: *The Penrose Triangle*. Originally published in: R. Penrose, 'Impossible Objects: A Special Type of Visual Illusion', *British Journal of Psychology*, 49, pp. 31-3, 1958.

Fig. 4 Bottom right: Vector Primitives in a $2\frac{1}{2}$D sketch of a cube. The slant of the arrows indicates surface orientation with respect to the viewer; and their length indicates their distance from the viewer. The dotted lines indicate occluding contours. From D. Marr, *Vision: a computational investigation into human representation and processing of visual information*, New York, Freeman, 1982, figure 4.2.

'grammar' that determines the combination and meaning of lines in a $2\frac{1}{2}$D representation. Hence, once we analyse the combination the line is part of, we know its meaning. The corollary is that 'ungrammatical' combinations of lines in a picture either fail to represent an object, or they represent impossible objects and spaces that quickly turn out to be implausible. Examples are the anomalous figures beloved of psychologists (Figure 3) and the works of Escher. The situation is rather different with Cubism, where, exceptionally, grammatical rules of combination are broken *in order to* create theoretically impossible but *convincing* shapes within a theoretically impossible but *convincing* picture space.

Another model of the $2\frac{1}{2}$D sketch proposed by Marr is that it represents shape through 'vector primitives' indicating the directions and degrees of slant

of different surfaces. A cube might therefore be symbolically represented by 'needles' whose orientation shows the direction in which the surface is orientated, and whose length maps the degree of slant (Figure 4). At any event, however it is envisaged, the $2\frac{1}{2}$D sketch comes close to providing all the information we need to construct objects' shapes, and because line drawings closely model the $2\frac{1}{2}$D sketch, they too can produce a powerful impression of shape.

The final stage of visual processing (before it enters consciousness) is when the brain forms fully elaborated three-dimensional representations. In these, information about different aspects of objects (edges, shading, texture etc.) is synthesised. We therefore see our world as one that is composed of solid surfaces with space between them. It is a world with depth and substance, unlike the one that flies see; and while ineluctably *our* world, it is safe to assume that it is closer in complexity to the world of surfaces and blobs the fly sees.

Object-Centred Descriptions

A very important aspect of Marr's theory of vision, which is especially consequential for understanding Cubism, is that the effectiveness of three-dimensional internal representations depends heavily on 'object-centred descriptions'. So far, all the internal visual representations discussed have been 'viewer-centred', that is, they derive from, and represent, objects *as they appear from a point of view*. Object-centred descriptions, on the other hand, are 'objective' representations of objects, or three-dimensional descriptions of objects as they are *in general*, or 'in the round'. These arise in several ways. Some object-centred descriptions can be inferred from viewer-centred internal representations of edges, since these can be analysed as transformations of the contours of a generalised 'cone': i.e. a symmetrical shape produced by rotation along an axis. So,

Fig. 5 Features exhibited by a cube allowing an object-centred description to be derived from them. From V. Bruce, P.. Green, and M.A. Georgeson, *Visual Perception: physiology, psychology and ecology*, 3rd edition, Hove, Psychology Press, 1996/7, figure 9.19.

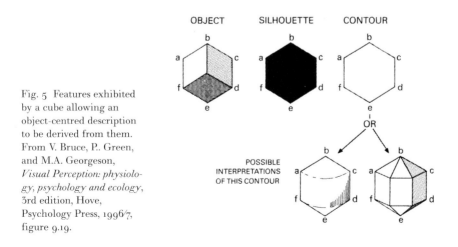

Fig. 6 Drawings of shapes which can be mentally rotated for comparison. Only the pairs (a) and (b) are indentical. From Marr, *Vision*, figure 1.2.

for instance, the visual system can extract the 'objective' shape of a cylinder or a vase from the more accidental and complex silhouette that such objects exhibit when seen from a particular view. Some shapes – the cube, for instance – less readily afford object-centred descriptions, since they produce contours and silhouettes that are ambiguous on their own (Figure 5). But when information about contours is taken together with information about shading, and/or the internal divisions of a shape, it is easily disambiguated, and an object-centred description can be derived from it. Again, though, while this is precisely what happens in normal vision, Cubism uses the potential ambiguity of silhouettes and contours to create its own, 'poetic' world.

One important aspect of object-centred descriptions is that when integrated into viewer-centred three-dimensional internal representations they can map the projection of an object's volume in *all* directions, including those not apparent in a particular view. They are therefore powerfully instrumental in creating the feeling that objects have solidity, and the intuition that there is a back to them.

Object-centred descriptions also play an important role in object recognition. One crucial piece of evidence for this is that we can ascertain whether or not two representations are different views of the same complex shape by mentally rotating one or the other, and comparing them (Figure 6). The point is that when we do this we are, it would seem, generating transformations or projections of a single, stored, object-centred description. We thus ascertain a match between the two shapes (or the absence of one) by seeing whether (or not) the two shapes can both be generated from the same object-centred description. More importantly perhaps, object-centred descriptions play a role in the recognition of real objects. This makes sense, as it is impossible for our brains to store the *infinite* number of viewer-centred descriptions that even a simple shape like a cube can generate. But since a shape like a cube has only one object-centred description, this is easily lodged in the memory as a kind

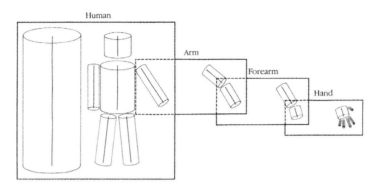

Fig. 7 Drawing indicating how a human can be recognised in relation to a series of progressively more finely articulated object-centred descriptions of cylinders (although these are shown lying along viewer-centred axes). From Marr, *Vision*, figure 5.3.

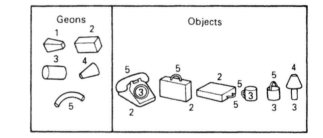

Fig. 8 'Geons' and their combinations in objects. From Bruce, Green and Georgeson, *Visual Perception*, figure 9.22.

of template against which we can test the object centred-descriptions we extract from the world for 'fit'.

We could also recognise more complex objects by matching them against combinations or assemblies of simpler object-centred descriptions. Marr suggests that we recognise a person, for example, by referring the object-centred descriptions we extract from a view of her or him to an *assembly* of simple object-centred descriptions of cylinders (Figure 7). (This may explain a remark of Cézanne's about a woman he was looking at in the street one day: were she to stand still, he said, 'she would be a cylinder!')[26]

One intriguing alternative to this theory is I. Biederman's suggestion that we recognise objects in terms of their conformity to a wide range of invariant shape descriptions, or 'geons'.[27] These shapes — which include wedges and cylinders — can, it is argued, be identified from 'key' features of the $2\frac{1}{2}$D sketch (i.e. without any need to make reference to explicitly three-dimensional shape representations), on the assumption that features of the virtual image (e.g. parallelism between lines, curvature, symmetry etc.) are also features of the world. Geons can also be assembled in any combination to provide schematic 'objective' templates for most objects (Figure 8). This may explain why geon-like forms are often used in drawing manuals to show

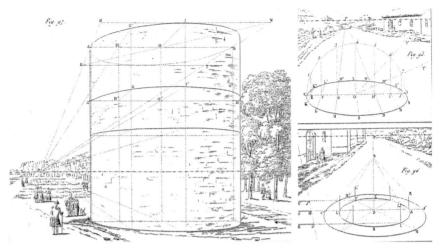

Fig. 9 Illustration from J.P.Thénot, *Traité pratique pour dessiner d'après nature mis à la portée de toutes les intelligences*, Paris, Carilian-Goeury et Dalmont, 1845. (These differ slightly from the illustrations in Cézanne's own edition of Thénot printed in 1839).

artists how to construct convincing shapes. When in 1904 Cézanne suggested to Emile Bernard that the artist could avoid flatness in the painting by treating nature in terms of 'the cylinder, the sphere, the cone', he was probably reiterating advice from one such manual he owned (Figure 9).[28]

Picasso almost certainly read one or other of the articles Bernard published in 1904 and 1907 incorporating Cézanne's remarks, and so geons – or object-centred descriptions – have real causal and explanatory relevance to Cubism.

Pictorial Representations of Shapes

How then do pictures map internal visual representations on to a plane, or two-dimensional surface? Put schematically, they transform the 'scene primitives' of internal representations into the 'picture primitives' of a particular 'denotation system', and project these within the geometry of one or another 'drawing system'.[29]

It is possible to identify denotation and drawing systems more specifically by looking at the stages that children's drawings pass through as they acquire greater technical sophistication. (Although different individuals vary, as do children in different cultures, there is nevertheless a strong and broad *universal* similarity in the pattern exhibited by these changes.) These can be shown in a schematic overview of typical drawings of a cube by children whose mean ages range from four to twelve (Figure 10).

Fig. 10 Drawing and denotation systems used in children's drawings of cubes. Object-centred descriptions are indicated by (o-c); and viewer-centred descriptions are indicated by (v-c). The asterisk indicates distortion in the drawing of regions. From Willats, *Art and Representation*, fig. 8.4. Based on drawings of cubes originally published in: A.L. Nicholls and J.M. Kennedy, 'Drawing Development: from similarity of features to direction', *Child Development*, 63, pp. 227–41, 1992.

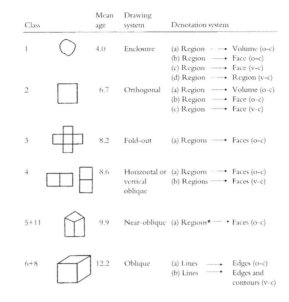

Class		Mean age	Drawing system	Denotation system		
1		4.0	Enclosure	(a) Region	⤍	Volume (o-c)
				(b) Region	⟶	Face (o-c)
				(c) Region	⟶	Face (v-c)
				(d) Region	⤍	Region (v-c)
2		6.7	Orthogonal	(a) Region	⟶	Volume (o-c)
				(b) Region	⟶	Face (o-c)
				(c) Region	⟶	Face (v-c)
3		8.2	Fold-out	(a) Regions	⟶	Faces (o-c)
4		8.6	Horizontal or vertical oblique	(a) Regions	⤍	Faces (o-c)
				(b) Regions	⤍	Faces (v-c)
5+11		9.9	Near-oblique	(a) Regions*	⤍	Faces (o-c)
6+8		12.2	Oblique	(a) Lines	⟶	Edges (o-c)
				(b) Lines	⟶	Edges and contours (v-c)

In the four-year-old's drawing (Figure 10a), the denotation system uses a 'region' as the picture primitive (it might be sometimes embellished with blob-like marks indicating corners). The drawing system in which this region is mapped onto the two-dimensional surface is known as 'enclosure': it merely shows the outline of the shape in relief against a ground, and has no other structure for projecting pictorial depth. The drawing may seem to be quite a competent drawing of the kind of scene primitive identifiable with the primal sketch, since it consists solely of crude indicators of basic topological information, describing whether or not the shape is extended, whether it is a long or a short shape, and whether or not it has edges. But since it is inconceivable that children only see and map the primal sketch, the drawing is perhaps better thought of as a rather incompetent representation of a higher-level internal representation. This drawing could thus be a viewer-centred internal representation of the face of the cube, or of a region; it could equally well represent an object-centred description of the cube's front face, or of its whole volume.

At the age of about six or seven, shape proper enters the picture when children begin to map regions within a more sophisticated and definite drawing system based on orthogonal projection (Figure 10b). Again, it is difficult to decide whether such a drawing represents the face of a cube as it might appear in a viewer-centred internal representation, or whether it represents an object-centred description of the face, or the volume, of a cube. At about eight years of age, children employ a system of projection to map regions that

results in so-called 'fold-out' drawings, in which the front and the sides of the cube radiate from a central front face (Figure 10c). Such drawings undoubtedly represent object-centred, and not just viewer-centred, descriptions because they show faces of the cube that are not visible from a view, but which the child only 'knows' to be there. As they approach nine years of age, children make drawings in which regions representing the front and one visible face of the cube are projected in one or other variety of oblique perspective (Figure 10d). While representing only what is seen by the viewer, they also exhibit a kind of primitive symmetry which implies the working of object-centred descriptions. Just before ten years old, children begin to map regions (still) into near-oblique perspective, characteristically making the so-called 'flat-bottom' error, in which the lower edge of the side faces of the cube is represented – not by an orthogonal – but by a horizontal line that would 'properly' indicate the bottom edge of a face seen frontally (Figure 10e). Again, this ungainly compromise indicates that a view is being affected by an object-centred description. At the next stage, at around twelve years of age, a child masters the use of use of oblique perspective, which no longer maps regions as picture primitives, but project *lines* representing edges – as they might 'appear' in the $2\frac{1}{2}$D sketch, or in fully elaborated three-dimensional internal representations (Figure 10f).

Much Chinese art, American 'primitive' painting, Persian miniatures and Cézanne's painting also use varieties of oblique perspective. Compared with drawings in conventional, western perspective, these representations approximate closely to object-centred descriptions (while 'distorting' viewer-centred descriptions). It turns out in fact that *all* pictures (even those purporting to represent views) can be derived from object-centred descriptions *alone*, while only *some* drawing systems map views. It would seem, in other words, that object-centred descriptions are at the very least a large part of what the vast majority of pictures actually project. Only in the western perspectival tradition are object-centred descriptions dispensed with altogether, in favour of subject-centred views pure and simple. And only in the western tradition is the plenitude and tactility of shape so much impoverished as a consequence. It would seem, in effect, that while object-centred descriptions are active within normal seeing from a point of view, they are *not* properly effective within *pictorial* views. Instead, object-centred descriptions have to be mapped into pictures in something close to their objective form, if pictorial shape is to possess fullness.

Pictures clearly vary significantly according to cultural conventions favouring the use of particular *combinations* of denotation and drawing systems. Nevertheless, very significant regularities obtain across different cultures among the denotation and drawing systems used: it appears especially that only a limited number of drawing systems are possible at all. It seems, then, that pictures are composed in large part of elements are not merely conven-

tional or 'arbitrary signs',[30] but which are *regular* – or rule-governed – trans-
formations of internal representations. By analogy with language, where
genetically-given rules dictate the transformation of thoughts into the gram-
matical structures underlying meaningful sentences, the rules governing the
transformation of internal representations into structures that have meaning
in pictures seem to be given innately, in the structure of the brain.[31] Put crude-
ly then, set rules effectively decide what kinds of representation are 'possible',
and what kinds of picture are coherent. There certainly seems to be a 'gram-
mar' governing the combination of denotation and drawing systems in any
picture, as only some combinations are possible without profound anomalies.
Regions, for instance, cannot be used without difficulty in a picture organised
according to linear perspective; and conversely, planes cannot normally be used
convincingly when the drawing system is orthogonal projection. In corollary,
some 'pairs' of denotation and drawing systems tend to appear together in pic-
tures with great frequency: regions are common in pictures using orthogonal
projection and planes in perspectival pictures (of all kinds).

Ultimately, no hard-and-fast rule determines which primitives can go with
which drawing systems – beyond the rule of thumb that they should produce
a coherent picture. Just as in language, the grammatical 'parameters' within
which pictures work are flexible. So it is that some 'ungrammatical' pictures
can be highly *effective* aesthetically,[32] rather as 'ungrammatical' writing can
sometimes be very poetic. Among such 'ungrammatical' pictures are Cubist
paintings like *Houses on the Hill, Horta d'Ebro*. Put very simply, this man-
ages to retain a semblance of being a view, while achieving a fully three-
dimensional look by mapping object-centred descriptions. But it only man-
ages this 'trick' because Picasso and Braque devised a highly unusual, picto-
rial 'grammar' in which to combine certain particular denotation and draw-
ing systems *coherently*.

Shape, Space and Tactility in Cubism

Just how then does *Houses on the Hill, Horta d'Ebro* produce salient shapes?
What is efficacious about its particular *combination* of denotation and draw-
ing systems? To answer this it is necessary first of all to recast the 'naïve'
description of the painting given above in terms that isolate the components
of the several denotation systems used. Then it will be possible to see how
these various kinds of picture primitive are projected in the several different
drawing systems the painting uses. Together, these two kinds of information
explain how Cubism works as a grammatical language.

Cubist Denotation Systems

Houses on the Hill, Horta d'Ebro is remarkable in that it actually uses several denotation systems in 'parallel': planes, shading and lines all being employed to define surfaces. And *only* in some places are these different kinds of spatial clue fully integrated in the manner of a conventional 'realist' painting. For instance, the 'facets' of the central house describe its shape by mapping surfaces of the kind that feature in three-dimensional internal representations, but these facets only more-or-less coincide with areas of shading. In 'normal' pictures shading provides important clues about the location of shapes in relation to one another, and to the ground plane, when integrated with line (Figure 11). In *Houses on the Hill, Horta d'Ebro*, however, several areas of shading – on the left slope of the central house's roof, its left wall and the ground to the left of this – help establish shape with greater clarity and salience: being to some extent independent of faceting, it acts as a complementary shape-defining denotation system. (Elsewhere, shadows serve to show the buildings attached to the ground plane in a way that is ambiguous or inconsistent locally, but which adds to the sculptural effects of shape that the whole picture produces.)

The painting also deploys contours that map edges of the sort represented internally in the $2^1/_2$D sketch. Sometimes these coincide exactly with the shapes indicated by facets and shading, but elsewhere in the picture – as in the house towards the top right of the picture – 'floating' contours act more independently of facets, emphasising or reinforcing the shape information

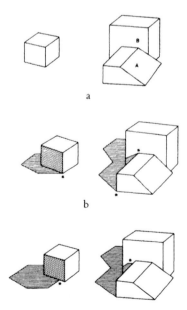

Fig. 11 Drawing indicating the role played by shadows in the perception of objects' relationships to one another. In (a) the absence of shadows means there is no evidence with which to judge whether they touch one another or the ground; in (b) shadows make it possible to judge that the shapes touch one another or the ground in those places marked by asterisks; (c) shadows provide evidence that the objects neither touch one another nor the ground in those places marked by asterisks. From Willats, *Art and Representation*, figure 6.6 (p. 138). Originally published in: D. Waltz, 'Understanding line drawings of scenes with shadows', in P.H. Winstin (ed.), *The Psychology of Computer Vision*, pp. 19–91, New York, McGraw-Hill, 1975 (courtesy of McGraw-Hill, Inc.).

carried by the other denotation systems. (Cézanne too had exploited the ability of lines to work to some extent independently of the edge of a form.) What happens in this situation is that the brain synthesises tone and line, which are initially represented separately in different areas of the visual cortex, into a single shape to form a fully three-dimensional view. Presenting either kind of clue separately to the eye seems to enhance this process, and adds to the prominence of shape. (In other parts of the picture, however, planes, shading and lines are inconsistent with one another. These 'inconsistent' clues — it will turn out — are nevertheless vital to the coherence of the picture as a whole.)

The denotation system in *Houses on the Hill, Horta d'Ebro* evidently maps shape in terms of block-like forms resembling geons, or object-centred descriptions. These shapes are akin to those Cézanne advocated, and do indeed appear to the 'mind's eye', as Picasso suggested when he stated: 'I paint things as I think them, not as I see them.'[33] Picasso's interest in varieties of African sculpture can perhaps be related therefore to his interest in finding a denotation system capable of expressing shape. What have been called the 'rational' forms of African sculptures are not only close to object-centred descriptions or geons, but as such they also repudiate the (anamorphic) distortion of 'objective' shapes characteristic of paintings in perspective — the system Guillaume Apollinaire called an 'infallible device for making things shrink'.[34]

Cubist Drawing Systems

The drawing systems used in *Houses on the Hill, Horta d'Ebro* work in concert with the denotation systems. The painting exploits 'exploded' perspective (in the majority of houses), horizontal oblique perspective (in the house in the right foreground) and the 'flat-bottom' projection system (in the house on the horizon left of centre) — alongside some informal linear perspective elsewhere. Together these various systems create the effect of 'multiple viewpoint'. All but the last drawing system map the facets of the denotation system into very salient, graspable and comparatively undistorted shapes corresponding closely to object-centred descriptions. Shapes generated by inverted perspective look especially solid and tactile,[35] perhaps because they supply information about 'stereo' views of the object that can be used to compute shape, rather as the two views from each eye can be used to compute shape in normal vision.

Although the different drawing systems in *Houses on the Hill, Horta d'Ebro* produce *local* effects of tactility and salience, the use of several different drawing systems creates its problems, just as the use of several denotation systems does. Upon first viewing at least, the shapes, and space itself, in the painting can seem to lurch about uncomfortably. However, the anomalies gen-

erated by the different drawing systems, along with the inconsistencies between the various denotation systems, are nevertheless resolved within the painting as a whole. That is, the painting manages to guarantee the shape-producing effects of its 'warring' components within the 'grammatical' coherence that it achieves as a *unity*. A sustained look shows that *Houses on the Hill, Horta d'Ebro* simply does not look incoherent or flat as a picture using several drawing systems normally does. It avoids the 'collapse' of shapes and space that occurs in icon paintings (which interested Picasso), for instance. And instead, it succeeds in weaving its seemingly anomalous and inconsistent shapes into a continuum from which they appear to *emerge*.

Cubist Coherence

A key element in the painting's attainment of coherence is its use of ambiguous spatial devices at points that would normally indicate recession. These devices have their own local effects to be sure, but their greater importance lies in how they contribute to the overall structure of the painting by creating a kind of seamless ambiguity which allows the devices mentioned previously to function to their full effect *without apparent anomaly*. It is these recession-denying devices, in other words, that are largely responsible for the *difference* in complexity and seriousness between Picasso or Braque and, say, Escher.

One of the more important recession-denying devices in *Houses on the Hill, Horta d'Ebro* is 'false attachment'. In this, lines which would normally be occluding contours (indicating a discrete surface in one spatial plane) are made to coincide with the occluding contours of other surfaces located in different spatial planes. In effect, then, this device is used in crucial areas where figure and ground are made to look detached from one another in a conventional painting, but only at the expense of solidity and salience. A particularly good example occurs at the base of the taller building in the right middle-ground: here the line marking the junction of the building's two faces coincides with corners belonging to the roof of the house to its left, to the 'shadow' 'cast' by its own doorway and to several other planes. The specific effect of false attachment is not so much to flatten the picture out as to deny recession, and so create a kind of spatial flux from which the shapes created by oblique and inverted perspective can push out.

An important partner to false attachment is *passage*. This device is used most noticeably in the sky, where planes seem to interpenetrate quite freely, creating a more-or-less solid-looking background which repels any attempt to penetrate it. *Passage* also occurs in the area in the right middle ground between the houses and the edge of the picture, where the edges of discrete planes are indistinct. Again, recession is made impossible, and instead space acquires a fluid continu-

Fig. 12 The Necker illusion.
The drawing (a) is ambiguous,
since it contains too many depth
clues, which allow it to be seen
as either of the two cubes repre-
sented in (b) and (c). From
Marr, *Vision*, figure 1.5, p. 26.

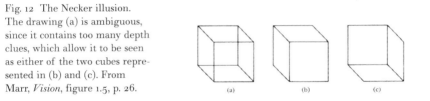

ousness from which shapes can materialise close to the spectator's reach.

'Inconsistent' shading is used in *Houses on the Hill, Horta d'Ebro* to produce similar effects. In the doorway of the leftmost house it indicates a concave shadow and, by virtue of partially occluding the ground plane, a positive shape. The result is an ambiguous space/shape that disrupts the logic of recession in this area of the painting. Other areas of shading disrupt the relationships between shapes indicated by lines and planes. The band of shadow to the left of the central house, the diagonal band on its roof and the shaded area to the right of the roof's lower edge all work against the more-or-less consistent recessional space indicated by lines and planes, and make the space in this part of the painting into a shifting or floating continuum, out of which the tangible shapes of inverted perspective can expand.

The band of deep shading immediately to the right of the leftmost house causes a strong sense of a hollow to its right edge, but this 'reading' of the area is thrown into confusion by the inconsistent shading in, and false attachment among, the planes to its right. In the same area, planes appear almost to 'flip' from being concave one moment to being convex another. Here the painting seems to trade off the fact that we so readily construct virtual objects and space from arrangements of lines in a picture – as we do from the $2\frac{1}{2}$D sketch in normal vision – that we are easily led to into 'error'. The so-called Necker Cube illustrates the point: because nothing decides the matter one way or another, its ambivalence amounts to an irresolvable ambiguity (Figure 12); in Picasso's painting the $2\frac{1}{2}$D clues can be made to flip either one of two ways also. In effect then, this area of the painting transgresses a fundamental rule of unambiguous representation: that lines must not change their meaning from convex to concave along their course; instead, as we scan this area, this is precisely what happens. As with the other devices that disrupt the grammar of recession, these introduce an elasticity into the overall structure of space in the painting that works against recession and shrinkage.

Braque's 'Tactile Space'

The Marr/Willats account of seeing and representation goes a long way towards explaining how a Cubist painting can achieve an overall effect of

salient shape. But it has its limits. Paintings like *Houses on the Hill, Horta d'Ebro* can be said to turn our attention to the very process of seeing, revealing especially how a quality like tactility, which cannot be seen straightforwardly by the eye is bound up in it. As mentioned earlier, a vivid sense of the tactile is sometimes internal to seeing, and recent neuroscientific studies strongly indicated that seeing shapes is not just a matter of mapping them, but that even before shape information is computed in the visual centres of the brain (the visual cortex) prior to emerging into consciousness, cruder information about shape is relayed directly (by the lateral geniculate nuclei) to other centres in the brain.[36] So even while 'pure' visual shape is computed independently of any knowledge of shape gained from non-visual sources, it is very likely that complex relays between visual and tactile responses are active in the brain, and thus in seeing (just as philosophers have argued at least since Locke).

Something like a complex sense of interaction between visual and tactile sense modalities is already operating at a low level in *Houses on the Hill, Horta d'Ebro*, but in Picasso's later paintings, and more so in Braque's, it begins to form a significant part of the work's content. Braque developed several new techniques to achieve the emphasis on tactility. First, he developed what he called 'fragmentation', or the minute faceting and complex ambiguation of shapes, to enable him 'to establish space and movement in space'.[37] That is, he represents objects *and* the space around them almost indistinguishably: in terms of shifting, interpenetrating planes and shapes. His technique also exploits a clever ambiguity. Normally picture primitives correspond to the *marks* the painter uses, but in Braque's work there is considerable ambiguity as to whether a mark equals a primitive: for instance, it is not at all whether some brushstrokes are meant to be read as separate areas of tone, or merely as components of some larger area of tone whose referent is impossible to isolate. The cumulative effect of paintings that do these things – *Mandora* of 1910 is an example – is that objects and a 'materialised' space appear as if threatening to cascade out of the picture, from the top especially (an effect enhanced by the vertical, or 'portrait', format).

Braque quickly evolved his own procedures to enhance tactile effects. In *Still Life with Fishes* of *c.* 1910, he establishes the space first with the aid of horizontal and diagonal grid lines that 'sit' flat on the picture surface and provide a framework into which shapes are inserted, and *out of* which they are left protruding. A similar logic informs Braque's introduction of letters into pictures such as *Clarinet, Bottle of Rum and Newspaper on a Mantelpiece* of 1911. As he explains, letters were for him 'forms which could not be deformed, because, being two-dimensional, they existed outside three dimensional space', and hence 'their inclusion in a picture allowed a distinction to be made between objects which were situated in space and those which belonged outside space.'[38] In effect, letters, like grid lines, mark the point where shapes and spaces either recede (a little), or – inevitably – emerge from the picture.

Braque also emphasised the physicality of his 'brushwork', making it into 'a sort of substance', and later he used 'sand, sawdust and metal filings' in his pictures to elicit a tactile response that links metonymically with the tactility their drawing creates.39

The significance of such techniques and effects is phenomenological: they expand our primal awareness of the material being of things, their graspability, and the ebb and flow of their presence in perception as it unfolds through time. By overcoming the incompatibility between the panoramic detachment from things characteristic of sight and the piecemeal proximity to them experienced through touch in this way, Cubism diminishes the perceptual gap between ourselves and the world.40 Even in almost illegible paintings, such as *The Emigrant* of 1911–12, Braque cues tactility with marks that suggest hands, as if inviting us to grope for the 'object' in the picture. Such paintings thus exemplify a perceptual truth that Merleau-Ponty described later when he wrote: 'a sensible datum which is on the point of being felt sets a kind of muddled problem for my body to solve'.41

Braque's preference for musical instruments as the content of his still lifes also fits with his concern with tactility. Not only did he like 'their plasticity' and 'volumes', but he said 'they come to life when you touch them.42 Although Braque avowed (in the same interview) that he 'was so attracted to musical instruments, far more than to . . . the human figure', his remark is in effect a denial of the strong connection between the two: not only do many string instruments metaphorically possess shape qualities (including absences) belonging to the female body, but their responsiveness to touch is equally a subjective ground for connecting them (in the imagination, at least). That many of the figures holding musical instruments in Braque's and Picasso's figure paintings of the period are women and not men only serves to reinforce such connections. For all they may appear to embody masculine sexual fantasies, Braque's still lifes and figure paintings (like Picasso's) are nevertheless about a kind of eroticism that has nothing to do with scopophilia, or the anxiety-driven transference of sexual feelings onto an act of looking that empowers the male subject. Especially since they contain many clues about *memories* pertaining to their subject matter (words indicating dancing, snatches of musical notation etc.), Braque's (like Picasso's) paintings are about what it can be like to touch someone loved, but *absent.* They thereby deny the stultifying fiction central to many 'erotic' paintings, that the absent figure is somehow present. Instead, the tactile feeling the picture gives is – in some respect at least – the feeling of life itself.

The contents that have been ascribed here to the Cubism of Picasso and Braque suggest links between their works and the ideas of the artist's wider intellectual circle. These contents could, for instance, quite plausibly be linked to philosophical notions of Bergson's about the *élan vital,* memory and the durational nature of experience. But while ideas may explain what Cubist

painters might have *told themselves* they were doing, the intentional visual interest of the paintings made by Picasso and Braque is irreducible to anything *else* in the last analysis. Considered as an intentional object, a Cubist painting does several things. It makes the tactility inherent, but sometimes submerged, in everyday acts of looking both more explicit and vivid. But in doing this, a Cubist painting goes beyond being a representation of what the world is, or can be, like: it creates a pictorial world of its own distinctive kind. Crucial to this peculiarity is the painting's refusal to solidify into a static image, even though it is otherwise coherent. Part of the importance of Cubism thus lies precisely in its insistence that perception is a never finalised process where 'subject' and 'object' (i.e. the real or the pictorial world) are porous entities engaged in a continual, mutually affecting, and inescapable encounter.

1 Cubist paintings are, however, arguably radically different from Cubist *papiers collés*, but it remains beyond the scope of this essay to investigate the relationships between the paintings and these other works.

2 Cubism is assimilated to this latter-day formalist aesthetic in Greenberg C., 'Modernist Painting', *Art and Literature*, no. 4, Spring 1965.

3 See Wollheim R., *Painting as an Art*, London, Thames and Hudson, 1987, pp. 43–5, and Schier F., 'Painting after Art?: Comments on Wollheim', in Bryson N., Holly M.A. and Moxey K. (eds.), *Visual Theory: Painting and Interpretation*, London, Polity, 1991.

4 Vallier D, 'Braque, la peinture et nous', *Cahiers d'art*. vol. 20, No. 1., October 1954, p. 14; Mullins E.B., *Braque*, London, Thames & Hudson, 1968, p. 10.

5 Wollheim R., 'On Drawing an Object', in *On Art and the Mind*, London, Allen Lane, 1973.

6 The ensuing account is developed from Golding J., *Cubism: a History and an Analysis 1907–1914*, London, Faber and Faber, 1959, pp. 47–95. Cf. Antliff M. and Leighten P., *Cubism and Culture*, London, Thames & Hudson, 2001, pp. 51–63, and Krauss R., 'The Motivation of the Sign', pp. 266–8 in Rubin W., Varnadoe K., and Selevansky L., *Picasso and Braque: a Symposium*, New York, Museum of Modern Art/Abrams, 1992.

7 Vallier, op.cit., 'Braque, la peinture et nous', p. 16; Mullins, op.cit., *Braque*, p. 55.

8 Roskill M., The Artist's Intentions and Some Related Issues' in *The Interpretation of Cubism*, Philadelphia, Art Alliance Press, London, Associated University Presses, 1984.

9 Richardson J., 'The Power of Mystery', *The Observer*, 1st December 1957; Mullins, op.cit., *Braque*, p. 128.

10 Vallier, op.cit., 'Braque, la peinture et nous', p. 16; Mullins, op.cit., *Braque*, pp. 40–1.

11 Leymarie J., 'Braque's Journey', p. 12, in Leymarie J., Moeller, M.M., Schultz-Hohhamann C., *Georges Braque*, New York, Solomon R. Guggenheim Museum, 1988.

12 Vallier, op.cit., Braque, la peinture et nous', p. 16.

13 Baxandall M., *Patterns of Intention: On the Historical Explanation of Pictures*, New Haven and London, Yale University Press, 1985, p. 68.

14 See for example, McGinn M., *Wittgenstein and the Philosophical Investigations*, London, Routledge, 1997, pp. 177–204, and Mitchell W.J.T, *Iconology: Image, Text, Ideology*, Chicago and London, Chicago University Press, 1986, pp. 5–46.

15 Richardson, op.cit., 'The Power of Mystery'; Mullins, op.cit., *Braque*, p. 183.

16 Cf. Crowther P., 'Merleau-Ponty: Perception into Art', *British Journal of Aesthetics*, vol. 22, no. 2, Spring 1982.

17 Cf. Podro M., 'Depiction and the Golden Calf', pp. 181–3, in Bryson N., Holly M.A., and Moxey K. (eds.), *Visual Theory: Painting and Interpretation*, London, Polity, 1991.

18 This account is based on Steer J., 'Art History and Direct Perception: a General View', *Art History*, vol. 12, no. 1, March 1989.

19 Cf. Krauss, op.cit., 'The Motivation of the Sign', p. 27, which argues against the integration of tactile and visual clues in *Houses on the Hill, Horta d'Ebro*.

20 The ensuing description of the visual system is taken from Marr D., *Vision: A Computational*

Investigation into the Human Representation and Processing of Visual Information, New York, Freeman, 1982.

21 Bruce V., Green R., and Georgeson M., *Visual Perception: Physiology, Psychology, and Ecology*, Hove, Psychology Press, 1996, pp. 3–24; Marr, op.cit., *Vision*, pp. 29–36.

22 Willats, op.cit., *Art and Representation*, pp. 331–3.

23 Marr, op.cit., *Vision*, pp. 17–18; Willats, op.cit., *Art and Representation*, pp. 112 and 114–15; and Bruce et al., op.cit., *Visual Perception*, pp. 120–1.

24 Willats, op.cit., *Art and Representation*, p. 113.

25 Willats, op.cit., *Art and Representation*, pp. 113 and 116–17.

26 Chavensol G., 'La Vie de Cézanne à Aix-en-Provence', *L'Intransigeant*, 31 January 1939.

27 Willats, op.cit., *Art and Representation*, p. 97.

28 Doran M. (ed.), *Conversations with Cézanne*, Berkeley, Los Angeles and London, University of California Press, 2001, p. 29: see also pp. 39, 63, and 229–30.

29 The following account is taken from Willats, *Art and Representation*, op.cit.

30 For discussions of the role of arbitrary signs in Cubism, see Krauss, 'The Motivation of the Sign', op.cit., Bois Y.-A., 'The Semiology of Cubism', in Rubin et al., op.cit., and (for a rather different view) Leighten P., 'Cubist Anachronisms: A-historicity, Cryptoformalism and Business-as-Usual in New York', *Oxford Art Journal*, vol. 17, no. 2., 1994.

31 For a comparison between the present theory and Noam Chomsky's theory of the 'generative grammar' underlying language-use, see Willats, op.cit., *Art and Representation*, pp. 175, 272–3, 279, 282.

32 Willats, op.cit., *Art and Representation*, pp. 154–8 and p. 207.

33 Comez de la Serna R., *Completa y veridical histporia de Picasso y el Cubiosmo*, Turin, Chiantore, 1945, p. 31; Golding J., op.cit., *Cubism*, p. 60.

34 Antliff and Leighten, op.cit., *Cubism and Culture*, p. 77.

35 Willats, op.cit., *Art and Representation*, p. 211.

36 Bruce, Green, and Georgeson, op.cit., *Visual Perception*, pp. 43–7.

37 Vallier, op.cit., 'Braque, la peinture et nous', p. 16; Mullins, op.cit., *Braque*, p. 76.

38 Vallier, op.cit., Braque, La peinture et nous', p. 16; Mullins, op.cit., *Braque*, p. 68. Cf. Willats, op.cit., *Art and Representation*, p. 237.

39 Vallier, op.cit., 'Braque, La peinture et nous', p. 17; Mullins, op.cit., *Braque*, p. 76.

40 Cf. Shiff R., 'Cézanne's Physicality: The Politics of Touch', pp. 149–66, in Kemal S., and Gaskell I. (eds.), *The Language of Art History*, Cambridge, CUP, 1991 which also touches on Cubist collage.

41 Merleau-Ponty M., *The Phenomenology of Perception*, London, Routledge & Kegan Paul, 1962, p.214.

42 Vallier, op.cit., 'Braque, la peinture et nous', p. 16; Bowness S., 'Braque and Music', p. 58, in Golding J., and Bowness S., *Braque: Still Lifes and Interiors*, London, South Bank Centre, 1990.

3. Clement Greenberg, 'The Pasted-Paper Revolution'

Many of the ideas expressed in this essay were first articulated by Clement Greenberg in a review of an exhibition entitled *Collage* held at the Museum of Modern Art, New York in 1948. There he argued that the medium of collage 'is the most succinct and direct single clue to the aesthetic of genuinely modern art'. Yet Greenberg resisted the reading of collage that saw it as 'modern' because it incorporated fragments of modern *reality*. In the present essay, he interprets collage as a means of emphasising the literal flatness of the picture surface and thus of accentuating the contrast between the picture plane and the illusion of pictorial space. The formal achievements of Braque and Picasso are contrasted to the use of collage by other artists for what Greenberg regards as 'shock value' and he laments the

medium's subsequent decline into 'montage and stunts of illustration'. 'The Pasted-Paper Revolution' was first published in *Art News* in September 1958. A substantially revised version was published as 'Collage' in Greenberg's collection of essays *Art and Culture* in 1961. The original version is reprinted in full from *The Collected Essays and Criticism, Vol. 4. Modernism with a Vengeance: 1957–1969*, ed. John O'Brian, University of Chicago Press, Chicago and London, 1993, pp. 61–6.

The collage played a pivotal role in the evolution of Cubism, and Cubism had, of course, a pivotal role in the evolution of modern painting and sculpture. As far as I know, Braque has never explained quite clearly what induced him, in 1912, to glue a piece of imitation wood-grain paper to the surface of a drawing. Nevertheless, his motive, and Picasso's in following him (assuming that Picasso did follow him in this), seems quite apparent by now – so apparent that one wonders why those who write on collage continue to find its origin in nothing more than the Cubists' need for renewed contact with 'reality.'

By the end of 1911 both masters had pretty well turned traditional illusionist paintings inside out. The fictive depths of the picture had been drained to a level very close to the actual paint surface. Shading and even perspective of a sort, in being applied to the depiction of volumetric surfaces as sequences of small facet-planes, had had the effect of tautening instead of hollowing the picture plane. It had become necessary to discriminate more explicitly between the resistant reality of the flat surface and the forms shown upon it in yielding ideated depth. Otherwise they would become too immediately one with the surface and survive solely as surface pattern. In 1910 Braque had already inserted a very graphic nail with a sharp cast shadow in a picture otherwise devoid of graphic definitions and cast shadows, *Still-life with Violin and Palette*, in order to interpose a kind of photographic space between the surface and the dimmer, fragile illusoriness of the Cubist space which the still-life itself – shown as a picture within a picture – inhabited. And something similar was obtained by the sculptural delineation of a loop of rope in the upper left margin of the Museum of Modern Art's *Man with a Guitar* of 1911. In that same year Braque introduced capital letters and numbers stencilled in *trompe-l'oeil* in paintings whose motifs offered no realistic excuse for their presence. These intrusions, by their self-evident, extraneous and abrupt flatness, stopped the eye at the literal, physical surface of the canvas in the same way that the artist's signature did; here it was no longer a question of interposing a more vivid illusion of depth between surface and Cubist space, but one of specifying the very real flatness of the picture plane so that everything else shown on it would be pushed into illusioned space by force of contrast. The surface was now *explicitly* instead of implicitly indicated as a tangible but transparent plane.

It was toward the same end that Picasso and Braque began, in 1912, to mix sand and other foreign substances with their paint; the granular surface achieved thereby called direct attention to the tactile reality of the picture. In that year too, Georges Braque 'introduced bits of green or gray marbleized surfaces into some of his pictures and also rectangular strips painted in imitation of wood grain' (I quote from Henry R. Hope's catalogue for the Braque retrospective at the Museum of Modern Art in 1949). A little later he made his first collage, *Fruit Bowl*, by pasting three strips of imitation wood-grain wallpaper to a sheet of drawing paper on which he then charcoaled a rather simplified Cubist still-life and some *trompe-l'oeil* letters. Cubist space had by this time become even shallower, and the actual picture surface had to be identified more emphatically than before if the illusion was to be detached from it. Now the corporeal presence of the wallpaper pushed the lettering itself into illusioned depth by force of contrast. But at this point the declaration of the surface became so vehement and so extensive as to endow its flatness with far greater power of attraction. The *trompe-l'oeil* lettering, simply because it was inconceivable on anything but a flat plane, continued to suggest and return to it. And its tendency to do so was further encouraged by the placing of the letters in terms of the illusion, and by the fact that the artist had inserted the wallpaper strips themselves partly inside the illusion of depth by drawing upon and shading them. The strips, the lettering, the charcoaled lines and the white paper begin to change places in depth with one another, and a process is set up in which every part of the picture takes its turn at occupying every plane, whether real or imagined, in it. The imaginary planes are all parallel to one another; their effective connection lies in their common relation to the surface; wherever a form on one plane slants or extends into another it immediately springs forward. The flatness of the surface permeates the illusion, and the illusion itself re-asserts the flatness. The effect is to fuse the illusion with the picture plane without derogation of either – in principle.

The fusion soon became even more intimate. Picasso and Braque began to use pasted paper and cloth of different hues, textures and patterns, as well as a variety of *trompe-l'oeil* elements, within one and the same work. Shallow planes, half in and half out of illusioned depth, were pressed still closer together, and the picture as a whole brought still closer to the physical surface. Further devices are employed to expedite the shuffling and shuttling between surface and depth. The area around one corner of a swatch of pasted paper will be shaded to make it look as though it were peeling away from the surface into real space, while something will be drawn or pasted over another corner to thrust it back into depth and make the superimposed form itself seem to poke out beyond the surface. Depicted surfaces will be shown as parallel with the picture plane and at the same time cutting through it, as if to establish the assumption of an illusion of depth far greater than that actually indicated. Pictorial illusion begins to give way to what could be more properly called optical illusion.

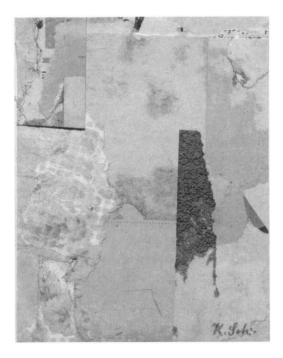

Plate 13 Kurt Schwitters,
Aphorism, 1923, collage on
card, support 8.9 x 7.3 cm.
© Tate, London 2003. © DACS,
London 2003.

The paper or cloth had to be cut out, or simulated, in relatively large and simple shapes, and wherever they were inserted the little facet-planes of Analytical Cubism merged perforce into larger shapes. For the sake of harmony and unity this merging process was extended to the rest of the picture. Images began to re-acquire definite and even more recognizable contours, and Synthetic Cubism was on the way. With the reappearance, however, of definite and linear contours, shading was largely suppressed. This made it even more difficult to achieve depth or volumetric form, and there seemed no direction left in which to escape from the literal flatness of the surface – except into the non-pictorial, real space in front of the picture. This, exactly, was the way Picasso chose for a moment, before he went on to solve the terms of Synthetic Cubism by contrasts of bright color and bright color patterns, and by incisive silhouettes whose recognizability and placing called up an association at least, if not a representation, of three-dimensional space.

Some time in 1912 he cut out and folded a piece of paper in the shape of a guitar and glued and fitted other pieces of paper and four taut strings to it. A sequence of flat surfaces on different planes in actual space was created to which there adhered only the hint of a pictorial surface. The originally affixed elements of a collage had, in effect, been extruded from the picture plane – the sheet of drawing paper or the canvas – to make a bas-relief. But it was a 'constructed,' not a sculpted, bas-relief, and it founded a new genre

of sculpture. Construction-sculpture was freed long ago from its bas-relief frontality and every other suggestion of the picture plane, but has continued to this day to be marked by its pictorial origins. Not for nothing did the sculptor-constructor Gonzalez call it the new art of 'drawing in space.' But with equal and more descriptive justice it could be called, harking back more specifically to its birth in the collage: the new art of joining two-dimensional forms in three-dimensional space.

After classical Cubism the development of collage was largely oriented to shock value. Arp, Schwitters and Miró grasped its plastic meaning enough to make collages whose value transcends the piquant, but the genre otherwise declined into montage and stunts of illustration, or into decoration pure and simple. [Plate 13] The traps of collage (and of Cubism in general) in this last respect are well demonstrated by Gris's case.

Cubism, in the hands of its inventors – and in those of Léger too – achieved a new, exalted and transfigured kind of decoration by reconstructing the flat picture surface with the very means of its denial. They started with the illusion and arrived at a quasi-abstract literalness. With Gris it was the reverse. As he himself explained, he started with flat and abstract shapes to which he then fitted recognizable three-dimensional images. Whereas Braque's and Picasso's images were dissected in three dimensions in the course of being transposed in two, Gris's tended, especially in the beginning, to be broken up in two-dimensional terms alone, in accordance with rhythms originating on the surface. Later on Gris became aware of the fact that Cubism was not just a question of decorative overlay and that its surface resonance derived directly from an underlying illusion which, however schematic, was fully felt; and in his collages we can see him struggling with this problem. But his collages also make it clear how unstable his solution was. Precisely because he continued to take the picture surface as given and not needing to be re-created, he became over-solicitous about the illusion. He used his pasted papers and *trompe-l'oeil* textures and lettering to assert flatness all right; but he almost always sealed the flatness inside the illusion of depth by placing images rendered with sculptural vividness on the nearest plane of the picture, and often on the rearmost plane too. At the same time he used more positive color in his collages than Picasso or Braque did, and more light and dark shading. Because their affixed material and their *trompe-l'oeil* seldom declare the surface ambiguously, Gris's collages lack the immediacy of presence of Braque's and Picasso's. They have about them something of the closed-off presence of the traditional easel picture. And yet, because their decorative elements tend to function solely as decoration – as decoration of the illusion – they also seem more conventionally decorative. Instead of that seamless fusion of the decorative with the spatial structure of the illusion which we get in the collages of the other two masters, there is an alternation, a collocation, of the decorative and the illu-

sioned. And if their relation ever goes beyond that, it is more liable to be one
of confusion than of fusion. Gris's collages have their merits, but they have
been over-praised. Certainly, they do not confirm the point of Cubism as a
renovation of pictorial style.

That point, as I see it, was to restore and exalt decoration by building it, by
endowing self-confessedly flat configurations with a pictorial content, an
autonomy like that hitherto obtained through illusion alone. Elements essen-
tially decorative in themselves were used not to adorn but to identify, locate,
construct; and in being so used, to create works of art in which decorativeness
was transcended or transfigured in a monumental unity. Monumental is, in
fact, the one word I choose to describe Cubism's pre-eminent quality.

4. Henri Lefebvre, from *The Critique of Everyday Life*

The French philosopher and sociologist Henri Lefebvre published the first
volume of his *Critique de la vie quotidienne* in 1947. (He subsequently pub-
lished two further volumes, the last of which appeared in 1981.) He sought
to assess what he saw as the adverse impact of twentieth-century scientific
and political developments on individual identity and creativity. In extend-
ing his analysis of the mechanisms of capitalism to include techniques such
as marketing and advertising and their effects on the 'everyday' life of indi-
viduals in modern societies, he opened up a new domain of research.
Against contemporary alienation he held out the prospect of an 'art of liv-
ing' in which each individual's existence would become a work of art. His
ideas were an important influence on the Situationists in the 1950s and
1960s, and their call for a permanent condition of creativity that could
overcome the isolation of art from everyday experience. The following
extract is taken from the translation by John Moore, *The Critique of Everyday
Life*, Verso, London, 1991, pp. 196–200.

The critique of everyday life will propose the undertaking of a vast survey, to
be called: *How we live.*

(a) We could begin this survey by attempting to reconstruct the real life of a
number of individuals (comparing their real lives with their consciousness of
them, their interpretations of them), using a variety of research techniques.

How were these 'private' individuals formed? Under what influences? How
did they choose their path in life, their profession? How did they get married?
How and why did they have children? How and why did they act in such and
such a situation in their lives? . . .

A survey of this kind would be fairly difficult to carry out (although some
newspapers and reviews have already collected and published confidential

information of the most intimate kind, if only for publicity purposes), but it would shed much unexpected light upon individual lives in our age. It would be fascinating to compare the results with religious, moral, political and philosophical ideas which are still in circulation – and especially with the individualism which is even more widespread in behaviour than it is in theory.

Methodically carried out, this survey would at long last supplant the ramblings of philosophers or novelists (including those who get emotional about 'beings' and harshly lucid about 'existence') with solidly established 'human truths'. In all likelihood it would help to shift our centres of interest, revealing the part played by alienation, fictions, chance and fate in the real life and death of men.

The documentation we have collected so far (some of which will be published in the *Critique of Everyday Life*) demonstrates the existence in today's social life of some largely unknown sectors – and all the more so inasmuch as the dominant ideologies suggest 'ideas' which appear to explain and schematize them.

(b) This survey should not be limited to a certain number of individual lives taken in their totality, but should examine the details of everyday life as minutely as possible – for example, a day in the life of an individual, any day, no matter how trivial.

A trivial day in our lives – what do we make of it? It is likely that the survey would reveal that taken socially (examined in the light of the hidden social side of individual triviality) this trivial day would have nothing trivial about it at all. During a day at work or a holiday, we each enter into relations with a certain number of social 'things' whose nature we do not understand, but which we support by our active participation; without realizing it we are caught up in a certain number of social mechanisms.

One question we can ask ourselves, for example, is how the average man in his ordinary, day-to-day life, relates to the large corporations. Where does he encounter them? How does he perceive them and imagine them? Theory reveals a complex structure here – in what ways does he move within it? And how does this structure appear to him from morning till night?

(c) Taken more broadly and more generally, this survey of everyday life would become a survey of French life and specifically French forms of life – as compared with the specific forms of other nations.

How have the different 'milieux' of the French nation organized their everyday life?

How do these different social groups use their money, how do they organize their budget? How do they spend their time, what are their leisure activities? In what forms do they act out their sociability, their solitude, their family life, their love life, their culture?

Going on the as-yet incomplete documentation we have collected, it would appear that genuine revelations may be expected.

The survey would reveal how the Frenchman has long been one of the most *exploited* members of the capitalist universe, and how the bourgeoisie which has exploited him has been one of the shrewdest – alternating between deceit and brutality, and always very 'modern', very much in touch with all the tactics of the class struggle (particularly and precisely when it indiscriminately uses either the nation or the individual to deny that the struggle exists . . .).

Using precise cases and examples, the survey would demonstrate how this deceitful pressure results in the debasement both of the social structure (agriculture or industry) and of individual, everyday life.

It would thus contribute towards dispelling certain harmful myths (for example, the economic myth of France's 'natural' wealth – the cultural and spiritual myths of the inherent lucidity and spontaneous moderation of French thought . . .) by demonstrating concretely *what is true* and *what is false* about them . . .

It would also contribute towards the critique of a number of illusions which are particularly disastrous for France. Is it not surprising and fascinating that at the harshest, most oppressive moment of high capitalism so many of the French should have believed and should go on believing that they are free, and that in the name of their freedom a certain (and apparently large) number of them are still rushing headlong into slavery? What can be the meaning of the stubborn and persistent success of this mystification? What can examining the lives of 'private' individuals teach us about it, and what can it teach us about the real lives of these individuals?

In the name of freedom and individuality, we are told, the French have been 'abandoned' (just think of the situation of French youth!). This extraordinary observation was made by Drieu la Rochelle, and the conclusions he attempted to draw from it, were equally extraordinary; we know what became of him. The fact is that the 'private' individual suffers from the kind of 'spiritual' abandonment which makes it easy for the whole gamut of phony 'spiritual' powers to tout their false solutions and vow to rid consciousness and life of their sickness . . .

It will probably never be possible to complete this picture of French life. But it would take but a few polls to counter the gloomy aspects of the situation, and to reveal the healthy, restorative side of our national life, its real possibilities and genuinely creative elements.

On a completely different level, the study of everyday life would dispel several literary and philosophical myths whose spuriousness is one decadent tendency among many. For example, the myth of *human solitude*. There is ample evidence to show that for the vast majority of human beings, immersed as they are in natural life or undifferentiated social life, being alone is a need, and something to be achieved. For the peasant, merged with the life of natural things, of animals, of the earth, of the village, as for the worker who lives with his family in cramped accommodation and who is even more unfamiliar

with freedom to move around than he is with freedom to use his own time, there is no solitude in the 'deep' and 'metaphysical' meaning of the word. Peasants and the workers can be alone: by accident or by chance, through illness, through inability to express themselves, etc., but they are not truly solitary. On the contrary, a worker who lives with his wife and children in one or two rooms feels the need to reflect, to be alone with himself for a while in order to think or to read. He rarely experiences the joys of solitude. For him the need to be alone is already progress, something gained. It is the most 'private' individuals − intellectuals, individualists, separated by abstraction and bourgeois scholasticism from any relationship or social life − who have invented solitude. Instead of seeing it as the time and the chance to develop a deeper awareness of human relations, they have transformed it − following the usual metaphysical pattern − into an absolute. And then they have used their poetry, their novels or their philosophy to moan and to wallow in self-pity. At the limits of the 'private' consciousness and in the human nothingness of their 'existence', they have rebelled − in vain − against the metaphysical alienation which their own attitude towards life helps to maintain . . . For them, the fiction of solitude becomes reality. For them 'alone'!

(d) The critique of everyday life has a contribution to make to *the art of living*.

This art, as new, as unknown as happiness itself, has been prefigured − in the context of an individualism and dilettantism which was limited even then and has been moribund every since − by several writers, including Stendhal.

It is a domain in which everything remains to be said. In the future the art of living will become a genuine art, based like all art upon the vital need to expand, and also on a certain number of techniques and areas of knowledge, but which will go beyond its own conditions in an attempt to see itself not just as a means but as an end. The art of living presupposes that the human being sees his own life − the development and intensification of his life − not as a means towards 'another' end, but as an end in itself. It presupposes that life as a whole − everyday life − should become a work of art and 'the joy that man gives to himself'.

As with every genuine art, this will not be reducible to a few cheap formulas, a few gadgets to help us organize our time, our comfort, or our pleasure more efficiently. Recipes and techniques for increasing happiness and pleasure are part of the baggage of bourgeois wisdom − a shallow wisdom which will never bring satisfaction. The genuine art of living implies a human reality, both individual and social, incomparably broader than this.

The art of living implies the end of alienation − and will contribute towards it.

From one point of view life strikes us like some immense anthill, swarming with obscure, blind, anonymous beings and actions − and from another we see it shining with the splendour and glamour which certain individuals and certain actions confer on it. We must not avoid the fact that the latter view is

produced by the former, and 'expresses' it – that the contrast between the two is only momentary – and that up until now everyday life has been 'alienated' in such a way that its own reality has been torn from it, placed outside it and even turned against it.

In any event, this contrast cannot go on permanently deceiving us, its drama (with the condemnation of life as its theme) cannot be an absolute one. It is merely a passing contradiction, a problem . . .

This problem, which is none other than the problem of man, can only be posed and then resolved by dialectical method. Should we admit for one moment that it is otherwise, and that the plebeian substance of day-to-day living and the higher moments of life are forever separated, and that the two cannot be grasped as a unity and made to become a part of life – then it will be the human that we are condemning.

5. Benjamin Buchloh, 'The Primary Colours for the Second Time: A Paradigm Repetition of the Neo-Avant-Garde'

In this short essay, Benjamin Buchloh sets out to counter the negative assessment of the neo-avant-garde movements of the 1950s and 1960s that Peter Bürger had put forward in his book *Theory of the Avant-Garde* [see text II.1, above]. Buchloh argues that rather than dismissing the work of the neo-avant-garde as a mere 'repetition' of earlier forms of practice, which are thereby treated as authentic and originary, we need to recognise that calculated repetition forms part of its intended effect. He focuses on the example of monochrome painting, and investigates the different meanings it acquires in the work of Alexandr Rodchenko and Yves Klein. The essay is reprinted in full from *October*, no. 37, Summer 1986, pp. 41–52.

> The concept 'historic avant-garde movements' distinguishes these [dada, constructivism, surrealism] from all those neo-avant-gardiste attempts that are characteristic for Western Europe and the United States during the fifties and sixties. Although the neo-avant-gardes proclaim the same goals as the representatives of the historic avant-garde movements to some extent, the demand that art be reintegrated in the praxis of life within the existing society can no longer be seriously made after the failure of avant-gardiste intentions.[1]

> The neo-avant-garde, which stages for a second time the avant-gardiste break with tradition, becomes a manifestation that is void of sense and that permits the positing of any meaning whatever.[2]

These two quotations give us, in highly abbreviated form, one of the cen-

tral hypotheses of Peter Bürger's important but problematic study, *The Theory of the Avant-Garde*. To rephrase it, the hypothesis runs roughly as follows: It was the goal of the original avant-garde, that of the period 1910–25, to criticize the notion of autonomy, the central term of modernist thinking. Furthermore, this avant-garde aimed to abolish the separation of the aesthetic from the real (what is often referred to as the gap between art and life) and attempted instead to integrate art within social praxis. At the very least, the historical avant-garde attempted to criticize the institutionalization of modernism. By contrast, all those activities of the generations of postwar artists that Bürger calls the neo-avant-garde are flawed from the beginning by the most obvious of all failures in art production: repetition. 'The neo-avant-garde,' Bürger claims, 'institutionalizes the *avant-garde as art* and thus negates genuinely avant-gardiste intentions.'[3]

The word *genuinely* betrays Bürger's evaluation of the 'historical' avant-garde artists: they were original, while their postwar followers are imitators, recapitulators. The neo-avant-garde has copied and therefore falsified the original moment of rupture with the discursive practice and institutional system of modernism. While it is evident that Bürger's model of repetition is infinitely more complex than those which traditionally separate the unique, auratic original from the debased copy (whether repetition is understood as a process of learning and ever-closer approximation to an ideal of perfection or as a manufacturing process of copies and fakes), it is also evident that Bürger's notion of the 'genuine' original versus the 'fraudulent' copy is still determined by the binary opposition ultimately deriving from the cult of the auratic original.

Bürger's historical scheme, valid and important as it might be in other respects, is marred by this one feature: the fiction of the origin as a moment of irretrievable plenitude and truth. This fictitious moment of an 'origin' functions, as we know, as the fulcrum of the historian's pursuit. Only after establishing this plenitude or originality in the past – and that past moment can, as in an infinite regress, either be shifted further back into history or be pulled to the forefront of present-day experience – only then can the work of the historian begin.

As is usually the case with such fictions, we find in Bürger's text the consequence of this loss of the original for the present. The present moment is devalued, is comparatively empty and meaningless, lacks the vigor of the original, and therefore, at best, offers us the randomness of historicism. Thus, the present is not only 'void of sense' and 'permits the positing of any meaning whatever,' but, 'through the avant-garde movements, the historical succession of techniques and styles has been transformed into a simultaneity of the radically disparate. The consequence is that no movement in the arts today can legitimately claim to be historically more advanced *as art* than any other.'[4]

I want to argue, against Bürger, that the positing of a moment of historical

originality in the relationship between the historical avant-garde and the neo-avant-garde does not allow for an adequate understanding of the complexity of that relationship, for we are confronted here with practices of repetition that cannot be discussed in terms of influence, imitation, and authenticity alone. A model of repetition that might better describe this relationship is the Freudian concept of repetition that originates in repression and disavowal. Rather than discarding forty years of neo-avant-garde history with the high-handed naiveté of the art historian who has staked out a field and predetermined its limits, it would be more appropriate to investigate the actual conditions of reception and transformation of the avant-garde paradigms. This would entail clarifying the peculiar dynamics of selection and disavowal, of repression and 'simple' omission that resulted from the particular dispositions and investments that the various audiences brought to their involvement with the avant-garde after the Second World War. Furthermore, I want to ask whether it might not be precisely the process of repetition which constitutes the specific historical 'meaning' and 'authenticity' of the art production of the neo-avant-garde.

This clarification should be developed first of all within the discursive practice itself, and not by instantly seeking recourse in transcendental categories of causality and determination. Nor can the relationship between the historical avant-garde and the neo-avant-garde be elucidated from a centralized point, that of the *authentic* moment of originality, from which all subsequent activities appear as mere repetitions.

In the following I want to discuss a single example, a case in which one of the central pictorial strategies of the original avant-garde of the 1910–25 period was in fact rediscovered and 'repeated' by artists of the neo-avant-garde, and was subjected to the process of institutionalization that Bürger discusses. As is well known by now, between 1919 and 1921, in the context of postcubist painting, monochromy became one of the most important reductivist pictorial strategies of the historical avant-garde. While Malevich, in his series of square and modular-cross paintings of 1915–19, was the first to introduce the monochrome figure and to map this figure onto an achromatic field in a non-relational central composition, it is not until 1921 that we can speak of a completely monochrome canvas from which *all* figure-ground and chromatic relationships have been eliminated as well.[5] Rodchenko's triptych *Pure Colors: Red, Yellow, Blue*, 1921, is the first work that not only abolishes the denotative functions of color but also liberates color from all spiritual, emotional, and psychological associations, analogies with musical chords, and transcendental meaning in general. Thus, with Rodchenko's introduction of the monochrome, we witness not only the abolition of relational composition but, more importantly, the abandonment of conventional attributions of the 'meaning' of color in favor of the pure *materiality* of color. It is only logical that this recognition of the *materiality of color* coincided historically with the discovery of the *chromatic values of materials* as pronounced one year earlier

in the *Realistic Manifesto* of Naum Gabo and Antoine Pevsner (and as it had already been put into practice in Duchamp's ready-mades). Thus it is perfectly convincing to read Rodchenko's claim (made retrospectively in his text 'Working with Mayakovsky' of 1939):

> [In 1921] I reduced painting to its logical conclusion and exhibited three canvases: red, blue, and yellow. I affirmed: this is the end of painting. These are the primary colors. Every plane is a discrete plane and there will be no more representation.[6]

While one cannot deny with certainty that a remnant of antibourgeois, futurist shock value still motivated Rodchenko's claim, it is nevertheless evident that the project of Rodchenko's critical modernist strategies was the demystification of aesthetic production, in this case the pictorial convention of assigning meaning to color. In its explicitly scientist attitude – since it adapts scientific models of empirio-criticism – it proclaims itself as a model for aesthetic practice, and thus as a model for cultural practice in general. Moreover, by the mysterious process of model imitation that is never clarified in modernist practice (how exactly did Mondrian, for example, expect his paintings to operate as models of the socialist society?), Rodchenko's triptych suggests the elimination of art's esoteric nature, the rationalistic transparence of its conception and construction supposedly inviting wider and different audiences. Rodchenko aims to lay the foundations for a new culture of the collective rather than continuing one for the specialized, bourgeois elite.

Inevitably, the reduction to the monochrome also implied a redefinition of the role of the artist. Insofar as the work eliminates the marks of manual creation – analogue of the specialized vision – in its form and structure, it opposes the social division of labor and that condensation of talent in the single individual that is synonymous with its suppression in the collective. This implication of the monochrome painting is programmatically and provocatively overstated in an anonymous text of 1924, written either by Malevich or El Lissitzky:

> With the increasing frequency of the square in painting, the art institutions have offered everybody the means to make art. Now the production of art has been simplified to such an extent that one can do no better than order one's paintings by telephone from a house painter while one is lying in bed.[7]

Exactly thirty years later the French artist Yves Klein – in many ways the quintessential neo-avant-garde artist – astounded the Parisian art world with his work, and he seems to have convinced that art world with his claim to have invented monochrome painting. While Klein acknowledged his awareness of Malevich at a point in time later than this 'invention,' we have no evidence that he had come in contact with any examples of postcubist monochrome painting before 1957, when he saw Malevich's and Strzemiński's paintings in Paris. This fact does not in the least, however,

resolve the questions that are raised by this clear-cut case of neo-avant-garde paradigm repetition. If anything, it should make us realize that these phenomena must be addressed in a way that avoids mechanistic speculations about priority and influence. This is corroborated by the fact that Klein was literally surrounded at the time by other artists of his generation who (re-) discovered the strategy with equal enthusiasm and naiveté — for example, Fontana, Rauschenberg, and Kelly.

This coincidence, as well as the simultaneity of rediscoveries and repetitions of other avant-garde paradigms, substantiates the hypothesis that the discursive formation of modernism generated its own historical and evolutionary dynamic. If we assume that visual paradigms operate analogously to linguistic paradigms, then the '*langue*' of modernism would constitute the neo-avant-garde 'speakers' and continuously replicate and modify their '*paroles*.'

Since the aesthetic objects that emerge from these discursive formations seem at first to be structurally, formally, and materially analogous, if not identical, traditional art-historical approaches have been confronted with two possibilities. Either choose Bürger's transcendental criticism (and it does not really matter whether this is argued on political or aesthetic grounds), which rejects neo-avant-garde practices as so much charlatanry, as insufficient in comparison to the authenticity and sublime seriousness of the 'original,' historical avant-garde's critical project; or revert to the opposite (and complementary) method of connoisseurship. This latter approach attempts to elevate the activities of the neo-avant-garde — often with an effort bordering on the grotesque — and to transform them into such traditional high-art categories as the oeuvre, within which each object becomes again inherently self-sufficient, its meanings understood as a function of its 'essence.'[8]

But it is precisely this traditional conception of the work of art as a complete, self-enclosed, self-sufficient entity that the repetitions of the neo-avant-garde calls into question. And even though Bürger argues for a conception of the work as a fragment, an open structure, he does not seem to realize that within such an open structure, all formal and material, not to mention iconographic, elements are no longer able to generate the traditional semantic functions that he nevertheless deems essential to original avant-garde practices. It is thus *inevitable* that these works have reached what Bürger calls, critically, a state of 'semantic atrophy.' This term betrays Bürger's expectations of a traditional meaning structure inside an open, fragmented work, a meaning centralized and integrated and residing within the elements of the aesthetic object itself, yet nevertheless maintaining a referential relation to the real world.

On the contrary, however, the repetitive structure of the neo-avant-garde work, with its apparently identical chromatic, formal, and structural elements, prohibits the perception of an immanent meaning and dislodges this

traditional structure. It displaces meaning to the peripheries, shifting it to the level of the syntagma and toward contingency and contextual heteronomous determination. Consequently, the inherent qualities of the work no longer offer sufficient possibilities of differentiation among one another. (What would be the point of a formal comparison between two ready-mades by Duchamp or two paintings of soup cans by Warhol?) Nor are the works of the neo-avant-garde to be distinguished from their paradigmatic predecessors in the historical avant-garde; structurally, formally, chromatically the two trip-tychs by Rodchenko and Klein are at first almost identical.

It therefore becomes obvious that the reading of these neo-avant-garde works consists exclusively in assigning meaning to them from what tradition-al discourse would call the *outside*, that is, the process of their reception – the audience's disposition and demands, the cultural legitimation the works are asked to perform, the institutional mediation between demand and legitima-tion. For the work of the neo-avant-garde, then, meaning becomes visibly a matter of projection, of aesthetic and ideological investment, shared by a par-ticular community for a specific period of time.

Yves Klein seems to have been aware of all of this when he decided to repeat the modernist strategy of monochromy, and he pushed all the inherent con-tradictions to their logical extreme. In one of his most 'scandalous' exhibitions, Klein installed ten identical blue monochrome paintings in a commercial gallery in Milan in 1957. The implications of what Klein called his 'mono-chrome adventure' seem at first glance to be that the very continuation of painting is threatened. And indeed monochromy had, in Rodchenko's case, lead to the conclusion of his painting production. By purging color of its last remnants of mythical, transcendental meaning; by making painting com-pletely anonymous through seriality and infinite repeatability; by imbuing painting with the status of the ready-made, the final blow to painting – con-sidered as a unique object and a moment of auratic experience – seemed to have been dealt. We are left with the infinite repetition of the structurally analogous or identical, as was precisely the case in the work of so many artists during the 1950s and '60s, the complete destruction of the closed, centered, self-contained work, as well as the destruction of the organic development of the oeuvre.

But there is an almost schizophrenic split between Klein's pictorial produc-tion and the perceptual experience he wants it to generate, as demonstrated in his own observations on the 1957 exhibition:

All of these blue propositions, all alike in appearance, were recognized by the public as quite different from one another. The *amateur* passed from one to another as he liked and penetrated, in a state of instantaneous con-templation, into the worlds of the blue.

However, each blue world of each picture, although of the same blue and

treated in the same manner, revealed itself to be of an entirely different essence and atmosphere; none resembled another, no more than pictorial moments or poetic moments resemble each other. . . .

The most sensational observation was that of the 'buyers.' Each selected out of the . . . pictures that one that was his, and each paid the asking price. The prices were all different of course. This fact proves, for one thing, that the pictorial quality of each picture was perceptible through something other than the material physical appearance. . . .

So I am in search of the real value of the picture, that is, suppose two paintings rigorously identical in all visible and legible effects, such as lines, colors, drawing, forms, format, density of surface, and technique in general, but the one is painted by a 'painter' and the other by a skilled 'technician,' an 'artisan,' albeit both officially recognized as 'painters' by the public. This invisible real value means that one of these two objects in a 'picture' and the other isn't. (Vermeer, van Meegeren.)[9]

It is in Klein's desperate (or is it facetious?) attempt to protect himself against the erosion of painting and to maintain it as a form of sublime and privileged experience that he reveals most poignantly (it is unclear whether his clairvoyance is innocent or cynical) the extent to which painterly production had already become subservient to the conditions of the culture industry. The realm of modernism — once a domain of resistance to the totalizing demands of ideology and those of the production of use value and exchange value; a domain that had offered a form of refuge, a utopian space where cognition and vision, sensual play and apperception could be experienced as integrated; where the primary process maintained its supremacy — this realm was now in the process of being converted into an area of specialization for the production of luxurious perceptual fetishes for privileged audiences.

But more than that, we read in Klein's account the way in which every single feature of the modernist pictorial strategy and its enlightenment agenda is turned on its head. While for Rodchenko it was the *tactility* of his monochrome panels, their relief character, so to speak, that suggested the abolition of the bourgeois contemplative mode of perception, it is precisely *contemplation* that Klein prescribes as the proper perceptual approach to his works. While Rodchenko wished to purge chromatic qualities of their mythical and transcendental meaning, Klein conjures up the essence and the atmosphere of the poetic moment of each individual painting. And finally, it had been evident from Rodchenko's positivist agenda, and from the Malevich/Lissitzky statement, that one of the most radical implications of the strategy of monochromy was the redefinition of the artist's role, the abolition of the painter's *patte* and his specialized vision in the systematic breakdown of the work's auratic status. In Klein's statement, by contrast, the artificial reconstitution of the aura is the

central issue, and he must therefore logically separate the art of the copyist or faker from that of the reconstructed, inspired, original, creative genius.

This reconstitution of the artist's traditional role is, however, by necessity mythical, and the products emerging from this restoration are inevitably fetishistic. They are fetishistic, first of all, because their auratic quality can only be demonstrated by their commodity status. The *hierarchy* of exchange value to which Klein refers with such candor reveals the myth as myth even in the act of constructing it. Secondly, and perhaps more importantly, the fetishistic nature of these products originates – as is crucial for the formation of the fetish in general – in *disavowal*, in this case, the disavowal of the historical legacy of modernism itself. Neither the original implications of the strategy of the monochrome nor its subsequent development (constructivism's transition to productivism, for example), could be acknowledged in the reception and repetition of this paradigm by the neo-avant-garde. The primary function of the neo-avant-garde was not to reexamine this historical body of aesthetic knowledge, but to provide models of cultural identity and legitimation for the reconstructed (or newly constituted) liberal bourgeois audience of the postwar period. This audience sought a reconstruction of the avant-garde that would fulfill its own needs, and the demystification of aesthetic practice was certainly not among those needs. Neither was the integration of art into social practice, but rather the opposite: the association of art with spectacle. It is in the spectacle that the neo-avant-garde finds its place as the provider of a mythical semblance of radicality, and it is in the spectacle that it can imbue the repetition of its obsolete modernist strategies with the appearance of credibility.

According to Klein – and to many of his apologists and exegetes – one of his prime achievements was to have 'liberated the pigment' from its traditional binding media. This was accomplished by discovering and mixing new materials to create his patented International Klein Blue. The recipe, which used transparent acrylic as a binder, made the blue pigment appear as if pure and unbound, sitting like a powder on the surface of the canvas. Paradoxically, though, it is just this extreme devotion to the details of the painting's surface which indicates most poignantly that the modernist concern with transparency of construction had run its course. Any attempt to refine it, to increase its precision, or to extend the life span of the paradigm was bound to result in fetishization.

Thus we find our hypothesis empirically confirmed on the level of the materials and procedures themselves, and so the *actual* differences between the two triptychs – Rodchenko's and Klein's – must be taken very seriously indeed. The one is by no means a mere repetition of the other using slightly altered colors (from yellow to gold, from red to pink, from blue to IKB); rather, the first triptych completed the modernist, materialist project in order to abolish the last vestiges of myth and cult to which high art had been inextricably tied within bourgeois culture. Rodchenko's work thereby made possi-

ble the conception of a new collective culture. By contrast, Klein's triptych resuscitated the idea of art as transcendental negation and esoteric experience precisely at that moment when the mass culture of corporate capitalism was in the process of dismantling all vestiges of bourgeois culture's individual experience and liquidating the oppositional functions of high art.

It becomes obvious, then, from these very minute material and procedural features of the neo-avant-garde paradigm repetition that the bourgeois public sphere from which the modernist project emerged had been utterly transformed and that modernist culture had lost its function of mediating between individual and public. The very same strategies that had developed within modernism's project of enlightenment now serve the transformation of the bourgeois public sphere into the public sphere of the corporate state, with its appropriate forms of distribution (total commodification) and cultural experience (the spectacle).

1 Peter Bürger, *Theory of the Avant-Garde*, trans. Michael Shaw, Minneapolis, University of Minnesota Press, 1984, p. 109, n. 4.

2 *Ibid.*, p. 62.

3 *Ibid.*, p. 61.

4 *Ibid.*, p. 63. The implications of this statement seem particularly problematic when considered in relation to current 'postmodernist' production, whose cynical apologists argue precisely for a value-free art practice based on the end of the avant-garde and the simultaneous availability of all historical styles through pastiche or quotation. Bürger's discussion of the neo-avant-garde shows no awareness whatever of those art practices of the late 1960s and early 1970s (his book was originally published in Germany in 1974) that radically opposed the 'institutionalization of the avant-garde as art,' for example, the work of Marcel Broodthaers, Daniel Buren, and Hans Haacke. For a more developed critique of this aspect of Bürger's book, see my review, 'Theorizing the Avant-Garde,' *Art in America*, vol. 72, no. 10 (November 1984), pp. 19–21.

5 For a first extensive and excellent discussion of the history of monochrome painting, see Yve-Alain Bois, 'Malevich, le carré, le degré zéro,' *Macula*, no. 1 (1978), pp. 28–49.

6 Alexander Rodchenko, 'Working with Majakowsky,' in *From Painting to Design: Russian Constructivist Art of the Twenties*, Cologne, Galerie Gmurzynska, 1981, p. 191.

7 Quoted in Bois, p. 37, n. 40; originally published in Hans Arp and El Lissitzky, *Kunstismen*, Munich, Eugen Rentsch Verlag, 1925, pp. ix–x.

8 For a recent example of this approach, see John Bowlt, 'The Zero of Forms,' in *Of Absence and Presence*, New York, Kent Fine Art, 1986, np.

9 Yves Klein, 'The Monochrome Adventure,' trans. and quoted in Nan Rosenthal, 'Assisted Levitation: The Art of Yves Klein,' in *Yves Klein*, Houston, Institute for the Arts, Rice University, and New York, The Arts Publisher, 1982, p. 105.

PART III
MODERNITY AND PHOTOGRAPHY

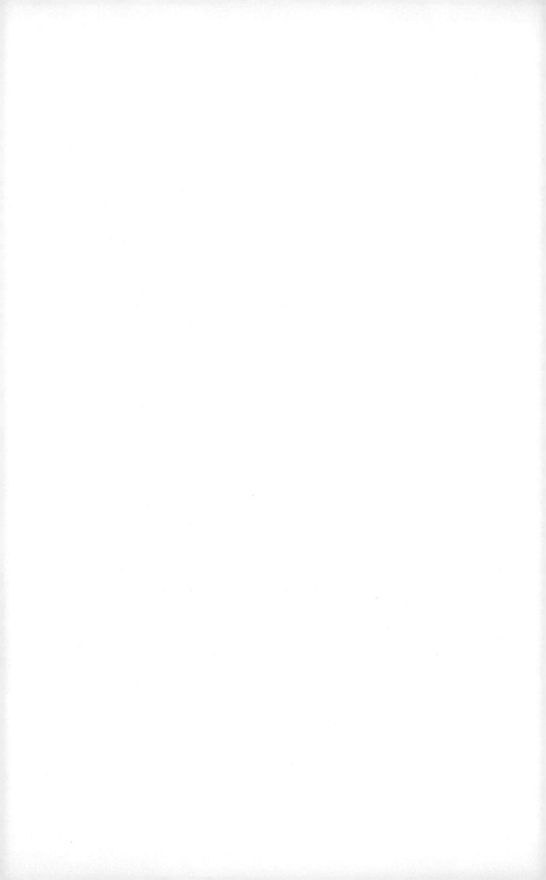

Introduction

Photography was publicly announced in France and Britain in 1839, and rapidly developed into the dominant form of picture making in western societies. The power of the photographic image was founded on its ability to record, relatively instantaneously, the appearance of things. In little over twenty years, photographs were regularly employed to record a whole range of phenomena (everything from geological formations to maps of the heavens), which had previously required the time-consuming labour of a painter or printmaker. From the 1860s, concerted attempts were made to create autonomous pictures with the camera. The 'art-photography' that developed in the nineteenth century was based on conventional pictorial subjects and styles. This changed when the avant-garde took up the medium as a tool for intervening in everyday life. Avant-gardists in the 1920s and 1930s responded to photography as one of the dynamic forms of modernity responsible for an exponential growth in the number and uses of images. From this moment on, photography became a major presence, if a troubling one, in modern art and the attendant critical discourse.

The six texts assembled here are intended to provide an overview of the changing perception of photography's place in twentieth-century art. The Part opens with one of the most acclaimed theorists of the medium: in 'News About Flowers', Walter Benjamin reflects on the way that Karl Blossfeldt's photographic techniques of enlargement and the selection of details could be used to extend human vision beyond its normal parameters. In the second text, Hannah Höch considers the emergence and transformation of photomontage in art and advertising. The essay by Rosalind Krauss negotiates the paradoxes of the use of photography in Surrealism and reasserts its importance to the Surrealist project. In the influential catalogue essay that follows, John Szarkowski – at the time, curator of photography at the Museum of Modern Art, New York – sets out what he believed were the five defining characteristics of photographic vision. The extract from an essay by Allan Sekula represents a militant challenge to what its author perceived as the dehistoricised account of photography in the modernist museum. In the final text in this Part, Jeff Wall considers the role of photography in Conceptual Art and looks back over the twentieth century as a whole to account for the peculiar place photography occupies in modern art. [SE]

1. Walter Benjamin, 'News About Flowers'

Walter Benjamin has been widely acclaimed as one of the twentieth centu-
ry's most significant intellectuals. Combining themes from Marxism and
Jewish theology, he wrote on literature, philosophy, mass culture and the
emerging technological media of film, photography and radio. In this short
review of Karl Blossfeldt's photo-book *Urformen der Kunst* (1928), which
consists of photographic enlargements of plant forms, Benjamin argues for
photography as a medium capable of extending and training human vision.
The German Word *Urformen* is translated here as 'originary forms', but the
book's title has also been rendered as *Art Forms in Nature*. The review was
first published in German in *Die literarische Welt*, November 1928. The text
is reprinted in full in a translation by Michael Jennings, from *Walter
Benjamin, Selected Writings, Vol. 2: 1927–1934*, Michael Jennings, Howard
Eiland and Gary Smith (eds), The Belknapp Press of Harvard University
Press, Cambridge Mass. and London, 1999, pp. 155–7. We have retained
the Harvard editors' explanatory endnotes.[SE]

Karl Blossfeldt, *Urformen der Kunst: Photographische Pflanzenbilder*
[Originary Forms of Art: Photographic Images of Plants], edited and with an
introduction by Karl Nierendorf (Berlin: Ernst Wasmuth, 1928), 120 pages.

Criticism is a sociable art.[1] A healthy reader mocks the reviewer's judgment.
But what pleases that reader most deeply is the delicious bad taste of taking
part uninvited when someone else reads. Opening a book so that it beckons
like a table already set, a table at which we are about to take our place with
all of our insights, questions, convictions, quirks, prejudices, and thoughts, so
that the couple of hundred readers (are there that many?) in this society dis-
appear and just for that reason allow us to enjoy life – this is criticism. Or at
least the only form of criticism that gives a reader an appetite for a book.

If we can agree on this, then the table is set with the one hundred twenty
plates in this book, inviting countless observations from countless observers.
Yes, we really wish this rich book (poor only in words) that many friends. The
silence of the scholar who presents these images must really be honored; per-
haps his knowledge is of the kind that makes the one who possesses it mute.
And here, doing is more important than knowing. The person who created
this collection of plant photos can eat more than bread. He has done more
than his share of that great stock-taking of the inventory of human percep-
tion that will alter our image of the world in as yet unforeseen ways. He has
proven how right the pioneer of the new light-image, Moholy-Nagy, was
when he said: 'The limits of photography cannot be determined. Everything
is so new here that even the search leads to creative results. Technology is, of

course, the pathbreaker here. It is not the person ignorant of writing but the one ignorant of photography who will be the illiterate of the future.' Whether we accelerate the growth of a plant through time-lapse photography or show its form in forty-fold enlargement, in either case a geyser of new image-worlds hisses up at points in our existence where we would least have thought them possible.

These photographs reveal an entire, unsuspected horde of analogies and forms in the existence of plants. Only the photograph is capable of this. For a bracing enlargement is necessary before these forms can shed the veil that our stolidity throws over them. What is to be said of an observer to whom these forms already send out signals from their veiled state? Nothing can better portray the truly new objectivity of his procedure than the comparison with that highly personal but ever so brilliant procedure by means of which the equally revered and misunderstood Grandville, in his *Fleurs animées*, made the entire cosmos emanate from the world of plants. Grandville took hold of the procedure – God knows, not gently – from the opposite end. He stamped the punitive mark of creatureliness, the human visage, directly onto the blossom of these pure children of nature. This great pioneer in the field of the advertisement mastered one of its fundamental principles, graphic sadism, as hardly any other of its adepts has done. Isn't it odd now to find here another principle of advertisement, the enlargement of the plant world into gigantic proportions, gently healing the wounds opened by caricature?

Originary Forms of Art – certainly. What can this mean, though, but originary forms of nature? Forms, that is, which were never a mere model for art but which were, from the beginning, at work as originary forms in all that was created. Moreover, it must be food for thought in even the most sober observer that the enlargement of what is large – the plant, or its buds, or the leaf, for example – leads us into a wholly different realm of forms than does the enlargement of what is small – the plant cell under the microscope, say. And if we have to tell ourselves that new painters like Klee and even more Kandinsky have long been at work establishing friendly relations between us and the realms into which the microscope would like to seduce us – crudely and by force – we instead encounter in these enlarged plants vegetal 'Forms of Style.'[2] One senses a gothic *parti pris* in the bishop's staff which an ostrich fern represents, in the larkspur, and in the blossom of the saxifrage, which also does honor to its name in cathedrals as a rose window which breaks through the wall. The oldest forms of columns pop up in horsetails; totem poles appear in chestnut and maple shoots enlarged ten times; and the shoots of a monk's-hood unfold like the body of a gifted dancer. Leaping toward us from every calyx and every leaf are inner image-imperatives [*Bildnotwendigkeiten*], which have the last word in all phases and stages of things conceived as metamorphoses. This touches on one of the deepest, most unfathomable forms of the creative, on the variant that was always, above all

others, the form of genius, of the creative collective, and of nature. This is the fruitful, dialectical opposite of invention: the *Natura non facit saltus* of the ancients.[3] One might, with a bold supposition, name it the feminine and veg-etable principle of life. The variant is submission and agreement, that which is flexible and that which has no end, the clever and the omnipresent.

We, the observers, wander amid these giant plants like Lilliputians. It is left, though, to fraternal great spirits – sun-soaked eyes, like those of Goethe and Herder – to suck the last sweetness from these calyxes.

1 Karl Blossfeldt (1865–1932) was a German photographer and art teacher whose entire photographic output was devoted to the representation of plant parts: twig ends, seed pods, tendrils, leaf buds, and so on. These he meticulously arranged against stark backgrounds and photographed with magnifica-tion, so that unfamiliar shapes from the organic world were revealed as startling, elegant architectur-al forms. Blossfeldt originally produced his work as a study aid for his students at the Berlin College of Art; he believed that the best human art was modeled on forms preexisting in nature.

2 Benjamin is referring to *Stilfragen* (1893), a work by Alois Riegl. It traces the influence of natural forms such as the acanthus through a series of stylistic periods in the ancient world.

3 *Natura non facit saltus*: Latin for nature does not make a leap. In rationalist philosophy, the phrase expresses the notion that God leaves no gaps in nature.

2. Hannah Höch, 'A Few Words on Photomontage'

Hannah Höch was an avant-garde artist associated with the Berlin Dada group. She is principally known for her pioneering photomontages, many of which splice images of women with pictures of mechanical contrivances. In this essay, she looks back on the development of photomontage, com-menting on the cutting and pasting of photographs in popular culture and distinguishing between the use of the technique in advertising and what she refers to as 'free-form photomontage'. The text was originally written in German in 1934, but first published in Czech. It has been translated from Czech into English by Jitka Salaguarda and is reprinted in full from Maud Lavin, *Cut With the Kitchen Knife: The Weimar Photomontages of Hannah Höch*, Yale University Press, New Haven and London, 1995, pp. 219–20. [SE]

First Photomontages

Photomontage is based on photography and has developed from photography. Photography has now been in existence for some one hundred years. Although photo-montage is not as old, it is not, as is often thought, the prod-uct of the postwar era. The first instances of this form, i.e., the cutting and rejoining of photos or parts of photos, may be found sometimes in the boxes of our grandmothers, in the fading, curious pictures representing this or that great-uncle as a military uniform with a pasted-on head. In those days the

head of a person was simply glued onto a pre-printed musketeer. Another picture might show us a ready-made landscape, perhaps of boat on a picturesque lake bathed in moonlight, with an entire family group pasted into that scene. Jocular images for picture postcards and such were also made earlier from cut-up and then re-pasted photographs. A sheet from 1880, belonging to Professor Stenger's collection (Berlin), shows us students who appear to be sawing one of their fellow students in pieces.

Photomontage Around 1919

When, in 1919, the Dadaists grasped the possibility of forming new shapes and new works through photography and made their aggressive photomontages, it happened, strangely enough and simultaneously, in a number of quite diverse countries, in France, Germany, Russia, and Switzerland. For the most part, the art groups of these countries did not have much contact with each other. The war had just ended and contacts were limited to initial diplomatic steps. That is why I would say 'strangely enough,' since this does not represent a new idea of one person or an idea created by a group of people, but because in this instance photography itself revived this genre. This rebirth was due, in the first place, to the high level of quality photography has achieved; second, to film; and third, to reportage photography, which has proliferated immensely. For decades, photoreportage has used photographs cut up very modestly but quite consciously, and often pasted on parts of photographs whenever it felt a need to do so. For example, when a potentate was welcomed in Tröchtelborn, and the journalistic photo taken on the spot was not impressive enough, various groups of people from different photographs were glued to it, and the sheet was photographed again, thus creating an immense crowd of people when in reality the welcoming crowd was only a male choir.

On Today's Photomontage

In the meantime, photomontage has proved its mettle conquering, in particular, the field of advertising. Posters, advertisements, publicity prints of all kinds demonstrate to us the multiplicity of uses. It was observed that the image impact of an article – for example, a gentleman's collar – could produce a stronger impression if a photograph of one of them were taken, cut out, and ten such cut-out collars were artfully arranged than if ten gentleman's collars were just laid on a table and a photograph made of them. Powerful decorative effects that could be obtained by means of photomontage were previously attainable only by draftsmen. The photographic approach had the advantage, however, that the detail would come out in the simplest

manner, as naturally and clearly as one could desire. Furthermore, pho-tomontage continues to be the best aid for photoreportage.

Finally, I come to what can be termed, in opposition to the 'applied' pho-tomontage that we have been discussing up to this point, 'free-form pho-tomontage,' that is, an art form that has grown out of the soil of photography. The peculiar characteristics of photography and its approaches have opened up a new and immensely fantastic field for a creative human being: a new, magi-cal territory, for the discovery of which freedom is the first prerequisite. But not lack of discipline, however. Even these newly discovered possibilities remain subject to the laws of form and color in creating an integral image sur-face. Whenever we want to force this 'photomatter' to yield new forms, we must be prepared for a journey of discovery, we must start without any pre-conceptions; most of all, we must be open to the beauties of fortuity. Here more than anywhere else, these beauties, wandering and extravagant, oblig-ingly enrich our fantasy.

3. Rosalind Krauss, 'Photography in the Service of Surrealism'

In this essay, originally written to accompany the exhibition *'L'Amour fou'. Photography and Surrealism* at the Hayward Gallery, London in 1986, Rosalind Krauss maintains that 'surrealist photography is the great unknown, undervalued aspect of surrealist practice, but that nonetheless, it is the *great* production of the movement'. She starts out with the identification of a seeming paradox: how can photography, with its direct, photomechani-cal trace of the real, be employed in the service of Surrealism's project of reor-ganising our very conception of reality? She shows that the various manipu-lations to which photography was subjected in Surrealism, including dou-blings, spacings, close-ups and cropping, allowed the Surrealists to interrupt photography's apparently seamless relation with reality. These techniques inscribed photography within the realm of language or signification, rather than that of a causal imprint or 'index' of reality. At the same time, however, Surrealist photographers exploited photography's privileged connection with the real in order to 'convulse reality from within' and to show that reality itself is already 'configured or coded or written'. The essay is repinted in full from Rosalind Krauss and Jane Livingston, *'L'Amour fou'. Photography and Surrealism*, exhibition catalogue, Hayward Gallery/Arts Council of Great Britain, London, 1986, pp. 15–42. We have only been able to reproduce a limited selection of the photographs that originally accompanied this text, and have renumbered the endnotes.

When will we have sleeping logicians, sleeping philosophers? I would like to sleep, in order to surrender myself to the dreamers...

– Manifesto of Surrealism[1]

Here is a paradox. It would seem that there cannot be surrealism *and* photography, but only surrealism *or* photography. For surrealism was defined from the start as a revolution in values, a reorganization of the very way the real was conceived. Therefore, as its leader and founder, the poet André Breton, declared, 'for a total revision of real values, the plastic work of art will either refer to a *purely* internal model or will cease to exist.'[2] These internal models were assembled when consciousness lapses. In dream, in free association, in hypnotic states, in automatism, in ecstacy or delirium, the 'pure creations of the mind' were able to erupt.

Now, if painting might hope to chart these depths, photography would seem most unlikely as a medium. And indeed, in the *First Manifesto of Surrealism* (1924). Breton's aversion to 'the real form of real objects' expresses itself in, for example, a dislike of the literary realism of the nineteenth-century novel disparaged, precisely, as photographic. 'And the descriptions!' he deplores. 'Nothing compares to their nonentity; they are simply superimposed pictures taken out of a catalogue, the author ... takes every opportunity to slip me these postcards, he tries to make me see eye to eye with him about the obvious.'[3] Breton's own 'novel' *Nadja* (1928), which was copiously illustrated with photographs exactly to obviate the need for such written descriptions, disappointed its author as he looked at its 'illustrated part.' For the photographs seemed to him to leave the magical places he had passed through stripped of their aura, turned 'dead and disillusioning.'[4]

But that did not stop Breton from continuing to act on the call he had issued in 1925 when he demanded, 'and when will all the books that are worth anything stop being illustrated with drawings and appear only with photographs?'[5] The photographs by Man Ray and Brassaï that had ornamented the sections from the novel *L'Amour fou* (1937) that had first appeared in the surrealist periodical *Minotaure* survived in the final version, faithfully keyed to the text with those 'word-for-word quotations ... as in old chambermaid's books' that had so fascinated the critic Walter Benjamin when he thought about their anomolous presence. Thus in one of the most central articulations of the surrealist experience of the 1930s, photography continued, as Benjamin said, to 'intervene.'[6]

Indeed, it had intervened all during the 1920s in the journals published by the movement, journals that continually served to exemplify, to define, to manifest, what it was that was surreal. Man Ray begins in *La Révolution surréaliste*, contributing six photographs to the first issue alone, to be joined by those surrealist artists like Magritte who were experimenting in photomontage and later, in *Le Surréalisme au sérvice de la révolution*, by Breton as well. In *Documents* it

was Jacques-André Boiffard who manifested the sensibility photographically. And by the time of *Minotaure's* operation. Man Ray was working along with Raoul Ubac and Brassaï. But the issue is not just that these books and journals contained photographs – or tolerated them, as it were. The more important fact is that in a few of these photographs surrealism achieved some of its supreme images – images of far greater power than most of what was done in the remorselessly labored paintings and drawings that came increasingly to establish the identity of Breton's concept of 'surrealism and painting.'

If we look at certain of these photographs, we see with a shock of recognition the simultaneous effect of displacement and condensation, the very operations of symbol formation, hard at work on the flesh of the real. In Man Ray's *Monument à D. A. F. de Sade*, for example, our perception of nude buttocks is guided by an act of rotation, as the cruciform inner 'frame' for this image is transformed into the figure of the phallus [Plate 14]. The sense of capture that is simultaneously implied by this fall is then heightened by the structural reciprocity between frame and image, container and contained. For it is the frame that counteracts the effects of the lighting on the flesh, a luminous intensity that causes the nude body to dissolve as it moves with increasing insubstantiality toward the edges of the sheet, seeming as it goes to become as thin as paper. Only the cruciform edges of the frame, rhyming with the clefts and folds of the photographed anatomy, serve to reinject this field with a sense of the corporeal presence of the body, guarantying its density by the act of drawing limits. But to call this body into being is to eroticize it forever, to freeze it as the symbol of pleasure. In a variation on this theme of limits, Man Ray's untitled *Minotaure* image displaces the visually decapitated head of a body downward to transform the recorded torso into the face of an animal. And the cropping of the image by the photographic frame, a cropping that defines the bull's physiognomy by the act of locating it, as it were – this cutting mimes the beheading by shadow that is at work inside the image's field. So that in both these photographs a transformation of the real occurs through the action of the frame. And in both, each in its own way, the frame is experienced as figurative, as redrawing the elements inside it. These two images by Man Ray, the work of a photographer who participated directly in the movement, are stunning instances of surrealist visual practice. But others, qualifying equally for this position as the 'greatest' of surrealist images, are not really by 'surrealists.' Brassaï's *Involuntary Sculptures* or his nudes for the journal *Minotaure* are examples. And this fact would seem to raise a problem. For how, with this blurring of boundaries, can we come to understand *surrealist* photography? How can we think of it as an aesthetic category? Do the photographs that form a historical cluster, either as objects made by surrealists or chosen by them, do they in fact constitute some kind of unified visual field? And can we conceive this field as an aesthetic category?

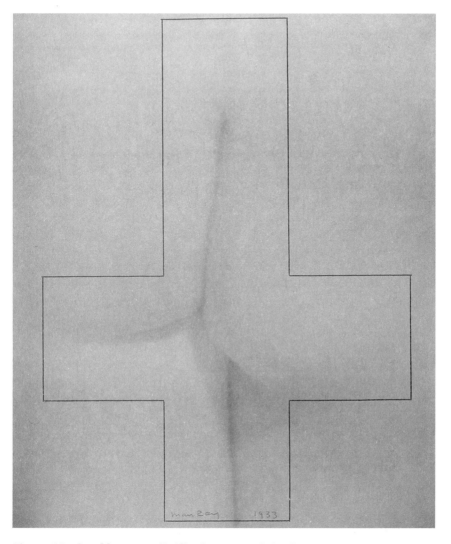

Plate 14 Man Ray, *Monument to D.A.F de Sade*, 1933, gelatin silver print and ink, 20 x 16 cm. Israel Museum, Jerusalem, courtesy of The Vera, Silvia and Arturo Schwarz Collection of Dada and Surrealist Art. Photo: Avshalom Avital. © Man Ray Trust/ADAGP, Paris and DACS, London 2003.

What Breton himself put together, however, in the first *Surrealist Manifesto* was not so much an aesthetic category as it was a focus on certain states of mind – dreams – certain criteria – the marvelous – and certain processes – automatism. The exempla of these conditions could be picked up, as though they were *trouvailles* at a flea market, almost anywhere in history. And so Breton finds the 'marvelous' in 'the romantic *ruins*, the modern *mannequin* . . . Villon's gibbets, Baudelaire's couches.'⁷ And his famous incantatory list of history's surrealists is

precisely the demonstration of a 'found' aesthetic, rather than one that thinks itself through the formal coherence of, say, a period style:

> Swift is Surrealist in malice.
> Sade is Surrealist in sadism.
> Chateaubriand is Surrealist in exoticism.
> Constant is Surrealist in politics.
> Hugo is Surrealist when he isn't stupid . . .[8]

In the beginning the surrealist movement may have had its members, its paid-up subscribers, we could say, but there were many more *complimentary* subscriptions being sent by Breton to far-off places and into the distant past.[9]

This attitude, which annexed to surrealism such disparate artists as Uccello, Gustave Moreau, Seurat, and Klee, seemed bent on dismantling the very notion of style. One is therefore not surprised at the position the poet and revolutionary Pierre Naville took up against the 'Beaux-Arts' when he limited the visual aesthetic of the movement to memory and the pleasure of the eyes and produced a list of those things that would produce this pleasure: streets, kiosks, automobiles, cinema, photographs.[10] In modeling what he intended as the movement's authoritative journal, *La Révolution surréaliste*, after the French scientific review *La Nature*, Naville wanted to clarify that this was not an *art* magazine, and his decision, as its editor, to include a great deal of photography was predicated precisely, he has said, on the availability of photography's images – one could find them anywhere.[11] For Naville, artistic style was anathema. 'I have no tastes,' he wrote, 'except distaste. Masters, master-crooks, smear your canvases. Everyone knows there is no *surrealist painting*. Neither the marks of a pencil abandoned to the accidents of gesture, nor the image retracing the forms of the dream . . .'[12]

To place in this way a ban on accident and dream as the basis of a visual style, thereby proscribing the very resources on which Breton depended, was to make of himself a kind of roadblock in the direction along which surrealism was moving. Naville's struggle with Breton is acted out in the masthead of *La Révolution surréaliste*, which is issued at its beginning from its rue de Grenelle headquarters, dubbed the 'Centrale,' its editors listed as Naville and Péret, then is wrested from them in the third issue by Breton and moved to the rue Fontaine, only to return for one number to the Centrale, until it is definitively taken back home by Breton to the rue Fontaine. Many things were at issue in this struggle, but one of them was painting. For by the middle of 1925 Breton had allowed the possibility of 'Surrealism and Painting,' in the text he produced by that name. At first he thought of it in terms of 'found' surrealists, like de Chirico or Picasso. But by March 1926 his second installment of this essay was bent on constructing precisely what 'everyone knows' there is none of: a pictorial movement, a stylistic phenomenon, a surrealist painting to go into the newly organized Galerie Surréaliste.

In going about formulating this thing, this style, Breton resorted to his very

own privileging of visuality, when in the first *Manifesto* he had located his own invention of psychic automatism within the experience of hypnogogic images – that is, of half-waking, half-dreaming visual experience. For it was out of the priority that he wanted to give to this sensory mode – the very medium of dream experience – that he thought he could institute a pictorial style.

'Surrealism and Painting' thus begins with a declaration of the absolute value of vision above the other senses.[13] Rejecting symbolism's notion that art should aspire to the condition of music, Breton rejoins that 'visual images attain what music never can,' and he adds, no doubt for the benefit of twentieth-century proponents of abstraction, 'so may night continue to descend upon the orchestra.' Breton had opened by extolling vision in terms of its absolute immediacy, its resistance to the alienating powers of thought. 'The eye exists in its savage state,' he had begun. 'The marvels of the earth . . . have as their sole witness the wild eye that traces all its colors back to the rainbow.' Vision, defined as primitive or natural, is good; it is reason, calculating, premeditated, controlling, that is bad.

No sooner, however, is the immediacy of vision established as the grounds for an aesthetic, that it is overthrown by something else, something normally thought to be its opposite: writing. Psychic automatism is itself a written form, a 'scribbling on paper,' a textual production. Describing the automatic drawings of André Masson – the painter whose 'chemistry of the intellect' Breton was most drawn to – Breton presents them, too, as a kind of writing, as essentially cursive, scriptorial, the result of 'this hand, enamoured of its own movement and of that alone.' 'Indeed,' he adds, 'the essential discovery of surrealism is that, without preconceived intention, the pen that flows in order to write and the pencil that runs in order to draw *spin* an infinitely precious substance.' So preferable is this substance, in Breton's eyes, to the fundamentally visual product of the dream, that Breton ends by giving way to a distaste for the 'other road available to Surrealism,' namely, 'the stablizing of dream images in the kind of still-life deception known as trompe l'oeil (and the very word "deception" betrays the weakness of the process).'

Now this distinction between writing and vision is one of the many antinomies that Breton speaks of wanting surrealism to dissolve in the higher synthesis of a surreality that will, in this case, 'resolve the dualism of perception and representation.'[14] It is an old opposition within Western culture and one that does not simply hold these two modalities to be contrasting forms of experience, but places one higher than the other.[15] Perception is better – truer – because it is immediate to experience, while representation must always remain suspect because it is never anything but a copy, a re-creation in another form, a set of signs for experience. Because of its distance from the real, representation can thus be suspected of fraud.

In preferring the products of a cursive automatism to those of dream imagery, Breton appears to be reversing the classical preference of vision to writing. For in

Breton's definition, it is the pictorial image that is suspect, a 'deception,' while the cursive one is true.[16]

Yet this reversal only *appears* to overthrow the traditional Platonic dislike of representation. In fact, because the visual imagery Breton suspects is a picture, and thus the representation of a dream rather than the dream itself, Breton here continues Western culture's fear of representation as an invitation to deceit. And the truth of the cursive flow of automatist writing or drawing derives precisely from the fact that this activity is less a representation of something than it is a manifestation or recording: like the lines traced on paper by machines that monitor heartbeats. What this cursive web makes present by making visible is a direct connection to buried mines of experience. 'Automatism,' Breton declares, 'leads us in a straight line to this region,' and the region he had in mind is obviously the unconscious.[17] With this directness, automatism makes the unconscious present. Automatism may be writing, but it is not representation. It is immediate to experience, untainted by the distance and exteriority of signs.

But this commitment to automatism and writing as a special modality of presence, and a consequent dislike of representation as a cheat, is not consistent in Breton. As we will see, Breton expressed a great enthusiasm for signs − and thus for representation − since representation is the very core of his definition of Convulsive Beauty, and Convulsive Beauty is another term for the Marvelous: the great talismanic concept at the heart of surrealism itself.

On the level of theory, these contradictions about the priorities of vision and representation, presence and sign, perform what the contradiction between the two poles of surrealist art manifests on the level of form. For the problem of how to forge some kind of stylistically coherent entity out of the apparent opposition between the abstract liquefaction of Miró's art, on the one hand, and the dry realism of Magritte or Dali, on the other, has continued to plague every writer − beginning with Breton himself − who has set out to define surrealist art.[18] Automatism and dream may seem coherent as parallel functions of unconscious activity, but give rise to image types that seem irreconcilably diverse.

It is within this confusion over the nature of surrealist art that the present investigation of surrealist photography should be placed. For to begin that investigation with the claim that surrealist photography is the great unknown, undervalued aspect of surrealist practice, but that nonetheless, it is the *great* production of the movement, is undoubtedly to write a kind of promissory note. Might not this work be the very key to the dilemma of surrealist style, the catalyst for the solution, the magnet that attracts and thereby organizes the particles in the field?

On the surface of things, this would seem a promise impossible to keep. The very same diversity, so troubling to the art historian or critic who tries to think coherence into the contradictory condition of surrealist pictorial production, repeats itself within the corpus of the photographs. The range of stylistic options taken by the photographers is enormous. There are 'straight'

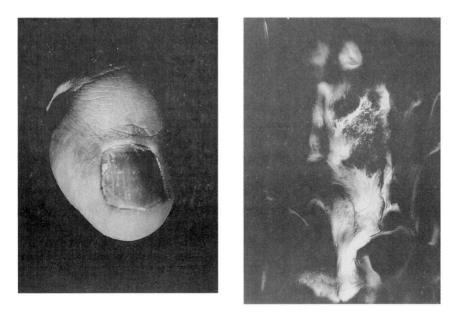

Plate 15 Jacques-André Boiffard, *The Big Toe*, 1929, photograph from Georges Bataille 'Le gros orteil' in *Documents, No 6*, 1929. Centre Pompidou-MNAM-CCI, Paris. Photo: © CNAC/MNAM Dist. RMN.

Plate 16 Raoul Ubac, *Woman/Cloud* (*La Nébuleuse*), 1939. Centre Pompidou-MNAM-CCI, Paris. CNAC/MNAM Dist. RMN © ADAGP, Paris and DACS, London 2003.

images, sharply focused and in close-up, which vary from the contemporaneous production of Neue Sachlichkeit or Bauhaus photography only in the peculiarity of their subjects – like Boiffard's untitled photographs of big toes, [Plate 15] or Dora Maar's *Ubu* (1936), or Man Ray's hands, or Mesens' *As We Understand It (Comme nous l'entendons . . .)* ; – but sometimes, as in the images Brassaï made for *L'Amour fou*, not even in that. There are photographs that are not 'straight' but are the result of combination printing, a darkroom maneuver that produces the irrational space of what could be taken to be the image of dreams. Some of these retain the crispness and definition of any contemporary Magritte or Dali; others, particularly those by Ubac, begin to slide into the fluid, melting condition that we associate more with the pictorial terms elaborated by Masson and Miró [Plate 16]. And there were of course techniques associated directly with automatist procedures and the courting of chance. Thus Ubac speaks of releasing photography from the 'rationalist arrogance' that powered its discovery and identifying it with 'the poetic movement of liberation' through 'a process identical with that of automatism.'[19] Ubac's *brûlages*, photographs in which the image is modified by melting the negative emulsion before printing, are thought to be one example of this;[20] Man Ray's rayographs – cameraless 'photograms' produced

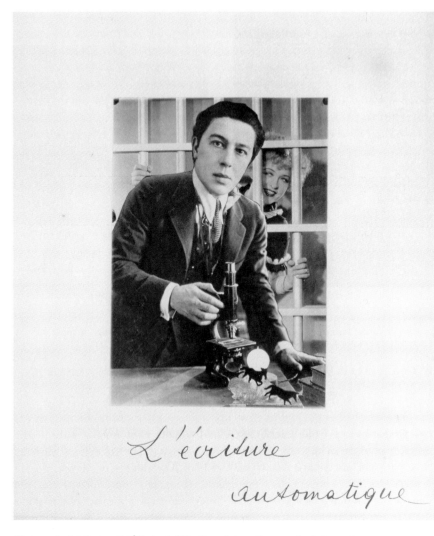

Plate 17 André Breton, *Self-Portrait: L'Ecriture Automatique*, 1938, photomontage, 14.2 x 19 cm.
The Vera, Silvia and Arturo Schwarz Collection of Dada and Surrealist Art at the Israel
Museum, Jerusalem. Photo: Avshalom Avital © ADAGP, Paris and DACS, London 2003.

by placing objects directly on photographic paper, which is then exposed to
light – can be seen as another. As Man Ray himself said by 'recalling the
event more or less clearly, like the undisturbed ashes of an object consumed
by flames,' the rayographs seemed like those precipitates from the uncon-
scious on which automatist poetic practice was founded.[21] The technical diver-
sity of photographic surrealism does not end here. We must add solarization,
negative printing, *cliché verre*, multiple exposure, photomontage, and photo
collage, noting that within each of these technical categories there is the pos-

sibility of the same stylistic bifurcation (linear/painterly or representational/ abstract) that surrealist painting exhibits.

Nowhere does this internal contradiction seem more immediately available than in the photo collage that André Breton made as a self-portrait, a work called *L'Écriture automatique* [Plate 17]. For here in a single work is enshrined the very split for which these stylistic terms are the surrogates: vision/writing. Breton portrays himself with a microscope, an optical instrument invented to expand normal eyesight, to extend its powers in ways not unlike those associated with the camera itself. He is shown, that is to say, as the surrealist seer, armed with vision. But this condition of vision produces images, and these images are understood as a textual product, hence the title *Automatic Writing*.

There is, however, one important factor that must be added to any consideration of Breton's *Automatic Writing* before concluding that its contradictions are irreconcilable. It is a factor that allows one to think, as Breton seems to have been doing here, about the relationship between photography and writing. Normally we consider writing as absolutely banned from the photographic field, exiled by the very nature of the image – the 'message without a code' – to an external location where language functions as the necessary interpreter of the muteness of the photographic sign.[22] This place is the caption, the very necessity of which produced the despair that Brecht, for example, felt about photography. Walter Benjamin cites this hostility to the 'straight' photograph when he quotes Brecht's objection to the camera image: 'A photograph of the Krupp works or GEC yields almost nothing about these institutions. . . . Therefore something has actively to be *constructed*, something artificial, something set-up.'[23] Throughout the avant-garde of the 1920s and 1930s that something, that *constructed* photograph, was the photomontage, about which it could be claimed that it 'expresses not simply the fact which it shows, but also the social tendency expressed by the fact.'[24] And this notion of the montage's insistence upon meaning, on a sense of reality bearing its own interpretation, was articulated by Aragon's reception of the work of the revolutionary artist John Heartfield: 'As he was playing with the fire of appearance, reality took fire around him. . . . The scraps of photographs that he formerly manoeuvred for the pleasure of stupefaction, under his fingers begin to *signify.*' The possibility of signification that Aragon saw in Heartfield seems to have been understood as a function of the agglomerative, constructed medium of photo collage. Referring in another context to the separate collage elements of Ernst's montages, Aragon compared them to 'words.'[25]

In what sense, we might ask, could the very act of collage/montage be thought of as textual – as it seems to have been so thought by these writers? And is this a logic that can resolve what is contradictory in *L'Écriture automatique?*

Objects metamorphosed before my very eyes; they did not assume an allegorical stance or the personality of symbols; they seemed less the outgrowths of an idea than the idea itself.

– Louis Aragon[26]

If these works were able to 'signify,' to articulate reality through a kind of language, this was a function of the cellular structure that montage exploits, with its emphatic gaps between one shard of reality and another, gaps that in the montages from the early 1920s by the dadaists Hannah Höch or Raoul Hausmann left rivers of white paper to flow around the individual photographic units. For this cell construction mimics not the look of words but the formal preconditions of signs: the fact that they require a fundamental exteriority between one another. In language this exteriority manifests itself as syntax, and syntax in turn is both a system of connection between the elements of a language, and a system of separation, of maintaining the difference between one sign and the next, of creating meaning through the syntactical condition of spacing.

By leaving the blanks or gaps or spaces of the page to show, dada montage traded in the powerful resource of photographic realism for the quality that we could call the 'language effect.' Normally, photography is as far as possible from creating such an effect. For photography, with its technical basis in an instantaneous recording of an event, captures what we could call the simultaneity of real space, the fact that space does not present itself to us as successive in nature, like time, but as pure presence, present-all-at-once. By carrying on its continuous surface the trace or imprint of all that vision captures in one glance, photography normally functions as a kind of declaration of the seamlessness of reality itself. It is this seamlessness that dada photo collage disrupts in an attempt to infiltrate reality with interpretation, with signification, with the very writing to which Breton refers in his own collage: *écriture automatique*. It is this seamlessness of the photographic field that is fractured and segmented in Dali's extraordinary collage *The Phenomenon of Ecstasy* (*Le Phénomène de l'extase*) [Plate 18]; as well, and with the similar production of the language effect. For, within the grid that organizes the ecstatic images of women, we find the inclusion of strips of different ears, taken from the catalogue of anatomical parts assembled by master police chief Alphonse Bertillon that stands as the nineteenth-century criminological attempt to use photography to construct the '*portrait parlant*,' or speaking likeness, witness to the last century's expectation that, like other 'mediums,' photography could wrest a message from the muteness of material reality.

If photo collage set up a relationship between photography and 'language,' it did so at the sacrifice of photography's privileged connection to the world. This is why the surrealist photographers, for the most part, shunned the collage technique, seeming to have found in it a too-willing surrender of photography's hold on the real. Darkroom processes like combination printing and double exposure were preferred to scissors and paste. For these techniques could preserve the seamless surface of the final print and thus reenforce the sense that this image, being a photograph, documents the reality from which it is a transfer. But, at the same time, this image, internally riven by the effects

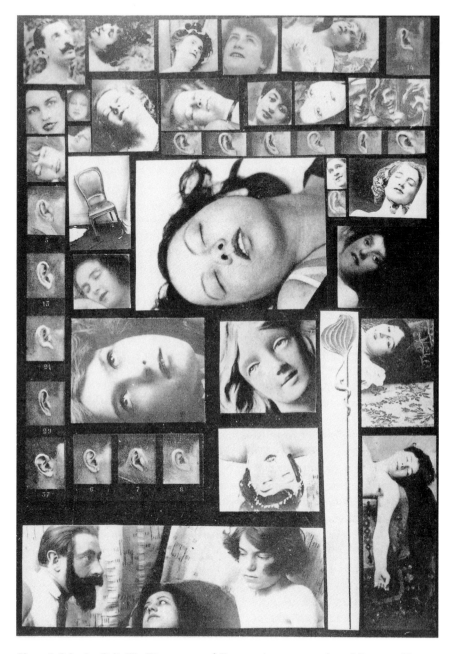

Plate 18 Salvador Dali, *The Phenomenon of Ecstasy*, photomontage from *Minotaure*, Nos. 3–4, 14 December 1933. Courtesy of The British Library, London. BL c.180.d.1. © Salvador Dali, Gala - Salvador Dali Foundations/DACS, London 2003.

of syntax – of spacing – would imply nonetheless that it is reality that has composed itself as a sign.

To convulse reality from within, to demonstrate it as fractured by spacing, became the collective result of all that vast range of techniques to which surrealist photographers resorted and which they understood as producing the characteristics of the sign. For example, solarization – in which photographic paper is briefly exposed to light during the printing process, thereby altering in varying degrees the relationship of dark and light tones, introducing elements of the photographic negative into the positive print – creates a strange effect of *cloisonné*, which visually walls off parts of a single space or a whole body from one another, establishing in this way a kind of testimony to a cloven reality. Negative printing, which produces an entirely negative print, with the momentarily unintelligible gaps that it creates within objects, promotes the same effect. But nothing creates this sense of the linguistic hold on the real more than the photographic strategy of doubling. For it is doubling that produces the formal rhythm of spacing – the two-step that banishes simultaneity. And it is doubling that elicits the notion that to an original has been added its copy. The double is the simulacrum, the second, the representative of the original. It comes after the first, and in this following it can only exist as figure, or image. But in being seen in conjunction with the original, the double destroys the pure singularity of the first. Through duplication, it opens the original to the effect of difference, of deferral, of one-thing-after-another.

This sense of opening reality to deferral is one form of spacing. But doubling does something else besides transmute presence into succession. It also marks the first in the chain as a signifying element – which is to say, doubling transforms raw matter into the conventional shape of the signifier. Linguistics describes this effect of doubling in terms of an infant's progress from babbling to speech. For babbling produces phonemic elements as mere noise as opposed to what happens when one phoneme is doubled by another. *Papa* is a word rather than only a random repetition of the sound *pa* because 'The reduplication indicates intent on the part of the speaker; it endows the second syllable with a function different from that which would have been performed by the first separately, or in the form of a potentially limitless series of identical sounds /papapapa/ produced by mere babbling. Therefore the second /pa/ is not a repetition of the first, nor has it the same signification. It is a sign that, like itself, the first /pa/ too was a sign, and that as a pair they fall into the category of signifiers, not of things signified.'[27]

Repetition is thus the indicator that the wild sounds of babbling have been rendered deliberate, intentional, and that what they intend is meaning. Doubling is in this sense the 'signifier of signification.'

Within surrealist photography, doubling also functions as the signifier of signification. It is this semiological, rather than stylistic, condition that unites the vast array of the movement's photographic production. As we observe the

Plate 19 Hans Bellmer,
Doll, 1936/49, silverprint
coloured with aniline, 41
x 32.9 cm. Centre
Pompidou-MNAM-CCI,
Paris. © Photo:
CNAC/MNAM Dist.
RMN. © ADAGP, Paris
and DACS, London 2003.

various technical options explored by surrealist photography, moving from unmanipulated straight photography, to negative printing, to solarization, to montage, to rayography, there is the constant preoccupation with doubling. We come to realize that this is not only a thematic concern, it is a structural one. For the structure of the double produces the mark of the sign.

We find this within Hans Bellmer's *Dolls* (*Poupées*, 1936), where the mechanically duplicated parts of a doll's anatomy allow for a doubling of these doubles and the doll herself can be composed of identical pairs of legs mirroring each other [Plate 19]. This can happen within the very construction of the doll, or from the doll's momentary arrangement for a given photo session, or through paired prints of near-twin images. All of these are rendered through techniques of documentary photography in which manipulation is studiously avoided. But at other points in Bellmer's production, the doubling can manifest itself technically within the image, as in the double exposures that multiply the multiples. Double exposure functions in Man Ray's work to produce, for example, the famous doubling of the eyes of the *Marquise Cassati*. That photographs, multiple by nature, can themselves be doubled makes further doubling available, as in the stacking of images. Man Ray's collage of doubled breasts in the opening number of *La Révolution surréaliste* (1924) serves as one example, or, again, Frederick Sommer's similarly doubled landscapes reproduced in the American surrealist journal *VVV* (1944), or Man Ray's doubles in rayographic form, as the mass-produced, multiple object of the phonograph record (manufactured of translucent plastic in the days when this work was made) is paired and thereby twinned. The *Distortions*, which

Plate 20 Man Ray, *Slipper-spoon*, 1934, photograph. Courtesy of Telimage –
2003. © Man Ray Trust, ADAGP, Paris and DACS, London 2003.

André Kertész made in 1933, exploit the doubling of the mirror to create a
series dedicated to this effect.

As we noted before, surrealist photography exploits the very special con-
nection to reality with which all photography is endowed. Photography is an
imprint or transfer of the real: it is a photochemically processed trace causal-
ly connected to that thing in the world to which it refers in a way parallel to
that of fingerprints or footprints or the rings of water that cold glasses leave
on tables. The photograph is thus genetically distinct from painting or sculp-
ture or drawing. On the family tree of images it is closer to palm prints, death
masks, cast shadows, the Shroud of Turin, or the tracks of gulls on beaches.
Technically and semiologically speaking, drawing and paintings are icons,
while photographs are indexes.[28]

Given photography's special status with regard to the real – that is, being a
kind of deposit of the real itself – the manipulations wrought by the surrealist
photographers, the spacings and doublings, are intended to register the spacings
and doublings of *that* very reality of which *this* photograph is merely the faith-
ful trace. In this way the photographic medium is exploited to produce a para-
dox: the paradox of reality constituted as a sign – or presence transformed into
absence, into representation, into spacing, into writing. In this semiological
move surrealist photography parallels a similar move of Breton's. For Breton,
though he promoted as surrealist a vast heterogeneity of pictorial styles, devised
a definition of beauty that is rather more unified and that is itself translatable
into semiological terms. Beauty, he said, should be convulsive.

In explaining the nature of that convulsion in the text that serves as prologue
to *L'Amour fou*, Breton spells out the process of reality contorting or convulsing
itself into its apparent opposite, namely, a sign.[29] Reality, which is present,
becomes a sign for what is absent, so that the world itself, rendered beautiful, is
understood as a 'forest of signs.' In defining what he means by this '*indice*,' this

sign, Breton begins to sketch a theory not of painting, but of photography.

Each of Breton's aspects or moments of convulsive beauty are ways of describing the action of signs. The first — '*érotique-voilée*' — invokes the occurrence in nature of representation, as one animal imitates another or as inorganic matter shapes itself to look like statuary. The second, termed '*explosante-fixe*,' is related to the 'expiration of movement,' which is to say the experience of something that should be in motion but has been, for some reason, stopped, derailed, or as Duchamp would have said, 'delayed.' In this regard Breton writes, 'I am sorry not to be able to reproduce, among the illustrations to this text, a photograph of a very handsome locomotive after it had been abandoned for many years to the delirium of a virgin forest.'[30] The convulsiveness, then, the arousal in front of the object is not to it perceived within the continuum of its natural existence, but detached from that flow by means of an expiration of motion, a detachment that deprives the locomotive of some part of its physical self and turns it into a sign of the reality it no longer possesses.

Breton's third example of convulsive beauty — '*magique-circonstancielle*' — consists of the found object or found verbal fragment, both instances of objective chance, where (specifically in the case of the found object) an emissary from the external world carries a message informing the recipient of his own desire. The found object is a *sign* of that desire. Breton recognized this kind of convulsive beauty in a slipper spoon he had found in a flea market, an object he recognized as the fulfillment of a wish spoken by the automatic phrase that had begun running through his mind some months before [Plate 20]. The phrase, *cendriller-Cendrillon*, translates as 'Cinderella ashtray.' The flea-market object — a spoon with a little shoe affixed to the underside of its handle — suddenly convulsed itself into a sign when Breton began to see it as a chain of representations in which the 'shoe' was reduplicated to infinity, as though caught in a hall of mirrors. In addition to the little shoe under the handle, he suddenly saw the bowl and handle of the spoon as the front and last of another shoe, of which the little carved slipper was only the heel. Then he imagined *that* slipper as having for its heel yet another slipper and so on to infinity. This chain of reduplicated and mirrored slippers Breton read as a kind of natural writing, a set of '*indices*' that signified his own desire for love and the beginning of a quest whose magical unfolding is plotted throughout *L'Amour fou*.

If we are to generalize the aesthetic of surrealism, the concept of convulsive beauty is at the core of its aesthetic, a concept that reduces to an experience of reality transformed into representation. Surreality *is*, we could say, nature convulsed into a kind of writing. The special access that photography, as a medium, has to this experience is photography's privileged connection to the real. The manipulations then available to photography — what we have been calling doubling and spacing as well as a technique of representational

reduplication, or structure *en abyme* − appear to document these convulsions. The photographs are not *interpretations* of reality, decoding it as in the phogomontage practice of Heartfield or Hausmann. Instead, they are presentations of that very reality as configured or coded or written.

The experience of nature as sign or representation comes naturally, then, to photography. This experience extends as well to the domain that is most inherently photographic: the framing edge of the image experienced as cut or cropped. This is possible even when the image does not seem folded from within by means of the reduplicative strategy of doubling, when the image is entirely unmanipulated, like the Boiffard big toes, or the *Involuntary Sculptures* by Brassaï, or the image of a hatted figure by Man Ray published in *Minotaure*.[31] For, at the very boundary of the image, the camera frame, which essentially crops or cuts the represented element out of reality at large, can be seen as another example of spacing.

Spacing, like the doubled phonemes of *papa*, is the signifier of signification, the indication of a break in the simultaneous experience of the real, a rupture that issues into sequence. Photographic cropping is always experienced as a rupture in the continuous fabric of reality. But surrealist photography puts enormous pressure on that frame to make it itself read as a sign − an empty sign, it is true, but an integer in the calculus of meaning nonetheless, a signifier of signification. The frame announces that, between the part of reality cut away and this part, there is a difference; and that this segment, which the frame frames, is an example of nature-as-representation or nature-as-sign. Even as it announces this experience of reality, the camera frame, of course, controls it, configures it.[32] This it does by point of view, as in the Man Ray, or focal length, as in the extreme close-ups of Brassaï. But in both these instances what the camera frames, and thereby makes visible, is the automatic writing of the world: the constant, uninterrupted production of signs. Brassaï's images are of those nasty pieces of paper, like bus tickets and theater-ticket stubs that we roll into little columns in our pockets or those pieces of eraser that we unconsciously knead − these are what his camera produces through the enlargements that he published as involuntary sculptures. Man Ray's photograph is one of several made to accompany an essay by dada's founding spirit, Tristan Tzara, about the constant unconscious production of sexual imagery throughout culture − here, in the design of hats.

The frame announces the camera's ability to find and isolate what we could call the world's constant production of erotic symbols, its ceaseless automatic writing. In this capacity the frame can itself be glorified, noticed, represented, as in the Man Ray monument to the Marquis de Sade. Or it can be there silently, operating as spacing, as in Brassaï's seizure of automatic production through his images of sculptural onanism or his captured grafitti.

In cutting into the body of the world, stopping it, framing it, spacing it,

photography reveals that world as written. Surrealist vision and photographic vision cohere around these principles. For in the *explosante-fixe* we discover the stop-motion of the still photograph; in the *érotique-voilé* we see its framing; and in the *magique-circonstancielle* we find the message of its spacing. Breton has thus provided us all the aesthetic theory we will ever need to understand that, for surrealist photography, too, 'beauty will be convulsive or it will not be.'

1 André Breton, *Manifestos of Surrealism*, trans. Richard Seaver and Helen R. Lane (Ann Arbor: The University of Michigan Press, 1969), p. 12.

2 André Breton, 'Le Surréalisme et la peinture,' *La Révolution surréaliste*, no. 4 (July 1925), p. 28. The complete series of essays was collected in Breton, *Surrealism and Painting*, trans. Simon Watson Taylor (New York: Harper & Row, 1972). Further references are to this translation.

3 Breton, *Manifestos*, p. 7.

4 André Breton, *Nadja*, trans. Richard Howard (New York: Grove Press, 1960), p. 152. In the preface to the 1963 French edition (Gallimard), Breton speaks of the photographs in relation to one of the 'antiliterary' principles that guided the creation of the book. 'The abundant photographic illustration,' he writes, 'had as its objective the elimination of all description – what had been chided as inane in the *Surrealist Manifesto* – and the tone that the narrative adopted was modeled on that of medical observation . . .' See Michel Beaujour. 'Qu'est-ce que "Nadja"?' *La Nouvelle Revue Française*, no. 172 (April 1, 1967), pp. 780–99, for an analysis of *Nadja*'s condition as a 'text' that is open to additions from what would normally be viewed as *hors-texte* and the role the photographs play in this regard.

5 This question had begun, 'The photographic print . . . is permeated with an emotive value that makes it a supremely precious article of exchange' (*Surrealism and Painting*, p. 32).

6 André Breton, 'La Beauté sera convulsive. . . .' *Minotaure*, no. 5 (1934), pp. 9–16. Walter Benjamin. 'Surrealism: The Last Snapshot of the European Intelligentsia,' in *Reflections*, trans. Edmund Jephcott (New York: Harcourt Brace Jovanovich, 1978), p. 183. See Rosalind Krauss, 'Nightwalkers,' *Art Journal* 45 (Spring 1981): 33–8.

7 Breton, *Manifestos*, p. 16.

8 Ibid., p. 27.

9 Besides the famous 'dictionary' definition of surrealism ('*n.* Psychic automatism in its pure state . . .'). Breton's first *Surrealist Manifesto* includes an 'encyclopedia' entry in which the performers of acts of 'absolute surrealism' are listed: Aragon, Baron, Boiffard, Breton, Carrive, Crevel, Delteil, Desnos, Eluard, Gérard, Limbour, Malkine, Morise, Naville, Noll, Péret, Picon, Soupault, Vitrac.

10 Pierre Naville, 'Beaux-Arts.' *La Révolution surréaliste*, no. 3 (April 1925), p. 27.

11 As told to the author in conversation, May 20, 1983. Naville also said that it was he who devised the three-pronged photo collage of the members at the Centrale for the cover of the first issue of *La Révolution surréaliste*. See his account in Pierre Naville, *Le Temps du surréal* (Paris: Galilée, 1977), pp. 99–110.

12 Naville, 'Beaux-Arts,' p. 27.

13 The quotations in this and the next paragraph are from Breton, *Surrealism and Painting*, pp. 68, 70.

14 André Breton, 'Océanie,' (1948), reprinted in Breton, *La Clé des champs* (Paris: Sagittaire, 1953; 1973 edition), p. 278.

15 Breton here reenacts the polarization between speech and writing, presence and representation, that Derrida analyzes as the oppositions that structure Western metaphysics. See Jacques Derrida, *Of Grammatology*, trans. G.C. Spivak (Baltimore: Johns Hopkins University Press, 1976). The concept of spacing developed there (pp. 65–73) and in 'Freud and the Scene of Writing' (in Jacques Derrida, *Writing and Difference*, trans. Alan Bass [Chicago: University of Chicago Press, 1978]) is important for the discussion that follows.

16 Thus Breton insists that 'any form of expression in which automatism does not at least advance undercover runs a grave risk of moving out of the surrealist orbit' (*Surrealism and Painting*, p. 68).

17 Ibid., p. 70.

18 William Rubin attempts to construct an '*intrinsic definition of Surrealist painting*' in his essay 'Toward a Critical Framework,' *Artforum* 5 (September 1966): 35. But because he reproduces the same bipolar or bivalent conceptual structure that Breton had established in 1925, his definition mir-

rors the problems of Breton's as well.

19 See Gamille Bryen and Raoul Michelet, *Actuation poétique* (1935; reprinted in Marcel Marien, *L'Activitié surréaliste en Belgique* [Brussels: Lebeer-Hossmann, 1979], pp. 269–70).

20 Ubac describes the procedure of *brûlage*, also called *soufflage*, as a system of placing the glass plate of an exposed negative over a heated pan of water in order to melt the emulsion: 'It was thus an automatism of destruction, a complete dissolution of the image towards an absolute formlessness. I treated a large number of my negatives in this manner – the result being for the most part disappointing, except in one case where a woman in a bathing suit was transformed into a thunderstruck Goddess – a photo titled "La Nébuleuse."' (In an unpublished letter to Yves Gevaert from Raoul Ubac, dated Dieudonné, 21 March, 1981.) . . .

21 Man Ray, *Exhibition Rayographs 1921–1928* (Stuttgart: L. G. A., 1963).

22 'Message without a code' is Barthes's term in his essays 'The Photographic Message' and 'Rhetoric of the Image.' See Roland Barthes, *Image, Music, Text*, trans. Stephen Heath (New York: Hill and Wang, 1977).

23 In Walter Benjamin, 'A Short History of Photography,' trans. Stanley Mitchell. *Screen 13* (Spring 1972): 24.

24 John Heartfield, *Photomontages of the Nazi Period* (New York: Universe Books, 1977), p. 26.

25 Louis Aragon, 'John Heartfield et la beauté révolutionnaire' (1935), reprinted in Aragon, *Les Collages* (Paris: Hermann, 1965), pp. 78–79.

26 *Nightwalker* (*Le Paysan de Paris*), trans. Frederick Brown (Englewood Cliffs, New Jersey: Prentice-Hall, 1970), p. 94.

27 Claude Lévi-Strauss, *The Raw and the Cooked*, trans. J. and D. Weightman (New York: Harper & Row, 1970), pp. 339–40.

28 Photography's position as an index was first established by C. S. Peirce within the taxonomy of signs that he developed in 'Logic as Semiotic: The Theory of Signs,' C.S. Peirce, *Philosophical Writings of Peirce*, ed. Justus Buchler (New York: Dover, 1955).

29 The text 'La beauté sera convulsive' (pp. cit.) became the first chapter of *L'Amour fou*. See André Breton, *L'Amour fou* (Paris: Gallimard, 1937), pp. 7–19.

30 Ibid., p. 13.

31 Boiffard's big toes accompanied the text by Georges Bataille, 'Le Gros Orteil,' *Documents*, no. 6 (1929); Brassaï's *Sculptures 1 Involuntaires* appeared in *Minotaure*, nos. 3–4 (1933), p. 68; Man Ray's photographs of hats illustrated Tristan Tzara's 'D'un Certain Automatisme du gout,' *Minotaure*, nos. 3–4 (1933), pp. 81–84.

32 Derrida analyzes the frame as 'an outside which is called inside the inside to constitute it as inside.' See Jacques Derrida, 'The Parergon,' trans. Craig Owens, *October*, no. 9 (Summer 1979).

4. John Szarkowski, from *The Photographer's Eye*

John Szarkowski worked as a photographer before becoming the curator of photographs at the Museum of Modern Art, New York in 1962, a post that he held until his retirement in 1991. Through a series of highly influential exhibitions and accompanying catalogues he elaborated a modernist account of photography that drew heavily on the idea of vernacular form. This text was originally written as a catalogue essay for the exhibition *The Photographer's Eye* held in 1969 at the Museum of Modern Art. It represents a key statement of Szarkowski's approach and clearly lays out the five elements that he held to be central to photography conceived as an art. The following extracts are taken from John Szarkowski, *The Photographer's Eye*, Museum of Modern Art, New York, 1969, unpaginated. [SE]

Introduction

This book is an investigation of what photographs look like, and of why they look that way. It is concerned with photographic style and with photographic tradition: with the sense of possibilities that a photographer today takes to his work.

The invention of photography provided a radically new picture-making process – a process based not on synthesis but on selection. The difference was a basic one. Paintings were *made* – constructed from a storehouse of traditional schemes and skills and attitudes – but photographs, as the man on the street put it, were *taken*.

The difference raised a creative issue of a new order: how could this mechanical and mindless process be made to produce pictures meaningful in human terms – pictures with clarity and coherence and a point of view? It was soon demonstrated that an answer would not be found by those who loved too much the old forms, for in large part the photographer was bereft of the old artistic traditions. Speaking of photography Baudelaire said: 'This industry, by invading the territories of art, has become art's most mortal enemy.'[1] And in his own terms of reference Baudelaire was half right; certainly the new medium could not satisfy old standards. The photographer must find new ways to make his meaning clear.

These new ways might be found by men who could abandon their allegiance to traditional pictorial standards – or by the artistically ignorant, who had no old allegiances to break. There have been many of the latter sort. Since its earliest days, photography has been practiced by thousands who shared no common tradition or training, who were disciplined and united by no academy or guild, who considered their medium variously as a science, an art, a trade, or an entertainment, and who were often unaware of each other's work. Those who invented photography were scientists and painters, but its professional practitioners were a very different lot. [. . .]

The enormous popularity of the new medium produced professionals by the thousands – converted silversmiths, tinkers, druggists, blacksmiths and printers. If photography was a new artistic problem, such men had the advantage of having nothing to unlearn. Among them they produced a flood of images. In 1853 the *New-York Daily Tribune* estimated that three million daguerreotypes were being produced that year.[2] Some of these pictures were the product of knowledge and skill and sensibility and invention; many were the product of accident, improvisation, misunderstanding, and empirical experiment. But whether produced by art or by luck, each picture was part of a massive assault on our traditional habits of seeing.

By the latter decades of the nineteenth century the professionals and the serious amateurs were joined by an even larger host of casual snap-shooters. By the early eighties the dry plate, which could be purchased ready-to-use, had replaced the refractory and messy wet plate process, which demanded that the

plate be prepared just before exposure and processed before its emulsion had dried. The dry plate spawned the hand camera and the snapshot. Photography had become easy. In 1893 an English writer complained that the new situation had 'created an army of photographers who run rampant over the globe, photographing objects of all sorts, sizes and shapes, under almost every condition, without ever pausing to ask themselves, is this or that artistic? . . . They spy a view, it seems to please, the camera is focused, the shot taken! There is no pause, why should there be? For art may err but nature cannot miss, says the poet, and they listen to the dictum. To them, composition, light, shade, form and texture are so many catch phrases. . . .'5

These pictures, taken by the thousands by journeyman worker and Sunday hobbyist, were unlike any pictures before them. The variety of their imagery was prodigious. Each subtle variation in viewpoint or light, each passing moment, each change in the tonality of the print, created a new picture. The trained artist could draw a head or a hand from a dozen perspectives. The photographer discovered that the gestures of a hand were infinitely various, and that the wall of a building in the sun was never twice the same.

Most of this deluge of pictures seemed formless and accidental, but some achieved coherence, even in their strangeness. Some of the new images were memorable, and seemed significant beyond their limited intention. These remembered pictures enlarged one's sense of possibilities as he looked again at the real world. While they were remembered they survived, like organisms, to reproduce and evolve.

But it was not only the way that photography described things that was new; it was also the things it chose to describe. Photographers shot '. . . objects of all sorts, sizes and shapes . . . without ever pausing to ask themselves, is this or that artistic?' Painting was difficult, expensive, and precious, and it recorded what was known to be important. Photography was easy, cheap and ubiquitous, and it recorded anything: shop windows and sod houses and family pets and steam engines and unimportant people. And once made objective and permanent, immortalized in a picture, these trivial things took on importance. By the end of the century, for the first time in history, even the poor man knew what his ancestors had looked like.

The photographer learned in two ways: first, from a worker's intimate understanding of his tools and materials (if his plate would not record the clouds, he could point his camera down and eliminate the sky); and second he learned from other photographs, which presented themselves in an unending stream. Whether his concern was commercial or artistic, his tradition was formed by all the photographs that had impressed themselves upon his consciousness. [. . .]

[I]t should be possible to consider the history of the medium in terms of photographers' progressive awareness of characteristics and problems that have seemed inherent in the medium. Five such issues are considered below.

These issues *do not* define discrete categories of work; on the contrary they should be regarded as interdependent aspects of a single problem – as section views through the body of photographic tradition. As such, it is hoped that they may contribute to the formulation of a vocabulary and a critical perspective more fully responsive to the unique phenomena of photography.

The Thing Itself

The first thing that the photographer learned was that photography dealt with the actual; he had not only to accept this fact, but to treasure it; unless he did, photography would defeat him. He learned that the world itself is an artist of incomparable inventiveness, and that to recognize its best works and moments, to anticipate them, to clarify them and make them permanent, requires intelligence both acute and supple.

But he learned also that the factuality of his pictures, no matter how convincing and unarguable, was a different thing than the reality itself. Much of the reality was filtered out in the static little black and white image, and some of it was exhibited with an unnatural clarity, an exaggerated importance. The subject and the picture were not the same thing, although they would afterwards seem so. It was the photographer's problem to see not simply the reality before him but the still invisible picture, and to make his choices in terms of the latter.

This was an artistic problem, not a scientific one, but the public believed that the photograph could not lie, and it was easier for the photographer if he believed it too, or pretended to. Thus he was likely to claim that what our eyes saw was an illusion, and what the camera saw was the truth. [. . .] William M. Ivins, Jr. said 'at any given moment the accepted report of an event is of greater importance than the event, for what we think about and act upon is the symbolic report and not the concrete event itself.'4 He also said: 'The nineteenth century began by believing that what was reasonable was true and it would end up by believing that what it saw a photograph of was true.'5

The Detail

The photographer was tied to the facts of things, and it was his problem to force the facts to tell the truth. He could not, outside the studio, pose the truth; he could only record it as he found it, and it was found in nature in a fragmented and unexplained form – not as a story, but as scattered and suggestive clues. The photographer could not assemble these clues into a coherent narrative, he could only isolate the fragment, document it, and by so doing claim for it some special significance, a meaning which went beyond simple descrip-

tion. The compelling clarity with which a photograph recorded the trivial suggested that the subject had never before been properly seen, that it was in fact perhaps *not* trivial, but filled with undiscovered meaning. If photographs could not be read as stories, they could be read as symbols.

The decline of narrative painting in the past century has been ascribed in large part to the rise of photography, which 'relieved' the painter of the necessity of story telling. This is curious, since photography has never been successful at narrative. It has in fact seldom attempted it. The elaborate nineteenth century montages of Robinson and Rejlander, laboriously pieced together from several posed negatives, attempted to tell stories, but these works were recognized in their own time as pretentious failures. In the early days of the picture magazines the attempt was made to achieve narrative through photographic sequences, but the superficial coherence of these stories was generally achieved at the expense of photographic discovery. The heroic documentation of the American Civil War by the Brady group, and the incomparably larger photographic record of the Second World War, have this in common: neither explained, without extensive captioning, what was happening. The function of these pictures was not to make the story clear, it was to make it *real*. The great war photographer Robert Capa expressed both the narrative poverty and the symbolic power of photography when he said, 'If your pictures aren't good, you're not close enough.'

The Frame

Since the photographer's picture was not conceived but selected, his subject was never truly discrete, never wholly self-contained. The edges of his film demarcated what he thought most important, but the subject he had shot was something else; it had extended in four directions. If the photographer's frame surrounded two figures, isolating them from the crowd in which they stood, it created a relationship between those two figures that had not existed before.

The central act of photography, the act of choosing and eliminating, forces a concentration on the picture edge – the line that separates in from out – and on the shapes that are created by it.

During the first half-century of photography's lifetime, photographs were printed the same size as the exposed plate. Since enlarging was generally impractical, the photographer could not change his mind in the darkroom, and decide to use only a fragment of his picture, without reducing its size accordingly. If he had purchased an eight by ten inch plate (or worse, prepared it), had carried it as part of his back-bending load, and had processed it, he was not likely to settle for a picture half that size. A sense of simple economy was enough to make the photographer try to fill the picture to its edges.

The edges of the picture were seldom neat. Parts of figures or buildings or

features of landscape were truncated, leaving a shape belonging not to the subject, but (if the picture was good one) to the balance, the propriety, of the image. The photographer looked at the world as though it was a scroll painting, unrolled from hand to hand, exhibiting an infinite number of croppings – of compositions – as the frame moved onwards.

The sense of the picture's edge as a cropping device is one of the qualities of form that most interested the inventive painters of the later nineteenth century. To what degree this awareness came from photography, and to what degree from oriental art, is still open to study. However, it is possible that the prevalence of the photographic image helped prepare the ground for an appreciation of the Japanese print, and also that the compositional attitudes of these prints owed much to habits of seeing which stemmed from the scroll tradition.

Time

There is in fact no such thing as an instantaneous photograph. All photographs are time exposures, of shorter or longer duration, and each describes a discrete parcel of time. This time is always the present. Uniquely in the history of pictures, a photograph describes only that period of time in which it was made. Photography alludes to the past and the future only in so far as they exist in the present, the past through its surviving relics, the future through prophecy visible in the present.

In the days of slow films and slow lenses, photographs described a time segment of several seconds or more. If the subject moved, images resulted that had never been seen before: dogs with two heads and a sheaf of tails, faces without features, transparent men, spreading their diluted substance half across the plate. The fact that these pictures were considered (at best) as partial failures is less interesting than the fact that they were produced in quantity; they were familiar to all photographers, and to all customers who had posed with squirming babies for family portraits. [. . .]

As photographic materials were made more sensitive, and lenses and shutters faster, photography turned to the exploration of rapidly moving subjects. Just as the eye is incapable of registering the single frames of a motion picture projected on the screen at the rate of twenty-four per second, so is it incapable of following the positions of a rapidly moving subject in life. The galloping horse is the classic example. As lovingly drawn countless thousands of times by Greeks and Egyptians and Persians and Chinese, and down through all the battle scenes and sporting prints of Christendom, the horse ran with four feet extended, like a fugitive from a carousel. Not till Muybridge successfully photographed a galloping horse in 1878 was the convention broken. It was this way also with the flight of birds, the play of muscles on an athlete's back, the drape of a pedestrian's clothing, and the fugitive expressions of a human face.

Immobilizing these thin slices of time has been a source of continuing fascination for the photographer. And while pursuing this experiment he discovered something else: he discovered that there was a pleasure and a beauty in this fragmenting of time that had little to do with what was happening. It had to do rather with seeing the momentary patterning of lines and shapes that had been previously concealed within the flux of movement. Cartier-Bresson defined his commitment to this new beauty with the phrase *The decisive moment*, but the phrase has been misunderstood; the thing that happens at the decisive moment is not a dramatic climax but a visual one. The result is not a story but a picture.

Vantage Point

Much has been said about the clarity of photography, but little has been said about its obscurity. And yet it is photography that has taught us to see from the unexpected vantage point, and has shown us pictures that give the sense of the scene, while withholding its narrative meaning. Photographers from necessity choose from the options available to them, and often this means pictures from the other side of the proscenium, showing the actors' backs, pictures from the bird's view, or the worm's, or pictures in which the subject is distorted by extreme foreshortening, or by none, or by an unfamiliar pattern of light, or by a seeming ambiguity of action or gesture.

Ivins wrote with rare perception of the effect that such pictures had on nineteenth-century eyes: 'At first the public had talked a great deal about what it called photographic distortion. . . . [But] it was not long before men began to think photographically, and thus to see for themselves things that it had previously taken the photograph to reveal to their astonished and protesting eyes. Just as nature had once imitated art, so now it began to imitate the picture made by the camera.'[6] [. . .]

The influence of photography on modern painters (and on modern writers) has been great and inestimable. It is, strangely, easier to forget that photography has also influenced photographers. Not only great pictures by great photographers, but *photography* – the great undifferentiated, homogeneous whole of it – has been teacher, library, and laboratory for those who have consciously used the camera as artists. An artist is a man who seeks new structures in which to order and simplify his sense of the reality of life. For the artist photographer, much of his sense of reality (where his picture starts) and much of his sense of craft or structure (where his picture is completed) are anonymous and untraceable gifts from photography itself.

The history of photography has been less a journey than a growth. Its movement has not been linear and consecutive, but centrifugal. Photography, and our understanding of it, has spread from a center; it has, by infusion, pen-

etrated our consciousness. Like an organism, photography was born whole. It is in our progressive discovery of it that its history lies.

1 Charles Baudelaire, 'Salon de 1859,' translated by Jonathan Mayne for *The Mirror of Art, Critical Studies by Charles Baudelaire*. London: Phaidon Press, 1955. (Quoted from *On Photography, A Source Book of Photo History in Facsimile*, edited by Beaumont Newhall. Watkins Glen, N.Y.: Century House, 1956, p. 106.)

2 A.C. Willers, 'Poet and Photography,' in *Picturescope*, Vol. XI, No. 4. New York: Picture Division, Special Libraries Association, 1963, p. 46.

3 E.E. Gohen, 'Bad Form in Photography,' in *The International Annual of Anthony's Photographic Bulletin*. New York and London: E. and H.T. Anthony, 1893, p. 18.

4 William M. Ivins, Jr., *Prints and Visual Communication*. Cambridge, Mass.: Harvard University Press, 1953, p. 180.

5 Ibid., p. 94.

6 Ibid., p. 138.

5. Allan Sekula, 'Dismantling Modernism, Reinventing Documentary (Notes on the Politics of Representation)'

Allan Sekula is both a photographer and a theorist of photography. This essay of 1976–8, which had a considerable impact in both academic and art/photography circles, can be seen as a kind of manifesto for a group of artists who, in the mid-1970s, combined photography and social critique. Sekula here rejects both 'formalism' and 'documentary' in photography as it has been traditionally conceived. These theoretical reflections appear as a foreword to a survey of photographic projects by Martha Rosler, Philip Steinmetz, Fred Lonidier, Chaucey Hare and Allan Sekula, and video work by Jon Jost and Bruce Conner. The following extract includes the material on documentary and Sekula's discussion of Rosler's *The Bowery in Two Inadequate Descriptive Systems*. It is taken from Allan Sekula, *Photography Against the Grain: Essays and Photo Works 1973–1983*, The Press of Nova Scotia College of Art and Design, Halifax NS, 1984, pp. 56–62. [SE]

A small group of contemporary artists are working on an art that deals with the social ordering of people's lives. Most of their work involves still photography and video; most relies heavily on written or spoken language. I am talking about a representational art, an art that refers to something beyond itself. Form and mannerism are not ends in themselves. These works might be about any number of things, ranging from the material and ideological space of the 'self' to the dominant social realities of corporate spectacle and corporate power. The initial questions are these: 'How do we invent our lives out of a limited range of possibilities, and how are our lives invented for us by those in power?' As I have already suggested, if these questions are asked only within the institu-

tional boundaries of elite culture, only within the 'art world,' then the answers will be merely academic. Given a certain poverty of means, this art aims toward a wider audience, and toward considerations of concrete social transformation.

We might be tempted to think of this work as a variety of documentary. That is all right as long as we expose the myth that accompanies the label, the folklore of photographic truth. This preliminary detour seems necessary. The rhetorical strength of documentary is imagined to reside in the unequivocal character of the camera's evidence, in an essential realism. The theory of photographic realism emerges historically as both product and handmaiden of positivism. Vision, itself unimplicated in the world it encounters, is subjected to a mechanical idealization. Paradoxically, the camera serves to ideologically *naturalize* the eye of the observer. Photography, according to this belief, reproduces the visible world: the camera is an engine of fact, the generator of a duplicate world of fetishized appearances, independent of human practice. Photographs, always the product of socially-specific *encounters* between human-and-human or human-and-nature, become repositories of dead facts, reified objects torn from their social origins.

I should not have to argue that photographic meaning is relatively indeterminate; the same picture can convey a variety of messages under differing presentational circumstances. Consider the evidence offered by bank holdup cameras. Taken automatically, these pictures could be said to be unpolluted by sensibility, an extreme form of documentary. If the surveillance engineers who developed these cameras have an esthetic, it is one of raw, technological instrumentality. 'Just the facts, ma'am.' But a courtroom is a battleground of fictions. What is it that a photograph points to? A young white woman holds a submachine gun. The gun is handled confidently, aggressively. The gun is almost dropped out of fear. A fugitive heiress. A kidnap victim. An urban guerrilla. A willing participant. A case of brainwashing. A case of rebellion. A case of schizophrenia. The outcome, based on the 'true' reading of the evidence, is a function less of 'objectivity' than of political manoeuvering. Reproduced in the mass media, this picture might attest to the omniscience of the state within a glamorized and mystifying spectacle of revolution and counter-revolution. But any police photography that is publicly displayed is both a specific attempt at identification and a reminder of police power over 'criminal elements.' The only 'objective' truth that photographs offer is the assertion that somebody or something – in this case, an automated camera – was somewhere and took a picture. Everything else, everything beyond the imprinting of a trace, is up for grabs.

Walter Benjamin recalled the remark that Eugène Atget depicted the streets of Paris as though they were scenes of crime.[1] That remark serves to poeticize a rather deadpan, non-expressionist style, to conflate nostalgia and the affectless instrumentality of the detective. Crime here becomes a matter of the heart as well as a matter of fact. Looking backward, through Benjamin

to Atget, we see the loss of the past through the continual disruptions of the urban present as a form of violence against memory, resisted by the nostalgic bohemian through acts of solipsistic, passive acquisition. (Baudelaire's 'Le Cygne' articulates much of that sense of loss, a sense of the impending disappearance of the familiar.) I cite this example merely to raise the question of the *affective* character of documentary. Documentary photography has amassed mountains of evidence. And yet, in this pictorial presentation of scientific and legalistic 'fact,' the genre has simultaneously contributed much to spectacle, to retinal excitation, to voyeurism, to terror, envy and nostalgia, and only a little to the critical understanding of the social world.

A truly critical social documentary will frame the crime, the trial, and the system of justice and its official myths. Artists working toward this end may or may not produce images that are theatrical and overtly contrived, they may or may not present texts that read like fiction. Social truth is something other than a matter of convincing style. I need only cite John Heartfield's overtly *constructed* images, images in which the formal device is absolutely naked, as examples of an early attempt to go beyond the phenomenal and ideological surface of the social realm. In his best work, Heartfield brings the economic base to the surface through the simplest of devices, often through punning on a fascist slogan. ('Millions stand behind me.') Here, construction passes into a critical *deconstruction*.

A political critique of the documentary genre is sorely needed. Socially conscious American artists have much to learn from both the successes *and* the mistakes, compromises, and collaborations of their Progressive Era and New Deal predecessors. How do we assess the close historical partnership of documentary artists and social democrats? How do we assess the relation between form *and* politics in the work of the more progressive Worker's Film and Photo League? How do we avoid a kind of estheticized political nostalgia in viewing the work of the 1930s? And how about the co-optation of the documentary style by corporate capitalism (notably the oil companies and the television networks) in the late 1940s? How do we disentangle ourselves from the authoritarian and bureaucratic aspects of the genre, from its implicit positivism? (All of this is evidenced in any one second of an Edward R. Murrow or a Walter Cronkite telecast.) How do we produce an art that elicits dialogue rather than uncritical, pseudo-political affirmation?

Looking backward, at the art-world hubbub about 'photography as a fine art,' we find a near-pathological avoidance of any such questioning. A curious thing happens when documentary is officially recognized as art. Suddenly the hermeneutic pendulum careens from the objectivist end of its arc to the opposite, subjectivist end. Positivism yields to a subjective metaphysics, technologism gives way to auteurism. Suddenly the audience's attention is directed toward mannerism, toward sensibility, toward the physical and emotional risks taken by the artist. Documentary is thought to be art when it transcends

its reference to the world, when the work can be regarded, first and foremost, as an act of self-expression on the part of the artist. To use Roman Jakobson's categories, the referential function collapses into the expressive function.[2] A cult of authorship, an auteurism, takes hold of the image, separating it from the social conditions of its making and elevating it above the multitude of lowly and mundane uses to which photography is commonly put. The culture journalists' myth of Diane Arbus is interesting in this regard. Most readings of her work careen along an axis between opposing poles of realism and expressionism. On the one hand, her portraits are seen as transparent, metonymic vehicles for the social or psychological truth of her subjects; Arbus elicits meaning from her sitters. At the other extreme is a metaphoric projection. The work is thought to express her tragic vision (a vision confirmed by her suicide); each image is nothing so much as a contribution to the artist's self-portrait. These readings coexist, they enhance one another despite their mutual contradiction. I think that a good deal of the generalized esthetic appeal of Arbus' work, along with that of most art photography, has to do with this indeterminacy of reading, this sense of being cast adrift between profound social insight and refined solipsism. At the heart of this fetishistic cultivation and promotion of the artist's humanity is a certain disdain for the 'ordinary' humanity of those who have been photographed. They become the 'other,' exotic creatures, objects of contemplation. Perhaps this would not be so suspect if it were not for the tendency of professional documentary photographers to aim their cameras downward, toward those with little power or prestige. (The obverse is the cult of celebrity, the organized production of envy in a mass audience.) The most intimate, humanscale relationship to suffer mystification in all this is the specific social engagement that results in the image; the negotiation between photographer and subject in the making of a portrait, the seduction, coercion, collaboration, or rip off. But if we widen the angle of our view, we find that the broader institutional politics of elite and 'popular' culture are also being obscured in the romance of the photographer as artist.

The promotion of Diane Arbus (along with a host of other essentially mannerist artists) as a 'documentary' photographer, as well as the generalized promotion of introspective, privatistic, and often narcissistic uses of photographic technology both in the arena of art photography and that of the mass consumer market, can be regarded as a symptom of two countervailing but related tendencies of advanced capitalist society. On the one hand, subjectivity is threatened by the increasingly sophisticated administration of daily life. Culture, sexuality, and family life are refuges for the private, feeling self in a world of rationalized performance-demands. At the same time, the public realm is 'depoliticized,' to use Jurgen Habermas' term; a passive audience of citizen-consumers is led to see political action as the prerogative of celebrities.[3] Consider the fact that the major television networks, led by ABC, no longer even

pretend to honor the hallowed separation demanded by liberal ideology between 'public affairs' and 'entertainment.' News reporting is now *openly*, rather than covertly, stylized. The mass media portray a wholly *spectacular* political realm, and increasingly provide the ground for a charismatically directed, expressionist politics of the Right. Television has never been a realist medium, nor has it been capable of narrative in the sense of a logical, coherent account of cause and effect. But now, television is an openly *symbolist* enterprise, revolving entirely around the metaphoric poetry of the commodity. With the triumph of exchange value over use value, all meanings, all lies, become possible. The commodity exists in a gigantic substitution set, cut loose from its original context, it is metaphorically equivalent to all other commodities.

The high culture of the late capitalist period is subject to the unifying semantic regime of formalism. Formalism neutralizes and renders equivalent, it is a universalizing system of reading. Only formalism can unite all the photographs in the world in one room, mount them behind glass, and *sell* them. As a privileged commodity fetish, as an object of connoisseurship, the photograph achieves its ultimate semantic poverty. But this poverty has haunted photographic practice from the very beginning.

I would like, finally, to discuss some alternative ways of working with photographs. A small number of contemporary photographers have set out deliberately to work against the strategies that have succeeded in making photography a high art. I have already outlined the general political nature of their intentions. Their work begins with the recognition that photography is operative at every level of our culture. That is, they insist on treating photographs not as privileged objects but as common cultural artifacts. The solitary, sparely captioned photograph on the gallery wall is a sign, above all, of an aspiration toward the esthetic and market conditions of modernist painting and sculpture. In this white void, meaning is thought to emerge entirely from within the artwork. The importance of the framing discourse is masked, context is hidden. These artists, on the other hand, openly bracket their photographs with language, using texts to anchor, contradict, reinforce, subvert, complement, particularize, or go beyond the meanings offered by the images themselves. These pictures are often located within an extended narrative structure. I am not talking about 'photo essays,' a cliché-ridden form that is the noncommercial counterpart to the photographic advertisement. Photo essays are an outcome of a mass-circulation picture-magazine esthetic, the esthetic of the merchandisable column-inch and rapid, excited reading, reading made subservient to visual titillation. I am also not talking about the 'conceptual' and 'post-conceptual' art use of photography, since most such work unequivocally accepts the bounds of an existing art world.

Of the work I am dealing with here, Martha Rosler's *The Bowery in Two Inadequate Descriptive Systems* (1974–5) comes the closest to having an unrelentingly *metacritical* relation to the documentary genre.[4] [Plate 21] The title

muddled

fuddled

flustered

lushy

sottish

maudlin

Plate 21 Martha Rosler, *The Bowery in Two Inadequate Descriptive Systems*, 1974–5, detail.
Photo: Courtesy Gorney Bravin and Lee, New York. © Martha Rosler.

not only raises the question of representation, but suggests its fundamentally
flawed, distorted character. The object of the work, its referent, is not the
Bowery *per se*, but the 'Bowery' as a socially mediated, ideological construc-
tion. Rosler couples twenty-four photographs to an equal number of texts.
The photographs are frontal views of Bowery storefronts and walls, taken
with a normal lens from the edge of the street. The sequence of street num-
bers suggests a walk downtown, from Houston toward Canal on the west side
of the avenue, past anonymous grates, abandoned shopfronts, flop house
entrances, restaurant supply houses, discreetly labeled doors to artist's lofts.
No people are visible. Most of the photos have a careful geometric elegance,
they seem to be deliberate quotations of Walker Evans. The last two pho-
tographs are close-ups of a litter of cheap rose- and white-port bottles, again
not unlike Evans' 1968 picture of a discarded pine deodorant can in a trash
barrel. The cool, deadpan mannerism works against the often expressionist
liberalism of the find-a-bum school of concerned photography. This anti-
'humanist' distance is reinforced by the text, which consists of a series of lists
of words and phrases, an immense slang lexicon of alcoholism. This simple
listing of names for drunks and drunkenness suggests both the signifying
richness of metaphor as well as its referential poverty, the failure of metaphor
to 'encompass,' to adequately explain, the material reality to which it refers.

We have nautical and astronomical themes: 'deck's awash' and 'moon-eyed.'
The variety and 'wealth' of the language suggests the fundamental aim of
drunkenness, the attempted escape from a painful reality. The photographs con-
sistently pull us back to the street, to the terrain from which this pathetic flight
is attempted. Rosler's found poetry begins with the most transcendental of
metaphors, 'aglow, illuminated' and progresses ultimately, through numerous
categories of symbolic escape mingled with blunt recognition, to the slang terms
for empty bottles: 'dead soldiers' and 'dead marines.' The pool of language that
Rosler has tapped is largely the socio-linguistic 'property' of the working class

and the poor. This language attempts to handle an irreconcilable tension between bliss and self-destruction in a society of closed options.[5]

The attention to language cuts against the pornography of the 'direct' representation of misery. A text, analogous formally to our own ideological index of names-for-the-world, interposes itself between us and 'visual experience.'

1 Walter Benjamin, 'The Work of Art in the Age of Mechanical Reproduction' (1936), *Illuminations*, New York, 1969, p. 226.
2 Roman Jakobson, 'Linguistics and Poetics' (1958), in R. and F. DeGeorge, eds., *The Structuralists: From Marx to Levi Strauss*, Garden City, 1972, pp. 84–122.
3 Jurgen Habermas, *Legitimation Crisis*, trans. Thomas McCarthy, Boston, 1975.
4 This work has since been reproduced in Martha Rosler, *3 Works*, Halifax, 1981.
5 The reader may want to compare Rosler's lexicon with one assembled under different conditions. See Edmund Wilson, 'The Lexicon of Prohibition' (1929), in *The American Earthquake*, New York, 1958, pp. 89–91.

6. Jeff Wall, ' "Marks of Indifference": Aspects of Photography in, or as, Conceptual Art'

After contributing to the Conceptual Art movement in the 1960s, Jeff Wall undertook postgraduate research in art history and began making the large-scale photographic transparencies for which he is best known. He also writes on modern and contemporary art. The present essay is a long and wide-ranging discussion of the role of photography in Conceptual Art. It represents both a series of reflections on Wall's own work and a historical investigation of the way in which photography succeeded in becoming a modernist art through pursuing a conscious strategy of amateurisation and de-skilling. In the process, Wall argues, a transformed conception of the 'Picture' was established. The following extracts are taken from Ann Goldstein and Anne Rorimer (eds), *Reconsidering the Object of Art*, exhibition catalogue, Museum of Contemporary Art, Los Angeles and MIT Press, Cambridge, Mass. and London, 1995, pp. 248–53, 254–7, 258–62, 263, 265–7. [SE]

I. From Reportage to Photodocumentation

Photography entered its post-Pictorialist phase (one might say its 'post-Stieglitzian' phase) in an exploration of the border-territories of the utilitarian picture. In this phase, which began around 1920, important work was made by those who rejected the Pictorialist enterprise and turned toward immediacy, instantaneity, and the evanescent moment of the emergence of pictorial value out of a practice of reportage of one kind or another. A new version of what could be called the 'Western Picture,' or the 'Western Concept of the Picture,' appears in this process.

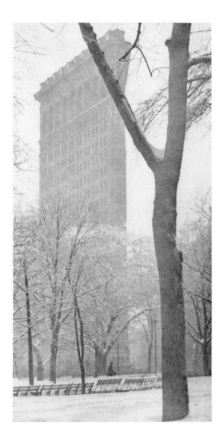

Plate 22 Alfred Stieglitz, *Flatiron Building*,
c. 1902–3, photograph, 17 x 8 cm. Museum
of Fine Arts, Boston, Gift of Miss Georgia
O'Keefe. 50.833. Photo: © 2003 Museum of
Fine Arts, Boston. © The Georgia O'Keefe
Foundation.

The Western Picture is, of course, that *tableau*, that independently beautiful
depiction and composition that derives from the institutionalization of perspec-
tive and dramatic figuration at the origins of modern Western art, with Raphael,
Dürer, Bellini and the other familiar *maestri*. It is known as a product of divine
gift, high skill, deep emotion, and crafty planning. It plays with the notion of the
spontaneous, the unanticipated. The master picture-maker prepares everything
in advance, yet trusts that all the planning in the world will lead only to some-
thing fresh, mobile, light and fascinating. The soft body of the brush, the way it
constantly changes shape as it is used, was the primary means by which the
genius of composition was placed at risk at each moment, and recovered, tran-
scendent, in the shimmering surfaces of magical feats of figuration.

Pictorialist photography was dazzled by the spectacle of Western painting
and attempted, to some extent, to imitate it in acts of pure composition.
Lacking the means to make the surface of its pictures unpredictable and
important, the first phase of Pictorialism, Stieglitz's phase, emulated the fine
graphic arts, re-invented the beautiful book, set standards for gorgeousness of
composition, and faded. [Plate 22] Without a dialectical conception of its own

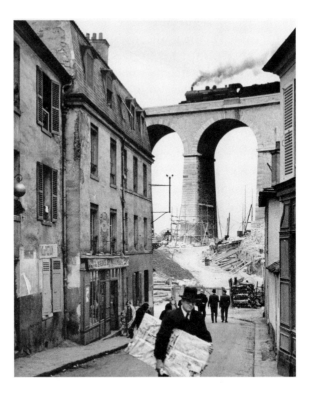

Plate 23 André Kertész,
Meudon, 1928, photo-
graph, 42 x 32 cm.
Courtesy of The
Metropolitan Museum of
Art, New York.

surface, it could not achieve the kind of planned spontaneity painting had put
before the eyes of the world as a universal norm of art. By 1920, photogra-
phers interested in art had begun to look away from painting, even from mod-
ern painting, toward the vernacular of their own medium, and toward the
cinema, to discover their own principle of spontaneity, to discover once again,
for themselves, that unanticipated appearance of the Picture demanded by
modern aesthetics [Plate 23].

At this moment the art-concept of photojournalism appears, the notion
that art can be created by imitating photojournalism. This imitation was
made necessary by the dialectics of avant-garde experimentation. Non-
autonomous art-forms, like architecture, and new phenomena such as mass
communications, became paradigmatic in the 1920s and 1930s because the
avant-gardes were so involved in a critique of the autonomous work of art, so
intrigued by the possibility of going beyond it into a utopian revision of soci-
ety and consciousness. Photojournalism was created in the framework of the
new publishing and communications industries, and it elaborated a new kind
of picture, utilitarian in its determination by editorial assignment and novel
in its seizure of the instantaneous, of the 'news event' as it happened. For both
these reasons, it seems to have occurred to a number of photographers (Paul
Strand, Walker Evans, Brassaï, Henri Cartier-Bresson) that a new art could be

made by means of a mimesis of these aims and aspects of photography as it really existed in the world of the new culture industries.

This mimesis led to transformations in the concept of the Picture that had consequences for the whole notion of modern art, and that therefore stand as preconditions for the kind of critique proposed by the Conceptual artists after 1965. Post-pictorialist photography is elaborated in the working out of a demand that the Picture make an appearance in a practice which, having already largely relinquished the sensuousness of the surface, must also relinquish any explicit preparatory process of composition. Acts of composition are the property of the tableau. In reportage, the sovereign place of composition is retained only as a sort of dynamic of anticipatory framing, a 'hunter's consciousness,' the nervous looking of a 'one-eyed cat,' as Lee Friedlander put it. Every picture-constructing advantage accumulated over centuries is given up to the jittery flow of events as they unfold. The rectangle of the viewfinder and the speed of the shutter, photography's 'window of equipment,' is all that remains of the great craft-complex of composition. The art-concept of photojournalism began to force photography into what appears to be a modernist dialectic. By divesting itself of the encumbrances and advantages inherited from older art forms, reportage pushes toward a discovery of qualities apparently intrinsic to the medium, qualities that must necessarily distinguish the medium from others, and through the self-examination of which it can emerge as a modernist art on a plane with the others.

This force, or pressure, is not simply social. Reportage is not a photographic type brought into existence by the requirements of social institutions as such, even though institutions like the press played a central part in defining photojournalism. The press had some role in shaping the new equipment of the 1920s and 1930s, particularly the smaller, faster cameras and film stock. But reportage is inherent in the nature of the medium, and the evolution of equipment reflects this. Reportage, or the spontaneous, fleeting aspect of the photographic image, appears simultaneously with the pictorial, tableau-like aspect at the origins of photography; its traces can be seen in the blurred elements of Daguerre's first street scenes. Reportage evolves in the pursuit of the blurred parts of pictures.

In this process, photography elaborates its version of the Picture, and it is the first new version since the onset of modern painting in the 1860s, or, possibly, since the emergence of abstract art, if one considers abstract paintings to be, in fact, pictures anymore. A new version of the Picture implies necessarily a turning-point in the development of modernist art. Problems are raised which will constitute the intellectual content of Conceptual art, or at least significant aspects of that content.

One of the most important critiques opened up in Conceptual art was that of art-photography's achieved or perceived 'aestheticism.' The revival of

interest in the radical theories and methods of the politicized and objectivis-
tic avant-garde of the 1920s and 1930s has long been recognized as one of the
most significant contributions of the art of the 1960s, particularly in America.
Productivism, 'factography,' and Bauhaus concepts were turned against the
apparently 'depoliticized' and resubjectivized art of the 1940s and 1950s.
Thus, we have seen that the kind of formalistic and 're-subjectivized' art-pho-
tography that developed around Edward Weston and Ansel Adams on the
West Coast, or Harry Callahan and Aaron Siskind in Chicago in those years
(to use only American examples) attempted to leave behind *not only* any *link*
with agit-prop, but even any connection with the nervous surfaces of social
life, and to resume a stately modernist pictorialism. This work has been greet-
ed with opprobrium from radical critics since the beginnings of the new
debates in the 1960s. The orthodox view is that Cold War pressures compelled
socially-conscious photographers away from the borderline forms of art-pho-
tojournalism toward the more subjectivistic versions of *art informel*. In this
process, the more explosive and problematic forms and concepts of radical
avant-gardism were driven from view, until they made a return in the activis-
tic neo-avant-gardism of the 1960s. There is much truth in this construction,
but it is flawed in that it draws too sharp a line between the methods and
approaches of politicized avant-gardism and those of the more subjectivistic
and formalistic trends in art-photography.

The situation is more complex because the possibilities for autonomous for-
mal composition in photography were themselves refined and brought onto
the historical and social agenda by the medium's evolution in the context of
vanguardist art. The art-concept of photojournalism is a theoretical formal-
ization of the ambiguous condition of the most problematic kind of photo-
graph. That photograph emerges on the wing, out of a photographer's com-
plex social engagement (his or her assignment); it records something signifi-
cant in the event, in the engagement, and gains some validity from that. But
this validity alone is only a social validity – the picture's success as reportage
per se. The entire avant-garde of the 1920s and 1930s was aware that validity
as reportage *per se* was insufficient for the most radical of purposes. What was
necessary was that the picture not only succeed as reportage and be socially
effective, but that it succeed in putting forward a new proposition or model of
the Picture. Only in doing both these things simultaneously could photogra-
phy realize itself as a modernist art form, and participate in the radical and
revolutionary cultural projects of that era. In this context, rejection of a clas-
sicizing aesthetic of the picture – in the name of proletarian amateurism, for
example – must be seen as a claim to a new level of pictorial consciousness.

Thus, art-photography was compelled to be both anti-aestheticist and aes-
thetically significant, albeit in a new 'negative' sense, at the same moment.
Here, it is important to recognize that it was the content of the avant-garde
dialogue itself that was central in creating the demand for an aestheticism

which was the object of critique by that same avant-garde. In *Theory of the Avant-Garde* (1974) Peter Bürger argued that the avant-garde emerged historically in a critique of the completed aestheticism of nineteenth-century modern art.[1] He suggests that, around 1900, the avant-garde generation, confronted with the social and institutional fact of the separation between art and the other autonomous domains of life felt compelled to attempt to leap over that separation and reconnect high art and the conduct of affairs in the world in order to save the aesthetic dimension by transcending it. Bürger's emphasis on this drive to transcend Aestheticism and autonomous art neglects the fact that the obsession with the aesthetic, now transformed into a sort of taboo, was carried over into the center of every possible artistic thought or critical idea developed by vanguardism. Thus, to a certain extent, one can invert Bürger's thesis and say that avant-garde art not only constituted a critique of Aestheticism, but also re-established Aestheticism as a permanent issue through its intense problematization of it. This thesis corresponds especially closely to the situation of photography within vanguardism. Photography had no history of autonomous status perfected over time into an imposing institution. It emerged too late for that. Its aestheticizing thus was not, and could not be, simply an object for an avant-gardist critique, since it was brought into existence by that same critique.

In this sense, there cannot be a clear demarcation between aestheticist formalism and various modes of engaged photography. Subjectivism could become the foundation for radical practices in photography just as easily as neo-factography, and both are often present in much work of the 1960s.

The peculiar, yet familiar, political ambiguity *as art* of the experimental forms in and around Conceptualism, particularly in the context of 1968, is the result of the fusion, or even confusion, of tropes of art-photography with aspects of its critique. Far from being anomalous, this fusion reflects precisely the inner structure of photography as potentially avant-garde or even neo-avant-garde art. This implies that the new forms of photographic practice and experiment in the sixties and seventies did not derive exclusively from a revival of anti-subjectivist and anti-formalist tendencies. Rather, the work of figures like Douglas Huebler, Robert Smithson, Bruce Nauman, Richard Long, or Joseph Kosuth emerge from a space constituted by the already-matured transformations of both types of approach – factographic and subjectivist, activist and formalist, 'Marxian' and 'Kantian' – present in the work of their precursors in the 1940s and 1950s, in the intricacies of the dialectic of 'reportage as art-photography,' as art-photography *par excellence*. [Plate 24] The radical critiques of art-photography inaugurated and occasionally realized in Conceptual art can be seen as both an overturning of academicized approaches to these issues, and as an extrapolation of existing tensions inside that academicism, a new critical phase of academicism and not simply a renunciation of it. Photoconceptualism was able to bring new energies from

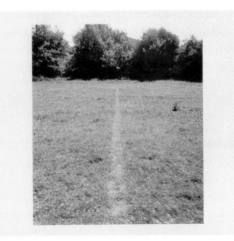

Plate 24 Richard Long,
A Line Made by Walking,
1967, photograph and
pencil on board, 37 x 32
cm. © Tate, London
2003. © Richard Long.

the other fine arts into the problematic of art-photojournalism, and this has tended to obscure the ways in which it was rooted in the unresolved but well-established aesthetic issues of the photography of the 1940s and 1950s.

Intellectually, the stage was thus set for a revival of the whole drama of reportage within avant-gardism. The peculiar situation of art-photography in the art market at the beginning of the 1960s is another precondition, whose consequences are not simply sociological. It is almost astonishing to remember that important art-photographs could be purchased for under $100 not only in 1950 but in 1960. This suggests that, despite the internal complexity of the aesthetic structure of art-photography, its moment of recognition as art in capitalist societies had not yet occurred. All the aesthetic preconditions for its emergence as a major form of modernist art had come into being, but it took the new critiques and transformations of the sixties and seventies to actualize these socially. It could be said that the very absence of a market in photography at the moment of a rapidly booming one for painting drew two kinds of energy toward the medium.

The first is a speculative and inquisitive energy, one which circulates everywhere things appear to be 'undervalued.' Under-valuation implies the future, opportunity, and the sudden appearance of something forgotten. The undervalued is a category akin to Benjaminian ones like the 'just past,' or the 'recently forgotten.'

The second is a sort of negative version of the first. In the light of the new critical skepticism toward 'high art' that began to surface in the intellectual glimmerings around Pop art and its mythologies, the lack of interest of art marketeers and collectors marked photography with a utopian potential. Thus, the thought occurred that a photograph might be the Picture which could not be integrated into 'the regime,' the commercial-bureaucratic-discursive order which was rapidly becoming the object of criticisms animated

by the attitudes of the Student Movement and the New Left. Naive as such thoughts might seem today, they were valuable in turning serious attention toward the ways in which art-photography had not yet become Art. Until it became Art, with a big A, photographs could not be *experienced* in terms of the dialectic of validity which marks all modernist aesthetic enterprises.

Paradoxically, this could only happen in reverse. Photography could emerge socially as art only at the moment when its aesthetic presuppositions seemed to be undergoing a withering radical critique, a critique apparently aimed at foreclosing any further aestheticization or 'artification' of the medium. Photoconceptualism led the way toward the complete acceptance of photography as art — autonomous, bourgeois, collectible art — by virtue of insisting that this medium might be privileged to be the negation of that whole idea. In being that negation, the last barriers were broken. Inscribed in a new avant-gardism, and blended with elements of text, sculpture, painting, or drawing, photography became the quintessential 'anti-object.' As the neo-avant-gardes re-examined and unravelled the orthodoxies of the 1920s and 1930s, the boundaries of the domain of autonomous art were unexpectedly widened, not narrowed. In the explosion of post-autonomous models of practice which characterized the discourse of the seventies, we can detect, maybe only with hindsight, the extension of avant-garde aestheticism. As with the first avant-garde, post-autonomous, 'post-studio' art required its double legitimation — first, its legitimation as having transcended — or at least having authentically tested — the boundaries of autonomous art and having become functional in some real way; and then, secondly, that this test, this new utility, result in works or forms which proposed compelling models of art as such, at the same time that they seemed to dissolve, abandon, or negate it. I propose the following characterization of this process: autonomous art had reached a state where it appeared that it could only validly be made by means of the strictest imitation of the non-autonomous. This heteronomy might take the form of direct critical commentary, as with Art & Language; with the production of political propaganda, so common in the 1970s; or with the many varieties of 'intervention' or appropriation practiced more recently. But, in all these procedures, an autonomous work of art is still necessarily created. The innovation is that the content of the work is the validity of the model or hypothesis of non-autonomy it creates.

This complex game of mimesis has been, of course, the foundation for all 'endgame' strategies within avant-gardism. The profusion of new forms, processes, materials and subjects which characterizes the art of the 1970s was to a great extent stimulated by mimetic relationships with other social production processes: industrial, academic, commercial, cinematic, etc. Art-photography, as we have seen, had already evolved an intricate mimetic structure, in which artists imitated photojournalists in order to create Pictures. This elaborate, mature mimetic order of production brought photography to the forefront of

the new pseudo-heteronomy, and permitted it to become a paradigm for all aes-thetically-critical, model-constructing thought about art. Photoconceptualism worked out many of the implications of this, so much so that it may begin to seem that many of Conceptual art's essential achievements are either created in the form of photographs or are otherwise mediated by them.

Reportage is introverted and parodied, manneristically, in aspects of photo-conceptualism. The notion that an artistically significant photograph can any longer be made in a direct imitation of photojournalism is rejected as having been historically completed by the earlier avant-garde and by the lyrical sub-jectivism of 1950s art-photography. The gesture of reportage is withdrawn from the social field and attached to a putative theatrical event. The social field tends to be abandoned to professional photo-journalism proper, as if the aesthetic problems associated with depicting it were no longer of any conse-quence, and photojournalism had entered not so much a postmodernist phase as a 'post-aesthetic' one in which it was excluded from aesthetic evolution for a time. This, by the way, suited the sensibilities of those political activists who attempted a new version of proletarian photography in the period.

This introversion, or subjectivization, of reportage was manifested in two important directions. First, it brought photography into a new relationship with the problematics of the staged, or posed, picture, through new concepts of performance. Second, the inscription of photography into a nexus of exper-imental practices led to a direct but distantiated and parodic relationship with the art-concept of photojournalism. Although the work of many artists could be discussed in this context, for the sake of brevity I will discuss the photo-graphic work of [Richard Long and] . . . Bruce Nauman as representative of the first issue, that of Dan Graham, [Douglas Huebler,] and Robert Smithson of the second. [. . .]

The photographer's studio, and the generic complex of 'studio photogra-phy,' was the Pictorialist antithesis against which the aesthetics of reportage were elaborated. Nauman changes the terms. [Plate 25] Working within the experimental framework of what was beginning at the time to be called 'per-formance art,' he carries out photographic acts of reportage whose subject-matter is the self-conscious, self-centered 'play' taking place in the studios of artists who have moved 'beyond' the modern fine arts into the new hybridi-ties. Studio photography is no longer isolated from reportage: it is reduced analytically to coverage of whatever is happening in the studio, that place once so rigorously controlled by precedent and formula, but which was in the process of being reinvented once more as theater, factory, reading room, meet-ing place, gallery, museum, and many other things.

Nauman's photographs, films, and videos of this period are done in two modes or styles. The first, that of *Failing To Levitate*, is 'direct,' rough, and shot in black and white. The other is based on studio lighting effects — multi-ple sources, colored gels, emphatic contrasts — and is of course done in color.

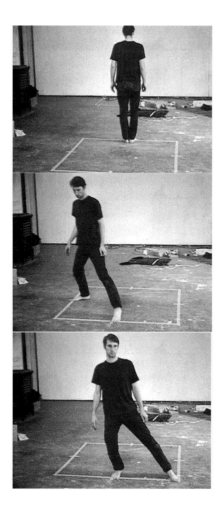

Plate 25 Bruce Nauman, *Dance or Exercise on the Perimeter of a Square (Square Dance)*, 1967–68. Courtesy of Electronic Arts Intermix (EAI), New York. © ARS, NY and DACS, London 2003.

The two styles, reduced to a set of basic formulae and effects, are signifiers for the new co-existence of species of photography which had seemed ontologically separated and even opposed in the art history of photography up to that time. It is as if the reportage works go back to Muybridge and the sources of all traditional concepts of photographic documentary, and the color pictures to the early 'gags' and jokes, to Man Ray and Moholy-Nagy, to the birthplace of effects used for their own sake. The two reigning myths of photography — the one that claims that photographs are 'true' and the one that claims they are not — are shown to be grounded in the same praxis, available in the same place, the studio, at that place's moment of historical transformation.

These practices, or strategies, are extremely common by about 1969, so common as to be *de rigueur* across the horizon of performance art, earth art, Arte Povera, and Conceptualism, and it can be said that these new methodologies of

photographic practice are the strongest factor linking together the experimental forms of the period, which can seem so disparate and irreconcilable.

This integration or fusion of reportage and performance, its manneristic introversion, can be seen as an implicitly parodic critique of the concepts of art-photography. Smithson and Graham, in part because they were active as writers, were able to provide a more explicit parody of photojournalism than Nauman or Long.

Photojournalism as a social institution can be defined most simply as a collaboration between a writer and a photographer. Conceptual art's intellectualism was engendered by young, aspiring artists for whom critical writing was an important practice of self-definition. The example of Donald Judd's criticism for *Arts Magazine* was decisive here, and essays like 'Specific Objects' (1964) had the impact, almost, of literary works of art. The interplay between a veteran littérateur, Clement Greenberg; a young academic art critic, Michael Fried; and Judd, a talented stylist, is one of the richest episodes in the history of American criticism, and had much to do with igniting the idea of a written critique standing as a work of art. Smithson's 'The Crystal Land,' published in *Harper's Bazaar* in 1966, is an homage to Judd as a creator of both visual and literary forms. Smithson's innovation, however, is to avoid the genre of art criticism, writing a mock-travelogue instead. He plays the part of the inquisitive, belletristic journalist, accompanying and interpreting his subject. He narrativizes his account of Judd's art, moves from critical commentary to storytelling and re-invents the relationships between visual art and literature. Smithson's most important published works, such as 'The Monuments of Passaic,' and 'Incidents of Mirror-Travel in the Yucatan' are 'auto-accompaniments.' Smithson the journalist-photographer accompanies Smithson the artist-experimenter and is able to produce a sophisticated apologia for his sculptural work in the guise of popular entertainment. His essays do not make the Conceptualist claim to be works of visual art, but appear to remain content with being works of literature. The photographs included in them purport to illustrate the narrative or commentary. The narratives, in turn, describe the event of making the photographs. 'One never knew what side of the mirror one was on,' he mused in 'Passaic,' as if reflecting on the parody of photojournalism he was in the process of enacting. Smithson's parody was a way of dissolving, or softening, the objectivistic and positivistic tone of Minimalism, of subjectivizing it by associating its reductive formal language with intricate, drifting, even delirious moods or states of mind.

The Minimalist sculptural forms to which Smithson's texts constantly allude appeared to erase the associative chain of experience, the interior monologue of creativity, insisting on the pure immediacy of the product itself, the work as such, as 'specific object.' Smithson's exposure of what he saw as Minimalism's emotional interior depends on the return of ideas of time and process, of nar-

rative and enactment, of experience, memory, and allusion, to the artistic fore-
front, against the rhetoric of both Greenberg and Judd. His photojournalism is
at once self-portraiture – that is, performance – and reportage about what was
hidden and even repressed in the art he most admired. It located the impulse
toward self-sufficient and non-objective forms of art in concrete, personal
responses to real-life, social experiences, thereby contributing to the new cri-
tiques of formalism which were so central to Conceptual art's project.

Dan Graham's involvement with the classical traditions of reportage is
unique among the artists usually identified with Conceptual art, and his
architectural photographs continue some aspects of Walker Evans's project. In
this, Graham locates his practice at the boundary of photojournalism, partic-
ipating in it, while at the same time placing it at the service of other aspects
of his oeuvre. His architectural photographs provide a social grounding for
the structural models of intersubjective experience he elaborated in text,
video, performance and sculptural environmental pieces. His works do not
simply make reference to the larger social world in the manner of photojour-
nalism; rather, they refer to Graham's own other projects, which, true to
Conceptual form, are models of the social, not depictions of it.

Graham's *Homes for America* (1966–67) has taken on canonical status in this
regard. Here the photo-essay format so familiar to the history of photography
has been meticulously replicated as a model of the institution of photojour-
nalism. Like Walker Evans at *Fortune*, Graham writes the text and supplies the
pictures to go along with it. *Homes* was actually planned as an essay on subur-
ban architecture for an art magazine, and could certainly stand unproblemati-
cally on its own as such. By chance, it was never actually published as Graham
had intended it. Thereby, it migrated to the form of a lithographic print of an
apocryphal two-page spread.[2] The print, and the original photos included in it,
do not constitute an act or practice or reportage so much as a model of it. This
model is a parody, a meticulous and detached imitation whose aim is to inter-
rogate the legitimacy (and the processes of legitimation) of its original, and
thereby (and only thereby) to legitimate itself as art.

The photographs included in the work are among Graham's most well-
known and have established important precedents for his subsequent photo-
graphic work. In initiating his project in photography in terms of a parodic
model of the photo-essay, Graham positions all his picture-making as art in a
very precise, yet very conditional, sense. Each photograph may be – or, must
be considered as possibly being – no more than an illustration to an essay, and
therefore not an autonomous work of art. Thus, they appear to satisfy, as do
Smithson's photographs, the demand for an imitation of the non-autonomous.
Homes for America, in being both really just an essay on the suburbs and, as
well, an artist's print, constituted itself explicitly as a canonical instance of
the new kind of anti-autonomous yet autonomous work of art. The photo-
graphs in it oscillate at the threshold of the autonomous work, crossing and

recrossing it, refusing to depart from the artistic dilemma of reportage and thereby establishing an aesthetic model of just that threshold condition.

* * *

II. Amateurization

Photography, like all the arts that preceded it, is founded on the skill, craft, and imagination of its practitioners. It was, however, the fate of all the arts to become modernist through a critique of their own legitimacy, in which the techniques and abilities most intimately identified with them were placed in question. The wave of reductivism that broke in the 1960s had, of course, been gathering during the preceding half-century, and it was the maturing (one could almost say, the totalizing) of that idea that brought into focus the explicit possibility of a 'conceptual art,' an art whose content was none other than its own idea of itself, and the history of such an idea's becoming respectable.

Painters and sculptors worked their way into this problem by scrutinizing and repudiating – if only experimentally – their own abilities, the special capacities that had historically distinguished them from other people – non-artists, unskilled or untalented people. This act of renunciation had moral and utopian implications. For the painter, a radical repudiation of complicity with Western traditions was a powerful new mark of distinction in a new era of what Nietzsche called 'a revaluation of all values.'[3] Moreover, the significance of the repudiation was almost immediately apparent to people with even a passing awareness of art, though apparent in a negative way. 'What! You don't want things to look three-dimensional? Ridiculous!' It is easy to experience the fact that something usually considered essential to art has been removed from it. Whatever the thing the artist has thereby created might appear to be, it is first and foremost that which results from the absence of elements which have hitherto always been there. The reception, if not the production, of modernist art has been consistently formed by this phenomenon, and the idea of modernism as such is inseparable from it. The historical process of critical reflexivity derives its structure and identity from the movements possible in, and characteristic of, the older fine arts, like painting. The drama of modernization, in which artists cast off the antiquated characteristics of their *métiers*, is a compelling one, and has become the conceptual model for modernism as a whole. Clement Greenberg wrote: 'Certain factors we used to think essential to the making and experiencing of art are shown not to be so by the fact that Modernist painting has been able to dispense with them and yet continue to offer the experience of art in all its essentials.'[4]

Abstract and experimental art begins its revolution and continues its evolution with the rejection of depiction, of its own history as limning and pic-

turing, and then with the deconsecration of the institution which came to be known as Representation. Painting finds a new *telos*, a new identity and a new glory in being the site upon which this transformation works itself out.

It is a commonplace to note that it was the appearance of photography which, as the representative of the Industrial Revolution in the realm of the image, set the historical process of modernism in motion. Yet photography's own historical evolution into modernist discourse has been determined by the fact that, unlike the older arts, it cannot dispense with depiction and so, apparently, cannot participate in the adventure it might be said to have suggested in the first place.

The dilemma, then, in the process of legitimating photography as a modernist art is that the medium has virtually no dispensable characteristics, the way painting, for example, does, and therefore cannot conform to the ethos of reductivism, so succinctly formulated by Greenberg in these lines, also from 'Modernist Painting': 'What had to be exhibited was not only that which was unique and irreducible in art in general, but also that which was unique and irreducible in each particular art. Each art had to determine, through its own operations and works, the effects exclusive to itself. By doing so it would, to be sure, narrow its area of competence, but at the same time it would make its possession of that area all the more certain.'[5]

The essence of the modernist deconstruction of painting as picture-making was not realized in abstract art as such; it was realized in emphasizing the distinction between the institution of the Picture and the necessary structure of the depiction itself. It was physically possible to separate the actions of the painter — those touches of the brush which had historically always, in the West at least, led to a depiction — from depiction, and abstract art was the most conclusive evidence for this.

Photography constitutes a depiction not by the accumulation of individual marks, but by the instantaneous operation of an integrated mechanism. All the rays permitted to pass through the lens form an image immediately, and the lens, by definition, creates a focused image at its correct focal length. Depiction is the only possible result of the camera system, and the kind of image formed by a lens is the only image possible in photography. Thus, no matter how impressed photographers may have been by the analytical rigor of modernist critical discourse, they could not participate in it directly in their practice because the specificities of their medium did not permit it. This physical barrier has a lot to do with the distanced relationship between painting and photography in the era of art-photography, the first sixty or so years of this century.

Despite the barrier, around the middle of the 1960s, numerous young artists and art students appropriated photography, turned their attention away from *auteurist* versions of its practice, and forcibly subjected the medium to a full-scale immersion in the logic of reductivism. The essential reduction came on the level of skill. Photography could be integrated into the new rad-

ical logics by eliminating all the pictorial suavity and technical sophistication
it had accumulated in the process of its own imitation of the Great Picture. It
was possible, therefore, to test the medium for its indispensable elements,
without abandoning depiction, by finding ways to legitimate pictures that
demonstrated the absence of the conventional marks of pictorial distinction
developed by the great auteurs, from Atget to Arbus.

Already by around 1955, the revalorization and reassessment of vernacular
idioms of popular culture had emerged as part of a new 'new objectivity,' an
objectivism bred by the limitations of lyrical *art informel*, the introverted and
self-righteously lofty art forms of the 1940s and 1950s. This new critical trend
had sources in high art and high academe, as the names Jasper Johns and Piero
Manzoni, Roland Barthes and Leslie Fiedler, indicate. It continues a funda-
mental project of the earlier avant-garde – the transgression of the boundaries
between 'high' and 'low' art, between artists and the rest of the people, between
'art' and 'life.' Although Pop art in the late fifties and early sixties seemed to
concentrate on bringing mass-culture elements into high-culture forms, already
by the 1920s the situation had become far more complex and reciprocal than
that, and motifs and styles from avant-garde and high-culture sources were cir-
culating extensively in the various new Culture Industries in Europe, the
United States, the Soviet Union, and elsewhere. This transit between 'high' and
'low' had become the central problematic for the avant-garde because it reflect-
ed so decisively the process of modernization of all cultures. The great question
was whether or not art as it had emerged from the past would be 'modernized'
by being dissolved into the new mass-cultural structures.

Hovering behind all tendencies toward reductivism was the shadow of this
great 'reduction.' The experimentation with the 'anaesthetic,' with 'the look
of non-art,' 'the condition of no-art,' or with 'the loss of the visual,' is in this
light a kind of tempting of fate. Behind the Greenbergian formulae, first
elaborated in the late 1930s, lies the fear that there may be, finally, no indis-
pensable characteristics that distinguish the arts, and that art as it has come
down to us is very dispensable indeed. Gaming with the anaesthetic was both
an intellectual necessity in the context of modernism, and at the same time
the release of social and psychic energies which had a stake in the 'liquida-
tion' of bourgeois 'high art.' By 1960 there was pleasure to be had in this
experimentation, a pleasure, moreover, which had been fully sanctioned by
the aggressivity of the first avant-garde or, at least, important parts of it.

Radical deconstructions therefore took the form of searches for models of
'the anaesthetic.' Duchamp had charted this territory before 1920, and his
influence was the decisive one for the new critical objectivisms surfacing forty
years later with Gerhard Richter, Andy Warhol, Manzoni, John Cage, and the
rest. The anaesthetic found its emblem in the Readymade, the commodity in
all its guises, forms, and traces. Working-class, lower-middle class, suburban-
ite, and underclass milieux were expertly scoured for the relevant utilitarian

images, depictions, figurations, and objects that violated all the criteria of canonical modernist taste, style, and technique. Sometimes the early years of Pop art seem like a race to find the most perfect, metaphysically banal image, that cipher that demonstrates the ability of culture to continue when every aspect of what had been known in modern art as seriousness, expertise, and reflexiveness had been dropped. The empty, the counterfeit, the functional, and the brutal themselves were of course nothing new as art in 1960, having all become tropes of the avant-garde via Surrealism. From the viewpoint created by Pop art, though, earlier treatments of this problem seem emphatic in their adherence to the Romantic idea of the transformative power of authentic art. The anaesthetic is transformed as art, but along the fracture-line of shock. The shock caused by the appearance of the anaesthetic in a serious work is calmed by the aura of seriousness itself. It is this aura which becomes the target of the new wave of critical play. Avant-garde art had held the anaesthetic in place by a web of sophisticated manoeuvres, calculated transgressive gestures, which always paused on the threshold of real abandonment. Remember Bellmer's pornography, Heartfield's propaganda, Mayakovsky's advertising. Except for the Readymade, there was no complete mimesis or appropriation of the anaesthetic, and it may be that the Readymade, that thing that had indeed crossed the line, provided a sort of fulcrum upon which, between 1920 and 1960, everything else could remain balanced.

* * *

Amateurish film and photographic images and styles of course related to the documentary tradition, but their deepest resonance is with the work of actual amateurs – the general population, the 'people.' To begin with, we must recognize a conscious utopianism in this turn toward the technological vernacular: Joseph Beuys's slogan 'every man is an artist,' or Lawrence Weiner's diffident conditions for the realization and possession of his works reflect with particular clarity the idealistic side of the claim that the *making* of artworks needs to be, and in fact has become, a lot easier than it was in the past. These artists argued that the great mass of the people had been excluded from art by social barriers and had internalized an identity as 'untalented,' and 'inartistic' and so were resentful of the high art that the dominant institutions unsuccessfully compelled them to venerate. This resentment was the moving force of philistine mass culture and kitsch, as well as of repressive social and legislative attitudes toward the arts. Continuation of the regime of specialized high art intensified the alienation of both the people and the specialized, talented artists who, as the objects of resentment, developed elitist antipathy toward 'the rabble' and identified with the ruling classes as their only possible patrons. This vicious circle of 'avant-garde and kitsch' could be broken only by a radical transformation and negation of high art. These arguments repeat

those of the earlier Constructivists, Dadaists, and Surrealists almost word for word, nowhere more consciously than in Guy Debord's *The Society of the Spectacle* (1967): 'Art in the period of its dissolution, as a movement of negation in pursuit of its own transcendence in a historical society where history is not directly lived, is at once an art of change and a pure expression of the impossibility of change. The more grandiose its demands, the further from its grasp is true self-realization. This is an art that is necessarily *avant-garde*; and it is an art that *is not*. Its vanguard is its own disappearance.'[6]

The practical transformation of art (as opposed to the idea of it) implies the transformation of the practices of both artists and their audiences, the aim being to obliterate or dissolve both categories into a kind of dialectical synthesis of them, a Schiller-like category of emancipated humanity which needs neither Representation nor Spectatorship. These ideals were an important aspect of the movement for the transformation of artistry, which opened up the question of skill. The utopian project of rediscovering the roots of creativity in a spontaneity and intersubjectivity freed from all specialization and spectacularized expertise combined with the actual profusion of light consumer technologies to legitimate a widespread 'de-skilling' and 're-skilling' of art and art education. The slogan 'painting is dead' had been heard from the avant-garde since 1920; it meant that it was no longer necessary to separate oneself from the people through the acquisition of skills and sensibilities rooted in craft-guild exclusivity and secrecy; in fact, it was absolutely necessary not to do so, but rather to animate with radical imagination those common techniques and abilities made available by modernity itself. First among these was photography.

* * *

'Great art' established the idea (or ideal) of unbounded competence, the wizardry of continually evolving talent. This ideal became negative, or at least seriously uninteresting, in the context of reductivism, and the notion of limits to competence, imposed by oppressive social relationships, became charged with exciting implications. It became a subversive creative act for a talented and skilled artist to imitate a person of limited abilities. It was a new experience, one which ran counter to all accepted ideas and standards of art, and was one of the last gestures which could produce avant-gardist shock. This mimesis signified, or expressed, the vanishing of the great traditions of Western art into the new cultural structures established by the mass media, credit financing, suburbanization, and reflexive bureaucracy. The act of renunciation required for a skilled artist to enact this mimesis, and construct works as models of its consequences, is a scandal typical of avant-garde desire, the desire to occupy the threshold of the aesthetic, its vanishing-point.

Many examples of such amateurist mimesis can be drawn from the corpus

Plate 26 Edward Ruscha, *Some Los Angeles Apartments*, 1965. Courtesy of Gagosian Gallery, New York.

of photoconceptualism, and it could probably be said that almost all photo-conceptualists indulged in it to some degree. But one of the purest and most exemplary instances is the group of books published by Edward Ruscha between 1963 and 1970.

For all the familiar reasons, Los Angeles was perhaps the best setting for the complex of reflections and crossovers between Pop art, reductivism, and their mediating middle term, mass culture, and Ruscha for biographical reasons may inhabit the persona of the American Everyman particularly easily. The photographs in *Some Los Angeles Apartments* (1965), for example, synthesize the brutalism of Pop art with the low-contrast monochromaticism of the most utilitarian and perfunctory photographs (which could be imputed to have been taken by the owners, managers, or residents of the buildings in question) [Plate 26]. Although one or two pictures suggest some recognition of the criteria of art-photography, or even architectural photography (e.g. '2014 S. Beverly Glen Blvd.'), the majority seem to take pleasure in a rigorous display of generic lapses: improper relation of lenses to subject distances, insensitivity to time of day and quality of light, excessively functional crop-ping, with abrupt excisions of peripheral objects, lack of attention to the spe-cific character of the moment being depicted – all in all a hilarious perfor-mance, an almost sinister mimicry of the way 'people' make images of the dwellings with which they are involved. Ruscha's impersonation of such an Everyperson obviously draws attention to the alienated relationships people have with their built environment, but his pictures do not in any way stage or dramatize that alienation the way that Walker Evans did, or that Lee

Friedlander was doing at that moment. Nor do they offer a transcendent experience of a building that pierces the alienation usually felt in life, as with Atget, for example. The pictures are, as reductivist works, models of our actual relations with their subjects, rather than dramatized representations that transfigure those relations by making it impossible for us to have such relations with *them*.

Ruscha's books ruin the genre of the 'book of photographs,' that classical form in which art-photography declares its independence. *Twentysix Gasoline Stations* (1963) may depict the service stations along Ruscha's route between Los Angeles and his family home in Oklahoma, but it derives its artistic significance from the fact that at a moment when 'The Road' and roadside life had already become an auteurist cliché in the hands of Robert Frank's epigones, it resolutely denies any representation of its theme, seeing the road as a system and an economy mirrored in the structure of both the pictures he took and the publication in which they appear. Only an idiot would take pictures of nothing but the filling stations, and the existence of a book of just those pictures is a kind of proof of the existence of such a person. But the person, the asocial cipher who cannot connect with the others around him, is an abstraction, a phantom conjured up by the construction, the structure of the product said to be by his hand. The anaesthetic, the edge or boundary of the artistic, emerges through the construction of this phantom producer, who is unable to avoid bringing into visibility the 'marks of indifference' with which modernity expresses itself in or as a 'free society.'

Amateurism is a radical reductivist methodology insofar as it is the form of an *impersonation*. In photoconceptualism, photography posits its escape from the criteria of art-photography through the artist's performance as a non-artist who, despite being a non-artist, is nevertheless compelled to make photographs. These photographs lose their status as Representations before the eyes of their audience: they are 'dull,' 'boring,' and 'insignificant.' Only by being so could they accomplish the intellectual mandate of reductivism at the heart of the enterprise of Conceptual art. The reduction of art to the condition of an intellectual concept of itself was an aim which cast doubt upon any given notion of the sensuous experience of art. Yet the loss of the sensuous was a state which itself had to be experienced. Replacing a work with a theoretical essay which could hang in its place was the most direct means toward this end; it was Conceptualism's most celebrated action, a gesture of usurpation of the predominant position of all the intellectual organizers who controlled and defined the Institution of Art. But, more importantly, it was the proposal of the final and definitive negation of art as depiction, a negation which, as we've seen, is the *telos* of experimental, reductivist modernism. And it can still be claimed that Conceptual art actually accomplished this negation. In consenting to read the essay that takes a work of art's place, spectators are presumed to continue the process of their own redefinition, and thus to par-

ticipate in a utopian project of transformative, speculative self-reinvention: an avant-garde project. Linguistic conceptualism takes art as close to the boundary of its own self-overcoming, or self-dissolution, as it is likely to get, leaving its audience with only the task of rediscovering legitimations for works of art as they had existed, and might continue to exist. This was, and remains, a revolutionary way of thinking about art, in which its right to exist is rethought in the place or moment traditionally reserved for the enjoyment of art's actual existence, in the encounter with a work of art. In true modernist fashion it establishes the dynamic in which the intellectual legitimation of art as such – that is, the philosophical content of aesthetics – is experienced as the content of any particular moment of enjoyment.

But, dragging its heavy burden of depiction, photography could not follow pure, or linguistic, Conceptualism all the way to the frontier. It cannot provide the experience of the negation of experience, but must continue to provide the experience of depiction, of the Picture. It is possible that the fundamental shock that photography caused was to have provided a depiction which could be experienced more the way the visible world is experienced than had ever been possible previously. A photograph therefore shows its subject by means of showing what experience is like, in that sense it provides 'an experience of experience,' and it defines this as the significance of depiction.

In this light, it could be said that it was photography's role and task to turn away from Conceptual art, away from reductivism and its aggressions. Photoconceptualism was then the last moment of the prehistory of photography as art, the end of the Old Regime, the most sustained and sophisticated attempt to free the medium from its peculiar distanced relationship with artistic radicalism and from its ties to the Western Picture. In its failure to do so, it revolutionized our concept of the Picture and created the conditions for the restoration of that concept as a central category of contemporary art by around 1974.

1 Peter Bürger, *Theory of the Avant-Garde*, trans. Michael Shaw (Minneapolis: University of Minnesota Press, 1984).

2 A variant, made as a collage, is in the Daled Collection, Brussels.

3 Friedrich Nietzsche, 'Ecce Homo,' in *On the Genealogy of Morals and Ecce Homo*, ed. Walter Kaufmann and trans. Kaufmann and R.J. Hollingdale (New York: Vintage Books, 1967), 290.

4 Clement Greenberg, 'Modernist Painting,' in *Clement Greenberg: The Collected Essays and Criticism*, vol. 4: *Modernism with a Vengeance, 1957–1969*, ed. John O'Brian (Chicago: University of Chicago Press, 1993), 92.

5 Ibid, 86.

6 Guy Debord, *The Society of the Spectacle*, trans. Donald Nicholson-Smith (New York: Zone Books, 1994), 135 (thesis 190).

PART IV
SUBJECTS AND OBJECTS

Introduction

Increasingly, the 1960s look like a turning point, the hinge between a modernist past and a postmodernist present. When Clement Greenberg wrote 'Modernist Painting' in 1960, erecting a great arch between his present in New York and the past of Manet's time in Paris in the 1860s, it must have seemed as though modernism was clear: art was free, free from literature, free from the academy and free from politics. Within two years, however, the cracks had appeared as Pop Art burst on the scene. In the mid-1960s, the conflict between Minimal Art and modernism was largely resolved in favour of the former, at least as far as younger artists were concerned. All this happened against the backdrop of the Civil Rights movement and the war in Vietnam, the May 1968 events in Paris, not to mention Woodstock. By 1969, with exhibitions of Conceptual Art such as *When Attitudes Become Form*, Greenbergian modernism was already history.

Since then the 1960s have been revisited, and revisited again. Art historians continue to debate the significance of Minimal Art and Antiform, Process, Performance and Conceptual Art, the more so as they are now widely seen to set the terms for subsequent developments in art. Even modernism has been reviewed again for what was good in it, for what was not merely silence in the face of cooptation, and for what was more than the client of American imperialism. The present continues to make the pictures it wants of the bits of the past it thinks it needs.

In this Part we offer a selection of texts all of which focus on aspects of that crucial period and its aftermath. Philip Leider, writing at the time, famously described Jackson Pollock's painting as 'the last achievement of whose status every serious artist is convinced', and proceeded to map the derivation of the conflicting inheritances of continued abstract painting and 'literalism' (i.e., Mimimal Art and its successors). Alex Potts, writing in art-historical retrospect, offers a complex account of how the encounter with the minimal object worked. Lucy Lippard and Clement Greenberg provide diametrically opposed assessments of what took place in the decade of the 1960s. For Greenberg, it was a kind of *trahison des clercs*, an evacuation of the hard-won terrain of aesthetic quality for the easily had, indisciplined thrills of the merely 'far out'. In Greenberg's view, convention, particularly the conventions derived from work in and upon some specific medium, provides the yardstick for significance in art. Lose that, and the freedom apparently gained turns to leaves: undifferentiated freedom is no real freedom at all, just a licence for mediocrity. For Lippard, by contrast, the breakout from modernist medium-speci-

ficity was a crucial series of 'escape attempts' whose success was to let art breathe again, a fundamentally democratic impulse to get out from under the 'sacrosanct ivory walls and heroic patriarchal mythologies with which the 1960s opened'. Charles Harrison, writing for the first major retrospective of Conceptual Art, *l'art conceptuel: une perspective*, in 1989, offers a differently inflected account of 'the moment of Conceptual Art' but one that also sees it as an attempt, albeit an ultimately unsuccessful one, to go beyond the closures of the managerial system of institutionalised modernism. For Harrison, Conceptual Art as manifest in the work of the English Art & Language group offered a powerful critique of the conventions of the art object, of the conventions of the artistic author and of the art public, aiming at nothing less than the 'transformation of spectators into participants'. Finally, in a retrospective view of developments since the 1960s, Miwon Kwon charts the moves out of 'cultural confinement' by which art has been brought 'more directly into the realm of the social'. She concludes, however, by stressing the continuing need for a 'serious critical examination' of the contradictions of contemporary art, uncertainly positioned between 'resistance' and 'capitulation' to 'the logic of capitalist expansion'.

1. Philip Leider, 'Literalism and Abstraction'

Philip Leider was the editor of *Artforum* in the years when it had a claim to be the most influential art magazine in the world, that is to say, the years of the crisis of modernism and the entry onto the scene of Minimal Art and the 'expanded situation' (as Robert Morris called it) that followed. Leider's extended review of Frank Stella's retrospective exhibition at the Museum of Modern Art, New York in 1970 included a synoptic overview of the two main contrasting developments that had succeeded the work of Jackson Pollock: on the one hand, a further extension of the tradition of abstract painting; on the other, an increasing emphasis on the literal nature of the art object as a physical thing encountered in real time and space. Stella's centrality stemmed from the fact that the paintings he had made in the late 1950s and early 1960s, particularly his shaped canvases, were open to both kinds of interpretation. The following extracts are taken from Philip Leider, 'Literalism and Abstraction: Frank Stella's Retrospective at the Modern', *Artforum*, New York, vol. 8, no. 8, April 1970, pp. 44–51.

The idea in being a painter is to declare an identity. Not just my identity, an identity for me, but an identity big enough for everyone to share in. Isn't that what it's all about?

– Frank Stella, in conversation

Both abstraction and literalism look to Pollock for sanction; it is as if his work was the last achievement of whose status every serious artist is convinced. The way one reads Pollock influences in considerable measure the way one reads Stella, and the way in which one reads Pollock and Stella has a great deal to do, for example, with the kind of art one decides to make; art ignorant of both looks it. The abstractionist view of Pollock was most clearly expressed by Michael Fried, basing himself in part on Clement Greenberg, and that view is now so thoroughly a part of the literature that students run it through by rote; how his art broke painting's dependence on a tactile, sculptural space; how the all-over system transcended the Cubist grid; how it freed line from shape, carried abstract art further from the depiction of *things* than had any art before; how it created 'a new kind of space' in which objects are not depicted, shapes are not juxtaposed, physical events do not transpire. In short, the most exquisite triumph of the two-dimensional manner. From this appreciation of Pollock, or from views roughly similar, have come artists like Morris Louis, Kenneth Noland, Jules Olitski, Helen Frankenthaler and, partially at least, Frank Stella.

The literalist view of Pollock emerged somewhat more hazily, less explicitly, more in argument and conversation than in published criticism. Literalist eyes – or what were to become literalist eyes – did not see, or did not see first and foremost, those patterns as patterns of line freed from their function of bounding shape and thereby creating a new kind of space. They saw them first and foremost as *skeins of paint dripped directly from the can.* Paint, that is, which skipped the step of having a brush dipped into it; paint transferred from can to canvas with no contact with the artist's traditional transforming techniques. *You could visualize the picture being made* – there were just no secrets. It was amazing how much energy was freed by this bluntness, this honesty, this complete obviousness of the process by which the picture was made. Another thing about Pollock was the plain familiarity with which he treated the picture as a *thing*. He left his handprints all over it; he put his cigarette butts out in it. It is as if he were saying that the kind of objects our works of art must be derive their strength from the directness of our attitudes toward them; when you feel them getting too arty for you (when you find yourself taking attitudes toward them that are not right there in the studio with you, that come from some place else, from some transmitted view of art not alive in the studio with you) give them a whack or two, re-establish the plain-ness of your relations with them.

Literalism thus sees in Pollock the best abstract art ever made deriving its strength from the affirmation of the *objectness* of the painting and from the directness of the artist's relations to his materials. In short, the greatness of the abstraction is in large measure a function of the literalness of Pollock's approach. Such a view of Pollock would naturally lead one to seek in quite different places for a way to continue making meaningful abstract art than

would a view based on the abstractionist reading of Pollock. The kind of an object a painting was began to emerge forcefully as an issue in painting.

The objectness of painting was explored with great ingenuity and enormous sophistication by Jasper Johns during the middle and late fifties, but his literalism is consistently undermined by a Duchampian toying with irony and paradox, an impulse to amuse and be amused above all. How cleverly he seemed to dismiss problems that were draining the life out of abstract art! How easily those flags and targets seemed to diagnose and then cure the lingering illusionism and vestigial representationalism that plagued abstraction in the fifties. All that had to be done was simple rehearsal of the differences between actual flags and actual paintings.

Needless to say, abstraction was not looking like that. Abstraction was discovering that objectness was the thing to beat, and that the breakthrough to look for was a breakthrough to an inspired two-dimensionalism, and that the way to do it was through *color*, and, as much as possible, through color alone. That the differences were immense can be seen simply by comparing a Noland circle painting with a Johns target. The one is about color and centeredness and two-dimensional abstraction, with no references whatever to objects or events of any kind in the three-dimensional world. The other is about an object called a target and an object called a painting, and, given the cleverness with which the problems are posed, were an instant success in colleges everywhere.

One college student, Stella, saw in Johns a way to an advanced alloverness. The cleverness, irony and paradox parts he left to others, perhaps figuring that if Still and Pollock could do without them he probably could too. From Johns, Noland could only have taken, if anything at all, the suggestion of the possibilities of a centered image. Stella, however, takes from Johns directly the striping idea: it solved the problem of keeping his pictures flat, and it solved it simply, clearly, and in a way that allowed him to move on to other things.

Stella was crucially interested in keeping his pictures flat because he was crucially interested in making abstract pictures that could survive as post-Pollock art. He was crucially interested in making abstract pictures, and *only* in making abstract pictures, and has never been interested in anything else to this day; the consistency of Stella's antiliteralist ideas throughout his career is remarkable ... As other abstractionists like Louis, Noland and Olitski — all older by at least ten years than Stella — pursued this ambition by exploring color, Stella thought the biggest obstacles to a greater abstraction were structural and compositional, and he went to work overcoming these with a cold, smartaleck, humorless methodicalness that showed up, in the paintings he finally exhibited at the Museum of Modern Art in 1960, like a slap in the face.[1]

The pictures were insufferably arrogant. They seemed to reiterate nothing but insultingly simple principles that only his paintings, however, seemed to understand. Thus, if you are going to make an abstract painting, then you cannot make it in the kind of space used for not-abstract painting. And if you

Plate 27 Frank Stella, *Six Mile Bottom*, 1960, metallic paint on canvas, 300 x 182 cm. © Tate, London 2003, © ARS, NY and DACS, London 2003.

are going to make abstract pictures you have to be sure that your colors don't suggest or take on the quality of non-abstract things, like sky or grass or air or shadow (try black, or if that's too poetic, copper or aluminum). And if one is going to make an abstract painting one should be thoughtful about what kind of image one chooses, how it is placed and what kind of shape the entire picture has because otherwise, before you know it, you are going back into all the classical problems: objects in a tactile space. Also, a picture isn't abstract just because the artist doesn't know when it's finished. Pollock's message wasn't 'Go Wild'; it was 1) keep the field even and without dominant image or incident; 2) be careful about color; 3) keep the space as free from the space needed to depict three-dimensional forms as possible; 4) eliminate gesture, let the method chosen seem to generate the picture. If the *whole* picture is working right, accidents

and inconsistent details don't matter any more than handprints and cigarette butts; there can be mistakes, awkward stretcher bars, even drips.

The main criticism of the pictures seems to have been that they had nothing to say.

The great irony that comes in here is this: all the while that Stella is pursuing, with ferocious single-mindedness, the idea of the completely consistent non-referential abstract painting, artists like Carl Andre and Don Judd are being absolutely fascinated with the literal *objectness* of Stella's paintings [Plate 27]. Andre, who was very close to Stella in the early sixties, seems to have been the first to draw the conclusion that almost all the literalist artists were to come to: if the best painting was moving inevitably toward three dimensions, then the best hope for a true post-Pollock abstraction may lie in three-dimensional art. The incipient move into three dimensions implied in Stella's paintings is made manifestly clear in Andre's work of the early sixties, most explicitly in a work like the 1959–60 untitled construction. Judd, too, made works which seemed to spell out the three-dimensional implications of Stella's work. Both artists seemed to share what can be called a fundamental presumption of literalism: if one has moved into three dimensions because that seems to be where the best abstract art can take form, then there is no sense in making art in three dimensions that tries to approximate the sensations or appearances of two dimensions. On the contrary, the more three-dimensionality is affirmed, acknowledged, declared, explored, the more powerful the work of art can be. One of the ways in which this is done, for Judd, is in the employment of simple orders. Writing in 1965, Judd remarked, 'Stella's shaped paintings involve several important characteristics of three-dimensional work,' and he goes on to list them. Among the things he lists is the *order* of the stripes, which he calls 'simply order, like that of continuity, *one thing after another*.' Stacking is such an order, simple progressions another. Andre depends heavily on orders which, as often as possible, correspond to the way in which materials are used in the literal world, common orders, one thing beside another, like a row of bricks. Almost all the literalist imperatives come from the need to explicitly acknowledge three-dimensionality: structural clarity, everyday materials, directness of relations with materials.

* * *

By the middle sixties almost all of Stella's contemporaries in New York were dealing with literalist issues in one way or another. In three dimensions, literalism was rapidly discovering that earlier blanket strictures against illusionism of any kind was [*sic*] too restrictive an attitude: materials themselves were making that clear enough. Some materials simply led one into certain kinds of illusionism – mirrors, plexiglass, various kinds of perforated metal,

fluorescent light. (By the end of the decade materials would have provided lit-
eralism with ways of drawing, with compositional relations, with fantasy,
with poetry, and all in ways perfectly consistent with the most deep-rooted lit-
eralist convictions.)

Stella's 1966 series — sometimes called the Wolfeboro or Moultonboro series
and in the catalog text called the Irregular Polygons — is one which Michael
Fried thought ought to have been 'unpalatable to literalist sensibility,' partly
because of the incipient illusionism which Stella permitted in them. But it is
interesting to compare the series with what Judd liked about the stripe paintings:

> Stella's shaped paintings involve several important characteristics of three-
> dimensional work. The periphery of a piece and the lines inside corre-
> spond. The stripes are nowhere near being discrete parts. The surface is far-
> ther from the wall than usual, though it remains parallel to it. Since the
> surface is exceptionally unified and involves little or no space, the parallel
> plane is unusually distinct. The order is not rationalistic and underlying,
> but is simply order, like that of continuity, one thing after another. A paint-
> ing isn't an image. The shapes, the unity, projection, order and color are
> specific, aggressive and powerful.

The periphery of the Irregular Polygons and the lines inside correspond; the
surface is even farther from the wall than previously; the order of the painting
is not rationalistic and underlying but is simply order, like the order of a map,
and, like a map, is not an image but a unity of shapes whose projection, order
and color are specific, aggressive and powerful. Certainly, the paintings were a
little 'soft on illusionism,' but illusionism, as Ron Davis was shortly to make
even clearer, wasn't the issue in 1966 that it was in 1961. The illusionism in the
Irregular Polygons didn't bother anybody. The pictures affirmed their object-
hood in as straightforward a way as any of his pictures had before.

Without a doubt, the *main* ambitions of the pictures were not related to lit-
eralism or to the issue of objecthood any more than were the main ambitions
of the stripe pictures. In the Irregular Polygons these ambitions seem to have
had more to do with getting to use color in a way not previously available to
Stella; the very fact that they *needed* color as they did pointed to a growing
conviction that a high post-Pollock abstract art founded on structure alone
could not be carried further than Stella had already carried it. ('The sense of
singleness . . . has a better future outside of painting,' Judd had written the
year before.)[2] A second ambition, obvious in the *blitzkrieg* manner of Stella's
attack (who ever thought of making paintings with shapes like *that?*), was to
raid the shaped canvas and convert it into what would be, for the next while
at least, virtual private property. But in the course of accomplishing these
ambitions Stella had given a whole lease on life to literalist painting.

By 1966 Stella had been under the gun for five years. In the Irregular
Polygons he accomplished a major change of style without having to give an

inch of his position in the center of advanced art in New York and without managing to repudiate any of the meanings which literalism attached to his work. The strain shows in the paintings, many of them the most explicitly violent Stella has ever made. Forms interpenetrate as if by naked force; spiked, sharp edges abound; colors often verge on the hysterical. It is astonishing that even as these paintings are being made the vision of a monumental decorative muralism is taking form in the artist's mind.

As the sixties drew to a close, the relationship between literalism and abstraction in American art changed considerably. When the decade opened, both literalism and abstraction shared the ambition to make the most advanced abstract art it was possible to make after Pollock. As the decade came to an end it was clear that within literalism several tendencies had emerged and the issue of whether the goal of art making was still high abstraction was no longer one on which everyone agreed. The move into three dimensions led further than anyone had anticipated; the interest in materials led to orders and applications vastly more complex than anyone had dreamed. Literalism was encompassing acts and arrangements unthinkable seven or eight years before and artists were making choices which had no sanction as certain, say, as Pollock had granted to the work of the early sixties. Sanction for many of the undertakings of these artists was sought – if it was sought at all – in traditions much older than Modernism, and in this many of the literalist artists of the late sixties resemble the emerging Abstract Expressionists of the mid-forties. For both, the sense of a new beginning was overwhelming; for both the idea of *what to do* as artists was up for grabs; for both uncertainty, especially as it pertains to their relationship to the tradition of modern art – and not merely the plastic tradition but the social and economic traditions of museums, dealers, collections and collectors – is the fundamental condition of their creative lives.

1 *ARTnews*, for example, went into shock. In writing up 'Sixteen Americans' Stella's name wasn't even *mentioned.* [The dates of the exhibition, *Sixteen Americans*, organized by Dorothy Miller, were December 16, 1959 to February 14, 1960.]

2 All the Judd quotations are from 'Specific Objects,' *Arts Yearbook*, 1965.

2. Alex Potts, 'Space, Time and Situation'

This text forms part of a longer chapter, 'Objects and Spaces', which is in turn part of an extended consideration of Minimal Art. Alex Potts's primary concern is with what he calls 'the phenomenological turn' that took place in sculpture in the 1960s. By this, Potts means the shift from the conditions of the ideal encounter with the modernist work of art – a disinterested spectator instantaneously apprehending the resolved formal configuration – to the conditions of the anticipated encounter with the literalist object: an

embodied viewer moving around a physical object that is present in the same physical space. Potts relates the work of the sculptor Donald Judd to the earlier painting of Jackson Pollock and Barnett Newman, even as he differentiates the experience it offers both from the modernist sculpture of Anthony Caro and from other, more resolutely materialist three-dimensional work such as that of Richard Serra, Carl Andre and Eva Hesse. The reference at the end of the extract to Theodor Adorno and Maurice Merleau-Ponty is to an earlier discussion in which Potts relates Adorno's aesthetic theory to Michael Fried's modernism, and contrasts both theories in turn with Merleau-Ponty's phenomenological account of perception. The following extract is taken from Chapter 8 of Alex Potts, *The Sculptural Imagination. Figurative, Modernist, Minimalist*, Yale University Press, New Haven and London, 2000, pp. 296–307.

There is an intriguing passage in a late essay by Judd called 'Abstract Expressionism' in which he explained how the painting he particularly admired, the work of Jackson Pollock and Barnett Newman, provoked a powerful response that was quite different from the 'immediate emotions you feel when looking at the world' — by these he no doubt had in mind, not just conventional poeticised emotions such as gloom or regret or elation, but also other immediate, less nameable affects. He went on: 'The thought and emotion of their work is of the more complex kind, undefinable by name, underlying, durable, and concerned with space, time and existence.[1] This take on Newman and Pollock is straightforwardly modernist, and in many respects directly echoes Greenberg's outlook. Judd was insisting that the most profound art, the art that engaged the viewer at the deepest level of which visual art was capable, was a radically abstract art that had no truck with representational content or conventional expressive feeling. But unlike Greenberg, Judd did believe that something could be said about the larger significance or content of such art.

He was explicit on this when he came to try to sum up what he felt the larger significance of his own work might be — work he clearly saw as continuing within the parameters opened up by Newman and Pollock:

> My work has the appearance it has, wrongly called 'objective' and impersonal', because my first and largest interest is in my relation to the natural world, all of it, all the way out. The interest includes my existence, a keen interest, that is created by the existing things. Art emulates this creation or definition by also creating, on a small scale, space and time.[2]

Nothing if not grandiose, but interestingly also specific in its phenomenological insistence that art has to do with the relation between self and physical world. Art's imbrication in one's sense of existing as a physical entity also had for Judd a latent social dimension, as he made clear when he commented that

'art is certainly about the existence of whoever is doing it and by implication about the existence of other people. And, of course, the existence and the circumstances a person exists in.3 Within this framing, the significant social – and also potentially political – content of art did not have to do with a social truth or attitude it expressed or represented but with the fact that it was of its very nature rooted in social existence. Art, in other words, did not articulate existential truths but functioned by being embedded in the network of relations between self and world and self and other that constitute our being alive.

Time and space, understood in these existential terms, were not objectively given entities but, according to Judd, needed to be activated in the process of establishing oneself as being there at a particular place and time. 'Space doesn't exist; time doesn't exist either', as he put it. 'So you have to make them exist. We know space and time, because things occur in them, are in it or happen in it. They are made by positions, events.' Judd's mind-set regarding this matter could be located somewhere between an eighteenth-century Humean empiricism and a twentieth-century existential phenomenology, though the rhetoric, the succinct concreteness of his formulations, puts his style of thinking more in the former category. What is particularly interesting, though, is that he then goes on to give a larger conceptual framing to an idea widely current among his contemporaries, that a three-dimensional work of art is not an autonomous resplendent thing but has the conditional autonomy of something intervening in and activating the relatively neutral space surrounding it. As he put it, 'When you make a work of art, you are making space or further architecture . . . We have space in this room, but it is a weak nondescript, neutral space.'4

Judd's fullest account of how a work of art might activate a heightened sense of being situated in space and time comes in his discussion of Barnett Newman [Plate 28]. Here he singles out several statements made by Newman, feeling that they 'explain much about his work' and also that of other Abstract Expressionists whom Judd admired, including the following:

> 'One thing that I am involved in about painting is that the painting should give a man a sense of place, that he knows that he's there, so he's aware of himself . . . that the on-looker in front of my painting knows that he's there . . .'5

Interestingly, Newman envisaged the sculpture of Judd and that of several of his contemporaries in exactly these terms, explaining how 'some do make something where if you stand in front of it you know that you're there'.6 It is clear that Newman's work was a particularly important point of departure for the new three-dimensional art of the 1960s. Serra indicated how and why this was the case: 'In Newman content is inseparable from your sense of space and time. Without your experience there is no content in a Newman painting.'7 Morris too felt deeply drawn to Newman's work and commented on its 'real sense of immediacy, the greatest sense of immediacy of any painting that I have experienced.'8

Plate 28 Barnett Newman, *Vir Heroicus Sublimis*, 1950–51, oil on canvas, 243 x 542 cm. The Museum of Modern Art, New York. Gift of Mr and Mrs Ben Heller. DIGITAL IMAGE © 2002 The Museum of Modern Art, New York/Scala, Florence. © ARS, NY and DACS, London 2003.

For Judd, the sense of situation produced by Newman's work was not that of a 'single whole thing' located firmly in one place but was more 'open and extended'. In Newman's painting, he explained, 'the areas are very broad and are not tightly delimited by either the stripes or the edges of the canvas'. Particularly striking was 'Newman's openness and freedom', qualities that the 'closed somewhat naturalistic form' of earlier painting did not have.9 According to Judd, the sense of ' "place", "here", "moment", "now" ' that his paintings asserted was an expansive one, though also one that involved an emphatic, almost heroic self-affirmation – I must admit I have cut out a certain amount of melodramatic heroics from the statements by Newman that Judd quotes. But if this accent is prevalent throughout Judd's commentary on art, he is also intrigued by other styles of being that works of art can posit, and it is probably most fruitful to see his own art as operating somewhere between heroic gesture and a down-beat matter-of-factness. I quote from some comments occasioned by an early exhibition of Morris's early grey plywood objects:

> these facts of existence are as simple as they are obdurate . . . Things that exist exist, and everything is on their side. They're here, which is pretty puzzling . . .10

The paintings of Newman, and of Pollock, were also exemplary for Judd because they apparently differed categorically from earlier European abstract painting by defining a new conception of pictorial wholeness. This insistence on a restructured sense of wholeness, shared by a number of Minimalist artists working in three dimensions at the time, now seems one of Judd's more

narrowly formalist obsessions.[11] However, already in the 1966 interview
'Questions to Stella and Judd', he was putting a larger philosophical gloss on
it. He made the point, often repeated in his later writing, that traditional pic-
torial composition related to a rationalist, one might say Cartesian, world
view that was no longer credible. An art based on compositional structures,
where discrete parts were carefully added together to create an integrated
whole, was, as he explained, 'based on systems built beforehand, *a priori* sys-
tems; they express a certain type of thinking and logic that is pretty much dis-
credited now as a way of finding out what the world's like' by 'both philoso-
phers and scientists'.[12]

Judd's views are firmly in line with much philosophical thinking in the
period that set up Cartesian rationalism as something of an aunt sally, epito-
mising an overly schematic and subject-centred understanding of conscious-
ness and perception. His ideas also have affinities with the phenomenological
critiques of rationalistic models of coherence implicit in traditional under-
standings of viewing and one-point perspective that were developed, for
example, by Merleau-Ponty. But this does not get us very far in understand-
ing precisely what was at issue in the non-compositional sense of wholeness
that Judd insisted on, in contrast with later post-modern or post-structuralist
deconstructors of rationalist paradigms. His notion of the art work as a thing
whose wholeness impresses itself on one immediately and forcefully carries
overtones of powerful, in some ways macho, intensity, but this, as we have
already seen, is not by any means all that is involved.

We need to begin with one of Judd's clearest early statements about how a
viewer experiences a work of art: 'The wholeness of a piece is primary, is
experienced first and directly', he wrote. 'It is not something understood by
the contemplation of parts.'[13] But what is this immediately felt sense of unity?
In a lecture he gave in 1983, he explained how, in his view, a work of art had
unity in the same way that a person had unity, as a basic fact of his or her exis-
tence rather than as an effect of his or her rational self-awareness:

> A person ordinarily lives in a chaos of a great diversity of ideas and
> assumptions, but does function after all as one in a natural way. A person is
> not a model of rationality, or even of irrationality, but lives, which is a very
> different matter. . . . Most people have some philosophical ideas. Almost
> none live by one of the grand systems, only by their fossil fragments.
> Neither is art at the present based on a grand system. The unity in art is the
> same kind of natural unity and is made similarly in the realization that
> knowledge is very uncertain and fragmentary. But as one lives with some
> assertion, art can be made with a corresponding assertion and confidence.
> There's no other way.[14]

The last comment makes it clear that the unity or wholeness of the art work
was not some given entity. It had to be constituted or asserted – 'one lives with

some assertion ... There's no other way.' Its unity was not to be compared to the vague unfocused unity of a whole person's life but to the condensed unity manifest in a single declarative action. As Judd put it, art 'must be as decisive as acts in life, hopefully more so'. So while 'Art is made as one lives', 'the assertions of art depend on more organization and attention than is usual in living ... so that it be clear and strong'. The 'clear and strong' gives a distinctive local, rather masculine, accent to the idea of wholeness and unity, which is amplified in a comment in Judd's essay on Malevich where he conjures up an even more specific sense of male Minimalist cool: 'With and since Malevich the several aspects of the best art have been single, like unblended Scotch. Free.'[15]

At this point we should remind ourselves that Judd is talking about unity constituted in the artist's act of making the work. In his view, 'embodiment is the central effort in art, the way it gets made, very much something out of nothing. Everything happens together and exists together ...'[16] But equally, this unity has to be understood as constituted in the viewer's encounter with the work. There is a necessary reflexivity between what Judd says about making and what we are to understand about apprehending a work, given that the declarative force of the making can only operate if there is an internalised other to whom the artist imagines addressing her or his work, however unconsciously.

To focus on the preoccupation with wholeness and unity is a little misleading, partly because it is manifestly at odds with the logic of Judd's own practice. It also does not tally with some of his theoretical pronouncements. In the essay 'Jackson Pollock' he published in 1967, which offers a much more fully developed account of the formal priorities of the new art as he saw them than his 'Specific Objects' essay of two years before, the really significant novelty of Pollock's work is seen as lying, not just in 'the large scale, wholeness and simplicity which have become common to almost all good work', but also in 'a different idea of the disparity between parts or aspects and ... a different idea of sensation.' Pollock, he explained, departed from the traditional conception of pictorial wholeness in which 'disparity is increased as much as possible within the limits of a given quality, wholeness or generality' and where the parts, for all their particularity, are subordinated to some 'general or main quality', and 'there's a gradation or evening out of parts and aspects.' By contrast, 'the elements and aspects of Pollock's painting are polarized rather than amalgamated ... Everything is fairly independent and specific.'[17]

The essay then identifies what Judd saw to be some of the specific, immediate and undiluted qualities found in Pollock's work: the effect of dripped paint, the materiality of certain particularly striking colours, the distinctive kind of space the work forms and odd fascinating configurations, like the right angle high in the upper right-hand corner of *Autumn Rhythm*. Such configurations may seem suspiciously like parts of a traditional composition. What Judd had in mind, however, were configurations that stand out and float

free and are not anchored in a larger overall configuration, and whose distinctive formation is independent of any shaping elsewhere in the canvas.[18] The really important point, though, is the conclusion he reached. This is stated most unequivocally in an assessment of Abstract Expressionism which he prepared in 1983 where he said of Pollock's work:

> The sensation of dripped paint, the configurations made by it and the whole of any painting are further apart in quality than is usual. A fragment of a Pollock would have much less of the quality of the whole than any part of a DeKooning . . . The greater the polarity of the elements in a work, the greater the work's comprehension of space, time and existence.[19]

Two points are particularly worth noticing. Firstly, Judd is indicating something of general significance, that the sense one has of the more vivid parts or aspects of a work is often not integrated within one's apprehension of its whole form or structure. If a compelling intuition of the wholeness of the work emerges as one experiences the flux of various and at times sharply distinct part-views or aspects, this intuition can be all the stronger if it sustains itself through – and is amplified by – the experience of a part or aspect that affects one so intensely that it momentarily completely holds one's attention. If something about the work's form or structure does come sharply into focus, then this is not the essence, the organising principle of the work, but rather one striking aspect of it. Judd is effectively challenging the parameters of, and suggesting an alternative to, a conventional formal analysis based on the idea that a work is defined by a determining compositional structure or overall shaping of plastic form – whether this structure or shaping is defined as integrative or in more modernist terms as some complex union of dissonant or conflicting parts.

Secondly, there is an important point that relates to the temporal rhythm of viewing implicit in Judd's insistence on the discreteness or specificity of the different aspects of a work. He might be seeming to advocate a return to a Humean understanding of the separateness and integrity of certain basic sensations, and there is no doubt an element of such eighteenth-century empiricism in his style of thinking. But he is making an important point about the particular kind of viewing invited by his own work and the abstract painting to which he felt such affinity. It is a kind of viewing that is continually shifting from one strongly felt aspect of the work to another, bringing with it a heightened awareness that the apprehension of the work is not entirely instantaneous but takes place over a period of time, a period enlivened by an intensified focusing of looking that does not occur in everyday perceptual encounters with things.

His detailed analysis of Newman's paintings can at first reading seem to be a rather bare, deadpan description of what is there before one's eyes, but it is also structured as a finely tuned account of the temporal experience one has in con-

centrating on different features. In the case of *Vir Heroicus Sublimis*, he briefly specifies the colour and width and spacing of each vertical stripe, and the colouring of the areas or fields to either side of them, and then makes the point: 'these stripes are described in sequence but of course are seen at once, and with the areas.'[20] The preceding description taken together with this statement are true to one's apprehension of the work as something that is seen both in a succession of differently focused apperceptions and as one thing. Judd then makes a point about the distinctive dynamic of viewing necessitated by the fact that Newman's paintings are very large in scale as well as being gallery works that one is invited to see from close to, 'not fifty feet back reducing them to pictures.'[21]

While in a traditionally composed picture, it is usually impossible fully to hold onto the overall composition as one stands close to a stretch of canvas, in the case of Newman's work, losing sight of the overall form does not matter in the same way. The painting is primarily to be experienced by moving along it, either literally or shifting the focus of one's gaze, honing in first on this stripe and its immediate context, then the next one, and perhaps lingering for a moment on the field of colour in between.[22] The sense of the whole work is generated in the interplay between these momentarily stabilised partial aspects and one's moving across the whole expanse of the canvas, whose scope one senses at any point without actually having it in sight. In an unpretentious way, Judd's description echoes this movement, pointing also to a richness and subtlety of immediate sensations of shifting colour values, of expansive surfaces and narrow punctuating vertical accents, and of differently coloured areas coming into phase with one another and falling out again, always being pulled back or forward flat to the canvas whenever they start configuring too definite a sense of depth.

With Judd's own work, the shifts occasioned by changes in viewing position and changing focus of attention are more insistent, partly because of its three-dimensionality but also because the surfaces are often opened up to allow a view into their interior. In some of his later work, an extremely plain exterior contrasts strikingly with an interior endowed with bright colouring and a structural complexity that is entirely hidden from certain points of view. The disparity between views onto the outside and ones that open into the interior can be such as to make one feel that one is looking at quite different works. A large steel open-topped box that rests on the ground [Plate 29], for example, whose three-foot high sides block out most of the interior when one stands back from it, looks to be an entirely plain, simple rust-brown structure as one first approaches. Closer to, however, its aspect is completely transformed as one is able to look over the sides into the lower parts of the interior and catch sight of the brilliant yellow colouring of the base and the structure of metal slats cutting into the space just above it.

Judd often colours the interior surfaces of his works, thereby giving a more

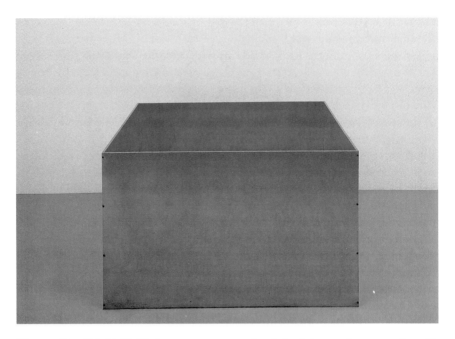

Plate 29 Donald Judd, *Untitled*, 1972, copper, enamel and aluminium, 91.6 x 155 x 178 cm. ©
Tate, London 2003. Art © Donald Judd Foundation/VAGA,New York/DACS, London 2003.

vivid, at times quite affectively loaded, inflection to the distinction between
interior and exterior, and also making one more aware of the variations in
what one can see of the interior from different positions. The inside of his
metal containers is sometimes painted, but most often a difference of texture
and reflectivity as well as hue is introduced, either by lining the interiors
with a very thin layer of coloured perspex or by placing a sheet of coloured
perspex over the open ends so that they tint the light falling inside. Judd
himself, when asked about those stacks in which the metal units had
coloured transparent perspex upper and lower surfaces, made the point that
the contrast between the coloured surfaces and the surfaces of relatively neu-
tral hue made the perception of the work noticeably dependent 'on the view-
ing position of the observer.'[23] Even for a static viewer, position-dependent
variations open up as one notices how different the units look depending on
the angle from which one sees them [Plate 30]. The units close to eye level,
where the plain metal exterior edges dominate, have only small hints of
colour, while those above and below take on an increasing richness of colour
as the tinted perspex tops or bottoms comprise an ever larger portion of the
overall view one has. These stacks also accentuate the double effect of dis-
persal and simple oneness that is such a strong feature of Judd's work. One
can see the work either as a stack of separate shelves or as a coloured column

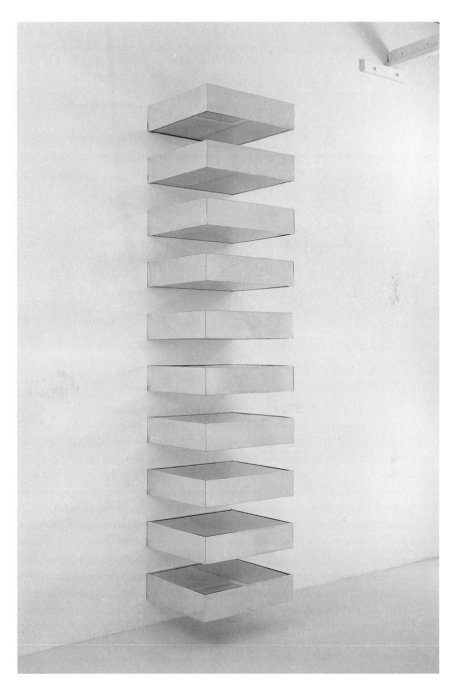

Plate 30 Donald Judd, *Untitled*, 1970, brass and red fluorescent Plexiglas, 15.2 x 68.6 x 61 cm
(ten units each), 305 x 68.6 x 61 cm overall. Courtesy of Pace Wildenstein, New York. Photo:
Ellen Page Wilson. Art © Donald Judd Foundation/VAGA, New York/DACS, London 2003.

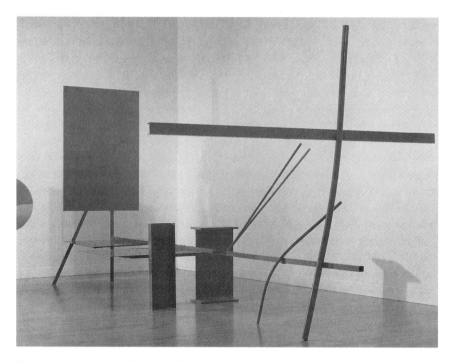

Plate 31 Anthony Caro, *Early One Morning*, 1962, painted steel and aluminium, 290 x 620 x 335 cm. © Tate, London 2003. © Anthony Caro.

of air running through the stacked units from top to bottom.

This rigorous, formalised play with situatedness is itself modernist in tenor, for all the emphasis on the positioning of the viewer in relation to the work. Indeed, in Judd's case, the modernist imperative to undo the massiveness of sculpture achieves a particular consistency and clarity. There are no lumps, no solid plastic forms. Instead, one is made most intensely aware of volumes, of enclosures and openings, of the blocking out and division of space. The structural partitions are so devised that one's attention is focused on the surfaces they define – their texture, colour and reflective or absorptive qualities – and one is hardly aware of their massiveness or substance, as one is, for example, in the case of Serra's work. The metal, perspex and plywood sheets seem more suspended in place than solidly supported. Judd's comment, 'I dislike sculptural bulk, weight and massiveness', is entirely apt.[24] Yet the works are substantial. They are not to be apprehended as pure optical forms, in the way that Fried envisaged Caro's work for example [Plate 31]. The shaping and occupancy of space, the sense of interiority and exteriority, of openness and enclosure, are palpably and sharply defined, are specific and unavoidably there.

The aspect of Judd's generally cool and insistently unexpressive, unanthropomorphic work that stands out as most evidently inviting a psychically

charged response, in addition to the declarative emphasis with which it intervenes in the surrounding space, is its resonant evocation of interior space or volume. This effect is particularly marked in works where the interior surfaces are suffused with the rich reflectivity and liquid texturing of tinted perspex. A contrast is set up between the optically activated yet empty interior spaces, distinguished by a soft, coloured glow and a subtle play of shadows, and the sheer flat expanses of the exterior planes, whether opaque metal, which partly absorbs and partly reflects the incident light, or translucent perspex, which allows light through but also has a slightly reflective sheen.

Characteristically, when Judd was asked about his opening the interiors of his boxes so that one could see inside, he insisted that 'It's fairly logical to open it up so the interior can be viewed. It makes it less mysterious, less ambiguous.'[25] And yet the effect is not all demystification and formal clarity. Judd also saw this opening of the interior volume as having a certain charge, as he indicated when he pointed out how 'none of the boxes has a bottom . . . This opens the box up. The whole scheme has to do with defined ends and open body; this has been a sort of steady idea.'[26] The key phrase 'defined ends and open body' suggests a particular body image. It evokes a volume-defining and specifically positioned shape that, while being clearly circumscribed ('defined ends') also opens out to the spaces around it ('open body'). The optical effect of the sheen of shiny metal and translucent perspex surfaces enhances the sensation of boundaries that are emphatically defined yet not inert and impermeable. For a viewer caught up in a close perceptual engagement with such work, it will resonate with an analogous sense of his or her own body's occupancy of space – a sense of being, not an inert solid mass weighed down on the ground, but an arena of interiority extending outwards into its immediate surroundings while also being sharply delimited and clearly located in one place. There is a vividly physical sense of being there in which substance and weight do not strongly impinge on one's awareness, as they do in different ways with the more realist work of Serra, Hesse and Andre [Plate 32].

Judd's work might just be envisaged as a categorically modernist analogue of the ideal classical nude of earlier figurative sculpture, particularly if one thinks of Greek figures with their poised positioning and their precise and clearly defined surfaces suggesting a certain lightness and openness, a free and easy interchange with the space immediately around them. In such sculpture, as with Judd's, the surfaces strike one more as an activated boundary between interior and exterior than an unyielding outer face of an inert solid lump. Depending on the disposition of the viewer, the forms of the finer classical Greek nudes can become charged with a certain affect, a certain sexiness, that is usually attributed to the representation of tactile bodily forms. Yet the source of the sexiness is not entirely to be located in the object viewed. It can also emanate from the internalised body image induced in the viewer by being in the presence of the work.

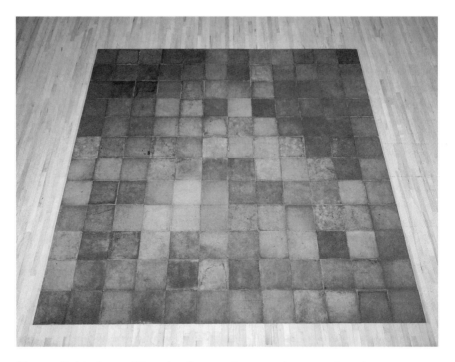

Plate 32 Carl Andre, *144 Magnesium Square*, 1969, magnesium, 144 units each 30.5 x 30.5 cm. Overall 1 x 365.5 x 365.5 cm. © Tate, London 2003. © Carl Andre/VAGA, New York/ DACS, London 2003.

What sharply separates the conception of Judd's work from that of a Greek nude is the categorical erasure of any direct representation of desirable forms or body images in the work itself. This imperative can be read in a number of ways. At its most banal it is a standard modernist negation of representation in the interests of a pure abstraction. What interests me, however, is what this imperative means in relation to the viewer's perceptual engagement with a sculptural object – how a situation has been reached where it is felt that any intensified bodily or libidinal charge will be blocked if these qualities are seen to be objectified in the work.

The mode of viewing that a work by Judd invites might be described phenomenologically as one in which the viewing subject immerses her or himself in the objective world, setting up a symbiosis that can no longer be assimilated to the standard model in which a viewer looks out at an object located apart from her or him. Within the parameters of this standard model, an art object will only come alive if it is projected anthropomorphically as the embodiment of a living presence, or as a subjective feeling or state of mind. With work such as Judd's, a presence emerges that is not locatable in the viewed object itself but in some indeterminate region embracing the viewer's interiorised awareness and the object with which he or she is engaging. While an ideal nude is

in part apprehended in this way, it also invites one to envisage it as a figure endowed with qualities and a presence independent of one's process of apprehending it — as does, in a less insistent way, an abstract modernist sculpture designed to be seen as an autonomous object with its own inner logic. That in Judd's scheme of things a subjective resonance or significance can only be sustained with work where the viewer is precluded from projecting its form as the image or objectified visual model of the subjectivity it intimates, as so much earlier sculpture had been assumed to do, is one of the many things about his project that is historically specific and ideological, relating as it does to newly sceptical understandings of subjectivity, agency and rationality that were gaining currency in the post-war late capitalist world which he inhabited.

Judd once made a point that superficially seems to be at odds with his own art: 'Certainly, form and content, whatever, are made of generalizations, but they are also made of particulars, obdurate and intimate.'[27] 'Obdurate and intimate' would not be my chosen characterisation of Judd's art, though this might be applicable to his writing. But it is still the case that any charged or affective response to his work is going to have an ineradicable tang of particularity, one that no doubt will vary wildly from viewer to viewer. I have been suggesting that some indefinable sexualised intensity, maybe even sexiness, is intimated by the visual and spatial qualities of Judd's work. The latter would include the luminous interiority of the coloured and lightly shadowed volumes enclosed by hard, flat but optically textured and reflective metal surfaces, and the finely tuned divisions of space and precise definitions of inner and outer surface and placement, combined with a suggestion of openness and expansiveness. To this could be added a sense of looming presence that impinges on one physically but never quite becomes dominating or engulfing, as well as the interplay of polished neutrality and lively intensity in the play of light reflected on and absorbed by the sheer surfaces.

These are my specific, some might say very male-biased responses. Other viewers have identified in Judd's work suggestions of dandyish anxiety and lack, or even violence.[28] All these reactions only make any sense if a work by Judd is also seen for what it evidently is — an object, potentially empty, alien and indifferent. It would not be true to the condition of art, particularly of sculpture, in our time if this ambiguity were not so plainly and squarely manifest in it. The work is intriguing because its very physical constitution makes the instabilities in the close bodily-invested engagement with things invited by later twentieth-century art so vivid. Faced with its immaculate structures, whose look both anticipates and echoes commercial Minimalist design, just as the forms of Brancusi's sculptures prefigure chique Art Deco, viewer responses can veer between a sense of rigid alienation and of vivid immediacy, of uncompromising blankness and of sparely, subtly and openly articulated significance. In other words, viewer interactions with Judd's work play out the divergent imperatives in the aesthetics of modern sculpture that I have asso-

ciated with Adorno on one hand and Merleau-Ponty on the other. The French philosopher's intensified focus on the immediate phenomenology of viewing has come to the fore in a context where there has also emerged a sharpened awareness of the reifications inherent in the definition and apprehension of art objects in the modern world.

1 Judd, *Complete Writings: 1975–1986* (Eindhoven, 1987), p. 44. He adds, 'It's what Bergson called "la durée".' Something of Judd's phenomenological take on a lived, interiorised experience of time and space may have come from his reading of Bergson, then standard fare for anyone with a philosophical turn of mind interested in the aesthetics of modern art.

2 Judd, *Writings* (1987), p. 32.

3 'Back to Clarity: Interview with Donald Judd', in *Donald Judd* (Staatliche Kunsthalle, Baden-Baden, 1989), p. 92.

4 *Donald Judd* (Kunstverein St. Gallen, 1990), p. 55.

5 Judd, *Writings* (1987), pp. 41–2. Judd is quoting from an interview David Sylvester conducted with Newman in 1966, published in *The Listener* in 1972, and reprinted in J. P. O'Neill (ed.), *Barnett Newman: Selected Writings and Interviews* (Berkeley and Los Angeles, 1992), p. 257. While Newman's paintings excited Judd, he was much less sure about the sculptures: J. Siegel (ed.), *Artwords: Discourses on the 60s and 70s* (New York, 1992), p. 49.

6 *Barnett Newman: Selected Writings*, p. 289 (1967).

7 Serra, *Writings Interviews* (Chicago and London, 1994), p. 280.

8 M. Compton and D. Sylvester, *Robert Morris* (Tate Gallery, London, 1971), p. 19.

9 Judd, *Complete Writings 1959–1975* (Halifax and New York, 1975), p. 202.

10 Ibid., p. 117.

11 See Serra, *Writings*, p. 169, and Andre, *Artforum*, June 1970, p. 57.

12 Battcock, *Minimal Art, A Critical Anthology* (Berkeley, Los Angeles and London, 1995), p. 151.

13 Judd, *Writings* (1975), p. 153 (1964).

14 Judd, *Writings* (1987), p. 29.

15 Judd, *Writings* (1975), p. 212. Compare the baseball metaphor Frank Stella used to explain what he meant by the 'quality of simplicity' in art: 'When Mantle hits the ball out of the park, everyone is sort of stunned for a minute because it's so simple': Battcock, *Minimal Art*, p. 164.

16 Judd, *Writings* (1987), p. 31.

17 Judd, *Writings* (1975), p. 195.

18 Ibid.

19 Judd, *Writings* (1987), p. 45.

20 Judd, *Writings* (1975), p. 201.

21 Judd, *Writings* (1987), p. 47.

22 On this see Y.-A. Bois, 'Perceiving Newman', *Painting as Model* (Cambridge, Mass., and London, 1990), pp. 187–213.

23 *Don Judd* (Pasadena Art Museum, 1971), p. 36.

24 Ibid., p. 37.

25 Ibid., p. 36.

26 Ibid., p. 41. Here he is referring to work with sides and tops that are closed, or mostly closed in, not the metal boxes with open tops and often coloured floor panels, or the boxes open at both ends that structurally require a floor element.

27 Judd, *Writings* (1987), p. 56 (from an article published in 1984).

28 See Briony Fer's suggestive interpretation (B. Fer, *On Abstract Art*, New Haven and London, 1997) of the formal and psychic ambiguities operating in Judd's work. A polished brass floor piece (*Untitled* 1968, Museum of Modern Art, New York) by Judd features in Chave's diagnosis of what she sees as the 'domineering, sometimes brutal rhetoric' of Minimalist art in her 'Minimalism and the Rhetoric of Power', *Art Magazine*, January 1990, p. 44.

3. Lucy Lippard, 'Escape Attempts'

Lucy Lippard was an active participant, both as an art critic and an exhibition organiser, in the anti-modernist avant-garde of the late 1960s. She went on to become a leading feminist critic during the 1970s and 1980s. The present essay was written for the catalogue of the exhibition *1965– 1975: Reconsidering the Object of Art*, held at the Museum of Contemporary Art, Los Angeles in October 1995. This was an ambitious attempt to re-examine the spectrum of activity in the post-minimalist expansion of art, and Lippard brings to bear her own intimate knowledge of the New York art scene of that period. She also conveys her scepticism for the would-be authoritative retrospective accounts of academic historians. Her text, accordingly, is resolutely written in the first person. She is particularly concerned to emphasise the relation between the radical art of the time and broader libertarian social movements, especially then-emergent feminism. Throughout her text, Lippard employs the notion of 'Conceptual Art' as an umbrella term covering a wide range of work, including performance. For her, it denotes activity 'in which the idea is paramount and the material form is secondary'. The following extracts are taken from Lucy Lippard, 'Escape Attempts', in Ann Goldstein and Anne Rorimer (eds), *Reconsidering the Object of Art*, exhibition catalogue, Museum of Contemporary Art, Los Angeles and MIT Press, Cambridge, Mass. and London, 1995, pp. 296–307.

I. Biased History

> *Conceptual artists are mystics rather than rationalists. They leap to conclusions that logic cannot reach . . . illogical judgements leap to new experience.*
> Sol LeWitt, 1969[1]

The era of Conceptual art – which was also the era of Vietnam, the Women's Movement, and the counter-culture – was a real free-for-all, and the democratic implications of that phrase are fully appropriate, if never realized. 'Imagine,' John Lennon exhorted us. And the power of imagination was at the core of even the stodgiest attempts to escape from 'cultural confinement,' as Robert Smithson put it, from the sacrosanct ivory walls and heroic, patriarchal mythologies with which the 1960s opened.

On a practical level, Conceptual artists offered a clear-eyed look at what and where art itself was supposed to be; at the utopian extreme, some tried to visualize a new world and the art that would reflect it. Conceptual art (or 'ultra-conceptual art,' as I first called it, in order to distinguish it from Minimal painting and sculpture, earthworks, performances, and other grand-

scale endeavors which appeared in the early sixties as abnormally cerebral) was all over the place in style and content, but materially quite specific. In 1973, I compiled *Six Years: The Dematerialization of the Art Object from 1966 to 1972*, a book 'focused on so-called conceptual or information or idea art with mentions of such vaguely designated areas as minimal, antiform, systems, earth, or process art'; the initial manuscript was about twice the size of that which was finally published. Looking back through it I am re-amazed by the richness and diversity of the genre(s). Unfettered by object status, Conceptual artists were free to let their imaginations run rampant. With hindsight it is clear that they could have run further, but in the late sixties art world, Conceptual art was the only race in town.

Conceptual art, for me, means work in which the idea is paramount and the material form is secondary, lightweight, ephemeral, cheap, unpretentious, and/or 'dematerialized.' Sol LeWitt distinguished between conceptual art 'with a small c' (e.g., his own work, in which the material forms were often conventional, although generated by a paramount idea) and Conceptual art 'with a capital C' (more or less what I have described above, but also, I suppose, anything by anyone who wanted to belong to a movement). This has not kept commentators over the years from calling virtually anything in unconventional mediums 'Conceptual art.'

There has been a lot of bickering about what Conceptual art is/was; who began it; who did what when with it; what its goals, philosophy, and politics were and might have been. I was there, but I don't trust my memory. I don't trust anyone else's either. And I trust even less the authoritative overviews by those who were not there. So I'm going to quote myself a lot here, because I knew more about it then than I do now, despite the advantages of hindsight.

The times were chaotic and so were our lives. We have each invented our own history, and they don't always mesh; but such messy compost is the source of all versions of the past. Conceptual artists, perhaps more concerned with intellectual distinctions in representation and relationships than those who rely on the object as vehicle/receptacle, have offered posterity a particularly tangled account. My own version is inevitably tempered by my feminist and left politics. Almost thirty years later my memories have merged with my own subsequent life and learnings and leanings. As I reconstitute the threads that drew me into the center of what came to be Conceptual art, I'll try to arm you with the necessary grain of salt, to provide a context, within the ferment of the times, for the personal prejudices and viewpoints that follow. I'm not a theoretician. This is an occasionally critical memoir of a small group of young artists' attempts to escape from the frame-and-pedestal syndrome in which art found itself by the mid-1960s.

When the decade began I was a free-lance researcher, translator, indexer, bibliographer, and would-be writer in New York. I began to publish regularly in 1964. The mid-to-late sixties were one of the most exciting times of my

life on every level: I began to make a living from free-lance writing (at almost the exact moment my son was born). I curated my first exhibition, gave my first lectures, published my first two books, began to travel, wrote some fiction, got unmarried, got politicized. Conceptual art was an integral part of the whole process. I came to it, as did most of my artist colleagues, through what came to be called Minimalism. But we converged from very different directions and eventually went off again in others.

The word Minimal suggests a tabula rasa – or rather the failed attempt at a clean slate, a utopian wish of the times that never came true but was important for the goals and desires it provoked. It was and still is an idea that appeals to me, though not for its reality quotient. In graduate school I had written a long paper about a tabula rasa swept clean by the Zen monk's broom and Dana's vitriolic humor. I saw materialist echoes of these impossible longings in the paintings of Robert Ryman and Ad Reinhardt. From 1960 to 1967, I lived with Ryman, who was never called a Minimalist in those days because the roots of his white paintings from the late fifties were in Abstract Expressionism; he was 'discovered' around 1967 through the advent of the messier 'process art' and was included in a surprising number of 'Conceptual art' shows, although the term is really inappropriate for his obsession with paint and surface, light and space. We lived on Avenue A and Avenue D and then on the Bowery. Sol LeWitt was a close friend of ours, and my major intellectual influence at the time. (We had all worked at The Museum of Modern Art in the late fifties. Ryman was a guard; LeWitt was at the night desk; I was a page in the library.)

On and around the Bowery, an art community formed that included LeWitt, Ray Donarski, Robert Mangold, Sylvia Plimack Mangold, Frank Lincoln Viner, Tom Doyle, and Eva Hesse. My own history of Conceptual art is particularly entwined with that studio community, and with LeWitt's work and writings; through him, around 1965–66, I met or saw the work of Dan Graham, Robert Smithson, Hanne Darboven, Art & Language, Hilla and Bernd Becher, Joseph Kosuth, and Mel Bochner.

Around 1964–65, Kynaston McShine and I had begun work at The Museum of Modern Art on what became the 'Primary Structures' exhibition he curated for The Jewish Museum in 1966. That year I also wrote the catalogue for The Jewish Museum's retrospective of Ad Reinhardt, the reluctant hero of one branch of what was to become Conceptual art. Joseph Kosuth's storefront Museum of Normal Art was 'dedicated' to him. Around the same time, I met Carl Andre, whose poetic detours around art-as-art made him a cantankerous part of the Conceptual community in spite of himself; he never liked or sympathized with the products, although he hung out with the artists. Donald Judd was also a powerful figure, an obdurately blunt artist and writer who was a model for many younger artists. And Robert Morris, elusive and virtually styleless, was the progenitor of many soon-to-be 'seminal' concepts.

In 1967, John Chandler and I wrote the article on 'The Dematerialization of Art' that was published in the February 1968 *Art International*, in which we saw 'ultra-conceptual art' emerging from two directions: art as idea and art as action. In late 1967, I went to Vancouver and found that Iain and Ingrid (then Elaine) Baxter (the N. E. Thing Co.) and others there were on a wavelength totally unconnected yet totally similar to that of many New York friends. This and later encounters in Europe confirmed my belief in 'ideas in the air' — 'the spontaneous appearance of similar work totally unknown to the artists that can be explained only as energy generated by [well-known, common] sources and by the wholly unrelated art against which all the potentially 'conceptual' artists were commonly reacting,' as I once described the phenomenon.

The question of sources has since become a sore point. Marcel Duchamp was the obvious art-historical source, but in fact most of the artists did not find his work all that interesting. The most obvious exceptions, perhaps, were the European-connected Fluxus artists; around 1960 Henry Flynt coined the term 'concept art,' but few of the artists with whom I was involved knew about it, and in any case it was a different kind of 'concept' — less formal, less rooted in the subversion of art-world assumptions and art-as-commodity. As responsible critics we had to mention Duchamp as a precedent, but the new art in New York came from closer to home: Reinhardt's writings, Jasper Johns's and Robert Morris's work, and Ed Ruscha's deadpan photo-books, among others. Duchampian 'claiming,' however, was an occasional strategy: the N. E. Thing Co. categorized its work as ACT (Aesthetically Claimed Things) or ART (Aesthetically Rejected Things); Robert Huot, Marjorie Strider, and Stephen Kaltenbach all did pieces that 'selected' art-like objects from real life in the city.

In my own experience, the second branch of access to what became Conceptual art was a jurying trip to Argentina in 1968. I returned belatedly radicalized by contact with artists there, especially the Rosario Group, whose mixture of conceptual and political ideas was a revelation. In Latin America I was trying to organize a 'suitcase exhibition' of dematerialized art that would be taken from country to country by 'idea artists' using free airline tickets. When I got back to New York, I met Seth Siegelaub, who has begun to reinvent the role of the 'art dealer' as distributor extraordinaire through his work with Lawrence Weiner, Douglas Huebler, Robert Barry, and Joseph Kosuth. Siegelaub's strategy of bypassing the art world with exhibitions that took place outside of galleries and/or New York and/or were united in publications that were art rather than merely *about* art dovetailed with my own notions of a dematerialized art that would be free of art-world commodity status. A practical man, unencumbered at the time by addiction to ideology or esthetics, Siegelaub went right ahead and did what had to be done to create international models for an alternative art network.

On my return from Latin America I was also asked to co-curate (with painter Robert Huot and political organizer Ron Wolin) an exhibition of important Minimal artworks against the Vietnam war, as a benefit for Student Mobilization and the opening show at Paula Cooper's new Prince Street space. (It included LeWitt's first public wall drawing.) In January 1969 the Art Workers Coalition (AWC) was formed on a platform of artists' rights which was soon expanded into opposition to the Vietnam war. (Anti-racism and then anti-sexism were soon added to the anti-war agenda.) The AWC provided a framework and an organizational relationship for artists who were mixing art and politics that attracted a number of 'Conceptual artists.' Kosuth designed a fake membership card for entrance to The Museum of Modern Art – one of our major targets – with AWC rubberstamped in red across it. Andre was the resident Marxist, Smithson, Judd, and Richard Serra were skeptical, non-participating presences. The Guerrilla Art Action Group (GAAG), consisting at that time of Jean Toche, Jon Hendricks, Poppy Johnson, and Silvianna, was a major force in the AWC's Action Committee, though maintaining its own identity. While GAAG's almost Dada letters to President Nixon ('Eat What You Kill') and other world leaders were in the spirit of the general 'conceptual movement,' their blood-and-guts performance style and their connections to Europe, via Fluxus and Destruction Art, separated them from the cooler, Minimal art-oriented Conceptual mainstream.

So 'Conceptual art' – or at least the branch of it in which I was involved – was very much a product of, or fellow traveler with, the political ferment of the times, even if that spirit had arrived belatedly in the art world. (A small group of artists, including Rudolph Baranik, Leon Golub, Nancy Spero, and Judd had been organizing against the war for several years by then. Even earlier, Reinhardt had also spoken out and demonstrated against intervention in Vietnam, but the Reinhardtian attitude remained that art was art and politics were politics and that when artists were activists they were acting as artist citizens rather than as esthetic arbiters.) The strategies with which we futilely schemed to overthrow the cultural establishment reflected those of the larger political Movement, but the most effective visual antiwar imagery of the period came from outside the art world, from popular/political culture.

For me, Conceptual art offered a bridge between the verbal and the visual. (I was writing abstract, conceptual 'fiction' then; at one point I tried alternating pictorial and verbal 'paragraphs' in a narrative; nobody got it.) By 1967, although I had only been publishing art criticism for a few years, I was very aware of the limitations of the genre. I never liked the term critic. Having learned all I knew about art in the studios, I identified with artists and never saw myself as their adversary. Conceptual art, with its transformation of the studio into a study, brought art itself closer to my own activities. There was a period when I saw myself as a writer-collaborator with the artists, and now

and then I was invited by artists to play that part. If art could be anything at all that the artist chose to do, I reasoned, then so could criticism be whatever the writer chose to do. When I was accused of becoming an artist, I replied that I was just doing criticism, even if it took unexpected forms. I organized my first exhibition ('Eccentric Abstraction') at the Fischbach Gallery in 1966, when critics rarely curated, and considered it, too, just another kind of 'criticism.' (At the height of my conceptually hybrid phase, Kynaston McShine asked me to write a text for The Museum of Modern Art's Duchamp catalogue. I constructed it of 'readymades' chosen by a 'random system' from the dictionary, and to my amazement, they used it.)

I also applied the conceptual freedom principle to the organization of a series of four exhibitions which began in 1969 at the Seattle Art Museum's World's Fair annex. They included wall works, earthworks, and sculptural pieces as well as more idea-oriented pieces. Three aspects (or influences) of Conceptual art were incorporated in these shows: the titles ('557,087' in Seattle) were the current populations of the cities; the catalogues were randomly arranged packs of index cards; and with a team of helpers, I executed (or tried to) most of the outdoor works myself, according to the artists' instructions. This was determined as much by economic limitations as by theory; we couldn't afford plane fare for the artists.

When the show went to Vancouver, it acquired a new title ('955,000'), additional cards, a bibliography, and many new works, which were shown in two indoor locations (the Vancouver Art Gallery and the Student Union at the University of British Columbia) and all over the city. My texts in the card catalogues included aphorisms, lists, and quotes and were mixed in, unsequentially, with the artists' cards. The idea was that the reader could discard whatever s/he found uninteresting. Among my cards:

> *Deliberately low-keyed art often resembles ruins, like neolithic rather than classical monuments, amalgams of past and future, remains of something 'more,' vestiges of some unknown venture. The ghost of content continues to hover over the most obdurately abstract art. The more open, or ambiguous, the experience offered, the more the viewer is forced to depend upon his [sic] own perceptions.(112)*

The third version, in 1970, was a more strictly conceptual and portable exhibition that originated at the Centro de Arte y Comunicación in Buenos Aires as '2,972,453'; it included only artists not in the first two versions: among others, Siah Armajani, Stanley Brouwn, Gilbert & George, and Victor Burgin. The fourth version, in 1973, was 'C. 7,500' – an international women's Conceptual show that began at the California Institute of the Arts in Valencia, California, and traveled to seven venues, ending in London. It included Renate Altenrath, Laurie Anderson, Eleanor Antin, Jacki Apple, Alice Aycock, Jennifer Bartlett, Hanne Darboven, Agnes Denes, Doree Dunlap, Nancy Holt,

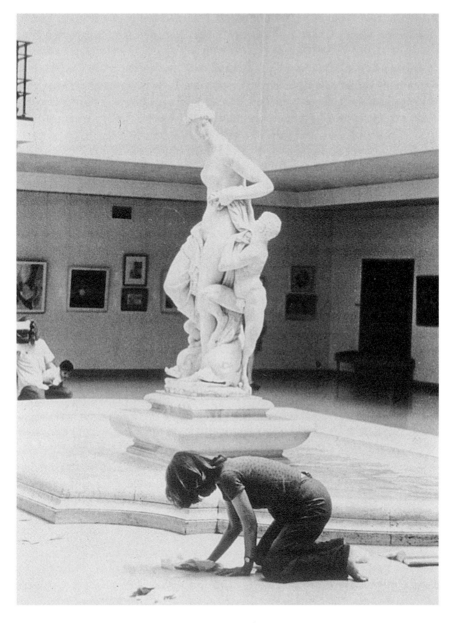

Plate 33 Mierle Laderman Ukeles, *Washing Tracks/Maintenance: Inside*, 1973, black and white photograph of performance at Wadsworth Atheneum, Hartford, Connecticut. Courtesy of Ronald Feldman Fine Arts, New York.

Poppy Johnson, Nancy Kitchel, Christine Kozlov, Suzanne Kuffler, Pat Lasch, Bernadette Mayer, Christiane Möbus, Rita Myers, Renee Nahum, N. E. Thing Co., Ulrike Nolden, Adrian Piper, Judith Stein, Athena Tacha, Mierle Laderman Ukeles, and Martha Wilson. I list all these names here, as I said on a catalogue card at the time, 'by way of an exasperated reply on my own part to those who say 'there are no women making conceptual art.' For the record, there are a great many more than could be exhibited here.

The inexpensive, ephemeral, unintimidating character of the Conceptual mediums themselves (video, performance, photography, narrative, text, actions) encouraged women to participate, to move through this crack in the art world's walls. With the public introduction of younger women artists into Conceptual art, a number of new subjects and approaches appeared: narrative, role-playing, guise and disguise, body and beauty issues; a focus on fragmentation, interrelationships, autobiography, performance, daily life, and, of course, on feminist politics [Plate 33]. The role of women artists and critics in the Conceptual art flurry of the mid-sixties was (unbeknownst to us at the time) similar to that of women on the Left. We were slowly emerging from the kitchens and bedrooms, off the easels, out of the woodwork, whether the men were ready or not − and for the most part they weren't. But even lip service was a welcome change. By 1970, thanks to the liberal-to-left politics assumed by many male artists, a certain (unprecedented) amount of support for the feminist program was forthcoming. Several men helped us (but knew enough to stay out of the decision-making) when the Ad Hoc Women Artists Committee (an offshoot of the AWC) launched its offensive on the Whitney Annual exhibition. The 'anonymous' core group of women faked a Whitney press release stating that there would be fifty percent women (and fifty percent of them 'non-white') in the show, then forged invitations to the opening and set up a generator and projector to show women's slides on the outside walls of the museum while a sit-in was staged inside. The FBI came in search of the culprits.

* * *

III. The Charm of Life Itself

I'm beginning to believe that one of the last frontiers left for radical gestures is the imagination. David Wojnarowicz, 1989[2]

Even in 1969, as we were imagining our heads off and, to some extent, out into the world, I suspected that 'the art world is probably going to be able to absorb conceptual art as another 'movement' and not pay too much attention to it. The art establishment depends so greatly on objects which can be

bought and sold that I don't expect it to do much about an art that is opposed to the prevailing systems' (7–8). (This remains true today – art that is too specific, that names names, about politics, or place, or anything else, is not marketable until it is abstracted, generalized, defused.) By 1974, I was writing with some disillusion in the 'Postface' of *Six Years*: 'Hopes that 'conceptual art' would be able to avoid the general commercialization, the destructively 'progressive' approach of modernism were for the most part unfounded. It seemed in 1969 . . . that no one, not even a public greedy for novelty, would actually pay money, or much of it, for a xerox sheet referring to an event past or never directly perceived, a group of photographs documenting an ephemeral situation or condition, a project for work never to be completed, words spoken but not recorded; it seemed that these artists would therefore be forcibly freed from the tyranny of a commodity status and market-orientation. Three years later, the major conceptualists are selling work for substantial sums here and in Europe; they are represented by (and still more unexpected – showing in) the world's most prestigious galleries. Clearly, whatever minor revolutions in communication have been achieved by the process of dematerializing the object. . . . art and artist in a capitalist society remain luxuries' (263).

Yet, with a longer view, it is also clear that the Conceptual artists set up a model that remains flexible enough to be useful today, totally aside from the pompous and flippant manners in which it has sometimes been used in the art context. Out of that decade from 1966 to 1975 came a flock of cooperative galleries (55, Mercer and A. I. R. being the notable survivors), a tide of artists' books (which led to the formation in 1976 of Printed Matter and the Franklin Furnace Archive), another activist artists' organization led by former Conceptualists (Artists Meeting for Cultural Change) after the AWC faded with the Vietnam war, and an international performance art and video network. Activist and ecological/site-specific work that had its beginnings in the 1960s in Conceptual-related projects has seen a revival in the 1980s and 1990s; the much-maligned Whitney Biennial of 1993 featured more-and-less 'political' art that recalled its Conceptual sources; and feminist activists like the Guerrilla Girls and the Women's Action Coalition (WAC) also renewed 1960s and early 1970s concerns with women's representation in the media, daily life, and role playing/gender-bending.

Perhaps most important, Conceptualists indicated that the most exciting 'art' might still be buried in social energies not yet recognized as art. The process of discovering the boundaries didn't stop with Conceptual art: These energies are still out there, waiting for artists to plug into them, potential fuel for the expansion of what 'art' can mean. The escape was temporary. Art was recaptured and sent back to its white cell, but parole is always a possibility.

1 Sol LeWitt, 'Sentences on Conceptual Art,' in Lucy R. Lippard, *Six Years: The Dematerialization of the Art Object from 1966 to 1972* (New York: Praeger, 1973), 75 Page numbers for further references of *Six Years* are cited in parentheses within the text.

2 David Wojnarowicz, 'Post Cards from America: X-Rays from Hell,' in *Witnesses: Against Our Vanishing*, exh. cat. (New York: Artists Space, 1989), 10.

4. Clement Greenberg, 'Convention and Innovation'

This essay forms one of a number of 'Seminars' that Clement Greenberg published in various art magazines between 1973 and 1979. These short and characteristically pugnacious essays are reworked versions of a series of seminars that he had given at Bennington College, Vermont, in 1971. They are closer to studies in 'aesthetics', in the modern sense of that term, than to art criticism as Greenberg had practised it throughout his career. However, they also provide a vehicle through which he could explain his refusal to endorse what he termed 'far out' art and the significance that a younger generation of artists attached to the work of Marcel Duchamp. In Greenberg's view, the absence of conventions that are felt as binding left much contemporary art 'vacuous' and 'arbitrary', and incapable of providing the same intensity of aesthetic experience as both the great art of the past and modernist art. This essay was originally published as 'Seminar Six' in *Arts Magazine*, June 1976. The following extracts are taken from Clement Greenberg, *Homemade Aesthetics: Observations on Art and Taste*, Oxford University Press, Oxford and New York, 1999, pp. 47–56.

Experience says that formalized art, the kind that most people agree to call art, offers greater satisfactions by and large than any other kind of esthetic experience. Formalizing art means making esthetic experience communicable: objectifying it – making it real – making it public, instead of keeping it private or solipsistic as happens with most esthetic experience. For esthetic experience to be communicated it has to be submitted to conventions – or 'forms' if you like – just as a language does if it's to be understood by more than one person.

Conventions put resistances, obstacles, controls in the way of communication at the same time that they make it possible and guide it. The particular satisfactions we get from formalized art are due, in some essential part, to the sense gotten of resistances coped with by dint of choices or decisions (*intuited* decisions or what I call *judgment-decisions*). Quality, the very success or goodness of formal art derives, formally, from these decisions, from their intensity or density.

The density or intensity of decision that goes into the making of commu-

nicable art has nothing to do with quantity or multiplicity. But it's impossible not to resort to quantitative terms in discussing the matter: thus as when I affirm that as 'much' density of decision can, in principle, go into the shaping of a box as into the carving or modeling of a representation of the human figure. The size, proportions, material, and color of a box can bear as great a weight of intuited decision as the sculpture that fills a pediment. The fact that this has proved unlikely so far (despite some of the achievements of one or two Minimal artists) doesn't make it any the less possible.

To say it over again: Under a certain aspect, and a very real one, quality in art appears to be directly proportionate to the density or weight of decision that's gone into its making. And a good part of that density is generated under the pressure of the resistance offered by the conventions of a medium of communication. This pressure can also act to guide and evoke and inspire; it can be an enabling as well as a resistant pressure; and it guides and enables and evokes and inspires precisely by virtue of its resistance. Measure in verse and in music, patterns in ballet, ordered necessities of progression in drama, prose or verse fiction, and movies: These have empowered creation at the same time as they have constrained it – and because they have constrained it.

The conventions of art, of any art, are not immutable, of course. They get born and they die; they fade and then change out of all recognition; they get turned inside out. And there are the different historical and geographic traditions of convention. But wherever formalized art exists, conventions as such don't disappear, however much they get transformed or replaced. This goes for 'low' art and for folk art and for tribal, pre-urban art as much as it does for high urban art.

Most of what I've just said is not new. But the emphasis I've put on decision or choice may be. If so, that would be thanks to what's happened in art itself in recent years. It's the boringness, the vacuousness of so much of the purportedly advanced art of the past decade and more that has brought home – at least to me – how essential the awareness of decision is to satisfying experience of formal art. For the vacuousness of 'advanced' art in this time is more like that of 'raw,' unformalized art or esthetic experience, which vacuousness derives precisely from the absence of enough conventions and the want of decisions made or received under the pressure of conventions.

'Convention,' 'conventional' became pejorative words during the last century. But another of the theoretical services done by recent 'advanced' art is to begin to rehabilitate them, to make us more careful in using them, just as we've also become more careful in using 'academic' in a pejorative way. Now when we object to art that's found to be too imitative or tame or routine, we have to say '*too* conventional' or '*too* academic' and not 'academic' or 'conventional' *tout court*. Now when we say 'academic' we begin to feel that we have to specify *which* academy and allow at the same time that not all academies were bad. (This, however, isn't just because of the lessons learned from the

latest bad art; it has also to do with the irrefragible fact that taste keeps becoming more catholic, in which respect – and it's the only respect – progress is being made in art or in the context of art.)

Bad, inferior art is not necessarily boring or vacuous. What is relatively new about the badness of recent 'advanced' art – new, that is, in the context of formal art – is that it *is* so boring and vacuous. This, because of the large absence of decisions that could be felt as 'meant,' as intuited and pressured, and not just taken by default. That's just it: that so many of the decisions that go into the supposedly newest art go by default, become automatic, and by the same token arbitrary, decisions. It used to be that the tutored artist failed through wrong or incomplete decisions; but the wrongness or the incompleteness came under the pressure of conventions, which made them 'meant' decisions. Which is why even the failed results could be interesting, at least up to a point. You could get intrigued by what went wrong, receive intellectual if not esthetic pleasure from seeing how it went wrong (even though the possibility of your getting that kind of intellectual pleasure depended upon having enough *taste* to see that something went wrong). The real newness of 'advanced' art in this time consists mostly in the uninterestingness of its failures, their desolateness.

I flatter myself with thinking that I can put myself into the state of mind of the 'far-out' artist. I think that I can do this because the idea of innovation, of newness in art, has been so epidemic since the mid-1960s, and the mind-set that goes with it has consequently become so familiar. Don't we all, in the art world, know now what it feels like to decide to innovate? To go far out? So you start by discarding every, or almost every, convention you can recognize as a convention. You leave easel-painting and 'sculptural' sculpture behind; that is, you 'free' yourself from the conventions that these arts have, as you suppose, been controlled and guided by. You next alight on an 'idea,' 'conception,' or category: serialization, objecthood, literalness, process, 'conditions of perception,' or simply the farfetched and startling. This becomes the decisive moment of creation; all following decisions are left to the care of this moment. You don't intuit your way any further; you don't, if you can help it, make any further decisions or choices; in principle you let that first moment carry you, logically or mechanically, all the way through execution.

No one can say that superior art can't possibly come about this way. Superior art can come about in any way, conceivable or inconceivable; there's no legislating or prescribing, or proscribing either, when it comes to art. There are only, at a given time, greater and lesser probabilities – neither of which are to be *believed* in. But I'm talking here about art that has already come about in the way just outlined. (Art that is already there is the only art that can be talked about.) That art happens to be almost entirely what I've said it was: uninterestingly bad. And I presume to think I can account for this badness, at

least in scheme. This art has been made too largely in freedom from pertinent esthetic pressures (if not from physical, economic, or social ones). The decisions that have gone into it have been too largely tangential in the esthetic context, however much governed by other terms (such as those, say, of serial repetition, or mathematical permutation, or those of the physical or mental environment, etc., etc.).

Esthetic pressure can come from only two directions. There is the pressure of what the artist has to say, make, express. Facing that is the pressure of the conventions of his medium, which is also the pressure of taste — for in the end it's taste and nothing else that empowers or disempowers convention. (But of that more later.) Convention isn't 'form'; rather it's a limiting and enforcing condition that functions in the interests of the communication of esthetic experience. This alone: whether it acts as measure in music; or perspective, shading, design, the 'integrity' of the picture plane in painting; or the notion of compactness or else that of light and shade in sculpture, or else that of a circumscribed ground plane; or as meter in verse; or as the obligation to go from beginning through middle to end in fiction. There are many, many less evident, less specifiable artistic conventions than the like of these 'old-fashioned' ones I've just listed. We have to go along with the notion of convention, for the most part, as with the notion of art: as something recognizable but not adequately definable. That belongs to what makes art what it essentially is, just as it makes intuitive experience in general what it essentially is.

I've already said: The conventions of art are neither permanent nor immutable. But no matter how feeble they may become, they don't — as the record shows — get finished off by fiat, by wishing and willing. At least not fruitfully, profitably, effectively, not in the interests of good art. Conventions will fade and they will die out, but not because anybody has simply resolved to have it that way [...]

Even a rather cursory review of the past of art (of any art and of any tradition of any art) shows that artistic conventions have hardly ever — and maybe never — been overturned or revised *easily*, not by even the greatest of innovative geniuses. A more than cursory review of the past of art, at least of the recent past, shows, however, that conventions have been, and can be, tampered with or abandoned prematurely. Premature innovation afflicts some of the best art of the nineteenth century and some of the just less than best of the twentieth. The frequent ungainliness of Blake's and Whitman's free verse is due to a certain thinness of decision that's due in turn to a departure from measured verse that isn't *lingering* enough; suggesting why they didn't influence or direct succeeding poets except at long and indirect range. Seurat is usually better, in oil, when he stays closest to Impressionism (as in his beachscapes) than when outrightly Pointillist. Both Gauguin and van Gogh are at their best too when closest to 'conservative' Impressionism. That the importance for the future of painting of all three of these artists stems from their

least Impressionist works doesn't change the case as far as sheer quality is concerned (which is part of what could be called the 'problematics' of art in general after 1860). The Impressionists themselves were more consistently successful when they were, as in the late 1860s and earlier 1870s, less than completely Impressionist, when they still hadn't worked themselves free of light-and-dark painting. It was because Cézanne never stopped regretting the light and dark of illusionist tradition, because he kept on trying to rescue the conventions that his Impressionist vision compelled him to undermine – it was in some very important part because of this, the back-drag of the quality of the past – that Cézanne's art steadied itself as it did, for all its ups and downs, on an extraordinarily high level. It was almost precisely because of his greater reluctance to 'sacrifice' to innovation that Cézanne's newness turned out to be more lasting and also more radical than that of the other post-Impressionists. Matisse and Picasso and Braque and Léger and even Mondrian and certainly Klee were likewise reluctant innovators, cherishing the very conventions they felt themselves forced to go against – and by their time it had become a little harder to do that kind of cherishing. It was still harder for Pollock, who from first to last kept yearning for the sculptural shading-modeling that his taste, involved with his own art in its own time and oriented by the best art of the time just before, would not let him return to.

How reluctant such artists as Kandinsky, Kupka, and Malevich were as innovators is hard to tell, but all three of them were premature innovators on the evidence of their art – and erratic because of their prematureness. This at the cost of quality. While shedding certain conventions all three stayed stuck in certain others whose revision was more fundamental to what they were trying to bring about. (That it takes hindsight to see this doesn't matter.) Something similar happened with Gauguin, and with Walt Whitman too (who stayed with certain conventions of rhetoric and diction that often deprived his poetry of a needed tautness). Kandinsky's is almost the exemplary case. His first abstractness, in the pictures he did from 1910 to 1918, fails to assimilate to itself, that is, modify enough, the traditional and conventional illusion of the third dimension, so that in too many of these pictures the abstract configurations get lost in the space that contains them: They wobble and float and sink (though it can't be denied that in certain rare moments this is just what brings a painting off; such being the wonderful inconsistency of quality in art). But it's Kandinsky's outrightly flat pictures, which come afterward, that offer the more obvious case of premature innovation. Here Kandinsky renounces stereometric illusion *in toto*, but the resulting flatness still doesn't stay flat enough because the configurations that he introduces, and still more the placing of these configurations, disrupt that flatness (violates the integrity, rather, of the picture plane, of which the flatness is just an agent); in the showdown there's more integral 'flatness' in a good Ruisdael than in this kind of Kandinsky. The

point is that Kandinsky went over into his all too literal flatness by a leap, so to speak, without having coped with, worked his way out of the conventions of spatial illusion that he was so abruptly discarding.

Duchamp after 1912 is a different kind of example of premature innovation. But in the paintings he made before 1913 his case was, as a case, much like Kandinsky's in scheme. That these paintings are quasi-Futurist and pseudo-Cubist doesn't necessarily hurt them: that is, that they put on a look of newness while retaining a conventional enough 'infra-structure.' But they don't really dispose of the conventions they seem to be shedding (they depend on a traditional illusion of depth more than Kandinsky's first abstract works do), which keeps them a little thin, even a little papery. They also tell us that Duchamp had hardly grasped what real Cubism was about. The first 'recovered objects' that he mounted, the *Bicycle Wheel* and the *Bottle Rack* of 1913, tell us that he didn't know, either, what Picasso's first collage-constructions were about. It was one thing to have your fun with long settled-in conventions (though even that was not so easy when it came to the essential conventions of illusion); it was another thing to 'play' with more recently established ones, like the shuffled planes of Cubism. Duchamp doesn't seem to have had enough taste to cope here. He seems to have thought that Cubism was too much a 'physical' way of art, and at the same time that it was theoretical enough to have required, as he said late in life, to be 'detheorized'!

I can't help thinking, and imputing, that it was out of frustration that Duchamp became so 'revolutionary' after 1912; and that it was out of despair of being new and advanced in his own art that he came to set himself against formal art in general. That he wasn't consistent in this direction; that he kept on making some things that took a proper place as formal art, even rather good formal art (the painting *Network of Stoppages*, the *Glasses* large and small, and still other works) — this doesn't affect my argument. (Duchamp was like most other human beings in not being able to control and program himself beyond a certain point. And formalization, and inspiration with it, can insinuate themselves without being summoned. Also, some artists make superior art only when they give up trying to make it, when they give up conscious awareness and self-awareness. Besides which, I think that Duchamp's unconscious absorbed more of Cubism, and of other excelling art in his time, than his rather mechanical conscious mind let him notice.)

All the same, Duchamp did by intention set himself against formal and formalized art. He did, in effect, try to make free-floating, 'raw' esthetic experience — which is inferior esthetic experience by and large — institutionally viable (showable in art galleries and museums, discussable in print and by art-interested people). His 'raw' art turned out, however, to be less than raw insofar as it had its own orientation to conventions; only these weren't esthetic ones, but the largely un-esthetic conventions of social propriety, decorum. The point became to violate these. So a urinal was shown in an art gallery; the

spread and unclothed lower limbs and the hairless vulva of the effigy of a recumbent young female were put on view through a peephole in a rather staid museum. The point was made. But there was a still further point: to defy and deny esthetic judgment, taste, the satisfactions of art as art. This remained the main point for Duchamp (even though he couldn't always adhere to it: the painted background of his Philadelphia Museum peepshow is beautiful in a small way). And it remains the main point for the sub-tradition that he founded. With the necessity or inevitability of esthetic judgment pushed aside, the making of art and of esthetic decisions, whether by artist or beholder, was freed of real pressure. You could create, act, move, gesticulate, talk in a kind of vacuum – the vacuum itself being more 'interesting,' or at least counting for more, than anything that happened inside it. The gist of consorting with art was to be intrigued, taken aback, given something to talk about, and so forth.

Yet Duchamp and his sub-tradition have demonstrated, as nothing did before, how omnipresent art can be, all the things it can be without ceasing to be art. And what an unexceptional, unhonorific status art as such – that is, esthetic experience – really has. For this demonstration we can be grateful. But that doesn't make the demonstration in itself any the less boring. That's the way it is with demonstrations: once they've demonstrated what they had to demonstrate they become repetitious, like showing all over again how two plus two equals four. That's not the way it is with more substantial art, good and bad: that kind of art you have to experience over and over again in order to keep on *knowing* it. [. . .]

And yet once again: Something has been demonstrated that was worth demonstrating. Art like Duchamp's has shown, as nothing before has, how wide open the category of even formalized esthetic experience can be. This has been true all along, but it had to be demonstrated in order to be realized as true. The discipline of esthetics has received new light. In this respect it doesn't matter that the body of art that has thrown this new light is possibly the worst and certainly the most boring formalized art known to recorded experience. Art as such has lost the honorific status it never deserved as such; and esthetics will never be again what it used to be.

In the meantime genuinely innovative art, major art – the relatively small amount of it there is – goes on in this time much as before. Only now it proceeds underground so to speak, working away at the less apparent conventions and parameters of convention: coping, that is, with what hamstrings and defeats the 'far-out' multitude.

5. Charles Harrison, 'Art Object and Art Work'

This essay was written for the catalogue of the first major retrospective of Conceptual Art, held at the Musée d'art moderne in Paris in 1989. Although authored by a single individual, it nonetheless aims to represent the view of the collaborative group Art & Language, which was formed in England in 1968 and in which a number of different artists have participated. Charles Harrison seeks to retrieve the oppositional character of the 'moment' of Conceptual Art against a now-dominant and highly adminstered postmodernism. However, he also identifies those aspects of high modernism that were felt as oppressive or unduly restrictive, and outlines the different strategies that were adopted in order to restore art's critical dimension. The essay is reprinted in full from *l'art conceptuel, une perspective*, exhibition catalogue, Musée d'art moderne de la ville de Paris, 1989, pp. 61–4.

In a retrospective view the moment of Conceptual Art forms a hiatus between the point of failure of the hegemony of American Modernism in the mid to late 1960s and the announcement of artistic business as normal under the soubriquet of Postmodernism in the later 1970s. In some accounts of this history it is to the moment of Conceptual Art that we should look for the initiation of the artistically Postmodern; in other accounts the success of a (managerially-tractable) and readily distributable Postmodern art represents the cultural defeat of those critical aspirations by which Conceptual Art was impelled. Meanwhile the relics of the movement serve to confuse and to bemuse a new generation of spectators. The aim of this essay is to represent an Art & Language point of view on the moment of Conceptual Art, and to encourage some speculation about the objects of Conceptual Art as these appear under a retrospective regard.

It is conventional wisdom that various forms of 'critique of the object' were conducted in avant-garde artistic circles during the later 1960s. Claims for epochal forms of change and liberation accompanied the broad anti-formal tendency surveyed in such exhibitions as *Op Losse Schroeven* (Stedelijk, Amsterdam 1969), *When Attitudes Become Form* (Kunsthalle Berne and ICA London 1969) and *Information* (Museum of Modern Art, New York 1970). In the years between 1967 and 1972 these claims took public form in the slogans and neologisms of cultural journalism. There was talk of the 'Dematerialization of Art',[1] of a 'Post-Object Art',[2] of 'Art as Idea',[3] of an art 'liberated from all its fetters'.[4]

There were indeed various strains of idealism in the broad avant-garde movement of the time. With the benefits of hindsight a weak anti-materialism may be seen to connect artistic Greens (from Joseph Beuys to Richard Long) with Californian Conceptual Artists, Concrete Poets and autistic savants of the New York artworld. Like the idealism of the Expressionist avant-gardes before

the First World War, this anti-materialism was or implied a form of rejection of the modern – or, at least, of certain interpretations of the meaning and value of modernity. For this reason the idealist tendency in the late-sixties avant-garde has been associated with the critique of Modernism.

Yet the pursuit of (a Baudelairian) modernity had been abandoned both in the mainstream critical theorisation and in the canonic artistic practice of Modernism long before the nineteen sixties. (Indeed in 'Modernist painting' as represented by Clement Greenberg[5] that abandonment was effective as early as the later eighteen seventies, by which time the Realist aspirations of Impressionism had already been practically diverted or frustrated). In turning their backs on the political culture of the time, the avant-garde idealists of the late sixties were doing little to threaten the authority of Modernism as a dominant culture of art. Such critical force as attached to their rejection of modernity was already instinct in the priorities of standard Modernist aesthetics and in the clichés of l'art pour l'art. Modernist critical theory was also alert to the possibility of an avant-gardism of *attitude*.[6] The pursuit of 'purity' in desert spaces and the necrotic exploration of a psychological Bohemia were already prescribed in Modernism's own account of evasive and marginal practices. The same may be said of the extension of the Duchampian 'ready-made' into the realm of 'ideas'. That agnostic disposition which had been productive of interesting anomalies in 1913–15 could not be adopted to the same critical ends in the late 1960s. Idea-tokens as art objects were merely *literal* fulfilments of that reductive tendency which had already been observed in Modernism's historicistic view.

Certainly the idea of a Conceptual Art provided a form of context within which the members of an avant-garde might identify themselves and each other. The artists both in England and New York who were to adopt the name of Art & Language were among those who had produced or proposed various forms of exotic artistic objects during the years 1965–68, as means to test or to resist the habits and assumptions of Modernist production and connoisseurship. It was a perception common to the four founders of Art & Language,[7] however – as well as to Mel Ramsden and Ian Burn and to the independent Victor Burgin – that the conclusion of inquiry into the artistic objects of Modernism was not that avant-garde idealism should be licensed, but rather that the practice of art was in need of more intellectually adequate concepts of 'objecthood'. In 1966–67, in a discussion of their projected *Air Show*,[8] Atkinson and Baldwin noted 'a challenge to the million years habit of identifying "things".' They continued, 'The recognizance of something as something is another question bound up with aspects of things, and not solely with "identification" per-se.' The object of the *Air Show* itself was not an avant-garde 'least object' but rather the hypothetical case around which a series of critical questions were explored. In 1970 Victor Burgin proposed 'a "moratorium" on things – a temporary withdrawal from real objects during

which the object analogue formed in consciousness may be examined as the origin of a new generating system'.[9] He showed what he had in mind in textual works such as *All Criteria*, composed in the same year.[10]

If we are to talk of significant change associated with the moment of Conceptual Art and if we are to associate that change with some effective critique of the culture of Modernism, we must look to more radical differences than the mere promotion of the marginal into the mainstream or the mere projection of 'language' (words) into the physical and cultural space of 'art'. We will look not to global or epochal critiques of 'the object', or of the 'materialism' of the modern, but rather to those forms of critical address which have as their focus the artistic object as specifically framed in the discourse of Modernism. Further, we will look for some critique of Modernism which is a critique of the grounds of its authority to represent art. This is to say that we will look for a critique of the concept of 'art' which assumes that its intensional character is open to question, and which thus seeks to explain – and so far as possible to undo – the historically specific mechanisms of cultural mystification and dominance. In so far as alternative forms of artistic work are proposed in the spirit of this critique, we will require of them that the principles according to which they are individuated are epistemologically adequate and philosophically interesting and not just neological.

In a project of this order the status of the work of art as object will be at best provisional and may have to be strategically cast as incidental. The occasion of the work of art is the point of intersection of two arcs: one formed by the range of intensions, from 'author' or 'creator' to 'producer', which is bounded by the concept 'artist'; the other formed by those terms, such as 'reader', 'spectator', 'audience' and 'consumer', which are values of the variable 'public'. Both 'artist' and 'public' are subject to more precise quantification as qualifying predicates are applied. Thus the point of intersection of that form of public which is represented by the 'adequately sensitive, adequately informed spectator'[11] with that form of artist which is an individual and expressive author locates the normal and normative work of modern art. Of those novel forms of artistic object which were variously proposed during the nineteen sixties, though many may have escaped inclusion within the categories of painting and sculpture, the majority were still capable of being accomodated within a standard form of relationship of artist to public. The practice of some significantly different form of art depended on the possibility of conceiving the intersection of a changed (sense of) artist with a changed (sense of) public, and of acting accordingly. It was this conception which distinguished the critically interesting forms of Conceptual Art from mere post-Minimal avant-gardism. As a critical project in this sense, Conceptual Art was a primarily *European* possibility; that's to say it required emancipation from that historicistic view of the reductive development of art which was a coercive condition of existence in the North-American art-world.

The adoption of the name of Art & Language by a number of individuals in 1968 was a symptom of agreement regarding this possibility of change. Of course, if does not follow that all who were committed to the implications of transformation in the practice of art were to be associated with Art & Language, nor that all who associated themselves with Art & Language were actually so committed. In effect those who were unable to entertain a practice of art unless they could conceive of it as transformable were not in a position to disassociate themselves in all worlds from those whose advertisement of their commitment to radical change was the currency of a normal career. The point is rather that the name of Art & Language may be used to identify a *tendency* in the practice and criticism of art since the later nineteen-sixties – a tendency which was variously to involve a number of people in addition to those who were its true representatives.

The practice of Art & Language can be identified with a specific form of critique of the art object. This critique attends to the discourse within which that object is represented and accorded a value. In the typical discourse of Modernist culture the value of the art object is predicated upon that form of experience or disposition for which it is supposed to be the occasion. The nature of the experience in question is in turn predicated upon the notional type – or *class* – of person to whom it is attributed: the ideally competent spectator. Painting and sculpture as represented within the normal culture of Modernism have typically been seen as occasions for the passive and discriminating contemplation of the supposedly disinterested gentleman. Indeed this form of experience on the part of this class of spectator is what the aesthetic has largely been taken to *mean*. It was the position of Art & Language in the early 1970s that painting and sculpture were contingently *unavailable* for the ends of critical practice, in so far as they were hostage to this form of the aesthetic, that no alternative medium offered the same potential coincidence of complexity and depth, and that the trajectory of Conceptual Art was bounded by its address to the moral culture of Modernist art. It was the position of Burgin, on the other hand, that painting was technically and historically redundant, that '. . . left art practice becomes a matter of practical work in semiotics',[12] and that the propitious medium for this work was photography.

One way to view the project of Art & Language in the late sixties and early seventies is as a sustained attempt to disqualify the competent spectator presupposed in the aesthetic discourse of Modernist culture, and to unseat him from his position as ideal arbiter of taste. In order that different competences might be brought to bear both in the production and in the criticism of art, it was necessary that a different representation of the public be installed in thought, and so far as possible in practice. The requirement of realism to which any image of the public must submit is that it should refer to some actual and potential constituency – and not simply be the self-serving product of liberal (or other) fantasy. Realistically, Art & Language could identify no *actu-*

al alternative public which was not composed of the participants in its own projects and deliberations – whoever they might be. In so far as there was a *potential* public, it was composed not of dispassionate spectators, but of interested readers and learners. The implication of this circumstance was not that the members of Art & Language constituted the only and sufficient audience for Art & Language work. It was rather that no secure principle existed whereby a body of members or teachers or authors could be divided off from the larger world of learners and readers.

Like Art & Language, Burgin conceived of the experience of art by reference to notions of learning rather than notions of contemplation, though where the self-image of Art & Language was of a collection of people who learned in each others' company and who maintained a didactic practice in common, Burgin cast the artist as a kind of radical teacher, emancipated from the self-image or the culture. He saw it as the dual task of the artist 'to unmask the mystifications of bourgeois culture by laying bare its codes ... and to expose the contradictions in our class society, to show us what double-think there is in our second nature'.[13] Burgin and Art & Language were on common ground in their awareness that the significant problems of Modernism are not artistic problems and that they are not open to mere solution in thought. The distance which developed between their respective positions may be suggested by an observation published in *Art-Language* on Burgin's specification of the role of the artist: 'How can a furious revolt, an actual historical practice, or for that matter any practice that conceives "change" as modally complex, fought for – and in – be confused with the "representations" of semiology? Stubborn historical facts will disperse the intoxicating effects of this dessication. The suggestion that we can somehow unmask the mystifications of capitalism and bourgeois ideology with the bogus systems of the French academy must be a joke'.[14] From the point of view of Art & Language 'stubborn historical facts' are limits upon the *effectiveness* of artistic practices. From the position which Burgin had come to adopt, however, the primary aim of struggle is not the redistribution of capital as envisaged in Marxist theory, but a redistribution in 'the economy of desire as mapped in the theory of psychoanalysis'.[15] In the exhibited work of Art & Language, no hostages were offered to the notion of disinterested contemplation. Rather, art was recast as a form of work, with which the spectator could come to terms only in so far as he or she was prepared to engage in the activity of reading. In the late sixties and early seventies, the practice of Art & Language was pursued as an *unaesthetic* practice within the locale of art. Or rather it was pursued as a practice unprotected by those forms of demarcation which have been used in Modernist culture to insulate the aesthetic from the contingent, the empirical from the theoretical, the individual from the collective, high art from popular culture, and art from language. The art object was not dissolved, not 'conceptualised' into immateriality. It was the

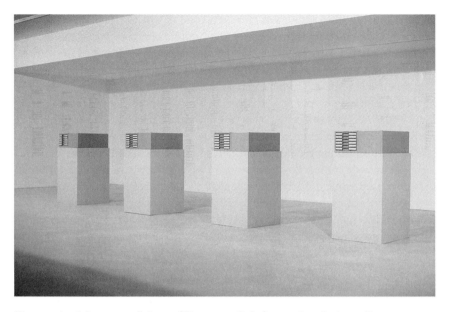

Plate 34 Art & Language, *Index 01*, (*'Documenta Index'*), 1972. Installation at 'l'art con-
ceptuel, une perspective', Musée d'art Moderne de la Ville de Paris, 1989. Eight file cabinets,
text and photostats, dimensions variable. Collection Daros, Zurich. Photo: Charles Harrison.

assumption of its *precedence* that was abandoned. Whatever might be allowed
to count as the 'work of art' was simply surrounded with the evidence of its
own contingency and made strategically to coincide with the materials of its
ratification. Thus, for example, 'work of art' and 'essay' were no longer seen
as securely distinguished by their relative positions within a dichotomous
hierarchy, the latter being generally attendant upon the former as commen-
tary or eulogy. Rather the terms were collapsed together. Linguistic texts were
presented as primary bearers of artistic meanings, while the requirement
made of 'works of art' was that they should be open to discursive readings.

 The intended suppression of the disinterested spectator entailed that the
status of the artist as author should also be treated with scepticism. As already
implied, assumptions about the status of the artist as author are connected
both to assumptions about the object character of the work of art – or to
assumptions about its transcendence of that character – and to presupposi-
tions of audience. Conventionalization of the relations between audience and
author tends to stabilize the technical categories of art. In turn, in so far as the
critical self-image of the culture depends upon the plausibility of the aes-
thetic, the idealisation of a patrician public and of its experience necessitates
a commensurable image of the artist as author. To identify the work of art
with the passive experience of the disinterested spectator is to require that the
character of art as production be masked. It follows that the character of the

artist as producer must be clothed in the fiction of the artist as creator.[16]

To open to question those conventions according to which the work of art is individuated and experienced was thus also to question assumptions about the individual artist and about his or her position as author of the work. The representative productions of Art & Language were intended to be devoid of those forms of signification of individuality which are normally associated with the authorship of art. It was assumed that where the prevailing stereotypes of artistic individuality were still in force – as they were, for instance, in the great majority of American Conceptual Art – there could be no significant change in the operative concept of public, and thus no real displacement of the ontology of art.

Of course, unity between theory and practice is not to be achieved simply by willing it. Indeed it is a condition of culture under capitalism that while the possibility of unity is held out in *theory*, it is not actually achievable, even in thought. In so far as practice could be made public, 'works of art' by Art & Language were often enough extruded, not as the contingent products of a discursive activity, but as the non-discursive objects of a passive regard. Anxious curators, faced with the need to include an Art & Language representation in mixed exhibitions, resorted to framing copies of the journal *Art-Language* and mounting them on gallery walls, thereby at one and the same time confirming their own stereotypes of avant-gardism and establishing the journal as literally unreadable. The normal requirements of exhibition were that modest enterprises be made to feature as big moments, stripped of all sense of their accidentality, while strategic enterprises be cast adrift from the contingent conditions to which they were addressed and left to stand as 'objects' enabling 'experiences'.

Whatever forms of 'difference' the Post-modern is supposed to have recognised, these requirements have not been transformed. They were confronted, however, in Art & Language's *Indexes* of 1972–74, the first of which was exhibited at *Documenta 5* in the summer of 1972. [Plate 34] This work was a product of the various problems touched on in this essay: the problem of the art object and of the means of its individuation in the light of critiques of Modernism; the problem of the public and of the means of transformation of spectator into participant: the problem of the artist as author and of the means of suppression of the individual artist as creator; and finally the problem of the art object as relic and residue – the problem of securing, in the abiding, curated form of the art *object*, some undefeasible representation of its contingent status as art *work*.[17]

1 See Lucy Lippard and John Chandler, 'The Dematerialization of Art', *Art International*, February, 1968.

2 See Donald Karshan, 'The Seventies: Post-Object Art', *Studio International*, September 1970. This essay was originally intended as an introduction to the exhibition *Conceptual Art and Conceptual*

Aspects. New York Cultural Center, New York, 1970.

3 'Art as Idea' was the title given to a collection of Conceptual Art 'works' and 'documents' acquired in
 1970 by the Circulation Department of the Victoria and Albert Museum, London. A selection of 'Art
 as Idea from England' was sent as a touring exhibition to South America in the following year. The
 present author had a hand in both.

4 'Avec ce nouveau mouvement, l'art s'est libéré de tous ses carcans!' Grégoire Muller, catalogue intro-
 duction to *When Attitudes Become Form*, Kunsthalle, Berne and Institute of Contemporary Arts,
 London, 1969.

5 See Clement Greenberg, 'Modernist Painting', *Forum Lectures* (Voice of America), Washington DC,
 1960. Reprinted with revisions in *Art and Literature*, Lugano, no. 4, Spring 1965, pp. 193–201.

6 See for instance, Clement Greenberg, 'Avant-Garde Attitudes: New Art in the Sixties', originally
 delivered as a lecture at the University of Sydney, Australia, on 17 May 1968, and published in *Studio
 International*, London, April 1970.

7 Terry Atkinson, David Bainbridge, Michael Baldwin and Harold Hurrell registered the name 'Art &
 Language' as a partnership in England in 1968, though they had been variously associated in joint
 projects for two years previously. After publication of the first issue of *Art-Language* by these four in
 May 1969, Joseph Kosuth was invited to act as American Editor, while Ian Burn and Mel Ramsden
 were invited to merge their Society for Theoretical Art and Analyses with the journal. Burn and
 Ramsden merged their separate collaboration with Art & Language in 1971. In the same year Philip
 Pilkington and David Rushton merged their journal *Analytical Art* with its effective parent, and my
 own relationship with Art & Language was formalised in the title of General Editor. These were the
 ten names which were listed in association with the exhibition of *Index 01 at* 'Documenta 5' in the
 summer of 1972.

8 *Air Show* was a project of 1966–67, undertaken by Atkinson and Baldwin. The project and its impli-
 cations were discussed in their essay *Frameworks*, published as a limited edition booklet by Art &
 Language Press, Coventry, 1968.

9 'Thanks for the memory', *Architectural Design*, August, 1970.

10 First published in the catalogue of the exhibition *Idea Structures*, Camden Arts Centre, London, 1970.

11 This form of specification of the ideal public is due to Richard Wollheim. See his *Painting as an Art*
 (The A.W. Mellon Lectures in the Fine Arts, 1984). Princeton and London 1987. For a relevant cri-
 tique see Michael Baldwin, Mel Ramsden and Charles Harrison, 'Informed Spectators', *Artscribe*,
 March/April 1988.

12 Burgin, introduction to *Two Essays on Art, Photography and Semiotics*, London, 1975.

13 Burgin, ibid, quoted in *Art-Language* vol. 3 no. 4 *(Fox 4)*, October 1976.

14 Art & Language, 'The French Disease', *Art-Language*, op. cit.

15 See Burgin, 'The absence of presence: conceptualism and post-modernisms', in the catalogue for *'1965
 to 1972 – when attitudes became form'*, Kettle's Yard Gallery, Cambridge, 1984.

16 The classic exposition of the conceptual relations between artist and producer is Walter Benjamin's
 'The Author as Producer', originally given as an address at the Institute for the Study of Fascism,
 Paris, in April 1934, and published in Benjamin, *Versuche über Brecht*, Frankfurt am Main, 1966. See
 also Art & Language, 'Author and Producer Revisited', in *Art-Language*, vol. 5 no. 1, October 1982,
 reprinted in Charles Harrison and Fred Orton eds., *Modernism, Criticism, Realism*, London and New
 York, 1984.

17 The raw materials of the *Index* were the accumulated contents of *Art-Language*, together with other
 texts by those associated with Art & Language. These were divided into some 87 discrete fragments,
 each of which was read with regard to each other. The resulting relations between the texts were
 expressed in terms of three possible relations: '+', signifying a relationship of compatibility, '–', sig-
 nifying a relationship of incompatibility; and 'T', signifying that the relevant documents did not
 share the same logical/ethical space and were therefore not to be compared in advance of some
 notional transformation. At *Documenta*, the texts themselves were housed in eight filing cabinets at
 the centre of a square room. The index of their relations was displayed on the surrounding walls. The
 form and the display paraphernalia of the *Index* solved a problem which had bedevilled Conceptual
 Art from the start: how did one prevent the audience from treating working materials – the pieces of
 paper – as the materials of 'art'; how did one transform 'spectators' into 'readers'?

6. Miwon Kwon, 'One Place After Another: Notes on Site Specificity'

This essay, which was originally published in the journal *October*, forms part of a larger project on site specificity. Here we reproduce the first part of the essay in which Miwon Kwon charts the emergence of site-specific art in the 1960s in targetted opposition to the modernist conception of the artwork as something autonomous and self-sufficient, and hence as indifferent to its location. Kwon identifies three different 'paradigms' of site specificity – the phenomenological, the social/institutional and the discursive – and shows that all three models continue to be operative today. However, she also reminds us that these practices present particular problems and contradictions, both in relation to artists and viewers and in respect of the wider circulation and distribution of artworks. The following extract is reprinted from *October*, no. 80, Spring 1997, pp. 85–96.

Site specificity used to imply something grounded, bound to the laws of physics. Often playing with gravity, site-specific works used to be obstinate about 'presence,' even if they were materially ephemeral, and adamant about immobility, even in the face of disappearance or destruction. Whether inside the white cube or out in the Nevada desert, whether architectural or landscape-oriented, site-specific art initially took the 'site' as an actual location, a tangible reality, its identity composed of a unique combination of constitutive physical elements: length, depth, height, texture, and shape of walls and rooms; scale and proportion of plazas, buildings, or parks; existing conditions of lighting, ventilation, traffic patterns; distinctive topographical features. If modernist sculpture absorbed its pedestal/base to sever its connection to or express its indifference to the site, rendering itself more autonomous and self-referential, and thus transportable, placeless, and nomadic, then site-specific works, as they first emerged in the wake of Minimalism in the late 1960s and early 1970s, forced a dramatic reversal of this modernist paradigm.[1] Antithetical to the claim 'If you have to change a sculpture for a site there is something wrong with the sculpture,'[2] site-specific art, whether interruptive or assimilative, gave itself up to its environmental context, being formally determined or directed by it.[3]

In turn, the uncontaminated and pure idealist space of dominant modernisms was radically displaced by the materiality of the natural landscape or the impure and ordinary space of the everyday. The space of art was no longer perceived as a blank slate, a tabula rasa, but a *real* place. The art object or event in this context was to be singularly *experienced* in the here-and-now through the bodily presence of each viewing subject, in a sensorial immedia-

cy of spatial extension and temporal duration (what Michael Fried derisively characterized as theatricality), rather than instantaneously 'perceived' in a visual epiphany by a disembodied eye. Site-specific work in its earliest formation, then, focused on establishing an inextricable, indivisible relationship between the work and its site, and demanded the physical presence of the viewer for the work's completion. The (neo-avant-garde) aspiration to exceed the limitations of traditional media, like painting and sculpture, as well as their institutional setting; the epistemological challenge to relocate meaning from within the art object to the contingencies of its context; the radical restructuring of the subject from an old Cartesian model to a phenomenological one of lived bodily experience; and the self-conscious desire to resist the forces of the capitalist market economy, which circulates art works as transportable and exchangeable commodity goods – all these imperatives came together in art's new attachment to the actuality of the site.

In this frame of mind, Robert Barry declared in a 1969 interview that each of his wire installations was 'made to suit the place in which it was installed. They cannot be moved without being destroyed.'[4] Similarly, Richard Serra wrote fifteen years later in a letter to the Director of the Art-in-Architecture Program of the General Services Administration in Washington, D.C., that his 120-feet, Cor-Ten steel sculpture *Tilted Arc* was 'commissioned and designed for one particular site: Federal Plaza. It is a site-specific work and as such not to be relocated. To remove the work is to destroy the work.'[5] He further elaborated his position in 1989:

> As I pointed out, *Tilted Arc* was conceived from the start as a site-specific sculpture and was not meant to be 'site-adjusted' or . . . 'relocated.' Site-specific works deal with the environmental components of given places. The scale, size, and location of site-specific works are determined by the topography of the site, whether it be urban or landscape or architectural enclosure. The works become part of the site and restructure both conceptually and perceptually the organization of the site.[6]

Barry and Serra echo each other here. But whereas Barry's comment announces what was in the late 1960s a new radicality in vanguard sculptural practice, marking an early stage in the aesthetic experimentations that were to follow through the 1970s (i.e., land/earth art, process art, installation art, Conceptual art, performance/body art, and various forms of institutional critique), Serra's statement, spoken twenty years later within the context of public art, is an indignant defense, signaling a crisis point for site specificity – at least for a version that would prioritize the *physical* inseparability between a work and its site of installation.[7]

Informed by the contextual thinking of Minimalism, various forms of institutional critique and Conceptual art developed a different model of site specificity that implicitly challenged the 'innocence' of space and the accom-

panying presumption of a universal viewing subject (albeit one in possession of a corporeal body) as espoused in the phenomenological model. Artists such as Michael Asher, Marcel Broodthaers, Daniel Buren, Hans Haacke, and Robert Smithson, as well as many women artists including Mierle Laderman Ukeles, have variously conceived the site not only in physical and spatial terms but as a *cultural* framework defined by the institutions of art. If Minimalism returned to the viewing subject a physical corporeal body, institutional critique insisted on the social matrix of class, race, gender, and sexuality of the viewing subject.[8] Moreover, while Minimalism challenged the idealist hermeticism of the autonomous art object by deflecting its meaning to the space of its presentation, institutional critique further complicated this displacement by highlighting the idealist hermeticism of the space of presentation itself. The modern gallery/museum space, for instance, with its stark white walls, artificial lighting (no windows), controlled climate, and pristine architectonics, was perceived not solely in terms of basic dimensions and proportion but as an institutional disguise, a normative exhibition convention serving an ideological function. The seemingly benign architectural features of a gallery/museum, in other words, were deemed to be coded mechanisms that *actively* disassociate the space of art from the outer world, furthering the institution's idealist imperative of rendering itself and its hierarchization of values 'objective,' 'disinterested,' and 'true.'

As early as 1970 Buren proclaimed, 'Whether the place in which the work is shown imprints and marks this work, whatever it may be, or whether the work itself is directly – consciously or not – produced for the Museum, any work presented in that framework, if it does not explicitly examine the influence of the framework upon itself, falls into the illusion of self-sufficiency – or idealism.'[9] But more than just the museum, the site comes to encompass a relay of several interrelated but different spaces and economies, including the studio, gallery, museum, art criticism, art history, the art market, that together constitute a system of practices that is not separate from but open to social, economic, and political pressures. To be 'specific' to such a site, in turn, is to decode and/or recode the institutional conventions so as to expose their hidden yet motivated operations – to reveal the ways in which institutions mold art's meaning to modulate its cultural and economic value, and to undercut the fallacy of art and its institutions' 'autonomy' by making apparent their imbricated relationship to the broader socioeconomic and political processes of the day. Again, in Buren's somewhat militant words from 1970:

> Art, whatever else it may be, is exclusively political. What is called for is the *analysis of formal and cultural limits* (and not one *or* the other) within which art exists and struggles. These limits are many and of different intensities. Although the prevailing ideology and the associated artists try in every way to *camouflage* them, and although it is too early – the conditions are not met – to blow them up, the time has come to *unveil* them.[10]

In nascent forms of institutional critique, in fact, the physical condition of the exhibition space remained the primary point of departure for this unveiling. For example, in works such as Haacke's *Condensation Cube* (1963–65), Mel Bochner's *Measurement* series (1969), Lawrence Weiner's wall cutouts (1968), and Buren's *Within and Beyond the Frame* (1973), the task of exposing those aspects which the institution would obscure was enacted literally in relation to the architecture of the exhibition space – highlighting the humidity level of a gallery by allowing moisture to 'invade' the pristine Minimalist art object (a mimetic configuration of the gallery space itself); insisting on the material fact of the gallery walls as 'framing' devices by notating their dimensions directly on them; removing portions of a wall to reveal the base reality behind the 'neutral' white cube; and exceeding the physical boundaries of the gallery by having the art work literally go out the window, ostensibly to 'frame' the institutional frame. Attempts such as these to expose the cultural confinement within which artists function – 'the apparatus the artist is threaded through' – and the impact of its forces upon the meaning and value of art became, as Smithson had predicted in 1972, 'the great issue' for artists in the 1970s.[11] As this investigation extended into the 1980s, it relied less and less on the physical parameters of the gallery/museum or other exhibition venues to articulate its critique.

In the paradigmatic practice of Hans Haacke, for instance, the site shifted from the physical condition of the gallery (as in the *Condensation Cube*) to the system of socioeconomic relations within which art and its institutional programming find their possibilities of being. His fact-based exposés through the 1970s, which spot-lighted art's inextricable ties to the ideologically suspect if not morally corrupt power elite, recast the site of art as an institutional frame in social, economic, and political terms, and enforced these terms as the very content of the art work. Exemplary of a different approach to the institutional frame are Michael Asher's surgically precise displacement projects, which advanced a concept of site that was inclusive of historical and conceptual dimensions. In his contribution to the '73rd American Exhibition' at the Art Institute of Chicago in 1979, for instance, Asher revealed the sites of exhibition or display to be culturally specific situations generating particular expectations and narratives regarding art and art history. Institutional siting of art, in other words, not only distinguishes qualitative and economic value, it also (re)produces specific forms of knowledge that are historically located and culturally determined – not at all universal or timeless standards.[12]

In these ways, the 'site' of art evolves away from its coincidence with the literal space of art, and the physical condition of a specific location recedes as the primary element in the conception of a site. Whether articulated in political and economic terms, as in Haacke's case, or in epistemological terms, as in Asher's, it is rather the *techniques* and *effects* of the art institu-

tion as they circumscribe the definition, production, presentation, and dis-
semination of art that become the sites of critical intervention. Concurrent
with this move toward the dematerialization of the site is the ongoing de-
aestheticization (i.e., withdrawal of visual pleasure) and dematerialization of
the art work. Going against the grain of institutional habits and desires, and
continuing to resist the commodification of art in/for the market place, site-
specific art adopts strategies that are either aggressively antivisual – infor-
mational, textual, expositional, didactic – or immaterial altogether – ges-
tures, events, or performances bracketed by temporal boundaries. The 'work'
no longer seeks to be a noun/object but a verb/process, provoking the view-
ers' *critical* (not just physical) acuity regarding the ideological conditions of
that viewing. In this context, the guarantee of a specific relationship
between an art work and its 'site' is not based on a physical permanence of
that relationship (as demanded by Serra, for example), but rather on the
recognition of its unfixed *impermanence*, to be experienced as an unrepeat-
able and fleeting situation.

But if the critique of the cultural confinement of art (and artists) via its
institutions was once the 'great issue,' a dominant drive of site-oriented
practices today is the pursuit of a more intense engagement with the out-
side world and everyday life – a critique of culture that is inclusive of non-
art spaces, non-art institutions, and non-art issues (blurring the division
between art and non-art, in fact). Concerned to integrate art more directly
into the realm of the social, either in order to redress (in an activist sense)
urgent social problems such as the ecological crisis, homelessness, AIDS,
homophobia, racism, and sexism, or more generally in order to relativize art
as one among many forms of cultural work, current manifestations of site
specificity tend to treat aesthetic and art-historical concerns as secondary
issues. Deeming the focus on the social nature of *art's* production and recep-
tion to be too exclusive, even elitist, this expanded engagement with culture
favors 'public' sites outside the traditional confines of art in physical and
intellectual terms.[13]

Furthering previous (at times literal) attempts to take art out of the muse-
um/ gallery space-system (recall Buren's striped canvases marching out the
gallery window, or Smithson's adventures in the wastelands of New Jersey or
isolated locales in Utah), contemporary site-oriented works occupy hotels, city
streets, housing projects, prisons, schools, hospitals, churches, zoos, supermar-
kets, etc., and infiltrate media spaces such as radio, newspapers, television, and
the Internet. In addition to this spatial expansion, site-oriented art is also
informed by a broader range of disciplines (i.e., anthropology, sociology, liter-
ary criticism, psychology, natural and cultural histories, architecture and
urbanism, computer science, political theory) and sharply attuned to popular
discourses (i.e., fashion, music, advertising, film, and television). But more
than these dual expansions of art into culture, which obviously diversify the

site, the distinguishing characteristic of today's site-oriented art is the way in which both the art work's relationship to the actuality of a location (as site) *and* the social conditions of the institutional frame (as site) are *subordinate* to a *discursively* determined site that is delineated as a field of knowledge, intellectual exchange, or cultural debate. Furthermore, unlike previous models, this site is not defined as a *pre*condition. Rather, it is *generated* by the work (often as 'content'), and then *verified* by its convergence with an existing discursive formation.

For example, in Mark Dion's 1991 project *On Tropical Nature*, several different definitions of the site operated concurrently. First, the initial site of Dion's intervention was an uninhabited spot in the rain forest near the base of the Orinoco River outside Caracas, Venezuela, where the artist camped for three weeks collecting specimens of various plants and insects as well as feathers, mushrooms, nests, and stones. These specimens, picked up at the end of each week in crates, were delivered to the second site of the project, Sala Mendoza, one of the two hosting art institutions back in Caracas. In the gallery space of the Sala, the specimens, which were uncrated and displayed like works of art in themselves, were contextualized within what constituted a third site – the curatorial framework of the thematic group exhibition.[14] The fourth site, however, although the least material, was the site to which Dion intended a lasting relationship. *On Tropical Nature* sought to become a part of the discourse concerning cultural representations of nature and the global environmental crisis.[15]

Sometimes at the cost of a semantic slippage between content and site, other artists who are similarly engaged in site-oriented projects, operating with multiple definitions of the site, in the end find their 'locational' anchor in the discursive realm. For instance, while Tom Burr and John Lindell each have produced diverse projects in a variety of media for many different institutions, their consistent engagement with issues concerning the construction and dynamics of (homo)sexuality and desire has established such issues as the 'site' of their work. And in projects by artists such as Lothar Baumgarten, Renée Green, Jimmie Durham, and Fred Wilson, the legacies of colonialism, slavery, racism, and the ethnographic tradition as they impact on identity politics has emerged as an important 'site' of artistic investigation. In some instances, artists including Green, Silvia Kolbowski, Group Material, and Christian Philipp Müller have reflected on aspects of site-specific practice itself as a 'site,' interrogating its currency in relation to aesthetic imperatives, institutional demands, socioeconomic ramifications, or political efficacy. In this way different cultural debates, a theoretical concept, a social issue, a political problem, an institutional framework (not necessarily an art institution), a community or seasonal event, a historical condition, even particular formations of desire, are now deemed to function as sites.[16]

This is not to say that the parameters of a particular place or institution no

longer matter, because site-oriented art today still cannot be thought or exe-
cuted without the contingencies of locational and institutional circumstances.
But the *primary* site addressed by current manifestations of site specificity is
not necessarily bound to, or determined by, these contingencies in the long
run. Consequently, although the site of action or intervention (physical) and
the site of effects/reception (discursive) are conceived to be continuous, they
are nonetheless pulled apart. Whereas, for example, the sites of intervention
and effect for Serra's *Tilted Arc* were coincident (Federal Plaza in downtown
New York City), Dion's site of intervention (the rain forest in Venezuela or
Sala Mendoza) and his projected site of effect (the discourse of nature) are
distinct. The former clearly serves the latter as material source and 'inspira-
tion,' yet does not sustain an indexical relationship to it.

James Meyer has distinguished this trend in recent site-oriented practice in
terms of a 'functional site': '[The functional site] is a process, an operation
occurring between sites, a mapping of institutional and discursive filiations
and the bodies that move between them (the artist's above all). It is an infor-
mational site, a locus of overlap of text, photographs and video recordings,
physical places and things. . . . It is a temporary thing; a movement; a chain of
meanings devoid of a particular focus.'[17] Which is to say the site is now struc-
tured (inter)textually rather than spatially, and its model is not a map but an
itinerary, a fragmentary sequence of events and actions *through* spaces, that
is, a nomadic narrative whose path is articulated by the passage of the artist.
Corresponding to the pattern of movement in electronic spaces of the Internet
and cyberspace, which are likewise structured to be experienced *transitively*,
one thing after another, and not as synchronic simultaneity,[18] this transfor-
mation of the site textualizes spaces and spatializes discourses.

A provisional conclusion might be that in advanced art practices of the past
thirty years the operative definition of the site has been transformed from a
physical location – grounded, fixed, actual – to a discursive vector –unground-
ed, fluid, virtual. But even if the dominance of a particular formulation of site
specificity emerges at one moment and wanes at another, the shifts are not
always punctual or definitive. Thus, the three paradigms of site specificity I
have schematized here – phenomenological, social/institutional, and discur-
sive – although presented somewhat chronologically, are not stages in a linear
trajectory of historical development. Rather, they are competing definitions,
overlapping with one another and operating simultaneously in various cul-
tural practices today (or even within a single artist's single project).

Nonetheless, this move away from a literal interpretation of the site and
the multiplicitous expansion of the site in locational and conceptual terms
seems more accelerated today than in the past. And the phenomenon is
embraced by many artists and critics as an advance offering more effective
avenues to resist revised institutional and market forces that now commodify
'critical' art practices. In addition, current forms of site-oriented art, which

readily take up social issues (often inspired by them), and which routinely engage the collaborative participation of audience groups for the conceptualization and production of the work, are seen as a means to strengthen art's capacity to penetrate the sociopolitical organization of contemporary life with greater impact and meaning. In this sense the possibilities to conceive the site as something more than a place — as repressed ethnic history, a political cause, a disenfranchised social group — is a crucial conceptual leap in redefining the 'public' role of art and artists.[19]

But the enthusiastic support for these salutary goals needs to be checked by a serious critical examination of the problems and contradictions that attend all forms of site-specific and site-oriented art today, which are visible now as the art work is becoming more and more 'unhinged' from the actuality of the site once again — unhinged both in a literal sense of physical separation of the art work from the location of its initial installation, and in a metaphorical sense as performed in the discursive mobilization of the site in emergent forms of site-oriented art. This 'unhinging,' however, does not indicate a retroversion to the modernist autonomy of the siteless, nomadic art object, although such an ideology is still predominant. Rather, the current unhinging of site specificity is reflective of new questions that pressure its practices today — questions engendered by both aesthetic imperatives and external historical determinants, which are not exactly comparable to those of thirty years ago. For example, what is the status of traditional aesthetic values such as originality, authenticity, and uniqueness in site-specific art, which always begins with the particular, local, unrepeatable preconditions of a site, however it is defined? Is the artist's prevalent relegation of authorship to the conditions of the site, including collaborators and/or reader-viewers, a continuing Barthesian performance of 'death of the author' or a recasting of the centrality of the artist as a 'silent' manager/director? Furthermore, what is the commodity status of anti-commodities, that is, immaterial, process-oriented, ephemeral, performative events? While site-specific art once defied commodification by insisting on immobility, it now seems to espouse fluid mobility and nomadism for the same purpose. But curiously, the nomadic principle also defines capital and power in our times.[20] Is the unhinging of site specificity, then, a form of resistance to the ideological establishment of art or a capitulation to the logic of capitalist expansion?

1 Douglas Crimp has written: 'The idealism of modernist art, in which the art object *in and of itself* was seen to have a fixed and transhistorical meaning, determined the object's placelessness, its belonging in no particular place. . . . Site specificity opposed that idealism — and unveiled the material system it obscured — by its refusal of circulatory mobility, its belongingness to a *specific* site' (*On the Museum's Ruins*, Cambridge: MIT Press, 1993, p. 17). See also Rosalind Krauss, 'Sculpture in the Expanded Field' (1979), in *The Anti-Aesthetic: Essays on Postmodern Culture*, ed. Hal Foster (Port Townsend, Wash.: Bay Press, 1983), pp. 31–42.

2 William Turner, as quoted by Mary Miss, in 'From Autocracy to Integration: Redefining the Objectives of Public Art,' in *Insights/On Sites: Perspectives on Art in Public Places*, ed. Stacy

Paleologos Harris (Washington, D.C.: Partners for Livable Places, 1984), p. 62.

3 Rosalyn Deutsche has made an important distinction between an assimilative model of site specifici-
 ty – in which the art work is geared toward *integration* into the existing environment, producing a
 unified, 'harmonious' space of wholeness and cohesion – and an interruptive model, in which the art
 work functions as a critical *intervention* into the existing order of a site. See her essays '*Tilted Arc* and
 the Uses of Public Space,' *Design Book Review*, no. 23 (Winter 1992), pp. 22–27; and 'Uneven
 Development: Public Art in New York City,' *October* 47 (Winter 1988), pp. 3–52.

4 Robert Barry in Arthur R. Rose (pseudonym), 'Four interviews with Barry, Huebler, Kosuth, Weiner,'
 Arts Magazine (February 1969), p. 22.

5 Richard Serra, letter to Donald Thalacker, January 1, 1985, published in *The Destruction of* Tilted
 Arc: *Documents*, ed. Clara Weyergraf-Serra and Martha Buskirk (Cambridge: MIT Press, 1991), p. 38.

6 Richard Serra, '*Tilted Arc* Destroyed,' *Art in America* 77, no. 5 (May 1989), pp. 34–47.

7 The controversy over *Tilted Arc* obviously involved other issues besides the status of site specificity,
 but, in the end, site specificity was the term upon which Serra hung his entire defense. Despite Serra's
 defeat, the legal definition of site specificity remains unresolved and continues to be grounds for
 many juridical conflicts. For a discussion concerning legal questions in the *Tilted Arc* case, see Barbara
 Hoffman, 'Law for Art's Sake in the Public Realm,' in *Art in the Public Sphere*, ed. W.J.T. Mitchell
 (Chicago: University of Chicago Press, 1991), pp. 113–46. Thanks to James Marcovitz for discussions
 concerning the legality of site specificity.

8 See Hal Foster's seminal essay, 'The Crux of Minimalism,' in *Individuals: A Selected History of
 Contemporary Art 1945–1986*, ed. Howard Singerman (Los Angeles: The Museum of Contemporary Art,
 1986), pp. 162–83. See also Craig Owens, 'From Work to Frame, or, Is There Life After "The Death of
 the Author"?' *Beyond Recognition* (Berkeley: University of California Press, 1992), pp. 122–39.

9 Daniel Buren, 'Function of the Museum,' *Artforum* (September 1973).

10 Daniel Buren, 'Critical Limits,' in *Five Texts* (1970; reprint, New York: John Weber Gallery, 1974), p. 38.

11 See 'Conversation with Robert Smithson,' edited by Bruce Kurtz, in *The Writings of Robert Smithson*,
 ed. Nancy Holt (New York: New York University Press, 1979), p. 200.

12 This project involved the relocation of a bronze replica of an eighteenth-century statue of George
 Washington from its normal position outside the entrance in front of the Art Institute to one of the
 smaller galleries inside devoted to eighteenth-century European painting, sculpture, and decorative
 arts. Asher stated his intention as follows: 'In this work I am interested in the way the sculpture func-
 tions when it is viewed in its 18th-century context instead of in its prior relationship to the façade of
 the building. . . . Once inside Gallery 219 the sculpture can be seen in connection with the ideas of
 other European works of the same period' (as quoted in Anne Rorimer, 'Michael Asher: Recent Work,'
 Artforum [April 1980], p. 47). See also Benjamin H.D. Buchloh, ed., *Michael Asher: Writings
 1973–1983 on Works 1969–1979* (Halifax, Nova Scotia, and Los Angeles: The Press of the Nova Scotia
 College of Art and Design and The Museum of Contemporary Art Los Angeles), pp. 207–21.

13 These concerns coincide with developments in public art, which has reprogrammed site-specific art
 to be synonymous with community-based art. As exemplified in projects such as 'Culture in Action'
 in Chicago (1992–93) and 'Points of Entry' in Pittsburgh (1996), site-specific public art in the 1990s
 marks a convergence between cultural practices grounded in leftist political activism, community-
 based aesthetic traditions, conceptually driven art borne out of institutional critique, and identity pol-
 itics. Because of this convergence, many of the questions concerning contemporary site-specific prac-
 tices apply to public art projects as well, and vice versa. Unfortunately, an analysis of the specific aes-
 thetic and political problems in the public art arena, especially those pertaining to spatial politics of
 cities, will have to await another venue. In the meantime, I refer readers to Grant Kester's excellent
 analysis of current trends in community-based public art in 'Aesthetic Evangelists: Conversion and
 Empowerment in Contemporary Community Art,' *Afterimage* (January 1995), pp. 5–11.

14 The exhibition 'Arte Joven en Nueva York,' curated by José Gabriel Fernandez, was hosted by Sala
 Mendoza and Sala RG in Caracas, Venezuela (June 9–July 7, 1991).

15 This fourth site, to which Dion would return again and again in other projects, remained consistent
 even as the contents of one of the crates from the Orinoco trip were transferred to New York City to
 be reconfigured in 1992 to become *New York State Bureau of Tropical Conservation*, an installation
 for an exhibition at American Fine Arts Co. See the conversation, 'The Confessions of an Amateur
 Naturalist,' in *Documents* 1/2 (Fall/Winter 1992), pp. 36–46. See also my interview with the artist in
 the forthcoming monograph, *Mark Dion* (London: Phaidon Press, 1997).

16 See the round-table discussion 'On Site Specificity,' in *Documents* 4/5 (Spring 1994), pp. 11–22. Participants included Hal Foster, Renée Green, Mitchell Kane, John Lindell, Helen Molesworth, and myself.

17 James Meyer, 'The Functional Site,' in *Platzwechsel*, exhibition catalogue (Zurich: Kunsthalle Zurich, 1995), p. 27. A revised version of the essay appears in *Documents* 7 (Fall 1996), pp. 20–29.

18 Despite the adoption of architectural terminology in the description of many new electronic spaces (Web sites, information environments, program infrastructures, construction of home pages, virtual spaces, etc.), the spatial experience on the computer is structured more as a sequence of movements and passages, and less as the habitation or durational occupation of a particular 'site'. Hypertext is a prime example. The (information) superhighway is a more apt analogy, for the spatial experience of the highway is one of transit between locations (despite the immobility of one's body behind the wheel).

19 Again, it is beyond the scope of this essay to attend to issues concerning the status of the 'public' in contemporary art practices. On this topic, see Rosalyn Deutsche, *Evictions: Art and Spatial Politics* (Cambridge: MIT Press, 1996).

20 See, for example, Gilles Deleuze, 'Postscript on the Societies of Control,' *October* 59 (Winter 1992), pp. 3–7; and Manuel Castells, *The Informational City* (Oxford: Basil Blackwell, 1989).

PART V

THE PERFORMANCE OF IDENTITY

Introduction

This Part is primarily concerned with issues of gender and identity as they relate to twentieth-century art practice and theory. The idea that identity is 'performed' by the subject, that is to say, enacted and negotiated through a variety of social and cultural roles rather than being something biologically determined, is principally associated with the writings of the feminist theorist Judith Butler. However, these ideas have been extended to include not only the construction of gender, but also differences of sexuality, race and class. The artist's presentation of an 'image' of his- or herself in the production of an artwork offers a paradigmatic example of the construction of a public identity, whether this be achieved through the trace of the artist's hand in the making of a physical object or the use of the artist's body in more recent art forms such as video and performance art.

Here we offer a selection of texts that address these themes in a variety of different ways. Frank O'Hara's 'Personism. A Manifesto' offers an ironic counter to the aggressive masculinity of mainstream culture in 1950s America, subtly debunking exalted conceptions of the creative artist. Griselda Pollock analyses the complex relation between painting, feminism and history by focusing on the different placements and significations of the 'body of the painter' and the 'feminine body'. Craig Owens addresses the role of feminist art practice and criticism within postmodernism, and considers the work of a number of women artists including Mary Kelly, Barbara Kruger, Sherrie Levine, Martha Rosler and Cindy Sherman. Amelia Jones discusses the categories of 'body art' and 'performance art' and responds to Mary Kelly's criticism that these types of art are informed by a 'naïve essentialism'. Finally, Briony Fer investigates the conjunction of women's art practice and psychoanalysis through an interpretation of some of the sculptural works of Louise Bourgeois and Eva Hesse.

1. Frank O'Hara, 'Personism. A Manifesto'

The American poet, art critic and curator Frank O'Hara published his first book of poetry in 1952. That same year he took up a post at the Museum of Modern Art, New York, which he held until his accidental death in 1966. He was a prominent figure in the contemporary art scene and an active supporter of the New York School. His poetry offers an ironic and humorous, yet genuinely celebratory response to popular culture. Recent attention has focused

on his embrace of 'queer' forms of speech, including gossip and camp, and the extent to which this represented a challenge to the elevated claims and masculinist posturing of much contemporary art. The manifesto is a characteristic melange of pastiche and seriousness. It was written in 1960 and is reprinted from *The Collected Poems of Frank O'Hara*, ed. Donald Allen, University of California Press, Berkeley, Los Angeles, London, 1995, pp. 498–9.

Everything is in the poems, but at the risk of sounding like the poor wealthy man's Allen Ginsberg I will write to you because I just heard that one of my fellow poets thinks that a poem of mine that can't be got at one reading is because I was confused too. Now, come on. I don't believe in god, so I don't have to make elaborately sounded structures. I hate Vachel Lindsay, always have; I don't even like rhythm, assonance, all that stuff. You just go on your nerve. If someone's chasing you down the street with a knife you just run, you don't turn around and shout, 'Give it up! I was a track star for Mineola Prep.'

That's for the writing poems part. As for their reception, suppose you're in love and someone's mistreating (*mal aimé*) you, you don't say, 'Hey, you can't hurt me this way, I care!' you just let all the different bodies fall where they may, and they always do after a few months. But that's not why you fell in love in the first place, just to hang onto life, so you have to take your chances and try to avoid being logical. Pain always produces logic, which is very bad for you.

I'm not saying that I don't have practically the most lofty ideas of anyone writing today, but what difference does that make? They're just ideas. The only good thing about it is that when I get lofty enough I've stopped thinking and that's when refreshment arrives.

But how can you really care if anybody gets it, or gets what it means, or if it improves them. Improves them for what? For death? Why hurry them along? Too many poets act like a middle-aged mother trying to get her kids to eat too much cooked meat, and potatoes with drippings (tears). I don't give a damn whether they eat or not. Forced feeding leads to excessive thinness (effete). Nobody should experience anything they don't need to, if they don't need poetry bully for them. I like the movies too. And after all, only Whitman and Crane and Williams, of the American poets, are better than the movies. As for measure and other technical apparatus, that's just common sense: if you're going to buy a pair of pants you want them to be tight enough so everyone will want to go to bed with you. There's nothing metaphysical about it. Unless, of course, you flatter yourself into thinking that what you're experiencing is 'yearning.'

Abstraction in poetry, which Allen [Ginsberg] recently commented on in *It Is*, is intriguing. I think it appears mostly in the minute particulars where decision is necessary. Abstraction (in poetry, not in painting) involves person-

al removal by the poet. For instance, the decision involved in the choice between 'the nostalgia *of* the infinite' and 'the nostalgia *for* the infinite' defines an attitude towards degree of abstraction. The nostalgia *of* the infinite representing the greater degree of abstraction, removal, and negative capability (as in Keats and Mallarmé). Personism, a movement which I recently founded and which nobody knows about, interests me a great deal, being so totally opposed to this kind of abstract removal that it is verging on a true abstraction for the first time, really, in the history of poetry. Personism is to Wallace Stevens what *la poésie pure* was to Béranger. Personism has nothing to do with philosophy, it's all art. It does not have to do with personality or intimacy, far from it! But to give you a vague idea, one of its minimal aspects is to address itself to one person (other than the poet himself), thus evoking overtones of love without destroying love's life-giving vulgarity, and sustaining the poet's feelings towards the poem while preventing love from distracting him into feeling about the person. That's part of Personism. It was founded by me after lunch with LeRoi Jones on August 27, 1959, a day in which I was in love with someone (not Roi, by the way, a blond). I went back to work and wrote a poem for this person. While I was writing it I was realizing that if I wanted to I could use the telephone instead of writing the poem, and so Personism was born. It's a very exciting movement which will undoubtedly have lots of adherents. It puts the poem squarely between the poet and the person, Lucky Pierre style, and the poem is correspondingly gratified. The poem is at last between two persons instead of two pages. In all modesty, I confess that it may be the death of literature as we know it. While I have certain regrets, I am still glad I got there before Alain Robbe-Grillet did. Poetry being quicker and surer than prose, it is only just that poetry finished literature off. For a time people thought that Artaud was going to accomplish this, but actually, for all their magnificence, his polemical writings are not more outside literature than Bear Mountain is outside New York State. His relation is no more astounding than Dubuffet's to painting.

What can we expect of Personism? (This is getting good, isn't it?) Everything, but we won't get it. It is too new, too vital a movement to promise anything. But it, like Africa, is on the way. The recent propagandists for technique on the one hand, and for content on the other, had better watch out.

2. Griselda Pollock, 'Painting, Feminism, History'

Griselda Pollock's writings and teachings have been influential in placing questions of gender inequality and difference at the forefront of modern art history. She has explored the social and psychic processes, driven and maintained by patriarchal capitalist discourses, which are involved in the construction of gender difference. She has also sought to problematise the disci-

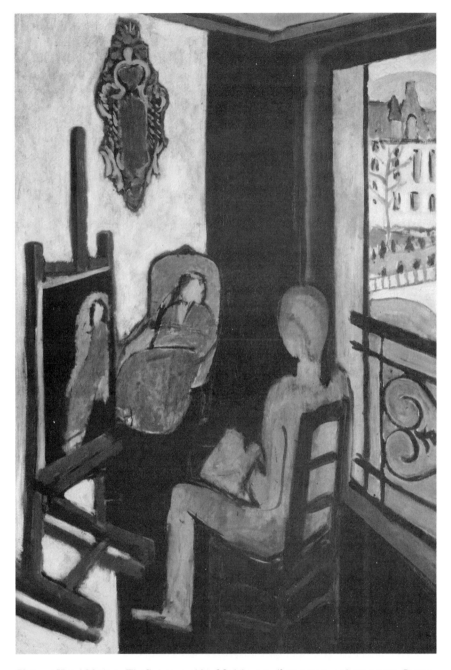

Plate 35 Henri Matisse, *The Painter and his Model*, 1917, oil on canvas, 146.5 x 97 cm. Centre Pompidou-MNAM-CCI, Paris. Photo: © CNAC/MNAM Dist. RMN. © Succession H. Matisse/DACS, London 2003.

pline of art history and its methods of interrogation, placing the construction of sexuality and desire at the centre of its concerns. In this essay, she addresses the complex relations between ideas of the painter's body (usually that of the male artist), the feminine body (as the object of representation) and feminist notions of 'women's bodies'. The following extracts are taken from Griselda Pollock, *Looking Back to the Future: Essays on Art, Life and Death*, G + B Arts International, Amsterdam, 2001, pp. 73–89, 94–9; 103–5. [GP]

In the painting *The Painter and his Model* (1917), Henri Matisse represents an artist at work in the privileged space of modern art, the studio. [Plate 35] Not a documentary image of Matisse's actual working space on the Quai St Michel in Paris, it symbolically represents the ideological conditions in which modern art was created – by *the* painter in *the* studio. The painter, Matisse, is a man, as is *the painter* he symbolizes. More often the man/artist is clothed, while the model, prototypically a woman, is naked, and often supine in some gracelessly uncomfortable posture. Matisse's reversal juxtaposes a caucasian flesh-coloured and possibly nude artist to the crumpled mess of faceless costume in the armchair in the corner, his female model. Masculine nudity, associated with Apollonian intelligence and creativity, signifies a mastering and active body, and strips the artist of any specific social or historical signs other than the white masculinity with which he is clothed because he is the artist. The body is not anatomically sexed; cultural connotations provide its gender through the assimilation of the term artist to man.

The painting is a palimpsest of three orders of space which define modern western art-making. It is a social space shaped in the concrete social and economic relations in one particular studio in Paris in 1917 in which a white bourgeois man paid a probably working-class woman to work for him. Then it is a representation of the symbolic space of art, the studio, and it makes a statement about the basic components of art-making – the artist, the model and the site of their one-way transaction, the canvas. Finally it presents to us the space of representation, that canvas, upon which is painted a fictive body which has been invented by the combination of the painter's look and gesture. A social and a sexual hierarchy are pictured: the artist is canonically male (signalling the fusion of Culture with masculinity); *his* material is female (the assimilation of nature, matter and femininity). By its formal disposition of man/artist: woman/model, the painting articulates the symbolic value and symbolic gender in western modernism's discourse of the 'body of the painter.'

This essay examines the problematic for women created by this regime, and I shall argue that the complex relations between painting (art), feminism and history can be rhetorically tracked in the contradictory placements and significations of two bodies: the 'body of the painter' and the 'feminine body.' Women want to make art, they want specifically to paint, a desire which is as

much about wanting the right to enjoy being the body of the painter in the studio – the creative self in a private domain – as it is about wanting to express individualistically the none the less collective experiences of women. These are potently connected with and represented by aspects of our bodies, life-cycles and sexualities. There are different theories about how much and what of this 'body of woman' women can represent against the grain of the dominant culture's trope of the active male creative body and the supine female object body, narratively figured in Matisse's reflexive modernist painting. The field is thus triangulated – the painter's body, the feminine body and the contestation of both through feminist discourse and practice of 'the woman's body.'

But in that formulation some 'women's bodies' are effaced in a false universalism. If the white woman's body has been objectified and prized as the material of fantasy and art, the black woman's body, brutalized and violated under slavery and racism, has not been figured so extensively in this privileged exchange.[1] However negatively present, indeed over-present, the white body of woman has been part of the spectacle.[2] The politics of white feminist resistance may thus involve a set of strategies of calculated invisibility and its corollary insistence of *presence* signified 'an-iconically.' For black women, however, the outrage against their absence in hegemonic cultures, and the insistence upon other traditions in the representation of women, dictate the necessity for a creative production of *presence*. This involves strategies for insisting on visibility through figuration and the production of icons.[3]

> I am a Blackwoman and my work is concerned with making images of Blackwomen. Sounds simple enough – but I'm not interested in portraiture or its tradition. I'm interested in giving space to Blackwomen presence. A presence which has been distorted, hidden and denied. I'm interested in our humanity, our feelings and our politics; some things which have been neglected ... I have a sense of urgency about our 'apparent' absence in a space we've inhabited for several centuries.[4]

There is no doubt that the body is a critical site of our oppressions and exploitations, the locus of social disciplines and violations, the field of pleasure and desire as all are traversed and differentially lived across the wounds of class, race, gender and sexuality. Diverse political campaigns and opposing theoretical programmes converge – in distinctively post-modernist fashion – upon this social, psychic, political, physical and metaphorical image of ourselves – the body, which is not inert matter or irreducible physicality, but figure, sign, space, name. The questions I want to pose are preliminary and strategic in character, mapping some of the contradictory pressures since the early 1970s which have shaped western feminist thought and cultural practice by reading a series of images of bodies in the studio.

The Artist in the Studio

A photograph by Hans Namuth of Jackson Pollock (d. 1956), perhaps as a result of these very photographs the most famous 'body of the painter,' frames the producing body and the arena of his activity, the canvas itself, supine on the floor receiving from his flurry of gestures the marks and traces of his presence and action. The sexual hierarchy pictured in Matisse is not visualized directly in Namuth's photographs of Pollock at work. But the legacy is there in the potency and activity of the masculine body now directly mastering the supine feminine space of the canvas, patterning that surface, that imaginary body, with his inscriptions.

Abstract Expressionism (the artistic movement epitomized by Pollock's manner of painting) reduced reference to a world, however stylized or oblique, and substituted these vivid, metonymic traces of the 'body of the painter,' epitomized by 'the gesture.' Pollock's practice was critically valorized in different ways, all of which celebrate, however subtextually, a colonizing masculine mastery. Harold Rosenberg, who coined the phrase 'Action Painting,' redefined this new art process as a kind of existential drama acted out in the theatre of the canvas's fictive space. Clement Greenberg defined Pollock in relation to his theory that the destiny of each modern art was its sacrifice of all ambitions for painting save those dictated by the material character of its medium. Painting, quintessentially defined by its flat, two-dimensional surface covered with coloured liquids which induce optical effects, achieves its modernist purity when it has banished literary subject matter, narrative and social content. Greenberg defined the law of modernism as the purification of each art: that 'the conventions not essential to the viability of a medium be discarded as soon as they are recognized.'[5] This process, however, did not in fact result in abstract art as such. The purity of the visual signifier, seemingly emptied of all reference to a social or natural world, is still loaded with significance through its function as affirmation of its artistic subject.[6] Abstract Expressionism is a celebration of the 'expressivity' of a self which is not to be constrained by expressing anything in particular except the engagement of that artistic self with the processes and procedures of painting. Thus 'painting' is privileged in modernist discourse as *the* most ambitious and significant art form because of its combination of gesture and trace, which secure by metonymy the presence of the artist. These inscribe a subjectivity whose value is, by visual inference and cultural naming, masculinity.[7]

The subject encountered through traces of his action upon the canvas is a self, imagined to be capable of total self-expression, free from division and articulation, producing meaning directly without the mediation of symbol or sign.[8] At a psychic level this must be read as a regressive fantasy to a moment when the proto-subject first imagines itself unified. It invents an imagined memory of being able to communicate spontaneously and fully by means of

the infant's primitive but physically freighted tools, the look and the gesture. For this reason the fantasy exerts a powerful appeal to all artists irrespective of their sex, for it evokes the imaginary phase, a moment in the process of being made a human subject which is common to us all, despite the fact that the inflections of culturally ordained sexual difference are already shaping different trajectories which will match our forming subjectivities to the positions of masculinity and femininity. But for all that this ideology of art services bourgeois mythologies of the self-possessing and self-realizing individual in this imaginary form, we must recognize that its function is also decisively on the side of the Symbolic; that is, the cultural-social-political order. The imaginary individual, as all the images so starkly insist in their iconography, is a man, empowered by his privileged place on the symbolic side of the division theorized as 'sexual difference.'[9]

'Where are the Women?'

In our book *Old Mistresses* (1981),[10] Roszika Parker and I juxtaposed a photograph by Ernst Haas of Helen Frankenthaler, a second-generation abstract expressionist, to Namuth's Pollock. The pairing iconically suggested what we dared not write. Is there a visible difference between men and women artists? Do Pollock's slashing and throwing of paint, his gyrations around a supine canvas, enact a macho assault upon an imaginary, feminine body? Are the traces of paint on canvas the residues of a psychic performance? Is this '*écriture/peinture masculine*' at its most vivid? How could we then read Frankenthaler's pouring, pushing, smoothing gestures as she knelt on or near the canvas as a surface continuous with her space and movements? Is this a feminine modality inviting us to invent metaphors uniting femininity and fluidity for these luscious effects? Do these gestures of the labouring, painting bodies register some profoundly different way of being in the body and being in artistic space which the viewer might then read in terms of the signs of gender and sexuality? Are the procedural and hence the resulting formal differences within a modernist discipline symptoms of sexual difference? Are sexual politics there in the formal and technical processes of high modernist art?

At that moment we had no language in which to raise these questions, let alone answer them. The problem then, as now, is to find terms in which to analyse the *specificity* of women as subjects in a social and historical world without confirming that particularity as nothing more than difference; that is, that women are just women. It would be easy now to mobilize Irigaray and Kristeva to create a feminine poetics of painting through which to commend the specific qualities of Frankenthaler's practice of abstract painting. . . . But affirmative action, however theoretically inspired, cannot spring us out of the

still powerful model of modernism which is a historically specific enunciation of sexual difference.

Of course women share the fantasy of the creative self, desire that privileged space of imaginary freedom called the studio. Feminism and the discourses of art are, however, locked in a profound contradiction at the site of the expression of the creative self. Feminist theory problematizes notions of the self, of woman, of the subject, arguing that these are not essences, the pre-social sources of meaning, but intricate constructions in social and psychic space. Furthermore, feminist cultural theory refuted absolutely the idea that art was a kind of blank space upon which to deposit meanings through the singular look and self-affirming gesture. A historical and materialist thesis challenged affirmative and expressive theories of art by insisting that the materials for art are social, part of socially and historically determined signifying systems.[11] Art is not the privatized space of self-generated significance; it is a form of textual politics.

Textual practice is, furthermore, institutionally constituted. Modernist art theory, as the images discussed above suggest, privileges the studio as *the* discrete space where art is made, relegating gallery or exhibition, journal or art lecture to a subsidiary role of circulation and consumption, an act of interpretation or use coming after the singular creative event. Feminist materialist theory suggests that the studio, the gallery, the exhibition catalogue are not separate, but form interdependent moments in the cultural circuit of capitalist production and consumption. They are also overlapping sets within the signifying system which collectively constitutes the discourse of art. While the spaces of art have specific and local determinants and forms, they are, furthermore, part of a continuum with other economic, social, ideological practices which constitute the social formation as a whole. The interconnection between art as text and art as institution no longer permits the galleries alone to be blamed for sexism. It is necessary to interrogate the political effects of images of art as symbolic presence, as figuration of the artistic self, no longer present in person as 'he' was when, as 'master' of 'his' world, he made 'his' artwork. The sociality of art is 'the question of institutions, of the conditions which determine the reading of artistic texts and the strategies which would be appropriate for interventions (rather than 'alternatives') in that context.'[12] Feminism, therefore, provides a theory of interventions within a field of signification, rather than an alibi for female expressivity; that is, for seeking to secure women's equal right to the 'body of the painter.' A critical debate hinges on this distinction and it is the purpose of this chapter to examine the politics of it.

Sexuality in the Field of Vision

Feminism and politics have been common-sensically associated with the content of art, not with formal issues. But this is a misapprehension. Judy Chicago, for instance, wanted to create not merely a feminist iconography but a visual language, a semi-abstract imagery based on the metaphor of female sexuality. Refusing the repression of its physical form in the visual arts (all those nudes without pubic hair or any indication of genitals), she portrayed the history of women through ceramic evocations of female genitalia. *The Dinner Party* (1978) opposed the silencing of women; women could speak through their labia, as it were. Powerful as a statement, the implications have troubled feminists, for the equation of woman with body, of sexuality with the genitals, seemed too limiting and indeed dangerous.

In contrast, feminist theory derived from psychoanalysis and film studies worked on what Jacqueline Rose defined as 'sexuality in the field of vision.'[13] Sexuality is understood not to be tied to genitals and gendered bodies. Sexuality is a representation. The 'sexual component of the image' goes beyond merely recognizing that figurative images play a part in the production of norms and stereotypes of gender. There is a cultural politics of sexuality in visual form and space itself, as well as in the practices of looking: 'the aesthetics of pure form are implicated in the less pure pleasures of looking.'[14] Psychoanalysis has provided an account of a politics of sexual difference secured in that relation between looking/seeing/form, especially in its analyses of fetishism, voyeurism, narcissism and exhibitionism. The 'body of woman' is perpetually figured in multifarious spaces of representation as both a threat of lack (bodily mutilation standing as metaphor for psychic disintegration) and an aesthetically super-perfect body whose beauty or harmony displaces the threat of lack. Matisse's painting narrates the threat, in the punishing dehumanization of the model, while it is disavowed and compensated for in the formal, almost abstract harmonies, the aesthetic beauties reworked by his artistry in the painting-within-the-painting of that model.

Rose states: 'We know that women are meant to *look* perfect, presenting a seamless image to the world so that man, in that confrontation with difference, can avoid any comprehension of lack. The position of woman in fantasy therefore depends upon a particular economy of vision.'[15] Much art can be seen to submit to that economy of vision – a fixed difference in which man is empowered with the look, rendering his fantasy of perfection, art formally beautifying the threatening otherness of woman. This is the sexual economy circulated through paintings and photographs of the man artist in his studio with his woman model. Indeed, part of the political force of critical, feminist art practices has been a purposeful strategy of fracture, of disruption of aesthetic perfection and the ease and fullness of familiar cultural pleasures. What has characterized a diversity of feminist modes is a refusal of an exclu-

sive 'visuality,' with its fantasies of looking, and a concurrent exploitation of a wider range of semiotic forms which call upon other drives, such as the invocatory, and other sign systems, including writing/inscription, incantation, rhythm, memory, echo.

Yet modernist painting at its height, Pollock's for instance, put that drive for aesthetic perfection at risk. The studio became the site of a terrifying and heroic struggle in which the artist abandoned every support, instrument, convention and tradition – even the body of the woman.[16] Reducing his means to himself and the paint, he set out to see if he could still make a picture work, conquer lack and recreate aesthetic unity. This battle was represented publicly in the language of avant-gardism – a great new endeavour, shedding the habits of the past, adventuring to create a future, pushing culture onwards into uncharted spaces: heroic, progressive, individualistic, it celebrated modernity's promise of freedom, which, read from other perspectives, signalled conquest, colonization and violence. Spurious and partial, freedom was enjoyed in imaginary, aesthetic spaces figured by the western, avant-garde, masculine artist; but that freedom was a powerful attraction, as sometimes the only freedom on offer.

Modernism's Appeal for Women

The tradition of modernist painting is still significant and alive, and there are plenty of important women practicing there. But it is interesting that there has been little serious feminist work on it. Few feminists have thought of putting on an exhibition of these modern 'mistresses,' while Victorian or baroque art by women has been fertile ground for exhibitions and publications. But in 1988–9 The Arts Council of Great Britain circulated an exhibition, 'The Experience of Painting: Eight Modern Artists,' of which, significantly, half the artists were women: Gillian Ayres, Jennifer Durrant, Edwina Leapman and Bridget Riley.

The very title already declares the liberal humanist character of its project. 'Before we speak of the experience of painting let us consider our experience of the world,' writes Mel Gooding in the exhibition catalogue. That 'our' is inclusive, suggesting a condition in which we all share experience of the world: 'Memories, dreams, desires, our imaginings of history, our projections of futurity, our sense of what is true and what is false, all converge upon this moment, as we stand, say, upon a beach, and looking seawards, smell the salt upon the air and feel the wind cold upon our cheek.'[17] History and time evaporate before the timeless moment of being in nature – a highly romantic concept which typically enlivens the technical procedures of painting to give them metaphysical resonance: 'Art may reflect something of this evanescence but its purposes are deeper than a mirroring of the actual. It is an imagina-

tive and metaphorical interaction with the world and its objects, answering to the deepest human impulse.'[18] This apologia is far from Greenberg's rigorous, disciplined, modernist project for abstract painting. Indeed it echoes the romanticism by which women's work is often 'feminized' and dehistoricized in one lyrical movement towards the monumental time of nature.[19]

The catalogue is prototypical in other ways, presenting each artist as an individual in his or her aesthetic cell, prefaced by a photograph of each person at work in her or his studio. The image is accompanied by the familiar artist's statement, couched in individualistic terms, projecting this liberal humanist vision through the aesthetic vocabulary of pure formalism. The major presence is Gillian Ayres, featured on the cover — not active as is Pollock in Hans Namuth's evocation of the painting body in the studio — but seated like Matisse's model, compressed against the overwhelming colour and activity of paintings and paint-pots which seem not to be the product of this contemplative figure. She states her lifelong commitment to abstract painting:

> Abstract art has been the vital force in visual art in this century. This is nothing to do with myself, with my own commitment to abstraction. Modernism meant a lot of different things, and some of those things one may not like or agree with. But what it meant above all was hope in a brave new world. And what did go on under modernism was a *questioning and thinking* . . . And under modernism that questioning was almost the condition of being creative.[20]

What I am trying to discern here is the contradictory formation in which a woman like Gillian Ayres has worked for thirty years, empowered by the possibilities of modernism which allowed her to be an artist while not prescribing what she should paint as a woman. She is also sharing in the project of modernity, a belief in progress, a critical sense of how that progress is created by 'questioning and thinking.' Artistic practice is posited as a privileged site of such open experiment: 'You could simply say that imagination is *anticliché*, against known experience. You're always trying to find something you haven't seen before, an experience that is true to oneself.'[21]

What interests me is the way in which imagination and the critical faculty are captured within an exclusively aesthetic domain. Jürgen Habermas has characterized modernity precisely by such divisions of social life into specialist compartments — science, morality, aesthetics.[22] Mainstream twentieth-century modernism, the extreme bourgeois realization of the autonomy of art, offered to women a means, but a vicarious one, to experience freedom. That is why they embraced it and, despite all, dedicated their lives to 'painting.' In that studio, with the canvas on floor or wall, women imagined themselves free; if not from being women, free from being seen and defined exclusively in those terms. Once outside the door, they would once again have to be women, forgotten or ignored, condescendingly acknowledged until such time

as the particular practice lost its place as culturally dominant. British abstract art in the 1990s is not where culture is at, and so the women who gave it vitality achieve belated recognition for their work in the house of culture, when everyone else has moved to another room.[23]

When Charles Harrison reviewed this show, he suggested that post-modernism might represent a shift as significant as that which ushered in modernism itself (which happened in the late nineteenth century for painting) and left many nineteenth-century academic painters desiring to continue to explore the still rich resources of their tradition, yet, as a result of the substantial reorientation signified by modernism, 'deprived of cultural and historical authenticity.'[24] Harrison's argument seems particularly pertinent to the feminist debate about painting. History, not feminism itself, has altered the terms and conditions of cultural practice. Yet feminist politics insists that within the community, we take seriously women's demands and do not judge their viability according to any given orthodoxy. Painting is not only very much on the agenda in art education, but it answers to many women's powerful desire for a way to represent women's experience as whole, human and thus equally important. Indeed that is what I think the call for feminist painting is about. It registers a demand for a permitted space in which the women who wish to be artists can experience, in the creative freedom of the studio and canvas, those expanding and personally challenging adventures symbolized through an encounter with the blank canvas, aided only by one's brushes and paints and fired by ambition and a sense of limitless possibility. In the name of what can feminists argue against such claims for women's right to participate in the modernist project, especially now that the formalism of Greenberg's modernism has been suspended and post-modernist painting allows the painter to enjoy the grand gesture, expressive figuration and, most importantly, historical and personal reference?

The answer is whatever we mean by post-modernity. But that is too trite, for we have only just begun to analyse post-modernity from a feminist perspective.[25] Modernism offered to women a delusive freedom from being defined as 'the sex,' as woman. Yet in its institutions and critical discourses modernism patrolled the boundaries of masculine hegemony not so much by an overtly gendered discourse, but obliquely. In an article entitled 'Mass Culture as Woman: Modernism's Other,' Andreas Huyssen identifies the force of gender politics in the rigidly policed divide between mass culture – defined as engulfing, dangerous, trivial, easy, feminine – and authentic, high culture, which is represented in masculine terms as a project requiring steely determination and single-minded dedication to preserve true art against the diluting threat posed by popular art.[26] The gendering of mass culture bespeaks a sexual politics, but it is also the form of a division created by capitalism of which both high modernism and popular culture are fragmented pieces. Huyssen writes: 'I know of no better aphorism about the

imaginary adversaries, modernism and mass culture, than that which Adorno articulated in a letter to Walter Benjamin: 'Both [modernist and mass culture] bear the scars of capitalism, both contain elements of change. Both are torn halves of freedom to which, however, they do not add up.' '27

Huyssen's suggestion of a 'masculine mystique,' secured across the division of high and popular culture, has direct repercussions for feminist theory and practice in the post-modern moment. Huyssen, for instance, questions the fashionable idea of the 'femininity' of avant-garde writing proposed by Kristeva, who argues that femininity signifies the repressed and the trans- gressive (a point taken up later as a possible route to a feminist theory of abstract painting). Huyssen reminds us of the pervasive fantasy of a 'male femininity,' in the work of Flaubert for example, a fantasy induced perhaps as a necessary reaction against the excessive masculinity demanded by the disci- pline of high art with its relentless abstention from pleasure – 'the suppres- sion of everything that might be threatening to the rigorous demands of being modern and at the edge of time.'28 Kristeva, celebrating the feminini- ty of Mallarmé's and Joyce's negative aesthetics, was dealing in imaginary sexualities and disregarded a tradition of writing by women and their com- plex social, ideological and semiotic inscriptions within modernism, produced under the sign of woman. Huyssen points out that 'the universalizing ascrip- tion of femininity to mass culture always depended on the real exclusion of women from high culture and its institutions.'29 Now that women are visible as practitioners in high art, the gendering device becomes obsolete but only because 'both mass culture and women's (feminist) art are emphatically implicated in any attempt to map the specificity of contemporary culture and thus to gauge this culture's distance from high modernism.'30

Huyssen falters just where we must not – is there not some significant dis- tinction between 'women's art' and 'art' qualified by feminism? The practices which constitute the most visible *feminist* interventions in culture are not to be defined according to the gender of their expressive subject, and not through residual modernist terminology as scripto-visual, photographic, video, or whatever other medium. By the same token we cannot be debating women's right to use oil or acrylic paint on canvas. To do so would be to renege on such political distance as we have achieved through the last two decades of feminist theory and practice in the cultural sphere.

In mass culture the manifest body, however, is the body of the woman, which becomes the very antithesis of individuality celebrated in high cul- ture's body of the artist. The feminine body in mass culture is the symbol of saturation by the commodity, the field of play for money, power, capital and sexuality. As the body of woman lost its necessity and supremacy within mod- ernist formalism, it continued to be ceaselessly circulated by its corollary, mass culture, which further devalued this body because it was produced without the authorizing signature of the artist.31 Thus two bodies – the body of the

painter and the body of woman – the signs of difference – stand opposed in modernist culture, caught up in the series of binary oppositions which figure sexual difference to us across these inter-related domains.

Feminist practices cannot simply abandon either of these bodies, but whatever constitutes the feminism of the practice results from the necessity to *signify* a relation to this complex.[32] That is not the same as desiring somehow to have a share in the painter's body while producing new meanings for the feminine body. They exist as a relation, fabricated interdependently across the disparate spaces which make up culture. Thus feminist interventions in the spaces of representation have begun to qualify and differentiate the feminine bodies fabricated in culture's inter-facing hierarchies of race, class, gender, sexuality and age. But such practices are rarely single works, or merely series. They form complex installations, documentations and events, which aim to create a signifying space in which the historical changes wrought by feminism can be perceived and represented while others still more radical can be imagined. The freedom here is not imaginary self-realization within the confines of the canvas, but the register of concrete struggles on and beyond the battlefield of representation.

After Modernism, Feminism?

Political feminist culture of the sixties and seventies was a part of a critique of modernism which in turn was symptomatic of a skepticism about *modernity*. Its legacy of belief in human progress and the humanist, rationalist ideals of freedom have been savaged by the revolt of those it had enslaved, violated, and repressed. But feminism itself, taken in a long historical perspective, is also a product of the Enlightenment project and of modernity.[33] Originally named the Women's *Liberation* Movement, its project was conceived of by the second wave in terms of emancipation from social structures of inequality. What the narratives of modern art paradigmatically represent finds echoes in the project of feminism – the self-realization of women/subjects/selves liberated from the constraints of external pressures and socially induced limits. Just as the materialist thesis on culture suggests an interdependence of text, institution and the production of sexual difference, materialist feminist theory has moved from this inside/outside dichotomy of individuals caught in a web of social oppression to a structural mode of analysis of our condition as systematically social, political, linguistic, cultural and psychic. In place of utopian dreams of the new society of post-liberation times, there is a stress on enacted resistances, oppositions, negotiations and the accumulation of local and particular strategies of intervention and redefinition.

I do not, however, think it is sufficient to suggest that we have witnessed a shift in feminist theory over two decades which has, as it were, propelled fem-

inism across a frontier, from its modernist liberation theology into some post-modernist relativism. Indeed, it is the predicament and paradox of women's struggles which constantly disrupts both neat historical narratives and theoretical constructs.

Since they seem to have much in common, feminism has been cited as a prototypical form of post-modernism. Indeed, much recent feminist art has been assimilated to post-modernism, especially those self-consciously 'strategic practices' conceived by Barbara Kruger, Mary Kelly, Cindy Sherman, Lubaina Himid, Susan Hiller, Jenny Holzer, Marie Yates, Yve Lomax, Martha Rosler, Sutapa Biswas, Mitra Tabrizian, Jo Spence, Zarina Bhimji, Mona Hatoum and so forth.[34] Their work is a site for a sustained analysis of the meanings of sexual difference authored by culture, across which 'cultural body' they inscribe feminist readings.[35] Each artist has a 'project,' a defined set of concerns and resources, but they cannot be assimilated to the paradigm of the expressive, self-affirming artist signified by 'the painter.' Wherever their work is made, the point at which its meanings are produced is a public space where viewers read its signs in relation to a wider field of representations and histories, collective as much as individual. While being exhibited, even in an art gallery, such work implies the social spaces and semiotic systems of both culture as a whole, and specific, often repressed or silenced constituencies to which the work so calculatedly refers, and which it reworks to produce as critical *presence* in culture as a whole. It is this radical reconceptualization of the function of artistic activity – its procedures, personnel and institutional sites – which is the major legacy of feminist interventions in culture since the late sixties. What distinguishes such practices from the generality of post-modernism is the refusal to abandon a sense of history and political effect.

* * *

Where Histories Converge

To take the issue beyond the troubling and impossible relation between 'feminism' and 'painting' we need a third term, 'history'.[36] The women's movement is predicated upon a seemingly self-evident collectivity, women. We have not, however, always been and are never only 'women.' Indeed feminism in the western form is a historical product of the fact that sex has a history.[37] The historian Denise Riley has argued for the necessity of a historical understanding of the formations and alterations of the collectivity 'women' in European history. From the seventeenth century and reaching a culmination in the nineteenth century, female people in the west undergo a historical process of increasing sexualization, whose effects are uneven according to hierarchies of power called class, race and gender. Riley's phrase 'the long march of the empires of gender over the entirety of the person' points to the

redefinition of women as 'the sex,' as only their sex — or rather 'the sex he uses.' Ruled by reproductive biology, white bourgeois women were subjected through a range of new disciplines and social practices which resulted in what we could name 'overfeminization.' Women — the name already encoding class- and race-specific references — became extensions of Woman, weighted with a sexuality that excluded from the definition of 'woman' most forms of political or economic power. In the formation of this highly sexualized division in western bourgeois society between masculine and feminine spheres, cultural forms, institutions and practices played a significant part at the level of representation. The femininity of 'women' was negotiated both by their inclusion in cultural narratives and imageries, though in a restricted range of types and settings, and by their exclusion from culture's most prestigious practices and institutions, such as the Royal Academy or History painting. None the less, women did practise professionally as artists, but in ways which as often reinforced as much as they criticized the sexualized, gendered vocabulary of bourgeois society. But, paradoxically, if femininity was on the cultural agenda, it meant there were cultural opportunities in which to examine the question of sexual difference and to speak out both from, and of, the specific psychic spaces and social bodies bourgeois culture *engendered*.[38]

Feminism emerged as a protest from within this overfeminization of bourgeois sexual order. An immediate if not simultaneous historical effect, it disputed the enunciations of femininity, but from within the boundaries of this sexually divided universe. But by the beginning of this century, to claim space in modernity, it became necessary for women to distance and denounce both bourgeois and nineteenth-century feminist enunciations of femininity. For women artists, for example, wishing to escape the possible but always limiting sphere of feminine art, the spaces and practices of cultural modernism permitted an apparent liberation from the culture's traditional overfeminization of women.[39] Women artists aligned themselves with the modernist project, which seemed to offer them access to freedom, equality, the chance to be just an artist — to be the body in the studio, free like Matisse's from time, place and, however momentarily, gender. In contrast to the highly gendered modes of the nineteenth-century bourgeois culture, the emergent modernist community appeared to embody the liberal ideal of humanity blissfully indifferent to gender.

Indifferent it was — to women, and any other community. Without any serious deconstruction of the masculine power it had sustained, this liberal ideal reinscribed that gender's privilege. What it offered women and the white bourgeoisie's colonial others was participation in modernism, on condition that they effaced their gender/cultural particularity. Well known in the study of racism, the discourse of tolerance has also functioned within the modern politics of gender.[40] Women had to choose between being human and being a woman.[41] As artists this was a paradoxical experience. In her probing inter-

views with women artists of the modernist generations, Cindy Nemser repeatedly recorded the pressures these women experienced to 'become one of the boys' in order to have access to the profession they desired.[42] Throughout the twentieth century, with honourable exceptions, women artists forged artistic identities under this modernist arrangement, signing their initials or defeminizing their names, like Lee Krasner, the painter who was married to Jackson Pollock.[43] The process of becoming an artist did not tolerate public avowal that being a woman made any difference. But being a woman made all the difference to the size of the studio you got to work in, to whether you got exhibitions, or to the terms in which your work was written about.

Helen Frankenthaler, for instance, was an up and coming post-graduate painter when she attracted the attention of leading modern art critic Clement Greenberg. He sent her to visit Jackson Pollock in his studio at East Hampton and she was duly astounded by his novel painting methods and the solutions his work was suggesting to the impasse of post-cubist art. It is generally agreed that Frankenthaler learnt that lesson well and in her immediate exploitation of techniques of staining and soaking unprimed canvas, in paintings such as *Mountains and Sea* (1952, Washington National Gallery), effectively created the next move in the game of avant-garde painting , a move which was taken up in the later 1950s by Kenneth Noland and Morris Louis. In 1960 Clement Greenberg hailed Louis and Noland as the leading American painters, the only ones who moved the art game on. His article is shadowed by a presence – Frankenthaler's. She is not acknowledged in his history of modernism, except obliquely in this passage securing Louis's pedigree: 'His first sight of middle period Pollocks, and of a large, extraordinary painting done in 1952 by Helen Frankenthaler called *Mountains and Sea*, led Louis to change his direction abruptly.'[44] That is the sum of her historical presence in a kind of art writing that is all about a league table of goals and innovations. In other works, she is removed from the linear, historical time of Greenberg's modernism. Her work is lyrically associated with landscape and nature – projecting Frankenthaler out of art historical time into a monumental temporality of eternal femininity.[45] Greenberg at least did not subject Frankenthaler to that fate, but his virtual silence eradicated her as effectively from history. While this may well be a product of his sexism, it is also an effect of modernism itself – how can gender be said to inflect facture, strategic painterly moves on late cubist space, relations between geometry and colour on a flat surface? It obviously can, as I have argued above, but it has required the perspective of feminist critique to found a vocabulary with which to deconstruct the in*difference* of modernist discourse.[46]

Late twentieth-century western feminism can be named a reaction against modernist liberalism's 'underfeminization.' Bourgeois society made sex a central categorization, an extremity which framed the resistance – a desire to escape being a woman. Art, like money and power, offered a respite for the

lucky few. But the categorization remained, if not at the political level then economically, legally, in employment and social welfare, etc. Being a woman made a difference, and feminism, has, since the late sixties, worked to repoliticize femininity.[47] The problem is how to develop enunciations of femininity that can cut across the twin poles of femininity as absolute difference (the nineteenth-century model) and femininity as a social disadvantage to be overcome in the ambition for equality with men (the twentieth-century liberal position). As Toril Moi has argued, western feminism is an impossible undertaking, a political struggle in the name of women, aiming either to render such a nomination a matter of indifference or to valorize difference within a system of binary oppositions which systematically privilege one term, man, over its negative other, woman.

> Given this logic, a feminist cannot settle for either equality or difference. Both struggles must be *aporetically* fought out. But we also know that both approaches are caught in the end in a constraining logic of *sameness* and *difference*. Julia Kristeva therefore suggests that feminism must operate in a third space: that which deconstructs all identity, all binary oppositions, all phallologocentric positions.[48]

This third space, projected in Julia Kristeva's essay 'Women's Time' (1979), is the theoretical space associated with the feminist analysis of sexual difference – that is, of a system by which human subjectivity is constituted and which no one can escape. This is perhaps also the space in which to think the issues of difference which feminism in its late twentieth-century form has not.

Femininity has also to be thought beyond its imperial bourgeois origins.[49] If women are not a stable or given unity but a historical category, a designation, we must think that for each aspect of social existence the same applies: class, race, sexuality. Each one person is captured by a plurality of categorizations, each of which works over, to reconfigure, the other categorizations. At the same time the dominant categorizations encounter and negotiate with historical residues, as well as emergent formations, which may be simply alternative or actively oppositional. Thus identities are not just plural (an idea typical of post-modern indifference). They are historical complexes of textured difference. The confrontations between imperial feminism and black feminists hinge on the misrecognition of the historical conditions of both attitudes. Feminism, a politics privileging gender, is the troubled effect of western bourgeois sexualization with its phony universals. The phrase 'black women' can be read to emphasize women as the category and black as the qualifier, as a composite noun; or to put the stress on black as the category and woman as the minor term, qualified by belonging to a larger community of the diaspora. These are the registers of historical and political affiliations and experiences which speak of the necessity to grasp persons as living, specific configurations of historical placement around deeply and mutually interac-

tive categorizations – race, class, gender – which are never discrete totalities, but complex formations operative as much at the level of psychic as of socio-economic construction.

* * *

In her essay 'Women's Time,'[50] Kristeva defines western feminism as being made up of three generations, two historically current, a third in the process of being imagined. The first generation campaigns for equal rights and leg-islative redress against discrimination in the name of women's human rights. A second, concurrent generation rejects political solutions and insists on the radical specificity of women's difference, using art and literature to found a language for the 'intrasubjective and corporeal experiences left mute in cul-ture in the past.' Either effacing the issue of difference or extravagantly insisting upon it in a kind of reverse sexism, this paradox can also be seen to shape debates on race and ethnicity. Kristeva wanted then to imagine a moment of feminism which will effect a radical questioning of the system by which all subjectivity, all identity, every sex is necessarily formed. That is to say that the division (the stage of separation and loss which produces the split unconscious/conscious condition we call subjectivity) is to be prised away from its self-presentation as a product of given sexual division, so that we can articulate the inevitable fact of difference not as binary opposition but as specificity and heterogeneity.

What this means is that such new significations will not emerge either from a repressed culture of those always-already women, nor from a position of rad-ical alterity, outside the system. They can only be the effect of a calculated strat-egy of transgression of the system's own divisions and orders. For Kristeva, meaning is the product of a perpetual play between unity (those forces like the state, family, religion, which try to fix meanings to a particular arrangement of power) and process (the drives and semiotic potential of sound and form, which unity tries to harness to its systematization). Thus in any system there is both order and the possibility of disruption and transformation. Signifying practices such as a new kind of text or art-work mean 'the acceptance of the symbolic law together with the transgression of that law for the purpose of renovating it.'[51] This theory of meaning and change allows for little of either the affirmative or expressive theses of various feminist cultural practices.

Kristeva hailed certain avant-garde writing strategies as transgressive and made them synonymous with femininity as a patriarchal order's obvious neg-ative. She failed to acknowledge that the heroic revolutions of modernism against the state, family and religion were executed in a concretely powerful system of sexual and racial power, so that the revolutions were effected only in the name of men, unable and unwilling seriously to dispute the basis of their own privilege. As neither modernism nor post-modernism, the women's move-

ment, with its complex relations to both moments and cultures, intervenes in signifying practice as the historically necessary realization of Kristeva's reconceptualization of modernism. This is a possibility only now being generated or recognized in the practices of those women who mount a feminist intervention at the level of the textual, the subjective and the historical.

Kristeva attributes a particular significance to aesthetic practices – and not as a minor field colonized by feminism for women's edification. In the historical project of the resistance movements, we can counter the scars of imperial capitalism in culture, where modernism's utopian ambitions for renewal, change, unforeseen possibilities were stunted by their confinement to an imaginary realm of subjective freedom (the studio). Semiotic understanding of the place of signification in the process of power attributes a strategic function to aesthetic practices, which remain a necessary realm for individual enunciation and creation.

> It seems to me that the role of what is usually called 'aesthetic practices' must increase not only to counterbalance the storage and uniformity of information by present day mass media, data-bank systems, and, in particular, modern communications technology, but also to demystify the identity of the symbolic bond itself, to demystify, therefore, the *community* of language as a universal and unifying tool, one which totalizes and equalizes. In order to bring out – along with the singularity of each person, and, even more, along with the multiplicity of every person's possible identifications . . . – the *relativity of his/her symbolic as well as biological existence*, according to the variation in her/his specific symbolic capacities.[52]

The ideological individualism of modernist culture gives way to an acknowledgement of a concrete historical singularity, itself both social and psychic, both symbolic and particular to a kind of existence of and in the body. Thus we achieve a sense of sexual particularity in lieu of being tied to bodies that are only allowed to speak of a monolithic difference. For Kristeva the socially produced and semiotically signified singularity of the subject is set up as an active agent against the galloping forces of modernization, the information society in which individuation is a means of administration of power. Overcoming the specializations through which modern society has oppressed its populations, aesthetic practices are necessarily allied to politics, not secreted in the studio escaping from contamination as the condition of defending the purity and purpose of art.[53]

The burden of Kristeva's piece, like the complex forms of feminist art practices, is to represent the stakes for feminism in terms of ambition clearly indebted to the project of modernity.[54] We cannot fail to sense the gravity of the undertaking nor the pleasures it promises. The debate for feminists involved in 'aesthetic practices' cannot be reduced to a question of 'painting' or scripto-visual forms. It is a historical project, an intervention in history,

informed by historical knowledges, which means not forgetting, in the act of necessary critique, the history of western feminism.

1 There is of course some representation of black women in western art, and a substantial iconography associated with sexual services and fantasized erotic scenarios. But it is indicative that in orientalist painting, for instance, where a European and an African woman are represented in a harem or bath-house, the two bodies are very differently treated to locate the white body as the object of desire. This point needs much more careful analysis and documentation than is possible here.

2 See R. Dyer, 'White,' *Screen*, 29 (1988), pp. 44–65, and *Heavenly Bodies* (Macmillan, London, 1986) for further analysis of the relations between femininity, whiteness and representation.

3 In the work of Sutapa Biswas for instance, 'Housewives with Steakknives,' the Hindu goddess Kali is represented to oppose western definitions of femininity as passive and powerless. On the notion of icons see Frederica Brooks, 'Ancestral Links: The Art of Claudette Johnson,' in Maud Sulter (ed.), *Passion: Discourse on Blackwomen's Creativity* (Urban Fox Press, Hebden Bridge, 1990), pp. 183–90; also quoted in Lubaina Himid (ed.), *Claudette Johnson: Pushing Back the Boundaries* (Rochdale Art Gallery, Rochdale, 1990), p. 5. See also Maud Sulter, 'Zabat: Poetics of a Family Tree,' in Sulter, *Passion*, pp. 91–105.

4 Claudette Johnson, quoted in Himid, *Claudette Johnson*, p. 2.

5 Clement Greenberg, 'American-type Painting,' *Art and Culture* (Beacon Press, Boston, Mass., 1961), p. 208.

6 On the notion of the artistic subject as the subject of art see Griselda Pollock, 'Artists, Mythologies and Media,' *Screen*, 21 (1980), pp. 57–96, reprinted in Philip Hayward (ed.), *Picture This: Media Representations of Visual Art and Artists* (John Libbey, London, 1988), pp. 75–114.

7 That this operation was Eurocentric is specified by Rasheed Areen in *The Other Story* (Hayward Gallery, London, 1989); that his challenge to a white hegemony in modernism remains masculinist underscores the sexual politics of this formation. See Rita Keegan, 'The Story So Far,' *Spare Rib*, February 1990; Sutapa Biswas, 'The Wrong Story,' *New Statesman*, 15 December 1990, pp. 41–2.

8 For an extensive analysis of this typical art school ideology, see Terry Atkinson, 'Phantoms of the Studio,' *Oxford Art Journal*, 13 (1990), pp. 49–62.

9 Michéle Barrett, 'The Concept of Difference,' *Feminist Review*, 26 (1987), pp. 29–42.

10 R. Parker and G. Pollock, *Old Mistresses: Women, Art and Ideology* (Pandora, London, 1981), p. 147.

11 This can be understood in one of two ways. Taken in terms of communication, it suggests that social practice and use invest things or sounds or images with the capacity to function as tokens of exchange between members of a group or system. These tokens are bearers of value and significance; meaning is produced by them in a transaction that involves the receiver as much as the sender. Taken in stricter semiotic terms, the idea of signification excludes the sender and receiver as agents of making mean-ing and throws meaning on to the effect of the chains of signifiers, which produce positions for us to occupy as speakers (I, you, he, she, it). Thus man, woman, artist, are not meaningful because of a rela-tion to, a reference from sound or word to, something already there, with its innate meaning, but only in their relations as signifiers within a system. That system then defines us as we occupy the places, the terms, that it sets. The signifying systems are not abstract or a historical, but the place where the culture, the social system is, as it were, written and thus writes itself upon us as both its users and its effects. See Christine Weedon, *Feminist Practice and Post-structuralist Theory* (Basil Blackwell, Oxford, 1987).

12 Mary Kelly, 'Reviewing Modernist Criticism,' *Screen*, 22: 3 (1981), pp. 41–62; p. 57.

13 Jacqueline Rose, 'Sexuality in the Field of Vision,' in Rose, *Sexuality in the Field of Vision* (Verso Books, London, 1986), pp. 225–34.

14 Ibid., p. 231.

15 Ibid., p. 232.

16 The female nude had become in early modernist art the image for the ambitious artist to dominate and excel with. Modernists continue to perform this initiation ritual: Manet's *Olympia*, Picasso's *Demoiselles d'Avignon*, Matisse's *The Blue Nude*, De Kooning's *Woman* series, F. N. Souza's *Black Nude* and so forth.

17 Mel Gooding, *The Experience of Painting* (Arts Council, London, 1988), p. 2.

18 Ibid.

19 See J. Kristeva, 'Women's Time' (1979), in T. Moi (ed.), *The Kristeva Reader* (Basil Blackwell, Oxford,

1986), pp. 186–213.

20 Gillian Ayres, statement, in Gooding, *The Experience of Painting*, p. 13.

21 Ibid.

22 Jürgen Habermas, 'Modernity – An Incomplete Project,' in Hal Foster (ed.), *The Anti-Aesthetic: Essays in Postmodern Culture* (Bay Press, Townsend, Wash., 1983), pp. 3–15; p. 9.

23 This brilliant insight into women's perpetual fate in art was first developed by the late Buzz Goodbody in a lecture at Bedford College, London, in 1973.

24 Charles Harrison, 'The Experience of Painting,' *Artscribe International*, 75 (1989), pp. 75–7; p. 76.

25 I define post-modernity as the socio-economic and ideological processes which currently define our horizons. Post-modernity refers to an epochal shift, whereas post-modernism refers to the cultural forms generated in this larger social transformation, which are the site for both affirmative and critical cultural responses to post-modernity. The distinctions are drawn from Clive Dilnot, 'What is the Post-modern?' *Art History*, 9: 2 (1986), pp. 245–63, and Hal Foster, 'Postmodernism: A Preface,' in Foster, *The Anti-Aesthetic*, pp. ix–xvi.

26 In 1939 Clement Greenberg wrote a mighty defence of the avant-garde culture threatened by fascism, in terms which implicitly feminize the masses and the ersatz culture, kitsch, which capitalism served up to them: 'Avant-garde and Kitsch,' in Greenberg, *Art and Culture*, pp. 3–21.

27 Andreas Huyssen, 'Mass Culture as Woman: Modernism's Other,' in Huyssen, *After the Great Divide: Modernism, Mass Culture and Postmodernism* (Macmillan, London, 1986), pp. 44–64; p.58.

28 Ibid., p. 55.

29 Ibid., p. 62.

30 Ibid., p. 59.

31 Of course it was never really lost to high culture and makes a major reappearance in surrealist discourse, and again after Greenbergian modernism by means of pop art's deceitful appropriations of comics and movie stars. Post-modernism represents yet another way high art has tried to get back to the feminine body – but only by confirming that mass culture is now almost synonymous with it.

32 I use the term here to mean the production of meaning by the production of new means to produce meaning. Most theories of art are referential, using terms like reflect or express, or even represent. These imply that there is something, a person, a thing, a world, with its already formed meaning, which art, as a secondary system, reflects, expresses or re-presents. Signification is a theory that argues that meanings are produced by the relation of signifiers, sounds or letters, in systems. Meaning is produced for the world, not derived from it. Feminism does not merely express already known meanings that real women know. As a movement we are making new meanings, enunciating, from a specific place and historical condition in the world, a femininity that has to be signified.

33 Alice Jardine, 'At the Threshold: Feminists and Modernity,' *Wedge*, 6 (1984), pp. 10–17; Gayatri Chakravorty Spivak, 'Imperialism and Sexual Difference,' *Oxford Literary Review*, 8 (1986), pp. 225–39.

34 Craig Owens, 'The Discourse of Others: Feminists and Postmodernism,' in Foster, *The Anti-Aesthetic*, pp. 57–82.

35 Many of these artists are specifically concerned with issues of identity, race, class, imperialism. I do not mean to subsume these within feminism, but hopefully to suggest that feminism is a variable term, not the property of those who privilege gender over everything. The meanings of feminism are constantly being expanded by women as they politically reconceive that identity in relation to other formations of power and consciousness.

36 History means more than an authoritative narrative of events. History stands for three things: first, an archive, what a culture remembers. It matters what is in the archive and how it is recorded. History refers to remembering what has been happening. History refers to a context, a way of understanding where we are, because there has been a process creating the present conditions, forces and problems. This makes for historical consciousness. But this is not a consciousness of change as progress and development, some alibi for the present. History also means understanding discontinuity and fracture; it also implies recognizing continuities where we seem to see change. Post-modernism itself may be one such delusion. Feminism is a historical event, but it has historical conditions, knowledge of which we need to inform current practices and decisions. History then is strategic understanding of location and the stakes.

37 The statement is taken from Denise Riley's paper, 'Does Sex have a History?' reprinted in her *Am I that Name?*, pp. 1–17.

38 See Tamar Garb, 'L'Art Féminin: The Creation of a Cultural Category in Late Nineteenth Century

France,' *Art History*, 12 (1989), pp. 39–65.

39 It is significant that so many women of the early twentieth century emigrated to Paris, the city of modernism, where through some aspects of its precocious metropolitanism they could have access to a serious art education, exhibition and a literary culture. Gwen John is only one of the better-known artists who joined the phenomenon Shari Benstock called *The Women of the Left Bank* (Virago Press, London, 1987). Modern Paris also hosted a protest against the heterosexuality of the overfeminized bourgeois societies that women artists and writers fled. There were many Afro-American women who were drawn to its modernist spaces.

40 Bill Williams, 'The Anti-semitism of Tolerance: Middle Class Manchester and the Jews 1870–1900,' in A. J. Kidd and K. W. Roberts (eds), *City, Class and Culture* (Manchester University Press, Manchester, 1985), pp. 74–102.

41 This argument has resurfaced in the challenge recently made by the exhibition *The Other Story*, curated and introduced by Rasheed Areen, Hayward Gallery, London, 1989. Critics found themselves unable to negotiate the worlds of art and the worlds fissured by racism: to be taken seriously as artists, critics advised artists to forget their skin colour – the key term. No idea of the arguments about hegemonies, ethnicities, cultural imperialism, 'coloured' (a term advisedly used) the mainstream critics discourse. There was art without colour, there was colour without art. The point Rasheed Areen intended to make was that they interfaced historically in the production of art by Asian and Afro-Caribbean artists and politically in negative appraisal by white critics.

42 Cindy Nemser, *Art Talk: Conversations with Twelve Women Artists* (Charles Scribner, New York, 1975).

43 Anne Wagner, 'Lee Krasner as L. K.,' *Representations*, 25 (1989), pp. 42–57, is an excellent study of the contradictions of women and modernism through the case of Leonore Krasner, alias Mrs Jackson Pollock and latterly a celebrated figure in the feminist canon.

44 Clement Greenberg, 'Louis and Noland', *Art International*, IV (1960), pp. 27–30; p. 28.

45 See Parker and Pollock, *Old Mistresses: Women, Art and Ideology*, pp. 145–51.

46 I have elsewhere argued precisely that modernism is to be read as a sexual politics at all levels including the technical and aesthetic devices and use of space and facture. But the increasing pre-eminence given to such apparently neutral facets of an artistic process serve to efface the sexual order they represent, and the only visible evidence is the persistent celebration of artistic 'mastery.' See my 'Modernity and the Spaces of Femininity' in Griselda Pollock, *Vision and Difference* (Routledge, London, 1988), pp. 50–90. This problem is reflected in the unevenness of feminist art history as a whole. Certain periods have solicited thorough-going analyses of women's practice in art and their relation to institutions as much as their use of imagery, composition and relation therefore to ideology and meaning. Sexuality and gender can be complexly discussed for the art of the Victorian period, but what does a feminist say when confronted with a woman's practice in mainstream modernist abstract painting, such as that of Gillian Ayres, Britain's leading exponent?

47 In 1963 Betty Friedan wrote of 'the problem that has no name' in her famous, silence-breaking book, *The Feminine Mystique* (Bantam Books, New York, 1963).

48 Toril Moi, 'Feminism, Postmodernism and Style: Recent Feminist Criticism in the United States,' *Cultural Critique*, 9 (1988), pp. 3–22; p.6.

49 Valerie Amos and Pratibha Parmar, 'Challenging Imperial Feminism,' *Feminist Review*, 17 (1984), pp. 3–20; pp. 9–12.

50 Kristeva, 'Women's Time.' pp. 186–213.

51 Julia Kristeva, 'The System and the Speaking Subject' (1973), in Moi, *The Kristeva Reader*, pp. 24–33; p. 29.

52 Kristeva, 'Women's Time,' p. 210.

53 'At this level of interiorization with its social as well as individual stakes, what I have called 'aesthetic practices' are undoubtedly nothing other than the modern reply to the eternal question of morality' (ibid.).

54 The phrase indicates the thesis of Jürgen Habermas, 'Modernity – An Incomplete Project' in H. Foster (1987), pp. 3–15.

3. Craig Owens, 'The Discourse of Others: Feminists and Postmodernism'

In this essay, first published in 1983, Craig Owens considers the relation between feminism and the emergence of a 'postmodern' condition. He resists the token acceptance of feminism into a plurality of voices and argues instead for the irreducibility of sexual difference to other forms of difference, including race and class. He addresses the work of a number of women artists – including Mary Kelly's *Post-Partum Document* (1973–9) and Martha Rosler's *The Bowery in Two Inadequate Descriptive Systems* (1974–5) – and shows that feminist critique extends to cover a wide range of issues, such as the privileging of vision over the other senses and the relegation of artists' texts to merely supplementary status. The following extracts are taken from *Postmodern Culture*, ed. Hal Foster, Pluto Press, London and Sydney, 1985, pp. 61–4, 68–82.

[. . .] However restricted its field of inquiry may be, every discourse on postmodernism – at least insofar as it seeks to account for certain recent mutations within that field – aspires to the status of a general theory of contemporary culture. Among the most significant developments of the past decade – it may well turn out to have been *the* most significant – has been the emergence, in nearly every area of cultural activity, of a specifically feminist practice. A great deal of effort has been devoted to the recovery and revaluation of previously marginalized or underestimated work; everywhere this project has been accompanied by energetic new production. As one engaged in these activities – Martha Rosler – observes, they have contributed significantly to debunking the privileged status modernism claimed for the work of art: 'The interpretation of the meaning and social origin and rootedness of those [earlier] forms helped undermine the modernist tenet of the separateness of the aesthetic from the rest of human life, and an analysis of the oppressiveness of the seemingly unmotivated forms of high culture was companion to this work.'[1]

Still, if one of the most salient aspects of our postmodern culture is the presence of an insistent feminist voice (and I use the terms *presence* and *voice* advisedly), theories of postmodernism have tended either to neglect or to repress that voice. The absence of discussions of sexual difference in writings about postmodernism, as well as the fact that few women have engaged in the modernism/postmodernism debate, suggest that postmodernism may be another masculine invention engineered to exclude women. I would like to propose, however, that women's insistence on difference and incommensurability may not only be compatible with, but also an instance of postmodern thought. Postmodern thought is no longer binary thought (as Lyotard

observes when he writes, 'Thinking by means of oppositions does not corre-
spond to the liveliest modes of postmodern knowledge [*le savoir postmod-
erne*]').[2] The critique of binarism is sometimes dismissed as intellectual fash-
ion; it is, however, an intellectual imperative, since the hierarchical opposition
of marked and unmarked terms (the decisive/divisive presence/absence of
the phallus) is the dominant form both of representing difference and justi-
fying its subordination in our society. What we must learn, then, is how to
conceive difference without opposition.

Although sympathetic male critics respect feminism (an old theme: respect
for women)[3] and wish it well, they have in general declined the dialogue in
which their female colleagues are trying to engage them. Sometimes femi-
nists are accused of going too far, at others, not far enough.[4] The feminist
voice is usually regarded as one among many, its insistence on difference as
testimony to the pluralism of the times. Thus, feminism is rapidly assimilat-
ed to a whole string of liberation or self-determination movements. Here is
one recent list, by a prominent male critic: 'ethnic groups, neighborhood
movements, feminism, various 'countercultural' or alternative life-style
groups, rank-and-file labor dissidence, student movements, single-issue move-
ments.' Not only does this forced coalition treat feminism itself as monolith-
ic, thereby suppressing its multiple internal differences (essentialist, cultural-
ist, linguistic, Freudian, anti-Freudian . . .); it also posits a vast, undifferenti-
ated category, 'Difference,' to which all marginalized or oppressed groups can
be assimilated, and for which women can then stand as an emblem, a *pars
totalis* (another old theme: woman is incomplete, not whole). But the speci-
ficity of the feminist critique of patriarchy is thereby denied, along with that
of all other forms of opposition to sexual, racial and class discrimination.
(Rosler warns against using woman as 'a token for all markers of difference,'
observing that 'appreciation of the work of women whose subject is oppres-
sion exhausts consideration of all oppressions.')

Moreover, men appear unwilling to address the issues placed on the critical
agenda by women unless those issues have first been neut(e)ralized –
although this, too, is a problem of assimilation: to the already known, the
already written. In *The Political Unconscious*, to take but one example,
Fredric Jameson calls for the 'reaudition of the oppositional voices of black
and ethnic cultures, women's or gay literature, 'naive' or marginalized folk art
and the like' (thus, women's cultural production is anachronistically identified
as folk art), but he immediately modifies this petition: 'The affirmation of
such non-hegemonic cultural voices remains ineffective,' he argues, if they
are not first *rewritten* in terms of their proper place in 'the dialogical system
of the social classes.'[5] Certainly, the class determinants of sexuality – and of
sexual oppression – are too often overlooked. But sexual inequality cannot be
reduced to an instance of economic exploitation – the exchange of women
among men – and explained in terms of class struggle alone; to invert Rosler's

statement, exclusive attention to economic oppression can exhaust considera-
tion of other forms of oppression.

To claim that the division of the sexes is irreducible to the division of labor
is to risk polarizing feminism and Marxism; this danger is real, given the lat-
ter's fundamentally patriarchal bias. Marxism privileges the characteristical-
ly masculine activity of production as the *definitively human* activity (Marx:
men 'begin to distinguish themselves from animals as soon as they begin to
produce their means of subsistence');[6] women, historically consigned to the
spheres of nonproductive or reproductive labor, are thereby situated outside
the society of male producers, in a state of nature. (As Lyotard has written,
'The frontier passing between the sexes does not separate two parts of the
same social entity.')[7] what is at issue, however, is not simply the oppressiveness
of Marxist discourse, but its totalizing ambitions, its claim to account for
every form of social experience. But this claim is characteristic of all theoret-
ical discourse, which is one reason women frequently condemn it as phallo-
cratic.[8] It is not always theory *per se* that women repudiate, nor simply, as
Lyotard has suggested, the priority men have granted to it, its rigid opposition
to practical experience. Rather, what they challenge is the distance it main-
tains between itself and its objects – a distance which objectifies and masters.

Because of the tremendous effort of reconceptualization necessary to pre-
vent a phallologic relapse in their own discourse, many feminist artists have,
in fact, forged a new (or renewed) alliance with theory – most profitably, per-
haps, with the writing of women influenced by Lacanian psychoanalysis
(Luce Irigaray, Hélène Cixous, Montrelay . . .). Many of these artists have
themselves made major theoretical contributions: filmmaker Laura Mulvey's
1975 essay on 'Visual Pleasure and Narrative Cinema,' for example, has gen-
erated a great deal of critical discussion on the masculinity of the cinematic
gaze.[9] Whether influenced by psychoanalysis or not, feminist artists often
regard critical or theoretical writing as an important arena of strategic inter-
vention: Martha Rosler's critical texts on the documentary tradition in pho-
tography – among the best in the field – are a crucial part of her activity *as
an artist*. Many modernist artists, of course, produced texts about their own
production, but writing was almost always considered supplementary to their
primary work as painters, sculptors, photographers, etc.,[10] whereas the kind of
simultaneous activity on multiple fronts that characterizes many feminist
practices is a postmodern phenomenon. And one of the things it challenges is
modernism's rigid opposition of artistic practice and theory.

At the same time, postmodern feminist practice may question theory – and
not only *aesthetic* theory. Consider Mary Kelly's *Post-Partum Document*
(1973–79), a 6-part, 165-piece art work (plus footnotes) that utilizes multiple
representational modes (literary, scientific, psychoanalytic, linguistic, archeo-
logical and so forth) to chronicle the first six years of her son's life. Part
archive, part exhibition, part case history, the *Post-Partum Document* is also a

contribution to as well as a critique of Lacanian theory. Beginning as it does with a series of diagrams taken from *Ecrits* (diagrams which Kelly presents as *pictures*), the work might be (mis)read as a straightforward application or illustration of psychoanalysis. It is, rather, a mother's interrogation of Lacan, an interrogation that ultimately reveals a remarkable oversight within the Lacanian narrative of the child's relation to the mother – the construction of the mother's fantasies vis-à-vis the child. Thus, the *Post-Partum Document* has proven to be a controversial work, for it appears to offer evidence of *female* fetishism (the various substitutes the mother invests in order to disavow separation from the child); Kelly thereby exposes a lack within the theory of fetishism, a perversion heretofore reserved for the male. Kelly's work is not anti-theory; rather, as her use of multiple representational systems testifies, it demonstrates that no one narrative can possibly account for all aspects of human experience. Or as the artist herself has said, 'There's no single theoretical discourse which is going to offer an explanation for all forms of social relations or for every mode of political practice.'[11]

* * *

Postmodernist artists speak of impoverishment – but in a very different way. Sometimes the postmodernist work testifies to a deliberate *refusal* of mastery, for example, Martha Rosler's *The Bowery in Two Inadequate Descriptive Systems* (1974–75), in which photographs of Bowery storefronts alternate with clusters of typewritten words signifying inebriety. [Plate 36] Although her photographs are intentionally flat-footed, Rosler's refusal of mastery in this work is more than technical. On the one hand, she denies the caption/text its conventional function of supplying the image with something it lacks; instead, her juxtaposition of two representational systems, visual and verbal, is calculated (as the title suggests) to 'undermine' rather than 'underline' the truth value of each.[12] More importantly, Rosler has refused to photograph the inhabitants of Skid Row, to speak on their behalf, to illuminate them from a safe distance (photography as social work in the tradition of Jacob Riis). For 'concerned' or what Rosler calls 'victim' photography overlooks the constitutive role of its own activity, which is held to be merely representative (the 'myth' of photographic transparency and objectivity). Despite his or her benevolence in representing those who have been denied access to the means of representation, the photographer inevitably functions as an agent of the system of power that silenced these people in the first place. Thus, they are twice victimized: first by society, and then by the photographer who presumes the right to speak on their behalf. In fact, in such photography it is the photographer rather than the 'subject' who poses – as the subject's consciousness, indeed, as conscience itself. Although Rosler may not, in this work, have initiated a counter-discourse of drunkenness – which would con-

```
                              in one's cups

                                     under the influence

                      liquored up                    tanked up

                      juiced up          slopped up      sloppy

                      bloated            loaded          full
```

Plate 36 Martha Rosler, *The Bowery in Two Inadequate Descriptive Systems*, 1974–75, detail. Courtesy Gorney Bravin and Lee, New York. © Martha Rosler.

sist of the drunks' own theories about their conditions of existence — she has nevertheless pointed negatively to the crucial issue of a politically motivated art practice today: 'the indignity of speaking for others.'[13]

Rosler's position poses a challenge to criticism as well, specifically, to the critic's substitution of his own discourse for the work of art. At this point in my text, then, my own voice must yield to the artist's; in the essay 'in, around and afterthoughts (on documentary photography)' which accompanies *The Bowery . . .*, Rosler writes:

> If impoverishment is a subject here, it is more certainly the impoverishment of representational strategies tottering about alone than that of a mode of surviving. The photographs are powerless to *deal with* the reality that is yet totally comprehended-in-advance by ideology, and they are as diversionary as the word formations — which at least are closer to being located within the culture of drunkenness rather than being framed on it from without.[14]

The Visible and the Invisible

A work like *The Bowery in Two Inadequate Descriptive Systems* not only exposes the 'myths' of photographic objectivity and transparency; it also upsets the (modern) belief in vision as a privileged means of access to certainty and truth ('Seeing is believing'). Modern aesthetics claimed that vision was superior to the other senses because of its detachment from its objects: 'Vision,' Hegel tells us in his *Lectures on Aesthetics*, 'finds itself in a purely theoretical relationship with objects, through the intermediary of light, that immaterial matter which truly leaves objects their freedom, lighting and illuminating them without consuming them.'[15] Postmodernist artists do not deny this detachment, but neither do they celebrate it. Rather, they investigate the particular interests it serves. For vision is hardly disinterested; nor is it indifferent, as Luce Irigaray has observed: 'Investment in the look is not privileged

in women as in men. More than the other senses, the eye objectifies and masters. It sets at a distance, maintains the distance. In our culture, the predominance of the look over smell, taste, touch, hearing, has brought about an impoverishment of bodily relations. . . . The moment the look dominates, the body loses its materiality.'[16] That is, it is transformed into an image.

That the priority our culture grants to vision is a sensory impoverishment is hardly a new perception; the feminist critique, however, links the privileging of vision with sexual privilege. Freud identified the transition from a matriarchal to a patriarchal society with the simultaneous devaluation of an olfactory sexuality and promotion of a more mediated, sublimated visual sexuality.[17] What is more, in the Freudian scenario it is by looking that the child discovers sexual difference, the presence or absence of the phallus according to which the child's sexual identity will be assumed. As Jane Gallop reminds us in her recent book *Feminism and Psychoanalysis: The Daughter's Seduction*, 'Freud articulated the "discovery of castration" around a sight: sight of a phallic presence in the boy, sight of a phallic absence in the girl, ultimately sight of a phallic absence in the mother. *Sexual difference takes its decisive significance from a sighting.*'[18] Is it not because the phallus is the most visible sign of sexual difference that it has become the 'privileged signifier'? However, it is not only the discovery of difference, but also its denial that hinges upon vision (although the reduction of difference to a common measure — woman judged according to the man's standard and found lacking — is already a denial). As Freud proposed in his 1926 paper on 'Fetishism,' the male child often takes the last visual impression prior to the 'traumatic' sighting as a substitute for the mother's 'missing' penis:

> Thus the foot or the shoe owes its attraction as a fetish, or part of it, to the circumstance that the inquisitive boy used to peer up at the woman's legs towards her genitals. Velvet and fur reproduce — as has long been suspected — the sight of the pubic hair which ought to have revealed the longed-for penis; the underlinen so often adopted as a fetish reproduces the scene of undressing, the last moment in which the woman could still be regarded as phallic.[19]

What can be said about the visual arts in a patriarchal order that privileges vision over the other senses? Can we not expect them to be a domain of masculine privilege — as their histories indeed prove them to be — a means, perhaps, of mastering through representation the 'threat' posed by the female? In recent years there has emerged a visual arts practice informed by feminist theory and addressed, more or less explicitly, to the issue of representation and sexuality — both masculine and feminine. Male artists have tended to investigate the social construction of masculinity (Mike Glier, Eric Bogosian, the early work of Richard Prince); women have begun the long-overdue process of deconstructing femininity. Few have produced new, 'positive'

images of a revised femininity; to do so would simply supply and thereby pro-
long the life of the existing representational apparatus. Some refuse to repre-
sent women at all, believing that no representation of the female body in our
culture can be free from phallic prejudice. Most of these artists, however,
work with the existing repertory of cultural imagery – not because they
either lack originality or criticize it – but because their subject, feminine sex-
uality, is always constituted in and as representation, a representation of dif-
ference. It must be emphasized that these artists are not primarily interested
in what representations say about women; rather, they investigate what rep-
resentation *does* to women (for example, the way it invariably positions them
as objects of the male gaze). For, as Lacan wrote, 'Images and symbols *for* the
woman cannot be isolated from images and symbols *of* the woman. . . . It is
representation, the representation of feminine sexuality whether repressed or
not, which conditions how it comes into play.'[20]

Critical discussions of this work have, however, assiduously avoided – skirt-
ed – the issue of gender. Because of its generally deconstructive ambition, this
practice is sometimes assimilated to the modernist tradition of demystifica-
tion. (Thus, the critique of representation is this work is collapsed into ideo-
logical critique.) In an essay devoted (again) to allegorical procedures in con-
temporary art, Benjamin Buchloh discusses the work of six women artists –
Dara Birnbaum, Jenny Holzer, Barbara Kruger, Louise Lawler, Sherrie
Levine, Martha Rosler – claiming them for the model of 'secondary mythifi-
cation' elaborated in Roland Barthes's 1957 *Mythologies*. Buchloh does not
acknowledge the fact that Barthes later repudiated this methodology – a
repudiation that must be seen as part of his increasing refusal of mastery
from *The Pleasure of the Text on*.[21] Nor does Buchloh grant any particular
significance to the fact that all these artists are women; instead, he provides
them with a distinctly male genealogy in the dada tradition of collage and
montage. Thus, all six artists are said to manipulate the languages of popular
culture – television, advertising, photography – in such a way that 'their ide-
ological functions and effects become *transparent*;' or again, in their work, 'the
minute and seemingly inextricable interaction of behavior and ideology' sup-
posedly becomes an '*observable* pattern.'[22]

But what does it mean to claim that these artists render the invisible visi-
ble, especially in a culture in which visibility is always on the side of the male,
invisibility on the side of the female? And what is the critic really saying
when he states that these artists reveal, expose, 'unveil' (this last word is used
throughout Buchloh's text) hidden ideological agendas in mass-cultural
imagery? Consider, for the moment, Buchloh's discussion of the work of Dara
Birnbaum, a video artist who re-edits footage taped directly from broadcast
television. Of Birnbaum's *Technology/ Transformation: Wonder Woman*
(1978–79), based on the popular television series of the same name, Buchloh
writes that it 'unveils the puberty fantasy of Wonder Woman.' Yet, like all of

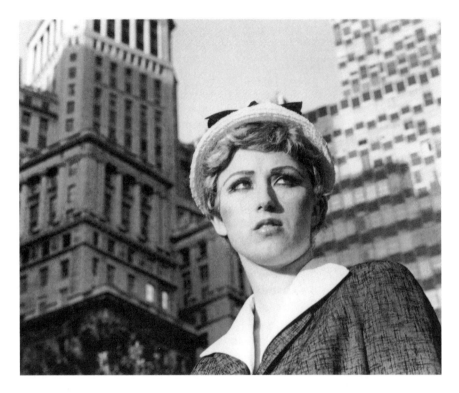

Plate 37 Cindy Sherman, *Untitled Film Still*, # *21*, 1978, photograph, 76.2 x 101.6 cm.
Courtesy Cindy Sherman and Metro Pictures, New York.

Birnbaum's work, this tape is dealing not simply with mass-cultural imagery, but with mass-cultural *images of women*. Are not the activities of unveiling, stripping, laying bare in relation to a female body unmistakably male prerogatives?[23] Moreover, the women Birnbaum re-presents are usually athletes and performers absorbed in the display of their own physical perfection. They are without defect, without lack, and therefore with neither history nor desire. (Wonder Woman is the perfect embodiment of the phallic mother.) What we recognize in her work is the Freudian trope of the narcissistic woman, or the Lacanian 'theme' of femininity as contained spectacle, which exists only as a representation of masculine desire.[24]

The deconstructive impulse that animates this work has also suggested affinities with poststructuralist textual strategies, and much of the critical writing about these artists – including my own – has tended simply to translate their work into French. Certainly, Foucault's discussion of the West's strategies of marginalization and exclusion, Derrida's charges of 'phallocentrism,' Deleuze and Guattari's 'body without organs' would all seem to be congenial to a feminist perspective. (As Irigaray has observed, is not the 'body without organs' the historical condition of woman?)[25] Still, the affinities

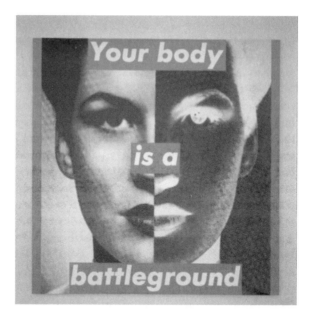

Plate 38 Barbara
Kruger, *Untitled, (Your
Body is a Battle Ground)*,
1989, photographic
silkscreen on vinyl, 92 ¾
x 126 inches. Courtesy of
The Broad Art
Foundation, California.
© Mary Boone Gallery,
New York.

between poststructuralist theories and postmodernist practice can blind a crit-
ic to the fact that, when women are concerned, similar techniques have very
different meanings. Thus, when Sherrie Levine appropriates – literally takes
– Walker Evans's photographs of the rural poor or, perhaps more pertinently,
Edward Weston's photographs of his *son* Neil posed as a classical Greek torso,
is she simply dramatizing the diminished possibilities for creativity in an
image-saturated culture, as is often repeated? Or is her refusal of authorship
not in fact a refusal of the role of creator as 'father' of his work, of the pater-
nal rights assigned to the author by law?[26] (This reading of Levine's strate-
gies is supported by the fact that the images she appropriates are invariably
images of the Other: women, nature, children, the poor, the insane. . . .)[27]
Levine's disrespect for paternal authority suggests that her activity is less one
of appropriation – a laying hold and grasping – and more one of expropria-
tion: she expropriates the appropriators.

Sometimes Levine collaborates with Louise Lawler under the collective
title 'A Picture is No Substitute for Anything' – an unequivocal critique of
representation as traditionally defined. (E.H. Gombrich: 'All art is image-
making, and all image-making is the creation of substitutes.') Does not their
collaboration move us to ask what the picture is supposedly a substitute for,
what it replaces, what absence it conceals? And when Lawler shows 'A Movie
without the Picture,' as she did in 1979 in Los Angeles and again in 1983 in
New York, is she simply soliciting the spectator as a collaborator in the pro-
duction of the image? Or is she not also denying the viewer the kind of visu-
al pleasure which cinema customarily provides – a pleasure that has been

linked with the masculine perversions voyeurism and scopophilia?[28] It seems
fitting, then, that in Los Angeles she screened (or didn't screen) *The Misfits* –
Marilyn Monroe's last completed film. So that what Lawler withdrew was not
simply a picture, but the archetypal image of feminine desirability.

When Cindy Sherman, in her untitled black-and-white studies for film
stills (made in the late '70s and early '80s), first costumed herself to resemble
heroines of grade-B Hollywood films of the late '50s and early '60s and then
photographed herself in situations suggesting some immanent danger lurk-
ing just beyond the frame, [Plate 37] was she simply attacking the rhetoric of
'auteurism by equating the known artifice of the actress in front of the cam-
era with the supposed authenticity of the director behind it'?[29] Or was her
play-acting not also an acting out of the psychoanalytic notion of femininity
as masquerade, that is, as a representation of male desire? As Hélène Cixous
has written, 'One is always in representation, and when a woman is asked to
take place in this representation, she is, of course, asked to represent man's
desire.'[30] Indeed, Sherman's photographs themselves function as mirror-
masks that reflect back at the viewer his own desire (and the spectator posit-
ed by this work is invariably male) – specifically, the masculine desire to fix
the woman in a stable and stabilizing identity. But this is precisely what
Sherman's work denies: for while her photographs are always self-portraits, in
them the artist never appears to be the same, indeed, not even the same
model; while we can presume to recognize the same person, we are forced at
the same time to recognize a trembling around the edges of that identity.[31] In
a subsequent series of works, Sherman abandoned the film-still format for
that of the magazine centerfold, opening herself to charges that she was an
accomplice in her own objectification, reinforcing the image of the woman
bound by the frame.[32] This may be true; but while Sherman may pose as a
pin-up, she still cannot be pinned down.

Finally, when Barbara Kruger collages the words 'Your gaze hits the side of
my face' over an image culled from a '50s photo-annual of a female bust, is
she simply 'making an equation . . . between aesthetic reflection and the
alienation of the gaze: both reify'?[33] [Plate 38] Or is she not speaking instead
of the *masculinity* of the look, the ways in which it objectifies and masters?
Or when the words 'You invest in the divinity of the masterpiece' appear over
a blown-up detail of the creation scene from the Sistine ceiling, is she simply
parodying our reverence for works of art, or is this not a commentary on artis-
tic production as a contract between fathers and sons? The address of Kruger's
work is always gender-specific; her point, however, is not that masculinity and
femininity are fixed positions assigned in advance by the representational
apparatus. Rather, Kruger uses a term with no fixed content, the linguistic
shifter ('I/you'), in order to demonstrate that masculine and feminine them-
selves are not stable identities, but subject to ex-change.

There is irony in the fact that all these practices, as well as the theoretical

work that sustains them, have emerged in a historical situation supposedly characterized by its complete indifference. In the visual arts we have witnessed the gradual dissolution of once fundamental distinctions — original/ copy, authentic/inauthentic, function/ ornament. Each term now seems to contain its opposite, and this indeterminacy brings with it an impossibility of choice or, rather, the absolute equivalence and hence interchangeability of choices. Or so it is said.[34] The existence of feminism, with its insistence on difference, forces us to reconsider. For in our country good-bye may look just like hello, but only from a masculine position. Women have learned — perhaps they have always known — how to recognize the difference.

1 Martha Rosler, 'Notes on Quotes,' *Wedge*, 2 (Fall 1982), p. 69.

2 Jean-Francois Lyotard, *La condition postmoderne* (Paris: Minuit, 1979), p. 29.

3 See Sarah Kofman, *Le Respect des femmes* (Paris: Galilée, 1982). A partial English translation appears as 'The Economy of Respect: Kant and Respect for Women,' trans. N. Fisher, *Social Research*, 49, 2 (Summer 1982), pp. 383–404.

4 Why is it always a question of *distance*? For example, Edward Said writes, 'Nearly everyone producing literary or cultural studies makes no allowance for the truth that all intellectual or cultural work occurs somewhere, at some times, on some very precisely mapped-out and permissible terrain, which is ultimately contained by the State. Feminist critics have opened this question part of the way, but *they have not gone the whole distance.*' 'American 'Left' Literary Criticism,' *The World, the Text, and the Critic* (Cambridge: Harvard University Press, 1983), p. 169. Italics added.

5 Fredric Jameson, *The Political Unconscious* (Ithaca: Cornell University Press, 1981), p. 84.

6 Marx and Engels, *The German Ideology* (New York: International Publishers, 1970), p. 42. One of the things that feminism has exposed is Marxism's scandalous blindness to sexual inequality. Both Marx and Engels viewed patriarchy as part of a precapitalist mode of production, claiming that the transition from a feudal to a capitalist mode of production was a transition from male domination to domination by capital. Thus, in the *Communist Manifesto* they write, 'The bourgeoisie, wherever it has got the upper hand, has put an end to all feudal, patriarchal . . . relations.' The revisionist attempt (such as Jameson proposes in *The Political Unconscious*) to explain the persistence of patriarchy as a survival of a previous mode of production is an inadequate response to the challenge posed by feminism to Marxism. Marxism's difficulty with feminism is not part of an ideological bias inherited from outside; rather, it is a structural effect of its privileging of production as the definitively human activity. On these problems, see Isaac D. Balbus, *Marxism and Domination* (Princeton: Princeton University Press, 1982), especially chapter 2, 'Marxist Theories of Patriarchy,' and chapter 5, 'Neo-Marxist Theories of Patriarchy.' See also Stanley Aronowitz, *The Crisis in Historical Materialism* (Brooklyn: J.F. Bergin, 1981), especially chapter 4, 'The Question of Class.'

7 Lyotard, 'One of the Things at Stake in Women's Struggles,' *Substance*, 20 (1978), p. 15.

8 Perhaps the most vociferous feminist antitheoretical statement is Marguerite Duras's: 'The criterion on which men judge intelligence is still the capacity to theorize and in all the movements that one sees now, in whatever area it may be, cinema, theater, literature, the theoretical sphere is losing influence. It has been under attack for centuries. It ought to be crushed by now, it should lose itself in a reawakening of the senses, blind itself, and be still.' In E. Marks and I. de Courtivron, eds., *New French Feminisms* (New York: Schocken, 1981), p. 111. The implicit connection here between the privilege men grant to theory and that which they grant to vision over the other senses recalls the etymology of *theoria*; see below.

Perhaps it is more accurate to say that most feminists are ambivalent about theory. For example, in Sally Potter's film *Thriller* (1979) — which addresses the question 'Who is responsible for Mimi's death?' in *La Bohème* — the heroine breaks out laughing while reading aloud from Kristeva's introduction to *Théorie d'ensemble*. As a result, Potter's film has been interpreted as an antitheoretical statement. What seems to be at issue, however, is the inadequacy of currently existing theoretical constructs to account for the specificity of a woman's experience. For as we are told, the heroine of the film is 'searching for a theory that would explain her life and her death.' On *Thriller*, see Jane Weinstock, 'She Who Laughs

First Laughs Last,' *Camera Obscura*, 5 (1980).

9 Published in *Screen*, 16, 3 (Autumn 1975).

10 See my 'Earthwords,' *October*, 10 (Fall 1979), pp. 120–132.

11 'No Essential Femininity: A Conversation between Mary Kelly and Paul Smith,' *Parachute*, 26 (Spring 1982), p. 33.

12 Martha Rosler interviewed by Martha Gever in *Afterimage* (October 1981), p. 15. *The Bowery in Two Inadequate Descriptive Systems* has been published in Rosler's book *3 works* (Halifax: The Press of The Nova Scotia College of Art and Design, 1981).

13 'Intellectuals and Power: A conversation between Michel Foucault and Gilles Deleuze,' *Language, counter-memory, practice*, p. 209. Deleuze to Foucault: 'In my opinion, you were the first – in your books and in the practical sphere – to teach us something absolutely fundamental: the indignity of speaking for others.'
 The idea of a counter-discourse also derives from this conversation, specifically from Foucault's work with the 'Groupe d'information de prisons.' Thus, Foucault: 'When the prisoners began to speak, they possessed an individual theory of prisons, the penal system, and justice. It is this form of discourse which ultimately matters, a discourse against power, the counter-discourse of prisoners and those we call delinquents – and not a theory *about* delinquency.'

14 Martha Rosler, 'in, around, and afterthoughts (on documentary photography),' *3 works*, p. 79.

15 Quoted in Heath S., 'Difference', *Screen*, 19, 4, Winter 1978–9, p. 84.

16 Interview with Luce Irigaray in M.-F. Hans and G. Lapouge, eds., *Les femmes, la pornographie, l'erotisme* (Paris, 1978), p. 50.

17 *Civilization and Its Discontents*, trans. J. Strachey (New York: Norton, 1962), pp. 46–7.

18 Jane Gallop, *Feminism and Psychoanalysis: The Daughter's Seduction* (Ithaca: Cornell University Press, 1982), p. 27.

19 'On Fetishism,' repr. in Philip Rieff, ed., *Sexuality and the Psychology of Love* (New York: Collier, 1963), p. 217.

20 Jacques Lacan, 'Guiding Remarks for a Congress on Feminine Sexuality', in J. Mitchell and J. Rose, eds., *Feminine Sexuality* (New York: Morton and Pantheon, 1982) p. 90.

21 On Barthes's refusal of mastery, see Paul Smith, 'We Always Fail – Barthes' Last Writings,' *SubStance*, 36 (1982), pp. 34–39. Smith is one of the few male critics to have directly engaged the feminist critique of patriarchy without attempting to rewrite it.

22 Benjamin Buchloh, 'Allegorical Procedures: Appropriation and Montage in Contemporary Art,' *Artforum*, XXI, 1 (September 1982), pp. 43–56.

23 Lacan's suggestion that 'the phallus can play its role only when veiled' suggests a different inflection of the term 'unveil' – one that is not, however, Buchloh's.

24 On Birnbaum's work, see my 'Phantasmagoria of the Media,' *Art in America*, 70, 5 (May 1982), pp. 98–100.

25 See Alice A. Jardine, 'Theories of the Feminine: Kristeva,' *enclitic*, 4, 2 (Fall 1980), pp. 5–15.

26 'The author is reputed the father and owner of his work: literary science therefore teaches *respect* for the manuscript and the author's declared intentions, while society asserts the legality of the relation of author to work (the '*droit d'auteur*' or 'copyright,' in fact of recent date since it was only really legalized at the time of the French Revolution). As for the Text, it reads without the inscription of the Father.' Roland Barthes, 'From Work to Text,' *Image/Music/Text*, trans. S. Heath (New York: Hill and Wang, 1977), pp. 160–61.

27 Levine's first appropriations were images of maternity (women in their natural role) from ladies' magazines. She then took landscape photographs by Eliot Porter and Andreas Feininger, then Weston's portraits of Neil, then Walker Evans's FSA photographs. Her recent work is concerned with Expressionist painting, but the involvement with images of alterity remains: she has exhibited reproductions of Franz Marc's pastoral depictions of animals, and Egon Schiele's self-portraits (madness). On the thematic consistency of Levine's 'work,' see my review, 'Sherrie Levine at A & M Artworks,' *Art in America*, 70, 6 (Summer 1982), p. 148.

28 See Christian Metz, *The Imaginary Signifier*, trans. Britton, Williams and Guzzetti (Bloomington: Indiana University Press, 1982).

29 Douglas Crimp, 'Appropriating Appropriation,' in Paula Marincola, ed., *Image Scavengers: Photography* (Philadelphia: Institute of Contemporary Art, 1982), p. 34.

30 Hélène Cixous, 'Entretien avec Francoise van Rossum-Guyon,' quoted in Heath, p. 96.

31 Sherman's shifting identity is reminiscent of the authorial strategies of Eugenie Lemoine-Luccioni as
 discussed by Jane Gallop; see *Feminism and Psychoanalysis*, p. 105: 'Like children, the various produc-
 tions of an author date from different moments, and cannot strictly be considered to have the same ori-
 gin, the same author. At least we must avoid the fiction that a person is the same, unchanging through-
 out time. Lemoine-Luccioni makes the difficulty patent by signing each text with a different name, all
 of which are 'hers'.'
32 See, for example, Martha Rosler's criticisms in 'Notes on Quotes,' p. 73: 'Repeating the images of
 woman bound in the frame will, like Pop, soon be seen as a *confirmation* by the 'post-feminist' society.'
33 Hal Foster, 'Subversive Signs,' *Art in America*, 70, 10 (November 1982), p. 88.
34 For a statement of this position in relation to contemporary artistic production, see Mario Perniola,
 'Time and Time Again,' *Artforum*, XXI, 8 (April 1983); pp. 54–55.

4. Amelia Jones, from Body Art/Performing the Subject

Amelia Jones is a feminist art historian who has also curated exhibitions on
feminist art. In this extract from her book *Body Art/Performing the Subject*,
published in 1998, she explores the 'intersubjective' nature of some exam-
ples of body art, including Ana Mendieta's *Silueta* series. She also seeks to
counter the criticism, made by the British artist Mary Kelly, that body and
performance art are informed by a 'naïve essentialism'. She offers Mendieta's
Siluetas as examples of works that resist this interpretation through their rep-
resentation of the body as a trace. The following extract is taken from Chapter
1 of Amelia Jones, *Body Art/Performing the Subject*, University of Minnesota
Press, Minneapolis, 1998, pp. 21–31. [GP]

Body art and performance art have been defined as constitutive of postmod-
ernism because of their fundamental subversion of modernism's assumption
that fixed meanings are determinable through the formal structure of the
work alone.[1] Thus, M. Bénamou states unequivocally that 'performance [is]
the unifying mode of the postmodern,' a claim seconded by Johannes
Birringer and numerous others.[2] And yet in 1980s art discourse, while per-
formance art in its more theatrical manifestations continued to generate
intellectual support and broad audiences (often outside the parameters of the
art world), body art was increasingly frequently dismissed by those interested
in debunking or overthrowing modernism because of its supposedly reac-
tionary desire to ensure artistic presence. By the late 1970s, artists had gener-
ally moved away from the relatively modest, raw staging of themselves in
body art projects.[3] Body art mutated into either performative photographic
work, such as the 'film stills' of Cindy Sherman, or large-scale, ambitious, and
at least seminarrative performance art practices such as Laurie Anderson's
theatrical, proscenium-bound *United States*.

Understanding this shift away from the body enables a deeper contextualiza-
tion of body art projects from the earlier period, projects that were largely dis-

missed, ignored, or downplayed in subsequent art critical discourses. In the 1980s, body art as conceived in the late 1960s and early 1970s was increasingly perceived and spoken of as modernist in the conservative, Greenbergian sense – especially by art historians and critics from England and the United States oriented toward a Marxian, feminist, and/or poststructuralist critical theory.4 A look at one particular example of the negative evaluation of body art during this period will highlight my strategic motivation in pulling body art out of this state of critical oblivion and will set the stage for a deeper examination of the philosophical issues I believe to be at stake in such negative determinations.

Feminist Condemnations of Body Art as Naive Essentialism

In her important 1981 essay 'Re-Viewing Modernist Criticism,' the feminist artist and theorist Mary Kelly articulated a harsh critique of 1970s 'performance work' as theoretically unsophisticated and idealist:

> In performance work it is no longer a question of investing the object with an artistic presence: the artist is present and creative subjectivity is given as the effect of an essential self-possession. . . . [According to supportive critics] . . . the authenticity of body art cannot be inscribed at the level of a particular morphology, it must be chiselled into the world in accordance with direct experience. The discourse of the body in art is more than a repetition of the eschatological voices of abstract expressionism; the actual experience of the body fulfills the prophecy of the painted mark.5

Kelly's argument, part of her extended and compelling critique of Greenbergian, formalist modernism, marks the decisive shift in 1980s U.S. and British art critical discourse away from an appreciation of the overt enactment of the artist's body. Here and elsewhere, Kelly has been unbending in her condemnation of artists (especially women) who deploy their own bodies in their works.6 Working at the time in the developing context of British poststructuralist feminist discourse in the visual arts and film (including the work of well-known figures such as Laura Mulvey and Griselda Pollock), Kelly focused her critique primarily on the rather crudely metaphysical statements of 1970s supporters and practitioners of body art (such as Lea Vergine and Ulrike Rosenbach),7 which she then criticizes for their idealism. Her criticism is convincing (especially when one understands the importance of this argument in its particular context at the time), but in dismissing wholesale the possibility of an embodied visual practice, I believe that Kelly's polemic is far too limiting in understanding the ways in which such work can radically engage the viewer toward ends not incompatible with those Kelly calls for in her own work and writing (activating the viewer, positing sexual and gender identities as fully contingent and intersectional with class, race, and other aspects of identity, etc.).

In the essay Kelly, whose writing and artwork have come to be paradigmatic of what we might call 'antiessentialist' feminist postmodernism as it developed in England in the 1970s and 1980s, demotes body art to the provinces of a naive essentialism – an untheorized belief in the ontology of presence and in an anatomical basis for gender. Again, Kelly's criticism of body art, which she aligns with her critique of Greenbergian modernism, was highly strategic at the time in that it served well the purpose of legitimating a rigorous antiessentialist feminist art discourse and practice. While acknowledging the importance of Kelly's writings and art practice to the development of a critical feminist practice in the 1970s and 1980s, it is useful at this point to open up the prescriptive dimension of Kelly's critique, which implies that *any* artwork including the artist's body is *necessarily* reactionary.

As I have suggested, Kelly's antipathy to body art is typical of 1980s art discourse in the United States and England, both feminist and otherwise, which tended to be motivated in its judgments by suspicion of the embodied and desiring subject – in Marxian terms, especially the spectatorial subject who could easily be manipulated by the seductive effects of commodity culture. Informed by an avant-gardist and Marxian conception of the political importance of building cultural resistance to capitalist structures and drawing on a particular interpretation of Jacques Lacan's model of subjectivity evacuated of its phenomenological dimension, this discourse turned definitively away from the body.[8] Employing a psychoanalytic, castration-oriented model of subjectivity pivoting around the registering of sexual difference in terms of the (visual) presence or absence of the penis/phallus as determined through the (male) 'gaze,' proponents of this art critical approach evaluated art practices in terms of their putative ideological effects on the spectatorial subject, in turn conceived virtually entirely as a function of vision. The phenomenologically experienced dimension of the corporeal (the subject as desiring and intersubjectively articulated body/self) slipped away in this emphasis on the body as image, whose visual effects are experienced on a psychic register.

While it is obviously tempting to focus exclusively on the visual in addressing a mode of expression (the 'visual' arts) that works to produce images and objects that can be seen, I would like to suggest, precisely as I believe body art is teaching us, that such a focus is not enough. Such a focus can miss the point of practices that, as I read them, beg us to reconsider the artistic and broader cultural dimensions in relation to open-ended but also definitively *embodied* intersubjective relations. Body art asks us to interrogate not only the politics of visuality but also the very structures through which the subject takes place through the inevitably eroticized exchange of interpretation.[9] While 1980s art critical discourse (including Kelly's article) viewed body art as reactionary and metaphysical, as reinforcing rather than challenging problematically exclusionary aspects of modernism, I insist here that this interrogation on the part of body art is deeply political when it is engaged with through a phenomeno-

logical and feminist model. Body art, unlike the static, almost inevitably com-
modified works produced in response to Lacanian-oriented theories of the
oedipal subject, more effectively gets at the *structures* of interpretation,
encouraging us to see that all political and aesthetic judgments are invested
and particular rather than definitive or objective.

The feminist articulation of this turn away from the corporeal was particular-
ly vehement about the absolute need to remove the *female* body from representa-
tion; *any* presentation or representation of the female body was seen as *necessar-
ily* participating in the phallocentric dynamic of fetishism, whereby the female
body can only be seen (and, again, the regime is visual in these arguments) as
'lacking' in relation to the mythical plenitude represented by the phallus.
Feminist artists, then, simply must avoid any signification of the female body
(since it is always already an object). In a 1982 interview, Kelly asserted that

> when the image of the woman is used in a work of art, that is, when her
> body or person is given as a signifier, it becomes extremely problematic.
> Most women artists who have presented themselves in some way, visibly, in
> the work have been unable to find the kind of distancing devices which
> would cut across the predominant representations of woman as object of
> the look, or question the notion of femininity as a pre-given entity.[10]

The negative attitude toward body art on the part of many feminists, then,
seems to have stemmed from a well-founded concern about the ease with which
women's bodies have, in both commercial and 'artistic' domains, been con-
structed as object of the gaze.[11] It also often stemmed in part from an anxiety
about the dangers of the artist (especially the female artist) exposing her own
embodiment (her own supposed 'lack') and thus compromising her authority.[12]

The 'distancing devices' Kelly invokes here relate to the Marxian dimen-
sion of the critical model dominant in 1980s art discourse. Bertolt Brecht's
theory of *distanciation*, an avant-gardist theory of radical practice, was adopt-
ed and developed by British feminists (including Kelly, a U.S. transplant at the
time) as a model: the radical feminist practice must aim to displace and pro-
voke the spectator, making her or him aware of the process of experiencing
the text and precluding the spectator's identification with the illusionary and
ideological functions of representation.[13] The rejection of 1970s body art in
general extends in part from this Marxian distrust of art forms that elicit
pleasure, that seduce rather than repel viewers, engaging them in the ideo-
logical field of the work of art as passive consumers rather than active crit-
ics.[14] As Griselda Pollock, a British feminist art historian who has strongly
articulated this view within feminism (and who has been a longtime sup-
porter of Kelly's visual artwork), argues, distanciation is a crucial strategy for
feminist artists because of its 'erosion of the dominant structures of cultural
consumption which . . . are classically fetishistic. . . . Brechtian distanciation
aims to make the spectator an agent in cultural production and activate him

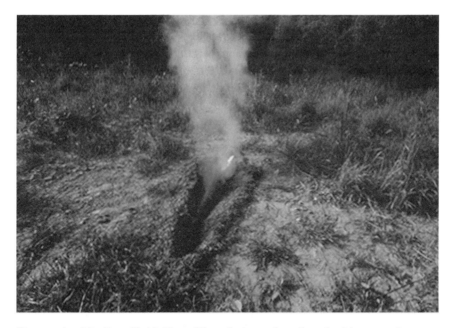

Plate 39 Ana Mendieta, *Untitled* from *Silueta Series*, 1978, earth work with gunpowder, executed in Iowa. Courtesy of the Estate of Ana Mendieta and Galerie Lelong, New York.

or her as an agent in the world.'[15] This is a feminist strategy for Pollock because the objectifying regime of consumerist capitalism is consummately patriarchal. Work that does not distanciate, then, is not effectively (or properly?) feminist.

My discomfort with arguments such as Pollock's and Kelly's stems from what I view as their insistence on one mode of production that will supposedly have effects in the viewer that can be determined in advance through an analysis of the formal structures and historical context of the work. I believe such readings, which polemically aim to produce a critical mode of cultural engagement as constitutive of a radical postmodern (or in this case radical feminist) practice, fundamentally foreclose on the most dramatic and transformative potential of such engagement precisely by assuming that spectators will necessarily react or participate in a predictable way. In this way, body art projects and body-oriented feminist art are simply rejected as necessarily reiterating the structures of fetishism; no possibility is allowed for the myriad disruptions that, in fact, these practices *have* made in the modernist fabric that Pollock and Kelly want so to dismantle.[16] The wholesale dismissal of body art practices (or, in Pollock's case, non-'Brechtian' practices) in 1980s art discourse fails to account for the strategic force of body art projects in the late 1960s and 1970s and for the contingency of all meanings and values of cultural products on the social and political contexts of reception as well as on the particular desires of

the interpreter in question (here, Pollock and Kelly themselves).

What I hope to suggest in this book as a whole is that such sweeping dismissals of a particular kind of practice (here, the performance of the artist's body in or as the work of art), while certainly strategically articulated at the time, can be seen with hindsight as reiterating one of the most damaging impulses of modernist criticism: the definitive evaluation of works of art in terms of an externally conceived, hierarchical system of value (in this case, replacing Greenberg's aesthetic categories with Brechtian ones). It is probably inevitable that we will tend to evaluate practices according to some arbitrary system of value, for art history and criticism are structured by this impulse. But, if we are to extend the insights of poststructuralist philosophy into art discourse in a convincing way, we must at least surface our own implication in such determinations. Body art, I believe, encourages such a surfacing in its dispersal and particularization of the subject (as body/self) and opening of the art-making and -viewing processes to intersubjective desires and identifications.[17]

The issue of interpretive engagement can be brought to the fore through attention to works such as Ana Mendieta's *Silueta* series (1973–1980) [plate 39] or, in fact, Kelly's own *Corpus* installation (part of the *Interim* project first installed in 1990), which produces certain effects that I interpret here (certainly against the grain of Kelly's proposed reading) as consistent with body art.[18] Born and raised in Cuba and brought to the United States at the age of thirteen, Ana Mendieta involved her body in ritual acts (related to Santería rites she first came into contact with as a child and to the Taíno Indians' goddess culture) that were documented by photographs in which she increasingly absented her body altogether.[19] These luminous, eerie photographs present the impression of her body on the landscape, often in vulvar formations reminiscent of stone-age 'goddess' sculptures. In the later photographs especially, with the body absent, Mendieta is marked as mere trace rather than idealist or essentialized, fully feminine self.[20] At the same time, Mendieta herself wrapped these pieces in an elegant shroud of essentializing language:

> I have been carrying on a dialogue between the landscape and the female body (based on my own silhouette). . . . I am overwhelmed by the feeling of having been cast from the womb (nature). My art is the way I re-establish the bonds that unite me to the universe. It is a return to the maternal source. Through my earth/body sculptures I become one with the earth . . . I become an extension of nature and nature becomes an extension of my body. This obsessive act of reasserting my ties with the earth is really the reactivation of primeval beliefs . . . [in] an omnipresent female force, the after-image of being encompassed within the womb, in a manifestation of my thirst for being.[21]

While the *Silueta* project is thus framed by the artist in terms of bodily performance of rituals and spiritual ideas concerning women's relationship to 'mother earth,' I insist in engaging the *Silueta* pieces for their other aspects,

deeply disruptive to modernism's desire for presence and transparency of meaning, which Kelly's wholesale condemnation of body art would overlook.

Kelly's model would position Mendieta's assertion of her body, and her verbal reiteration of an essential link between her female body as maternal and as the womb of the earth, as acceding too easily to psychoanalytic notions of women's incapacity to be subjects; in Griselda Pollock's terms, Mendieta is offering herself as fetish object for a pleasure-seeking male gaze. And yet, working through her own body and ultimately producing photographs documenting its absence (marking her body's having been there as a wound on the landscape), Mendieta's project also opens itself to an intense intersubjective engagement — one that encourages the spectator's acknowledgment of Mendieta's *particularized* relationship to the earth through her adoption of Cuban Santería beliefs, including the idea that the earth is a 'living thing' from which one can derive personal power.[22] I experience the burning wound that links Mendieta's body to the earth as the same wound that marks the absence and loss of her body/self (as Cuban immigrant woman trying to be an artist in the United States in the 1970s). Mendieta's feminist desire to recuperate lost goddess cults or matriarchal cultures, with their putative celebration of women's power, 'female' attributes such as nurturing, and holistic attitudes toward life, merged with her particular experience as a privileged Cuban exiled from her country as a child. This particular experience or identity has no 'essential' meaning in relation to her work: on the contrary, I read her particularity *through* the works (including the discourses contextualizing them) and vice versa; I know her particularity only as I engage with the codes I experience in the works and their descriptive contexts.

Mendieta's late images of her body's trace as gashes in the earth relate closely to Kelly's *Corpus*. Mendieta marks *her* (highly particular) body (as absence) on the earth; Kelly marks *the* female body or 'corpus' through photographed images of twisted and knotted articles of clothing, placed alongside text panels with hand-written first-person accounts of older women experiencing their bodies in the social realm. Both produce a stand-in for the body itself in order to explore the effects of subjectivity as well as the social processes that inform it. Mendieta's primary referents are Santería and goddess rituals; Kelly's referents are the photographs of female hysterics taken under the direction of Freud's mentor J.M. Charcot (the articles of clothing are arranged in 'passionate attitudes' reminiscent of these female hysterics and labeled with Charcot's terminology).[23] Mendieta's absent bodies are conditioned, written into, and given meaning by culturally specific discourses assigning spiritual value to the female body/self; Kelly's absent bodies are conditioned, written into, and given meaning by a theoretical project (Freudian and Lacanian psychoanalysis) and personal narratives construing femininity as a cultural construct. Both projects negotiate the (female) body/self in its absence/presence. Both ultimately confirm that it cannot be

known outside of its cultural representations (which, paradoxically, produce subjectivity as absence rather than plenitude). Both may distance as well as seduce various spectators to various effects. Both produce female bodies/selves that are particularized in various ways, as they engage specific subjects in a negotiatory and highly charged project of reading and seeing.[24]

Postmodernism as Pastiche, Allegory, or Montage: Resisting the Body/Self

As I have already noted, the prohibition against representing or including the body in the work of art and against the pleasurable effects assumed to accompany such inclusions resulted in the wholesale turn away from body art – and, not incidentally, a general devaluation and subsequent historical exclusion of 1970s body art and of most U.S. feminist practices (which did tend to reference the body) – in the 1980s.[25] In this turn away from the body, postmodernism came increasingly to be defined not in relation to subjectivity, identity, or embodiment but was generally stripped of its corporeal politics and situated in terms of strategies of production.[26] In mainstream critical writing, dominated by venues such as *October* and *Artforum*, postmodernism came to be defined again and again in relation to strategies such as appropriation, allegory, pastiche, or, more broadly, institutional critique. Thus, Benjamin Buchloh and Craig Owens, both associated with the *October* editorial board, published articles in *Artforum* and *October* in the early 1980s ('Allegorical Procedures' and 'The Allegorical Impulse,' respectively). These essays situate allegorical strategies of appropriation and montage as, in Owens's words, a 'unified' impulse behind postmodern art.[27] Bypassing questions of subjectivity (here, especially, authorial identity) and interpretation (especially their own interpretive investments), Buchloh and any number of other historians and critics have focused on the political effects of works (especially their capacity for institutional critique) as determined through their formal or narrative structure (read through coded symbolic systems such as allegory) and, to a lesser extent, content.[28] Not incidentally, the body/self, including the relations of desire informing particular interpretations, is generally left out of this broader picture: body art, with its solicitation of spectatorial desires and deliberate confusion of conventional artistic presentational formats, complicates the tendency to codify postmodernism purely in terms of artistic strategies of production.

The focus on production in dominant discourses of postmodernism links problematically to a metaphysics of intentionality that contradicts the poststructuralist claim to understand meaning as contingent rather than fixed. Thus, Kelly's wholesale rejection of all body art as necessarily essentialist, while it was strategic at the time, failed to account for Kelly's own investment – as an *embodied* artist and critic reacting to the messy and, in her view, ide-

ologically problematic effects of other artists' bodies in performance – in interpreting them (*essentializing* their meanings) in this way.[29]

It is precisely the acknowledgment of such investments that Craig Owens remarked upon in a later, self-critical reflection on his allegory essay. In an essay published in 1983 as 'The Discourse of Others: Feminists and Post-modernism,' Owens deconstructs his own earlier reading, in 'The Allegorical Impulse,' of Laurie Anderson's *Americans on the Move* (not incidentally, it is a multi-media performance/body art work that has motivated his rereading). In the 1983 essay he chastises himself for having completely ignored the ways in which her work particularizes the examination of language and subject formation in terms of sexual difference. He writes, 'if I return to this passage . . . it is not simply to correct my own remarkable oversight, but more importantly to indicate a blind spot in our discussions of postmodernism in general: our failure to address the issue of sexual difference – not only in the objects we discuss, but *in our own enunciation as well.*'[30] Through his deep engagement with Anderson's body art work, then, Owens recognizes, precisely, both his own investment in interpreting her work and the particularization of subjectivity that it puts into play.

Owens's self-reflections highlight the limitations of much dominant writing about postmodern art, which, in its refusal to acknowledge interpretation as an exchange and haste to proclaim particular practices as politically efficacious or not, largely operates to reinforce the modernist project of privileging certain practices and derogating others on the basis of their interpretively determined cultural value. Such a strategy (which has entailed the derogation of body art) simply replaces the modernist formalist conception of aesthetic value with an avant-gardist notion of political value, determined according to systems of judgment that are ultimately just as authoritative as those they seek to go beyond. The judgments of self-proclaimed *post*modernist criticism (or criticism of postmodern art that aligns itself with poststructuralism) have tended to rely on value systems and methods of analysis that are still heavily informed by the rhetoric of avant-gardism so central to modernist criticism: a rhetoric that *disembodies* – that, as Owens acknowledges in his later essay, insists upon a 'disinterested' relation to the work of art and that assumes that this work's cultural value lies in its formal structure or its conditions of production.

My interest in the work of Mendieta, Schneemann, Kusama, and other body artists is informed both by a desire to rethink postmodern culture (and subjectivity) in the broadest sense and by a desire to push beyond what I perceive to be the prescriptive nature of 1980s art history and criticism as well as its rather narrowly conceived focus on the formal or narrative structures of the work (including its for the most part disembodied structures of vision and power). I am intrigued by the propensity of body art to unveil the hidden assumptions still embedded in critical discussions about postmodernism, its interweaving of the corporeal, the political, and the aesthetic: thus,

Mendieta's photographs of her body-as-trace both address the spectator's own interpretive body and thwart its conventionally masculinist, colonizing 'gaze' by ritualizing and in many cases erasing the 'actual' body from their purview. I have turned with pleasure to body art for its dramatic potential to interrupt the closed circuit of modernist and most postmodernist critical practice. I want both to *give in* to Mendieta's anti-Brechtian solicitation of a pleasurable gaze and also to extricate myself from moment to moment in order to interrogate my own desiring relationship (here, as potentially colonizing Anglo-American feminist 'eye' gazing on Mendieta's 'exotically' ritualized body) to the work that I study here.[31]

Body art practices solicit rather than distance the spectator, drawing her or him into the work of art as an intersubjective exchange; these practices also elicit pleasures – seen by Marxian critics to be inexorably linked to the corrupting influence of commodity culture, but interpreted here as having potentially radical effects on the subject as it comes to mean within artistic production and reception.[32] Body art, in all of its permutations (performance, photograph, film, video, text), insists upon subjectivities and identities (gendered, raced, classed, sexed, and otherwise) as absolutely central components of any cultural practice .

1 Karen Lang's suggestions and comments were of invaluable assistance in the completion of this chapter.
2 M. Bénamou is cited in Régis Durand, 'Une nouvelle théâtricalité: La performance,' *Revue français d'études américaines* 10 (1980): 203; see also M. Bénamou and Charles Caramello, eds., *Performance in Postmodern Culture* (Madison: Coda, 1977). Johannes Birringer discusses the fact that 'performance today . . . is perceived as 'postmodern'' in *Theatre, Theory, Postmodernism* (Bloomington and Indianapolis: Indiana University Press, 1991), 47. On the link between performance art and postmodernism, see also Philip Auslander, *Presence and Resistance: Postmodernism and Cultural Politics in Contemporary American Performance* (Ann Arbor: University of Michigan Press, 1944); Sally Banes, *Greenwich Village 1963: Avant-Garde Performance and the Effervescent Body* (Durham, N.C.: Duke University Press, 1933); Herbert Blau, *To All Appearances: Ideology and Performance* (New York and London: Routledge, 1992); Marvin Carlson, *Performance: A Critical Introduction* (New York and London: Routledge, 1996); C. Carr, *On Edge: Performance at the End of the Twentieth Century* (Hanover, N.H., and London: Wesleyan/New England Presses, 1993); Sue-Ellen Case, ed., *Performing Feminisms: Feminist Critical Theory and Theatre* (Baltimore: Johns Hopkins University Press, 1990); Sue-Ellen Case, Philip Brett, and Susan Leigh Foster, *Cruising the Performative: Interventions into the Representation of Ethnicity, Nationality, and Sexuality* (Bloomington and Indianapolis: Indiana University Press, 1995); Jill Dolan, *Presence and Desire: Essays on Gender, Sexuality, and Performance* (Ann Arbor: University of Michigan Press, 1993); Lynda Hart and Peggy Phelan, eds., *Acting Out: Feminist Performance* (Ann Arbor: University of Michigan Press, 1993); Nick Kaye, *Postmodernism and Performance* (New York: St. Martin's, 1994); Peggy Phelan, *Unmarked: The Politics of Performance* (New York and London: Routledge, 1993); Janelle G. Reinelt and Joseph R. Roach, eds., *Critical Theory and Performance* (Ann Arbor: University of Michigan Press, 1992); and Henry Sayre, *The Object of Performance: The American Avant-Garde Since 1970* (Chicago and London: University of Chicago Press, 1989).
 Of these texts, only Sayre's, Carr's, and Phelan's deal extensively with performance in an *art* rather than theater context; Carr's book is journalistic, and Sayre and Phelan both broaden performance to the issue of 'performativity,' encompassing work from Mira Schor's paintings of penises, in Phelan's case, to Earthworks in Sayre's. Banes's book is the most useful history of the early development of performance art out of experimental dance, the work of John Cage, and Fluxus. Kathy O'Dell's Ph.D. dissertation, 'Toward a Theory of Performance Art: An Investigation of Its Sites' (City University of

New York, 1992), is the only text I am aware of that deals intensively and theoretically with what I am here calling body art within an art historical context. I am indebted to this text, and to my ongoing discussions with O'Dell.

3 For a discussion about this shift in the 1980s vis-à-vis the Australian context, see Anne Marsh, chapter 5, 'Performance Art in the 1980s and 1990s: Analysing the Social Body,' in *Body and Self: Performance Art in Australia 1969–1992* (Oxford: Oxford University Press, 1993), 184–224.

4 To my knowledge, Italian, French, and German art discourse did not shy away from the body so radically during this period. But U.S. and British figures have dominated contemporary art criticism and art history (since the 1940s in the case of the United States, the 1970s in the case of England).

5 Mary Kelly, 'Re-Viewing Modernist Criticism,' originally published in *Screen* (1981), reprinted in *Art after Modernism: Rethinking Representation*, ed. Brian Wallis (New York: New Museum of Contemporary Art; and Boston: Godine, 1984), 95, 96.

6 See also 'No Essential Femininity: A Conversation between Mary Kelly and Paul Smith,' *Parachute 37*, n. 26 (Spring 1982): 31–35.

7 See Vergine's ecstatic and melodramatic utopianism in *Il corpo come linguaggio (La 'body-art' e storie simili)*, tr. Henry Martin (Milan: Giampaolo Prearo Editore, 1974); I discuss Vergine's text later.

8 See, for example, Kelly's 'Re-Viewing Modernist Criticism,' especially 95–97. While Merleau-Ponty's work was singularly important for many U.S. artists in the 1960s (including artists who did body art work, such as Robert Morris and Vito Acconci), art discourse from the early 1970s on mainly passed Merleau-Ponty by in its rush to embrace Lacanian psychoanalysis (often, though surely not in Kelly's case, through secondary models from film or literary theory). Along with Kelly's written and artistic work, Laura Mulvey's formative psychoanalytic critique of Hollywood films' objectification of women, 'Visual Pleasure and Narrative Cinema' (first published in *Screen* in 1975), was also a key force in the turning against the body. Mulvey claims here that cinematic codes create an implicitly male 'gaze . . . world . . . and . . . object, thereby producing an illusion cut to the measure of desire' that must be thwarted: 'It is these cinematic codes and their relationship to formative external structures that must be broken down before mainstream film and the pleasure it provides can be challenged.' The goal is to destroy 'the satisfaction, pleasure, and privilege' of the spectator (who, again, is implicitly male for Mulvey). Mulvey, 'Visual Pleasure and Narrative Cinema,' in *Visual and Other Pleasures* (Bloomington and Indianapolis: Indiana University Press, 1989), 25, 26. Mulvey and many other feminists have subsequently reworked this rather narrow, polemical formulation since 1975, but it still has enormous authority (especially within art discourse).

9 To a certain extent, the coincident movements of minimalism and conceptualism also similarly but perhaps not as insistently engaged questions of the relationship between the body and thought, the object and the spaces it inhabits.

10 Mary Kelly, in 'No Essential Femininity,' 32.

11 See Laura Mulvey's 'Visual Pleasure and Narrative Cinema.' John Berger's polemical *Ways of Seeing* (London: British Broadcasting Corporation; Harmondsworth: Penguin, 1972), provides an earlier example of the British, Marxian approach to the convention of representing the female body as an object of the gaze.

12 This is especially true of U.S. feminists such as Lucy Lippard, whose anxiety about Hannah Wilke's self-display is discussed in chapter 4. Kelly's view on the authority of the female artist is quite different; she focuses more on the conflict experienced by women who are positioned as objects but attempt to be subjects of artistic production. See Kelly's 'Desiring Images/Imaging Desire,' *Wedge*, n. 6 (1986): 5–9; and Lucy Lippard's *From the Center: Feminist Essays on Women's Art* (New York: Dutton, 1976), and *The Pink Glass Swan: Selected Feminist Essays on Art* (New York: New Press, 1995).

13 There is a complex history behind the development of these theoretical models by British feminists in the 1970s and 1980s in venues such as the Marxist/Althusserian journal *Screen* and Edinburgh Festival publications. See Laura Mulvey's untitled article tracing this history in *Camera Obscura* 20–21, 'The Spectatrix' issue, 248–52; Griselda Pollock, 'Screening the Seventies: Sexuality and Representation in Feminist Practice – A Brechtian Perspective,' *Vision and Difference: Femininity, Feminism and the Histories of Art* (London and New York: Routledge, 1988), 155–99; and Griselda Pollock and Rozsika Parker, eds., *Framing Feminism: Art and the Women's Movement 1970–1985* (London and New York: Pandora, 1987).

14 I discuss the 'antipleasure' paradigm of dominant 1980s feminist criticism and its effects at greater

length in 'Feminist Pleasures and Embodied Theories of Art,' in *New Feminist Criticisms: Art/Identity/Action*, ed. Cassandra Langer, Joanna Frueh, and Arlene Raven (New York: HarperCollins, 1994), and in the unpublished essay 'Pleasures of the Flesh: Feminism and Body Art.' The prohibition of pleasure within this segment of the left can be counterposed to the Marcusian rush to confirm pleasure as an antidote to the repressive apparatus of capitalism. See Herbert Marcuse, *Eros and Civilization: A Philosophical Inquiry into Freud* (London: Routledge & Kegan Paul, 1956). Marcuse's model was extremely influential among U.S. artists in the 1960s and early 1970s, the heyday of the 'free love' movement and youth and drug cultures. See Bryan Turner on the Marcusian ideal of the revolutionary potential of sexuality in *The Body and Society: Explorations in Social Theory* (New York and Oxford: Basil Blackwell, 1984).

15 Griselda Pollock, 'Screening the Seventies,' 163. Pollock's argument is intimately linked to the terms Mulvey uses in 'Visual Pleasure and Narrative Cinema,' where, as noted, she argues that *the* feminist project vis-à-vis Hollywood representations of women is to 'destroy . . . the satisfaction, pleasure and privilege of the [presumably male] 'invisible guest'' by breaking the voyeuristic structures of the film experience and freeing the 'look of the audience into . . . passionate detachment' (26).

16 I have discussed extensively elsewhere the way in which works such as Judy Chicago's *Dinner Party* (1979), a piece that has been harshly criticized by Kelly, Pollock, and other British feminists, have disrupted modernist discourse in spite of their problematic, 'essentializing' tendencies identified by these critics. See my 'The 'Sexual Politics' of *The Dinner Party*: A Critical Context,' in *Sexual Politics: Judy Chicago's* Dinner Party *in Feminist Art History*, ed. Amelia Jones (Los Angeles: UCLA/Armand and Hammer Museum of Art; Berkeley and Los Angeles: University of California Press, 1996), 82–118.

17 This latter insight, into the contingency of meaning on the social and political context, is one that Kelly and Griselda Pollock, as theorists committed to a Marxian point of view, have extensively developed in their work. In a sense I am using the very insights that feminists such as Pollock and Kelly introduced, but pushing them farther to argue that there is a contradiction in the wholesale rejection of a particular kind of practice.

18 For reproductions of a number of the *Silueta* works, see Mary Jane Jacob, *Ana Mendieta: The 'Silueta' Series, 1973–1980* (New York: Galerie Lelong, 1991); Kelly's project is documented in Mary Kelly, *Interim* (New York: New Museum of Contemporary Art, 1990). Kelly's work is characterized by its inclusion of didactic as well as playful textual materials within the objects themselves and extensive critical texts, developed by Kelly and her supporters (such as Griselda Pollock), which lead interpretive accounts of the works toward a deeply theoretical, Lacanian/Marxian reading. See, for example, Pollock's 'Interventions in History: On the Historical, the Subjective, and the Textual', in *Interim*, 39–51.

19 Mendieta was brought to the United States as a teenager under the auspices of the Catholic Church, which placed Cuban children in U.S. foster homes to 'save' them from communism. Mendieta came from a home with servants, a number of whom were African-Cubans who practiced Santería. She returned to Santería in the early 1970s, combining this tradition with her feminist interest in affirming women's power by studying and representing figures from goddess cults. See Jacob, *Ana Mendieta: The 'Silueta' Series*, 3–8. On her interest in the Taíno Indians of the pre-Hispanic Antilles (West Indies), see Bonnie Clearwater, *Ana Mendieta: A Book of Works* (Miami Beach: Grassfield, 1993), 12–13. Clearwater documents Mendieta's project *Rupestrian Sculptures*, a series of photo etchings of female goddess figures Mendieta carved and molded into the walls of two caves near Havana in 1981; as in the later *Silueta* works, Mendieta absents her body but forces the earth itself to 'become' her, as documented for audiences through the photographic trace. Mendieta viewed these caves in female, corporeal terms, calling the goddess images 'an intimate act of communion with the earth, a loving return to the maternal breasts'; she stated that 'the earth/body sculptures come to the viewers by way of photos. . . . The photographs become a very vital part of my work' (13, 41).

20 Mendieta's *Body Tracks* performance, executed at Franklin Furnace in New York in 1982, also marks the body emphatically as trace rather than 'presence' (even in the act of performance). Here, she covered her arms with blood, then faced a large piece of paper on the gallery wall, dragging her arms downward to produce imprints of hands and arms in bloody supplication. See Petra Barreras del Rio and John Perreault, *Ana Mendieta: A Retrospective* (New York: New Museum of Contemporary Art, 1987), 34–38. Rebecca Schneider discusses Mendieta's self-erasure as an effect of the 'pressure she was under to conform, to Americanize . . . to disappear' in *The Explicit Body in Performance* (New York and London: Routledge, 1997), 119.

21 Ana Mendieta, unpublished statement quoted by John Perreault in 'Earth and Fire, Mendieta's Body

of Work,' *Ana Mendieta: A Retrospective*, 10; Mendieta's sense of having been 'cast from the womb' comes, she states, from 'my having been torn from my homeland (Cuba) during my adolescence.' In other places Mendieta exalts the 'primitive,' writing, 'It was during my childhood in Cuba that I first became fascinated by primitive art and cultures. It seems as if these cultures are provided with an inner knowledge, a closeness to natural resources. And it is this knowledge which gives reality to the images they have created. . . . I have thrown myself into the very elements that produced me, using the earth as my canvas and my soul as my tools' (Clearwater, *Ana Mendieta*, 41). See also Miwon Kwon's interesting discussion of Mendieta's 'process of self-othering . . . [and] self-primitivizing' in 'Bloody Valentine: Afterimages by Ana Mendieta,' *Inside the Visible/An Elliptical Traverse of 20th Century Art/In, of, and from the Feminine*, ed. M. Catherine de Zegher (Cambridge, Mass., and London: MIT Press; Boston: Institute of Contemporary Art; and Kortrijk, Flanders: Kanaal Art Foundation, 1996), 167–68.

22 Jacob, *Ana Mendieta: The 'Silueta' Series*, 5.

23 On Kelly's use of Charcot's images, see Marcia Tucker, 'Picture This: An Introduction to Interim,' *Interim*, 19.

24 All of this is not by any means to level the obvious differences between the two projects. Indeed, Kelly has spoken of *Interim* as, like *Post-Partum Document*, 'problematiz[ing] . . . the image of the woman not to promote a new form of iconoclasm, but to make the spectator turn from looking to listening. I wanted to give a voice to the woman, to represent her as the subject of the gaze. . . . *Interim* proposes not one body but many bodies, shaped within a lot of different discourses. . . . [T]he installation should be an event where the viewer gathers a kind of corporeal presence from the rhythm or repetition of images.' Kelly proposes, then, to represent 'many bodies' particularized through many different discourses and argues that her work, indeed, is deeply invested in exploring the body. At the same time, however, she is clear about her attempt to avoid the spectator's *engagement* in the bodies she 'represents' synecdochically, through clothing: '[W]riting for me is . . . a means of invoking the texture of speaking, listening, touching . . . a way of visualizing, not valorizing, what is assumed to be outside of seeing. This is done *in order to distance the spectator from the anxious proximity of her body* – ultimately, the mother's body – the body too close to see' (emphasis added); Kelly, in 'That Obscure Subject of Desire,' an interview by Hal Foster, in *Interim*, 54–55. This anxiety about ensuring the distance between the representation and the spectator (and perhaps the author/artist as well) is what concerns me here, and is what marks the radical difference between Mendieta's project and Kelly's as these works have been critically framed.

Norman Bryson's claim that '*Interim* is a work about identification' (in 'Interim and Identification,' *Interim*, 27), also complicates the reading of the piece. I am arguing that all works *entail* identifications, but it is certainly true that Kelly's work insistently attempts to direct the way in which these identifications take place. This, if anything, is the most striking difference between *Interim* and 1970s body-oriented work such as Mendieta's – while the latter works through a kind of intersubjective seduction that allows for open-ended possibilities of highly charged and loaded identifications, Kelly's work is perhaps paradigmatic of the impulse in 1980s practice to *direct* specific readings and identifications. Kelly is certainly just as (if not much more) aware of the possibilities of intersubjective engagement and, apparently, *uses* such awareness to produce the specific (Brechtian) effects she desires. The viewer/reader identifies with the 'women' produced in these images/texts yet may feel curiously (but predictably) distanced from them in their rather clinical and didactic mode of address. It is interesting to imagine how the photographs of clothing alone, without the layers of directive textual and contextual materials (from the labels within the images as they appear in the piece to the text panels to the other components of *Interim* to the institutional settings in which it appears to the spoken and written commentary about it), would mean differently and perhaps engage us *too* closely from Kelly's point of view.

25 See the various essays in Jones, ed., *Sexual Politics*.

26 Again, I am speaking of *dominant* discourses, which came almost entirely from New York and the academic centers of England and, even then, I am necessarily being highly reductive in order to trace very broad patterns as I perceive them. An alternative discourse did develop during the 1980s – one that insistently referenced identity politics as a central concern. See Lucy Lippard, *Mixed Blessings: New Art in a Multicultural America* (New York: Pantheon, 1990).

27 Owens, 'The Allegorical Impulse: Toward a Theory of Postmodernism,' parts 1 and 2 (*October* 1980), reprinted in *Beyond Recognition: Representation, Power, and Culture*, ed. Scott Bryson, et al. (Berkeley and Los Angeles: University of California Press, 1992), 52–87; Benjamin Buchloh. 'Allegorical

Procedures: Appropriation and Montage in Contemporary Art,' *Artforum* 21 (September 1982), 43–56.

28 As is common in dominant discourses of postmodernism in the 1980s, Buchloh's numerous essays on postmodernism, which are heavily indebted to Peter Bürger's conception of institutional critique from *Theory of the Avant-Garde* (1974; tr. Michael Shaw [Minneapolis: University of Minnesota Press, 1984]), posit postmodernism within avant-gardist terms. See also the writings of Hal Foster, another 'Octoberist,' including *Recodings: Art, Spectacle, Cultural Politics* (Seattle: Bay Press, 1985). While I single out the 'Octoberists' here, it is more because of the vast influence and importance their work has had than because they are more egregiously modernist than the innumerable other codifiers of postmodern art in *Artforum* or other art magazines and journals.

29 On the essentialism of antiessentialist feminist criticism, see Andrea Partington, 'Feminist Art and Avant-Gardism,' in *Visibly Female: Feminism and Art Today*, ed. Hilary Robinson (New York: Universe, 1988), 228–49, and my essay 'Feminist Heresies: 'Cunt Art' and the Female Body in Representation,' in *Herejias: Critica de los mecanismos*, ed. Jorge Luis Marzo (Canary Islands: Centro Atlántico de arte moderno, 1995), 583–644.

30 Craig Owens, 'The Discourse of Others: Feminists and Postmodernism' (1983), in *Beyond Recognition*, 170; emphasis added.

31 The equivocality of my approach might be summed up philosophically by Martin Heidegger's observation that '[n]earness cannot be encountered directly,' in 'The Thing,' in *Poetry Language Thought*, tr. Albert Hofstadter (New York: Harper & Row, 1971), 166.

32 On the left's disdainful view of pleasure and its alignment with capitalism, see Frankfurt School texts such as Theodor Adorno and Max Horkheimer, 'The Culture Industry: Enlightenment as Mass Deception' (1944) in *Dialectic of Enlightenment* (New York: Herder and Herder, 1972), 120–67. See also Roland Barthes, *The Pleasure of the Text*, tr. Richard Miller (New York: Hill and Wang, 1975), 22; and Pierre Bourdieu, *Distinction: A Social Critique of the Judgement of Taste*, tr. Richard Nice (Cambridge, Mass.: Harvard University Press, 1984). Sally Banes discusses this prohibition in relation to 1960s avant-garde performance, which she sees as having been motivated by the desire to democratize culture and embrace sensual pleasure, which was identified by 1950s intellectuals as linked to popular culture, 'consumption, passivity, ease of interpretation, realism, and narrativity' (*Greenwich Village 1963*, 105). And Fredric Jameson, who is not known for his sensitivity to feminist issues, nonetheless makes a strong point in favor of an antipleasurable stance for feminism when he argues that the most powerful statement of the puritanism of the left (as typified in Frankfurt School theories of culture) has been in the feminist movement: 'the reintroduction of the 'problem' of pleasure on the Left (thematized by Barthes out of a whole French theoretical culture, most notably marked by Lacanian psychoanalysis) now paves the way for an interesting reversal, and for the kind of radical political argument *against* pleasure of which Laura Mulvey's 'Visual Pleasure and Narrative Cinema' is one of the more influential statements' ('Pleasure: A Political Issue,' in *Formations of Pleasure* [London: Routledge and Kegan Paul, 1983], 7).

5. Briony Fer, 'Objects Beyond Objecthood'

This essay was first published in 1999 in a special issue of the *Oxford Art Journal* dedicated to the work of the French–American artist Louise Bourgeois. Briony Fer has frequently sought to investigate the relationship between psychoanalytic models and art objects. In this essay, she explores the idea of the 'literalness' of the artwork (a term derived from the writings of the art historian Michael Fried) in relation to some of the anthropomorphic 'soft sculptures' of Bourgeois and Eva Hesse. Drawing on psychoanalytic theory, she considers the possible effects of these works on the viewer, and suggests ways in which we might read such sculpted objects in terms of imaginary models of feminine subjectivity. The essay is reprinted in full from the *Oxford Art Journal*, vol. 22, no. 2, 1999, pp. 25–36. [GP]

For the critic Lucy Lippard, Louise Bourgeois held a special position in the 'Eccentric Abstraction' show which she organized at the Fischbach Gallery in New York in 1966. Thankfully the title did not stick, but the exhibition brought together the work of a group of artists including Eva Hesse and Bruce Nauman, mainly younger artists except for Bourgeois, whose resonance continues to be intensely felt in the work of any number of artists. If object-hood was a term used to describe the literalness of the object, its mere thing-like status, then this work moved beyond objecthood, not by repairing the rift and returning to the object its aesthetic plenitude, but by taking it even fur-ther down the road of literalness itself and into a realm of excessive, bodily materiality. In so doing, it laid the ground for a whole range of work which has subsequently come to be labelled Postminimalist. The moment is mythic in so far as it has come to be charged with the significance of revealing all that Minimal art itself had sought to repress. Certainly Lippard initially set up the show as an alternative to 'dead-set Minimalism' and to the 'rigours of structural art'.[1] As she described it in the essay she wrote in *Art International*, whilst 'Eccentric Abstraction' shared some common ground with 'primary structures', it also shared some of Pop's perversity and a fundamentally Surrealist concern with the 'reconciliation of distant realities'.[2] The opposi-tion to Minimalism, that has since become rather too firmly entrenched in the critical imagination, must have been vividly staged, not least by the coin-cidence that 'Ten', the show Ad Reinhardt helped to organize, was showing at the same building at the Dwan Gallery, and showing some of that 'dead-set' Minimal art at its best, with Judd, Morris, LeWitt and so on.

Small as her works were, just visible on the left hand side of the installa-tion photograph and completely dwarfed by Frank Viner's hanging pieces, Bourgeois' position in the show as an older artist made her both participant and precedent. According to Lippard, her work had tended in the direction of 'Eccentric Abstraction' since the 1940s because of its visceral bodily qualities, as well as a direct link to European Surrealism and work such as Meret Oppenheim's *Fur Teacup*. 'Organic', 'erotic', 'sensuous': these were the words Lippard used to describe the work in this idiom and the 'near-visceral identi-fication with form' that has the capacity to activate the most powerful physi-cal sensation.[3]

Yet it was Eva Hesse whose work seems to have been at the back of Lippard's mind throughout, especially pieces like *Several* [Plate 40] and *Ingeminate*, both of which ended up in the show. She refers to this as the 'organic' work which Hesse had been producing over the previous year to explain why initially she was unprepared for the very large piece *Metronomic Irregularity* [Plate 41] which Hesse also exhibited. *Several* was made by laying papier-mâché over rubber hose and painting over it with shiny acrylic black through to matte grey. It hangs on strings, hooked up to the top of the wall. Its shapes as well as its textures, like the painted papier-mâché or the straggling

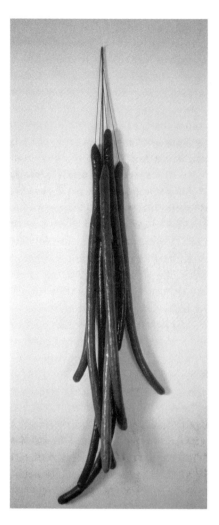

Plate 40 Top: Eva Hesse, *Several*, 1965, acrylic paint and papier-mâché over seven balloons with rubber cord, 84 x 117 inches. © The Estate of Eva Hesse, Galerie Hauser and Wirth, Zurich.

Plate 41 Bottom: Eva Hesse, *Metronomic Irregularity II*, 1966, painted wood, sculp-metal and covered wire, 48 x 240 inches. © The Estate of Eva Hesse, Galerie Hauser and Wirth, Zurich.

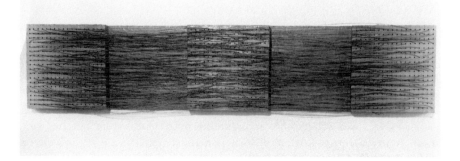

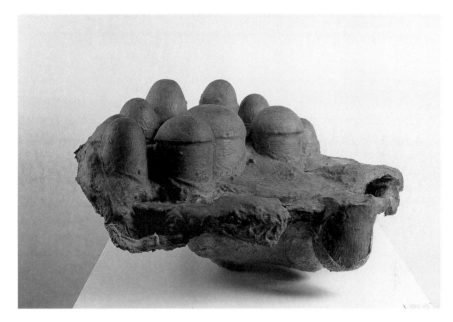

Plate 42 Louise Bourgeois, *Double Negative*, 1963, latex over plaster, 49.2 x 92.2 x 79.6 cm.
Kröller-Müller Museum, Otterlo, The Netherlands. © Louise Bourgeois/VAGA, New
York/DACS, London 2003.

bits of rope or the shapes bound round and round with string, signalled very
clearly the alternative to 'dead-set' Minimalism. The organic character of
Hesse's work, for Lippard, 'paralleled in one way or another by Viner's floppy
pop-colored envelopes, Louise Bourgeois' overtly sexual latex membranes,
Alice Adams' giant chainlink womb form, Bruce Nauman's exhausted rubber
streamers, Don Potts' undulating wood and leather sculptures, Gary Kuehn's
frozen-to-melted conjunctions and Keith Sonnier's vinyl-versus-wooden enclo-
sures, one of which "breathed".'4 Clearly, only an intensely formal under-
standing of the 'organic' could combine Bourgeois' 'overtly sexual membranes'
with Alice Adam's 'womb-form' with Nauman's 'exhausted' streamers. But of
course, the formal is intimately bound up in a language of description, in this
case a vocabulary of description which invests form with a palpable sense of
bodily states, bodily parts, and bodily functions like breathing.

It was also a show that was adamantly abstract, with Lippard claiming that
abstraction could be a 'more potent vehicle of the unfamiliar' than figura-
tion.5 Artists like Westerman and Kusama, though she talks about them in the
article as close relations and even precedents for some of this work, were left
out because they were figurative. And she famously claimed 'In eccentric
abstraction, evocative qualities or specific organic associations are kept at a
subliminal level, without the benefit of Freudian clergy. Ideally a bag
remains a bag and does not become a uterus, a tube is a tube and not a phal-

Plate 43 Louise Bourgeois, *Le Regard,* 1966, latex and cloth, 12.7 x 39.4 x 36.8 cm. Courtesy of Cheim and Reed, New York. Photo: Christopher Burke. © Louise Bourgeois/VAGA, New York/DACS, London 2003.

lic symbol.'[6] For all its critical force, by the early 1970s Lippard was taking this back word for word, picking over the very phrase as if to make clear the bench mark it represented. In an essay of 1975, she says she can simply no longer support that claim: '. . . the time has come', she wrote, 'to call a semi-sphere a breast if we know damn well that's what it suggests, instead of suppressing the association and negating an area of experience that has been dormant except in the work of a small number of artists, many of them women'.[7] That is, damn it, a breast is a breast, or so it seemed as she looked back and accused herself of too much compromise with a Minimalist aesthetic (she was also writing by now about artists like Judy Chicago whose work demanded a

different kind of language). Lippard's politicization as a feminist demanded precisely, at that time, a clearer message, less of the understatement she had eloquently applied to, say, Nauman's 'barely marked areas of space'.[8] But whilst the shift claimed the pressing need for reinstating a female subject, it lost something of the radical possibility of a more precarious subjectivity, one that now in turn, I think, becomes pressing (and possible) to consider again, not least because of the work done by feminism then. That is, what seems interesting now is not to think in terms of a subject matter but of how the work places the subject or spectator, how it might incur the coming-into-being of the subject – in particular the feminine subject. If Lippard's sense of what was pressing was to place the body and the erotic at the centre of contemporary art, then the question which presses more urgently now is this: where is the subject to be placed? That is, the question which arises now is not so much how the work of these artists fit together, but instead something of the strange encounters that were set up, principally in the encounter of Bourgeois and Hesse and what I want to suggest are their quite different ways of situating the subject or spectator within the field of vision.

A starting point might be Mel Bochner's comments, the tone of which Lucy Lippard grants gets closer to the work than her own epithet 'eccentric abstraction'. Admiring Hesse's work as the best in the show, Bochner came up with a stark observation of its emptiness: 'Regular, remote, lifeless. Her other pieces, atrophied organs and private parts, encased in string and painted black are not garish and horrifying'. They had, he said, a sort of 'detached presence'.[9] This remark is suggestive precisely because it points away from the continual re-play of bodily empathies towards what we might describe in terms not of an encounter replete with meaning, but one in which there is an element of detachment, in which something is taken away, almost a piece taken out of the encounter. A detachment that interrupts the constant circling of bodily empathies; not a filling up but a making a hole in; not a directness but a kind of opacity. Contradictorily, then, to be in the picture is to be out of the picture. What seems interesting now is not simply how the body comes to be placed in the work, but how it does so only to expose a fundamental absence in the bits and pieces of subjectivity that seem to get detached in the process.

The whole question of 'Soft Sculpture' would invite a language of anthropomorphism, of bodily projection and empathy. Bulbous forms, organic forms, seemed deliberately to inscribe an erotics of the body. Even when most insistent on the qualities of form, she cannot avoid the literalism demanded by Bourgeois.[10] Lippard talked of Bourgeois' 'overtly sexual membranes'. She tries in her language to make equally explicit the sexual connotations of ' "crowds" of breast-phallus protrusions, finger-like growth. . . .', like *Double Negative* [Plate 42], as she writes in her 1975 *Artforum* article on Bourgeois. Of the latex pieces one has 'a slit into a labial interior', referring to *Le Regard* [Plate 43]. She used hyphens a lot: 'breast-phallus protrusions' or 'hill-breast-

clouds' of *Cumulous*.[11] It is as if these linguistic contractions were needed to express the heightened sense of the bodily, visceral presence of the objects, to circumvent the problem of likeness they embody and express the more-than-likeness, the lack of representation. In a way, it is not the recognition of suppressed imagery that requires such condensation, even for Lippard, so much as the sheer literalness of Bourgeois's work as it is experienced by the viewer. For example, *Le Regard* is a latex sculpture which insistently figures the eye as a sexual organ, and *vice versa*. A devouring eye is also devoured, it appears, from within, in this hollowed out cavity which metonymically elides bodily orifices. The eye is libidinized and voracious, the very act of looking pathologized as scopic for the feminine subject. It is the scopic rather than the optical which concerns me, the ways in which the subject is torn apart by the scopic drive in a way that runs quite counter to a notion of bodily empathies and what, in the language of the 1960s, was called 'anthropomorphism'.

Oldenburg was the artist whose work most readily seemed to exemplify the term 'anthropomorphic'. The critic Max Kozloff was one of many to elaborate a rich repertoire of bodily empathies and identifications in his essay 'Poetics of Soft Sculpture', which he wrote for an exhibition in Los Angeles in 1967. Putting in question the familiar objects of a domestic interior, Oldenburg transformed a fan into a giant, collapsing bodily form – suggestive of fatigue, inertia, deterioration. All bodily affect, yet even Kozloff at one point has to ask what if all this squirming stuff makes the spectator feel not more but less organic?[12] Oldenburg was the focus of such criticism, but not exclusively, and the same litany of artists that featured in 'Eccentric Abstraction' in 1966 would feature again, culminating in 1968 in Lucy Lippard's 'Soft and Apparently Soft Sculpture' that would travel all over the States and include, once again, Bourgeois, Hesse, Sonnier, Nauman as well as Kusama and Oldenburg. Oldenburg was seen as a prototype and Lippard placed him at the beginning of her essay 'Eccentric Abstraction' in relation to Dalì, who had made a fur-lined bath for a window display in 1941: 'The viewer was invited figuratively to immerse himself in a great fur womb, as he was 25 years later invited by Claes Oldenburg's gleaming, flexible blue and white vinyl bathtub'.[13] It seemed clear that this kind of relation to the object came from Surrealism, just as it seemed clear that it entailed breaking with certain fundamental protocols of modernist distance and disinterestedness.

Anthropomorphism is a loaded and ubiquitous term; it veers from something very very good to something very very bad. The same year, 1967, Michael Fried proffers the most anthropomorphic reading of Minimalism in order, precisely, to establish its 'latent anthropomorphism'.[14] That is, the anthropomorphism of Minimal art lies not in its residual connotations of bodily form but in the looming presence of objects which appear as actors might on a stage. The literalness of the object, mere objecthood, is sustained only by recourse to a highly metaphorized account of the encounter with the object – a theatrical encounter

involving a monstrous body. On the other hand, Robert Smithson was equally insistent that Hesse avoided the anthropomorphic in her *Laokoon*.[15] Whatever we make of claim and counter-claim, what is obvious is that the anthropomorphic *mattered*, though quite why is less clear. In an obvious way, this has to do with the associations of certain kinds of 'organic' form – straggly bits as opposed to straight bits, soft, bulging surfaces as opposed to hard ones and so on. Yet these oppositions tend to keep the conventional relationship between subject and object intact, even though they may be now tuned to a rhythm of echoes in bodily states and movements. It was precisely a kind of superficial anthropomorphism from which Judd and Smithson and Hesse and even Bourgeois wanted to distance themselves.

On the other hand, we might think of another kind of anthropomorphism, the kind claimed as central by the Surrealist writer Roger Caillois, whose understanding of the anthropomorphic was entirely in terms of the spatial lure of the subject, the way in which the subject could inhabit their surroundings. Anthropomorphism, to Caillois, is the very antithesis of anthropocentrism, which is the presumption of the individual and the centrality of man. In his model of mimicry, Caillois describes the way an insect which changes colour through camouflage does so in order to become invisible; as it disappears, it loses irreparably its distinctness.[16] Rather than a sign for its surroundings, camouflage acts as a negative signifier, a sign of non-being, which effaces rather than produces connotational value. This desire for self-effacement is the opposite of the kinds of bodily empathies I have been describing so far as anthropomorphic, but corresponds far more closely with the spatial lure of the objects under discussion here. It runs quite counter to the kinds of erotic identification that Lippard had intended, and requires us to think rather differently the disjunction between desire and drive, especially as it might be played out in relation to femininity. This sense of mimetic compulsion is not a matter of the art object carrying associations to or connoting things in the world, as we might understand resemblance; rather, it has to do with the coming-into-being of the subject in the scopic field, on the understanding that the scopic field is something we inhabit and which we cannot view from outside.

It is Bourgeois' latex works from the 'Eccentric Abstraction' show, and a small group of works produced shortly after it, that I want to think about from this point of view. Bourgeois had exhibited her latex pieces before at the Stable Gallery show in 1964. These were a series of latex moulds, flesh-coloured or earth-coloured, 'small, flattish, fluid moulds' according to Lippard.[17] Here in *Eccentric Abstraction*, she showed *Portrait* from 1963, the latex piece that belonged to her friend Arthur Drexler. With its untidy edges curling out, this is like some shiny, lumpy blister, which erupts off the surface of the wall, interrupting the wall as a picture might. It is made of latex, the cast off mould of one of her plaster torsos. It is both crumpled and smooth, a latex case taken from one of her hanging objects. Though it protrudes out

from the wall, it has the quality of an inside of something. Merleau-Ponty once described how we can imagine parts of the body that we have never seen and how certain people could hallucinate 'their own face *seen from inside*'.[18]

Like other works from this time, *Portrait* hangs from the wall as a picture but also like a carcass. Like Hesse's work, they are situated between image and object. Or rather, they hang on the wall like an image but they function as an object, protruding into the spectator's visual field. There is lack of distance determined by the object's relatively small scale which causes the object, viewed from close-up, to take on magnified proportions in the imagination, quite disproportionate to its actual size.

Latex or liquid rubber is a casting material and it is a material which behaves in odd ways. It can be poured or painted. It has a viscosity which solidifies in time; it is skin-like, mostly like a shed skin with raw unfinished edges. Latex was considered soft, in contrast to a hard dry material like plaster. Sometimes, as in *Soft Landscape* from 1963 she mixed the two. Hesse discovered latex later than Bourgeois, in the autumn of 1967, though Nauman had already used latex for his streamers with a cloth backing in the 'Eccentric Abstraction' show. Hesse painted latex on like paint, and liked the translucency of latex, which in time turns syrupy brown, but even the potential change that would inevitably happen to the material appealed to her. For Hesse, latex was close to painting and could even reiterate that moment when the fluidity of paint freezes in time and hardens, that was captured in Pollock's drips.[19] Hesse liked the way you could alter the colour and the translucency depending on the proportion of rubber to filler.[20] For Bourgeois, on the other hand, it was how the material seemed to *perform* – the viscosity of the pouring, the event of its malleable action – of which she spoke: 'The poured form is stretched from the inside and obeys the laws of gravity' or the way 'hot wax poured into freezing water will assume a unique shape'[21]. In Bourgeois, latex does not so much bear the mark of touch – it is not modelled – as act out its previous liquidity, of wetness, of bodily secretions which make the skin of surface bulge and almost leak or seep out. According to Lippard, Bourgeois thought about getting a performer dressed in a latex mould to act out the symbolic origins of the work, soft plaster turning hard, reverting to soft in a latex mould, then to hard marble and so on. Lippard said some of them hung on the wall like memories of performances.[22] One could go further and say that the work is performative rather than sculptural in Bourgeois' very approach to materials, as so many props in the imagination, so many materials for the body to mimic; not so much a matter of creating new forms out of new materials, as destroying one material in favour of another, trading in and off obsolescence, not just using but making cast-offs.

The combination of hard and soft, wet and dry, animates much of Bourgeois' work, even when it is not made of latex. The way hard materials like bronze or plastic are made to mimic soft ones in her various *Soft*

Landscapes is an example of this and part and parcel of her literalist approach, paradoxical as that may be. This is quite a different effect from that of Hesse's work, even though there is in both a similar movement between the works in different materials, for example, works in latex and works in plaster, which intimately binds them together. But in Hesse the relationship of image to object is one of mutual cancellation: a draining of the body's substance. In Bourgeois' work, there simply is not that contradiction. Materials heighten and even exaggerate the qualities of lumpenness or collapse that the shapes would suggest rather than work against them. As a result, there is a disintegration but not the same evacuation of meaning. To exaggerate the difference for a moment, we could invoke what Robert Ryman seemed to see in Hesse's work. Then married to Lippard and with a studio in the same Bowery building as Hesse, Ryman traded one of his paintings in return for an unfinished work by Hesse, still all white plaster. Ryman preferred the white papier-mâché shell without the cord to some of the finished pieces which she was making out of papier-mâché over balloons, the kind in the 'Eccentric Abstraction' show, but without the string bound around it.[23] What Ryman saw, I would suggest, was there, latent, as the shell of Hesse's work, a claim we could never make of Bourgeois' white plaster pieces. In Bourgeois' hands, white plaster is somehow just as awkward, just as resistant to immateriality, as anything else.

On the other hand, that axis between too much material presence and too little is dramatised by Kusama, another of the artists cited by Lippard as a precursor of 'Eccentric Abstraction' (though, like others ruled out because of their figuration). Like Hesse, Kusama had, since 1961, created sculptures which combined object and monochrome – both to exacerbate the sense of bodily affect and at the same time to cancel it out through serial repetition. Like Bourgeois', the work was characterized by bunching bulbous forms protruding from a slack surface which Lippard calls her 'phallus-studded furniture'.[24] But her objects – a large table, a chair – covered in white protuberances, interested Judd because of their 'obsessive repetition' where the 'masses of white protuberances are more alike than the underlying forms are unlike',[25] a kind of obsessive repetition that can also be linked to Lucas Samaras' pin-covered objects. Judd draws attention to the emptying out of meaning through the very serial repetition which puts the masses of phallic shapes in place. This is not just a question of emphasis, but of how we might go on to understand the work's effects in relation to the place of the subject.

André Green has coined the term 'une angoisse blanche' to describe the anxiety of separation distinct from the anxiety of castration – though both are forms of detachment.[26] In French, the word 'blanc' means both white and blank and this approximation to the double function of the monochrome seems to be brought into play and set against the function of the object as body, or the bodily analogy of interior-exterior, for example, or Kusama's dresses, shed skins which hang on the wall. In what he calls the 'série blanc'

he counts negative hallucinations which Freud had first talked about in con-
nection with the hysteric. Negative hallucinations are where portions of the
field of vision may simply be cut out, scotomized. If we think of the subject
in these terms she is but an imprint or stain within the scopic field. This is
reminiscent of Caillois' mimetic compulsion in which a subject is rendered
invisible. But the example of hallucinations gives more force – appropriately
here I think – to that swing between an intensification of vision, the exag-
geration of bits like the bulbous protrusions in Kusama, to a kind of blanking
and the exacerbation of what André Green talks of as 'trous psychiques' in
negative hallucinations. For all that 'Eccentric Abstraction' was criticised for
being 'sick',[27] pre-empting as it were a culture of trauma, this blanking, or
effacing of the subject, was its other face.

So what of Bourgeois within this economy? If one asks from what point of
view is the object the object of a sadistic destructive drive then the answer has
to be only from the infantile and that is the point of view Bourgeois unmasks,
or more precisely, acts out in a performative gesture. And what she unmasks
is the scopic drive as it might operate for a feminine subject; the scopic, that
is , not the optical; the scopic, that is, not bodily empathy; the scopic, that is,
as partial drive, with all the force that carries with it of a pathologized femi-
nine subject for whom looking is a form of destruction as it is a form of pleas-
ure. The Imaginary is that realm within the psychoanalytic field in which
aggression is the necessary corollary to the narcissistic structure of the com-
ing-into-being of the subject. This fantasy of the fragmented body became
the model of disintegration in art in the 1980s, but which Bourgeois had
explored in the work that I have looked at here. The Imaginary is the realm
Klein described in terms of the falling to bits of the ego. Within the realm of
the Imaginary, which is where Bourgeois's work has to be placed I think,[28] the
subject may identify with precisely what is repellent as a kind of pleasure,
still within the register of the pleasure principle, of desire. But the other
model which emerged at that same moment – that moment of the 'Eccentric
Abstraction' show – was not so much the disintegration of the subject-into-
pieces but the drive to self-effacement. This signals the unfolding of a model
of nonintegration as the subject is both caught and effaced in what Smithson
called the 'lost tempo' of Hesse's *Metronomic Irregularity*.[29]

The breast is not a breast, damn it, when it is also a serial monochrome
object. It is not a question of an image that is latent. It is both less than a
breast in that what we encounter is a series of substitutions, latex, string
whatever, something inanimate, and more than a breast in that it is much
more like a breast than a picture of a breast might be, operating as it does as
the lost object par excellence, what Torok and Abraham have called 'the lost
object – me'.[30] It is that border between desire in all its destructive forms
which is where Bourgeois would seem to situate us, and the more than pleas-
ure or *jouissance* which is where Hesse's work touches on a drive that we

might think of as a kind of fault-line or interval within subjectivity itself. As I have tried to describe it, that interval is between desire and drive, and between disintegration and detachment. I would not want to overstate it, or set up another set of oppositions, so much as suggest that the work shown at 'Eccentric Abstraction' played between these poles, and so within a fractured subjectivity. Perhaps what is most interesting is how work gets *made* out of such negativity; how work gets made, that is, whose effects are neither simply reparative nor simply — at the other end of the scale — desublimatory. Detachment ends up being not just a necessary cost but also a gain — a condition of viewing objects that would deal not with bodily empathies so much as what gets lost in the very processes of identification, lost in the sense of falling into pieces of a subject in disintegration, as in Bourgeois, or a subject who is effaced and rendered invisible in Hesse. Detachment in these terms, then, is anything but neutral. Rather, it is the very presence of the object that heightens the sense of losing a portion of oneself.

From this point of view, although the work of Louise Bourgeois is usually characterised as being somehow more direct and less mediated than the work of others, that is not really what is different about her. What is different, particularly at this moment in the mid-sixties when her work seems closest to the work of a range of younger artists, is the way her work stages or performs its disintegrating effects that mark her out.

1 Lucy Lippard, 'Eccentric Abstraction', *Art International*, Lugano, vol. 10, no. 9, November 1966, p. 28. As Lippard noted in a footnote, the article provided the basis for lectures she gave at the University of California in Berkeley and at the Los Angeles County Museum in the summer of 1966 as well as the exhibition at the Fischbach Gallery in the autumn. There was a similar text expounding the basic ideas of the show that accompanied the pink soft vinyl announcement for it, and this Lippard quotes from later in her book *Eva Hesse*, (Da Capo Press: New York, 1976).

2 Lippard, 'Eccentric Abstraction', p. 28.

3 Lippard, 'Eccentric Abstraction', p. 34.

4 Lippard, *Eva Hesse*, p. 83.

5 Lippard, 'Eccentric Abstraction', p. 40.

6 Lippard, 'Eccentric Abstraction', p. 39.

7 Lucy Lippard, *The Pink Glass Swan; Selected Essays on Feminist Art* (The New Press: New York 1995), p. 83.

8 Lippard, 'Eccentric Abstraction', p. 38.

9 Mel Bochner, *Arts Magazine*, November 1966, quoted by Lippard, *Eva Hesse*, p. 83.

10 See Anne Wagner's discussion of literalism in *Oxford Art Journal*, vol. 22, no. 2. 1999.

11 Lucy Lippard, *Artforum*, March 1975, p. 27.

12 Max Kozloff, 'The Poetics of Soft Sculpture', in *Renderings* (Studia Vista: London 1970), p. 233.

13 Lippard, 'Eccentric Abstraction', p. 28.

14 Michael Fried: 'I am suggesting, then, that a kind of latent or hidden naturalism, indeed anthropomorphism, lies at core of literalist theory and practice', 'Art and Objecthood', in *Art and Objecthood*, (University of Chicago Press: Chicago, 1998), p. 157.

15 Robert Smithson, 'Quasi-Infinities and the Waning of Space', in *The Collected Writings*, ed, Jack Flam (University of California Press: Berkeley, CA, 1996), p. 37

16 Caillois draws a distinction between anthropomorphism, the heading under which he can bracket all his arguments, and anthropocentrism, which is the presumption of man's centrality. Roger Caillois 'Courte Note sur "Anthropomorphisme"', in *Meduse et Cie*, (Gallimard: Paris, 1960). Caillois dis-

cusses the three types of mimicry which he defines as camouflage, travesty and intimidation in 'Les Trois Fonctions de Mimétisme' in *Meduse et Cie*, p. 81 et passim. See also 'Mimicry and Legendary Psychasthenia' translated in Annette Michelson, Rosalind Krauss, Douglas Crimp and Joan Copjec (eds.), *October: The First Decade*, (MIT: Cambridge, MA and London, UK, 1987), pp. 58–74.

17 Lippard, 'Eccentric Abstraction', p. 34.

18 Merleau-Ponty draws the example from Lhermitte, *L'Image de notre corps*, in *Phenomenomology of Perception*, (Routledge: London and New York, 1962), p. 149.

19 Morris, *Continuous Project Altered Daily*, p. 44.

20 Lippard, *Eva Hesse*, P. 106. Hesse's earliest works in latex are the incomplete *Repetition Nineteen II* (the test pieces) and *Schema*, both 1967.

21 Louise Bourgeois, *Writings*, p. 81.

22 Lippard, 'Eccentric Abstraction', p. 29.

23 Lippard, *Eva Hesse*, p. 66.

24 Lippard, 'Eccentric Abstraction', p. 28. Munro accepts this term, it would seem, calling them 'phallus encrusted', *Yoyoi Kusama* (Museum of Modern Art: New York, 1998), p. 81.

25 Donald Judd, September 1964 in *The Complete Writings* (New York University Press: New York, 1973).

26 André Green, *Narcissisme de Vie, Narcissisme de Mort*, (Les Editions de Minuit: Paris, 1983), p. 226.

27 Lippard also describes how it has been called an 'aesthetics of nastiness', 'Eccentric Abstraction' (1966), p. 39.

28 Mignon Nixon has powerfully argued how one might think the aggressive feminine subject in Kleinian terms, see 'Bad Enough Mother', *October* 71, Winter 1995.

29 Robert Smithson, *The Collected Writings*, p. 344.

30 Nicolas Abraham and Maria Torok elaborate this idea in ''The Lost Object – Me': Notes on Endocryptic Identification' in *The Shell and the Kernel*, vol. 1, Chicago 1994, pp. 139–156.

PART VI
GLOBALISATION

Introduction

The phenomenon of 'globalisation' extends far beyond the arts. Indeed, its impact on the arts is in some ways a secondary effect of deeper and wide-ranging economic, technological and political changes. The emergence of a global system has not, of course, been an overnight phenomenon. Earlier twentieth-century imperialism knitted most areas of the world into a system dominated by the western capitalist countries. However, the term 'globalisation' as it is used to today is generally employed to describe events since the end of the old imperial systems, that is to say, since the 1960s approximately. As such, it is coincident with the phenomena that are often collectively described as 'postmodernism'. Technological developments, particularly information and communications technology, have had the effect of drawing hitherto remote parts of the world closer together. But these developments cannot be separated from the growth of multinational corporations, many of which have become more powerful than individual nation states. With gathering force since the end of the Cold War, from which the USA emerged as the only global superpower, the phenomenon of globalisation has in effect meant the imposition of capitalism on a world scale. That is to say, in both economic and political terms, globalisation is a partial synonym for 'capitalisation', or indeed, Americanisation.

In cultural terms, however, and particularly in terms of art, the situation is not so clear cut. Certainly, American television, music and fashion have made unprecedented inroads into other cultures. But there has also been an influx of non-western music and other cultural forms such as cuisine into the metropolitan western cultures. The result has been an increasingly rich mix, a 'hybridity' of cultural forms. This phenomenon is no less marked in the visual arts.

It goes almost without saying that this is a very complex area in which traditional terminologies buckle under the strain of attempting to incorporate types of activity they were never originally intended to include. 'Art' itself is one such term; 'modernism' another. The word 'art' acquired many of its contemporary meanings in a western situation, largely between the eighteenth and twentieth centuries. Modern western art has always had a relation to the visual cultures of the rest of the world, no less so than modern western society as such. In fact, it has been persuasively argued that the notion of 'primitivism' in terms of which modernist art was related to the culture of non-western societies, was itself a subset of a wider imperialism. In the post-colonial period, for obvious reasons, 'primitivism' lost any credibility it may ever have possessed as a way of describing these relations. Indeed, the journey from

'primitivism' to 'globalisation' in the arts is in part the story of the transition
to post-colonialism.

There is now an enormous literature on cultural globalisation and post-
colonialism. The four texts we reprint here are not intended to be represen-
tative of that wider literature, but to stand in their own right as contributions
to an expanding field of debate. Stuart Hall uses the concept of 'black', as in
'black popular culture', as a lens through which to focus a discussion of essen-
tialism and difference in relation to a counter-hegemonic struggle to 'displace
European models of high culture'. Sarat Maharaj also seeks to think beyond
what he calls 'absolutist' distinctions, such as those between difference and
identity, self and other. He concludes that 'no position permits a viewing
without itself turning into the viewed'. Rex Butler investigates the specific
case of Australian Aboriginal art and the problems it poses for the recovery of
meaning. In so doing, Butler shifts the ground from reflection on aesthetic
response to the question of doing *justice* to the work and its authors. Finally,
Okwui Enwezor, artistic director of the exhibition *Documenta XI* in Kassel in
2002, looks at the implications of post-colonialism for the notion of an artis-
tic avant-garde. Once again the idea of justice is central: what is the role of
'cultural and artistic responses' in the pursuit of a just society? Using the fig-
ure of 'Ground Zero', Enwezor argues that 'what is at stake in the radical pol-
itics and experimental cultures of today' in the pursuit of this end is resist-
ance to 'total integration into the Western system'.

1. Stuart Hall, 'What is this "Black" in Black Popular Culture?'

Stuart Hall directed the Centre for Contemporary Cultural Studies in
Birmingham when it was at the height of its influence in the 1970s and
early 1980s, before becoming Professor of Sociology at the Open University.
In the present essay, he discusses the implications of what he terms (with
considerable reservation), a shift in the 'cultural dominant' away from a
sense of Europe as 'the universal subject of culture' into 'the global post-
modern'. One of the distinctive features of Hall's writing is its commitment
to a cultural politics. His analysis is not conducted for the sake of academic
enquiry alone, but in the service of a wider struggle for 'cultural hegemo-
ny', which he believes is contested with particular force in the field
of popular culture. Indeed he remarks that one of the most important
features of the 'global postmodern' is its increasing displacement of the
high/popular distinction so central to artistic modernism. His main aim here
is to point out the dangers for the struggle over cultural hegemony that may
result from essentialising difference ('white'/'black'; 'self'/'other'). Instead,
he advocates 'dialogic strategies and hybrid forms', a cultural politics that

works to dislocate fixed identities. The essay from which the following extracts are taken was originally published in Gina Dent (ed.), *Black Popular Culture*, Bay Press, Seattle, 1992, pp. 465–75.

I begin with a question: What sort of moment is this in which to pose the question of black popular culture? These moments are always conjunctural. They have their historical specificity; and although they always exhibit similarities and continuities with the other moments in which we pose a question like this, they are never the same moment. And the combination of what is similar and what is different defines not only the specificity of the moment, but the specificity of the question, and therefore the strategies of cultural politics with which we attempt to intervene in popular culture, and the form and style of cultural theory and criticizing that has to go along with such an inter-match. In his important essay, 'The new cultural politics of difference',[1] Cornel West offers a genealogy of what this moment is, a genealogy of the present that I find brilliantly concise and insightful. His genealogy follows, to some extent, positions I tried to outline in an article that has become somewhat notorious,[2] but it also usefully maps the moment into an American context and in relation to the cognitive and intellectual philosophical traditions with which it engages.

According to West, the moment, this moment, has three general co-ordinates. The first is the displacement of European models of high culture, of Europe as the universal subject of culture, and of culture itself in its old Arnoldian reading as the last refuge . . . I nearly said of scoundrels, but I won't say who it is of. At least we know who it was against – culture against the barbarians, against the people rattling the gates as the deathless prose of anarchy flowed away from Arnold's pen. The second co-ordinate is the emergence of the United States as a world power and, consequently, as the centre of global cultural production and circulation. This emergence is both a displacement and a hegemonic shift in the *definition* of culture – a movement from high culture to American mainstream popular culture and its mass-cultural, image-mediated, technological forms. The third co-ordinate is the decolonization of the Third World, culturally marked by the emergence of the decolonized sensibilities. And I read the decolonization of the Third World in Frantz Fanon's sense: I include in it the impact of civil rights and black struggles on the decolonization of the minds of the peoples of the black diaspora.

Let me add some qualifications to that general picture, qualifications that, in my view, make this present moment a very distinctive one in which to ask the question about black popular culture. First, I remind you of the ambiguities of that shift from Europe to America, since it includes America's ambivalent relationship to European high culture and the ambiguity of America's relationship to its own internal ethnic hierarchies. Western Europe did not

have, until recently, any ethnicity at all. Or didn't recognize it had any. America has always had a series of ethnicities, and consequently, the construction of ethnic hierarchics has always defined its cultural politics. And, of course, silenced and unacknowledged, the fact of American popular culture itself, which has always contained within it, whether silenced or not, black American popular vernacular traditions. It may be hard to remember that, when viewed from outside of the United States, American mainstream popular culture has always involved certain traditions that could only be attributed to black cultural vernacular traditions.

The second qualification concerns the nature of the period of cultural globalization in progress now. I hate the term 'the global postmodern', so empty and sliding a signifier that it can be taken to mean virtually anything you like. And, certainly, blacks are as ambiguously placed in relation to postmodernism as they were in relation to high modernism: even when denuded of its wide-European, disenchanted marxist, French intellectual provenance and scaled down to a more modest descriptive status, postmodernism remains extremely unevenly developed as a phenomenon in which the old centre-peripheries of high modernity consistently reappear. The only places where one can genuinely experience the postmodern ethnic cuisine are Manhattan and London, not Calcutta. And yet it is impossible to refuse 'the global postmodern' entirely, insofar as it registers certain stylistic shifts in what I want to call the cultural dominant. Even if postmodernism is not a new cultural epoch, but only modernism in the streets, that, in itself, represents an important shifting of the terrain of culture toward the popular – toward popular practices, toward everyday practices, toward local narratives, toward the decentring of old hierarchies and the grand narratives. This decentring or displacement opens up new spaces of contestation and affects a momentous shift in the high culture of popular culture relations, thus presenting us with a strategic and important opportunity for intervention in the popular cultural field.

Third, we must bear in mind postmodernism's deep and ambivalent fascination with difference – sexual difference, cultural difference, racial difference, and above all, ethnic difference. Quite in opposition to the blindness and hostility that European high culture evidenced on the whole toward ethnic difference – its inability even to speak ethnicity when it was so manifestly registering its effects – there's nothing that global postmodernism loves better than a certain kind of difference: a touch of ethnicity, a taste of the exotic, as we say in England, 'a bit of the other' (which in the United Kingdom has a sexual as well as an ethnic connotation). Michele Wallace was quite right, in her seminal essay 'Modernism, postmodernism and the problem of the visual in Afro-American culture',[3] to ask whether this reappearance of a proliferation of difference, of a certain kind of ascent of the global postmodern, isn't a repeat of that 'now you see it, now you don't' game that modernism once played with primitivism, to ask whether it is not once again achieved at

the expense of the vast silencing about the West's fascination with the bodies of black men and women of other ethnicities. And we must ask about that continuing silence within postmodernism's shifting terrain, about whether the forms of licensing of the gaze that this proliferation of difference invites and allows, at the same time as it disavows, is not really, along with Benetton and the mixed male models of *The Face*, a kind of difference that doesn't make a difference of any kind.

Hal Foster writes — Wallace quotes him in her essay — 'the primitive is a modern problem, a crisis in cultural identity'⁴ — hence, the modernist construction of primitivism, the fetishistic recognition and disavowal of the primitive difference. But this resolution is only a repression; delayed into our political unconscious, the primitive returns uncannily at the moment of its apparent political eclipse. This rupture of primitivism, managed by modernism, becomes another postmodern event. That managing is certainly evident in the difference that may not make a difference, which marks the ambiguous appearance of ethnicity at the heart of global postmodernism. But it cannot be only that. For we cannot forget how cultural life, above all in the West, but elsewhere as well, has been transformed in our lifetimes by the voicing of the margins.

Within culture, marginality, though it remains peripheral to the broader mainstream, has never been such a productive space as it is now. And that is not simply the opening within the dominant of spaces that those outside it can occupy. It is also the result of the cultural politics of difference, of the struggles around difference, of the production of new identities, of the appearance of new subjects on the political and cultural stage. This is true not only in regard to race, but also for other marginalized ethnicities, as well as around feminism and around sexual politics in the gay and lesbian movement, as a result of a new kind of cultural politics. Of course, I don't want to suggest that we can counterpose some easy sense of victories won to the eternal story of our own marginalization — I'm tired of those two continuous grand counter-narratives. To remain within them is to become trapped in that endless either/or, either total victory or total incorporation, which almost never happens in cultural politics, but with which cultural critics always put themselves to bed.

What we are talking about is the struggle over cultural hegemony, which is these days waged as much in popular culture as anywhere else. That high/popular distinction is precisely what the global postmodern is displacing. Cultural hegemony is never about pure victory or pure domination (that's not what the term means); it is never a zero-sum cultural game; it is always about shifting the balance of power in the relations of culture; it is always about changing the dispositions and the configurations of cultural power, not getting out of it. There is a kind of 'nothing ever changes, the system always wins' attitude, which I read as the cynical protective shell that, I'm sorry to

say, American cultural critics frequently wear, a shell that sometimes prevents them from developing cultural strategies that can make a difference. It is as if, in order to protect themselves against the occasional defeat, they have to pretend they can see right through everything – and it's just the same as it always was.

Now cultural strategies that can make a difference, that's what I'm interested in – those that can make a difference and can shift the dispositions of power. I acknowledge that the spaces 'won' for difference are few and far between, that they are very carefully policed and regulated. I believe they are limited. I know, to my cost, that they are grossly underfunded, that there is always a price of incorporation to be paid when the cutting edge of difference and transgression is blunted into spectacularization. I know that what replaces invisibility is a kind of carefully regulated, segregated visibility. But it does not help simply to name-call it 'the same'. That name-calling merely reflects the particular model of cultural politics to which we remain attached, precisely, the zero-sum game – our model replacing their model, our identities in place of their identities – what Antonio Gramsci called culture as a once and for all 'war of manoeuvre', when, in fact, the only game in town worth playing is the game of cultural 'wars of position'.

Lest you think, to paraphrase Gramsci, my optimism of the will has now completely outstripped my pessimism of the intellect, let me add a fourth element that comments on the moment. For, if the global postmodern represents an ambiguous opening to difference and to the margins and makes a certain kind of decentring of the western narrative a likely possibility, it is matched, from the very heartland of cultural politics, by the backlash: the aggressive resistance to difference; the attempt to restore the canon of western civilization; the assault, direct and indirect, on multiculturalism; the return to grand narratives of history, language and literature (the three great supporting pillars of national identity and national culture); the defence of ethnic absolutism, of a cultural racism that has marked the Thatcher and the Reagan eras; and the new xenophobias that are about to overwhelm fortress Europe. The last thing to do is read me as saying the cultural dialectic is finished. Part of the problem is that we have forgotten what sort of space the space of popular culture is. And black popular culture is not exempt from that dialectic, which is historical, not a matter of bad faith. It is therefore necessary to deconstruct the popular once and for all. There is no going back to an innocent view of what it consists of.

* * *

I have the feeling that, historically, nothing could have been done to intervene in the dominated field of mainstream popular culture, to try to win some space there, without the strategies through which those dimensions were con-

densed onto the signifier 'black'. Where would we be, as bell hooks once remarked, without a touch of essentialism? Or, what Gayatri Spivak calls strategic essentialism, a necessary moment? The question is whether we are any longer in that moment, whether that is still a sufficient basis for the strategies of new interventions. Let me try to set forth what seem to me to be the weaknesses of this essentializing moment and the strategies, creative and critical, that flow from it.

This moment essentializes difference in several senses. It sees difference as 'their traditions versus ours', not in a positional way, but in a mutually exclusive, autonomous and self-sufficient one. And it is therefore unable to grasp the dialogic strategies and hybrid forms essential to the diaspora aesthetic. A movement beyond this essentialism is not an aesthetic or critical strategy without a cultural politics, without a marking of difference. It is not simply re-articulation and re-appropriation for the sake of it. What it evades is the essentializing of difference into two mutually opposed either/ors. What it does is to move us into a new kind of cultural positionality, a different logic of difference. To encapsulate what Paul Gilroy has so vividly put on the political and cultural agenda of black politics in the United Kingdom: blacks in the British diaspora must, at this historical moment, refuse the binary black *or* British. They must refuse it because the 'or' remains the sight of *constant contestation* when the aim of the struggle must be, instead, to replace the 'or' with the potentiality or the possibility of an 'and'. That is the logic of coupling rather than the logic of a binary opposition. You can be black *and* British, not only because that is a necessary position to take in the 1990s, but because even those two terms, joined now by the coupler 'and' instead of opposed to one another, do not exhaust all of our identities. Only some of our identities are sometimes caught in that particular struggle.

The essentializing moment is weak because it naturalizes and dehistoricizes difference, mistaking what is historical and cultural for what is natural, biological, and genetic. The moment the signifier 'black' is torn from its historical, cultural, and political embedding and lodged in a biologically constituted racial category, we valorize, by inversion, the very ground of the racism we are trying to deconstruct. In addition, as always happens when we naturalize historical categories (think about gender and sexuality), we fix that signifier outside of history, outside of change, outside of political intervention. And once it is fixed, we are tempted to use 'black' as sufficient in itself to guarantee the progressive character of the politics we fight under the banner – as if we don't have any other politics to argue about except whether something's black or not. We are tempted to display that signifier as a device which can purify the impure, bring the straying brothers and sisters who don't know what they ought to be doing into line, and police the boundaries – which are of course political, symbolic and positional boundaries – as if they were genetic. For which, I'm sorry to say, read 'jungle fever' – as if we can translate

from nature to politics using a racial category to warrant the politics of a cultural text and as a line against which to measure deviation.

Moreover, we tend to privilege experience itself, as if black life is lived experience outside of representation. We have only, as it were, to express what we already know we are. Instead, it is only through the way in which we represent and imagine ourselves that we come to know how we are constituted and who we are. There is no escape from the politics of representation, and we cannot wield 'how life really is out there' as a kind of test against which the political rightness or wrongness of a particular cultural strategy or text can be measured. It will not be a mystery to you that I think that 'black' is none of these things in reality. It is not a category of essence and, hence, this way of understanding the floating signifier in black popular culture now will not do.

There is, of course, a very profound set of distinctive historically defined black experiences that contribute to those alternative repertoires I spoke about earlier. But it is to the diversity, not the homogeneity, of black experience that we must now give our undivided creative attention. This is not simply to appreciate the historical and experiential differences within and between communities, regions, country and city, across national cultures, between diasporas, but also to recognize the other kinds of difference that place, position, and locate black people. The point is not simply that, since our racial differences do not constitute all of us, we are always different, negotiating different kinds of differences – of gender, of sexuality, of class. It is also that these antagonisms refuse to be neatly aligned; they are simply not reducible to one another; they refuse to coalesce around a single axis of differentiation. We are always in negotiation, not with a single set of oppositions that place us always in the same relation to others, but with a series of different positionalities. Each has for us its point of profound subjective identification. And that is the most difficult thing about this proliferation of the field of identities and antagonisms: they are often dislocating in relation to one another.

Thus, to put it crudely, certain ways in which black men continue to live out their counter-identities as black masculinities and replay those fantasies of black masculinities in the theatres of popular culture are, when viewed from along other axes of difference, the very masculine identities that are oppressive to women, that claim visibility for their hardness only at the expense of the vulnerability of black women and the feminization of gay black men. The way in which a transgressive politics in one domain is constantly sutured and stabilized by reactionary or unexamined politics in another is only to be explained by this continuous cross-dislocation of one identity by another, one structure by another. Dominant ethnicities are always underpinned by a particular sexual economy, a particular figured masculinity, a particular class identity. There is no guarantee, in reaching for an essentialized racial identity of which we think we can be certain, that it will always turn out to be

mutually liberating and progressive on all the other dimensions. It *can* be won. There *is* a politics there to be struggled for. But the invocation of a guaranteed black experience behind it will not produce that politics. Indeed, the plurality of antagonisms and differences that now seek to destroy the unity of black politics, given the complexities of the structures of subordination that have been formed by the way in which we were inserted into the black diaspora, is not at all surprising.

These are the thoughts that drove me to speak, in an unguarded moment, of the end of the innocence of the black subject or the end of the innocent notion of an essential black subject. And I want to end simply by reminding you that this end is also a beginning. As Isaac Julien said in an interview with bell hooks in which they discussed his new film *Young Soul Rebels*, his attempt in his own work to portray a number of different racial bodies, to constitute a range of different black subjectivities, and to engage with the positionalities of a number of different kinds of black masculinities:

> blackness as a sign is never enough. What does that black subject do, how does it act, how does it think politically . . . being black isn't really good enough for me: I want to know what your cultural politics are.5

1 Cornel West, 'The new cultural politics of difference', in *Out There: Marginalization and Contemporary Cultures*, ed. Russell Ferguson *et al.* (Cambridge: MIT Press in association with the New Museum of Contemporary Art, 1990), 19–36.

2 Stuart Hall, 'New ethnicities', *Black Film/British Cinema, ICA Document 7*, ed. Kobena Mercer (London: Institute of Contemporary Arts, 1988), 27–31.

3 Michele Wallace, 'Modernism, postmodernism and the problem of the visual in Afro-American culture', in *Out There: Marginalization and Contemporary Cultures*, 39–50.

4 Hal Foster, *Recodings: Art, Spectacle, and Cultural Politics* (Port Townsend, Wash.: Bay Press, 1985), 204.

5 bell hooks, 'States of desire' (interview with Isaac Julien), *Transition* 1, no. 3, 175.

2. Sarat Maharaj, 'Perfidious Fidelity: the Untranslatability of the Other'

Sarat Maharaj is Professor of History and Theory of Art at Goldsmiths College in London, and has written widely on postmodernist art and culture. He was involved in curating *Documenta XI* in Kassel in 2002. In the present essay, written in 1994, he addresses concerns arising from the then recently broached issue of a post-Cold War 'new international order'. Wary of what he regards as the myth of potential transparency between different cultures and different languages, Maharaj employs the concept of 'translation' as a metaphor for wider problems of negotiating difference. Setting the unviable notion of complete translatability against apartheid, conceived as a negative instance of the assertion of unbridgeable difference, Maharaj seeks a position that avoids both extremes. Following the French philoso-

pher Jacques Derrida, he advances a view of meaning-making as partial and speculative, one in which the loss of sense mutates into a new sense: a position that he regards as borne out in certain post-Duchampian art projects. The term that is most frequently used to capture this situation is that of the 'hybrid', but Maharaj wants to stop hybridity from settling into the cliché of a new internationalism and instead attempts to recharge it as an open, provisional term. The essay, which is reprinted in full, was originally published in Sarat Maharaj, *Global Visions: Towards a New Internationlism in the Visual Arts*, Kala Press/inIVA, London, 1994, pp. 28–36.

27.4.'94 From Apartheid's dying grip, gently, gently ease the idea it turned against us with such murderous force – 'the untranslatable other'

28.4.'94 The funeral pyre's torched. Speak the idea differently now – for those who survived and those who didn't?

These are rather rough-grained sketch notes towards 'recoding the international' – a task both massive and daunting. My focus is essentially on two things:

1. To move towards reindexing the international space which I should like to describe as the 'scene of translations'. Beyond the demand for assimilation, beyond absolutist notions of difference and identity, beyond the reversible stances of 'self and other' in which the Eurocentric gaze fashions itself as the other, as the intoxicating exotic as in the heady stuff of a Smirnoff ad – in the 1990s, we have come to see the international space as the meeting ground for a multiplicity of tongues, visual grammars and styles. These do not so much translate into one another as translate to produce difference. Have we been all too affirmative about this difference-producing space? How might it be recorded in the light of a more inflected concept of translation? In everyday terms, we see translation as the business of imperceptibly passing through from one language to another, not unlike stacking panes of glass one on top of another, a matter of sheer transparency. But is it no less about taking the measure of the untranslatable, about groping along and clawing at dividing walls, about floundering in an opaque stickiness? This might seem like flying in the face of our workaday notions of translation. Yet words and images as much mimic as stand off from and pull faces at one another. How therefore to recode translation taking on board ideas about its limits and dead-ends, its impossibility,[1] the notion of the untranslatable, what we might call 'the untranslatability of the term other'?

2. My second focus is on trying to recode what the scene of translations throws up – hybridity – to recharge it in a double-turn, a positive and negative force in one go. On the one hand, the idea is to see it as a creative force: since each language seems to have its own system and manner of meaning, the construction of meaning in one does not square with that of another.

From their very opacity to each other, from in-between them, translation thus cooks up and creates something different, something hybrid. On the other hand, the idea is to ask if the hybrid might not also be seen as the product of translation's failure, as something that falls short of the dream-ideal of translation as a 'transparent' passage from one idiom to another, from self to other.

Two issues, therefore, need to be explored. Is there a danger of hybridity – made-up lingo and style or visual Esperanto – becoming the privileged, prime term, a danger of its swapping places with the notion of stylistic purity? Is it heading towards operating as a catch-all category in which we lump together as diverse works as those of Yasumasa Morimura, Jamelie Hassan, Huang Yong Ping, Doris Salcedo, Vivan Sundaram, Vuyile Cameron Voyiya, Lani Maestro, Sue Williamson and Rasheed Araeen? With this, hybridity – vehicle for demarcating and disseminating difference – seems paradoxically to flip over into its opposite, to function as the label of flattening sameness, as 'new international gothic'. At stake is staving off the tendency for hybridity to settle down into a one-dimensional concept, into what Gayatri Spivak speaks of as 'translatese'[2] – what we might liken to bureaucratese or officialese. The concern is with safeguarding its volatile tension, its force as a double-voicing concept. A recoding would need to affirm its bright and cloudy dimensions – the fact that it is at once the 'success' of translation and its 'failure': that it marks the site of an unceasing tussle between something hard won out of opacity and the impossibility of transparency.

The notion of 'untranslatability' was given a singular twist by Apartheid for its own ends. It projected the impossibility of translation, of transparency, to argue that self and other could never translate into or know each other. This sense of opacity served to underpin its doctrine of an absolute 'epistemic barrier' – grounds for institutionalising a radical sense of ethnic and cultural difference and separateness. Self and other were deemed to be locked in their own discrete, pure spaces. Recoiling from Apartheid's 'pessimistic', violating scripting and staging of the untranslatable, the drive has been to promote hybridity as its 'optimistic' flip side – as the triumph over untranslatability. How to recharge 'hybridity' so that it is prised free from this oppositional coupling? The aim is to prevent it from narrowing down into a reductive, celebratory term. To recode it in more circumspect key involves defining it as a concept that unceasingly plumbs the depths of the untranslatable and that is continually being shaped by that process. It is to reinscribe it with a double-movement that cuts across 'optimism and pessimism, the opaque and the crystal-clear' – to activate it as a play-off between the poles. It amounts to reindexing hybridity as an unfinished, self-unthreading force, even as a concept against itself. At any rate, as an open-ended one that is shot through with memories and intimations of the untranslatable. I have expressed the above in rather clear-cut, decisive terms – in an English kitted out in sturdy, sensible shoes and off on a brisk walk. I should say immediately, however, that it

hides much that is undecided, hesitating. For behind the above map lies a vast panic-making searching and exploring that stretches back to my earlier, even more tentative attempts at probing the lines of the inter-cultural 'epistemic barrier'.3

Paradoxically, perhaps scandalously, to find solace for my sense of panic and to get to grips with the process of recoding itself, I turned to the *Panic Encyclopedia*, to the section on Panic Hamburgers, skipping over other hair-raising, heebie-jeebie entries.4

An ordinary hamburger, as I suppose all of us take for granted — whether diehard or dithering vegan or not — is filled with wholesome chunks of suc-culent meat. These are, in the *Panic Encyclopedia*'s thinking, metaphors for chunks of nutritious meaning, portions of semantic substance. The Panic Hamburger, on the contrary, devoid of such content, has practically no decent filling to its credit. We might even suspect it of harbouring some sort of syn-thetic stuff, perhaps even slivers of a textured soya spun mix. At any rate, hardly any semantic substance to sink our teeth into. Except that we might see it in terms of a variety of constructions and recodings: a hamburger for every occasion — for the happy hour or for the blossoming or broken romance. A hamburger constructed as the family afternoon treat or a hamburger for the cranky vegan. I am sure we can agree this has little to do with either McDonalds or other fast-food joints — it's strictly about the process of inscrip-tion, erasure and recoding. Are some centuries longer than others? How might we construct and recode the new international century as the longest of them all? — as one that takes in the ancient and modern Jewish diaspora through to the transportation of the enslaved to the Caribbean and US, from the inden-tured and colonised to the postwar 'dark migrations' and the contemporary scene thick-scribbled with foot and fingerprints of refugees, exiles, deportees. One of Joyce's panic-stricken 100 letter desperation/diasportation words from *Finnegans Wake* evokes it:

Lukkedoerendunandurraskewdylooshooferoyportetooryzoo ysphalnabortansporthaokansakroidverjkapakkapuk

The word for 'shut door' in six languages, it captures the unhinging, trapping fear that accompanies the new international order and its sense of exhilaration, both its closures and openings. What Joyce hammers out is an unspeakable, untranslatable Babel word.

Boutique Product of Chohreh Feyzdjou — this is how the exile artist of Iranian Jewish background bills her work. [Plate 44] Framed as the 'Bazaar of Babel', the installation cites and cancels at least four acts and scenes of translation. Firstly, it stages the stereotyped Jewish space — the entrepreneur-ial scene of exchange, speculation, transaction. If it marks the still, tradition-al sacred space of the Talmudic scroll it is no less the tumultuous, profane space of buying, selling, shopping and over-the-counter commerce.

Plate 44 Chohreh Feyzdjou, *Sans titre* [*Boutique Product of Chohreh Feyzdjou*], 1975–89.
Courtesy of Documenta Archiv, Kassel, Germany. © Fonds national d'art contemporain,
Ministère de la culture, Paris.

An ashen Auschwitz dust powders the scored, weather-beaten surfaces –
space of the diaspora, deportation, death. Lastly it stages the Situationists'
avant-garde space. Exasperated with the commodification of art, they had
demanded that it be churned out by the metre in a parody of its commodified
fate – not unlike stacked rolls of cloth and fabric on display. Browsing through
this space one might ask for a metre or two of painting please. But the trans-
lations do not square, each overshoots the other and is opaque to it. An excess
silently dribbles out. Between the constructions we are left with the remain-
der of the untranslatable.

Translation, as Derrida therefore puts it, is quite unlike buying, selling,
swapping – however much it has been conventionally pictured in those terms.
It is not a matter of shipping over juicy chunks of meaning from one side of
the language barrier to the other – as with fast-food packs at an over-the-
counter, take-away outfit. Meaning is not a readymade portable thing that can
be 'carried over' the divide. The translator is obliged to construct meaning in
the source language and then to figure and fashion it a second time round in
the materials of the language into which he or she is rendering it.

The translator's loyalties are thus divided and split. He or she has to be
faithful to the syntax, feel and structure of the source language and faithful
to those of the language of translation. We have a clash and collision of loy-
alties and a lack of fit between the constructions. We face a double writing,
what might be described as a 'perfidious fidelity' or, to use Joyce's words, a

'double-cressing' loyalty – tressing, cross-dressing, double-crossing, treacher-
ous. We are drawn into Derrida's 'Babel effect'.

Marcel Duchamp's remarks on the English translation by Richard
Hamilton (1960) of his handwritten *Green Box* notes (1912–34) anticipated
something of this view of translation. He complimented the English version
by noting its 'monstrous veracity' – touching on its skewed fidelities, its truer-
than-true unfaithfulness to the original. Referring to the project as a 'crys-
talline transubstantiation' rather than as a translation – he was to throw
together the qualities of sheer transparency against those of the opaque, the-
ological mystery of transformation. His stress is on transmutation – the sense
of translation as a semiotic gear-switch, a break from one system of signs and
images to another.5 We might scan the scene of translations taking as its sym-
bol Duchamp's lamp from *Etant Donnés* – the project he secretly worked on
from 1946 to 1966. But what more magical a lamp than Aladdin's – which
touches on the processes of translation as transmutation and transformation
rather than as transfer. The word Aladdin – pronounced in old colonial
English fashion with the accent on the first syllable – is itself Allah Din, reli-
gion of Allah. It changes to A'laddin – the stress is on the 'l' as north country
English and Hollywood meet and mix.

A contemporary cartoon raises the transmutation stakes by representing
the see-through, spectral genie in Scottish tartan kilt and sporran. Aladdin
further translates into the Bengali-voiced Alauddin and Co., UK Sweetmeats,
Brick Lane and Tooting Bec. We step into the scene of translations of Britain
today, into the rough present of the 'dark migrations' – out of what might
have seemed like a remote, abstruse linguistics debate between thinkers about
the nature of translation.

The Western tourists have come and gone, bird-vanished as swiftly as they
had arrived. Only their litter on Sri Lankan shores – photo bulbs, empty
shampoo sachets, discarded bottles and jars, ballpoints, sweet containers,
clapped-out batteries, cassettes, disposable cameras, throwaway plastics, Coca-
Cola cans bobbing on the waves. . . . Picked up by some Sri Lankans they are
crafted and wrought into objects of everyday use – colanders, graters, bowls,
spoons and mugs, ladles. A treasure trove, an Aladdin's Cave of utensils ham-
mered from tourist-junk. We have chanced upon an Aladdin's lamp made
from local waste materials – tinned food can, light bulb, string wick,
newsprint. The tourists have flocked back delighted with these magical
objects and utensils. They buy them, admiringly, affectionately. Overseen by
the Institut für Auslandsbeziehungen in Stuttgart, Dr Grotheus's collection of
such 'objects from foreign lands' went on exhibition-tour across Germany. It
was requisitioned by the Sydney Biennale '93 – for a less formal, less muse-
um style display. It was thus translated for the third time by being displayed
as something between the ethnographic item, the avant-garde readymade and
the everyday object. As the indeterminate object between Sri Lanka,

Stuttgart, Sydney, the hybrid stands before us: beyond it, traces of untranslatable leftovers?

Where translation is understood as a process of 'carrying over' and simply in terms of 'transparency' it tends to encourage a superficial, if seductive, attitude to 'multicultural translation' as the immediate visibility of all elements of multicultural community to one another – even in the face of an adverse actuality that thwarts and distresses such an ideal at every turn. Dare we hold on to the ideal, however, for the value of its critical demand – a utopian horizon against which multiculturalism might be scanned, kept on its toes, and shown up for having fallen short of its own claims?

But to focus on untranslatability is not only to acknowledge from the start the impossibilities and limits of translation. It is to highlight the dimension of what gets lost in translation, what happens to be left over. Since what is gained in the translation tussle – elements of hybridity and difference – is so impressive, it is easy to slip into thinking of it as an outright overcoming of the untranslatable. The concept then begins to function as the mirror image of 'purity' with no less of the latter's triumphal overtone. It takes on an all too positive, optimistic ring billed as the new international visual Esperanto – a tellingly hunky-dory word, Steiner reminds us, that half-echoes the Spanish for hope.

What antidote for this drive towards becoming a reductive, one-dimensional term? A recoding would need to index hybridity as a site shot through and traced with the untranslatable which serves as its supplement and prop. The upshot of this is to dramatise the incomplete, unfixed nature of the category. We begin to see hybridity not so much as a self-standing, fixed term but as an interdependent one – changing and rechanging as it interacts with the aura of the untranslatable, with the remains and leftovers of the translation exercise. These need to be accounted for and acknowledged at every turn, for, to use Adorno's words, like blood stains in a fairytale, they cannot be rubbed off.

But can the untranslatable be voiced at all? How to articulate the leftover inexpressibles of translation? Is it perhaps to be glimpsed in a back-to-front crazy word, an image's shimmer, the flick of a gesture, the intimacies of voice, in listening to its silences – an attentiveness that opens on to an erotics and ethics of the other beyond its untranslatability? Having kicked off its sturdy walking shoes, my English is in danger of perhaps becoming too comfortably slippered at this point.

Lothar Baumgarten's installation *Imago Mundi* for the *Wall to Wall* show (Serpentine, London, 1994) stages the international space – quite literally reindexing it through a look at the codes, lens, optics and manuals of representation itself. Wherever we stand, wherever we position ourselves, we are not able to grasp the dispersed elements of the drifting continents. However acrobatically we twist, turn and contort ourselves to bring things into view, it only serves to make us aware of the limits and blindspots of the view and viewing. Africa, Asia, Australia, Europe – no position permits a viewing without itself

turning into the viewed. What prevails is the sense of watching as we are being watched, of someone looking over our shoulder as we look *l'autre l'ailleurs* – the other, elsewhere, everywhere and besides. The very transparency blocks off and shutters, occludes. We are unable to totalise this mapping of the world, each time something slips out of our grip. We grapple with the left-overs, the remainder of the untranslatable. How to signal this except perhaps through Derek Jarman's blank-screened *Blue* (1993) – *silent, throbbing*.

1 Jacques Derrida, *Dissemination*, 1981, pp. 71–72 and 'Des Tours des Babel' in *Difference in Translation*, Ithaca, 1985, pp. 165–207 and 209–48, in which the object of commentary is Walter Benjamin. 'The Task of the Translator' in *Illuminations*, New York, 1969, pp. 69–82.
2 Gayatri Spivak, 'The Politics of Translation' in *Outside in the Teaching Machine*, Routledge, New York, 1993, pp. 179–200.
3 'The Congo is Flooding the Acropolis' in *Interrogating Identity*, Grey Art Gallery, New York University, 1991–92, pp. 13–42. Also A.R. Chakraborty, *Translational Linguistics of Ancient India*, Calcutta, 1976.
4 A. Kroker, M. Kroker & D. Cook, *Panic Encyclopedia*, London, 1989, p. 119.
5 Marcel Duchamp to Richard Hamilton (26.11.'60) from the Duchamp/Hamilton unpublished letters (1957–68).

3. Rex Butler, 'Emily Kame Kngwarreye and the Undeconstructible Space of Justice'

One of the main debates about 'world art' concerns the terms of its reception. Early modernists are often criticised for their lack of attention to the social meanings of the objects they prized so highly for their formal properties. Such a restricted attitude to meaning is not viable in the postmodernist situation. Other modernist criteria such as 'authenticity' or 'purity' are challenged by the hybrid nature of much 'world art', which in modernist terms would be downgraded as 'kitsch'. Furthermore, it is not merely a matter of extending the western canon to include exotic additions. In short, the widespread interest in the visual cultures of non-western societies poses considerable problems for the western concept of 'art' itself. Rex Butler, who has written widely on Australian art, here considers the work of the Aboriginal woman artist Emily Kame Kngwarreye [variant: Kam Kngwarrey]. As with Maharaj [VI.2, above], the question of translation looms large, and once again it is the impossibility of complete transference of meaning that becomes evident. Butler's most radical proposal is to shift the terms of judgement from the aesthetic to the terrain of social justice, and to acknowledge that it is in the aporia between positions (an acknowledgement of the sense we cannot make rather than the sense we might wish to fabricate) that the possibility of justice lies. The essay, which is reprinted in full, first appeared in *Eyeline. Contemporary Visual Arts*, no.36, Brisbane, Autumn/Winter 1998, pp. 24–30.

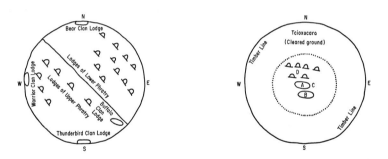

Fig. 13 Plan of a Winnebago village according to informants of the lower phratry.
Fig. 14 Plan of a Winnebago village according to informants of the upper phratry.
Both taken from *Structural Anthropology*. Claude Lévi-Strauss, Allen Lane, The Penguin Press, 1963 reprint 1969.

In the chapter 'Do Dual Organisations Exist?' of his *Structural Anthropology*, Claude Lévi-Strauss takes up the case of a tribe of North American Indians, the Winnebago of the Great Lakes, who possess two different ways of mapping their village. One section of the tribe, let us call it 'conservative', perceives the layout of the village as circular, with rings of huts successively arranged, in decreasing order of importance, around the moiety chief's central temple. [Fig 13] The other section of the tribe, let us call it 'radical', sees the social space of the village as split, with distinct clusters of huts separated by an invisible boundary. [Fig 14] Where does the truth lie here? Although it is tempting simply to fly a helicopter over the village to ascertain its 'objective' state, Lévi-Strauss cautions against this. For him, neither factual evidence nor mere relativism, in which we say that reality depends upon which side of the village we come from, is sufficient. Rather, the 'truth' of the village *is* this traumatic split in its social fabric, a split with which both plans, in their way, attempt to deal (the first by denying it altogether; the second by representing this division, which is precisely not an objective state of affairs realised by all). Both sides speak the 'truth' of the situation, but only in a symptomatic, unconscious manner. In other words, they speak it by not speaking it. It is their dissimulation which is revealing. Lévi-Strauss concludes: 'The study of so-called dual organisations discloses so many anomalies and contradictions in relation to extant theory that we should be well advised to reject the theory and to treat the apparent manifestations of duality as superficial distortions of structures whose real nature is quite different and vastly more complex'.[1]

This example has recently been taken up by the social theorist Slavoj Zizek in an effort to elaborate Lacan's notion of the Real. The Real is not some object out there in 'reality', but instead is what is excluded to allow that reality to be produced. The perhaps surprising equivalent Zizek gives in our supposedly post-ideological times is the Marxist idea of class struggle. Why is class strug-

gle an instance of what Lacan calls the Real? Because – just as with the social situation of that village above, which of course is a perfect embodiment of it – in any attempt to speak of class struggle we always have to take sides; there is no way of balancing conflicting views to take all into account. That is, although we can never entirely say what class struggle is, every statement about it is necessarily subject to it; our attitude towards it is not objective, but an effect of the very phenomenon we are seeking to analyse. As Zizek writes: 'Class struggle is none other than the name for the unfathomable limit that cannot be objectivised, located within the social totality, since it is itself that limit which prevents us from conceiving society as a closed totality'.[2] And insofar as this is so, then the attempt to dismiss class, to argue it is no longer relevant, is the most ideological stance of all. How then to speak of class, to analyse its effects, without all the biases implied by ideology itself? Zizek does not deny wanting to do this; his is not the old Althusserian position of 'all is ideology'. However, in a more complicated strategy, he argues that, although we must try to occupy this neutral point, we must also realise we can never do so. We must attempt to occupy this neutral point, but only to ensure that no one (else) is able to do so: 'Ideology is not all; it is possible to assume a place that enables us to maintain a distance from it, but this place from which one can denounce ideology must remain empty, *it cannot be occupied by any positively determined reality* – the moment we yield to this temptation, we are back in ideology'.[3]

Of course, for 'us' Australians it is Aborigines who are our Real. And Real in that there is no neutral meta-position with regard to them, no 'objective' truth that can be spoken about them, not even by Aborigines themselves. (Those who believe they speak non-ideologically, non-racially, are the most ideological and racist of all, for example, the Federal Liberal Government in talking about striking a 'balance' between competing interests, representing 'all' Australians, *etcetera*.) With regard to Aborigines, we necessarily go either too far or not far enough. And this is always the problem of the 'other'. Anthropologists in their studies have designated two possible attitudes towards 'primitive' cultures: the emic and the etic. The emic attempts to see things from the point of view of the tribal participants themselves, to enter as far as possible into their world. The etic acknowledges that we cannot do this, that we are only able to perceive things through our own (European) point of view. Both attitudes, in a way, seek a form of knowledge: the first believes that we can translate tribal experiences into Western terms; the second that, if we cannot do so, we can at least think *this*. But, as we see in the famous debate between the curator William Rubin and the critic Thomas McEvilley over the exhibition *'Primitivism' in 20th Century Art: Affinity of the Tribal and Modern* at New York's Museum of Modern Art, the two attitudes cannot be separated; this scientific ideal cannot be maintained.[4] The most emic response is revealed as etic, ultimately only a reflection of white

preconceptions. And the etic response, the admission that we cannot say any-
thing about the other, only hides the even deeper belief that we can. This is
the true problem of the other in discourse: not that we cannot represent it,
but that we already have done so, that it is implied from the beginning in
whom we are.

This was the daring aspect of the recent Queensland Art Gallery show of
the works of Emily Kame Kngwarreye, *Alhalkere: Paintings from Utopia*.
The strength of the exhibition, paradoxically, was its willingness to take
sides, or more exactly its refusal to balance perspectives, to provide some
final synthesis. Rather, it simply presented these alternatives – the emic
and the etic – and revealed that the truth was not to be attained by either
of them, that each was caught up in the other it sought to avoid. As a result,
the show escaped the two obvious rhetorics regarding the putting of
Aboriginal art into the museum: both the unambiguous celebration of its
maker and the ethnographical critique from the outside. Instead, some-
thing far more uncanny and disturbing was produced (and rare, despite vir-
tually all contemporary art being devoted to the task): a profoundly anti-
museological show held within a museum. That is, curator Margo Neale
did a very brave thing here – and its power lies in the fact that we don't
know whether to congratulate her for it or not, whether it was accidental
or deliberate – in that she did not, unlike her more timid colleagues,
attempt to pre-empt or forestall criticism, meet in advance objections of
assimilating, appropriating Kngwarreye, *etcetera*. On the contrary, she
allowed that this was inevitable – and thus in her way, like the artist, ended
up creating something new (the aim of all good curators). The show did
not try to master the impossible Real of Aboriginality, occupy some neutral
position in relation to it, but was both the effect of it and brought it about
in its failure to represent it. In this – in a final paradox – it both grasped
the methodological dilemma at stake in any approach to Kngwarreye's
work and understood itself as necessarily unable to do so.

Take, for instance, the sheer profusion and range of works selected (some
one hundred and ninety paintings, batiks and ceremonial objects produced
over a ten year period). [Plate 45 and Plate 46] At the same time, and contra-
dictorily, we were presented with an image of extraordinary formal inven-
tiveness, an untutored native genius able to ring almost unlimited changes on
a restricted iconography, and of an overworked and exploited old black
woman, pushed by the economic needs of her tribe, mercenary art dealers
and, indeed, the whole museological apparatus itself into over-production, for
whom the whole aesthetic distinction between good and bad works of art was
simply not relevant. And this dichotomy was brought out at every stage of the
show's installation and hanging. At once we had the Utopia Room, with its
ceremonial objects, Inentye figurines and videos detailing the ethnographic
background to Kngwarreye's practice, and the mounting of the twenty-two

Plate 46 Above: Emily Kam Kngwarrey, *Anooralya II*, 1995, 120 x 90 cm. The Holt Collection, Delmore Gallery, Alice Springs, Australia. Photo: Rex Butler. © DACS, London 2003.

Plate 45 Left: Emily Kam Kngwarrey, Eastern Anmatyerre, *c.* 1910–1996, *Ankerr Mern-Intekw*, synthetic polymer paint on canvas, 199.4 x 128.3 cm, Purchase from Admission Funds 1990, National Gallery of Victoria, Melbourne. Australia. © DACS, London 2003.

Plate 47 Emily Kam Kngwarrey, Eastern Anmatyerre, c. 1910–1996, Installation view of
Queensland Art Gallery exhibition 'Emily Kam Kngwarrey', 1996, showing installation of
Utopia Panels, synthetic polymer paint on canvas, 18 panels each 280 x 100 cm (approx)
Commissioned 1996 by the Queensland Art Gallery with Funds from the Andrew Thyne
Reid Charitable Trust through and with assistance of the Queensland Art Gallery
Foundation. Queensland Art Gallery, Brisbane. © DACS, London 2003.

panels of the *Alhalkere Suite* in an imposing minimalist grid, or the position-
ing of the striped *Utopia Panels* above the water mall, turning them into a
form of interior decoration in a Monet-like play on reflected light. [Plate 47]
Or the exhibition spoke of the tribal body painting origins of the early batiks
and suspended one of them from the roof like the banners announcing an
international blockbuster. In fact, this was typical of the hanging of the
whole show, with works from different periods but of the same size being
grouped together for formal purposes (for example, the three batiks of 1981,
1988 and 1988 in the left hand corner of the top gallery) or the monumen-
talising black frames around the final, almost diaphanous canvases of late
1996.[5] In a way, it was through the very 'museumisation' of the work – rather
than being offered some neutral distance onto it – that we most felt its for-
eignness to the whole Western critical enterprise.

We see the same thing in the conflicting approaches of the various cata-
logue essays, which again were not so much contextualised as simply present-
ed. On the one hand, that is, we have universalising and totalising responses,
which emphasise the essential 'sameness' of Kngwarreye's art to European
and American models, its ability to cross cultural divides. Typical of this is

Aboriginal art dealer Christopher Hodges' 'Alhalkere', which stresses, apparently on the basis of conversations with the artist herself, Kngwarreye's 'confidence in the power of her art as a communicative device',[6] to speak 'directly without the need for language' (38). Or we have the formalist-modernist reading of the Senior Research Curator of Australian Art at the National Gallery of Victoria, Judith Ryan, in her essay ' "In the Beginning is My End": The Singular Art of Emily Kame Kngwarreye', which in its very title, a quotation from T.S. Eliot's *4 Quartets*, indicates both the series of parallels that will be drawn to modernist masters (Claude Monet, Jackson Pollock, Franz Kline) and its autonomous, teleological grasp of Kngwarreye's *oeuvre*, with its deliberate bracketing of any Aboriginal 'content': 'The paintings do not encode narrative or, if they do, we are none the wiser' (41). On the other hand, art consultant and researcher, Anne Marie Brody emphasises in her predominantly ethnographical account (despite her own undeniably close contact with the Utopia community) the essential unknowability of Kngwarreye, her distance from European ways of thinking about art. Or Neale's own essay for the collection, 'Two Worlds: One Vision', once more evokes the 'otherness' of Kngwarreye's work, its intractability to Western modes of description and evaluation: [Her ability to capture] 'the soul of her "country" . . . is beyond the linguistic impasse that prevents us from articulating the full power of her work' (31). Finally, these two positions are brought together in urban Aboriginal lecturer Philip Morrissey's essay, 'Emily Kame Kngwarreye Meets the Metropolitan', in which he attempts to delineate a position for Kngwarreye as being at once the most authentic and indigenous to this country and the most alien and exotic (perhaps the very position of Morrissey himself as urban Aboriginal – and the crucial aspect of Morrissey's essay is that this 'irreconcilable' (56) split between black and white understandings of Aborigines, the impossibility of adopting a neutral position, is seen to apply to Aborigines themselves). He writes: 'As an Aboriginal person with *no* direct experience of traditional Aboriginal culture, I was challenged by the invitation to write on Emily Kame Kngwarreye. There was always the risk of entering into bad faith by pretending to be what I wasn't. Yet I also felt that I was too closely involved by virtue of my Aboriginality to carry off a sympathetic, if detached, narration which ignored my own personal involvement in any consideration of Emily'.[7]

However, it is with Roger Benjamin's essay for the catalogue, 'A New Modernist Hero', that all these issues come to a head. In it the contradiction that was perhaps implicit in those others becomes for the first time explicit, self-conscious. Benjamin begins by wanting to explain what he sees as Kngwarreye's extraordinary – and, indeed, unique – success for an Aboriginal artist in the Western art world, such that, a few short years after abandoning batik and taking up painting, she was able to eclipse her countrymen like Clifford Possum Tjapaltjarri and Michael Nelson Tjakamarra. He provides in

his essay five possible reasons for this success – and what he seeks to do by means of them is show that it can be accounted for by the way her work fits the pre-existing discursive conventions or 'myths' governing Western art. For example, under the head of the 'abstract disposition' (47–48), Benjamin notes that, unlike the marks symbolising waterholes or animal tracks in traditional desert painting. Kngwarreye's non-iconic stipples and swathes can easily be assimilated to contemporary taste, reminding viewers of similar 'all-over' works by such Abstract Expressionists as Jackson Pollock, Willem de Kooning and Jules Olitski. Or, under the head of 'productivity and old age' (49–50), Benjamin speaks of the way Kngwarreye's taking up of art at an advanced age and her constant shifts of style resonate with the legend of those rare great talents whose faculties are unimpaired by the passing of the years and whose approaching mortality grants special insight (Titian, Rembrandt, Henri Matisse, Philip Guston). Or, finally, under the head of the 'cult of spiritual meaning' (52), Benjamin argues that the tribal lore apparently encoded in Kngwarreye's canvases distinguishes her from the apparent lack of content in her post-modernist peers and aligns her instead with the original spiritual impulses of the pioneering generation of abstractionists (Kasimir Malevich, Mark Rothko, Barnett Newman).

In terms of his analysis, Benjamin is undoubtedly correct. As we have already seen – and as further reading would reveal – assumptions regarding Western art are constantly being made about Kngwarreye. In an accusation that goes all the way back to McEvilley's critique of the *'Primitivism'* show, they all commit the error of 'isomorphism' (53), the belief that just because two works of art look the same they mean the same thing. In fact, as Benjamin observes in his essay, the supposed 'universality' this points to is not universal at all, but only a European (and perhaps even more localised) projection: 'It remains to be seen whether art experts in Munich or Boston, let alone Nairobi or Beijing, will recognise the "greatness" of this art' (53). Against this, Benjamin proposes another kind of art criticism, one more 'attuned to Aboriginal cultural values; to begin with, an informed sense of what her painting means within [Kngwarreye's] own community, and the development of alternatives to the formalist and biographical readings that so far dominate approaches to her work' (53). And, in a sense, we cannot but agree. It *is* true that Western categories misrepresent Aboriginal art. It *is* true that another criticism, one more attuned to Aboriginal values, is necessary. Nevertheless – and this is not so much a personal criticism of Benjamin as a testament to the difficulty of the issues he raises, an inquiry into the meaning of a certain failure – why does this conclusion still strike us as so arbitrary and tacked on, a compromise perhaps to the forces of 'political correctness' or the desire not to offend? Why does this call for another criticism seem like a contradiction of all that came before, impossible within – or at least unprepared for by – the terms previously set up? We must ask: if Benjamin is so crit-

ical of those other approaches, in the name of what does he speak? If this is in fact the way we do think, from where could this alternative arise?

Put simply, the problem with Benjamin's analysis is that, on the one hand, he is profoundly able to challenge the ability of Western artistic categories to think about Kngwarreye's work, to demonstrate that something goes missing; and yet, on the other hand, he is unable to propose any concrete terms for this 'more attuned' criticism beyond the mere invocation of one. Why? Because no matter how he attempted to do so, how he sought to make it more substantial, it would always stand accused – as he is able to show so well with those other critics – of once again repeating European biases. And this is always the problem for those who actually attempt to produce this emic response, one more allied to Aboriginal values. Take, for instance, *The Sydney Morning Herald* critic John McDonald, who, in the course of a generally sympathetic review of the show, wrote of Benjamin's essay: 'After spending an entire essay discussing modernist attitudes in relation to numerous Western artists, all [he] can do is emphasise the inadequacy of existing approaches, including his own. There is a slightly absurd aspect to the attempt to deconstruct Kngwarreye's art or career. The artist herself obviously had clear ideas about what she was doing – so clear, they hardly permitted explanation. She didn't require dozens of pages to say "Whole lot" '.[8] In fact, we would say that McDonald has it exactly wrong here, in that the most valuable aspect of Benjamin's essay is the hesitation or silence it manages to open up and its weakest is its desire immediately to fill it in. (And McDonald's own attempt to use Kngwarreye's well-known statement 'Whole lot' as some self-evident explanation of the work only serves to demonstrate his own inability to do so.) More precisely, although we must always attempt to substantialise this alternative – and in a way already have – we must also, as Zizek says, keep it open, ensure that this critique from the 'empty point' of the other always remains possible. That is to say, the real position of this Aboriginal 'other' is not, or not only, to be found 'out there' in the world or in some radically new speaking position, but in the breakdowns and inadequacies of language 'in here'. This 'alternative' Benjamin calls for lies not in the suggestion made in the essay's epilogue, but rather in the impossible-ethical position that allows him to speak of the limitations to the Western conception of Kngwarreye's art, to achieve some critical distance upon his own practice as a white art historian, in the essay's first part.

It is just this split or division we see in Kngwarreye's work. Although there is a massive effort in the catalogue to render her work representational, with photos of anthills or flowers in bloom next to one of her 'dump-dump' paintings, or of gum trees reflected in water next to one of her final 'impressionist' canvases, we would say that what occurs there is instead the (unrepresentational) act of *spacing*. In her work, the various lines or stripes simply divide up or create a space. Indeed, we would suggest that the ultimate trajectory of her work is from objects being depicted within a pre-existing space, to objects and space

Plate 48 Emily Kam Kngwarrey, Eastern Anmatyerre, *c.* 1910–1996, *Utopia Panel*, 1996, synthetic polymer paint on canvas, 262.8 x 85.6 cm. Commissioned 1996 by the Queensland Art Gallery with Funds from the Andrew Thyne Reid Charitable Trust through and with assistance of the Queensland Art Gallery Foundation. Queensland Art Gallery, Brisbane. © DACS, London 2003.

Plate 49 Top right: Emily Kam Kngwarrey, Eastern Anmatyerre, *c.* 1910–1996, *Body Paint: Awelye I-VI,* 1994, synthetic polymer paint on paper, 6 works each 77 x 56.3 cm. Purchased through The Art Foundation of Victoria with assistance of Alcoa of Australia Ltd, Governor, 1194. National Gallery of Victoria, Melbourne, Australia. © DACS, London 2003.

having no particular relationship, to objects and space being grasped all at once.9 It is in this sense that we would say that Kngwarreye is Australian, carries on the discoveries of Nolan, Williams, Burn and Tillers: her work is the impossible depiction of void or distance not merely between this country and others but within this country itself. But, of course, to the very extent that Kngwarreye now enters this canon, we must retrospectively re-read this Australian void or space as that between Aborigines and whites. And the crucial point to be made about Kngwarreye's black and white compositions is that, to

the extent that figure and ground are henceforth indivisible, it is impossible to say which comes first. [Plates 48 and 49] There is no pre-existing ground that would allow us to compare them. They are at once inseparable and irreconcilable – and we could write an entire essay on the relationship between the colours black and white and their equivalents in Kngwarreye's work as the direct expression of the relationship between the races in Australia.

In fact – and all this is a suggestion for more work to be done in the future – we would want to think this space between black and white in Kngwarreye's work in the closest relationship to the *law* (and we know the connection these stripe paintings have to women's body marking ceremonies, that is to say, to Aboriginal law). How to think this space in terms of the law? How to think this space as the very space of the law? In order to answer these questions, we might turn to a number of recent jurisprudential writings arising out of the High Court's landmark *Mabo* decision. For there too we saw precisely the attempt to reconcile the irreconcilable, to think this impossible space between cultures. More specifically, what was at stake in *Mabo* was how to provide justice to Aborigines within the Western legal system, to recognise a version of native title within an English-based common law. One of the more ambitious

attempts to think the notion of justice implied there is by Professor of Law at Adelaide University, M.J. Detmold, in his article 'Law and Difference: Reflections on Mabo's Case', where he writes of the paradoxical nature of what he calls 'stopping-points' in legal decisions, those things that cannot be questioned to allow legally binding verdicts to be made. An example of this in *Mabo* is the High Court's unwillingness to open up for questioning the British Crown's claiming of sovereignty over the country so that the High Court itself remained empowered to make a decision concerning native title. For Detmold, insofar as law is always a process of 'recognising difference', it is always a matter of overturning these 'stopping-points' (the non-recognition of native title), but this could only be done in the name of another such 'stopping-point' (the refusal to recognise Aboriginal sovereignty). He writes: 'The process of distinguishing (the recognition of difference) is the common law's (and law's) essence. No common law statement is ever final, ever a (univocal) stopping-point but is always available for reconsideration by virtue of a difference in the next case. Nor is it even right to think of a series of common law cases as a series of absolute stopping-points. The process is a process of difference, and lies (rather, moves) between the points'.[10]

This line of inquiry is also pursued by the political philosopher Paul Patton, who finds a similar intuition in Derrida in his reading of a famous short story by Kafka, 'Before the Law'. For Derrida, we are always 'before the law' in the sense that we have already been judged, a decision has already been made; and we are 'before the law' in that justice has not been reached, there is always a certain forcing and injustice in any decision. Law, therefore, as with Detmold, is not an all or nothing affair, cannot be rendered all at once – hence the whole thematics in Kafka of the 'intermediaries' or 'gatekeepers' of the law[11] – but ongoing, a sort of perpetually receding 'horizon' or '*à-venir*'.[12] Particular judicial decisions both contest and re-affirm the law. Justice is both attained and deferred. This is to be seen in the *Mabo* decision, which is both just (in that it grants to Aborigines certain rights to land which hitherto had not been recognised in Australian law) and unjust (in that these rights can still be extinguished according to Australian law). As Patton writes, citing Derrida: 'Justice is realised in the *Mabo* decision to the extent that judgements of fact and law, which in the past have prevented forms of native title to land from being recognised and protected, are no longer permitted to hold sway. Justice is not realised to the extent that Australian law still falls short of recognising indigenous law as another legal system. Justice therefore reveals itself to be isomorphic to *différance*: at once present and absent in this historic judgement'.[13]

How to apply this to Kngwarreye? In one sense, there is always a certain judgement made, some attempt to speak for the other. There is always a particular case before us (the etic can always be shown to be emic). Against this, it is always a matter of another judgement, an attempt to show that this stopping-point is not a proper consideration of the difference of the other, is

Plate 50 Emily Kam Kngwarrey, Eastern
Anmatyerre, *c.* 1910–1996, *Untitled*
(*Awelye*), 1989, synthetic polymer paint on
linen, 90.5 x 60.5 cm. Purchased 1999.
Queensland Art Gallery Foundation Grant
and Queensland Art Gallery Functions
Reserve Fund. Collection: Queensland Art
Gallery, Brisbane. © DACS, London 2003.

unjust. And it is only through this more 'attuned', emic criticism that justice
is to be attained. But at the same time it can always be shown that this judge-
ment is only ever in the name of another such stopping-point. Justice can
never be finally arrived at. Every attempt at reconciliation is always revealed
as no reconciliation. This is why the accusation of speaking in the name of the
'other' can always be made – as we see today in almost every conference
involving post-colonial or cross-cultural theory – but also why no one should
ever think they are beyond this (even those 'others' themselves). For precise-
ly every attempt actually to produce this alternative ends up in self-contra-
diction; the emic can always be shown to be etic. However, as Derrida argues,
without foregoing the necessity for actual decisions, it is perhaps in this very
uncertainty, the sense that something is missing without being able to say
what, the unsatisfactoriness of all existing positions without being able to pro-
vide an alternative, that the possibility of justice is to be found – and that we
might say the encounter with Kngwarreye's work forces us to experience
[Plate 50]. As he writes in another of his essays, 'Force of Law: "The Mystical

Foundation of Authority" ': 'I think that there is no justice without this experi-
ence, however impossible it may be, of aporia. Justice is an experience of the
impossible. A will, a desire, a demand for justice whose structure wouldn't be an
experience of aporia would have no chance to be what it is, namely, a call for
justice.'[14] (This is why, again, that radical new speaking position for which
Benjamin calls is not to be found 'out there', but 'in here', in the flaws, incon-
sistencies — to use Neale's word — impasses of our own language, which is why
we have paid such close attention to the various texts we have cited here.) In the
name of what do we respond in Kngwarreye's work? What is it that makes us
want to render justice to this old Aboriginal woman who made it? We perhaps
cannot say, but the feeling is inexhaustible. Already realised yet unrealisable,
forcing a decision and yet leaving us unable to proceed, making us desire to
speak its truth but with every such attempt contestable as 'ideology', is this not
the very pressure of the Real as diagnosed by Zizek? Or is it not, as Derrida says,
justice itself as the final 'reality', what lies beyond deconstruction itself? 'Justice
in itself, if such a thing exists, outside or beyond law, is not deconstructible'.[15]

1 Claude Lévi-Strauss, *Structural Anthropology*, Basic Books, London, 1963, p. 161.

2 Slavoj Zizek, *Mapping Ideology*, Verso Books, London, 1994, p. 22.

3 Ibid, p. 17.

4 See on this William Rubin, *'Primitivism' in 20th Century Art: Affinity of the Tribal and Modern*,
 Museum of Modern Art, New York, 1984; Thomas McEvilley, 'Doctor, Lawyer, Indian Chief',
 Artforum, November 1984; and two further exchanges of letters (*Artforum*, February 1985 and May
 1985). A similar debate also took place in Australia between Tony Fry and Anne-Marie Willis
 ('Aboriginal Art: Symptom or Success?', *Art in America*, July 1989) and Roger Benjamin ('Aboriginal
 Art: Exploitation or Empowerment?', *Art in America*, July 1990).

5 Another aspect of Kngwarreye's art worth commenting on in this regard is the way she increasingly
 came to internalise the vertical hanging of the museum as opposed to the horizontality of Aboriginal
 ground painting; or at least the verticality of the original body paintings and batiks became indistin-
 guishable from the verticality required by the museum (for example, the dripping purple of a 1996
 Untitled or the dangling roots of a number of smaller 'yam' paintings).

6 Christopher Hodges, 'Alhalkere', in *Emily Kame Kngwarreye – Alhalkere: Paintings from Utopia*, ed.
 Margo Neale, Queensland Art Gallery, Brisbane, 1998, p. 33. All further references to this catalogue
 will appear in brackets within the main text.

7 Ibid, p. 55. The suggestive aspect of Morrissey's paper is that it is not simply a cancelling out of oppo-
 sites, but an impossible meeting of them across a void. The two are not the same; but each at its limit
 reveals itself as the other; the most extreme decontextualisation of Aboriginal art ensures its survival; the
 inhabitants of big-city megalopolises will discover for themselves the privations of desert life;
 Kngwarreye is at once the most pristine embodiment of a pure Aboriginality and a hyper-urban black or
 white. Morrissey concludes with a brilliant paradox. 'The realisation that we are not merely what is per-
 ceived by others, or that social relations in the workplace do not define the sum of who we are, may be
 – like the victim strategy – a position which only seems attractive when no others are available. Yet this
 knowledge, formerly limited to prisoners and Trappist monks, is I suggest now becoming part of ordi-
 nary life. One of the reasons for the seductive power of slogans such as Nike's 'Just do it' is the positing
 of personal agency and transcendence in the face of structural barriers which, while apparently insur-
 mountable, are not infinite. A life *in extremis* in the desert, in the city – the Kngwarreye phenomenon
 encompasses both' (57–8). There is no time to comment on this passage in detail, but one of its most
 intriguing features is the 'performative', self-creating notion of Aboriginality implied there: 'Just do it'.

8 John McDonald, 'Eyeing the Dots', *The Sydney Morning Herald*, 4/4/98, p. 14s. We also see the same
 difficulty in Michelle McDonald. 'The Problem of Criticism: Emily Kame Kngwarreye'.

9 See on this, Terry Smith, 'Kngwarreye Woman Abstract Painter', in *Emily Kngwarreye Paintings*,

Craftsman House, Sydney, 1997, p. 28, although we think we go further than Smith in stressing the indivisibility of figure and ground in Kngwarreye's work. In terms of this problematic, we would want to read a number of articles on Barnett Newman: Kenneth Baker's 'Reckoning with Notation: Pollock, Newman, Louis', *Artforum*, Summer 1980, where he writes: 'Newman's unerring feel for scale makes his works on paper seem composed in black *and* white rather than black *on* white' (p. 35); W.D. Bannard's 'Touch and Scale: Cubism, Pollock and Still', *Artforum*, June 1971; and Newman's own interview with Dorothy Sackler, 'The Frontiers of Space', *Art in America*, Summer 1962.

10 M.S. Detmold, 'Law and Difference: Reflections on Mabo's Case', *Sydney Law Review*, Vol. 15, No. 2, 1993, p. 164.

11 Jacques Derrida, 'Before the Law', in *Acts of Literature*, ed. Derek Atridge, Routledge, New York, 1992, pp. 208–209.

12 Jacques Derrida, 'Force of Law: "The Mystical Foundation of Authority"', in *Deconstruction and the Possibility of Justice*, eds. Drucilla Cornell, Michel Rosenield and David Gray Carison, Routledge, New York, 1992, p. 27.

13 Paul Patton, '*Mabo*, Difference and the Body of the Law', in *Thinking Through the Body of the Law*, eds. Pheng Cheah, David Fraser and Judith Grabich, Allen and Unwin, Sydney, 1996, p. 55. See also Patton's 'Justice and Difference: The *Mabo* Case', In *Transformations in Australian Society*, University of Sydney, 1997, pp. 95–6. The Aboriginal lawyer Noel Pearson also shares the same 'gradualist' conception of justice. See his 1993 Boyer Lecture, 'Towards Respecting Equality and Difference', ABC Books, 1993, esp. p. 101.

14 Derrida, op. cit., p. 16.

15 Ibid, p. 14.

4. Okwui Enwezor, 'The Black Box'

Okwui Enwezor is founder editor of *NKA: Journal of Contemporary African Art*, and was guest curator of the Lagos section of Tate Modern's global exhibition *Century City* in 2001. He was also artistic director of *Documenta XI* in Kassel in 2002. The extract is from his introductory essay to the catalogue of the latter exhibition, in which he examines the implications of the postcolonial condition for the concept of an artistic avant-garde. From Enwezor's perspective, the 'economic, social, cultural and political questions' that emerged in the second half of the twentieth century served to abrogate the claim to artistic autonomy. He argues that the avant-garde today lies not in contemporary art 'but in the field of culture and politics'. For him, contemporary art has become 'thoroughly disciplined and domesticated within the scheme of Empire', and some other model of resistance has to be found. The implications of this for the western conception of art, and indeed for those who work in institutions consecrated around that concept, are challenging: Enwezor is calling for resistance to 'the frame of artistic and canonical integration and totalisation that grounds the principle of Westernism as such', and seeks instead 'new relations of artistic modernity not founded on Westernism'. He concludes by invoking the aftermath of September 11, 2001 as a metaphor for a new beginning. In a disturbing image of Ground Zero, he contrasts the 'dead certainties' of westernism with the 'chaos' that characterises the contemporary situation. It remains to be seen whether that 'chaos' does indeed presage a new beginning or a further

descent into cultural negation. The following extracts are taken from Okwui Enwezor, 'The Black Box', in *Documenta XI*, exhibition catalogue, Hatje Kantz, Ostfildern-Ruit, Germany, 2002, pp. 44–55.

What is an Avant-Garde Today?
The Postcolonial Aftermath of Globalization and the Terrible Nearness of Distant Places

One feature of most definitions of globalization is the degree to which the term is constantly brought into the phenomenological orbits of spatiality and temporality in order to be disciplined inside the cold logic of the mathematical analysis of capital production and accumulation, and economic rationalization. Another point about globalization gives rise to the thought that its cumulative effects and processes are to be understood as mediations and representations of spatiality and temporality: globalization is said to abolish great distances, while temporality is at best experienced as uneven.

In his essay 'At the Edge of the World: Boundaries, Territoriality, and Sovereignty in Africa,' Achille Mbembe makes the case clear by evoking Fernand Braudel's monumental study of capitalism and the world system. Mbembe writes:

> If at the center of the discussion on globalization we place three problems of spatiality, calculability, and temporality in their relations with representation, we find ourselves brought back to two points usually ignored in contemporary discourses, even though Fernand Braudel had called attention to them. The first of these has to do with temporal pluralities, and we might add, with the subjectivity that makes these temporalities possible and meaningful.[1]

Such temporal plurality could be understood, according to Mbembe, by the distinction Braudel drew between 'temporalities of long and very long duration, slowly evolving and less slowly evolving situations, rapid and virtually instantaneous deviations, the quickest being the easiest to detect.'[2]

Whatever definition or character we invest it with, it is in the postcolonial order that we find the most critical enunciation and radicalization of spatiality and temporality. From the moment the postcolonial enters into the space/time of global calculations and the effects they impose on modern subjectivity, we are confronted not only with the asymmetry and limitations of globalism's materialist assumptions but also with the terrible nearness of distant places that global logic sought to abolish and bring into one domain of deterritorialized rule. Rather than vast distances and unfamiliar places, strange peoples and cultures, postcoloniality embodies the spectacular mediation and representation of nearness as the dominant mode of understanding the present condition of globalization. Postcoloniality, in its demand for full inclusion within the global system and by contesting existing epistemo-

logical structures, shatters the narrow focus of Western global optics and fixes its gaze on the wider sphere of the new political, social, and cultural relations that emerged after World War II. The postcolonial today is a world of proximities. It is a world of nearness, not an elsewhere. Neither is it a vulgar state of endless contestations and anomie, chaos and unsustainability, but rather the very space where the tensions that govern all ethical relationships between citizen and subject converge. The postcolonial space is the site where experimental cultures emerge to articulate modalities that define the new meaning- and memory-making systems of late modernity.

In the analysis of postcoloniality we witness a double move: first through the liberatory strategy of decolonization: Decolonization – that is to say, liberation from within – as the political order of the postcolonial is not only counter-normative and counter-hegemonic but also tends toward the reproduction of the universal as the sign of the rupture from imperial governance. Decolonization is also understood here by what Mbembe and Janet Roitman call a 'regime of subjectivity,' which they describe as:

> . . . a shared ensemble of imaginary configurations of 'everyday life,' imaginaries which have a material basis and systems of intelligibility to which people refer in order to construct a more or less clear idea of the causes of phenomena and their effects, to determine the domain of what is possible and feasible, as well as the logics of efficacious action. More generally a regime of subjectivity is an ensemble of ways of living, representing, and experiencing contemporaneousness, while at the same time, inscribing this experience in the mentality, understanding, and language of historical time.[3]

Postcoloniality's second lesson is that it exceeds the borders of the former colonized world to lay claim to the modernized, metropolitan world of empire by making empire's former 'other' visible and present at all times, either through the media or through mediatory, spectatorial, and carnivalesque relations of language, communication, images, contact, and resistance within the everyday: Two decades ago, a number of theorists would have called this double move postmodernism's saving grace. But postcoloniality must at all times be distinguished from postmodernism. While postmodernism was preoccupied with relativizing historical transformations and contesting the lapses and prejudices of epistemological grand narratives, postcoloniality does the obverse, seeking instead to sublate and replace all grand narratives through new ethical demands on modes of historical interpretation.

In this regard, it could be said that the history of the avant-garde falls within the epistemological scheme of grand narratives. What, then, is the fate of the avant-garde in this climate of incessant assault upon its former conclusions? Seen from this purview, all economic, social, cultural, and political questions that emerged in the last half century, and the vital relations of power that attend their negotiations, have had the distinctive historical

impact of abolishing all the claims that the former European avant-gardes made for themselves. Nowhere is this historical termination more visible than in the recent drive by global capitalism to frame a new optics of spatial and temporal totality that forms the project of neo-liberalism after the demise of the crudely managed and regulated Soviet Communist system. To understand what constitutes the avant-garde today, one must begin not in the field of contemporary art but in the field of culture and politics, as well as in the economic field governing all relations that have come under the overwhelming hegemony of capital. If the avant-gardes of the past (Futurism, Dada, and Surrealism, let's say) anticipated a changing order, that of today is to make impermanence, and what the Italian philosopher Giorgio Agamben calls *ater-riroriality* 4 the principal order of today's uncertainties, instability, and insecurity. With this order in place, all notions of autonomy which radical art had formerly claimed for itself are abrogated.

Calculating the effects of these uncertainties within the new imperial scheme of 'Empire,' Michael Hardt and Antonio Negri inform us of the features of a new type of global sovereignty which, in its deterritorialized form, is no longer defined by the conservative borders of the old nation state scheme. If this Empire is materializing, hegemonizing, and attempting to regulate all forms of social relations and cultural exchanges, strong, critical responses to this materialization are contemporary art's weakest point. In their thesis, Empire is that domain of actions and activities that have come to replace imperialism; whose scope also harbors the ambition to rule not just territories, markets, populations, but most fundamentally, social life in its entirety.5 Today's avant-garde is so thoroughly disciplined and domesticated within the scheme of Empire that a whole different set of regulatory and resistance models has to be found to counterbalance Empire's attempt at totalization. Hardt and Negri call this resistance force, opposed to the power of Empire, 'the multitude.'6 If Empire's counter-model is to be found in the pressing, anarchic demands of the multitude, to understand what sustains it historically returns us yet again to the move by postcoloniality to define new models of subjectivity. In postcoloniality we are incessantly offered counter-models through which the displaced – those placed on the margins of the enjoyment of full global participation – fashion new worlds by producing experimental cultures. By experimental cultures I wish to define a set of practices whereby cultures evolving out of imperialism and colonialism, slavery and indenture, compose a collage of reality from the fragments of collapsing space.

Ground Zero or Tabula Rasa: From Margin to Center

> But we have precisely chosen to speak of that kind of tabula rasa which
> characterizes at the outset all decolonization. Its unusual importance is
> that it constitutes, from the very first day, the minimum demands of the
> colonized. To tell the truth, the proof of success lies in a whole social
> structure being changed from the bottom up. The extraordinary impor-
> tance of this change is that it is willed, called for, demanded. The need
> for this change exists in its crude state, impetuous and compelling, in the
> consciousness and in the lives of the men and women who are colonized.
> But the possibility of this change is equally experienced in the form of a
> terrifying future in the consciousness of another 'species' of men and
> women: the colonizers.
>
> Frantz Fanon[7]

As in the early years of decolonization and the liberation struggles of the
twentieth century, radical Islam has today come to define (for now) the terms
of radical politics in the twenty-first century. Also, following the strategies of
the liberation struggles of the last century, the program of political Islam
today is based on an agonistic struggle with Westernism; that is, that sphere
of global totality that manifests itself through the political, social, economic,
cultural, juridical, and spiritual integration achieved via institutions devised
and maintained solely to perpetuate the influence of European and North
American modes of being. Two chief attributes of this integration are to be
seen in the constitution of the first and second phases of modernity: firstly, in
the far-reaching effects of the world system of capitalism and the state form;
and secondly, in the perpetual interpretation of what a just society ought to be,
pursued through the secular vision of democracy as the dominant principle of
political participation. The main political rupture of today is properly caught
in the resistance struggles being initiated by a host of forces (whether Islamic
or secular) in order to prevent their societies from total integration into these
two phases of the Western system.

If we are to have a proper analysis by which to interpret the fundamen-
tal rationale for such resistance, we must try to understand that processes of
integration proper to the idea of Westernism rest somewhat on what Jürgen
Habermas calls 'boundary-maintaining systems,'[8] which are also systems of
conceptual appropriation of socio-cultural processes schematized in his dis-
tinction between society and lifeworld. One way of touching on this dis-
tinction is communicated by a view that sees non-Western societies in evo-
lutionary stages of movement towards integration: from tribal to modern
society; feudal to technological economy; underdeveloped to developed;
theocratic and authoritarian to secular democratic systems of governance.
In his classic study on the colonial discourse around Africa. V.Y. Mudimbe
writes about the colonial system 'as a dichotomizing system [with which] a

great number of current paradigmatic oppositions have developed: tradi-
tional versus modern; oral versus written and printed; agrarian and cus-
tomary communities versus urban and industrialized; subsistence economies
versus highly productive economies.'9 This evolutionary principle of inte-
gration returns us to Braudel's notion of 'temporalities of long and very
long duration, slowly evolving and less slowly evolving situations.' In every
stage of this evolutionary scheme, Westernism's insistence on the total
adoption and observation of its norms and concepts cornes to constitute the
only viable idea of social, political, and cultural legitimacy from which all
modern subjectivities are seen to emerge. As I shall argue later, the social
and political struggles of today have their roots in the flaws inherent in the
two concepts on which Westernism is based.

Within the field of art, the concepts of the museum and art history rest
on a similar unyielding theology that founds the legitimacy of artistic
autonomy, canons, and connoisseurship upon the same interpretive pursuit
of modernity, which would also formulate the historical and formal under-
standing of all artistic production for all time. In the specific instance of
large-scale international exhibitions, Gerardo Mosquera has proposed the
view that Western modernism's theology of values turns into a moment
from which to gauge the asymmetry in the relationship between those he
calls 'curating cultures' and those others who are 'curated cultures.'10 In
hindsight, the top-down view of curating contemporary art operates simi-
larly within the frame of artistic and canonical integration and totalization
that grounds the principle of Westernism as such. The horizon of artistic
discourses of the last century, regardless of claims made for the affinities
between the tribal and modern, is neatly described by the cleavage that
defines the separation between Western artistic universalism and tribal
object particularities and peculiarities which also define their marginality.
While strong revolutionary claims have been made for the avant-garde
within Westernism, its vision of modernity remains surprisingly conserva-
tive and formal. On the other hand, the political and historical vision of the
Western avant-garde has remained narrow. The propagators of the avant-
garde have done little to constitute a space of self-reflexivity that can under-
stand new relations of artistic modernity not founded on Westernism. The
foregoing makes tendentious the claims of radicality often imputed to exhi-
bitions such as Documenta or similar manifestations within the exhibi-
tionary complex of artistic practice today. What one sees, then, in
Documenta's historical alliance with institutions of modernism is how
immediately it is caught in a double bind in its attempt to negotiate both its
radicality and normativity.

The events of September 11, 2001, in the United States have provided us
with a metaphor for articulating what is at stake in the radical politics and
experimental cultures of today, while opening a space from which culture,

qua contemporary art, could theorize an epistemology of non-integrative discourse. The metaphor of September 11 is to be found in the stark notion of Ground Zero. But what does Ground Zero mean at that moment it is uttered? Where do we now locate the space of Ground Zero? What constitutes its effects on the nature of radical politics and cultural articulations today? Is Ground Zero the space of the kind of antagonistic politics in which the enemy always appears the same, undifferentiated, making his annihilation all the more justifiable? Or is it to be found in the terrible pile of molten steel, soot, broken lives, and scarred, ashen ground of the former World Trade Center in downtown Manhattan? In Gaza, Ramallah, or Jerusalem? In the ruins of Afghan cities? Or is Ground Zero the founding instant of the reckoning to come with Westernism after colonialism?

Let's begin again. It may be said – in the sense of the insecurity, instability, and uncertainties it inspires – that the kind of political violence we are experiencing today may well come to define what we mean when we invoke the notion of Ground Zero. Beyond the symbolic dimension of its funerary representation, the notion of Ground Zero resembles most closely Fanon's powerful evocation of the ground-clearing gesture of *tabula resa*, as a beginning in the ethics and politics of constituting a new order of global society moving beyond colonialism as a set of dichotomizing oppositions, and beyond Westernism as the force of modern integration. No contemporary thinker comes closer than Fanon to articulating with such radical accuracy and propinquity the chaos that now proliferates inside the former dead certainties of the imperial project of colonialism and Westernism. These dead certainties are still to be found in the discourses that have equality proliferated to describe the radical spatial and temporal violence of the actions of September 11. Some call it the clash of civilizations, others the axis of evil, or the battle between good and evil, between the civilized and uncivilized world; others call it jihad, intifada, liberation, etc. In all the jingoistic language that mediates this state of affairs, cultural and artistic responses could, however, posit a radical departure from the system of hegemony that fuels the present struggle. [. . .]

1 Achille Mbembe, 'At the Edge of the World: Boundaries, Territoriality, and Sovereignity in Africa,' *Public Culture*, no. 30, winter 2000, p. 259.
2 Fernand Braudel, *Civilization and Capitalism: The Fifteenth Century to the Eighteenth Century*, vol. 3, *The Perspective of the World*, trans. Siân Reynolds, New York: Harper and Row, 1984, quoted in Mbembe, 'At the Edge of the World,' p. 259.
3 Achille Mbembe and Janet Roitman, 'Figures of the Subject in Times of Crisis,' *Public Culture*, no. 16, winter 1995, p. 324.
4 See Glorgio Agamben, *Means Without End: Notes on Politics*, trans. Vincenzo Binetti and Cesare Casarino, Minneapolis: University of Minnesota Press, 2000.
5 See Michael Hardi and Antonio Negri, *Empire*, Cambridge, Mass.: Harvard University Press, 2000, p. xv.
6 Ibid.
7 Frantz Fanon, *The Wretched of the Earth*, New York: Grove Press, 1963, pp. 35–36.

8 Jürgen Habermas, *The Theory of Communicative Action*, vol. 2, *Lifeworld and System: A Critique of Functionalist Reason*, trans. Thomas McCarthy, Boston: Beacon Press, 1987, p. 151.

9 V.Y. Mudimbe, *The Invention of Africa: Gnosis, Philosophy, and the Order of Knowledge*, Bloomington and Indianapolis: Indiana University Press, 1988, p. 4.

10 See Gerardo Mosquera, 'Some Problems in Transcultural Curating,' in *Global Visions: Towards a New Internationalism in the Visual Arts*, ed. Jean Fisher, London: Kala Press, 1994, pp. 133–39.

INDEX

'A Picture is No Substitute for Anything' (art project) 257
Aboriginal art 306–18
Abraham, Nicolas 284
abstract art 23–31, 157, 169–74
Abstract Expressionism xx, xxi, 20, 38, 174, 176, 180, 191, 231, 232, 312
Abstraction
 Geometrical and Non-Geometrical 23
 in poetry 226–7
Acconci, Vito 269n
Ad Hoc Women Artists Committee 196
Adams, Alice 275
Adams, Ansel 149
Adorno, Theodor 32, 175, 188, 238, 303
advertising 111, 113
aesthetic emotion xx, 6
aesthetic self-consciousness/ self-reflexiveness 32, 36
aestheticism 56–61, 148–50
Africa 323
African sculpture 83
 see also 'negro sculpture'
Agamben, Giorgio 322
A.I.R. gallery 197
Air Show 206
Alhalkere: Paintings from Utopia (exhibition) 307–17
alienation 162–3
allegory 267–8
Altenrath, Renee 194
Althusser, Louis 306
amateurization 160, 161–3

ambiguity 33–4, 35, 84–5, 86
American Civil War 136
Americanisation 289
L'Amour fou. Photography and Surrealism (exhibition) 114
anaesthetic 159–60, 163
Analytical Art (journal)212n
anarchism 47, 51
Anderson, Laurie 194
 Americans on the Move 267–8
 United States 261
Andre, Carl 172, 175, 185, 191, 193
 144 Magnesium Square 186
anthropocentrism 281
anthropomorphism 279–80
Antiform 167
Antin, Eleanor 194
apartheid 297, 298, 299
Apollinaire, Guillaume 83
aporia 316–17
Apple, Jacki 194
Araeen, Rasheed 248n, 297
Aragon, Louis 123, 131n
Arbus, Diane 142, 159
Armajani, Siah 194
Arnold, Matthew 291
Arp, Hans 15n, 93
art
 definitions of 289
 of living 97
 as object 210–11
 as politics 233
 and praxis of life 58–61
Art & Language group 152, 168, 191, 205, 206, 208–11
 Index 01 210, 211

l'art conceptuel: une perspective
 (exhibition) 168, 205
Art Deco 187
art informel 159
Art Institute of Chicago, 73rd
 American Exhibition 216
Art International (journal) 192,
 275
Art Workers' Coalition (AWC)
 193, 197
Art-Language (journal) 209, 211,
 212n
Artaud, Antonin 227
Arte Povera 154
Artforum (journal) 168, 268, 279
artist, status of 210–11
Artists Meeting for Cultural
 Change 197
Arts Council of Great Britain 235
Arts Magazine (journal) 155
Asher, Michael 215, 216
aterritoriality 322
Atget, Eugène 140–1, 159
Atkinson, Terry 206, 212n
Australia, aboriginal art 288,
 304–18
auteurism 142, 158–9, 163, 258
automatism 119–20, 121, 130
autonomous art 152
avant-garde xxi, xxii, 36–7, 159
 historic 61n
 and neo-avant-garde xxi,
 53–106, 98–106, 152
 and photography 109, 147,
 150
 and postcoloniality 317–25
Aycock, Alice 194
Ayres, Gillian 235, 236, 248n

Bainbridge, David 212n
Baker, Kenneth 319n
Baldwin, Michael 206, 212n
Ball, Hugo 15n

Banes, Sally 269n, 274n
Baranik, Rudolph 193
Baron, Jacques 131n
Barr, Alfred H. xix, 20, 22–3, 26,
 27–8
 Cubism and Abstract Art (exhi
 bition and essay) xix, 3, 22,
 24–5
Barry, Robert 192, 214
Barthes, Roland 159, 220, 273n
 Mythologies 255
 The Pleasure of the Text 255
Bartlett, Jennifer 194
Bartok, Béla 33
bas-relief 92
Bataille, Georges 132n
Baudelaire, Charles 15n, 33, 35,
 36, 117, 133, 206
 Le Cygne 141
Baudrillard, Jean 260n
Bauhaus 32, 47, 121, 149
Baumgarten, Lothar 218
 Imago Mundi 301
Baxter, Iain and Ingrid (Elaine)
 192
beauty, convulsive 120, 128–9, 131
Becher, Hille and Bernd 191
Beckett, Samuel 34
Bell, Clive xix, xx, 3, 19
 'The Aesthetic Hypothesis'
 3, 4
 Art 4
Bellini, Giovanni 146
Bellmer, Hans 160
 Dolls 127
Bénamou, M. 261
Benjamin, Roger, 'A New
 Modernist Hero' 309–11, 315
Benjamin, Walter 32, 48, 109, 110,
 115, 123, 140, 151, 238, 304n
Benstock, Shari 248n
Béranger, Pierre de 227
Bergson, Henri 87, 188n

Berlin College of Art 112n
Berlin Wall 47
Bernard, Claude 52
Bernard, Émile 77–8
Bertillon, Alphonse 124
Beuys, Joseph 160, 205
Bhimji, Zarina 240
Biederman, I. 77
binarism 249–50, 295
Birnbaum, Dara 254, 255
 Technology / Transformation: Wonder Woman 255
Biswas, Sutapa 240, 246n
black
 masculine identities 296
 popular culture 290–97
 as term/ signifier 290, 295
 women 230, 243
Blake, William 37n, 201
Der Blaue Reiter (*The Blue Rider*) 17
Blossfeldt, Karl 109
 Urformen der Kunst 110
Blue (film) 302
Boccioni, Umberto 16n
Bochner, Mel 191, 277
 Measurement series 216
bodies
 of black men and women 293
 of painters and women 229–39, 254–5
 of women, presented, as fetishism 264
body art 214, 225, 260–73
 and distancing devices 263–4
 as naive essentialism 261, 262–6, 267
Bogosian, Eric 254
La Bohème 259n
Boiffard, Jacques-André 116, 131n
 The Big Toe 121, 121, 130
boundary-maintaining systems 321

Bourgeois, Louise 225, 274–84
 Cumulous 277
 Double Negative 276, 277
 latex works 280–1
 Portrait 280
 Le Regard 277, 278
 Soft Landscapes 280, 281
Bowery, New York, photographs 143–5
Brady group 136
Brancusi, Constantin 10, 16n, 187
 Fish 12
Braque, Georges 32, 53, 55, 65, 66, 69, 71, 84, 202
 and collage 89–94
 still lifes 67
 and tactility 86–8
 Castle at la Roche-Guyon 66–7, 68
 Clarinet, Bottle of Rum and Newspaper on a Mantelpiece 86
 The Emigrant 87
 Fruit Bowl 91
 Man with a Guitar 90
 Mandora 66–7, 67, 88
 Still-Life with Fishes 86
 Still-life with Violin and Palette 90
Brassaï 115, 116, 121, 147
 Involuntary Sculptures 116, 130
Braudel, Fernand 317–18, 321
Brecht, Bertolt 32, 34, 123, 264–5, 270
Breton, André 60, 61, 115–23, 128–9, 131n
 L'Amour fou 115, 121, 128–9
 First Manifesto of Surrealism 115, 117–18, 119, 131n
 Nadja 115
 Self-Portrait: L'Écriture

Automatique (Automatic Writing) 122, 123
'Surrealism and Painting' 118–19
Brody, Anne Marie 311
Broodthaers, Marcel 106n, 215
Brouwn, Stanley 194
Die Brücke (The Bridge) 17
brûlages 121
Bryson, Norman 272n
Buchloh, Benjamin 55, 98, 255
'Allegorical Procedures' 268
Buren, Daniel 106n, 215, 217
Within and Beyond the Frame 216
Bürger, Peter xxi, 55, 56
Theory of the Avant-Garde 56, 98–100, 102, 150
Burgin, Victor 194, 206–9
All Criteria 207
Burn, Ian 206, 212n, 312
Burr, Tom 218
Butler, Judith 225
Butler, Rex 288, 302–3

Cage, John 159, 270n
Caillois, Roger 281
California Institute of the Arts, Valencia 194
Callahan, Harry 149
cameras, automated 140
Capa, Robert 136
capitalism 46, 50, 94, 95–6, 141, 142–3, 168, 197, 209, 220, 289, 319, 320, 322
Carnap, Rudolph, *Scheinprobleme in der Philosophie (Illusory Problems in Philosophy)* 14
Caro, Anthony 175, 184
Early One Morning 184
Carr, C. 270n
Carrive, Jean 131n
Cartier-Bresson, Henri 138, 147

Centre for Contemporary Cultural Studies, Birmingham 290
Centro de Arte y Comunicación, Buenos Aires 194
Century City (exhibition) 317
Cézanne, Paul 3, 4, 5–6, 19, 38, 48, 51, 52, 63, 64, 65, 77–8, 80, 82–3, 202
Still-Life with Plaster Cupid 64
Three Bathers 5
Chandler, John 192
chaos 317, 323
Charcot, J.M. 266
Chateaubriand, René, Vicomte de 118
Chelsea Book Club 8
Cheney, Sheldon 3
Expressionism in Art 18
A Primer of Modern Art 18
The Story of Modern Art 18–19
Chicago, Judy 276
Dinner Party 234, 270n
children's art 24, 30, 78–80, 79
Chinese art 9–10, 80
Chirico, Giorgio de 118
Civil Rights movement 167
Cixous, Hélène 251, 258
Clark, T.J. 3, 38
Farewell to an Idea 38
Clearwater, Bonnie 272n
coherence 84, 84–5
collage xx, 89–94, 122, 203, 255
Collage (exhibition) 89
colour 22, 32, 92, 100–1, 170, 173, 182–4
absence of 65
materiality of 100
see also monochrome painting
commodification of art 217, 220, 301
commodity 143

commodity aesthetics 61
Communism
 Soviet 319
 War 47–8, 49
Conceptual Art xxii, 55, 109, 145,
 148–64, 167, 168, 189–98,
 205–12, 214, 270n
 exhibitions 194–6, 205
concrete poets 205
Conner, Bruce 139
Constant, Benjamin 118
construction xx, 92–3
Constructivism xx, xxi, xxii, 55,
 98, 161
contingency 49–51
contour lines, floating 64
contours 76, 92
 floating 82
convention 198–201
Cooper, Paula 193
Corot, Camille 52
Courbet, Gustave 51, 52
Crane, Hart 226
Crevel, René 131n
Cronkite, Walter 141
Cubism xx, xxi, 10, 19, 34, 38, 45,
 48, 49, 55, 62–88, 169, 203
 Analytical and Synthetic 92
 and collage 89–94
 denotation systems of 81–3
 drawing systems of 83–4
cultural hegemony 290, 293–4
cultural politics 290–1
'Culture in Action' (art project)
 221n
cultures, curating and curated 321

Dadaism xx, xxi, 20, 45, 55, 57,
 59, 60, 98, 124, 130, 161, 255,
 322
Daguerre, Louis 148
Dalí, Salvador 120, 121, 280
 The Phenomenon of
 Ecstasy 124
D'Annunzio, Gabriele 36
Darboven, Hanne 191, 194
David, Jacques-Louis 19, 45, 49
 Marat 38
Davis, Ron 173
de Kooning, Elaine 3
 The Spirit of Abstract
 Expressionism: Selected
 Writings 20
 Untitled 21
De Kooning, Willem 180, 312
Debord, Guy, The Society of the
 Spectacle 161
decolonization 318
dehumanization 34
Deleuze, Gilles 260n
 and Guattari, Felix 256
 body without organs 256
Delteil, Joseph 131n
Denes, Agnes 194
Denis, Maurice 20
denotation and drawing systems
 78–81
 Cubist 81–4
 grammar of 81
depiction, art as 157–9, 163–4, 169
depoliticization 142
Derrida, Jacques 131n, 132n, 255,
 298, 301–3
 'Before the Law' 314
 'Force of Law: "The
 Mystical Foundation of
 Authority"' 316–17
Descartes, René 178, 214
design 7
Desnos, Robert 131n
Detmold, M.J., 'Law and
 Difference: Reflections on
 Mabo's Case' 313
Deutsche, Rosalyn 221n
différance 314
difference 262, 267–8, 290, 292,

293–7, 303
Dion, Mark
 New York State Bureau of
 Tropical Conservation 221n
 On Tropical Nature 218, 219
distanciation 263–4
Documenta (exhibition) 324
Documenta 5 211
Documenta XI 290, 296, 318–20
documentary 139, 140–2, 154
Documents 115–16
Donarski, Ray 191
doubling 126–8, 129–30
Doyle, Tom 191
Drexler, Arthur 281
Drieu la Rochelle, Pierre 96
Dubuffet, Jean 227
Duchamp, Marcel 59–60, 129,
 170, 192, 194, 198, 203–4, 298,
 302
 Bicycle Wheel 203
 Bottle Rack 203
 Etant Donnés 302
 Green Box, notes on 302
 Network of Stoppages 203
 Ready-Mades 60, 62n, 100,
 103, 159, 160, 194, 206
 Urinoir (Fountain) 62n
 works on glass 203
Dunlap, Doree 194
Duras, Marguerite 258–9n
Dürer, Albrecht 146
Durham, Jimmie 218
Durrant, Jennifer 235
Dwan Gallery 275

earth art 154
'*Eccentric Abstraction*' (exhibi-
 tion) 194, 273, 275–83
École de Paris 47
Eisenstein, Sergei 33
Eliot, T.S., *Four Quartets* 311
Éluard, Paul 15n, 131n

embodiment 179, 267
emic and etic approaches (to
 'primitive' cultures) 306–7, 316
Empire 320–22
Enwezor, Okwui 290, 319
eroticism in art 87
Escher, M.C. 74, 85
Euclid 24
eurocentrism 296
Evans, Walker 144, 147, 156, 162,
 255, 260n
exhaustion and reaction 25–6, 31
'*The Experience of Painting:*
 Eight Modern Artists' (exhibi-
 tion) 235–6
Expressionism xx, xxi, 55, 61n,
 205, 260n

The Face (magazine) 293
factography 149, 150
Fanon, Frantz 291, 323, 323–5
Fauvism 17
Feininger, Andreas 260
feminism 189, 196, 225, 227–46,
 261–4, 293
 'antipleasure' tendency in
 270n
 see also women
Fer, Briony 225, 274
fetishism 251, 253–4, 266, 293
Feyzdjou, Chohreh, *Sans titre*
 [*Boutique Product of Chohreh*
 Feyzdjou] 300, *301*
Fiedler, Leslie 159
55 gallery 197
Fischbach Gallery, New York
 194, 273
Flaubert, Gustave 238
Fluxus 55, 192, 193
Flynt, Henry 192
Fontana, Lucio 102
form 19, 24
 significant xx, 6–7, 19

formalism 139, 143, 156, 198–9, 237, 261
Fortune (magazine) 156
Foster, Hal 291
Foucault, Michel 256, 259n
fragmentation 34, 86
Frank, Robert 163
Frankenthaler, Helen 169, 232, 242
 Mountains and Sea 242
Frankfurt School 272–4n
Franklin Furnace Archive 197
Freud, Sigmund 52, 100, 253, 266, 282
 'Fetishism' 254
Fried, Michael 20, 52, 155, 169, 173, 175, 184, 214, 274, 280
Friedlander, Lee 148, 162–3
Fry, Roger xix, 3, 4, 20, 26
 'Essay in Aesthetics' 3, 7
Fry, Tony 318n
functional site 219
Futurism xx, xxi, 55, 61n, 203, 322

Gabo, Naum, and Pevsner, Antoine, *Realistic Manifesto* 100
Galerie Surréaliste 118
Gallop, Jane 260n
 Feminism and Psychanalysis: The Daughter's Seduction 253
Gauguin, Paul 17, 201, 202
gay and lesbian movement 293
gaze, male 266, 268
gender 225, 227–48
geometry 24
Gérard, Francis 131n
Géricault, Théodore 52
gesture 20, 22
Gibson, J.J. 70
Gide, André, *The Counterfeiters* 32
Giedion-Welcker, Carola, *Modern Plastic Art* 3, 10

Gilbert & George 194
Gilroy, Paul 293
Ginsberg, Allen 226
 It Is 226
Glier, Mike 254
'global postmodern' 290, 292–4
globalisation xxii, 289–325
Goethe, Johann Wolfgang von 112
Goldwater, Robert 3
 Primitivism in Modern Art 16
Golub, Leon 193
Gombrich, E. H. 257
Gonzalez, Julio 93
Gooding, Mel 235
Goya, Francisco de 19
Graham, Dan 153, 154, 156, 191
 Homes for America 156–7
grammar, pictorial 73–4, 81, 84, 85
Gramsci, Antonio 294
Graña, César 36
grand narratives 294, 320
Grandville, Jean-Jacques, *Fleurs animées* 111
Greek art 7–8, 185–6
Green, André 281–2
Green, Renée 218
Greenberg, Clement xx, xxi, xxii, 20, 55, 155, 156, 157, 159, 169, 198, 231, 236, 237, 242, 262, 263, 265
 Art and Culture 90
 'Avant-Garde and Kitsch' 3
 'Collage' 89–90
 'Modernist Painting' 3, 158, 167, 206
 'The Pasted-Paper Revolution' 89
 'Seminars' 198
Gris, Juan 93
Grosz, George 33
Grotheus, Dr 302
Ground Zero 290, 319, 323
Group Material 218

'Groupe d'information de prisons'
 259n
Guerrilla Art Action Group
 (GAAG) 193
Guerrilla Girls 197
Guston, Philip 310
Haacke, Hans 106n, 215, 216
 Condensation Cube 216
Haas, Ernst 232
Habermas, Jürgen 142, 236, 323
Hall, Stuart 288
Hamilton, Richard 302
Happenings 55
Hardt, Michael, and Negri,
 Antonio, Empire 319–20
Hare, Chaucey 139
Harper's Bazaar (magazine) 155
Harrison, Charles 168, 205, 237
Hassan, Jamelie 299
Hatoum, Mona 240
Hausmann, Raoul 124, 130
Haussmann, Georges Eugène,
 Baron 51
Hayward Gallery, London 114
Heartfield, John 123, 130, 141, 160
 A New Man - Master of a
 New World 39–41, 41, 43, 44,
 47
Hegel, G.W. F., Lectures on
 Aesthetics 58, 253
hegemony 323
Heine, Heinrich 39
Hendricks, Jon 193
Herder, Johann Gottfried 112
Hesse, Eva 175, 185, 191, 225, 273,
 275, 277, 278, 280–1, 283
 Ingeminate 275
 Laokoon 279
 Metronomic Irregularity II
 275, 276, 284
 Several 275, 276
Hiller, Susan 240
Himid, Lubaina 240

Hindemith, Paul 16n
history painting 241
Höch, Hannah xix, 109, 112n, 124
Hodges, Christopher, 'Alhalkere'
 308–9
Holt, Nancy 194
Holzer, Jenny 240, 254
hooks, bell 295, 297
Huebler, Douglas 150, 153, 192
Hugo, Victor 118
human body, depiction of 26, 29
Hume, David 176, 180
Huot, Robert 192, 193
Hurrell, Harold 212n
Husserl, Edmund 69
Huyssen, Andreas, 'Mass Culture
 as Woman: Modernism's
 Other' 237–8
hybridity xx, 287, 293, 298–9,
 303, 304
hysterics, female 267

icon paintings 84
identity xxii, 168, 225, 243, 262
ideology 306
illusionism 172–3
Impressionism 7, 201–2, 206
individuality, crisis of 35
Industrial Revolution 158
Information (magazine) 205
Ingres, Jean-Auguste-Dominique 52
installations xx, 55, 214, 300, 303
Institut für Auslandsbeziehungen,
 Stuttgart (Institute for exter-
 nal relations) 302
institutional critique 215–17
intentional object, painting as
 62–3
internal visual representations
 71–81
International Klein Blue 105
Irigaray, Luce 232, 251, 253, 256
Islam 323–4

isomorphism 312
Ivins, William M., Jr. 135, 138

Jacobinism 47, 49
Jakobson, Roman 142
Jameson, Fredric 273n
 The Political Unconscious
 250, 258n
Jarman, Derek 304
 Blue 302
Jewish Museum 191
Jewish theology 110
John, Gwen 248n
Johns, Jasper 159, 170, 192
Johnson, Poppy 193, 196
Johnson, Samuel 8
Jones, Amelia 225, 260
Jones, LeRoi 227
Jost, Jon 139
Joyce, James 33, 238, 300–1
 Finnegans Wake 298
 Ulysses 32
 'Work in Progress'
 (*Finnegans Wake*) 15n
Judd, Donald (Don) 155–6, 172,
 173, 174–88, 181, 193, 275, 281
 'Abstract Expressionism' 175
 'Jackson Pollock' 179
 'Questions to Stella and
 Judd' 178
 'Specific Objects' 155, 179
 Untitled (1970) 182–4, 183
 Untitled (1972) 181–2, 182, 183
Julien, Isaac 295
justice 290, 304, 314–16
juxtaposition 32, 33

Kafka, Franz 34, 314
Kahnweiler, Daniel-Henry 68
Kaltenbach, Stephen 192
Kandinsky, Vassily 19, 28, 32, 111,
 202–3
Kant, Immanuel 150

Keats, John 227
Kelly, Ellsworth 102
Kelly, Mary 225, 240, 261
 and body art 261–6, 267,
 269–70n
 Corpus installation 264, 266
 Interim project 264, 271–2n
 Post-Partum Document 249,
 251–2, 271n
 'Re-Viewing Modernist
 Criticism' 261–2
Kertész, André
 Distortions 127–8
 Meudon 147
Kitchel, Nancy 196
kitsch 160
Klee, Paul 111, 118, 202
Klein, Melanie 282
Klein, Yves 98, 101, 103–5
Kline, Franz 309
Kngwarreye, Emily Kame
 [Kngwarrey, Emily Kam]
 304–17
 Alhalkere Suite 307
 Ankerr Mern-Intekw 308
 Anooralya II 309
 Body Paint: Awelye I–VI 315
 Untitled (Awelye) 315
 Utopia Panels 310, *310, 314*
Kolbowski, Silvia 218
Kosuth, Joseph 150, 191, 192, 193,
 212n
Kozloff, Max 280
Kozlov, Christine 196
Krasner, Lee 242
Krauss, Rosalind 10, 109, 114–32
Kristeva, Julia 232, 238, 243
 Théorie d'ensemble 259n
 'Women's Time' 243, 244–6
Kroker, A., Kroker, M., and Cook,
 D., *Panic Encyclopedia* 298
Kruger, Barbara 225, 240, 257–8
 Untitled, (Your Body is a

Battle Ground) 257, *257*
Kuehn, Gary 275
Kuffler, Suzanne 196
Kupka, Frank 202
Kusama, Yayoi 268, 275, 278,
 282–3
Kwon, Miwon 168, 213

Lacan, Jacques 251, 254, 262, 264,
 267, 269n, 273n, 305
 Écrits 251
 Real, the 305, 306, 318
land/earth art 214
language 80–1, 144–5
Lasch, Pat 196
Lawler, Louise 255
 'A Movie without the Picture'
 255
Leapman, Edwina 235
Lefebvre, Henri, *Critique of
 Everyday Life* 55, 94
Léger, Fernand 93, 202
Leider, Philip 167, 168
Lemoine-Luccioni, Eugenie 259n
Lennon, John 189
letters in pictures 86, 90–1
Lévi-Strauss, Claude, 'Do Dual
 Organisations Exist?' 305
Levine, Sherrie 225, 254, 255–6
LeWitt, Sol 190, 191, 193, 276
life, everyday 94–8
Limbour, Georges 131n
Lindell, John 218
Lindsay, Vachel 227
Lippard, Lucy 167–8, 189, 270n,
 273–81
 'Eccentric Abstraction' 279
 *Six Years: The Demateri-
 ization of the Art Object
 from 1966 to 1972* 190, 197
 and Chandler, John, 'The
 Dematerialization of Art'
 192, 205

Lissitzky, El 52, 101, 104
 and Moholy-Nagy, László,
 The Isms of Art xix
literalism 169, 172–4
literalness 273
Locke, John 86
Lomax, Yve 240
Long, Richard 150, 153, 154, 205
 A Line Made by Walking 151
Lonidier, Fred 139
Louis, Morris 169, 170, 242
Lukács, Georg 32
Lunn, Eugene 3, 31–2
 Marxism and Modernism 32
Lyotard, Jean-François 249, 251

Maar, Dora, *Ubu* 121
Mabo decision 313–14
McDonald, John 311
McEvilley, Thomas 306, 312
McShine, Kynaston 191, 194
Maestro, Lani 297
Magritte, René 115, 120, 121
Maharaj, Sarat 288, 295–6
Malevich, Kasimir 45, 49, 51, 100,
 101, 104, 179, 202, 312
 *Complex Presentiment (Half-
 Figure in a Yellow Shirt)*
 39, 41, 42, *42*
Malkine, Georges 131n
Mallarmé, Stéphane 15n, 32, 227,
 238
Man Ray 115, 116, 121–2, 130, 154
 Marquise Cassati 127
 Monument à D. A. F. de Sade
 116, 117, 130
 Slipper-spoon 128, 129
Manet, Édouard 19, 51–2, 167
Mangold, Robert 191
Mangold, Sylvia Plimack 191
Manzoni, Piero 159
Marc, Franz 260n
Marcuse, Herbert 58, 272n

marginality 291
Marr, David 70–2, 74, 75, 85
Marx, Karl 250–1
 and Engels, Friedrich, *The
 Communist Manifesto* 258n
Marxism 32, 37, 45, 56, 110, 150,
 209, 250–1
 and body art 261, 262, 263,
 268, 273n
 and class struggle 304–6
 and sexual inequality 258n
masculine identities 296
mass culture 162
Masson, André 119, 121
mathematics, as analogy 24
Matisse, Henri 32, 51, 202, 310
 The Painter and his Model
 228, 229–30, 234, 236, 241
Mayakovsky, Vladimir 160
Mayer, Bernadette 196
Mbembe, Achille, 'At the Edge of
 the World: Boundaries,
 Territoriality, and
 Sovereignty in Africa' 320
Meegeren, Han van 104
Mendieta, Ana 268
 Body Tracks 271n
 Rupestrian Sculptures 271n
 Silueta series 260, 264–6,265
Menzel, Adolph, *Moltke's
 Binoculars* 39, 39, 43, 44, 45
Mercer gallery 197
Merleau-Ponty, Maurice 69, 87,
 175, 178, 188, 270n, 280
Mesens, E.L.T., *As We Understand
 It* 121
Meyer, James 219
Meyerhold, Vsevolod 32, 36
mimesis 152, 161
Minimal Art, Minimalism xx,
 xxii, 155, 167, 168, 174–88,
 189, 191, 193, 199, 213–16,
 270n, 273–5, 276, 278

Minotaure (journal) 115, 116, 130
Miró, Joan 93, 120, 121
 The Misfits 256
Möbus, Christiane 196
modernism (Modernism, modern
 movement) xix–xxii, 1–52,
 157–8, 167, 174, 205–12
 appeal for women 235–9
 Greenbergian modernism 261,
 262
 as term 287
Modotti, Tina, *Men Reading 'El
 Machete'* 44, 44
Moholy-Nagy, László xix, 110, 154
Moi, Toril 243
Mondrian, Piet 25, 101, 202
Monet, Claude 19, 52, 310, 311
monochrome paintings 100–5
Monroe, Marilyn 256
montage xx, 32–3, 35, 93, 127, 255,
 268
 see also photomontage
Montrelay, Michèle 251
Moreau, Gustave 118
Morimura, Yasumasa 297
Morise, Max 131n
Morris, Robert 176, 191, 192, 269n,
 275
Morrissey, Philip, 'Emily Kame
 Kngwarreye Meets the
 Metropolitan' 311
Mosquera, Gerardo 323
Mudimbe, V.Y. 323
Müller, Christian Philipp 218
multiculturalism 292, 301
Mulvey, Laura 262
 'Visual Pleasure and
 Narrative Cinema' 251, 271n
Murrow, Edward R. 141
Musée d'art moderne, Paris 205
Museum of Modern Art, New
 York 89, 109, 132, 170, 191, 193,
 194, 225, 306

music 14
musical instruments, depicted 87
Muybridge, Eadweard 137, 154
Myers, Rita 196

N. E. Thing Co. 192, 196
Nahum, Renee 196
Namuth, Hans 231, 232, 236
narrative painting 136
nature 35–6
Nauman, Bruce 150, 153, 154, 273,
 275, 277, 279, 280–2
 Dance or Exercise on the
 Perimeter of a Square
 (Square Dance) 154
 Failing to Levitate 153
Naville, Pierre 118, 131n
Neale, Margo 307, 318
 'Two Worlds: One Vision' 311
Necker illusion 85, 85
negative printing 122, 126, 127
'negro sculpture' 7–10
Nemser, Cindy 242
neo-avant-garde see avant-garde
Nerval, Gérard de 52
Neue Sachlichkeit 121
New Architecture 13, 14
New Left 152
New York School 225
New-York Daily Tribune 133
Newman, Barnett 175, 176–7,
 180–1, 312, 319n
 Vir Heroicus Sublimis 171,
 177
Nietzsche, Friedrich 35, 47, 157
1965–1975: Reconsidering the
 Object of Art (exhibition) 189
Nixon, Mignon 284n
Nixon, Richard M. 193
NKA: Journal of Contemporary
 African Art 319
Nolan, Sidney 312
Noland, Kenneth 169, 170, 242

Nolde, Emil 32
Nolden, Ulrike 196
Noll, Marcel 131n

object-centred descriptions 75–80,
 75
objecthood 273
objectness 169–70
October (journal) 267
O'Dell, Kathy 269n
O'Hara, Frank xix, 52, 225–6
Oldenburg, Claes 279–80
Olitski, Jules 169, 170, 312
Op Losse Schroeven (exhibition)
 205
Oppenheim, Meret, Fur Teacup
 275
orientalist painting 246n
originality 99–100
originary forms 110–11
The Other Story (exhibition) 248n
Owens, Craig 225, 249, 268–9
 'The Allegorical Impulse' 267
 'The Discourse of Others:
 Feminists and Post-mod-
 ernism' 268–9
Oxford Art Journal 274

painting 14
 and depiction 157–8
Panic Hamburgers 300
paper and cloth, pasted onto pic-
 tures 91–2, 93
papiers-collés 88n
paradox 33–4, 35
Paris 51, 167, 248n
 May 1968 events 167
Parker, Roszika 232
passage 64–5, 85
patriarchalism 259n, 264
Patton, Paul 316
Pearson, Noel 319n
Peirce, C.S. 132n

The Penrose Triangle 74
perception, direct 70
Péret, Benjamin 118, 131n
performance art xx, 55, 154, 167,
 214, 225, 260–1, 267, 268
Perniola, Mario 260n
Persian miniature painting 80
perspective 29, 81, 83, 90
 Cubism and 66–9
 oblique 80, 83
phallocentrism 255, 263
phallus
 presence or absence as sexual
 difference 262
 as signifier 253–4
Phelan, Peggy 269n
phenomenology 69–70, 71, 174–5,
 176, 178, 188, 215, 262
Philadelphia Museum 204
philosophy 14
photo collage 122–4
photo-essays 143, 156
photoconceptualism 150–2, 153,
 162–4
The Photographer's Eye (exhibi-
 tion) 132
photography xxi, 109–64, 208,
 231, 252, 255–7
 art-photography 150–3, 158,
 163
 as body art 264–5, 268
 conceptual and post-concep
 tu al 143, 145–64
 and detail 135–6
 documentary 139, 140–2
 film-still format 258, 261
 and frame 136–7
 history of 133–4, 138–9
 and language 124
 police 140
 and reality 135
 and time 137–8
 vantage point 138–9

photojournalism 147–8, 152–7
photomontage xix, 109, 112–14,
 122, 123–4, 136
 free-form 114
photoreportage 113
physics 14–15
Picasso, Pablo 10, 18, 25, 32, 45,
 51, 55, 63, 84, 118, 202, 203
 and African sculpture 83
 and Bernard 78
 and collage 89–94
 pictorial grammar of 81
 sculptures 63
 statements on art 66, 68
 and tactility 86, 87
 Brick Factory in Tortosa 65
 Figure 65
 *Houses on the Hill, Horta
 d'Ebro* 62–88
 Italian Woman 39, 41, 42–3
Picon, Pierre 131n
Pictorialism 145–9, 153
picture primitives 78, 80, 81, 86
Pilkington, Philip 212n
Ping, Huang Yong 299
Piper, Adrian 196
Pirandello, Luigi 32
Pissarro, Camille 38, 45, 49, 51, 52
plants, photographs of 110–12
plastic art *see* sculpture
poetry 14, 226–7
Pointillism 201
Pollock, Griselda 225, 227–9, 261,
 263–4, 266, 270n, 271n
 and Parker, Roszika, *Old
 Mistresses* 232
Pollock, Jackson 45, 48, 50, 51,
 167, 168–74, 175, 177, 202, 242,
 282, 311, 312
 Autumn Rhythm 179
 photographed by Namuth
 231, 232, 235, 236
Pop Art xx, 151, 159, 160, 162, 167,

275
Porter, Eliot 260n
positivism 35
Post-Impressionism 5, 202
 exhibitions 4
post-Minimalism 207, 273
'post-object art' 205
postcolonialism/ postcoloniality
 217, 288, 320–25
postmodernism/ postmodernity
 xxi–xxii, 45, 205, 237, 287
 and blacks 292–3
 and feminism 240–5,
 249–59
 as pastiche, allegory or mon-
 tage 267–9
 and postcoloniality 320
poststructuralism 261
 and feminism 255
Potter, Sally 259n
Potts, Alex 167, 174–5
Pound, Ezra 33
primal sketch 72–3
'Primary Structures' exhibition 191
'primitive' art, primitivism 7–10,
 15, 16–18, 24, 30–1, 287–8,
 292–3
 American 80
'Primitivism' in 20th Century Art:
 Affinity of the Tribal and
 Modern (exhibition) 306, 312
Prince, Richard 254
Process Art 167, 214
productivism 149
Proust, Marcel 33
psychoanalysis 209, 234, 266,
 269n, 273n
psychoanalytic theory 273
'psychopathic' art 30
'pure' art 27–8

Queensland Art Gallery 307
'queer' forms of speech 226

racial identity 296–7
racism, cultural 292
Ramsden, Mel 206, 212n
Raphael 68, 146
Rauschenberg, Robert 102
rayographs 121–2, 127
Read, Sir Herbert xix
 Art Now xix
Reagan, Ronald 294
realism 57, 140, 143, 206, 208
reductivism 157–64
referential and expressive func-
 tions 142
Reinhardt, Ad 191, 192, 193, 275
Rejlander, Oscar 136
religious art 11, 26, 29
Rembrandt van Rijn 312
Renaissance art 29
repetition 100, 101–2, 126
reportage 148, 153, 156
representation 6, 158, 163
La Révolution surréaliste 115, 118,
 127, 131n
Richter, Gerhard 159
Ricoeur, Paul 159
Riegl, Alois, Stilfragen (Questions
 of Style) 112n
Riis, Jacob 252
Riley, Bridget 235
Riley, Denise 240
Rimbaud, Arthur 15n, 47
Robbe-Grillet, Alain 227
Robinson, Henry Peach 136
Rodchenko, Alexandr 98, 104
 Pure Colors: Red, Yellow,
 Blue 100–1, 103, 105
 'Working with Mayakovsky'
 101
Roitman, Janet 320
romanticism 35, 45
Rose, Jacqueline 234
Rosenbach, Ulrike 261

Rosenberg, Harold 231
 'American Action Painters'
 3, 20
Rosler, Martha 225, 240, 249, 250,
 251, 254
 The Bowery in Two
 Inadequate Descriptive
 Systems 139,
 143–5, *144*, 249, 252–3, 253
Rothko, Mark 312
Rousseau, Henri 18
Rubin, William 131–2n, 304
Ruisdael, Jacob van 202
Ruscha, Edward 162–3, 192
 Some Los Angeles Apartments
 162–3, *162*
 Twentysix Gasoline Stations
 163
Rushton, David 212n
Ruskin, John, *Political Economy of*
 Art 24
Russell, Bertrand 14
Russia 47, 49
 October revolution 61n
Ryan, Judith, '"In the Beginning
 is My End": The Singular Art
 of Emily Kame Kngwarreye'
 309
Ryman, Robert 191, 281

Sade, D. A. F., Marquis de 118
Said, Edward 258n
Sala Mendoza, Caracas 218
Salcedo, Doris 297
Samaras, Lucas 283
Santería rites 264, 266
Sayre, Henry 269n
Schapiro, Meyer 3
 'The Nature of Abstract Art'
 23
Schiele, Egon 260n
Schiller, Friedrich 45, 161
Schneemann, Carolee 269

Schor, Mira 269n
Schwitters, Kurt 15n, 93
 Aphorism 92
scopic field 279, 282
Screen (journal) 270n
sculpture 7–16, 174–5
 African 7–10, 83
 construction 92–3
 Greek 185–6
 religious 11
 'Soft' 277, 278
Seattle Art Museum 194
Second World War 136
secularization 46
Sekula, Allan 109, 139
self and other 290, 299
self-criticism 57
self-expression 20
September 11, 2001, events 319,
 324–5
Serra, Richard 175, 176, 184, 185,
 193, 214, 217
 Tilted Arc 214, 219
Seurat, Georges 50, 52, 118, 201
sexism 233
sexual difference 262, 267–8
sexual inequality 258n
sexuality 234–5
shading 76, 82–3, 84–5, 90, 92
shadows (in drawings) 82
shape 71–5, 86
shapes
 pictorial representations of
 78–81
 rotating and comparing 76,
 76
Shelley, Percy Bysshe, *Prometheus*
 Unbound 43–4
Sherman, Cindy 225, 240, 256–7,
 261
 Untitled Film Still 256
Siegelaub, Seth 192
signs and signifiers 126, 129–30,

231

silhouettes 76, 92
Silvianna 193
simplicity 17–18
simplification 6
simultaneity 32–3, 35, 126
Siskind, Aaron 149
site-specific/ site-oriented art
 213–20
Situationists 94, 299
slang lexicon 144–5
Smith, Adam 46
Smith, Paul 55, 62, 260n
Smith, Terry 316n
Smithson, Robert 150, 153, 155,
 156, 189, 191, 193, 215, 216, 217,
 279
 'The Crystal Land' 155
 'Incidents of Mirror-Travel
 in the Yucatan' 155
 'The Monuments of Passaic'
 155
socialism 47–8
Society for Theoretical Art and
 Analyses 212n
'Soft and Apparently Soft
 Sculpture' (exhibition) 278
'Soft Sculpture' 277
solarization 122, 126, 127
solitude, human need for 96–7
Sommer, Frederick 127
Sonnier, Keith 275, 278
soufflage 132n
Soupault, Philippe 131n
spacing 126–30
spatial devices 84–5
spatial form 33, 35
spatiality 318
spectator, suppression of 208–10
Spence, Jo 240
Spero, Nancy 193
Spivak, Gayatri 295, 299
Sri Lanka 300–1

Stable Gallery 281
Stein, Judith 196
Steiner, George 303
Steinmetz, Philip 139
Stella, Frank 168, 169–74, 188n
 Six Mile Bottom 171
 Wolfeboro or Moultonboro
 series (Irregular Polygons)
 173–4
Stenger, Professor Erich 113
Stevens, Wallace 52, 227
Stieglitz, Alfred 145–6
 Flatiron Building 146
Still, Clyfford 170
Strand, Paul 147
Stravinsky, Igor 14, 33
Strider, Marjorie 192
Strzemiʃski, Vladislav 101
Student Mobilization 193
student movement 152
subjectivism 150
subjectivity, regime of 320–21
sublation of art 58–61
Sundaram, Vivan 299
Suprematism 38
Surrealism xx, xxi, xxii, 20, 24,
 55, 61, 98, 109, 160, 161, 275,
 279, 322
 and photography 109, 114–32
Le Surréalisme au service de la
 révolution (Surrealism in the
 service of the revolution) 115
Swift, Jonathan 118
Sydney Biennale '93 302
Sydney Morning Herald 313
symbolism 35
Szarkowski, John xxi, 109

Tabrizian, Mitra 240
tabula rasa 321, 325–6
Tacha, Athena 196
tactility 66–71, 83, 85–8, 104
Taíno Indians 266

Tate Modern, London 317
television 142–3
temporality 320, 321
'Ten' (exhibition) 275
Terror 49
Thatcher, Margaret 294
Thénot, J.P. 78
Third World, decolonization 291
three-dimensionality 8–9, 76, 172,
 174, 176
 and 2 $\frac{1}{2}$D sketch 72–5, 77,
 80, 82–3, 85
Thriller (film) 259n
Tillers, Imants 312
Titian 310
Tjakamarra, Michael Nelson 311
Tjapaltjarri, Clifford Possum 311
Toche, Jean 193
tonal contrast 72
Torok, Maria 284
touch, in Cubism 66, 69–71
translatese 297
translation 297–9, 300–4
transparency 302, 303, 304
trompe-l'oeil 90–1, 93, 119
Turner, J.M.W. 19
Tzara, Tristan 15n, 60, 130, 132n

Ubac, Raoul 116, 121
 La Nébuleuse 132n
 Woman/Cloud 121
Uccello, Paolo 118
Ukeles, Mierle Laderman 196, 215
 Washing Tracks/Maintenance:
 Inside 195
uncertainty 33–4
United States of America
 popular culture of 290–94
 and September 11, 2001,
 events 319, 324
 as world power 289, 291
unity 178–9, 211, 244
UNOVIS 45, 48, 49

untranslatability 297, 299, 303
Urformen (originary forms) 110–11

Valéry, Paul 45, 59
van Gogh, Vincent 52, 201
Vancouver Art Gallery 194
vector primitives 74–5, 74
Vergine, Lea 261
Vermeer, Jan 104
Vienna Circle (Wiener Kreis) 14
Vietnam war 167, 189, 193, 197
viewing position (for paintings)
 181–2
viewpoint, multiple 63–4
Villon, François 117
Viner, Frank Lincoln 191, 275
vision 119–20
visual processing 72–5
Vitrac, Roger 131n
Voyiya, Vuyile Cameron 299
VVV 127

Wall, Jeff 109, 145
Wall to Wall (exhibition) 303
Wallace, Michele, 'Modernism,
 postmodernism and the
 problem of the visual in
 Afro-American culture' 292–3
Warhol, Andy 103, 159
Weber, Max 45
Weiner, Lawrence 160, 192, 216
West, Cornel, 'The new cultural
 politics of difference' 291
Westerman, H.C. 275
Westernism 320–3
Weston, Edward 149, 255, 260n
When Attitudes Become Form
 (exhibition) 167, 205
Whistler, James A.M. 19
Whitman, Walt 201, 202, 226
Whitney Annual exhibition 196
Whitney Biennial 197
Wilde, Oscar 47

Wilenski, R.H. 19
Wilke, Hannah 270n
Willats, John 70–1, 85
Williams, Fred 314
Williams, William Carlos 226
Williamson, Sue 299
Willis, Anne-Marie 318n
Wilson, Fred 218
Wilson, Martha 196
Winnebago Indians 305
Winnebago village, plans *305*
Wolin, Ron 193
women
 art of 238
 black 230, 243
 bodies of 229, 238–9
 as fetish objects 265–6
 history of 240–2
 see also body art; feminism

Women's Action Coalition 197
Women's (Liberation) Movement
 189, 239
 see also feminism
Wonder Woman 255
Woodstock (rock festival) 167
Woolf, Virginia, *To the Lighthouse*
 33
Worker's Film and Photo League
 141
world art 304

Yates, Marie 240
Young Soul Rebels 297

Zizek, Slavoj 305–6, 312, 318
Zola, Émile 52

TEXT ACKNOWLEDGEMENTS

Bell, Clive: 'Simplification and Design', 1913, excerpts from *Art*, ed., J.B. Bullen, Oxford University Press, 1987, pp. 215–16, 219–20, 223–25, 228–29. Originally published by Chatto and Windus, 1920. © The Society of Authors as the Literary Representative of the Estate of Clive Bell.

Benjamin, Walter: 'News about Flowers', trans. Michael Jennings, from *Walter Benjamin, Selected Writings, Vol. 2: 1927–1934*, Michael Jennings, Howard Eiland and Gary Smith, eds., The Belknap Press of Harvard University Press, Cambridge, Mass., and London, 1999, pp. 155–7.

Buchloh, Benjamin: 'The Primary Colours for the Second Time: A Paradigm Repetition of the Neo-Avant-Garde' from *October*, no. 37, summer, 1986, pp. 41–52.

Bürger, Peter: excerpt from *Theory of the Avant-Garde*, 1974, 1984, University of Minnesota Press, Minneapolis, p. 14, p. 17, pp. 22–23, pp. 49–54. Originally published in German as *Theorie der Avantgarde*, copyright 1974, 1980 by Suhrkamp Verlag. English translation copyright 1984 by the University of Minnesota.

Butler, Rex: 'Emily Kame Kngwarreye and the Undeconstructible Space of Justice', from *Eyeline. Contemporary Visual Arts*, no. 36, Autumn/Winter 1998, pp. 24–30.

Cheney, Sheldon: from *The Story of Modern Art*, The Viking Press, New York, 1941. Reprinted by Methuen Publishing Ltd, 1958, pp. vi–viii.

Clarke, T.J.: excerpt from *Farewell to an Idea: Episodes from a History of Modernism*, 1999, Yale University Press, New Haven and London, pp. 1–13.

De Kooning, Elaine: 'Statement' from *The Spirit of Abstract Expressionism: Selected Writings*, George Braziller Inc., New York, 1994, pp. 175–6.

Enwezor, Okwui: 'The Black Box' from *Documenta 11*, exhibition catalogue, Documenta GmbH, Kassel, 2002, pp. 42–55.

Fer, Briony: 'Objects Beyond Objecthood' from *Oxford Art Journal*, vol. 22, no. 2, 1999, pp. 25–36.

Fry, Roger: 'Negro Sculpture', from *Vision and Design*, Oxford University Press, Oxford, 1981, pp. 70–73. © Annabel Cole.

Giedion-Welcker: *Modern Plastic Art. Elements of Reality, Volume and Disintegration.* English translation by P. Morton Shand, H. Girsberger, Zurich, 1937, pp. 7–8, 15–18.

Goldwater, Robert: 'A Definition of Primitivism', 1938, excerpt from *Primitivism in Modern Art*, pp. 250–53, 1986, Belknap Press of Harvard University Press, Mass.

Greenberg, Clement: 'The Pasted Paper Revolution', 1958, in *The Collected Essays and Criticism*, Vol. 4, *Modernism with a Vengeance: 1957–1969*, ed., John O'Brian, 1993, University of Chicago Press, Chicago, 1993, pp. 61–66.

— 'Convention and Innovation', from *Homemade Esthetics: Observations on Art and Taste*, Oxford University Press, New York, 1999, pp. 61–64.

Hall, Stuart: 'What is this "black" in black popular culture?', from Michelle Wallace, *Black Popular Culture*, Bay Press, 1992.

Harrison, Charles: 'Art Object and Art Work', from *L'art conceptuel, une perspective*, exhibi-

tion catalogue, Musée d'Art Moderne de la Ville de Paris, Paris, 1989, pp. 61–4.

Höch, Hannah: 'A Few Words on Photomontage', 1934, trans. Anne Halley, from Maud Lavin, Hannah Höch, *Cut with the Kitchen Knife: the Weimar Photomontages of Hannah Höch*, pp. 219–20, Yale University Press, New Haven and London, 1993.

Jones, Amelia: 'Postmodernism, Subjectivity, and Body Art: A Trajectory', from *Body Art, Performing the Subject*, University of Minnesota Press, 1998, pp. 21–31.

Krauss, Rosalind: 'Photography in the Service of Surrealism', from *'L'Amour Fou'. Photography and Surrealism*, exhibition catalogue, Hayward Gallery/Arts Council of Great Britain, 1986.

Kwon, Miwon: 'One Place After Another: Notes on Site Specificity', in *October 80*, Spring 1997, The MIT Press, Massachusetts, pp. 85–110.

Lefebvre, Henri: excerpt from *The Critique of Everyday Life*, 1947, trans. John Moore, 1991, Verso, London, pp. 196–200.

Leider, Philip: 'Literalism and Abstraction: Frank Stella's Retrospective at the Modern', *Artforum 8*, n. 8, April 1970, pp. 44–51.

Lippard, Lucy: 'Escape Attempts', from Anne Goldstein and Anne Rorimer, *Reconsidering the Object of Art*, exhibition catalogue, Museum of Contemporary Art Los Angeles/The MIT Press, Massachusetts, 1995, pp. 17–38.

Lunn, Eugene: 'Modernism in Comparative Perspective', 1982, excerpt of chapter from *Marxism and Modernism*, 1985, Verso, London, pp. 34–37.

Maharaj, Sarat: 'Perfidious Fidelity: the Untranslatability of the Other', from *Global Visions: Towards a New Internationalism in the Visual Arts*, ed., Jean Fisher, Kala Press, in association with the Institute of International Visual Arts, 1994, pp. 28–36.

O'Hara, Frank: 'Personism: A Manifesto', from Frank O'Hara, *Collected Poems*, copyright © 1971 by Maureen Granville-Smith, Administratrix of the Estate of Frank O'Hara. Used by permission of Alfred A. Knopf, a division of Random House, Inc.

Owens, Craig: 'The Discourse of Others: Feminists and Postmodernism', from *Postmodern Culture*, ed., Hal Foster, Pluto Press, London, 1985, pp. 64, 68–77.

Pollock, Griselda: 'Painting, Feminism, History', from *Looking Back to the Future: Essays on Art, Life and Death*, Gordon and Breach Arts International, 2001, pp. 73–89.

Potts, Alex: 'Space, Time and Situation', from *The Sculptural Imagination. Figurative, Modernist, Minimalist*, Yale University Press, New Haven and London, 2000, pp. 296–307.

Schapiro, Meyer: 'The Nature of Abstract Art' from *Modern Art. 19th and 20th Centuries. Selected Papers*, George Braziller Inc., New York, 1978, pp. 185–90, 195–202.

Sekula, Allan: 'Dismantling Modernism, Reinventing Documentary (Notes on the Politics of Representation)', from *Photography Against the Grain: Essays and Photo Works 1973–1983*, pp. 56–62, The Press of the Nova Scotia College of Art and Design, Halifax, 1984.

Szarkowski, John: Introduction to *The Photographer's Eye*, Museum of Modern Art, New York, 1969.

Wall, Jeff: 'Marks of Indifference: Aspects of Photography in, or as, Conceptual Art', from Ann Goldstein and Anne Rorimer, *Reconsidering the Object of Art 1965–1975*, exhibition catalogue, The MIT Press, Massachusetts, 1995, pp. 247–67.